LEONARDO DA VINCI

Daniel Arasse

LEONARDO DA VINCI

The Rhythm of the World

Translated from the French
by Rosetta Translations

KONECKY&KONECKY

ACKNOWLEDGEMENTS

The author warmly thanks Mmes Claire Lagarde and Lola Jimenez-Blanco, M. Carlo Pedretti
and, in particular M. Also Cecconi and the publishers Giunti,
for their valuable help and confidence.

Konecky & Konecky
150 Fifth Avenue
New York, NY

ISBN: 1-56852-198-7

Printed in Italy

CONTENTS

To the grace of Catherine, and for Urbi et Orbi

LEONARDO TODAY

With the exception of God, Leonardo da Vinci is undoubtedly the most written about of all artists. He has been the subject of very detailed studies, such as Carlo Pedretti's clarification of the use of the phrase "etc." in Leonardo's manuscripts. Meticulous surveys have been written about him, one of the most recent being that by Martin Kemp seventeen years ago.[1] He has inspired the most legitimate fantasies and the most absurd deductions. As his enormous production bears witness (it is said to include over a hundred thousand drawings and six thousand pages of notes), the extreme diversity of his interests has attracted specialists in many academic and artistic disciplines.

So what is the reason for yet another analysis of Leonardo's work? It is because this vast production, no bibliography of which could be complete, has benefited from recent work carried out by historians in many fields—art, science, literature, music and society. This has greatly changed our understanding of his work in its innumerable aspects by throwing new light on the objective understanding of Leonardo's legacy, and the way of reading and interpreting it. Leonardo has changed since the appearance of the various works published in 1952 to commemorate the five-hundredth anniversary of his birth: he has become rejuvenated.

The manuscripts are a case in point. These have been known since the end of the nineteenth century from the publications of Richter and Ravaisson-Mollien. It may be that Kenneth Clark was right in saying in his preface to the French edition of his book *Leonardo da Vinci* in 1967 that the discoveries made about the artist since the first edition of his book in 1935 were "relatively unimportant."[2] But as it happened, it was in 1967 that two of Leonardo's manuscripts were discovered in the Biblioteca Nacional in Madrid, an event whose importance was not to be ignored in the revival of Leonardo studies. Covering the period 1493–97, *Manuscript I* deals in a fairly coherent manner with a wide range of questions concerning mechanics and hydraulics, while *Manuscript II* is less homogenous and dates from 1491 to 1505. We learned from this manuscript, supported by its drawings, that in 1504 Leonardo had worked at Piombino with the title of military engineer, having been "lent" to its ruler Jacopo Appiani by the republic of Florence. This has enabled us to have a clearer picture of his activities in the field of military engineering, which

greatly contributed to his prestige at the time. The manuscript
of one hundred and sixteen books, representing just a part of his
mation that could not fail to change our perception of his cultura

In *Manuscript II* one can follow his work on the equestrian
Francesco Sforza step by step, learning that the technique he in
occasion was the same as would be used again in France in th
century for casting the equestrian statue of Louis XIV. Contrar
been thought, Leonardo was evidently planning to publisl
manuscripts since he invented a device for simultaneously prin
illustrations. In addition to various drawings that reveal his in
mechanisms, *Manuscript II* also provides exact information c
interests of which hardly anything was known, except that t
tributed much to his reputation.

The Madrid manuscripts did not simply provide detailed infor
also helped to clarify, in some cases decisively, the meaning of
sketches and fragments that were already known but difficult tc
is undoubtedly in the work of deciphering and arranging data, if
logically, that Leonardo studies have progressed most in the las
A better knowledge of his writing and its development during h
enabled certain floating texts to be dated with accuracy, and not
the same sheet at different dates can now be distinguished. Leonard
and drawings in a remarkably disorganized state, and their postl
ment, when they were cut and re-assembled in a most arbitrary v
this chaos. But with painstaking care, several parts of this gigantic puzzle have
been successfully rearranged. The re-insertion of a fragment into the sheet of
which it was originally part does not always provide interesting information,
but it can sometimes be illuminating. For example, when the two little figures
from the Royal Library at Windsor (RL, 12461r and 12720) were re-inserted
in folio 358v-b of the *Codex Atlanticus*, they appeared next to a piece of stage
machinery, and it became clear that they were ideas for costumes for the per-
formance of *Danaë* produced by Leonardo in Milan 1496. The roughly sketched
architectural drawings in the top right part of the sheet were at the same time
shown to be of unexpected importance: long before Baldassare Peruzzi,
Leonardo had conceived a theater stage systematically unified by perspective,
anticipating by half a century the raked stage designed by Sebastiano Serlio.[4]

This meticulous research greatly improved the method and spirit with which
Leonardo's work is now studied. These fragments are now normally read in a

way that relates them logically and chronologically to the contemporary works of Leonardo and his colleagues. There is now a better understanding of the rhythm with which his thought developed, and most importantly his relationship to contemporary culture has been clarified: he is no longer thought of as a solitary genius.

It was already known that Leonardo did not have the enormous cultural fluency that had been ascribed to him by Pierre Duhem,[5] but his reputation as an illiterate autodidact, an *uomo sanza lettere*, has also been questioned, even though this reputation was supported by certain polemical and tactical opinions expressed by Leonardo himself. If the "universal man" of the Renaissance, its genius *par excellence*, was indeed self-taught, he acquired his knowledge from two sources: first the *abaco* school and then Andrea Verrocchio's *bottega* or studio. As will be seen, this training helps explain both the "homemade" quality, which was a characteristic of most of his work, and his inability to construct a conceptual system that could go beyond the boundaries of the craftsman-like structure of his initial way of thinking.

But it was this fondness for the "homemade" that also enabled him not to depend exclusively on the established structure of knowledge, and to introduce a fruitful disorder while developing the outlines of systematic thought. It was as an engineer that Leonardo most effectively demonstrated his advanced way of thinking. Instead of being just an inexplicable forerunner, he was the only one among his contemporaries to transform the skill of the technician and his empirical approach into a technological way of thinking; he was the first to become interested in the very principles of mechanics and mechanisms, rather than in particular or individual machines.[6]

The study of Leonardo's paintings has also been profoundly affected. This has not so much been the result of sensational discoveries or a clearer classification of the corpus of his work; this had already been broadly defined, and Leonardo's particular way of working remains the subject of critical discussions. But laboratory research and the combined analysis of his notes on art and his painting methods have led to a better understanding of how, while making painting a total art, he produced so little, and moreover how the idea of "unfinished" is often not appropriate to his work. It also confirms that his activity as a painter cannot be separated from his work as a scientist, an engineer, and so on.

Far from explaining Leonardo da Vinci's genius, the work of historians has raised as many (new) questions as it answers. But a better understanding of

his working methods enables the boundaries within which his genius operated to be better defined. As Augusto Marinoni has emphasized, the fragmentary reading of his manuscripts, disarranged and incomplete, has turned Leonardo into an absolute, superhuman genius. These manuscripts, which are hard to decipher, have only recently begun to be read in a systematic manner. This has corrected the image of the universal genius. For example, Leonardo was not simply bad at arithmetic; there were gaps in his knowledge of mathematical theory that led him, as often happens with self-taught people, to cast doubt on the validity of some fundamental rules and then to copy word for word the solutions put forward by his mathematician friend, Luca Pacioli.[7]

It is a cause for rejoicing to see Leonardo's genius redefined in this way. His uniqueness becomes measurable, and this only serves to highlight his originality, which is truly extraordinary.

The painter quickly became famous, but the unusual conditions in which this fame was acquired has greatly affected his image in the eyes of posterity. Already at the beginning of the 1490s, the rhyming *Chronicle* written by Raphael's father, Giovanni Santi, a respected painter in Urbino, thought him "divine," equal to Perugino.[8] Although Leonardo had painted much less than Perugino, Raphael's future master, he was already enjoying a fame based more on what was said about him than on what was seen or known of his work[9]. The important role which Vasari subsequently ascribed to him, calling him the originator of the *bella maniera* ("beautiful style") of the Cinquecento, reinforced the gap between what was known and what was imagined. During his lifetime Leonardo contributed to this discrepancy and, more than any other famous artist of the time, he influenced his posthumous destiny. On the basis of clues both insubstantial and unverified, each era has found itself "inventing Leonardo."[10]

Unlike Michelangelo with the Sistine Chapel or Raphael with the Stanza della Segnatura, Leonardo's fame does not depend on an important building, a particular work or a series of famous and accessible works. From the end of the sixteenth century, his image has been impressive yet unclear, strong yet blurred. Thought of primarily as a painter, his reputation was originally as a great artistic thinker and as a master of shadows. This lack of precision persisted throughout the seventeenth century: in 1699, Roger de Piles, observed in his *Abrégé de la vie des peintres* ("Summary of the life of painters") that in order to appreciate the vanished work of Leonardo, it was necessary to rely on what historians had said about it. Nevertheless, Leonardo's reputation

continued to increase. In 1651, French and Italian editions of his *Treatise on Painting* with engravings by Errard after drawings by Poussin had been published, and this confirmed the image of Leonardo as a theoretician. The work was based on summaries of the original treatise compiled from Leonardo's notes on painting by his pupil Francesco Melzi. The *Treatise* published in 1651 was extremely successful, sixty-two editions appearing before the end of the eighteenth century, and it caused Leonardo to be seen as a precursor of French academic thought on art.

At the same time as this tendentious intellectual recognition, people in the seventeenth century took a systematic interest in Leonardo's "grotesque heads"— albeit without differentiating between his original drawings and works by followers or imitators. These enjoyed a remarkable though ambivalent success through their appearance as series of engravings. The first series was made by Wenceslaus Hollar between 1637 and 1642 and reprinted in 1648 and 1666.

The eighteenth century added nothing and had a fragmented image of Leonardo: he was at the same time the first great theoretician of classical painting, the inventor of the "grotesque heads" and the painter of a masterpiece unknown because it had virtually disappeared: *The Last Supper* in Milan.

The nineteenth century invented a new Leonardo, replacing this striking but almost incoherent image with that of an artist with a "modern" personality. Richard Turner convincingly argues that a vital part in the creation of this "invention" was played by Luigi Lanzi's attribution to Leonardo of a *Medusa's Head* in the Uffizi, which was actually a seventeenth-century Flemish work painted in the style of the *Medusa's Head* by Rubens.[11] Serious historical studies began to proliferate about 1800, but they appear to have had less impact than this false attribution, which was encouraged by Vasari's text mentioning an unfinished Medusa's head by Leonardo in the collections of Cosimo I de' Medici.[12] Lanzi's attribution had far-reaching consequences. Although swiftly rejected by art historians, it was enthusiastically accepted by writers (Stendhal and Shelley in particular) who, as a result, could evoke the appealing picture of a painter whose genius ranged from the horrific to the graceful.

In 1852 Théophile Gautier turned Leonardo into a romantic painter of twilight, mystery, and the unutterable (*Italia*, 1852). Michelet developed the theme in 1855: Leonardo was "this incredible magician, the Italian brother of Faust, [who] amazed and terrified" (*Histoire de France*, III). Then in 1869 Walter Pater made the connection by suggesting that the *Mona Lisa*, a legendary creature "like the Vampire," was a sister of the famous *Medusa*. Pater was saying nothing

new, because as early as 1851 Gustave Planche had declared that the *Medusa* in the Uffizi contained the seed of "what we admire in the *Mona Lisa* of the Louvre."[13] But Pater formalized what had been a somewhat diffuse feeling, and the persuasiveness of his words had a lasting effect on men such as Merejkowski and consequently Freud.[14]

But from the 1880s, the publication of more and more of Leonardo's manuscripts began to modify this image, particularly by revealing Leonardo's sustained interest in technology and science. Paul Valéry, in 1894, drew the most extreme conclusions in his first version of *La Méthode de Léonard de Vinci* ("Leonardo da Vinci's Method"). But yet again, the philosopher invented a Leonardo who suited him, as did Pierre Duhem who, in 1904, described Leonardo as an assiduous reader of medieval texts, although he actually preferred to read Aesop in a French translation.[15]

Inevitably the pages that follow will also "invent Leonardo." More than any other artist of the Renaissance, the very multiplicity of his interests and his famous "universality" confront the historian with two questions. The first, perhaps illusory, is the search for unity in Leonardo, which his very diversity encourages: a unity of inspiration that is clearly revealed in the originality of his artistic style, and that one would like to see reflected in his other work, especially since Leonardo himself declared that painting was the synthesis of all the sciences. The second question is one that arises with any exceptional person: how should these exceptional qualities be interpreted *historically*?

To answer these questions the terms must first be defined. Interpreting Leonardo's genius from a historical point of view does not consist in unraveling the mysteries of his personality; the aim is not to define what is exceptional, but to study how it came to be, consisting of what it did. The fact is that, far from being isolated and outside his time, Leonardo was very much part of that period of forty years when the classicism of the Renaissance became established, marking the end of the Middle Ages. Culturally, artistically, scientifically and sociologically he belongs to that era. His exceptional character and genius reveal themselves in the way that in similar situations he behaved differently from his colleagues, whether as artist, thinker, engineer or scholar. It was the universality of his interests that set him apart. Although he was far from being the only "universal man" of the Renaissance, he went beyond the technical and artistic boundaries of this universality as they were usually defined in court circles;[16] his interests seemed to touch every field of activity and knowledge. Leonardo's universality expressed itself within the limits that

made its application possible. For instance, although he did not succeed in building the equestrian monument in honor of Francesco Sforza, it was not through fickleness. It was actually because of the political and military situation at the end of the century, which, in the opinion of Ludovico the Moor (Ludovico Sforza), made the use of bronze for military purposes more urgent than for artistic celebration. A historical approach is an excellent tool for understanding and interpreting the conditions in which Leonardo's universality expressed itself.

As for the unity of inspiration that is believed to lie at the source of Leonardo's curiosity, to understand this it must no longer be seen as static and closed. From 1470 until his death, Leonardo's painting evolved considerably, while his thoughts on sometimes decisive matters changed radically. Especially in the field of science, the more accurate dating of his writings has made it possible to reconstruct his extraordinary intellectual journey. In writing about Leonardo, we will therefore try to recreate this internal dynamism and his continual transformations.

This book will not follow a purely chronological order. This arrangement would appear artificial because of frequent repetition and the cyclical, "spiral" nature of Leonardo's activities. For instance, in Milan in 1508, he returned to some old ideas and started working on old projects again: the *Madonna of the Rocks*, the equestrian monument, the activities of the court, and so on. Instead, we will try to place the subjects discussed in their contemporary context, and in relation to their development over time, since a drawing appearing early on as sketches in the notebooks might only come to fruition several decades later.

Deeply anchored within his personal continuity, Leonardo's production also reflected the external conditions in which he carried out his various activities. So the series of drawings depicting universal floods and collapsing landscape that he made during the 1510s were the spectacular conclusion to the studies of water, its movement and its power, both invigorating and destructive, that he had made over many years. But it is probable that these drawings were also made in response to the *Deluge* painted by Michelangelo on the ceiling of the Sistine chapel, a representation that Leonardo would have thought artistically poor and scientifically incorrect; indeed his notes confirmed this reaction when he returned to the theme of the *paragone* (comparison) between painting and sculpture.[17]

The same is true of the manuscripts. It is now known that Leonardo only started to write systematically (particularly on the subject of painting) when

he was about thirty-five. In other words, if he had died at the age of thirty-seven like Raphael, he would have painted hardly anything, and written hardly anything either. This raises the question of the connection of his practice of writing with that of artists and, above all, contemporary architect-engineers; and also the reasons that led Leonardo to become involved in what was to become one of his most important activities, indeed the central, never-ending task of his life. It will be apparent that the question is an important one; it brings into play Leonardo's education, and his relationship with languages (Latin as well as Tuscan) and language itself. It is possible that Leonardo originally examined the contemporary theory of painting so thoroughly as a reaction to the criticism and patronizing tone of the humanists at the court of Ludovico the Moor.[18] But the theory of art itself was not affected, especially since this literary project developed over the years and became detached from the conditions which caused it to be started. So this also implies that Leonardo's writings should not all be looked at in the same light: some are tactical and polemical, some are developments free of all circumstantial influence, others are tentative sketches, warming up the mind, like a pianist playing scales, before defining the actual concept and putting it to the test.

The cohesion of Leonardo's interests lies in his movement from one subject to another, from one hypothesis to another; the unity of his work and thought is based on this very dynamic, and this assessment provides a special way of determining what distinguished Leonardo's inspiration and "genius." The recent work of historians has described him separately in each of his fields of activity. Now may not be the time to evaluate the sum or the results of his works, but rather, by comparing and interlacing them, to clarify what they say about the latent coherence of his mind and his actual practice, which was extremely varied. If this book proves useful, it will be because it succeeds in "inventing" (in the archeological sense of the word, it is hoped) a Leonardo closer to the conditions in which he applied the liveliness of his genius.

We shall therefore see Leonardo "in movement." First of all, this will allow him to be placed at the heart of a fundamental tendency of the Renaissance. By this we do not mean the search for movement in painting or sculpture, which was the main aim of the *bella maniera* or "beautiful style," but the new consciousness of the constituent mobility of the world and man within it, which was progressively formalized during the Quattrocento. The works of Nicholas of Cusa were undoubtedly among the first to shake up (speculatively) the static, hierarchical cosmos that defined the closed world of

Aristotelianism.[19] But Nicholas of Cusa had his precursors, and if, with hindsight, it is said that he played a fundamental part in the revolution that was about to start, it was because in the middle of the fifteenth century he founded a line of thought that would carry on into the future and whose most famous representatives would include among others Copernicus, Giordano Bruno, Kepler—and Montaigne.

The great importance of this awareness of the world's universal mobility was underlined by the fact that it was not restricted to scientific concepts; it also affected the definition of man and his spiritual and moral function within nature. Outlined in the middle of the fifteenth century by Gianozzo Manetti, the theme of human *dignitas* found its ultimate expression in the *De hominis dignitate oratio* ("Oration on the dignity of man") by Giovanni Pico della Mirandola (1486). According to Pico, God's message to mankind is quite unambiguous; the moral and spiritual dignity of human beings stems from their ability to move through the hierarchy of other creatures: "Adam, I have not given you a specific position, nor a special face, nor a particular skill, so that you yourself may long for, conquer and possess your own place, your own face and your own skills. Other species in nature are limited by laws which I have laid down. But unrestricted by any boundaries and through your own free will under whose control I have placed you, you can define yourself [...]. I have made you neither celestial nor terrestrial, neither mortal nor immortal, so that, as your own master, you may achieve your own form freely, as a painter or a sculptor would do. You may degenerate into a lower form, like that of animals or, regenerated, you may achieve a superior form which is divine."[20] While acknowledging the actions through which men technically transform nature, this new feeling that the world was animated by infinite movement altered the very consciousness and concept of time, whether in relation to nature or to human history.

This awareness of a dynamic existing at the heart of creation, which is both an irresistible material mobility of the macrocosm and an inalienable spiritual energy of the microcosm, was at the very center of Leonardo's thinking and art. This intuition was first of all a fundamental awareness of the unity of the world (and of man, *pars mundi*, part of the world) as a continuous transformation. As André Chastel stressed, most of the ideas that Leonardo developed on this subject were borrowed, sometimes directly, from Ovid. In particular they came from the great treatise of Book XV of the *Metamorphoses* in which Pythagoras describes the world as being in a permanent state of flux. From

the mountains, which used to be at the bottom of the oceans (and we know the importance of Leonardo's geological intuitions), to the beautiful Helen, whose beauty was consumed by time (and we know the vehemence with which Leonardo looked out for the first signs of fading beauty in the old), "every form is a wandering image."[21] But far from sinking into depression or sorrow, Leonardo used this perception as a foundation for his researches, whether they were abstract (on geometry, for instance), technical (about machines and the like), or artistic.

Leonardo's works often had their origin and conclusion in painting. In this context it is significant that, unlike the static basis of Alberti's geometry in which juxtaposed points formed the lines while the lines "assembled like the threads of a canvas" formed the surface, Leonardo developed a dynamic theory of geometry. Here it was the movement of the point which produced the line, the transverse movement of the line which produced the surface, so the body was produced by movement (*Codex Arundel*, 159r). But he did not stop there. Rejecting the idea of a discontinuous space with separate stationary points, his concept of a point in motion led him to a vision of space itself in motion, almost fluid, and from there to a concept of time as an instant in motion: "The instant is timeless; time is created by movement of the instant and all instants are expressions of time."

As Augusto Marinoni wrote, for Leonardo, "at the origin of everything, as the 'principle of everything', movement is found"[22]—and movement, its perception, its mathematical interpretation, its technical application, and its artistic rendering can be found throughout his work, as its "prime mover." The study of the laws of motion was at the center of his research into the "fall of heavy bodies," the theory of *impetus*, hydraulics, ballistics and the flight of birds. The engineer and the anatomist worked to invent and understand the mechanisms that generate movement; the man of the theater invented automata and stage machinery to bring the stage to life by changing the scenery; the artist, the architect, the sculptor and the painter put movement and dynamic continuity between forms at the center of their creations. From the beginning of the 1480s, before Michelangelo, Leonardo had turned his attention to the development of the "serpentine curve" which was to become a symbolic figure of the Renaissance, classical then mannerist.[23] The vital intensity of this feeling was also reflected at a more intimate level in the process of artistic creation, in the course of which, it should not be forgotten, "the spirit of the painter transformed itself into an image of the spirit of God."

Leonardo tried to define shapes through their formation, and in order to convey this feeling the finished shape had to preserve its original dynamism. This was reflected, for instance, in his revolutionary use of preparatory drawings, in which the final shape appeared out of the original chaos created by the gradual accumulation of intertwining and the superimposition of gestures of the hand, creating the form on the surface of the sheet (fig. 4). Far from being a last resort or a sign of hesitation, this completely new technique was based on the conviction that there was "a correspondence between the form of motion in nature and the motion of his own hand in drawing."[24] Once the sinuous line of the shape ("true" and "beautiful") had been established, the painstaking technique of shading the contours, *sfumato*, was used to reveal in the painting, "between the seen and unseen" as Vasari said,[25] the lifelike throbbing of the figure and, of course, the fluidity that links every shape in the world, from the apparently inert deep to the smiling figure. This essential mobility explains why Leonardo often seemed to develop his artistic projects like a debate, with each project sustaining the possibility of an alternative, and its transformation sometimes taking place on the surface of work in progress. It is also why he had a tendency to create works that, though unfinished in the eyes of his contemporaries, appear to us today as taken to such a level of equilibrium that any further work would freeze, fix, and kill the representation. It is undeniable that, in the words of Paul Klee (whose writings and interests often echo Leonardo's), one of the fundamental aspects of Leonardo's art is that he wanted to express in his work the feeling of "the formation beneath the form," in accordance with his perception of the world.

This feeling of movement inherent in the world, which human creativity tries to capture and reproduce, is absolutely central to Leonardo's work because it reveals an essential aspect of his genius, thereby defining his uniqueness among his contemporaries. The rhythm of the world is at the heart of Leonardo's interests, his work and his thoughts, and this concept will therefore guide us, like Ariadne's thread, sometimes apparent and sometimes hidden, through the pages which follow. But here "rhythm" will be used in its original, exact meaning, as defined by Emile Benveniste in his studies on the use of the word by Democritus. For the Ionian philosopher, the word *ruthmos* described a specific modulation of the "form." While the word *schema* described a form which was "fixed, made and positioned in a way like an object," *ruthmos* described "the form at the moment it is assumed by what is moving, mobile, fluid."[26] This is the form that is found in Leonardo's work.

One finds it at first, of course, in his drawings that capture the relationship between whirlpools of water, spiraling plants, curling locks and the wild embrace of animal or human combat. This form "assumed by what is moving" is also found in his studies on the appearance of trees in certain lights or the effect of wind on the flight of birds. It is also found in his geometric studies on changing surfaces and the presentation of the muscles of the human body in motion, in his plans, sketches and architectural drawings, and of course in his paintings. From the early *Madonnas*, through the portraits, to *Saint John the Baptist*, Leonardo caught the figure in motion. The immediate and exceptional impact of the *The Last Supper* was largely due to the fact that Leonardo replaced the traditional arrangement with a rhythmical composition that considerably changed the very idea of the subject.

The rhythm of the world is so strongly present in the thoughts, work and art of Leonardo that his entire work appears to be a "symbolic expression"[27] of a perception of the world in which macrocosm and microcosm are part of the same universal rhythm, which the artist listens to and tries to incorporate within the intimacy of his creation.

Page 22: Fig. 2. *Storm over an Alpine valley*, detail, *c.* 1506, red chalk, 8 x 6 in. (20 x 15 cm.) Windsor Castle, Royal Library, RL 12409

Fig. 1. *Movements of birds in flight*, *Codex Atlanticus*, fol. 308 r-b. Milan, Biblioteca Ambrosiana.

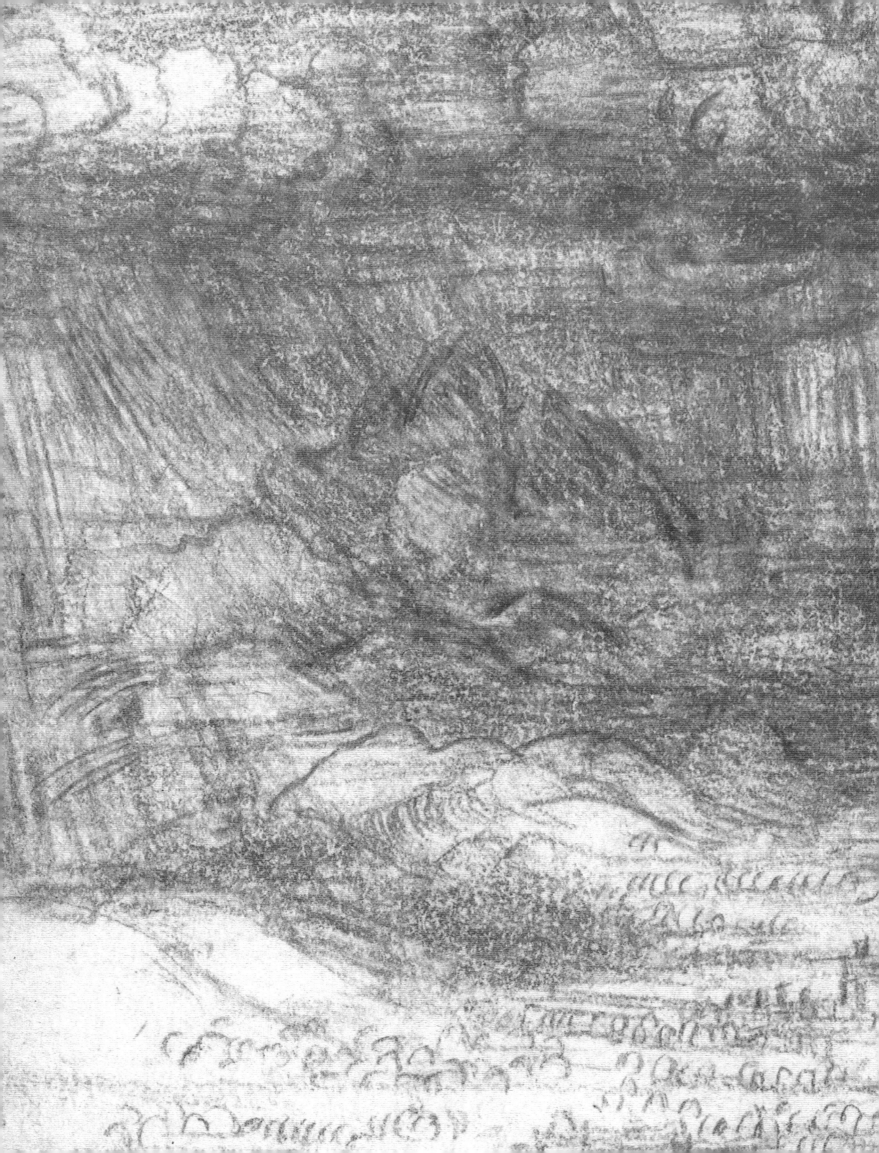

PART ONE

An Unfinished Universality

Portrait of the Artist as a Philosopher

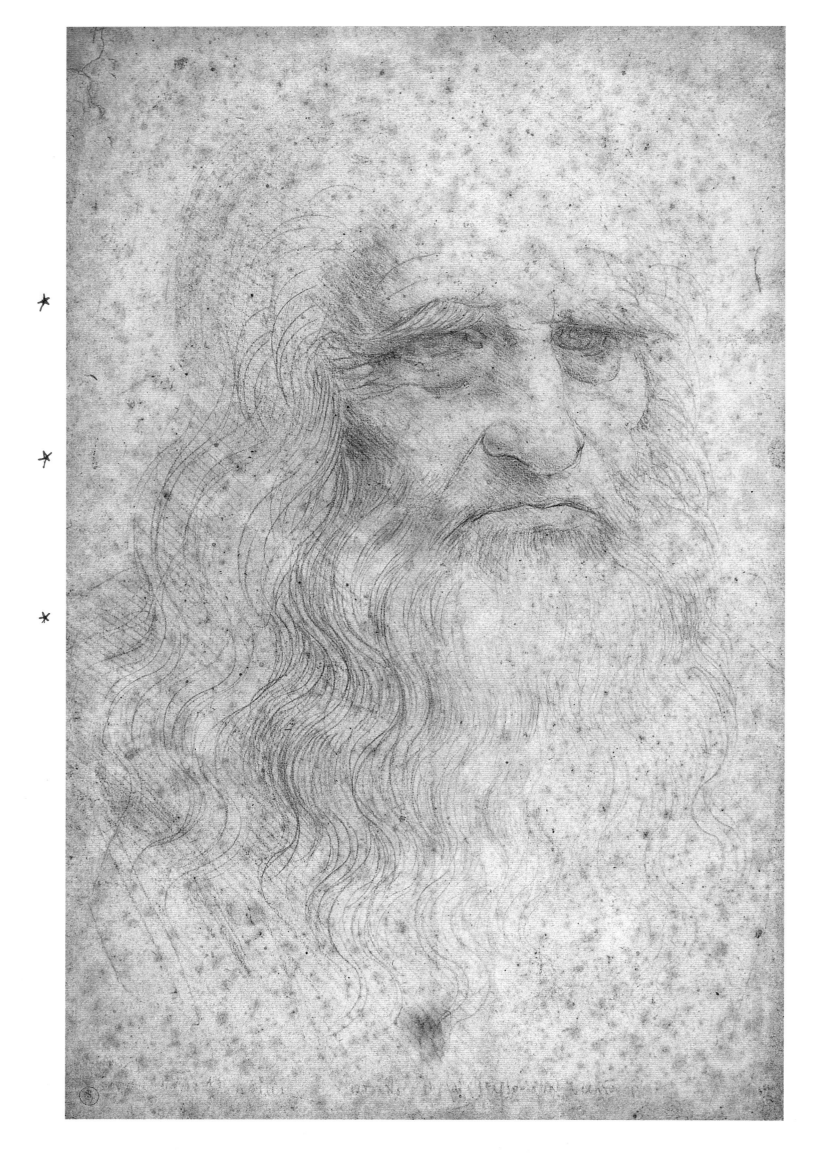

THE TURIN SELF-PORTRAIT

The *Self-portrait* in the Royal Library in Turin (fig. 3), the only one to have reached us, has imprinted Leonardo's features on our collective memory. Subjected to reproduction in almost as many ways as the *Mona Lisa*, it has ensured one thing: this is what Leonardo da Vinci looked like. As a result, other self-portraits have been found here and there over the years which uphold the image. For instance, Carlo Pedretti had no hesitation in describing the Windsor drawing of an old man bitterly contemplating the swirling waters as a "symbolic self-portrait" (fig. 4).[28] The date of this drawing (about 1513) makes this a plausible identification. But this was not the case when others claimed to recognize Leonardo in a Michelangelo drawing of about 1503, or even worse, in the study of an old man made for the *Adoration of the Magi*, when Leonardo was barely thirty years old. The impact of the self-portrait has been so great that it has made one forget that Leonardo could still have had his artistic career ahead of him.

Bearing the marks of time, the face is beautiful and the expression (unconsciously bitter or haughty) suggests a strong awareness of the realities of the world and human vanity. This is the very embodiment of an old man whose internal knowledge is so profound that it is impossible to communicate or measure. This portrait illustrates what Vasari suggested: "Such was Leonardo [...] This mind endowed by God with such innate grace possessed such a strong reasoning power, further supported by intelligence and memory [...] that he dominated and confounded the greatest minds with his line of argument [...] The splendor which shone from his wonderful features influenced the most obstinate minds. His power tamed the most violent furies [...]."

In 1590, Gian Paolo Lomazzo was more precise and his description of Leonardo's physical appearance seems to be directly inspired by this drawing: "Leonardo had long hair, and such long eyebrows and beard that he seemed to embody the nobility of study, like Hermes the druid was in the past or Prometheus in antiquity."[29] This is indeed like the face of the man depicted in the portrait of Turin: the face of a hero of the mind.

Such was Leonardo. But there are now some doubts—as if this "self-portrait" fits too well the image of what Leonardo is expected to look like, as if it was too beautiful to be true (as in Vasari's text), as if it had been inspired by Lomazzo's text instead of having inspired it. First, this face is too old; after

Page 26: Fig. 3.
Leonardo da Vinci (?),
Self-portrait,
c. 1515, red chalk,
13 x 8½ in.
(33.3 x 21.4 cm.)
Turin, Biblioteca Reale.

28

all, Leonardo was only sixty years old in 1512–13, which is the approximate date of the portrait. By interpreting his own face in this way, Leonardo was giving a distorted image of himself. But what did he want the portrait to represent? The complex questions raised by this drawing have even led recently to doubts about its authenticity.

Since Adolfo Venturi put forward the hypothesis in 1926, a tradition has evolved that Raphael gave Plato the features of Leonardo in the *School of Athens* (fig 5). In doing this he was paying homage to the master whose decisive impact a few years earlier in Florence had enabled his own painting to progress beyond the repetitiveness of Perugino, and whose influence is present in many places in the Stanza della Segnatura.[30] The resemblance between the Turin self-portrait and the Raphaelesque *Plato* is striking but the chronology is disconcerting. This Plato already existed in Raphael's preliminary cartoon for the fresco, made in 1510–11; but at that time Leonardo had not yet arrived in Rome (he came there in 1513). So Raphael probably painted Leonardo as he remembered him when he came across him a few years earlier in Florence, in other words a man only just fifty, a man who could not possibly have had

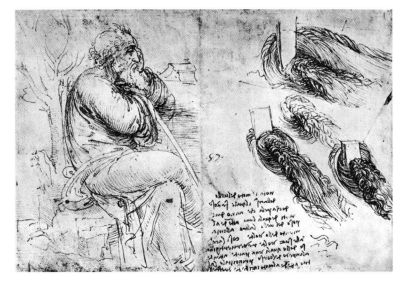

Fig. 4. *Profile of old man seated and studies of whirlpools*, c. 1513, pen and ink,
6 x 8½ in.
(15.2 x 21.3 cm.)
Windsor Castle, Royal Library, RL 12579r.

this elder's majestic appearance. Perhaps the resemblance was the other way round, with Leonardo adjusting his appearance to match that of Raphael's *Plato*. But this remains an arbitrary hypothesis. It is more satisfactory to believe that these two faces are derived from a common source, an ancient bust entitled "Philosophus," which had been drawn by the humanist Cyriacus

of Ancona in the middle of the Quattrocento. This had become the portrait of the Philosopher *par excellence*, Aristotle[31] (fig. 6). By giving his *Plato* the features of the "Philosopher," that is those of the scholar Aristotle, Raphael would have elegantly suggested the preeminence of Neoplatonism's iconography. For Leonardo, the "Philosopher" was always Aristotle, and the artistic reality of the 1510s had enabled him to appropriate the modern image of the Raphaelesque *Plato* for himself (while Raphael was accepted at the pontifical

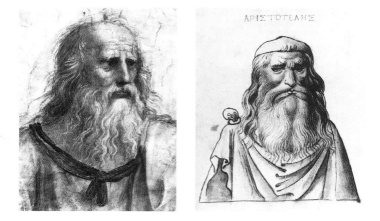

Right: Fig. 5. Raphael, *School of Athens*, detail of Plato, fresco. Vatican, Stanza della Segnatura.

Far right: Fig. 6. Cyriacus of Ancona, *Aristotle*. Ms. Laurentianus Ashburnensis 1174, fol. 121v. Florence, Biblioteca Medicea Laurenziana.

court, Leonardo was excluded from it). This reaction would explain why he took such care at the age of sixty to draw what is, to our knowledge, his only self-portrait.

The explanation is not improbable but a few questions still need to be asked. If Leonardo indeed drew himself as a "Neoplatonized Aristotle," if he was able to produce an honest "intellectual portrait," according to a current conception of what constituted a portrait at the time, it is likely that it does not show his true features: the drawing would be as much a mask as a face.

This is even more true if it is not by Leonardo, or even worse, if it is a fake produced at the beginning of the nineteenth century. This hypothesis was put forward by Hans Ost in 1980,[32] and it is based on the conditions in which the drawing came to light. It has only been known since the 1840s, yet it is identical to the engraving which Giuseppe Bossi used in 1810 as a frontispiece to the four volumes he devoted to *The Last Supper* (fig. 7). Bossi claimed to have been inspired by a late copy of a missing original (fig. 8), and he said he was convinced that this original really existed. An excellent neoclassical artist, a friend of Stendhal, Foscolo and Manzoni, secretary of the Milan Academy who also encouraged the founding of the museum which was to become the

Brera Gallery, Giuseppe Bossi was a leading figure in the cultural and artistic circles of Milan in the first fifteen years of the century (he died in 1815). His personality encourages credibility. But all the same it is possible that he invented this image of Leonardo and thus gave a visible face to the intellectual hero presented by the works of Giovanni Battista Venturi in 1797 and Carlo Amoretti in 1804. His (decisive) invention would have been to use a seventeenth century arrangement (fig. 9), presenting the Leonardo portrait as a three-quarter view.

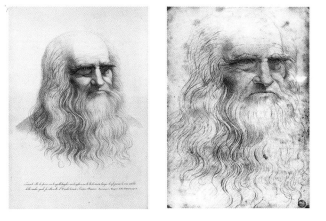

Far left: Fig. 7. *Portrait of Leonardo da Vinci*, frontispiece of *Del Cenacolo…* by Giuseppe Bossi, 1810. Paris, Bibliothèque nationale de France.

Left: Fig. 8. After Leonardo da Vinci (?), *Portrait of Leonardo da Vinci*, Venice, Galleria dell' Accademia.

In the sixteenth century it would have been given in profile, as in the Pinacoteca Ambrosiana drawing or the engraving in the second edition of the Vasari's *Lives* (fig. 10, 11). By being turned towards the beholder the face acquires a presence not found in the earlier style, and this presence became known at the time when Romanticism was creating the coherent image of a Faustian Leonardo.

We will not try to settle this question here; it is enough to accept the possibility that the Turin self-portrait is not necessarily by Leonardo, and that it is no longer recognized as such by everyone. As far as we are concerned, the authorship of this drawing is a secondary question because this (self) portrait is in any case a mask. At best it is a "self-portrait as a philosopher" in which Leonardo has visually crystallized the image he had created of himself, and his contemporaries passed this on while criticizing it. For instance, still during Leonardo's lifetime Baldassare Castiglione regretted that "one of the leading painters in the world should despise the art in which he is unique and has started to study philosophy, in which he has developed such strange concepts and fanciful ideas that he could never depict even with all his painting skills."[33] Vasari also mentioned this and according to Benvenuto Cellini, when François I praised Leonardo as a "great philosopher," one should also read in these words

the disappointment faced by the French king at the unproductiveness of the artist he had succeeded in bringing to his court. Revived by the publication of the manuscripts, this image of a "philosopher Leonardo" still inspired *Leonardo als Philosoph*, the little book written by Karl Jaspers in 1953, and it is probably behind the efforts of André Chastel to find some common ground as well as some slight differences, between Leonardo's thinking and Florentine Neoplatonism.[34]

Right: Fig. 9. Anonymous, seventeenth century, *Portrait of Leonardo da Vinci*. Florence, Uffizi.

Center right: Fig. 10. Anonymous, early sixteenth century, *Portrait of Leonardo da Vinci*. Milan, Biblioteca Ambrosiana.

Far right: Fig. 11. *Portrait of Leonardo da Vinci* in *Le Vite de' piu eccellenti pittori, scultori, e architettori* by Giorgio Vasari, 1568.

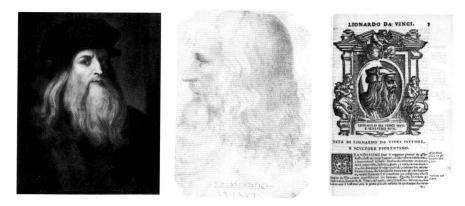

But although it is undeniable that Leonardo was a "thinker," he was not a "philosopher." Leaving theology to the priests, he was always violently opposed to abstract, theoretical constructions, and he states the importance of experience rather than a bookish approach to knowledge. At best, Leonardo was a philosopher in the meaning of the word at that time: a scholar in "natural philosophy," a master of the natural sciences. He went even further and developed this concept of natural philosophy in a thorough, original manner. He rejected the intellectual and social hierarchy which considered mechanical arts less important than the liberal arts and excluded the former from the realms of "philosophy"; he even assimilated painting and philosophy in as far as painting "deals with the movements of bodies in the liveliness of their actions." The reasoning is unexpected but, in the terms of his time, he succeeded in combining the Neoplatonic theory of beauty with the subject of the movement of bodies, which was the central problem of Aristotelian "philosophy" in its scholastic version.[35]

More seriously, if Leonardo could not be a real "philosopher" it was because he never succeeded in producing a single treatise, let alone a developed system—even though his projects, brought to a successful conclusion, would have filled some twenty volumes. In other words, although Leonardo had thoughts, he

did not have a systematically organized way of thinking. This failure in Leonardo has been the subject of much debate for many years. Some see in it a certain side of his personality, an aspect of his temperament. But it is more correct to see it as consequence of Leonardo's cultural fluency, that is as a consequence of the structure of the education he received, and his (intellectual) aspiration to go beyond the boundaries of a craftsman. These boundaries nonetheless served to restrain him, revealing themselves in his inability to think systematically.

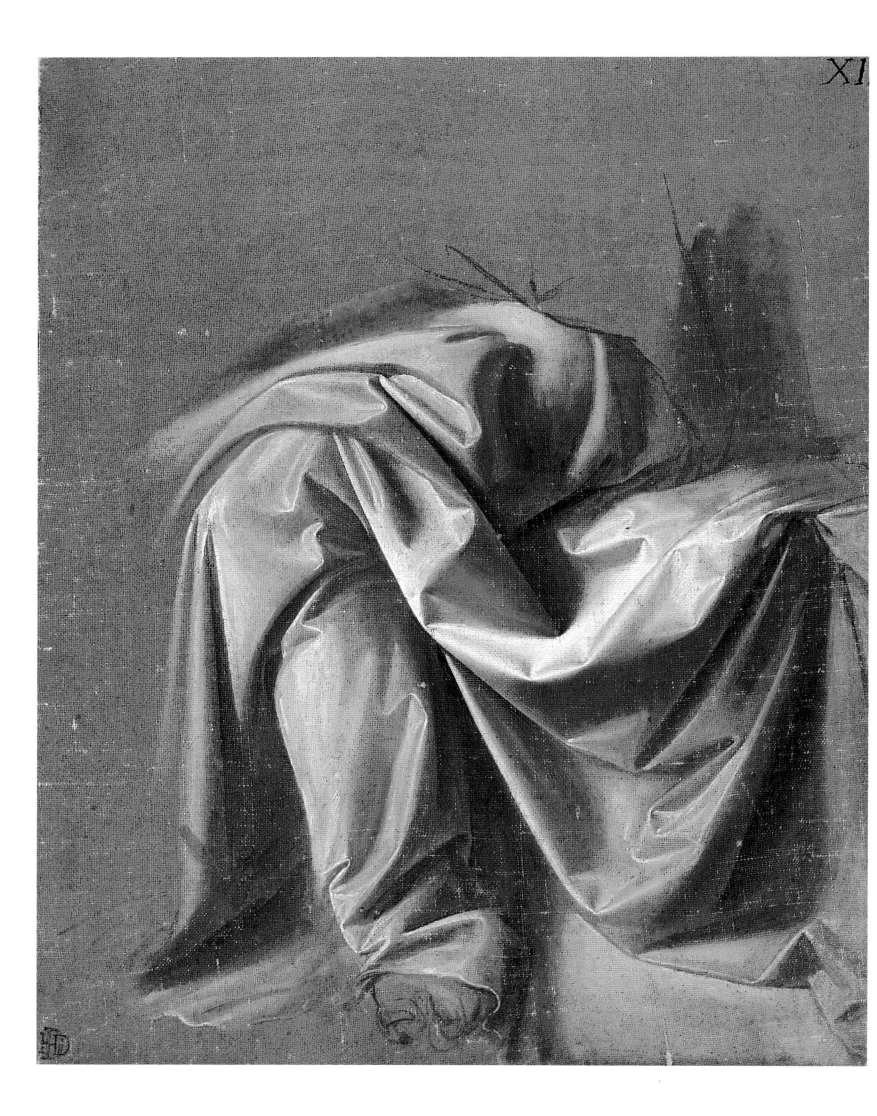

THE EDUCATION OF LEONARDO

"I am well aware that, because I am not a scholar, some presumptuous people will think that they can find fault with me and accuse me of ignorance. Bunch of ignoramuses themselves! They do not know that I would be able to reply to them like Marius to the Roman patricians: 'Those who take credit for the work of others do not want to give me credit for mine.' They will say that my ignorance of letters prevents me from expressing myself on the subjects that I want to develop. But in order to be developed, my subjects require experience more than the words of others. And experience having been the mentor of those who write well, I too also choose it as my mentor and will call upon it in any case." (*Codex Atlanticus*, 119v-a.)

In speaking in this way without embarrassment, in about 1487, the *uomo sanza lettere* ("illiterate"), Leonardo delivered a private plea on his own behalf. He had taken up the position of practicing engineer at the court in Milan. But his declaration should not be taken too literally. It was ironic to justify his lack of education by quoting the words of the Roman Marius from the *Bellum Jugurthinum* by Sallust—even though it is Ramusio's Italian version of *De Re Militari* by Valturius that Leonardo quotes from. This declaration should not be dissociated from the lines that precede it, in which the court artist introduced himself as someone lacking intellect, "the person who always arrives last at the fair because of his poverty" and who must carry his "modest load" of "despised merchandise" and go "not to the large cities but to the poor hamlets, distributing and receiving the price that the goods he offers are worth." His speech was obviously ironic and polemic.[36] In any case he changed: some twenty years later, Leonardo criticized modern commentators who, unable to invent for themselves, attacked the "ancient writers" who created the "grammars and sciences" (*Ms. F*, 27v).

The question of Leonardo's cultural fluency and his relationship with scholarly tradition is a fundamental factor in defining his position in the culture of his time. The knowledge or ignorance of "letters" reflected an important dichotomy in Italian society at the beginning of the sixteenth century because it helped to preserve the Aristotelian distinction between *episteme*, theoretical science, and *techne*, practical matters aiming at the production of material goods:[37] a distinction that Leonardo violently opposed even when the development and results of his research revealed its structural force.

Page 34: Fig. 12. *Drapery covering the left leg of a seated figure*, brush and gray-brown tempera, heightened with white, 9½ x 7½ in. (24 x 19.3 cm.) Paris, Institut Néerlandais, Collection Frits Lugt, inv. 6632.

LEONARDO'S BOOKS

Folios 2v and 3r of *Madrid Manuscript II* show that in 1505 Leonardo possessed at least 116 books. Comparison with an equivalent list drawn up in about 1490 (*Codex Atlanticus*, f. 210r-a) and a study of the quotations contained in all his manuscripts indicate that including books borrowed and those he owned personally, Leonardo's "library" consisted of about 200 books.[38] This is a relatively small number compared to the mass of books people at the beginning of this century thought he had read; but it is a considerable number for the social and professional milieu to which Leonardo belonged. His library alone was enough to distinguish him from his colleagues.

However, one cannot turn Leonardo into an "educated scientist." In the first place, his personal library took time to grow. In about 1482–83 when he was about to leave Florence for Milan, the inventory of what he took with him includes no books (*Codex Atlanticus*, 324r), and it therefore seems that he was not spending a lot of time reading and writing. A few months later, folio 2r of the *Codex Trivulziano* lists five books;[39] in 1490, thirty-five new titles were added to the first five (*Cod. Atlanticus,* r-a), and the number of books continued to increase steadily up to the 116 titles listed in 1505.

Leonardo's interest in books only developed in his thirties, after he had left Florence for Milan: the atmosphere at the court undoubtedly played an important part, and it is probable that the rivalries between courtier-artists and scholarly courtiers also helped develop this interest. Looking more closely at the list of these books and their influence on Leonardo's writings, it is noticeable that quite a number of them appear to have left no trace on his manuscripts. In fact, it is probable that Leonardo accumulated these to read but somehow never had or made the time to read them. For the major part, this library expressed Leonardo's desire to overcome his inferiority as a *uomo sanza lettere* compared with the humanist, the philosopher or poet who had the verbal skills to express the dignity of their discipline. A remark in the *Treatise on Painting* illustrates this clearly: "If painters have not described painting and have not turned it into a science, the fault lies not with painting [...] Few painters are familiar with the humanities because their life does not enable them to understand them."[40] Leonardo's library expressed his decision to become a writer capable of using his writing to ensure the acknowledgment of the "liberal dignity" of the arts and research he practiced, to go beyond the field of *techne* to reach the kingdom of the *episteme*.

The structure of this library established the conditions of this choice—and the difficulties this raised for Leonardo. From the reconstruction based on the inventory of 1505, it is apparently very well balanced. Half the books (fifty-eight out of one hundred and sixteen) deal with the sciences (fifty-one books) and technical subjects (seven books); the other half may be divided into three groups of unequal importance: twenty-five works on profane literature, fourteen on religious and moral literature, sixteen on Latin, its grammar and vocabulary. It is not the library of a technician, who would in any case not have had one. Nor is it the library of someone interested in the humanities. Leonardo ignored the disciplines of this branch of learning (philosophy, theology, history, literature and poetry). Even more strikingly, he did not own any work by a contemporary humanist, with the notable exception of the *De Re Aedificatoria* ("On architecture") and *Ludi Matematici* ("On games of mathematics") by Alberti who was also, as will be seen, the only contemporary author mentioned in his writings.

In the field of literature he had translations of Aesop's fables, some of the *Annals* of Livy, Lucan's *Pharsalia*, the *Metamorphoses* and *Epistulae* of Ovid, as well as a Petrarch and compilations of letters. But apart from these Leonardo favored popular literature and burlesque poetry, the traditions of chivalry,

Right: Fig. 13. *Portrait of Andrea Verrocchio* in *Le Vite de' piu eccellenti pittori, scultori, e architettori* by Giorgio Vasari, 1568.

Far right: Fig. 14. Leon Battista Alberti, *Self-portrait*, fifteenth century. Plaque, Paris, Bibliothèque nationale de France.

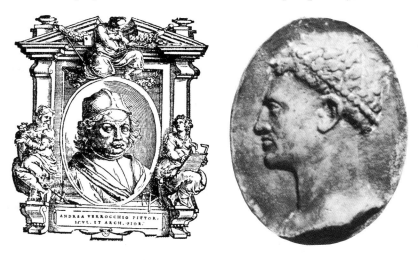

re-tellings of Roman history, and *Chronicles* of the world.[41] But it was not only a question of taste: this library accurately reflected the education Leonardo had received—and this is really the heart of the matter. If Leonardo was not a "man of letters" in the sense of the word at the time, it was because when he left the *abaco* school where he studied from twelve to fifteen, he did not

move on to the *scuole di lettere* but instead went straight to work in Verrocchio's studio.[42] This was quite normal for the (bastard) son of a notary, but it had a decisive influence on his intellectual orientation and development. Leonardo knew almost no classical Latin at all, and this was the language used exclusively in the teaching of scholars and the culture of men of letters.

Considered in Florence as a necessary stage between primary education and the literary education preparing students for university, the *abaco* schools provided an education of applied mathematics, adapted to the needs of the merchants, and the Florentine masters of this discipline were the most famous in Italy. Inspired by the *Liber abaci* ("Book of the abacus"), a kind of encyclopedia of applied mathematics which had been written at the beginning of the thirteenth century by Leonardo Fibonacci (*c.* 1170–*c.*1240), the *scuole d'abaco* ("abacus schools") taught the techniques of arithmetic, concentrating on how to solve the kind of problems a merchant might encounter in his commercial activities. Concentrating on *how* to find solutions rather than the reasons *why* they work, the *abaco* schools did not formulate general theories. Working example by example, mainly using the rule of three and analogy between the various cases studied, education in the *abaco* schools was based more on good reasoning than on theoretical mathematics.[43] The *abaco* school also provided religious and moral education, based on the guided reading of a number of texts in the vernacular. It is therefore no coincidence that Leonardo's library should have included both the *Fior di virtù* which was part of the curriculum in the *abaco* schools, and works of chivalry which played an important part in popular culture during the Quattrocento and certainly became part of the curriculum for education in Italian.[44]

Education in the *abaco* schools was completely different from that in the *scuole di lettere*, which taught the humanities to students from the age of sixteen onwards who were preparing for university. This education was distinguished by the consistency and unity of its syllabuses, which were based almost entirely on the study of the great Latin authors and included rhetoric, poetry, history and moral philosophy. By contrast the texts of the *scuole d'abaco* were a mixture from the Middle Ages and the Renaissance. In Florence itself, there appeared to be no contact between the humanists and teachers of the *abaco*. In general, the humanists were not particularly interested in mathematics, and if they were, it was for the pleasure of intellectual speculation and certainty. Vittorino da Feltre, one of the great humanist teachers in the first half of the fifteenth century, was one of the very few to recommend the study of mathematics,

based on the medieval university tradition. It is true that Alberti recommended two years of apprenticeship at the *abaco*, in the Florentine manner, but this was only as a preliminary to moving on to study the "poets, orators and philosophers," in other words the writers taught in the *scuole di lettere*.

This difference in intellectual direction also reflected a clear social division. According to Sassola di Prato, a pupil of Vittorino da Feltre, mathematics "are good for craftsmen."[45] In fact, of the young Florentines who went to school three-quarters stopped their education after the apprenticeship at the *abaco* and only one-quarter went on to university.[46] It therefore seems, as his tradesman-like handwriting confirms,[47] that Leonardo belonged to this intermediate social category, situated between *dotti* and *non dotti* ("scholars" and "non-scholars"), which was indeed that of merchants and craftsmen. Paradoxically, the only Latin Leonardo ever learned was that which he was taught at primary school between the ages of seven and twelve. Even though Latin was then by no means a dead language and was still used in certain areas of social life, Leonardo probably had only an empirical knowledge of it, just enough to understand it.

This situation was quite common among cultured artists. Lorenzo Ghiberti's *Commentari* were written in Italian with a few Latinized Italian passages here and there, and Piero della Francesca's *De Prospectiva pingendi* ("On perspective painting") is a treatise written in the vernacular but "ennobled" by a Latin title and a few Latinisms.[48] In Leonardo da Vinci's case, however, and indeed in his own eyes too, this ignorance of Latin became a definite disadvantage when he found himself and developed intellectual ambitions far beyond those of his colleagues. This is reflected in the considerable efforts he made at the age of nearly forty to remedy to the situation, by drawing up long lists of Latin words, compiling dictionaries for his own use, collecting grammars (sometimes so detailed and complex as to be useless to him), attempting pathetically clumsy translation exercises, and so on.[49] He was never able to master the language of Cicero and Livy, or that of Marsilio Ficino or Campano, the translator of Euclid, although he owned a copy in spite of that. His perseverance in overcoming this handicap shows how much he considered this a serious obstacle to his intellectual ambitions, an obstacle he succeeded in circumventing without ever completely overcoming. These efforts demand a closer look, in that they reflect one of the conditions of the very structure of Leonardo's work: both its limitations and also, which is certainly most significant, his remarkable inventiveness.

The first consequence of Leonardo's ignorance of Latin, a negative one, was that he could not directly consult the great literary and scientific texts, ancient or medieval, which were usually written in Latin. The few texts available in Italian fell far short of covering the field of ancient or medieval knowledge. That is why he discovered many of the scientific or philosophical ideas that would help him to establish his own thought through intermediaries. These included *Della composizione del mondo* ("On the composition of the world")

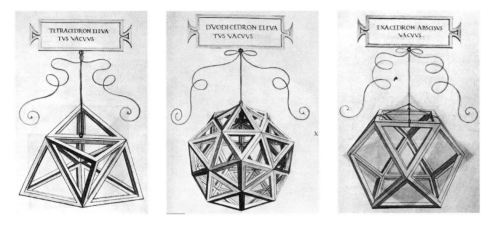

Fig. 15, 16 and 17. Regular Platonic solids (dodecahedron, octahedron and icosahedron). Milan, Biblioteca Ambrosiana.

by Ristoro d'Arezzo (who, for instance, developed the idea of the analogy between the human body and the world), *L'Acerba*, a scientific poem by Cecco d'Ascoli, and *Quadrireggio* by Federico Frezzi. Similarly, it was probably in *De Re Militari* ("On military matters") by Valturius that he found an exact quotation from the *De Rerum Natura* ("On the nature of things") by Lucretius.[50]

It would be wrong to think that Leonardo read all the scholarly books that were in his library.[51] The case of the geometry of Euclid is a good example. He owned two copies of the book, one in the vernacular containing the first three books, and the other a difficult, scholarly Latin translation by Campano. The *M* and *I* manuscripts confirm that Leonardo studied Euclid systematically between 1497 and 1499, and the few words accompanying the drawings show that he consulted the Latin text; yet at the same time he was transcribing elementary details of Latin grammar from *Rudimenta grammaticae* ("Rudiments of grammar") by Perotti. So he would not have been able to study Campano's text on his own, and it is reasonable to believe that he was helped by the mathematician Luca Pacioli. At the Milan court from 1496, Pacioli asked Leonardo to draw the regular polyhedrons which would illustrate his *De Divina Proportione* ("On divine proportion") (fig. 15, 16, 17).

This collaboration implies that the scholar had given Leonardo an oral summary and explanation of Euclid's text, which Leonardo condensed into the form of drawings accompanied by a few notes, intended for himself alone.[52] Leonardo continued to be interested in Euclid when working in Florence in the early years of the sixteenth century, and this was because Luca Pacioli was also in Florence where he was teaching Euclid.[53]

Leonardo's manuscripts show repeatedly that he was prepared to ask for this kind of help: indeed he would turn to a scholar, an engineer, a master at an *abaco* school or a stonemason.[54] This should be seen in the context of a society which read aloud, for whom knowledge was acquired by listening as much as by reading, and for whom culture and science were transmitted orally as much as through the written word. The reason Leonardo's "quotations" are often confused is not because of the breadth of the readings that he would have committed to memory, but because a large part of his culture was based on conversation, hearsay, and the vague ideas typical of the milieus he frequented: court and university.[55]

Nevertheless, in this context ignorance of Latin still proved to be an obstacle to Leonardo's intellectual ambitions, because the Tuscan language did not have in its vocabulary the abstract terms necessary for a conceptually precise expression of ideas. This is reflected in his inexact and inconsistent scientific vocabulary (even for the time), and the difficulty in understanding his scientific propositions this sometimes causes. Here is one example, concerning the cylinder. Leonardo called a right prism a *cilindro laterato*, and the prisms whose height is less than the side of the square of the base he called "plates" (*tavola*). The term "plate" in turn can also refer to flat figures sometimes called "pyramidal";[56] but when Leonardo writes that the area covered by a falling body "grows in the manner of a pyramid," he does not say whether he is referring to the sharp edge, the volume or the section of a pyramid[57]—even though the purely theoretical discovery of the center of gravity of the pyramid is owed to him. Similarly, it was wrongly assumed that Leonardo discovered the theory of the wave propagation of light centuries before anyone else; but, in spite of a knowledge of the classic texts on the subject of optics that his writings reveal, the comparison he makes between the diffusion of the shape of objects and the movement of waves made by the water when a stone is thrown in is actually only a metaphor.[58]

However, here the positive effects of these linguistic gaps on Leonardo begin to be seen because of his efforts to improve his knowledge. (Later on

the importance of drawing in Leonardo's demonstrations will be mentioned:
he was the first to make sight, rather than hearing, the special support for the
acquisition and transmission of knowledge.) Before even attempting to learn
Latin, Leonardo concentrated on improving his knowledge of Tuscan, his
own language. From the late 1480s, when he started to write systematically,
he tried to widen his abstract vocabulary by drawing up lists of Italian words
(nouns, adjectives, adverbs and verbs) which were derived from the Latin and
were not part of the Italian current vocabulary. As the *Codex Trivulziano* and
the *Manuscript B* show, Leonardo transcribed almost half of Luigi Pulci's
Vocaboli latini tutti per ordine e per alfabeto ordinati ("All Latin words in
order and arranged alphabetically") and, when he read a text translated from
the Latin, he copied out the *vocaboli latini*, namely, the words that clearly showed
their Latin origin in Italian. The list of *vocaboli* (with derivatives established
by Leonardo) in folio 87 of the *Codex Trivulziano* follows, almost to the
letter, pages 7, 8, 9 and 10 of *De Re Militari* by Valturius.[59] It was not an
attempt, as has sometimes been thought, to create the first Tuscan dictionary;
the abstract quality and rarity of the words collected indicate, on the con-
trary, that Leonardo was trying to enrich his own oral vocabulary, with words
whose meaning he did not always understand as is shown by the derivatives
he came up with. This was an indispensable requirement for anyone wishing
to read and write scholarly works. According to Augusto Marinoni, Leonardo
would have transcribed almost 9,000 such words.

Leonardo's painstaking efforts to improve his vocabulary are reflected in
his writings. A series of adjectives transcribed in folio 92 of the *Codex
Trivulziano (collerico sanguigno malinconico flemmatico [...] salutifero, salse-
dine)* are also found, arranged differently, in a description of the water, described
as "salutifera [...] salsa sanguigna malinconica flemmatica collerica,"[60] and the
stunning cascade of adjectives strung together to describe the infinite move-
ments, sounds and effects of the water (*Ms. I*, folio 72r-71v) could not have
been created without this patient linguistic preparation.[61] In 1504–06, Leonardo
said in the *Quaderni d'Anatomia* (folio 1-r) that, all things considered, his
"mother tongue" had such a wide vocabulary that we should "complain more
about the problem of understanding things than about the lack of words to
express the concept we have in our mind."

To a certain extent, this work of enriching his vocabulary, of *renovatio*
("renewal") and of *illustratio* ("illustration") of the vernacular seems to follow
the advice (and method) of the Florentine humanist Cristoforo Landino, while

also anticipating the work of the French poets of the Pléiade half a century later.[62] But Leonardo's aim was not to reform the Tuscan language. The *uomo sanza lettere* only worked in order to become an "author." He would never succeed in writing an organized work, but he became a writer in the full meaning of the word in his own *tongue*: by systematically developing his *writing*, he also progressively defined his own *style*.[63]

More irregular than was usual at the time, his spelling was not only phonetic but "pure chaos;"[64] a number of his verbal forms were archaic and had already disappeared from the current literature of his time; he had not learned at the *scuole di lettere* how to build a complete sentence or to articulate the progressive development of a thought; his reasoning could not extend to the architectural dimension of a page; his way of expressing himself was incomplete and fragmentary. But it was in his writing that Leonardo first made his voice heard, a very Tuscan voice—so much so that it has been said that while Dante had created the "illustrious vernacular," Leonardo "expressed himself in exalted demotic."[65] He would probably have thought of doing this in view of the prestige of the Tuscan language, especially in a court of Northern Italy. The reality, however, is much more complicated and, following Leonardo in the progress of his development, it soon becomes obvious that his writing evolved with time and also that it varied according to the subject and the recipient. It was in Milan that the *uomo sanza lettere* conceived and realized his project of becoming, if not an "author," at least a writer.

It would be wrong to believe that the chaotic mass of manuscripts was only made of scattered fragments with no concern for the quality of the writing. As Augusto Marinoni rightly remarked, Leonardo had, quite surprisingly at first sight, tried his hand at all the literary genres of the time: from the less important ones such as fables and enigmas (a kind of courtly exercise and a distraction to which we shall return) to the most important one, the treatise, in which he was extremely interested. He also tried his hand at dissertation, dialogue and letter writing.[66] His efforts in this regard were considerable. When he was writing an important letter, addressed to a correspondent and seeking to obtain something from him, Leonardo usually had to ask for help because he had not learned the art of letter writing usually taught at the *scuole di lettere*, on the basis on Ciceronian models. His manuscripts included countless rough drafts of letters that were not sent. The famous letter, for instance, that he wrote to Ludovico the Moor for an appointment at the court in Milan is not in his own hand.[67] That is why one is the more surprised by the achievement of the draft

of the letter to Benedetto Dei about the "giant coming from the desert of Libya," and even more so by the long letter, almost finished, that Leonardo addressed fictitiously to the "Defterdar of Syria, Lieutenant of the sacred Sultan of Babylon," where he describes Mount Taurus. This letter was particularly revealing because, imagining himself sent to observe a mysterious natural phenomenon, Leonardo describes a cataclysm in a way that anticipates the final drawings of the universal deluge.[68] The literary achievement of these two letters is most probably due to the fact that Leonardo allowed his imagination to run loose on subjects he was passionately interested in: the creative and destructive omnipotence of nature and the infinite mutation of shapes.

Leonardo developed his style on the basis of a particular element: the use of a brief, sometimes lapidary, linear expression. The absence of rhetoric suited the exact demonstration of the scientist, even if his inability to construct a complete sentence hindered the development of complex reasoning. Leonardo's style became progressively more supple, more like a transcription of oral expression. In *Manuscript C* for instance (*c.* 1490), the presence of *vocaboli latini*, indirect constructions, a slower rhythm in the sentence, the quality of the drawings and the careful writing seem to be aimed at an important reader. But it is in the more personal passages that Leonardo's own style stands out most strongly. Always based on conciseness and an absence of rhetorical outbursts, the sentences follow each other like rhythmic groups or short musical units. For instance this sentence, advising a painter on the lighting of his workshop, sounds like a short prose poem: "Poni mente per le strade, / sul fare della sera, / I volti d'uomini e donne, / quando è cattivo tempo, / Quanta grazia e dolcezza / si vede in loro." (*Ashmolean I*, 15a). Sometimes, probably unconsciously, hendecasyllables are inserted musically into the sentence and the piece displays the harmonious balance of a poetically rhythmic prose, with lyrical tonalities.

It is not surprising that this style is at its most forceful when Leonardo verbally describes the dynamism and universal fluidity of nature. He does the same with the line when he draws, describing this mysterious, omnipotent *Forza* which is both physical and spiritual, and which gives the world its life. It is in his descriptions of the aspects of water that Leonardo achieves a truly rhythmical cadence, sometimes through a simple juxtaposition of words. The search for literary self-improvement of the *uomo sanza lettere* is inseparable from his visual activities; his style expresses a deep, intimate adherence to the universal dynamism of life,[69] or to be more precise, to the rhythm of the world.

STUDIO PRACTICE

Towards the middle of the 1460s, Leonardo starts working in Andrea Verrocchio's *bottega* or studio. There he will meet those who will dominate the world of painting in central Italy during the last quarter of the century: most importantly Domenico Ghirlandaio (1449–94) and Pietro Perugino (*c.* 1450–1523), but also Lorenzo di Credi (1456–1537) and even Sandro Botticelli (1444–1510) who, without being a member of the *bottega*, frequents it fairly regularly.[70] It is at the time the most prestigious studio in Florence, even more so than that of the brothers Pollaiuolo; it is supported by Lorenzo the Magnificent and very popular with young artists. Its importance in the artistic circles of Florence is due to the fact that, besides the great skills of its master, it is completely "polytechnic." Unlike the specialized masters, of whom there are many in Florence, Verrocchio is a sculptor, a goldsmith, a painter (to a lesser degree), probably also an architect, and in a more general way, an engineer as well.[71] After a basic apprenticeship, each member is expected to take part in a wide range of projects in the studio in order to become "universal." Moreover, workshop practices also imply an active collaboration between its members and, often, the involvement of several artists in the same project.

In two cases at least it is certain that Leonardo was involved in such collaboration. The first case, relatively simple, is still being discussed: it is the small predella panel depicting the *Annunciation*, in the Louvre (fig. 18). This was prob-

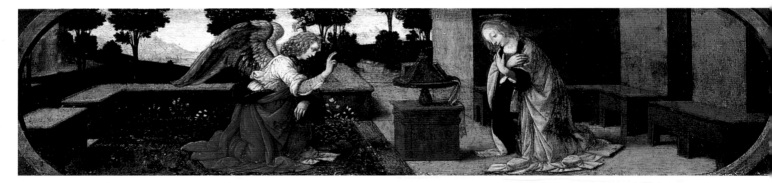

Fig. 18.
Lorenzo di Credi,
the *Annunciation*,
oil on wood, 6¼ x 23½ in.
(16 x 60 cm.)
Paris, Musée du Louvre.

ably painted by Lorenzo di Credi in about 1478, but it is based on an idea and perhaps drawings by Leonardo. The second case is more famous. Begun by Verrocchio, perhaps in about 1470, it was continued by Leonardo (possibly after Botticelli), who worked on the left side of the landscape and on the angel on the left, probably between 1472 and 1475. The *Baptism of Christ* in the

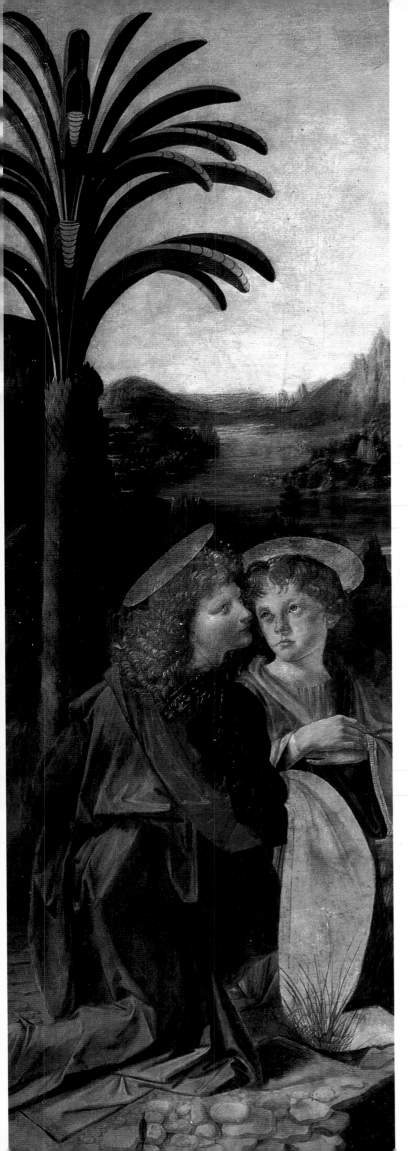

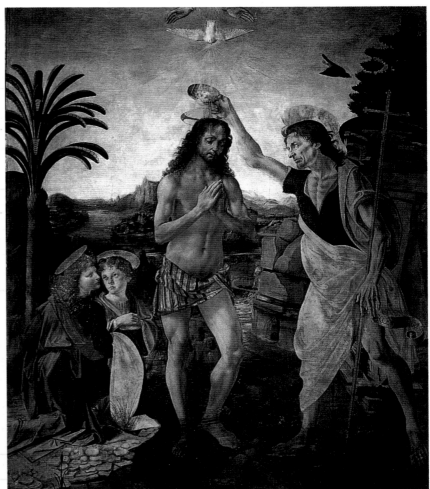

Fig. 19.
Andrea Verrocchio and
Leonardo da Vinci,
the *Baptism of Christ*,
1470–76, oil and tempera
on wood, 69½ x 59½ in.
(177 x 151 cm.)
Florence, Uffizi.
Whole picture and detail.

Uffizi (fig 19) appears to have been completed at the beginning of the 1480s by Leonardo, who tried to unify the painting by going over the body and face of Christ with oil paint. In doing this he turned this panel into a palimpsest of Florentine art at the beginning of the fourth quarter of the Quattrocento.[72]

The prestige of the orders placed with Verrocchio and their large number encouraged the pupils who had become masters to continue working in his studio. Lorenzo di Credo takes over its management after Verrocchio's departure for Venice in 1485, while Leonardo stays until 1476, even though he is registered at the Company of St Luke from 1472 onwards. The years at Verrocchio's studio clearly played a vital part in Leonardo's development: he is a perfect representative of this "workshop culture" whose importance in the general history of Italian Renaissance is becoming increasingly recognized. It is as a result of this training that Leonardo's artistic and intellectual personality developed and progressively distinguished itself with its unique character.

One aspect of this "workshop culture" in particular contributed to the shaping of Leonardo's development: the multi-functional activities of the studio, which always treated projects on a case-by-case basis. Following the tradition of the *abaco*, the *bottega* did not provide a systematic or theoretical training. There were no books. Based on spoken advice and actual examples, teaching consisted of a series of accumulated experiences, on the basis of which the pupil, when he became a master, would have to solve the problems he would encounter in his profession. Founded on analogy and empiricism, the *bottega* training marked Leonardo on at least three vital points: the importance given to experience, the continuous process of accumulating and expanding knowledge, and the fundamental role of drawing in the search for solutions, their recording and their transmission to others.

There is no doubt that Leonardo belongs to this world and this culture, but he also develops a new systematic approach whereby he is not only concerned with professional efficiency, but he is also interested in pursuing his reflections and research beyond the solution of a particular problem. Already in the 1470s and 1480s the *Studies of Draperies*, drawn with a brush on a linen canvas (fig. 12, 20–23, 37), demonstrate this spirit of enquiry. These are preparatory *Studies*, concentrating on the representation of drapery, and they use small figures which were dressed and lit to achieve the desired effect. They were probably quite common in the studio of Verrocchio, who in this respect was still following Donatello's example.[73] Some of Leonardo's studies have been

Page 50: Fig. 21. Leonardo da Vinci (?), *Drapery for a seated figure seen from the front*, brush and gray-brown tempera, heightened with white, 10½ x 7 in. (26.8 x 17.8 cm.) Berlin, Staatliche Museen, Kupferstichkabinett, inv. 5039.

Page 51, top: Fig. 22. *Drapery for a kneeling figure, profile from the right side*, brush and gray tempera, heightened with white, 8 x 11 in. (20.6 x 28.1 cm.) Paris, Musée du Louvre, department of graphic arts, RF 41904.

Bottom: Fig. 23. *Drapery for a kneeling figure, profile from the right*, brush and gray tempera, heightened with white, 7 x 9¼ in. (18 x 23.4 cm.) Paris, Musée du Louvre, department of graphic arts, inv. 2256.

Fig. 20. *Drapery for a seated figure*, brush and grey tempera heightened with white on grey prepared linen, 10½ x 10 in. (26.5 x 25.3 cm.) Paris, Musée du Louvre, department of graphic arts, RF 2255.

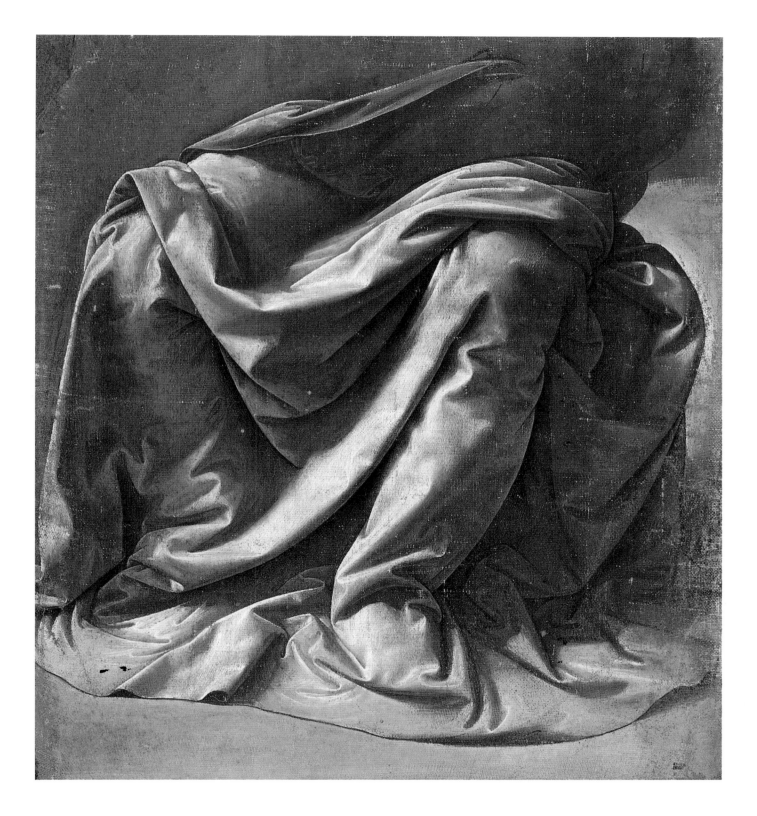

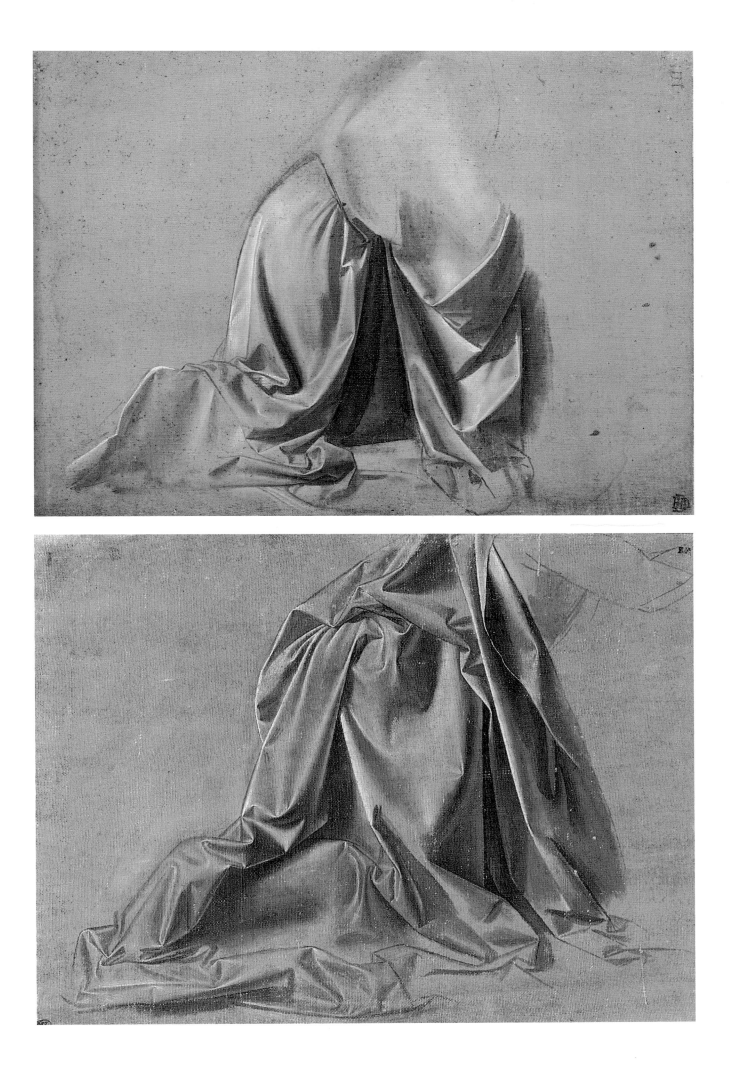

attributed to Verrocchio, Ghirlandaio (fig. 21) or Lorenzo di Credi, those studies that can with confidence be attributed to him show a rare brilliance in this type of exercise (fig. 24, 25). Probably at least six of these drapery studies had a preparatory role: three for the angel in the *Baptism of Christ* (fig. 22, 23), and three for the Virgin in the Uffizi *Annunciation*.[74] So at a first level, Leonardo is not doing anything very original. But these preparatory studies help him to develop a systematic approach in which the "case-by-case" method offers an opportunity for an intellectual experience. Thus the three studies which were possibly for the Virgin of the Uffizi *Annunciation* show that the angle of view has slightly moved from the first to the second, while the third concentrates more on the details of the right side. This meticulous research goes beyond what would have been necessary for a preparatory study and is somewhat evocative of the "revolving anatomies" which he will create in about 1510–11.

It is probably no coincidence that Leonardo is the first artist whose work of this kind has been preserved. His interest in these studies goes far beyond what would have been necessary for simple practical studies. Indeed, years later, he

Left: Fig. 24. Lorenzo di Credi, *Drapery for a seated figure*, metal-point, brush and gray-brown wash, heightened with white on pale pink prepared paper, 8½ x 7 in. (21.9 x 17.6 cm.) Paris, Institut Néerlandais, Collection Frits Lugt, inv. 2491.

Right: Fig. 25. Lorenzo di Credi, *Drapery for a man standing, from the front*, brush and gray tempera, heightened with white on first outlines drawn in black chalk, with red chalk and white gouache, finished with brush and oil pigments on ochre brown paper, 15¼ x 10¾ in. (38.7 x 27 cm.) Paris, Musée du Louvre, department of graphic arts, inv. 1791.

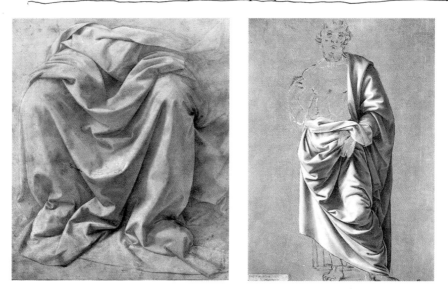

decides to devote at least one chapter in his *Treatise on Painting* to the subject of "Drapery and ways of dressing figures with grace, and clothes, and the nature of drapery."[75] The use of the word "grace" is very significant here. Following in Alberti's tradition, Leonardo's objective is to bring to life the figure "inhabiting" the drapery. In other words, and repeating what Vasari

said about "grace," the fundamental aspect of the *bella maniera* ("beautiful style") which in his eyes had been initiated by Leonardo, the objective is to make one conscious in the drapery itself (and not only in the musculature) of what "appears between the seen and the non-seen, which is present in the living flesh."[76]

The way in which he tries to achieve this effect of living presence is in itself important. Comparing his drapery studies with those of Lorenzo di Credi, a subtle but decisive difference is seen. With Lorenzo, the form absorbs the light without reflecting it and the drawing, very sculptural, brings out the figure from its surroundings volumetrically, thus creating an effect of relief, reminiscent perhaps of the intention of the sculptor, who inspired this kind of study. By contrast, with Leonardo the figure is inseparable from the aerial milieu that surrounds it. Even in the study that seems the most sculptural of all (fig. 20), the distribution of light and shadows and the carefully drawn background ensure a unity and continuity of the light in the circulation of the chiaroscuro. Leonardo uses the shape to create the luminous air surrounding it, thus anticipating his future research (artistic and scientific) on the fluidity of light and shadow, changing qualities distinguished by a dynamic exchange, in contrast with the fixed qualities of objects.[77]

Leonardo's research on drapery, an expression of his fascination for the changing aspects of the unity of the world, already shows the *ostinato rigore* ("determined exactitude") that will later become his motto.[78] From his days in Verrocchio's workshop, Leonardo aims at becoming a specialist in all the disciplines he is involved in. In this he differs both from the artist-craftsman who is only interested in mastering his skill and from his humanist models, such as Alberti, for whom the painter has only to be a specialist in drawing and geometry, while the artist is expected to have a general education in the field of letters.[79]

However, and this is a vital point in understanding the impact of Leonardo's background on his work, his systematic approach does not take place in a context that is systematic itself. Leonardo is always planning to write down his research work in an organized theoretical structure. For instance, folio 35r of the *Codex Leicester* contains observations on the movement of ebbing and flowing water in rivers, and beside them is the note, "As is proved in the twenty-first [proposition] of the fourth [book] of my theory." Indeed, folio 15v of the *Codex Leicester* gives the plan of a Treatise on water in fifteen volumes whose fourth volume deals with "rivers."[80] There are many of these

internal references in his manuscripts (the *Codex Leicester* alone contains twenty-six), and if Carlo Maccagni is correct, the organized corpus of the complete work would have consisted of one hundred and twenty volumes.[81] They were never written and, in spite of his many attempts at the systemization of knowledge, as regular as they were scattered, Leonardo's scientific investigations take the form of observations, juxtaposed and autonomous, based on actual researches.

Leonardo is conscious of this aspect of incompleteness, of disarray. In folio 2v of the *Codex Leicester*, for instance, he interrupts a "demonstration" on the movement of bodies thrown into water: "I shall not deal with the proofs at this point but will do so later in the organized work; I shall only concentrate on finding cases and inventions, and I shall arrange them in the order that they come to me; I shall put them in a proper order later by grouping those of the same kind together; so that, at the moment, you should not be surprised and laugh at me, reader, if here we make such great leaps from one subject to another."[82] These fairly frequent remarks have even led some to believe that it was lack of time which prevented Leonardo writing the treatises he had planned. But this incompleteness is above all an intrinsic characteristic of the twin traditions that come together in his manuscripts: that of the *zibaldone* ("commonplace book") and, even more, that of the *libro di bottega* or "studio book."

An indispensable companion of the man of letters, especially at court, the *zibaldone* was a collection of unusual words and quotations notable for their style or content, chosen to be used at the right time, such as in a poem for a special occasion, at a time when printed books were still rare. Leonardo recognizes the value of such a helpful compilation at the court in Milan, and its particular importance for the *uomo sanza lettere*.

The written work of artists fell into three categories: the treatise with a humanist approach (of which Alberti provided an extraordinary example), the professional manual (in the manner of Cennino Cennini, Ghiberti, Piero della Francesca or Francesco di Giorgio) and the studio book. Kept up to date every day, it contained technical recipes, passages copied from famous authors, mentions of personal events, moral reflections, some theoretical remarks, details of bookkeeping, family memories, drawings and diagrams for recording and passing on a particularly successful solution. Continuously updated, annotated and corrected, the *libro di bottega* was the daily witness and record of the activities in the studio.[83]

The composite character of the studio book, empirical and disorganized, is found in Leonardo's manuscripts, and it makes interpretation a particularly delicate matter. How can one distinguish between an original thought and a quotation, direct or indirect? How can one tell the difference between a polemical proposal and a serious note, a first idea and a final formulation?[84] It is not only that some phrases (obviously reminders) are repeated many times but, while some pages are clearly organized as if for a forthcoming publication, the majority have an accumulation of notes and drawings without any connection between them, and these have sometimes been scribbled on the page at different times. Folio 12641r-v preserved at the Royal Library, Windsor, is a typical example of this extraordinary lack of order. Its verso (fig. 26) includes, in the spaces left free by some notes on the movement of water, two mathematical calculations and drawings of siphons, some men using a sledgehammer, a plant (*Calla palustris*), a side silhouette view of a man blowing into a trumpet (undoubtedly inspired by antiquity) and, below this figure, a plan of canals in an ideal city, which is reminiscent of Leonardo's first studies in town planning in Lombardy in about 1487–90, which would be revived in the designs for Romorantin in France in about 1517–18. As for the word "*Quella*," clearly readable from left to right, this was certainly written by Francesco Melzi. On the recto, on the other hand, it is Leonardo who wrote some notes (on water, once again) on a sheet that Melzi had previously used to sketch some figures and landscapes, probably with a view to using them in a painting.[85]

On one occasion at least, this disorder in the studio and these interventions by pupils have saved an "invention" of genius by Leonardo from being forgotten. The restoration of the *Codex Atlanticus* in the 1960s saw the reappearance of the verso of folio 133, which had been folded when the volume was bound by Pompeo Leoni. This led to a sensational discovery. Apart from a satirical drawing lampooning the homosexuality of Salai, one of Leonardo's assistants, the page contains a rough drawing of what is unarguably a bicycle (fig. 27), shown in the form that it was to achieve only by about 1900, that is, with the two wheels the same size and, most significantly, the pedals and transmission chain conveying power to the rear wheel. This rough sketch is further evidence of Leonardo's interest in the idea of a transmission chain, a detailed drawing of a similar one appearing in folio 10r of *Madrid I* (fig. 28).[86]

The disorder in the manuscripts has certainly been made worse by the manipulations to which they have since been subjected. Certainly too Leonardo is the first artist-researcher whose working notes have been preserved in their

Fig. 26. *Various studies*, before 1508,
pen and ink on white paper, 9½ x 6¾ in. (23.9 x 17 cm.)
Windsor Castle, Royal Library, RL 12641v.

raw state—which in itself confirms the importance in which they were held by Leonardo's entourage. This means that the notebooks are neither accidental nor anecdotal: the very intimacy of the documents brings us closer to Leonardo's thought processes, their limits and their effectiveness. The collective practice of the studio and its "case-by-case"culture has obviously contributed to the disorder in which Leonardo worked, and they have certainly formed a major obstacle to the systematic synthesis that he wanted to

Fig. 27. Studio of Leonardo da Vinci, *Drawing of a bicycle*, *Codex Atlanticus*, fol. 133v, detail. Milan, Biblioteca Ambrosiana.

bring to a successful conclusion. But this "method" also contributed to freeing his thinking from the constraints and prejudices that were imposed by the existing structure of knowledge, its influence and the respect in which it was held.

One sheet at least suggests that Leonardo was conscious of the inevitably piecemeal character of this simultaneous multiplicity of interests. Folio 12283r from Windsor is one of Leonardo's largest (12.6 x 17.6 in / 32 x 44.6 cm) and also one of the oldest, dating from 1489–90 (fig. 29). At first sight its contents are disparate. The text consists of geometrical commentaries and a recipe for lightening hair color. The drawings show studies of nature (clouds, plants, trees and rocks), horses and human figures (naked and clothed), and two sketches for a machine, as well as the geometric figures. But as Carlo Pedretti[87] has observed, the page almost seems to be designed to be "rhythmically balanced." In particular, the left side of the sheet visually associates the side view of the human figure with the elements surrounding it. On the right of the figure the branches of a dead tree seem to metamorphose into a network of veins seen through fabric, and the left side the geometrical figure serves to define the shape of the cape; its other side becomes transformed into a view of rocks.

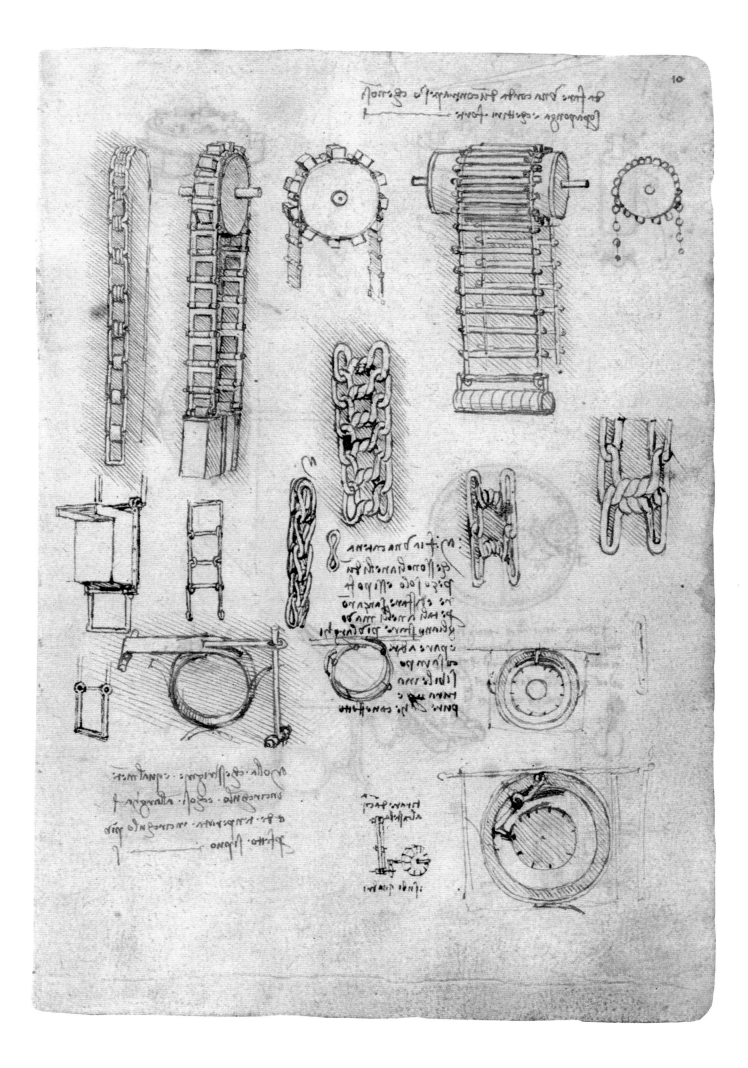

According to Carlo Pedretti, this sheet constitutes "a remarkable document about the mode of thought" of Leonardo and offers "a complete synthesis of his scientific curiosity and his artistic versatility." One thing is certain: Leonardo's systematic curiosity combined with the "studio culture" acquired in Florence, obliges him to defy tradition, taking each question back to its very origins—when he is not inventing a new question. This radical attitude can arrive at an impasse. In the geometric study of aquatic whirlpools, Leonardo is aware of the failure—inevitable in the face of the apparently infinite number of possible movements—and he does not have at his disposal the "uncertainty" principle by which modern scientists can integrate that which escapes from calculation.[88] But Leonardo's most significant researches and discoveries are also due to this meticulous approach, carried out *con ostinato rigore* ("with determined exactitude"). So if Leonardo is the only person in the fifteenth century to be interested in the theory of optics,[89] this is primarily because he is not satisfied by current opinion: "The eye, which offers such evident proof of its functions, has until now been defined by countless writers in a certain way, but experience showed me that it works in a different manner" (*Codex Atlanticus*, 119v-a). This dissatisfaction causes him to ask a series of detailed questions that have the appearance of a preliminary program of study to be carried out in order to explain so many practical observations (*Codex Atlanticus*, 360r-c):

"Why the eye changes from hour to hour, enlarging and contracting.

"Why the pupil contracts when there is more light facing it, and why on the other hand it expands in darkness.

"Why things looked at continuously are small inside the eye and yet appear large [...]

"Why a building surrounded by clouds seems larger.

"Why the eye sees perfectly only in a straight line.

"Why the pyramidal lines leaving the eyes arrive in the form of a point at the object being looked at.

"Why, when the said pyramid leaves the eyes and arrives at a point on a submerged object, the lines bend on reaching the water and no longer keep their straightness.

"How things seen form a pyramid in the eye.

"How the two eyes form a pyramid in the object seen."

The solutions that Leonardo brings to the problems he poses are often unorthodox and sometimes uncertain because of the imprecision of his learned

Fig. 28. *Studies of gearing*,
Ms. Madrid I, fol. 10r. Madrid, Biblioteca nacional.

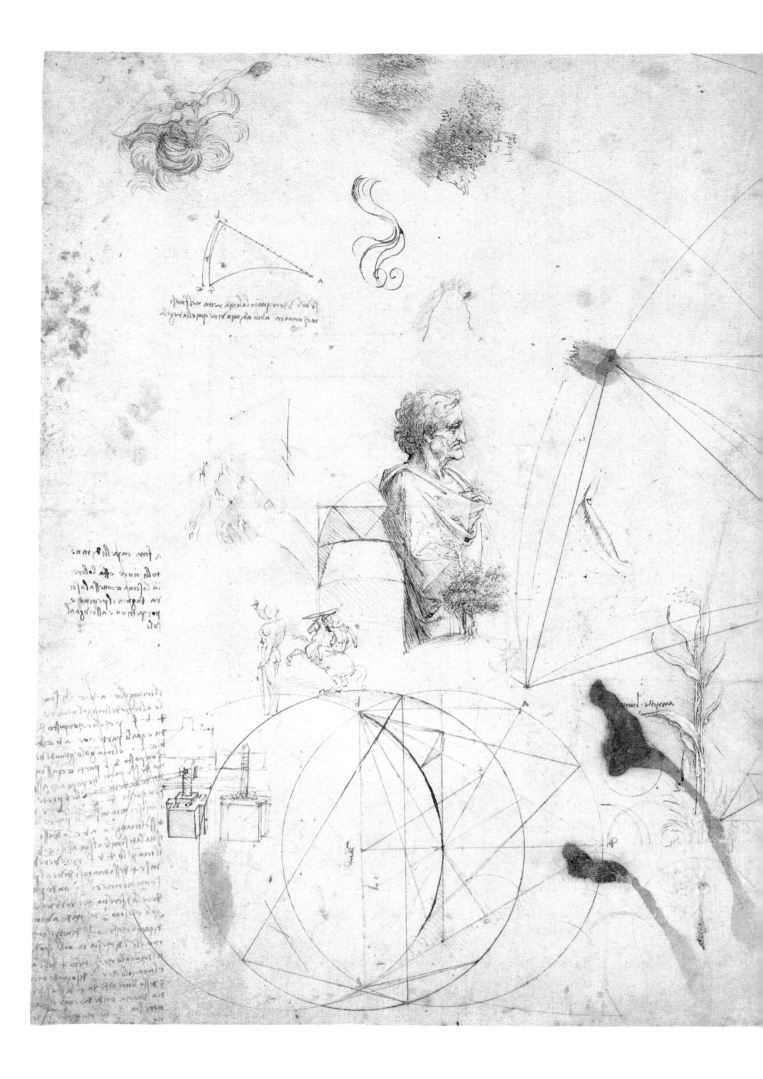

Fig. 29. *Various studies*, before 1489–90, pen and brown ink, 12½ x 17½ in. (32 x 44.6 cm.) Windsor Castle, Royal Library, RL 12283r. (See commentary, page 57.)

vocabulary. It is even possible to argue that he was not an important "scientist" because he was content to jump from one observation to another, and because he did not formulate theories that would have given his observations a proper scientific value.[90] Admittedly, Leonardo is not a Galileo. But this absence of orthodoxy also allows him to challenge the contemporary orthodoxy and to be able, "alone in his time […] to give a practical value to speculative themes."[91]

But the most revealing aspect is that this open attitude is found in all the different areas of his artistic activity. There will be setbacks as a result of following this radical approach, in the field of mural painting for example. But it also allows him to make discoveries and propositions, which, like the bicycle already mentioned, did not exist in either the theory or the practice of his time. Leonardo also proposes some musical instruments, such as the *glissando* recorder (Swanee whistle) and keyboards for wind instruments (fig. 30), which will not come into existence for centuries because they did not suit the musical practices of the time.[92] As Emanuel Winternitz has shown, their invention is inspired by using an analogy with the mechanics of the human body (the operation of the larynx and the fingers of the hand). These proposals show how a unity founded on analogy structures Leonardo's "disparate" researches and gives them the effectiveness of "genius" to the point that they cannot be implemented at the time.

The same is true about Leonardo's relationship to existing culture and the arts of antiquity. Folio 110r of *Madrid I* (fig. 31) contains four drawings with accompanying words showing that they illustrate a text from the Natural History of Pliny the Elder (*Historia Naturalis*, XXXVI, 24). This described the rotating theater devised by the curial aedile (magistrate) to enable spectators to watch successively the gladiatorial spectacles and then, without moving, the funerary rites in honor of his father. Apart from the technical ingenuity of the device,[93] the page is a revelation because, in his translation of Pliny in 1476 (which Leonardo owned), Cristoforo Landino left out precisely those lines that described the back-to-back arrangement of the two theaters and their rotation. (It is possible he felt justified in doing this in view of their technical character and the criticisms that Pliny expressed on discovering an invention that he thought was irresponsible and unworthy of a nation that ruled the earth.) One may therefore assume that Leonardo had been read the Latin text, perhaps by an admirer of the stage machinery that he had devised for the scene changes of *Orfeo* by Politian in Milan. It is even possible that, seeing the omission in the text, Leonardo derived some pleasure in illustrating the device

Left: Fig. 30. *Keyboards for wind instrument and tuned drum, Codex Arundel*, fol. 175r. London, The British Library.

Right: Fig. 31.*Mobile theater* (after Pliny the Elder), *c.* 1497, *Ms. Madrd I*, fol. 110r. Madrid, Biblioteca nacional.

and putting before the eyes of the men of letters the explanation that the text did not provide. By his unprejudiced approach, the engineer restored antiquity better than the humanist.

The same freedom is found in his relationship with the art of antiquity. Only recently has a direct reference to the antique been found, in the seated figure drawn on folio 12540 from the Royal Library at Windsor (fig. 32). The pose with the bent left leg identifies the figure with certainty as a drawing of the famous

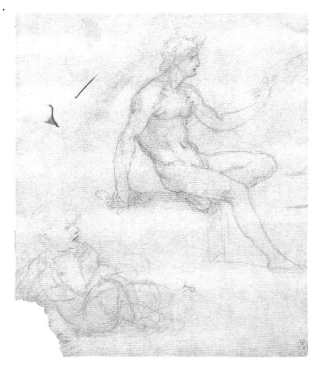

Fig. 32. *Seated figure,*
c. 1503–06, black chalk
on white paper,
6¾ x 5½ in. (17.3 x 14 cm.)
Windsor Castle, Royal
Library, RL 12450

ancient Diomedes, owned by Niccolò Niccoli, Pius II and then Lorenzo the Magnificent. After Donatello, Michelangelo was freely inspired by it for several of the *Ignudi* (naked figures) in the Sistine Chapel. It took some time to identify this source from antiquity in Leonardo's drawing, because it has been executed with such uninhibited freedom. The treatment of the body gives the impression that a living model was used, and Leonardo has put his individual mark on the figure by giving the left arm the characteristic gesture of the index finger pointed to the sky.[94]

Leonardo absorbs everything he touches. It is in this spontaneity, and sometimes in his wild ingenuity, that part of his uniqueness resides. Leonardo is not the only universal artist in the years around 1500: the Sienese Francesco

di Giorgio might have seemed even more gifted in the eyes of the time, since as well as being sculptor, architect and painter he also published a treatise on architecture, which Leonardo owned and annotated.[95] Nor is Leonardo the only artist to have contributed to the scientific revival of the Renaissance; on the contrary several painters, architects and engineers played a driving role in this area.[96] But, more than anyone else, Leonardo's genius possessed the "terrible strength of reasoning," which Vasari described in the middle of the sixteenth century[97] and whose characteristics one must try to understand.

LEONARDO'S INTELLECTUAL MILIEU

Leonardo is not the Italian brother of the Faust of romance, and he is not the superhuman genius that the nineteenth century took delight in inventing, the absolute and sole precursor who had, centuries in advance, preceded humanity in every field of activity and knowledge. His technical and scientific imagination is certainly exceptional, and the list of inventions and discoveries he made that anticipated the scholars and engineers of the future[98] would be too long to draw up here. But, while this is characteristic of his individual genius, his ability follows routes and processes that link the universal man to his period and enable originality to flourish.

More Daedalus than Pythagoras, Leonardo believes above all that mathematics are a "means of construction."[99] The declaration on folio 8v of *Manuscript E,* made as late as 1513–14, could not put this more clearly: "Mechanics are the paradise of the mathematical sciences because, thanks to them, one may harvest the fruit." By training Leonardo is "a man of *praxis,* that is to say a man who does not construct theories, but objects and machines and who, most often, thinks in that way."[100] For him science is not a subject for contemplation but a tool for action, and his attitude to it is usually that of an engineer. He searches for practical solutions that, at times, require the aid of mechanical instruments. For example, Leonardo tackles what was known as the "Alhazen" problem—"to find the point of incidence on a spherical mirror of a ray coming from a given luminous source, such that the reflected ray passes through a given point." His many attempts to find a geometric solution are unsuccessful (it was discovered only in the seventeenth century by Huygens), so he pictures an instrument that arrives at the solution mechanically; it is also one of the first jointed systems in the history of science.[101] The rigor

of reasoning matters less to him than the effectiveness of the result: it is still not known by what "method" Leonardo made the important mathematical discovery of the center of gravity of a tetrahedron.[102]

This concern with effectiveness separate from strict theoretical development is in the tradition of studio culture. But, in the progress and development of his thinking, Leonardo tends also to go beyond the initial elements of the problem. Theoretical considerations were not neglected; they sometimes took on a fundamental importance, so much so that he can write in apparent contradiction of his first principles: "Take care of the reasons and you will have no need for experience" (*Codex Atlanticus*, 147v). This decisive expression seems to have been made in about 1490 when he is engineer at the court of Milan and is faced, for example, by the problems presented by the flow of rivers, canals and locks. Leonardo realizes that he ought to know about the element "water" in order to subjugate and exploit it with the help of appropriate devices. So it is that the Paris *Manuscript A* (1490–92) first announces the "Start of the treatise on water" (folio 55v). This is also the period of the first theoretical studies concerning optics and mechanics. Leonardo's route is typical of the self-taught: having

Right: Fig. 33.
Studies of water falling,
Ms. Madrid I,
fol. 152r. Madrid,
Biblioteca nacional.

Far right: Fig. 34.
Studies of water falling,
Ms. Madrid I,
fol. 134v. Madrid,
Biblioteca nacional.

consulted the main traditional texts,[103] he would make verbal inquiries of contemporary scholars and then try to set down general principles, confirmed by experience. In this quest, it seems to him that geometry (of which he was ignorant) would be the unifying instrument of his researches. He therefore undertakes the systematic study of this discipline, following the same course. At the same

time, he develops his theory of the "four powers" of nature—movement, weight, force and percussion—on which all natural phenomena depend.

In the final years of the century this approach leads Leonardo to genuine "mental experiments," to proposals for experiments and instruments founded entirely on his theoretical predictions from which he expects the anticipated effects to derive. He also asks himself what the power of a waterfall depends on and becomes convinced that its effect comes from a combination of the weight of water and its "percussion," the latter being itself, by virtue of its impetus, proportional to the height of the waterfall. Following from this he illustrates devices whose results he can predict without carrying out any experiments (fig. 33, 34).[104]

As will be seen, since Leonardo had not learned to think in an abstract manner, this "exaltation of theoretical thought remains, alas, somewhat theoretical."[105] This limitation explains what seem with hindsight to be unexpected failures. For instance, Leonardo is not the first to use the camera obscura, but he is certainly the first to use a lens with it, and more than a century before Kepler he becomes the first to discover that it works like a model of the eye:

Fig. 35 and 36.
Drawing of camera obscura and the anatomy of the eye,
Ms. D, fol. 10 v. Paris, Institut de France.
Whole picture and detail.

he draws the two side by side on the same sheet (fig. 35, 36). But, tied to tradition, he cannot imagine that the image which is reversed on the retina can be turned the right way up by the brain; he therefore draws a sketch (which contradicted his anatomical observations) in which the image is re-inverted before it reaches the optic nerve.[106]

These ambiguities and uncertainties are evidently connected with the fact that Leonardo's universality is that of a self-taught person who, while having great freedom of spirit and being inclined (sometimes to a fault) to question the established truths, is held back by the institutional prestige of the university tradition. But it would be wrong to leave it at that: that would be a distortion of the importance of his research. In the thinking of the time, the innovative strength of his propositions and his "demonstrations" stem from two forms of thought, radically unrelated to one another, yet co-existing. Trained by the "case-by-case" knowledge of the studio and a universal autodidact in the field of scientific theory, Leonardo behaves like an "intellectual magpie"[107] and his most remarkable advances sometimes have the homemade quality that distinguishes the practice of a "primitive" thinker—in the sense that "the primitives are not always the backward ones, they are also those who make discoveries."[108]

While tradition draws a clear distinction between the practical mechanics of the engineer and the theoretical mechanics taught at university, Leonardo aims to work on a synthesis. This attitude sets him apart from his colleagues but it also makes him, more than the rest, a representative of the "intellectual milieu" between humanism and scholasticism that—sometimes borrowing from both—plays an essential role in the transformation of knowledge and practice that the Renaissance begins. Forming "a third specifically modern form of knowledge and the *desire to know*," this intellectual milieu has been perfectly described by Ernst Cassirer: "In this third direction it was not a matter of setting down and scientifically understanding a particular religious content, or of returning to the great traditions of antiquity and seeking there the renewal of humanity, but of concentrating on the tasks of practical artistic techniques for which a 'theory' was sought. This creative activity emphasized the need for careful thought about the activity itself which can only be achieved by returning to the very foundation of knowledge, more particularly of mathematics."[109] Leonardo's intellectual attitude could not be more accurately described, and one is also close to what roots the singularity of his genius in his own time.

For Cassirer, three personalities embody in various ways the aspirations of this milieu: Nicholas of Cusa, Alberti and Leonardo. Alberti and Nicholas of Cusa were contemporaries; they lived at the same time in Padua, Ferrara and, most importantly, Rome where they were both very close to Pope Nicolas V and the Florentine doctor Paolo dal Pozzo Toscanelli; it is therefore likely that they knew each other, and, in any case, they knew each other's ideas,

which were often developed from the same sources.[110] The contrasting relationship between Leonardo the artistic theorist and Alberti the intellectual humanist will be considered again later.

The relationship between Nicholas of Cusa and Leonardo was of a different kind, because Leonardo clearly did not know Nicholas of Cusa and it is unlikely that he could read his scholarly, complex Latin.[111] Nicholas of Cusa is, in the full sense of the term, a philosopher who proceeds by way of speculation. Some vital points of his doctrine, such as theocentrism or the dialectical doctrine of the infinite, were unknown to Leonardo, permitting Eugenio Garin to declare that "the speculation of Cusa, matured through the meeting of Neoplatonism and German theology, has absolutely nothing to do with the 'science' of Leonardo."[112] However, without even recalling a number of phrases, admittedly taken out of context, in which one seems to hear an echo of the sayings of Nicholas of Cusa,[113] it seems likely that Leonardo knew something of at least two of his works: *De transmutationibus geometricis* ("On geometrical transformations") and *De ludo globi* ("On the game of the sphere"). In the early 1500s, the manuscripts *Forster I* and *Madrid II*, as well as many pages of the *Codex Atlanticus* (fig. 64), see an increase in the number of studies on the transformations of solid bodies and the transformation of curved surfaces into rectilinear ones. Leonardo also completes a project for a treatise *De ludo geometrico* ("On the game of geometry").[114] Similarly, *Manuscript E* (1513–14) contains some drawings (folios 34, 35) that illustrate the "game of the sphere," which had exercised the speculations of the German philosopher; this was not a childish question, since the spiral movement of a spherical body invited consideration, in a precise and complex case, of the question of movement given to a heavy body. This was a central question of Aristotelian physics. In the fifteenth century it raised the idea of *impetus*, with regard to which Leonardo proposed his own definition of *force*, which is at the heart of his concept of nature.[115]

In spite of the criticisms of Garin, Cassirer was therefore right. Undoubtedly, Leonardo had not read Nicholas of Cusa, but it is probable that he had some verbal knowledge of him.[116] This does not mean that Leonardo was influenced by Nicholas of Cusa. What is significant is the kinship of the spirit that links the two men and, precisely because of all the differences that there are between a theological philosopher and an engineer artist, contributes to the creation of an intellectual milieu distinguished by unity and fertility.

On three fundamental points the texts of Nicholas of Cusa anticipate

Leonardo with remarkable accuracy. First, of course, is the fundamental role of mathematics in a theory of knowledge founded on measurement and proportion. Next, more originally, is the status accorded to the "layman," to the *uomo sanza lettere* ("the illiterate man"). In *De idiota* ("On the uneducated") written in 1450, Nicholas of Cusa makes him the mentor of the orator and the philosopher, and his criticism of bookish learning in favor of nature recalls very closely the terms used by Leonardo at the beginning of this chapter: "The first people who set out to write about wisdom did not become great by wallowing in books that did not yet exist, it was the natural food that made them accomplished men, and they have far exceeded in wisdom those who believed they would profit from the books."[117] Last and most important, Nicholas of Cusa and Leonardo make painting and the activity of painting a model for thought. For Cusa, the concept is founded on the original idea of painting as an infinite movement towards an exact representation of the model. Treating human thought as an "image of divine art," Nicholas of Cusa explains his concept of the route towards knowledge as an infinite movement towards the truth, inaccessible in its transcendent, absolute unity. He compares it with the "unfinished" art of painting: the "imperfect" work, not completed, is more perfect than the totally finished work because in that case it "still tends to conform increasingly and without limit to the inaccessible model," because in doing so it "imitates the infinite by means of the picture."[118]

These pages from *De idiota* help to place within the framework of fifteenth century thought this desire to bring out "the formation beneath the form," which explains the "unfinished" nature of some of the works painted by Leonardo. They are related to those in which Leonardo glorifies painting, divine art and philosophy, and the painter—whose spirit "transforms itself into an image of the spirit of God." The thought arranged by the philosopher, the theologian of "learned ignorance" and the initiator of thought about the cosmos as a universe in movement[119] undoubtedly provides a contemporary theoretical framework for the fragmentary thoughts of "the practical man" who was Leonardo.

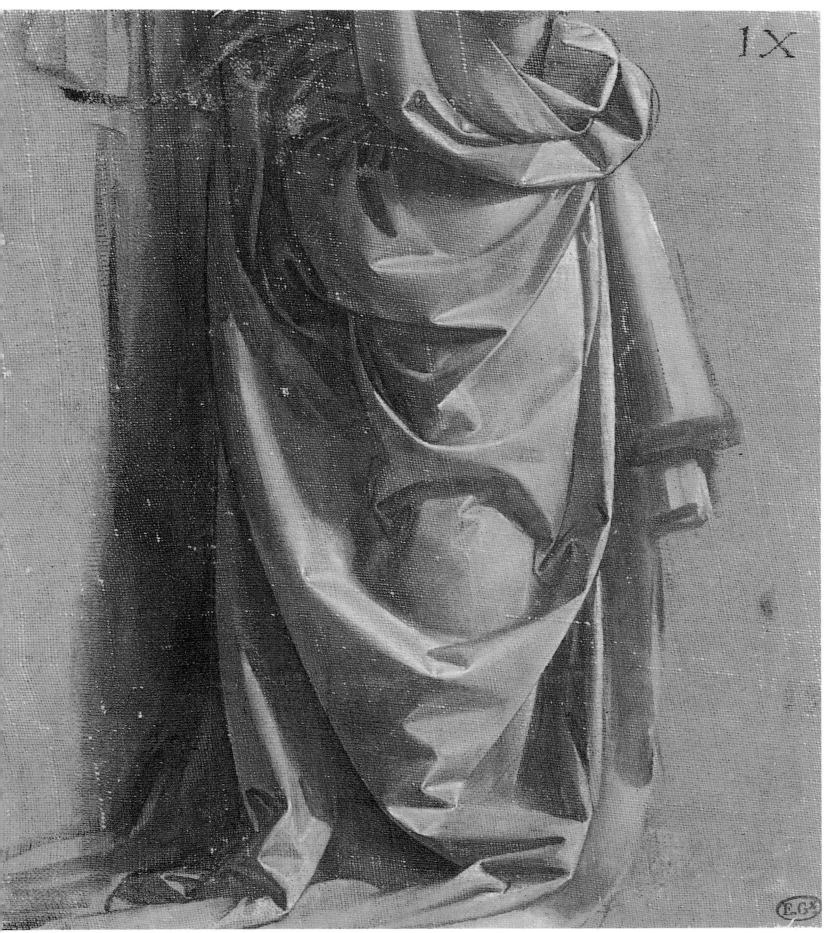

IX

Fig. 37. *Drapery for a standing figure, seen in profile from the right,*
brush and gray tempera, heightened with white, 7¾ x 6 in. (19.6 x 15.3 cm.)
Paris, Musée du Louvre, department of graphic arts, RF 1082.

A Science in Movement

"The ancients called man a microcosm, and indeed this epithet is well applied to him. Because if man is made up of water, air and fire, it is the same for the body as the earth; and if man has in him an armature of bone for his flesh, the world has its rocks, supports of the earth; if man contains a lake of blood where the lungs, when they breathe, dilate and contract, the terrestrial body has its ocean which increases and diminishes every six hours, with the breathing of the universe; if from this lake of blood veins leave which branch through the human body, the Ocean fills the body of the earth with an infinity of watery veins. Indeed the terrestrial body has no nerves, which are created for the purpose of movement; the world being perpetually stable in itself, no movement is produced, and therefore the nerves are no longer necessary; but as for the rest, man and the world present a great analogy." (*Ms. A*, 54v.)

THE TWIN USES OF ANALOGY

From the time of this famous page, written in about 1492 in the introduction to an unwritten "Treatise on water," until 1508–10, when the same kind of expression is found in the *Codex Leicester*, analogy is at the heart of Leonardo's scientific and artistic thought. Towards 1504–05 for example, while he was preparing the fresco *The Battle of Anghiari*, he draws an analogy between the expressions of fury in man, horse and lion (fig. 39). Again, in 1509, in space left free on a sheet used in about 1506–07, he draws three skeletons which, by comparing the anatomy of the man and the horse, lead logically to the invention of a hybrid skeleton in which the species are combined (fig. 40). Around 1510–11, Leonardo still believes that "all the terrestrial animals have similar muscles, nerves and bones and they vary only in size or thickness" (*Ms. G*, folio 5v). It is also this context of universal analogy which gives its theoretical support to the plan he has of "revealing" in his Treatise on anatomy "the cosmography of the *minor mondo* (lesser world) [...] in fifteen complete figures, according to the order which Ptolemy observed in his Cosmography" and to arrange the limbs "as he has done for his division into provinces" (*Quaderni I*, 2r). In yet other fields, it is thinking by analogy that brings the human soul into a situation of harmonious resonance with the

beauty of the world, while ruling the body as an earthly ruler controls his territories.[120]

This omnipresence of analogy is not at all surprising, since one is dealing with a way of thought dominant in the Renaissance theory of knowledge. Together with *convenientia* (harmony), *aemulatio* (emulation), and the "sympathies," analogy is one of the four main figures of this similitude, which, according to Michel Foucault, "until the end of the fifteenth century played a

Fig. 39.
*Studies of horses,
a man and a lion,*
c. 1503–04, pen and ink
with wash, 7¾ x 12¼ in.
(19.6 x 30.8 cm.)
Windsor Castle, Royal
Library, RL 12326.

constructive role in the learning of western culture" and "organized the game of symbols, allowing the knowledge of visible and invisible things, and guiding the art of depicting them."[121]

At the root of this concept lies the idea that the universe is a living organism whose general properties reflect themselves in each of its smaller parts. Few authors have experimented with this idea with the conviction of Leonardo in the *Codex Leicester*: "Nothing is born wherein there exists no sensitive fiber or rational life. Feathers grow on birds and renew themselves every year; skin grows on animals and changes every year except in certain parts, like the mustaches of lions, cats, and other creatures of the same species. Grass grows in fields, leaves grow on trees, and each year they are largely renewed. We may therefore say that a spirit of growth animates the earth. Its flesh is the soil; its bones are the successive stratifications of the rocks that form the mountains; its cartilage is tufa; its blood, the gushing waters. The lake of blood that surrounds the heart is the ocean. Its beat becomes the raising and lowering of blood in the pulse,

75

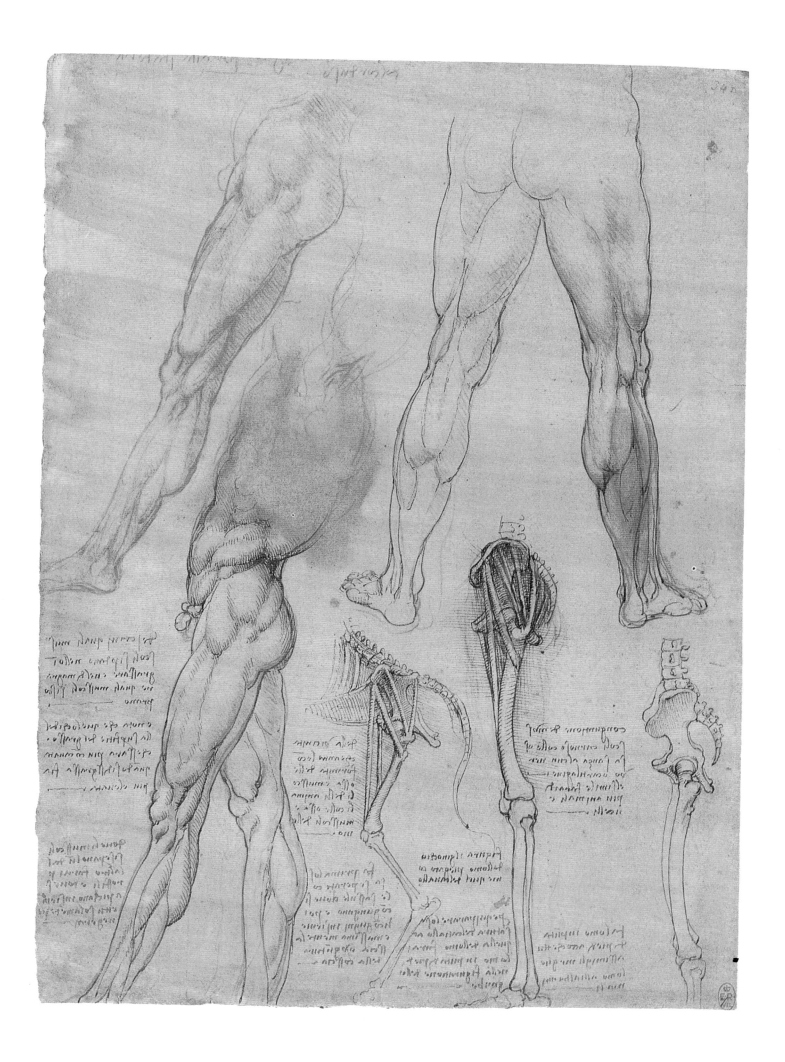

reflected in the earth by the ebb and flow of the sea. The vital warmth of the world is fire, infused through all the earth, and its creative spirit resides in the fires that at various points of the globe breathe out in the form of thermal springs, sulfur mines and volcanoes, such as Mount Etna in Sicily, and several other places."[122]

Thought by analogy between the microcosm and the macrocosm dates back to Plato (in particular in *Timaeus*, 30a). At the end of the Middle Ages and until the sixteenth century, it possessed the authority of a tradition, uninterrupted since antiquity.

"The water that rises within the mountain is the blood that keeps the mountains alive" (*Ms. H*, 77r). Leonardo was faced with the phenomenon of mountain springs, which seems to contradict "the natural course" of the weight of water. For a long time, he follows the tradition, which, from Aristotle, through Seneca, Albertus Magnus and Ristoro d'Arezzo, to Dante, puts forward various explanations founded on the analogy between the circulation of water in the earth and that of blood in the human body.[123] Similarly, it is in following Aristotle that Leonardo rejects the idea that the seas are under the influence of the moon—even though it had been supported by Pliny the Elder, Albertus Magnus, Ristoro d'Arezzo and others too. Leonardo prefers to attribute all movements of water to the life inherent in the earth and, as Carlo Pedretti has noted, each time that he embarks upon a campaign of anatomical studies, he prepares himself also to consider the geological structure of the earth.[124]

But Leonardo is not content just to make use of analogy more systematically than his contemporaries. He completely renews the way of using it and, ultimately, even the concept itself. It can first of all serve as a starting point for hypotheses of interpretation, eventually capable of being subjected to experiment. So, beneath the "geological" sketch of the entrails of the earth visualizing how the subterranean water (which comes from the sea) can rise up towards the peak of mountains under the action of the fires "that are found in the interior or rather in the body of the earth," folio 3B (3v) of the *Codex Leicester* (fig. 41) shows two drawings that are probably inspired by *De Meteoris* by Albertus Magnus. These show how water rises inside a receptacle when the latter, previously heated, cools down. But, unlike Albertus Magnus, Leonardo attributes this phenomenon to the rarefaction of the air inside the receptacle and not to the direct action of heat; he is thus prepared to reject the hypothesis according to which it is the heat of the sun that draws the water to the heights of mountains.[125]

Fig. 40. *The muscles and bones of the leg and the hip, study comparing the skeletons of a man and a horse,* c. 1506–08, pen and ink with red chalk on red prepared surface, 11¼ x 8 in. (28.5 x 20.5 cm.) Windsor Castle, Royal Library, RL 12625r.

In other respects, when he resorts to a descriptive analogy, it is not in the poetic spirit that Aristotle had already criticized (*Meteorology*, III, 3) in Empedocles when he compared the sea to the sweat of the earth. For Leonardo, the descriptive analogy allows the clarification, by comparison, of the structure of an object or a phenomenon. For example, the famous drawing of the "hair-like whirlpools" of water (fig. 4) undoubtedly has a poetic value; but the text that accompanies it clearly demonstrates that his declared intention is to make vis-

Fig. 41. *Geological sketch of underground water*, *Codex Leicester*, 1508–10, fol. 3 B, 11¾ x 16¾ in. (29.9 x 42.6 cm.) Seattle, private collection.

ible an analogy in the dynamic structure of phenomena. He writes: "Observe the movement of the water on its surface, how it resembles that of hair. There are two movements, one following the undulations of the surface, the other the lines of the curves; so the water forms whirlpools which partly follow the impulse of the main current, and partly the rising and incidental movements." It is in the same spirit that Leonardo compares the human head to an onion: their structure is similar because "the tunics or skins which form concentric circles round an onion" are comparable in the way in which "the hair, then the skin, the muscular flesh and the pericranium, then the cranium with, inside it, the hard mother, the magpie mother and the brain [...]" succeed each other (*Quaderni V*, 6v). In the same way, the network of veins behaves like oranges "whose skin thickens and whose pulp reduces as they become older" (*Feuillets B*, 10v).

Beyond this descriptive use, analogy such as that which Leonardo used most often is a legitimate scientific method even today, so long as it is used in the stating of the hypothesis or conjecture and not in its proof. (Kepler himself

"cherished" analogies as well, and he saw them as his "most trustworthy masters" who "knew all the secrets of nature.")

Indeed, far from confining himself to "positive" analogy (which highlights the similarities between two objects or phenomena), Leonardo often uses the "negative" analogy: in bringing out the differences between two similar objects or phenomena, it clarifies a hazy analogy and gives it its operative value.[126] Leonardo is particularly mindful of these clarifications by negative analogy in the field of comparative anatomy. While, in general terms, he affirms the analogy between all terrestrial animals—and while he can therefore draw a skeleton that is a hybrid of a man and a horse—the detail of his comparative researches is founded on negative analogy: "Draw here the paws of a bear, of a monkey and of other animals, and in what they differ from a man's foot; and add here some bird's feet" (*Feuillets A*, 17r). "Here I make a note to show the difference between a man and a horse, and the same with other animals" (*Ms. K*, 109v). "Notice if the muscle which flares the nostrils of a horse is the same as that which is found in this man here at *f*" (RL, 19012v). Leonardo can exploit artistically the expressive resemblances that exist between man and animal in their war-like fury, the "altogether bestial madness"; but in his scientific journey he pays exceptional attention to the infinite objective variety of reality.

The frequency with which Leonardo has recourse to analogy no doubt also stems from the fact that he is progressively becoming aware of the relationships that can be established between his various preoccupations. In his systematic research into the underlying causes of the whole range of visible phenomena (which may concern the formation of fossils or the luminosity of celestial bodies, the operation of the heart or the erosion of river banks), Leonardo comes to interest himself in the interrelationships between these phenomena. Thus, the study of the flight of birds appears progressively inseparable from that of the movements of water: "To arrive at a true knowledge of the movement of the birds in the air, it is first necessary to give the science of winds, which we establish through the movements of water within itself" (*Ms. E*, 54r, 1513–14).

There is also much interchange between Leonardo's genuinely scientific researches and the propositions or inventions of the engineer, which come under applied science. As a result of the well-established analogy between the man's body and the urban organism, the scientific analysis of the human body and its functions inspires his concept of the ideal city. Conversely, the central role played by geometry and mechanics in his profession of engineer changes

his interpretation of the functioning and form of cardiac valves, among other things.

To Leonardo, thought by analogy is such a natural thing that he never defines or discusses it. That attitude can lead to erroneous theories. In opposition to Galen, who fixed the origin of the vascular system in the liver, Leonardo follows the Aristotelian view of Mondino dei Liucci, professor of anatomy at the University of Bologna at the beginning of the fourteenth century, for whom the veins "sprang from the heart like the trunk of a tree."[127] So towards 1508, to "demonstrate" this analogy graphically, he draws a cross-section of a heart with veins and a peach stone which has taken root (fig. 42). On the same page he makes a drawing of the vascular network of the thorax in which the human and the animal are combined.[128]

But it is even more striking to see Leonardo elsewhere rejecting an old analogy, which he had at first accepted, after observation or reflection. While he never really renounces the universal analogy between microcosm and macrocosm, he comes to reject the similarity between the sea and blood. "The origin of the sea is the opposite of that of blood: the sea absorbs all the rivers, which are entirely produced by water vapor that has risen into the air; but the sea of blood is the origin of all veins" (*Feuillets A*, 4r). He needs analogy for guidance in the "dark forest" of natural philosophy: "It is more difficult to understand the working of Nature than any poet's book" (*Madrid I*, 87v). But progressively he comes to use quantitative terms more, and this practice lends him both to reject established opinions and to displace analogy in favor of the laws that rule natural phenomena.

When Leonardo tries, on the model of the human respiration, to quantify the "respiration of the earth" (as revealed by the seas), the determination of volume assumed for terrestrial lungs results in contradictory results according to the method of calculation used. The quantitative reasoning applied here to a poetic kind of analogy makes this sort of failure inevitable. Leonardo is sometimes discouraged by this, but it also leads him, after writing the *Codex Leicester*, largely to give up wanting to provide a scientific basis for the analogy of the model of microcosm and macrocosm. Then, finally, he no longer makes analogy the objective of his joint researches into the earth and the human body.[129] In rejecting a theory that he had held for more than twenty years and that had the authority of tradition behind it, Leonardo demonstrates remarkable intellectual courage. But he does even more, because this rejection is accompanied by a revitalization of the very principle of analogy. Leaving to

Fig. 42. *Cardio-vascular system*, c. 1508, pen and ink on charcoal outline, 7½ x 5½ in. (19.2 x 14 cm.) Windsor Castle, Royal Library, RL 19028r.

one side the idea of universal correspondence between microcosm and macrocosm, he develops little by little the theory that, in their infinite variety, phenomena obey similar processes: the analogy that brings them together is the law that rules them. For him, the question of moving liquids is at the heart of the analogy between the microcosm and the macrocosm; he therefore develops in particular the study of the dynamics of movement, which he believes are ultimately controlled by similar laws, which in turn can be formulated in geometrical and arithmetical terms. Whether the milieu in which movement is propagated is air, water or light, its weakening should be described as a "perspective" or "pyramidal" (that is, proportional) reduction of percussive force as a function of distance.[130]

Crucial in the gestation of modern scientific thought, this shift does not take place all at once. Various factors had prepared and supported the way. Since the middle of the 1490s for example, Leonardo changed his working practice as engineer. While continuing to work on a case-by-case basis, he puts forward machines whose mechanisms are founded solely on theoretical predictions, which have themselves been formulated as a result of experiments. Whether executed or not, they are the fruit of the widening field of his studies. Similarly, while the meeting with Luca Pacioli plays a decisive role at the end of the 1490s in the development of mathematics as a basis for all reliable knowledge, Leonardo's collaboration with the anatomist Marcantonio della Torre in 1510 stimulates a teleological approach in the tradition of Galen to the basic knowledge of the organism, which relates the form of an organism to its function. But this impact of Galenism has itself been made possible by the personal approach of Leonardo, for whom mechanics are "the paradise of the mathematical sciences." Similarly again, when, in 1513–14 (*Ms. E*) he returns to studying the flight of birds from both the aerodynamic and hydrodynamic point of view, he closely associates detailed descriptions with axioms of a general nature. This approach is possible because years earlier Leonardo has already been able to write, in the tradition of Archimedes, that "the bird is an instrument which operates according to mathematical law" (*Codex Atlanticus*, 161r).

From about 1507, the doubt cast on the universal analogy of microcosm and macrocosm causes Leonardo to reexamine each particular case in a specific way. From then on he follows the principle that the true analogy of the various phenomena studied is to be found in the laws of geometry and mathematics which govern them. On four occasions in the pages of the *Codex Arundel*

which date from the last years of his life, Leonardo opens his "Treatise on waters" with a geometrical definition of the point, the line and the surface. This is not fortuitous: as Augusto Marinoni emphasized, this singular opening declares that henceforth for Leonardo "every scientific treatise must start with the first natural 'principles', which are the principles of geometry"[131]—even though he never manages to revise his discourse on water and the elements according to these principles.

The adoption of this geometrical and mechanical model is particularly evident in his study on the body and its physiological processes. The famous drawing of the fetus inside the uterus (fig. 44) appears on a page whose text is almost entirely devoted to questions of mechanics and machines. Leonardo states in it that "in this book on the active movements made by Nature in animals," he is going to demonstrate "why Nature cannot give movements to animals without mechanical instruments." At the same time he explains that it is because of the weight of the head that the fetus usually presents itself head-first during labor, thus explaining mechanically a physiological rotation.[132] Moreover he pictures all the complicated movements of the body according to a mechanical model. For example when he analyzes the linked movement of the muscles of the leg, he is on the verge of formulating the principle of reciprocal innervation. But the theoretical model of the mechanical transformation of forms leads him to compare this phenomenon to a cord on a pulley, and in some drawings he therefore replaces the muscles with cords to explain their operation.[133] Similarly, Leonardo takes great pains to give an account of the multiple movements of the tongue "using [its] mathematical principles" (RL, 19046r): he analyzes them according to the twenty-four muscles and the seven main movements of the tongue (RL, 19115r) and concludes his text with enthusiastic praise for the inventions of Nature where "nothing is missing and nothing is superfluous."[134]

Through this mechanistic concept of laws uniformly controlling natural phenomena, Leonardo finally replaces the qualitative analogy of tradition with a quantitative concept. For him, the natural world consists of the four traditional elements (earth, air, fire and water) and the four "powers": movement, weight, force and percussion. Although these powers can have very violent effects, their operations are nonetheless governed by the laws of mathematics, including circular diffusion and "pyramidal" or "perspective" (that is, proportional) reduction. A note in the *Codex Atlanticus* (folio 267r-a) indicates that after about 1495 he also encounters the mathematical harmonies of dynamics

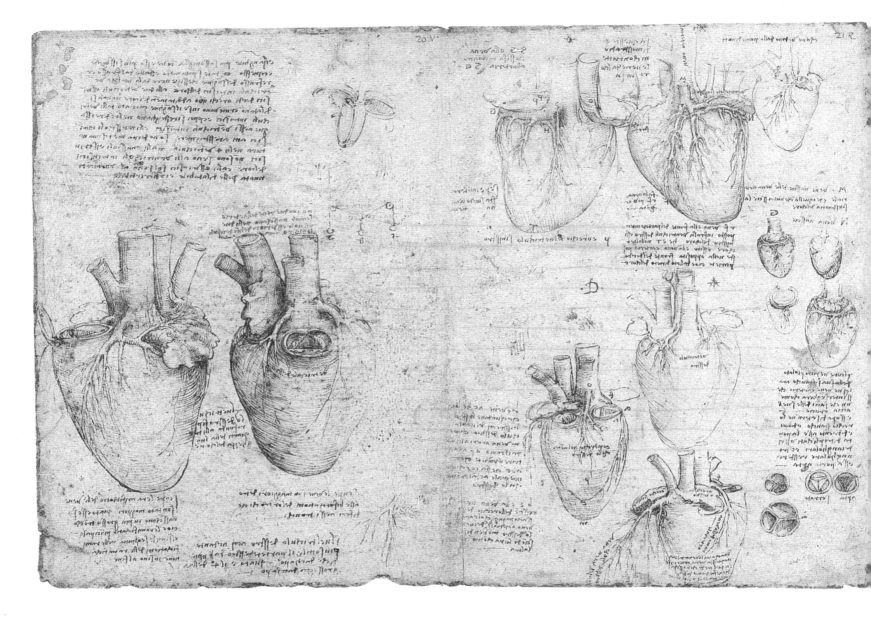

Above: Fig. 43. *The heart, c.* 1512–13, pen and ink on blue paper, 16¼ x 11 in. (41 x 28 cm.)
Windsor Castle, Royal Library, RL 19073v-19074v.

Opposite: Fig. 44. *The fetus and interior of the uterus, c.* 1510–12,
pen and ink with wash on red chalk, 11¾ x 8½ in. (30.1 x 21.4 cm.)
Windsor Castle, Royal Library. RL 19102.

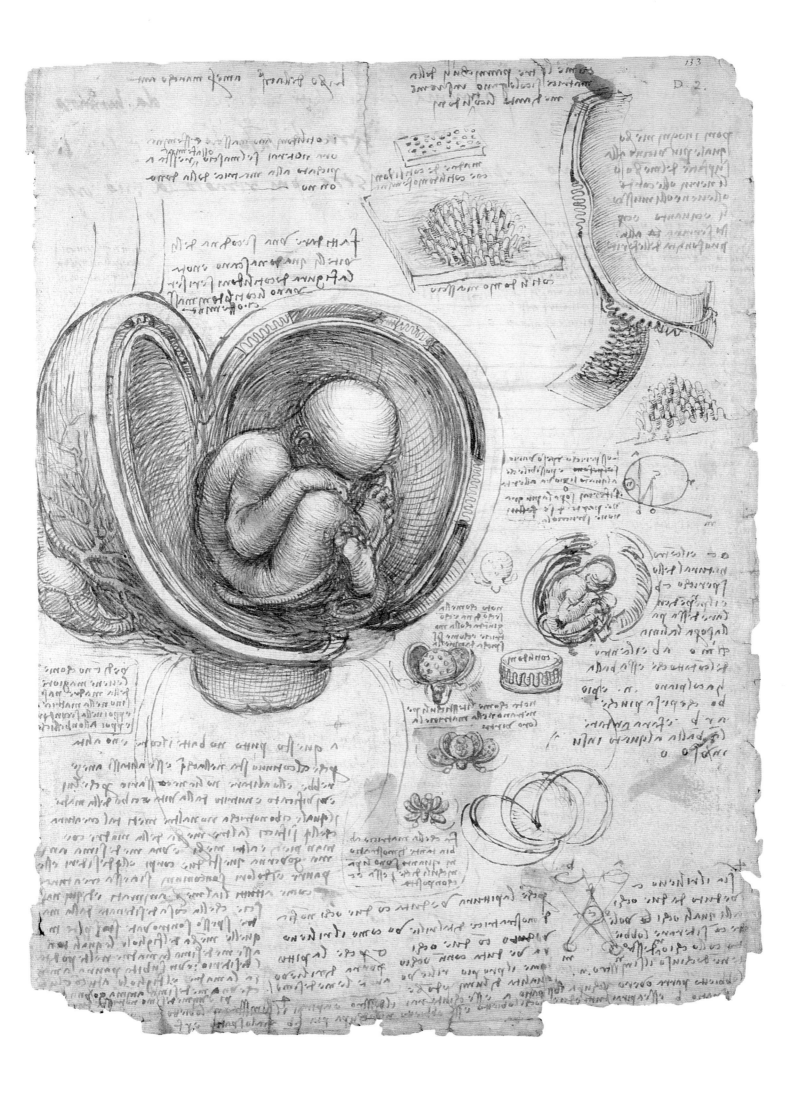

in relation to sound and music: "For these two rules of percussion and force, one can use the proportions used by Pythagoras in music." Leonardo finds the same laws in the diffusion of heat and in the natural architecture which formed an air bubble on the surface of the water; the principles of the latter are repeated in the human constructions of arches and domes, while because of the weight of water and of the "desire" of the air bubble to travel upwards, its movement follows a spiral course similar to that of a gliding bird. This spiral form is of the same order as that produced by the whirlpool through the force of water when it encounters an obstacle.[135] As he summarizes in a note in *Manuscript K* (folio 49r), "Proportion is not only found in numbers and measurements, but also in sounds, weights, times, position and in whatever power exists." By the end of his studies, Leonardo can well imagine that he has introduced the laws of geometry into physical science and that he has succeeded in constructing the picture of a mathematically coherent physical world.

† Music

AN "EXTRAORDINARY" SCIENCE

It is hard to define clearly the theoretical coherence of Leonardo's intellectual enterprise because of the dynamic continuity of his scientific thought, the way he progressively developed and improved it, his habit of returning to reconsider questions he had already studied, and the internal transformations and displacements that give it rhythm. From the end of the 1490s for example, he hesitates as to how much importance to give to the interpretation of experience and how much to "reason," meaning the theoretical approach. The man who, in opposing the book learning of commentators, alleges that experience is the "mistress of their masters" (*Codex Atlanticus*, 117r-b), believes that "experience is never wrong; only our judgment of it is wrong because it expects alien things from its power" (*Codex Atlanticus*, 154r-c), or that "all our knowledge follows our sensitiveness" (*Codex Trivulziano*, 41a), Leonardo also declares that "In nature, nothing happens without a cause; understand the cause, and you will not need to experience it" (*Codex Atlanticus*, 147v-a). With time, the primacy of mathematics affirms itself: "O students, study mathematics and do not build anything without foundations" (*Quaderni I*, 7r); and "Where none of the mathematical sciences nor any of those which are based on mathematical sciences can be applied, nothing is certain" (*Ms. G*, 96v).

This approach is sometimes clearly reminiscent of Platonism: "Anyone who reads nothing in my principles is not a mathematician" (*Quaderni IV*, 14v). And, while he believes that all general law needs a double "reason" and a double experience for it to be confirmed (*Madrid I*, 129r), the confidence that he has in "reasons" and the conviction that he has found correct explanations often persuades him to base assertions on "mental experiments." The very fact that some drawings "demonstrating" an experiment are countersigned "*valido*" or "*non valido*" leaves it unclear how many experiments mentioned in Leonardo's manuscripts were actually carried out.[136] His scientific work therefore occupies a singular position within the history of science: in spite of the abundance of his intuitions and, sometimes, discoveries in the most varied fields, specialists generally attach little importance to it.

From botany to optics, from geology to astronomy, from acoustics to physiology or anatomy, the manuscripts of Leonardo abound in observations, interpretations and hypotheses, sometimes preceding the corresponding, properly scientific discovery by several centuries. For example, Leonardo not only discovers what was to be Newton's third law of motion (equality of action and reaction, *Ms. A*, 24r); he also has an intuition regarding the conservation of energy, and seems therefore to have opened the way that would lead Galileo and Newton to the formulation of the principle of inertia. "Everything moving continues its movement according to its principle" (*Ms. F*, 52r).[137]

In a completely different area, when Leonardo becomes interested in the formation of fossils, he rejects the biblical explanation of the Flood (maintained by Ristoro d'Arezzo) as well as the explanations that depended on astrology or alchemy. Basing his conclusions on observation, on the ancient theory of "mineralizing virtue" and on his experience of casting, he draws the process of fossilization on a sheet that dazzles with the accuracy of his imagination: "[...] As the rivers abated over time, these encrusted animals and prisoners in the silt—with their flesh and organs consumed and their bones remaining, but having lost their natural arrangement—fell to the bottom of the mold formed by their impression; the silt flowed as it rose above the level of the river, so that it dried up and formed first a sticky paste, and then changed into stone, completely sealing up what it contained, filling every crevice; and having found the hollow animals' imprint, it penetrated gradually through the tiny fissures of the earth—from where the air could only escape sideways, because it could not fly upwards as a result of the sediment which had fallen into the cavity, nor downwards because the sediment which had already fallen

had blocked up the porosity. Therefore there remained only the side openings, from which the air, condensed and under pressure from the action of the descending sediment, escapes with the same slowness as the sediment settles there; and in drying this paste becomes stone, and devoid of heaviness, preserves the shapes of animals which have left their imprint, and contains their bones within it." (*Ms. F*, 79v.)

So one could multiply the examples, particularly in anatomy where, though he does not go so far as to recognize the role of the heart in the circulation of the blood (discovered by William Harvey in the seventeenth century), Leonardo identifies the existence of the four cardiac cavities (where Vesalius and Descartes see only two) and, even more accurately, the dilation of the aorta in the vicinity of the valves, known today as the *sinus de Valsalva* (fig. 43 and 54) after the name of their "inventor" two centuries later.[138]

The balance sheet of Leonardo's scientific activity therefore seems considerable. Nevertheless, although they are spectacular, these results are still modest in the eyes of the historian of science.[139] His concept of dynamics remains based on the medieval notion of *impetus*, his theory of optics consists of a "confused and altered form" of the medieval tradition, and it is only in the mechanical field that his work is significant in the opinion of those specializing in the discipline.[140] Undoubtedly Enrico Bellone is going too far when he writes that "Leonardo ultimately contented himself with noting commonplaces of the culture of his time on scattered pages from time to time." He is however right when he says that "it is not enough to praise this or that organ, source of our knowledge, to succeed effectively in explaining an optical phenomenon or to state the first principles of a new theory of motion," and that "the properties of metals, the orbit of Mars [...] and the law of inertia are not just questions of language."[141] It is also true that to be "the first" to set out or discover an idea, an invention or an observation is only a criterion of excellence within a conventional anecdotal history of science. Besides, the improvement in our knowledge of science at the end of the Middle Ages is in itself enough to put in proportion the range and quantity of Leonardo's "discoveries" from this point of view.

To understand the scientific thought of Leonardo, his experience, and, in particular, his method of working, we must understand his position in the history of this same scientific thought. Undoubtedly, the unfinished character of his researches, the disorder and barely-varying repetition of numerous concepts stem from the very conditions in which Leonardo worked and from the

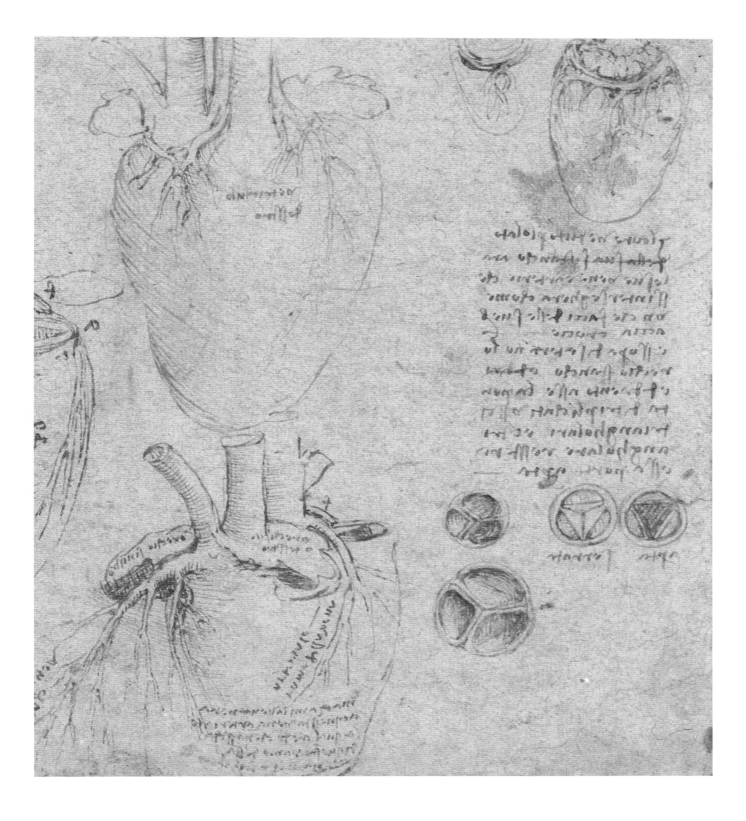

Fig. 45. *The heart and mitral valves*, detail from Fig. 43.

"studio culture" described above. Undoubtedly too, his attempts at systemization suffered from the objective historical conditions under which he was working. For example the unit of measurement, the *braccio* ("arm," about two feet / 60 cm), changed in size according to the city or material under consideration. But there is certainly more to it than that, since one can argue that Leonardo's scientific "method" was in itself "extremely confused," mixing inherited rules, wild free imagination, tightly packed theoretical discussions, fertile observation and experiments carried out with varying degrees of strictness.[142] In fact, the ambiguity that distinguishes Leonardo's scientific work is not only caused by the limitations in his own scientific culture. To a great extent, in this respect too, Leonardo da Vinci belongs to his times: he is fully a scientist of the Renaissance, whose status is itself very uncertain from the point of view of the history of science.

In this light the Renaissance is no longer seen as a period of "depression between two summits,"[143] but its contribution to the history of science stems less from the discoveries which are made in the fifteenth and sixteenth centuries than from a renewal of the practices on which the scientific revolution of the seventeenth century would be based—and Leonardo is clearly an emblematic figure of this. Above all, this renewal results from the "decompartmentalization"[144] which progressively takes place between the "liberal" and "mechanical" arts, between theoretical and practical knowledge. More than a reciprocal lack of interest between the two, the very ancient separation between "pure" science and "applied" science arose from a fundamental impossibility of communication, since pure science deals with philosophically defined *qualities* while applied science deals with actual operations, usually reducible to questions of *quantity*.[145] Inseparable from the increasing prestige of engineers and artists, whose activity enjoys a prominent social role in the military field as well as the civilian one, this decompartmentalization is most evident in the development and upheaval of techniques of representation. These are decisive in the sciences of observation and description (zoology, botany, paleontology, physics and, in particular, anatomy) where "the picture is not so much the illustration of the account as the account itself."[146]

In any case, saying that in the history of science the Renaissance corresponds to a period preceding the scientific revolution would hardly be of interest if one sees it only as a chronological fact or if one looks at the scholars of the period as mere predecessors who failed to detect and formulate the principles on which Galileo (and others) would base modern science. It is no

longer a matter of only seeing in the fragmentary character of Leonardo's notes the signs of his efforts to reconcile traditional knowledge and unprejudiced observation—an effort whose failure would ultimately lead him to a state of doubt that would, in itself, be a necessary condition for the advent of modern science. The science of the Renaissance precedes that of the seventeenth century in a deeper, properly structured way. To repeat the terms used by Thomas Kuhn, it is a phase during which an "extraordinary" practice of science reveals the inability of "normal" science to pursue its operations.[147]

As the work of Leonardo abundantly shows, the scientific research procedures of the Renaissance reveal a crisis in the dominant patterns of interpretation (or "paradigms," in Kuhn's terminology), without it being possible to replace them with others. The impasse that Leonardo encounters in relation to the theory of vision is an example. Having adopted the theory of "transmission" (which went back to Galen, and according to which the eye saw by emitting visual rays), he accepts the inverse hypothesis, formulated by Alhazen among others, according to which the eye receives visual impulses from outside. This inevitably confronts him with the question of the inversion of the visual image inside the eye and, as the drawing shows where he juxtaposes a cross section of an eye and a *camera oscura* (*Ms. D*, 10v, fig. 35, 36), he is on the verge of perceiving—as Kepler will— that the visual image is inscribed, inverted, on the rear surface of the eye. But at this point he cannot detach himself from tradition and believe that the image is set the right way up by the brain. As he thinks, this has to happen before it reaches the optic nerve, and the strength of this supposition is such that, by a deductive route and contrary to his own anatomical observations (particularly delicate in the matter, it is true), he imagines various geometrical arrangements for uprighting the image in the interior of the eye itself, before contact with the optic nerve.[148]

The contradictions and uncertainties that Leonardo faces sometimes make him somewhat discouraged—a typical state when a scientific hypothesis is in crisis.[149] This is understandable if one admits that, as well as individual cases and phenomena, the whole Aristotelian model of physical science was entering a crisis towards the end of the Middle Ages.

This model did not only take account of the visible; it constituted a coherent scientific theory. Founded on sensitive perception and refusing to replace with the abstractions of geometry facts qualitatively determined by experiments, Aristotelian physics had been supported by the evidence of common sense.[150] As Ernst Gombrich emphasizes, "it was not easy to pick holes in Aristotle's

mechanics:" its "virtue was precisely the simplicity that allowed it to subsume the most disparate phenomena of nature under one unitary law."[151] The "normal" science of the Middle Ages worked to adjust and clarify Aristotelian physics by forcing "nature to pour itself into the preformed inflexible box" that it provided.

The scientific revolution of the seventeenth century will constitute a "displacement of the conceptual network through which men of science see the world."[152] But before this revolution was possible—and for it to become possible—it was necessary, structurally, to go through a period in which, because "normal" scientific activity was not managing to resolve the problems posed within the existing theory, speculative theoretical propositions and, often, inaccuracies multiplied. Thus the researcher inevitably found himself in a situation of intellectual insecurity, in a "dislocated world."[153] It is significant that in describing the activity of the "man of science" practicing this "extraordinary" science, Thomas Kuhn, without thinking, makes something like a portrait of Leonardo : "[...] He will, in the first place, often seem a man searching at random, trying experiments just to see what will happen, looking for an effect whose nature he cannot quite guess. Simultaneously, since no experiment can be conceived without some sort of theory, the scientist in crisis will constantly try to generate speculative theories that, if successful, may disclose the road to a new paradigm, and, if unsuccessful, can be surrendered with relative ease."[154] The scientific thought of Leonardo and his way of working is undoubtedly explained by the structure of his culture; but they will be better understood if one sees them as an "extraordinary" practice, structurally connected to the crisis of the Aristotelian paradigm.

The special attention which Leonardo pays to the problems of the movement of heavy bodies certainly makes him a pre-Galilean if one agrees, with Alexandre Koyré, that modern physics "studies in the first place the movement of heavy bodies" and that at the heart of the Galilean revolution is the (paradoxical) decision to "treat mechanics as a branch of mathematics."[155] But to qualify Leonardo as a pre-Galilean requires the definition of his "conceptual network" in relation to that of Galileo, because while the latter founds a new paradigm (therefore opening the way to a new "normal" science), Leonardo does not go beyond the stage of an "extraordinary science" within the established paradigm.

One of the crucial points of distinction between the two scientific practices arises from the relation which they maintain between observation and the spontaneous experience of common sense. Even when he glorifies "reasons"

and the certainties of mathematics, Leonardo never resolutely turns his back on experience and, while opposing the book learning of the commentators and "abridgers," he continues the empirical tradition of medieval science as expressed for example by Buridan or Oresme. On the other hand, observation does not play a major role in the foundation of modern science. Before Descartes, Galileo has already rejected the perception of common sense as a source of knowledge, holding that "intellectual knowledge and even *a priori* reasoning is our sole and unique means of perceiving the essence of reality."[156] As Alexandre Koyré strongly emphasized, Galileo replaces experience with experiment, that is an interrogation of nature which "presupposes and implies a *language* in which we can formulate questions, just as a dictionary allows us to read and interpret the answers," an interrogation where "the formulation of hypotheses and the deduction of their consequences precedes and guides the course of the observation."[157] This difference is fundamental and it stands out in particular in the instruments serving as intermediaries in the observation. For example, to detect the shape of movements in water, air or fire, Leonardo uses the most varied markers (dust, smoke and leaves for wind; grains of millet, sprigs of straw, cork, pebbles, mud, and silt in water). He also designs and constructs floats of different specific gravity so that the directions and speeds of the currents at various depths in the water can be perceived. To note the angles of incidence and reflection of the water, he makes containers of glass specially designed to this end (with a base lined with sand and the rear surface painted black).[158] However, in spite of their effectiveness—it is with the help of this kind of marker that he discovers the *sinus de Valsalva* and the method by which the valves of the aorta close—these markers and other instruments are only tools of observation, useful in measuring the observed facts. Their purpose was to make things visible: sensory perception remains the foundation of the scientific approach. By contrast Galileo's telescope is the incarnation of an optical theory; it has been developed from and according to this theory in order to cover the limits of the observable. He sanctions "a split between the world given to the senses and the real world, that of science."[159]

The science of Leonardo is largely founded on the strength and sharpness of his capacity for observation, but at the same time these contribute to the fact that he remains attached to observation as a stage in the development of knowledge. When in about 1507 he gives an account of the importance of optical illusions and thereby appreciates that the eye is not a perfect instrument, this

leads him to examine more closely the conditions of vision, rather than to call in question the validity of observation as a foundation of the experience. Similarly, while increasingly making mathematics the criterion of scientific certainty, he notices the difference between mathematical theory and physical reality, such as is shown for example in experiments carried out on scales, where the material thickness of the beams of the scales affects the mathematical equation of balance. This leads him to be very attentive to the material determinations of mechanical science, not to work on changing the principles themselves of this science. At best, the increasing awareness of what separated mathematical theory and actual practice indicates a recognition of the dilemma that Galileo will resolve in postulating that reality must be reduced to geometry.[160] The idea of an entirely mathematical physics goes back to Archimedes: "Archimedes the superhuman," as Galileo describes him in *De motu* ("On motion"). While the direct or indirect influence of Archimedes on Leonardo becomes increasingly apparent after 1500,[161] the idea of founding physics on a collection of first principles and propositions serving as the basis for subsequent developments remains an ideal for Leonardo.

Leonardo's position in the history of scientific thought actually stems from the fact that within him were concentrated tensions which are typical of the science of the Renaissance. His great scientific and philosophical contribution will have been, if one believes Alexandre Koyré, the destruction of the Aristotelian synthesis which nonetheless embodied the very conditions of his thought.[162] By the universality—still medieval—of his interests, by his meticulous advances, and by his failures, the "genius" of Leonardo represents the ambitions and limits of science in the Renaissance before the Galilean revolution.

But one can describe Leonardo's scientific thought as that of science "in a wild state" rather than as the "childhood of science."[163] Here the definition that Claude Lévi-Strauss gives to "wild thought" as the "science of the concrete"[164] comes to mind. For all that, it is not a question of likening the practice of Leonardo to that of a native Hawaiian or a Micmac Indian. Two fundamental differences set them apart. First, the thought of Leonardo is strictly unrelated to magic, even though the crisis of Aristotelianism in general brought the Renaissance to an ontology of magic.[165] Secondly, Leonardo is an engineer, one of the greatest of the Renaissance, and perhaps he can even be seen as the first "technologist." Speculative as his instrumental point of view is, his approach is radically different from that of the "homemade" which is the characteristic of wild thought. Lévi-Strauss sums it up by saying that the engineer "interrogates the universe,

while the handyman addresses a residue of human works, that is to say a subset of culture."[166]

So the scientific thought and practices of Leonardo could therefore not be those of a "first science." In describing them as belonging to a science "in the wild state," one explains two of their original aspects within the "extraordinary" science of the Renaissance.

It is not only intellectually that Leonardo's scientific "method" is, as has been said, "extremely unsystematic," sharing the "homemade" intellectual quality which is often a peculiarity of the self-taught. It is in the very conception of experimental processes that Leonardo's scientific practice has "homemade" aspects. For example, to establish that the pitch of a note is connected with the rapidity of the percussive movement of the air, he coats the wings of a fly with honey and, observing that the note produced by this fly in flight is lower, he attributes the phenomenon to the lower speed with which the ballasted wings are beating the air.[167]

But above all it is in the relationship he maintains with the scientific thought of his time that Leonardo develops thought "in the wild state." If it is possible for him to be fully part of an intellectual milieu, it is not of the contemporary scientific milieu: he is not a member of that learned community whose existence forms the basis of the exercise of science, even in an "extraordinary" period.[168] He has personal contacts with some contemporary scholars, the most important for the influence they exercised on him being Luca Pacioli and Marcantonio della Torre. But these selective and occasional contacts come too late to constitute a truly scientific training. It is the same with his relationship to the scientific texts which are the basis of all "normal" science. Having rejected them in the first place, in the interests of experience and to overcome his own ignorance, he later immerses himself in them. In the texts which he devotes to the movement of liquids, nearly twenty authorities can be identified whose name he cites or whose influence is clearly recognizable: Aristotle, Ptolemy, Cleomedes, Hero of Alexandria, Seneca, Pliny, Vitruvius, Avicenna, Albertus Magnus, Albert of Saxony, Pietro d'Abano, Ristoro d'Arezzo, Dante, Latini, Cecco d'Ascoli, Dati and Alberti.[169] But he has not mastered this self-taught knowledge: he knows contemporary Aristotelianism badly and fragmentarily, and he combines some of his ideas with an outmoded Aristotelianism. Though he sometimes wants a return to the "true Aristotle," this is because his knowledge of recent theories of dynamics is poor.[170]

This "wild" practice of scientific reflection is indissoluble from his effort to reject the Aristotelian model where it no longer manages to save appearances. His effort is accordingly all the more heroic, "Faustian" in the eyes of Michelet, in that it is certainly not a trained scientist. One can even see the manifestation of an intellectual ambition disproportionate to the means at his disposal.[171] But this discrepancy between the end envisaged and the intellectual means available is, in itself, significant. Leonardo's scientific approach is the expression of a personal need, of a curiosity whose stakes are not only (and certainly not initially) intellectual. This is suggested by the admirable and celebrated page where he describes himself at the edge of the "great cavern": "And pushed by my ardent desire, impatient to see the immensities of the strange, varied forms which are created by artistic nature, I wandered for some time among the dark rocks; I reached the threshold of a great cavern, before which I rested a moment struck with amazement, in the presence of something unknown. I folded my loins into an arch, I leaned my left hand on my knee, and with my right I sheltered my lowered, knitted brows; and I leaned from one side to the other to see if I could discern anything; but the great darkness which reigned there did not let me. A moment later, two sentiments invaded me: fear and desire, fear of the dark, menacing grotto, and a desire to see if it did not enclose some extraordinary marvel."[172]

Whether this experience was real or imaginary, it enables one to understand that Leonardo's curiosity, this desire for knowledge which overcomes his fear, his scientific ambition, has some ancient, buried motives—and that one should look for the coherence of his thought less on a theoretical or intellectual level than as an intuition of the world, the world which surrounded him and in which he took part.

Fig. 46. *The surface anatomy of the shoulder*, *c.* 1510–11, pen and ink with wash on charcoal outline, 11½ x 7¾ in. (28.9 x 19.8 cm.) Windsor Castle, Royal Library, RL 19001v.

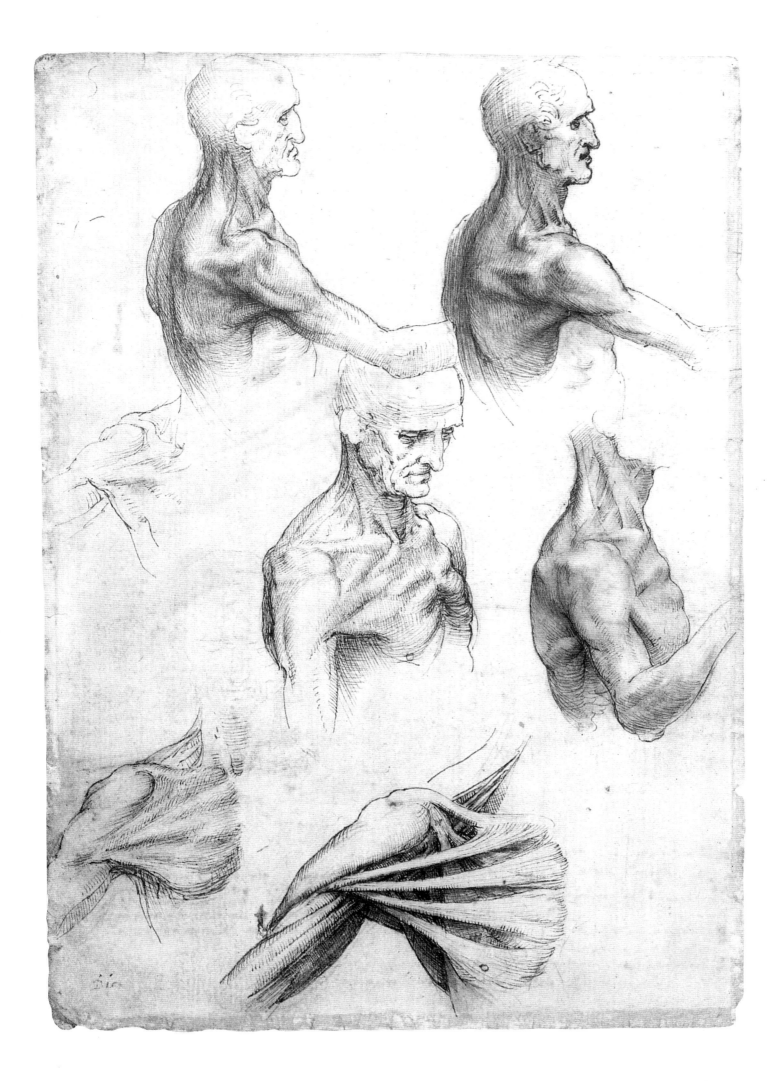

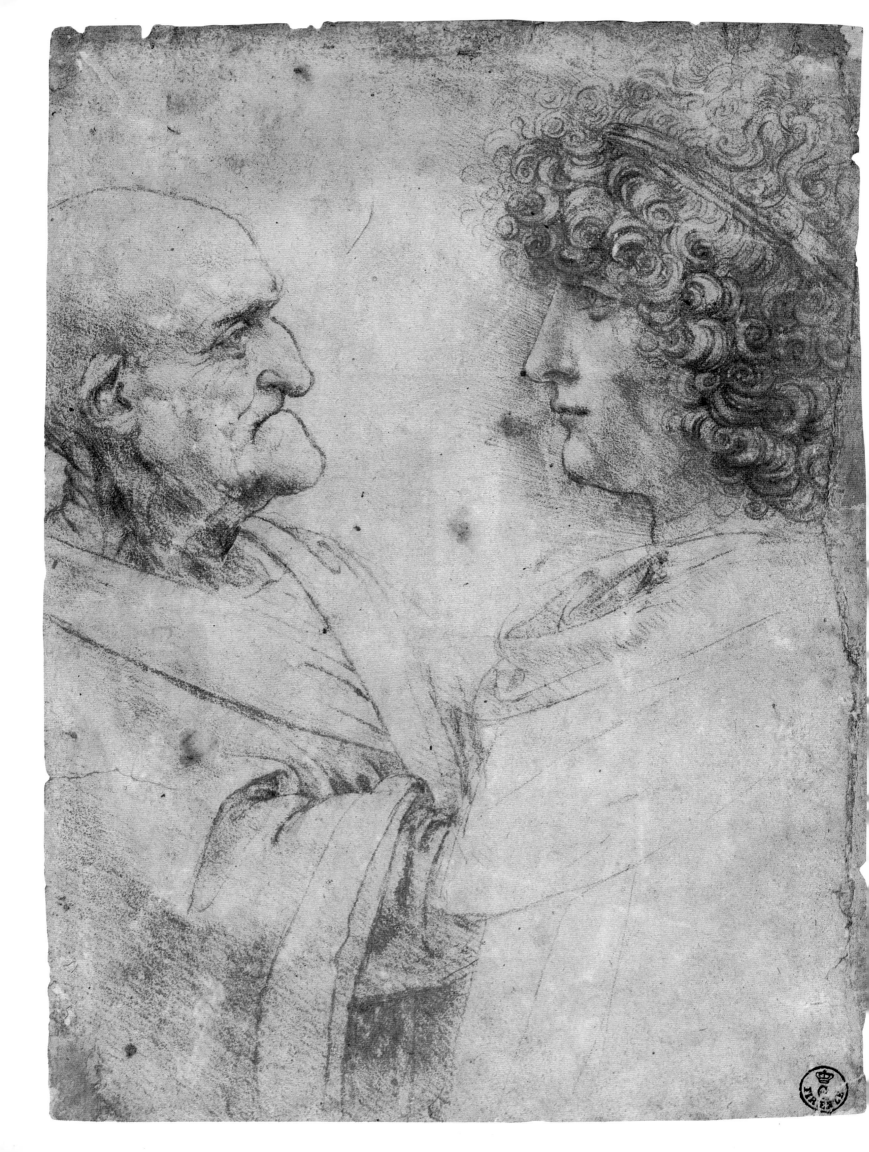

THE WORLD OF LEONARDO

"**L**ike all really original phenomena, movement is not susceptible to definition."[173] Now, for Leonardo the unity of the world is, most probably, founded on the feeling that such an "original" movement exists, and research into its laws (if not its definition) lies behind the major part of his activities. In fields ranging from the observation and representation of natural forms to the theory of the proportions of the human body, from the theory of *impetus* to that of "immaterial movements," from the dynamic concept of geometry to that of anatomy or the origins of metals, through all the many facets of Leonardo's "universal" interest, forms in movement and the movement of forms make up the preferred subject of his attention; and in this attention an intellectual approach and poetic intuition, science and art, are indissolubly intertwined.

It is this feeling that leads him, for example, to push the analogy of the move-

Fig. 48.
Studies of drapery,
Codex Atlanticus,
c. 1515, fol. 317v-a.
Milan, Biblioteca
Ambrosiana.

Page 98: Fig. 47.
*Profiles of a young and
an old man*, red chalk,
8¾ x 6¼ in. (21 x 15 cm.)
Florence, Uffizi.

ments of air and of water to the extreme, when he declares that "the movement of water within water behaves like that of air within air" (*Codex Atlanticus* 184v-a), and also that "all the movements of the wind resemble those of water" (*A*, 602). In the same way, as has been seen, the structural analogy of natural movements did not simply concern the microcosm and

the macrocosm (the movements of hair likened to those of water). It also has to do with the form of certain plants, such as the Star of Bethlehem (fig. 50), whose growth and development is analogous to that of the whirlpools created by a waterfall. Then towards 1515 the final studies of drapery (military standards and dancers' robes, fig. 48, 49) show them agitated by the wind, their movements evoking both the intermingled configurations of horses and men overwhelmed by a storm as well as other interactions of his own invention.[174]

The power that this awareness of universal movement holds over Leonardo's imagination is apparent in the return in his works of a motif that is typical of this aspect and can be seen as a "symbolic form" of his vision of the world: the swirling spiral. The movement of a bird in the sky follows the same form as a bubble of air in water or of blood in the valves of the aorta (fig. 2, 52). Folio 191v-b of the *Codex Atlanticus*, dating from about 1490–92, includes the drawing of a *mazochio* or medieval headdress (fig. 51) that is built up progressively from right to left and of which Leonardo gives this proud commentary:

Fig. 49. *Studies of dancers, c. 1515,* lead-point, pen and ink, 3¾ x 5¾ in. (9.6 x 14.9 cm.) Venice, Galleria dell'Accademia.

"Body born from the perspective of Leonardo Vinci, disciple of experience. This body must be made without the model of any body but only with simple lines."[175]

Leonardo does not restrict himself to observing, capturing and describing the forms of movement. He also works towards revitalizing Euclidean geom-

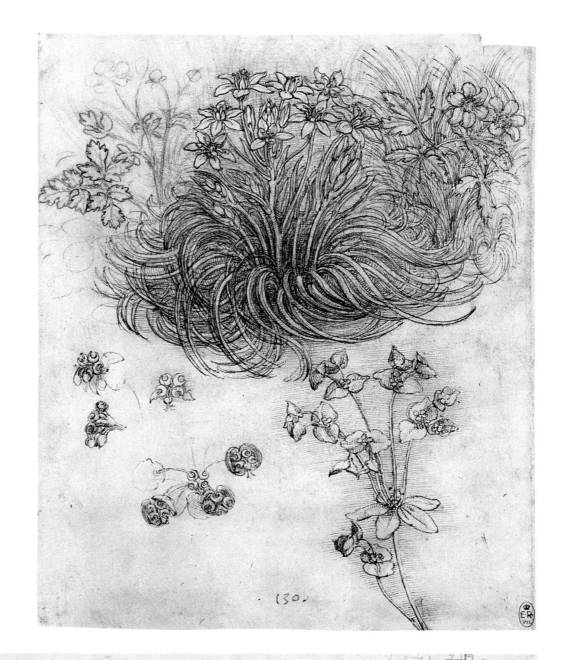

Right: Fig. 50.
Star of Bethlehem,
c. 1505–08, red chalk
and pen, 7¾ x 6¼ in.
(19.8 x 16 cm.)
Windsor Castle, Royal
Library, RL 12424.

Below: Fig. 51.
*"Body born of perspective
by Leonardo Vinci [...],"
Codex Atlanticus*,
fol. 191v-b.
Milan, Biblioteca
Ambrosiana.

Opposite: Fig. 52.
*Codex On the
flight of birds*.
Turin, Biblioteca Reale.

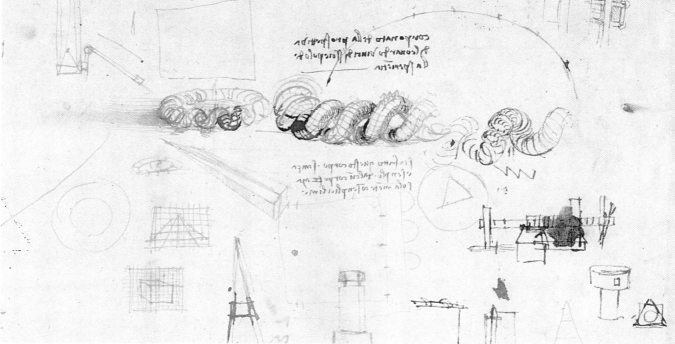

etry itself and develops the vision of a world where space, time and body would be the joint results of an "original" movement.

Starting from meditation about time and its relationship to the moment, where Aristotle saw only the "isolation of the moment" (*apostasis tou nûn*) between the past and the future, Leonardo compares that instant to a point: "The instant is in time and is indivisible. The point is in the line and in itself it has no substance." He continues this analogy in dynamic terms: "The instant is not of time; time consists in movement from the moment, and instants are the terms of time. The point has no part; the line is the transit from a point and points are the elements of the line." (*Codex Arundel*, 176r). But time has only one dimension, it therefore escapes from the "power of geometry" (*potenza geometrica*). By contrast, space is three-dimensional and is the continuity itself of this "original movement" of the point which makes up surfaces and volumes. Denying that the point would be "a part of the line" (*Codex Trivulzio*, 63), Leonardo supposed that "the line is created by movement from a point (...), the surface is generated by the transverse movement of the line (...), and the body is made by movement" (*Codex Arundel*, 159v).[176]

This idea of generating surfaces and volumes by the movement of a point does not remain at a purely speculative or theoretical level. It is at the heart of

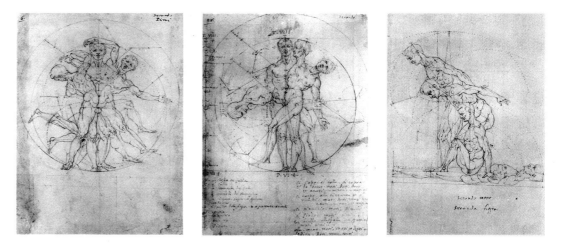

Fig. 53, 54, 55. Carlo Urbino, *Codex Huygens*, c. 1580, fol. 6, 28 and 22, pen, brown ink and lead point on black chalk. New York, The Pierpont Morgan Library.

Leonardo's intuition of the world, inspiring for example his project for a treatise on the movements of the human body, the *Moto actionale*. Although it was never written down, this treatise has reached us, loyally distorted, through the *Codex Huygens*, written in Milan at the end of the 1560s by a distant follower, Carlo Urbino.[177] Following a "kinetic approach" that has no

equivalent in Renaissance treatises, Leonardo would have developed a "graphical method of analyzing and representing" movement, conceived as a continual transition (or "mutation," in the revealing term which he uses) within which each phase of movement, each configuration is conceived as an instant (in the sense given above) within an infinite, uninterruptable process: "Man's movement is infinitely varied even in a unique event (…) Whatever the case, who would deny that movement has been carried out in space, that space is a

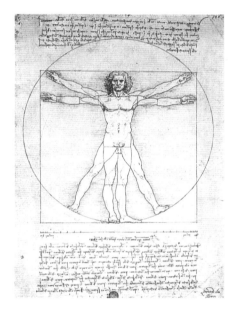

Fig. 56. Leonardo da Vinci, *Vitruvian man*, pen and ink, 13½ x 9¾ in. (34.4 x 24.5 cm.) Venice, Galleria dell' Accademia, inv. 228.

continuous quantity, and that every continuous quantity is infinitely divisible? Hence, the conclusion: every movement (…) is infinitely variable."[178] With the dogged but illuminating loyalty of the disciple, Carlo Urbino explains this kinetic approach geometrically and figuratively. His drawings (fig. 53, 54, 55), which recall the silhouettes of the Pollaiuolos, give multiple examples of Leonardo's version of Vitruvian man (fig. 56). When he brought together Vitruvius's "man in a circle" and "man in a square" in a single image, Leonardo did not restrict himself to giving a more condensed version than his contemporaries. In what was a symbolic figure of the human body's ideal perfection, he gave life to the proportions by drawing them to show the apparent movement of the figure. While acknowledging the success of this image, those whom it inspired directly (Fra Giocondo in 1511, Cesare Cesariano in 1521) separated the man in a circle and the man in the square into two distinct images. In doing so they confirmed the singularity of Leonardo's kinetic approach: he

had succeeded in "demonstrating" the continuous unity of proportions in the "transformation" itself of the positions of the body.

While the rational explanation (and, one should add, the exploitation) of movement in the broadest sense of the term makes up one of the major objectives of Leonardo's various researches, according to Fritz Saxl,[179] this is also because the question of movement (seen as change and process) is to be found at the heart of the Aristotelian physics of the world. This faced one major difficulty in particular: the movement of thrown bodies when separated from their driving force. Once it was assumed that every body tends to return to its "natural place," how could it be explained that a stone when thrown does not immediately fall to the ground the moment it is released? Leonardo belatedly comes to reject rather ambiguously the inspired but erroneous Aristotelian solution of *antiperistasis*. According to this theory, the action of its surroundings pushes the moving object crossing it from behind. Then on folio 29v of the *Codex Leicester* (1497–1508) he clearly declares that "it is proved that the air does not push the moving object," and Leonardo then adopts the very widespread theory of *impetus*, or impulse: this was the motive power that transmitted a force to the moving object enabling its movement to continue in spite of the resistance of the surrounding milieu.[180]

But it is not their scientific significance that makes these texts interesting. As in many other fields, the technical vagueness of Leonardo's vocabulary makes the expression of his concept of *impetus* confused; indeed the idea itself is confused although it fully satisfies common sense.[181] If his thinking on this matter deserves attention, it is because it is in line with an attempt to give physics a dynamic quality: "Gravity, force, percussion and impulse are the daughters of movement, being born of it," (*Codex Atlanticus*, 123 r-a). Above all, to Leonardo the very notion of "force" is as poetic as it is scientific. At the properly scientific level, "force" refers to the power that "accidentally" exists in driven bodies. But, itself produced by the "inherent power" of nature (*Quaderni I*, 1r), "force" takes on an explicitly spiritual dimension for Leonardo[182] and the enthusiastic descriptions that he devotes to it display all the poetic value of a notion, which, purely physical in origin, is bearer of the life of the world: "I define force as a spiritual virtue, an indivisible power, which, through accidental external pressure, is generated by movement, accumulated and infused in the bodies dragged and diverted from their natural use. In granting them an active life of wonderful power, it forces every created thing to change its form and position (…) It is born of violence and dies through freedom; and the larger it is

the faster it consumes itself. It furiously chases away everything which is opposed to its destruction. It aspires to conquer and kill the cause of any obstacle it encounters and, in taming it, destroys itself. The larger it is, the more its power increases. Everything instinctively flees from death. Everything subjected to pressure puts pressure on others. Without force nothing moves."[183]

This inseparable combination of scientific analysis and poetic intuition is particularly apparent in the pages Leonardo devotes to water and the sun.

Water was the subject that Leonardo studied and researched most thoroughly. In both Milan and Florence his studies on hydraulics and canals were sparked off as a result of his duties as civil and military engineer. But the more thorough examination of this technical activity and its development into independent research arose from the fascination that water, its function and its power exerted over him. It is no coincidence that the earliest of Leonardo's surviving works is the famous drawing of the valley of the Arno, drawn on August 5, 1473 (fig. 57). Of the four elements, water is the only one which displays movement and heaviness at the same time; it is therefore a living manifestation of the two fundamental "forces" of his theory on dynamics, *impetus* and percussion. Further, while "the water conceals an infinity of movements" (*Ms. G*, 93r), one of these movements in particular held his attention: the whirlpool. This is because the whirlpool's shape displays a "dynamic geometry" which develops simultaneously through space and time.[184] Indeed, Ernst Gombrich observed that, among his many detailed descriptions of natural movements, it is with water that "he allows himself an expression of delight" at the beauty of the movements produced by the "interpenetration of elements."[185] But there is more to it than this aesthetic emotion. The descriptions he makes of its constant, cyclical movement reveal the suggestive power that Leonardo saw in the element itself: "Thus, united to itself, the water turns in a continual revolution. Rushing hither and thither, up and down, it never rests, neither in its course nor in its character; it owns nothing but seizes everything, borrowing as many different characters as the landscapes it crosses (…) So, continually changing its place and its color, it becomes impregnated with new odors and flavors, sometimes retaining new properties or essences; now deadly, now source of life, it disperses into the air; at other times, it is saddened that the heat has taken it to the cold regions where this heat that guided it is limited" (*Codex Atlanticus*, 171r-a).[186] "Now deadly, now a source of life," and "continually changing form": water draws its poetic strength from this profound ambivalence and the inhuman indifference of its power, which seem to embody

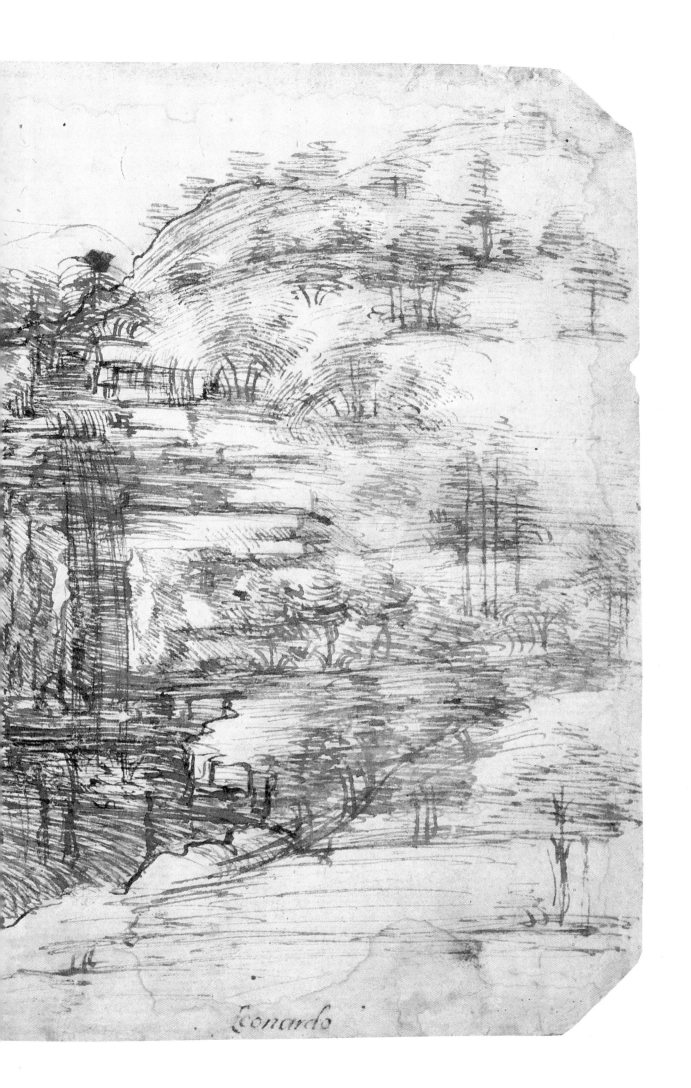

Leonardo

the life of nature. Whether it is the "vital humor of the terrestrial machine" or the "catalyst" of this vital humor (*Ms. H*, 95[47v]r), "without it, there would be no life among us" (*Codex Arundel*, 57v); like the blood and humors of animate bodies, "hither and thither, high and low, it roams around, forever restless, always rushing to help where the vital humor is lacking" (*Codex Arundel*, 210r). But water is also responsible for earthquakes: locked up "in vast caverns" and heated by "the warmth of the fire generated by the body of the earth," it turns into vapor which "disperses in the entrails of the earth in various places, roaming and rumbling thunderously until it reaches the surface; with powerful upheavals it shakes whole regions and often makes mountains crumble; it destroys cities and many areas of the land, and with violent uproar it bursts through the fissures of the earth" (*Codex Leicester*, 28r).

Water also causes "the wind in the air (...) through the disintegration and formation of the clouds." Leonardo was able to observe this phenomenon: "One day, above Milan, towards Lake Maggiore, I saw a cloud that looked like a high mountain on fire because the rays of the setting sun, red on the horizon, had tinted it with the same color. This enormous cloud attracted the other smaller clouds that surrounded it (...) Some two hours after nightfall, there was a sudden blustering wind. And when it found itself contained, it caused the air enclosed in it, compressed by condensation, to burst from it and escape through its weakest part, hurling itself through the air in great, unremitting turmoil, like a sponge pressed by the hand under water (...)" (*Codex Leicester*, 28r). As well as creating lightning,[187] water is the cause of what Leonardo considers the most "frightening and horrifying" of all cataclysms, the floods caused by swelling rivers: "How can one describe these awful, abominable evils, against which man has no defense? Deluges devastate high mountains with their awesome, foaming waves, they destroy the strongest sea-walls and embankments, they tear up deeply-rooted trees, and their voracious waters, laden with the mud of plowed fields, carry off the fruits of the hard work of the miserable tillers of the soil, leaving the valleys bare and naked with the misery they leave in their wake." (*Codex Atlanticus*, 108v-b). Leonardo feels he is incapable of describing these catastrophes: "In what language, with what words can one possibly express or describe the appalling ruin, the extraordinary, merciless devastation, caused by these devouring rivers, which man is powerless to avert?" (*Codex Atlanticus*, ibid.)

He will find words to describe the deluge and its "representation in painting," and significantly, these words will be the same as those he uses to describe the

Pages 108–09: Fig. 57.
The valley of the Arno,
1473, pen and ink,
7½ x 11¼ in. (19 x 28.5 cm.)
Florence, Uffizi, drawing
collection, no. 8 P.

movements of the water "scientifically": "We shall see parts of mountains, already bared by raging torrents, crumble and obstruct the valley, thus causing the level of the captive waters to rise and cover the vast plains and their inhabitants (...) The swollen waters rush into the pond that contains them, striking the various obstacles with swirling eddies (...) The momentum of the circular waves flying from the point of impact hurls them in the way of other circular waves moving in the opposite direction; and after the shock they shoot up into the air without becoming detached from their base. Where the water flows out of the pond, the broken waves can be seen spreading towards the outlets; then falling or descending through the air, they acquire heaviness and impetus; they penetrate the water that they strike, cutting it and plunging furiously to the bottom; then they recoil and bounce back to the surface of the lake, together with the air engulfed with them that remains in the slimy foam, surrounded by floating wood and other objects lighter than water, round which more waves form whose circles become larger and larger" (RL, 12605v and r).[188]

The impressive series of deluge drawings at Windsor graphically confirms this combination of observation and fiction, of science and art (fig. 60, 61, 62). Conceived perhaps as a reaction to Michelangelo's rather "unatmospheric" *Deluge*, painted on the ceiling of the Sistine Chapel,[189] these drawings are the culmination of Leonardo's studies of the devastating effects of raging water. They may also have been inspired by two catastrophes, which occurred in 1513 and 1515 in the region of Bellinzona,[190] and attempts have been made to arrange them in a narrative order, as if they were depicting the progress of a hurricane. But the experts' hesitations about the order[191] reveal both the dramatic effectiveness of these drawings and the visionary character of this explosion of natural forces, which is resistant to any narrative organization. Although the graphic formalization of the whirlpool, elevated to the status of principal motif, takes on a decorative aspect and may, according to Kenneth Clark, appear as inoffensive as "the petals of a chrysanthemum,"[192] these *Deluges* clearly show how scientific analysis is able to help Leonardo *picture* what he observes. Halfway between the drawing capturing the luminous effect of a thunderstorm over a valley (fig. 58) and the mysterious allegory in which destructive forces descended from heaven recalling the Christian theme of the Apocalypse (fig. 59), the *Deluge* drawings are a "scientific allegory" (or "natural apocalypse") in which scientific analysis and poetic vision are indissolubly linked.

Leonardo, on the other hand, is not at all interested in the movement of the

Page 112: Fig. 58. *Storm over an Alpine valley*, c. 1506, red chalk, 8 x 6 in. (20 x 15 cm.) Windsor Castle, Royal Library, RL 12409.

Page 113: Fig. 59. *Study of cataclysm*, c. 1511–12, black chalk heightened with pen, 11¾ x 8 in. (30 x 20.3 cm.) Windsor Castle, Royal Library, RL 12388 .

111

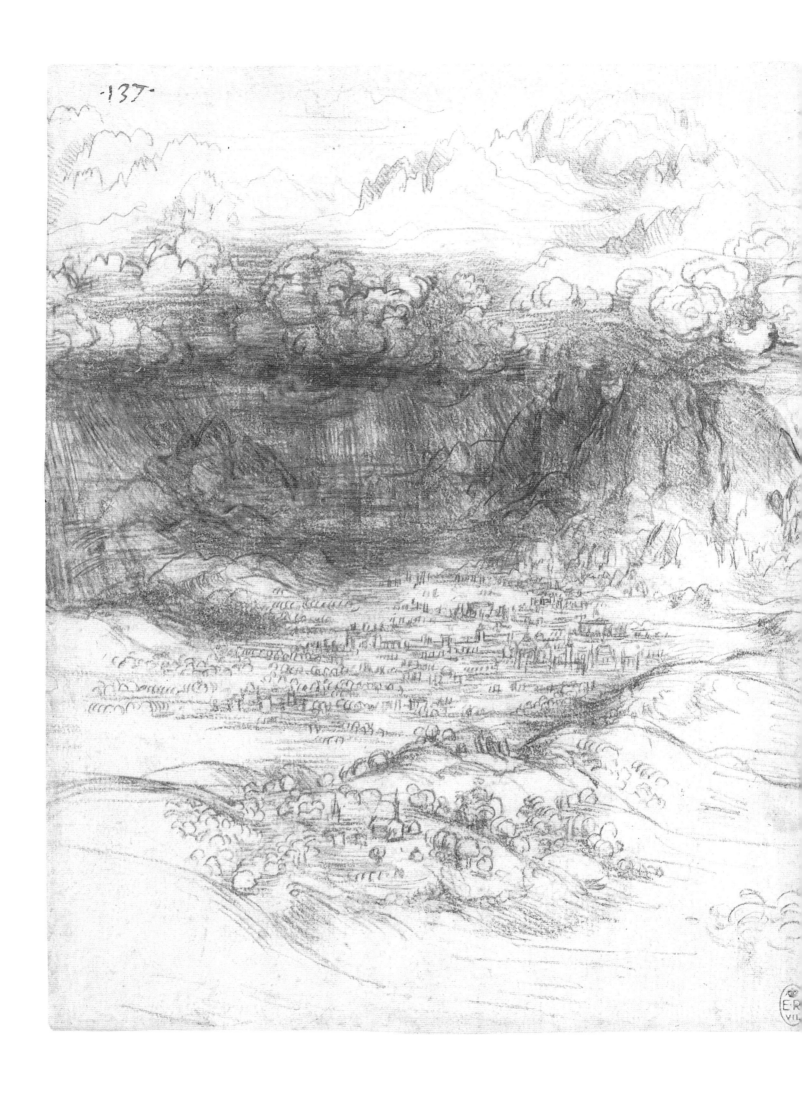

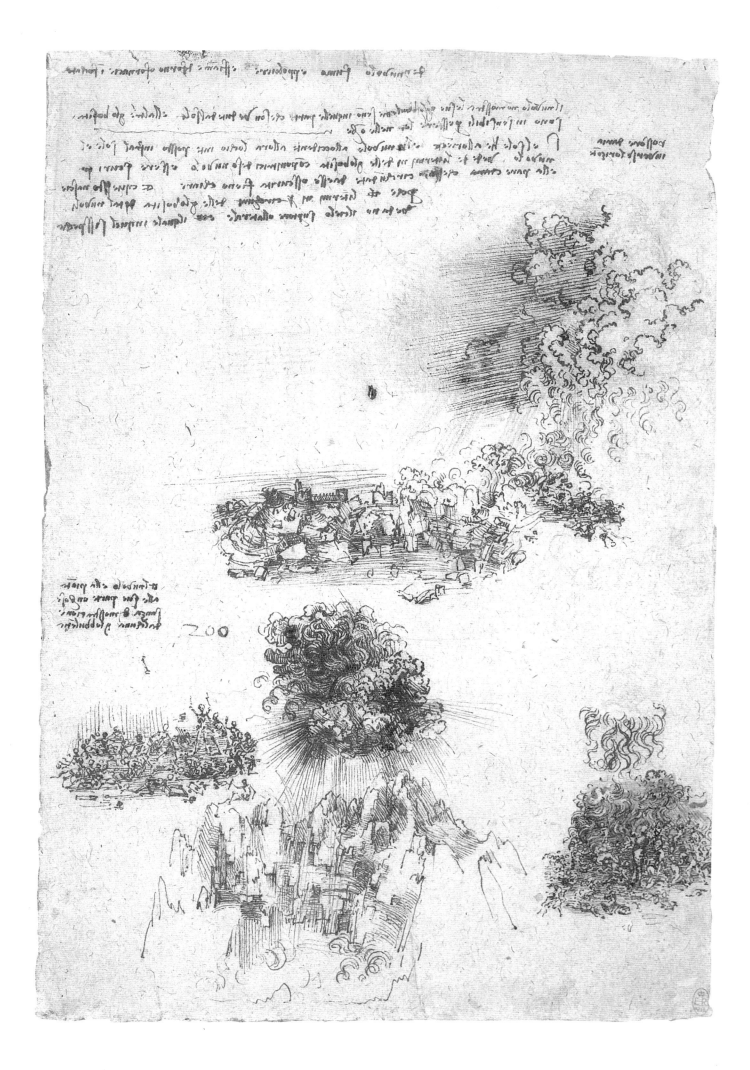

Fig. 60. *Study of deluge*,
c. 1517–18, black chalk,
6½ x 8¼ in. (16.3 x 21 cm.)
Windsor Castle, Royal
Library, RL 12378.

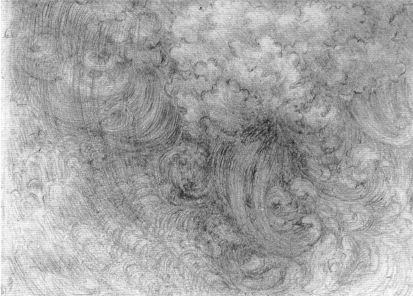

Fig. 61. *Study of deluge*,
c. 1517–18, black chalk,
6¼ x 8¼ in. (15.8 x 21 cm.)
Windsor Castle, Royal
Library, RL 12383.

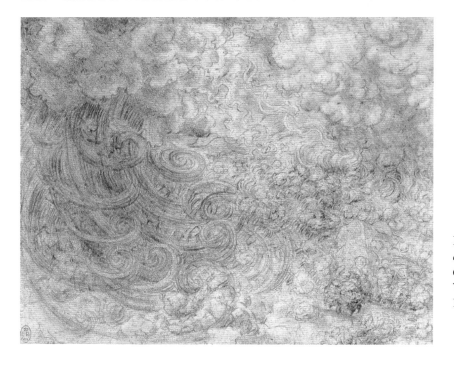

Fig. 62. *Study of deluge*,
c. 1517–18, black chalk,
6½ x 8 in. (16.5 x 20.4 cm.)
Windsor Castle, Royal
Library, RL 12384.

sun. His astronomy was of a visual kind; his astronomical observations deal mainly with the appearance of the sky, the heavenly bodies and the stars (mainly the sun and the moon), and the diffusion of light from one body to another.[193] But a page of *Ms. F* (5r and 4v) shows the poetic prestige of the sun in Leonardo's eyes. Leonardo begins by suggesting that all the heavenly bodies "scattered in dark space" have a common nature; therefore the substance of the earth would be identical to that of the stars. In thus assuming a unified, continuous cosmos, Leonardo echoes Nicholas of Cusa and implicitly reverses the hierarchical view of the cosmos, which traditionally distinguished the nature of earth, namely the sub-lunar world, from that of the celestial spheres.[194] But Leonardo still continues to exalt the inherent grandeur and nature of the sun: "I would like to find words that would allow me to censure those who place the cult of men above that of the sun; because I do not see a larger, more powerful body than the sun in the entire universe, and its light illuminates all the celestial bodies scattered in the universe. All vital principles proceed from the sun, because the warmth that is found in all living creatures is derived from it, which is the vital principle; and there is no other warmth or light in the universe, as I will show in the fourth book. And certainly, those who wanted to worship men like the gods, Jupiter, Saturn, Mars and others, have committed a serious mistake; because man, even if he was as big as our world, would only be a dot in the universe like one of the smallest stars, and in any case men are mortal, putrescible and corruptible in their graves." As Cesare Vasoli has shown,[195] Leonardo's ideas here reflect the traditional doctrines revived in the years 1460–90 by Marsilio Ficino and the Florentine Neoplatonists. The sun was not seen as the astronomical center of the cosmic system but much more as the source of universal life, the source of the *anima mundi* ("breath of the world"). To use the pantheist vocabulary of Marullo's *Hymni naturalis* ("Hymns of nature"), a work mentioned explicitly by Leonardo, the sun is "the king of men and of Gods, the father of all." But Leonardo removes all metaphysical implications from this glorification: the sun incorporates the highest virtue of Nature insofar as it is the source of life.

In this context it would be wrong to read a revolutionary statement of helio-centrism into the observation "Il sole non si muove" ("The sun does not move"; *Quaderni V*, 25r).[196] Leonardo remains resolutely geocentric. While the idea of the immobility of the sun attracts his attention (but without retaining his interest), this is largely in relation to the Aristotelian idea of the *Primo motore* ("prime mover") which, itself immobile, sets in motion the sphere of

the *Primum mobile* ("prime movable thing"). Leonardo glorifies the existence of this ultimate source of the "original movement" and the Force which results from it. But he takes care not to define it, leaving that, like the care of the soul, "to the monks, these fathers of the people who know all the mysteries through revelation" (*Quaderni IV*, 10r). For him, the sun as a figure of the Prime Mover is as sufficient as it is satisfactory.

From the sun whose warmth is a universal source of life to the water, infinitely mobile, reviving and deadly, the world of Leonardo is driven by a universal dynamic. Truly "original" because it was the "cause of all life" (*Ms. H*, 141r), movement has a continuity and universality that ensures the very cohesion of space and time, in accordance with a particular "image of nature, all of it brimming with life and soul, rich with an infinity of forms and endowed with a harmonious beauty."[197]

The idea that the volume of opaque bodies and their visibility are the ultimate result of the movement of the point is inseparable from Leonardo's theory of "immaterial movements." Visually imperceptible, these immaterial movements are grouped in five categories. The first "is called temporal because it only refers to the movement of time and embraces all the others." The other four include the diffusion of images, the diffusion of sounds (and smells), the "mental" movement that "resides in animate bodies," and the movement that animates "the life of things" (*Codex Atlanticus*, 203v-a).[198] This firm belief leads Leonardo to try and discover laws of dynamics that would explain the visible structure of the living and to perceive space itself not as a receptacle of bodies, exclusively and abstractly geometric, but as a place for the emergence and individualizing of these bodies. Space is a medium, continually fluid and crossed by forces, a medium in which the definition and reciprocal demarcation of bodies and elements rest, strictly speaking, on "nulla," nothing, a nothingness seen as an incorporeal being. "A surface forms the common boundary between two non-continuous bodies, and it is not part of one or the other (...) Only nothingness separates these two bodies." (*Codex Arundel*, 159v.)

This last question, that of *essere del nulla* or the "being of nothing,"[199] fills several pages of the *Codex Arundel*. The resulting paradoxes and, in some places, the confusion it causes in Leonardo's thinking underline its growing importance. Indeed, at the outset, the concept of *essere del nulla* enables him to assert the existence in nature of the geometric entities of the point, the line and the surface.[200] But it expands and also comes to refer to all "things spiritual" or immaterial, including Time itself. As Augusto Marinoni wrote, "the great

reign of Nothing is invisible and immaterial": "If Nothing is the immaterial that exists locally without occupying a place, the energies that move the world, the points, the contours of things (...), and the surfaces that cover bodies, making them visible and resplendent in beauty, all belong to it. The solid, inert matter is only there to fill these forms, to provide a point of support for these energies. It is precisely this feeling of impalpable fluidity spreading through matter, giving shape internally and externally to all things, this feeling of infinite, latent energy, which underlies Leonardo's vision of the world."[201]

Leonardo perceives the life of nature as a continuous process of infinite development, and this feeling is strongly conveyed, for instance, on the page where he describes the infinity of potential images that inhabit the atmosphere and travel through it. This text probably echoes several commonplace beliefs in medieval optics,[202] but its tone makes it a true "scientific poem" in prose, comparable to his descriptions of the deluge, and it shows Leonardo's ability to give unexpected vitality to tradition: "The mass of air is full of an infinity of pyramids consisting of rectilinear rays, caused by the surfaces of opaque bodies contained in it. The further the pyramids move away from their cause, the more pointed they become, and although their path is littered with intersections and crossings, they do not become confused with one another, and expand while progressively spreading in opposite directions, occupying all the surrounding air. They are all of equal strength and equal value and thanks to them, the image of a body is carried in its entirety everywhere, complete in every detail, and each pyramid accommodates in its smallest part the whole form of its cause." (BN 2038, 6v).

The infinite unity of the dynamic processes of nature also makes its appearance in the analogy and continuity that connect light and shade by their very opposition: "Shade is the reduction of light and darkness. Shade is an infinite darkness which can be reduced to infinity. The birth and the boundaries of shade spread between light and darkness, and they can be reduced or increased to infinity" (*Quaderni II*, 6r). "The first level of shade is darkness, and the last is light" (BN 2038, 21b). The eye itself takes part in the world which it observes. By the 1490s, Leonardo has improved his knowledge of medieval optics, and this leads him to reject the idea that visual rays originate in the eye that sees. (This idea had had the advantage of turning the eye into an active organ and of glorifying its power of vision, this "spiritual power that works at a distance," *Codex Atlanticus*, 178r.) Rejecting this tradition of the "emission" of visual rays (which had been supported by Plato, Euclid, Ptolemy

and Galen), he adopts that of the "intromission" (taken up after Alhazen by Vitellius, Pecham and Bacon). Giving up the view of the eye as an active sensory organ, he compares its operation to that of a glass ball filled with water. But he still extols the "miracle" of vision, which, although it no longer depends on the "spiritual power" of the eye, still contains the entire world within it. Leonardo now expresses himself with a lyrical enthusiasm not shown by his predecessors: "Who would believe that such a small space could contain images of the whole universe? Oh, remarkable phenomenon! What talent could boast of being able to penetrate nature in this way? What language would be able to express such a great feat? [...] Here the figures, the colors, and the images of all the parts of the universe are concentrated in one point. Oh, what other point is as wonderful? Oh miraculous, atonishing Necessity, you whose law forces every effect to be born from its cause, through the shortest route! There are the wonders [...] of forms already lost, mixed up in such a small space, which it can recreate and reconstitute by becoming dilated [...]" (*Codex Atlanticus*, 345v-b).

In addition, and in accordance with the advocates of intromission, Leonardo also rejects the purely geometric, Euclidian concept that situated the *virtù visiva* ("visual faculty ") in a mathematical point located at the summit of the visual pyramid. Instead, he sees it as a "natural point," that is a "continuous quantity," infinitely divisible,[203] and he even goes as far as to state that "the visual faculty [*virtù visiva*] is distributed with equal power throughout the whole cornea [*popilla*] of the eye, so that the visual act [*operazione visiva*] is whole throughout all the cornea and whole too in each one of its parts" (*Codex Atlanticus*, 237r-a).

Similarly, on the subject of the representation of the world, Leonardo criticizes in particular the Albertian-inspired geometric construction, which supposes that the spectator is a Cyclops with a fixed eye.[204] He bases this criticism on the actual physiological conditions of natural vision, the movement of the spectator and his eyes. As will be seen, Leonardo also distinguishes between different kinds of perspective, and he invents the idea of anamorphic representation (fig. 63), whose working depends on the spectator moving from the position normally adopted with linear perspective, that is, facing the work.[205] This invention shows that, if Leonardo is opposed to the "loss of freedom of the seeing eye," supported by Alberti, it is because for him "the seeing and the visible must be thought in common," that "between the visible and the seen, between the subject seeing and the world, there is no break."[206] In

1508, he reaches a formula, which, although metaphorical, also sounds unexpectedly modern: "Every point of the cornea [*popilla*] sees the whole object, and every point of the object sees the whole cornea." (*Ms. D*, 2v)[207]

But this idea of the world as a continuous process also created a specific problem for Leonardo: how to express the concept of *continuous quantity*, in other words a quantity that is infinitely divisible, and that of *continuity*, "a simple idea, irreducible to any other idea, in the same way as that of infinity." The

Fig. 63. *Anamorphic study, Codex Atlanticus,* fol. 35 v. Milan, Biblioteca Ambrosiana.

continuous implies indeed the absence of parts; it cannot be measured, or broken up, it is not a unit or a multiplicity; "it is (in as far as it is) a 'unit' which is not a unit, a 'multiplicity that is not multiple.'"[208] How can "continuous" quantities in an indivisible continuity be measured and divided? How can the continuous "which transcends all definition of size" be based on a straight line, a distance, or a body? These questions are, as Koyré pointed out, of an *ontological* nature (how to divide and limit the continuous One?), and it is probably their context that enables us best to understand the unity of Leonardo's twin undertakings, artistic and scientific. Everything takes place as if he was working, on the one hand, to reconcile his intuition of the continuity of the world with the scientific analysis of its continuous quantities, and, on the other hand, to use art to make visible the indivisible continuity of the world—and thus the continuity that exists between human subjects and this world in which they are immersed.

Now, it is precisely movement that goes beyond the "abyss" separating

the continuum from continuous quantity (or size). Because movement itself is of necessity continuous and indivisible ("the mobile moves and is in motion at every point and every moment of its trajectory"),[209] it travels through continuous, and therefore divisible, quantities of space. So it is obviously no coincidence that, as Panofsky observed about the *Codex Huygens*, "it is only in Leonardo's writings that the theory of human movement is based on the idea of *continuity,* or what amounts to the same thing, *infinity.* "[210] But it is also possible to suppose that Leonardo would not have conceived the "curious system of circles and epicycles" pictured by Carlo Urbino in the *Codex Huygens*; and that he would not have "animated [his] geometric sketches with figures performing the successive stages of one and the same movement." Far from illustrating "crystallized poses," these drawings are meant to show "transitional stages"; nevertheless, they are still, wrongly, based on the idea of continuity within the principle of infinite divisibility, and so figuratively they produce monsters. For Leonardo, this principle of continuity of movement is sufficiently demonstrated by the drawing of the Vitruvian man (fig. 56) whose movement stops precisely at its beginning and its end (the pose "in a circle" and the pose "in a square"), that is, with two "events without duration."[211]

In fact, one has to go further, because it is this context that makes necessary the "perspective of erasure" and *sfumato* ("delicate gradation") to portray the boundary of bodies in painting. Leonardo perceives this boundary as the "departure" and the "arrival" of figures, "momentary phenomena, instantaneous events which (…) do not, as it were, possess any extension or thickness in themselves."[212] This is no facile or arbitrary association: in place of the *nulla*, which constitutes the boundary between bodies and occupies a position without occupying any space, *sfumato* diminishes the effect of immobility in painting—which intrinsically opposes itself to the movement of the world. It does this by bringing to the fore the process of painting, the act and movement of the brush, which without itself being visible, makes movement visible, reflecting the processes of nature and its "immaterial movements." Perhaps Vasari perceived this when he praised the grace "which appeared between the seen and the not-seen, and which is also found in flesh and living things," and when he mentioned the "terrible movement" created by "a certain darkness of well-understood shadows."[213]

Understanding the world, but also representing it, means understanding and representing its rhythm and the laws that organize it, the laws of movement,

the "cadence of indivisible time." The visible forms of the world are those of the *rhythms* of its movement, in the precise sense of the word we mentioned earlier on and to which it is now time to return. In Greek thought before Plato, and more especially in the Ionian philosophy since Heraclitus, while *schèma* is defined as "a fixed 'form', produced and positioned like an object," *ruthmos* indicates "the form in the instant in which it is assumed by what is moving, mobile, and fluid […]; it can be applied to the *pattern* of a fluid element […], to a garment arranged to one's liking […]. It is the improvised, momentary, modifiable form […]. The choice of a form of the word *reîn*, meaning 'to flow,' to express this specific modality of the shape of things is characteristic of the philosophy that inspires it; it is a representation of the universe in which the particular configurations of the moving object are defined as 'flowings.'"[214] These words by Benveniste perfectly describe the world as it appears to Leonardo, as he analyzes it scientifically and describes it artistically and literarily: his approach to the actual is *morphological*; he is interested in the genesis of shapes, in the analogy of laws founded on the principle of geometric proportions and the irreducible and infinite diversity of the appearance of things. Seeking to "grasp forms through their causes,"[215] concentrating his attention particularly on this "passage" "from forms born of movement […] towards movements which become forms with the help of a simple variation of duration,"[216] Leonardo "acts in a way on the basis of the appearance of objects; he reduces, or tries to reduce the morphological characteristics to systems of forces; and these systems being known, *felt*, and thought out, he completes or rather renews their movement in the execution of the drawing or the picture."[217]

Thus, his scientific and artistic world is a world whose configurations and forms are momentary stages in a process of continuous flux, transformations structured by the laws of the development in which they participate. His analysis and representation of the world are based on the intuition that "the process, the development would be a constituent of physical existence."[218] Although he makes mechanics the "paradise of mathematics," and although he makes the knowledge of craftsmen and builders of machines a new way of carrying out the rational exploration of nature, he does not ignore "the growth of the living, this process of independent transformation."[219] It is precisely in this that he is not, as we have seen, a "pre-Galilean." Through intuition as much as through reflection, he preserves this ancient "alliance" of man and nature in which man, who observed nature was, to quote the beautiful phrase of Michel Serres, "a whirlwind in turbulent nature."[220]

Pages 122–123: Fig. 64. *Studies of geometrical transformations*, *Codex Atlanticus*, fol. 167r a-b, 11¼ x 17 in. (28.9 x 43.4 cm.) Milan, Biblioteca Ambrosiana.

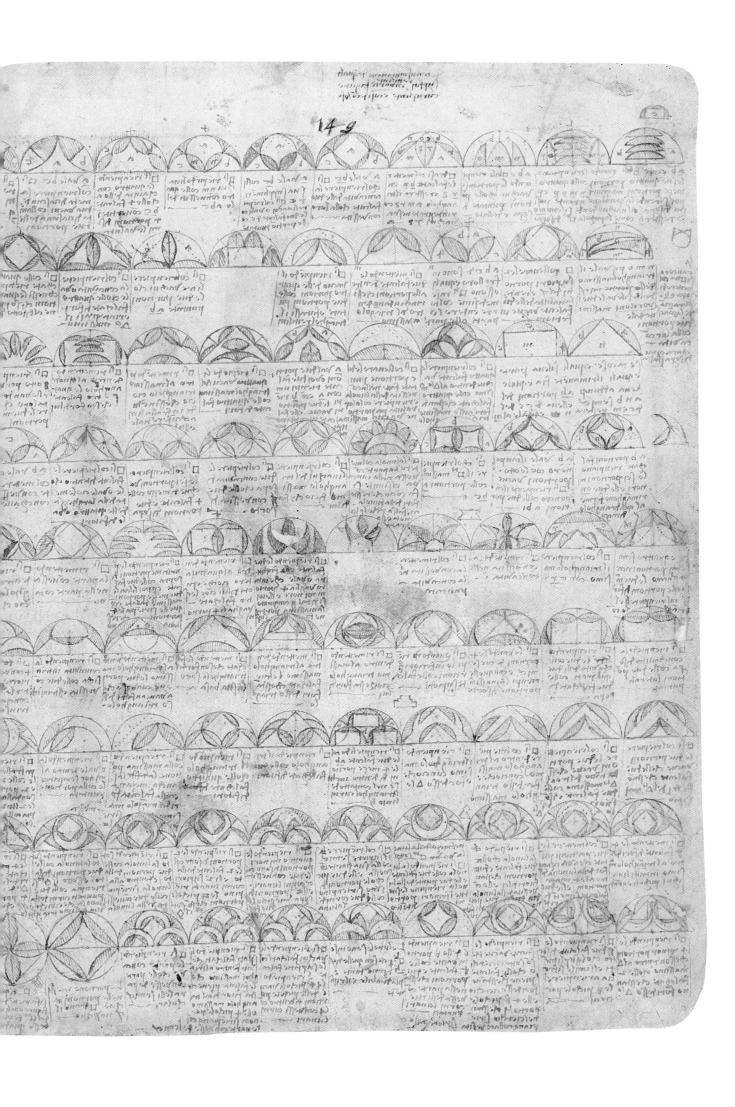

This feeling of the "rhythm" of the world shows itself in the observation (in which geometry and the dynamics of development are linked) of the change undergone by a drop of water on a progressively inclined plane (*Ms. I*, 90r).[221] But on the level of pure geometric forms, it also inspires the analysis of their correlations and their possibilities for infinite transformation without loss or increase of quantity. Symbolized by the "squaring of the circle," where Leonardo claims to have improved on the solution of Archimedes "on the night of Saint Andrew" 1504, this research or *scientia de equiparantia* has interested him since 1495–1500 and his meeting with Luca Pacioli. He works on it during the last fifteen years of his life. Folio 167r a-b of the *Codex Atlanticus* (fig. 64) may express a "geometrical-maniacal"[222] tendency but it is also a "mathematical game" in the tradition of Alberti and Nicholas of Cusa. He introduces the principle of the continuous generation of forms into the world of geometry, the infinitely varied beauty of motifs obtained from the development of a single mathematical rule. This recalls the beauty of the countless human profiles, which, stage by stage, examines the modulations of ideal beauty—and which, as soon as the factor of Time, "consumer of all things," intervenes, highlights through successive distortions the inexorable internal logic of the disfigurement of beauty (fig. 47, 65, 66, 67). Thus the famous

Right: Fig. 65.
Profiles of men and bust of a young woman,
c. 1478–80, pen and ink,
16 x 11½ in. (40.5 x 29 cm.)
Windsor Castle, Royal
Library, RL 12276v.

Center right: Fig. 66.
Profile of a bearded man,
probably c. 1513,
black chalk, 7 x 5 in.
(17.8 x 13 cm.)
Windsor Castle, Royal
Library, RL 12553.

Far right: Fig. 67.
Profile of a man, c. 1510,
red chalk corrected in black
on red prepared surface
heightened with white,
8¾ x 6¼ in. (22.2 x 15.9 cm.)
Windsor Castle, Royal
Library, RL 12556

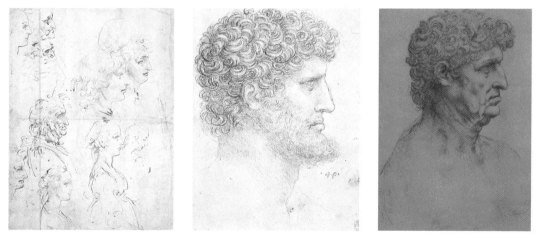

"grotesque heads" (fig. 68, 69) appear as the constituents of an infinitely extensible repertory of "ideal ugliness" in which this "voluptuousness of the *individuality* of objects,"[223] typical of Leonardo, is always palpable. Taking the human figure and working on a particular structure that is initially imperceptible, Leonardo causes the universal process of development suddenly to

reveal itself in the amazing fullness of its coherence, monstrous yet natural and human.

This feeling for the rhythm of the world is also present in Leonardo's anatomical research. In his first version, dating from 1487–89, his general treatise on human anatomy would have been organized according to the progressive growth of the body, from conception in the womb and the embryonic state to adulthood (*Ms. B*, 20v). Leonardo gives up this idea and, in 1509–10 (*Quaderni I*, 2r) he adopts an arrangement based on "demonstration," which emphasizes the analogy between microcosm and macrocosm. But the feeling for the movement of forms remains. Not only does his meticulous studies closely link anatomy and physiology (which takes into account facts of a dynamic order, associated with the use and functions of the body and its organs), but his anatomical representations also aim at recreating the change of configuration according to the shifting of the figure, through multiplying the points of view. For instance, the double page showing the muscles of the arm, the shoulder and the neck makes use of eight successive views, from the face to the back (fig. 70, 71); and as well as the turning movement, the surreptitious movement of the arm being progressively raised has been added.[224]

The anatomy and physiology of the tongue illustrate particularly clearly the

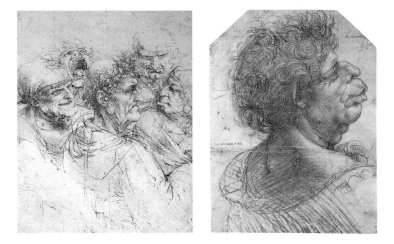

Left: Fig. 68. *Five grotesque heads*, *c.* 1494, pen and ink, 10¼ x 8 in. (26 x 20.5 cm.) Windsor Castle, Royal Library, RL 12495r.

Left: Fig.69. *Grotesque head (Scaramouche?)*, charcoal partly retouched by another hand, 15¾ x 11 in. (39 x 28 cm.) Oxford, Christ Church.

fact that, for Leonardo, the practice of anatomy is inseparable from this feeling of ceaseless development of beings and forms. Leonardo is particularly interested in the tongue because "no other part of the body uses as many muscles [...] There are twenty-four known muscles, in addition to the ones I have discovered; and of all the parts that move consciously, the number of movements

of the tongue exceeds those of others" (*Feuillets B*, 28v). The two long texts which Leonardo devotes to the functioning of the tongue give him the opportunity to expand his thoughts on the creative power of nature. It is important to follow this exposition to understand the profound unity of Leonardo's world. In the first text (*Quaderni IV*, 10r), Leonardo praises the beautiful, simple, direct inventions of nature—in particular that of life because nature "does not need a counterweight to create the parts designed for movement in the body of animals"; it is life which has placed within them "the soul of the body which created them" (the mother). Leonardo recognizes that this "discourse" is out of place in an essay on the tongue; but significantly, he considers it necessary "as it concerns the structure of animate bodies." The other page is even more astonishing. The study of the tongue first leads him to meditate on the human languages, their diversity, their infinite variations over time and, finally, their ephemeral character: "They change constantly from century to century, and from country to country, because of the mixing of peoples which wars and other accidents have brought together. These same languages may also fall into oblivion, being mortal like things created; and while we admit that our world is eternal we will say that they were and must be of an infinite variety, throughout the countless centuries that constitute the infinity of time." His thoughts then turn to a comparison between the creations of nature and those of man, "the principal instrument of nature." He then expresses a (measured) criticism of alchemists, who are incapable of "creating anything that could equal nature." Leonardo continues by explaining the natural production of gold by two of the "figures of resemblance," later mentioned by Michel Foucault: the *aemulatio* ("emulation" between gold and the sun) and the *convenientia* ("harmony" between the gold and the stone which it veins).[225] Gold, "the most excellent of all [natural products], is generated by the sun because it resembles it more than anything else in the world" and, "in the mines where nature produces this gold," only the heat "of nature which gives life to our world" has an effect. "… Examine this vein of gold closely, and you will see that its extremities are continuously developing through a slow movement, transforming everything that they touch into gold and note that there is there a vegetative soul that is not within your power to produce." In spite of this apparent digression and the disorder in his thoughts, Leonardo associates ideas and things strictly in relation to his fundamental intuition of the continuous processes through which life in nature creates its forms in an infinite development.

We have seen how *Vitruvian Man* illustrated in a very original way the idea

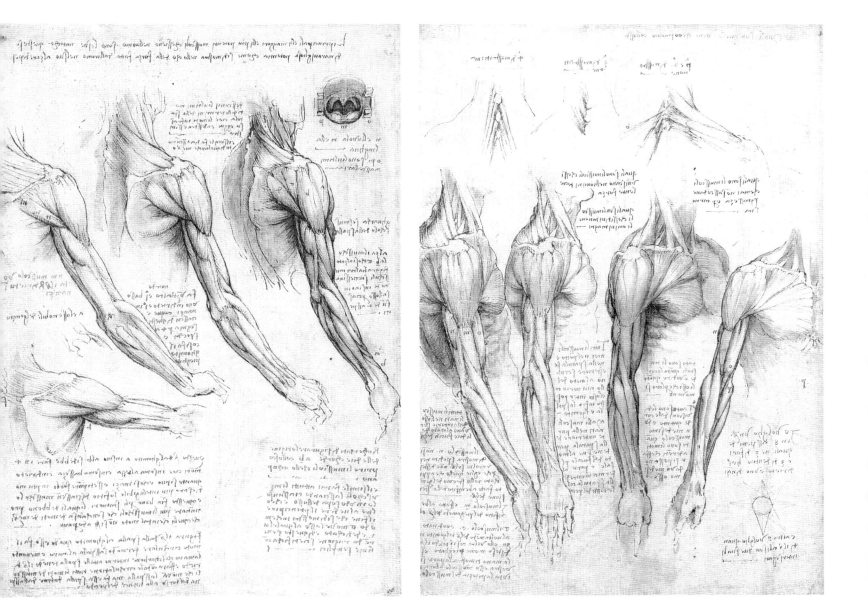

Above left: Fig. 70. *The muscles of the arms, shoulder and neck*, after 1510,
pen and ink with wash on charcoal outline and drawing in metal-point, with little touches of red chalk,
11¼ x 7¾ in. (28.5 x 19.5 cm.) Windsor Castle, Royal Library, RL 19005v.

Above right: Fig. 71. *The muscles of the arms, shoulder and neck*, after 1510,
pen and ink with wash on charcoal outline and drawing with point, with little touches of red chalk,
Windsor Castle, Royal Library, RL 19008v.

127

that the proportions of the human body are moving in a continuous "rhythm," from the circle to the square and from the square to the circle. But, apart from this exceptional image, as Panofsky mentioned, the whole system for calculating the proportions of the human body is developed by Leonardo in an original way, according to his intuition that the perfection of the natural form corresponds to the achievement of a continuous organic process. Unlike other theoreticians of human proportions, Leonardo does not simply express each "quantity" as a fraction of the overall height of the body or as a multiple of a given unit, which is itself a fraction of this overall height. He probably ends up doing so, relating his measurements to the "head" or the "face." But "before thus reducing them to a unit of absolute measure, he tried to establish connections or, to use the expression of Pomponius Gauricus, 'analogies.'"[226] This attempt is also significant in itself because it shows how Leonardo is led to establish "analogous" connections between the parts of the body that have no anatomical relation. He compares the various parts of the body and expresses their proportional relationship in the form of equations ("a–b, b–c, d–e are all similar to each other," "a–b is comprised once in c–d, once in d–e and once in e–f"). Most importantly, the elements of these equations can be applied to a part of the body whose movement changes the fixed dimension—and it is hardly surprising that this movement should be that of smiling. The proportions of the outstretched arm thus establishes a correspondence between the "thickness or width of the arm at the point where it is attached to the hand" with the length of the thumb, the inside length of the little finger, the length of the ear, the length of the nose from the eyebrows to the nostrils, the width of the kneecap, the thickness of the bottom of the leg but also, like a comment on the *Mona Lisa* in the style of Duchamp, the thickness of the testicles and "the mouth when it smiles."[227]

This page is not by Leonardo, but it is nevertheless quite revealing. Somewhat laboriously, its author Carlo Urbino discloses a fundamental aspect of Leonardo's anthropometry. The perfection of this "opaque body," which is the human body, is not related to an absolute, transcendent unit of measurement. It is measured on the basis of the reduction of equivalences and harmonies in which the omnipresent coherence of the "spiritual force" which organizes the development of living forms manifests itself in a "marvelous" way. This approach is also reflected in another aspect that distinguishes Leonardo's theory of proportions from that of Dürer—although the latter was profoundly influenced by the former. In the diagrams based on a fixed unit of measurement, also

shown by Panofsky,[228] the anthropometric drawings of the *Codex Huygens* are based on a "uniform grid" in which the horizontal markers are separated by equal intervals.[229] With Dürer, on the other hand, the intervals set by the horizontal markers are distributed irregularly and determined by the natural divisions of the human body. At first glance, Dürer might be thought to record the intrinsic irregularity of the "living geometry" of the human body more closely than Leonardo. But, for Leonardo, the natural divisions (nose, chin, nipples, navel) "*give rhythm*" to the beauty of the body. When Leonardo applies an ideal unit of measurement, mechanical and canonical, he highlights the irreducibility of the living being to static geometry. The distribution of the nine canonical units in the body involves an aberrant unit, typically Leonardo: this ninth unit includes the throat, plus the height of the foot, plus the top of the head. One can understand that, faced with such irregular regularity, Carlo Urbino's notes should define the *disegno* ("drawing") as a "concert of lines conceived by the spirit, associated with the ability to represent them in action so that they resemble a thing which exists or could exist."[230] In the eyes of Leonardo, figures produced by a theory of proportions founded on the fixed return of an absolute unit of measurement are false or, as Gregorio Comanini would later put it, "a fantastic imitation," which imitates non-existent things.[231]

If one has to find a framework in which to position Leonardo's intuition of the rhythm of the world, it would be found in the works of Ovid. As André Chastel has indicated,[232] the great speech attributed to Pythagoras in Book XV of the *Metamorphoses* (of which Leonardo owned a copy) is, in several places, the direct source of some of Leonardo's pages, and a number of his annotations are direct or memorized quotations from Ovid's writings. References include the theme of "Time, consumer of all things" and Helen's beauty in particular, or the matter of marine fossils, which are found at the top of hills and mountains as a result of the rising of the land. On the whole, "the cosmology, physics and even the morals of Leonardo" are remarkably similar to those of Ovid's Pythagoras, whose vision of the world can be summed up in the famous verse: "Cuncta fluunt omnisque vagans formatur imago" ("Everything flows and each image is a wandering image").

But at this point several clarifications and qualifications are called for. First, Ovid attributes to Pythagoras a thought that was actually that of Anaximander, who succeeded Thales as head of the school of Miletus. Naturally, Leonardo could not have known this. But this is nonetheless important because it is not just a mode of expression that Leonardo seems to rediscover through the

Ionian philosophy.[233] It is also a way of thinking, in particular one in which the world is conceived as infinite or unlimited (*apeiron*) and matter as indeterminate, all birth being the separation of opposites, and all death the return to a union in the unlimited. Giorgio de Santillana has highlighted the unusual relationship between Leonardo and the Ionian philosophers. But it seems that Bramante had already made this association since, as Carlo Pedretti convincingly stated,[234] the double portrait of Heraclitus and Democritus, painted in Milan above the entrance door of the Casa Panigarola (fig. 72), very likely represented Bramante himself as Democritus, and Leonardo as Heraclitus.

That does not mean that we should see a duplication of pre-Socratic physics in Leonardo's world. It is true that on folio 385v-c of the *Codex Atlanticus* Leonardo sums up most elegantly the concepts of Anaxagoras (disciple of Anaximenes who himself was a disciple of Anaximander): "Anaxagoras. Everything is born from everything, and everything develops from everything, and everything becomes everything again because everything which exists in the elements is made up of these elements." But again, there is no need to assume that Leonardo had a direct knowledge of Anaxagoras (which would in any case have been impossible), or that he was familiar with contemporary

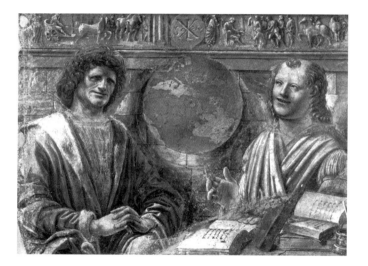

Fig. 72. Bramante, *Heraclitus and Democritus*, dismounted fresco, 40 x 50 in. (102 x 127 cm.) Milan, Pinacoteca di Brera.

philosophical writings (again quite improbable). At the time, Aristotle's *Physics* is one of the main sources on the thought of Anaxagoras.[235] So, Leonardo's world becomes that of an "Aristotelian Anaximander-Anaxagoras." Through fast or slow mutations, things and beings are born from chaos and will return to chaos; but this cyclical process depends, in Aristotelian terms on the "desire"

of the elements to go back to their "natural place" from which the *Primo motore* has extracted them. Folio 156v of the *Codex Arundel*, one of the Leonardo's earliest works, expresses this clearly: "Consider the hope and desire that man has to go home and return to the primordial chaos, similar to a moth's attraction to the light." This desire to "go home" is "inherent in this quintessence, this spirit of the elements, which, imprisoned like the soul in the human body, always wishes to return to its source. Know that this desire is this quintessence, this companion of nature, and that man is the model of the world." The momentary equilibrium of the world, or rather its rhythm, is fragile; it depends on the power of the "immaterial movement" of living things, and on the fact that "nature, capricious and happy to create and produce a continuous succession of lives and forms […] is more willing and quicker to create than time is to destroy" (*Codex Arundel*, 156 v).

The reference to Ionian philosophy also explains why Leonardo's vision of the world does not only have a poetic dimension, but why it is also, inseparably, scientific: he perceives the world "at a level in which objective thought, analysis and aesthetics have not yet become dissociated, but, rather, support one another."[236] More than animist, his world is "biological" and, even better, "vitalist."[237] If movement in his world is the "cause of all life," the living being is in itself a "spiritual force," an "immaterial movement," a force and a principle of organization of matter. When Leonardo glorifies "sublime Necessity," he is not referring to the mechanical laws of the world of Galileo but to those laws which guide the "admirable inventions" of nature in which forms, destined for a particular function, show the correlation between the laws of mathematics and the natural structures of living things.

The depth and intensity of this morphological vision of the world are particularly apparent in the complementarity of three works produced by Leonardo in Milan between 1495 and 1500 whose nature and functions are nevertheless radically heterogeneous: the drawings of the regular Platonic solids, intended to illustrate *De divina proportione* ("On divine proportion") by Luca Pacioli, the tracery of the *Achademia Leonardi Vinci* and the plant decoration in the Sala delle Asse, painted in the Castello Sforzesco for Ludovico the Moor.

Between 1496 and 1499, with his "ineffable left hand" (to quote the words of Luca Pacioli in his *De viribus quantitatis*), Leonardo draws models of Platonic solids, which, with their variants, will be reproduced in the manuscript version of 1498 and then in 1509 in the printed edition of *De divina proportione*.

The five Platonic solids establish a correspondence between the elements and the simple bodies: earth and the cube (hexahedron, six squares), fire and the pyramid (tetrahedron, four equilateral triangles), water and the icosahedron (twenty equilateral triangles), air and the octahedron (eight equilateral triangles), to which is added the sky, a dodecahedron consisting of twelve pentagons. These drawings are one of the first manifestations of Luca Pacioli's influence on Leonardo. Three verses in which Pacioli extols intellectual contemplation and

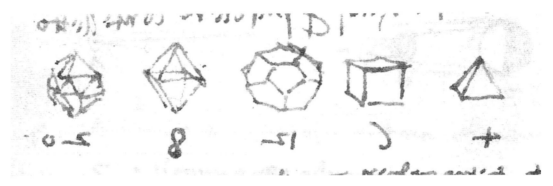

Fig. 73. *Sketch of the five Platonic solids, Ms. B*, fol.80v, detail. Paris, Institut de France.

the *diletto* ("delight") aroused by the intellectual beauty of pure mathematics[238] accompany a rough sketch of the five Platonic solids (*Ms. M*, 80v, fig. 73). This sketch reflects Leonardo's amazing ability to visualize geometry and represent pictorially the hypothesis of an invisible form on the basis of purely abstract indications (a geometric shape and a number). This collaboration between Leonardo and Pacioli evokes the one which, between 1609 and 1613, will bring together Galileo and the Florentine painter Lodovico Cigoli, when Galileo asks the painter to draw sun spots. In full agreement with Galileo, Cigoli will be able to write that "a mathematician, however great, would only be half a mathematician or even a man without sight, if he had no skill at drawing."[239] But this understanding also shows what is distinctive in Leonardo's talents and it allows the state of mind in which he draws the Platonic solids to be identified. For Galileo, Cigoli represents graphically what is observable in nature with the aid of a telescope. By contrast, for Pacioli, Leonardo makes pure geometric entities visible; he invents forms that do not exist in nature. These intellectually perfect forms are based on the Platonic concept of the absolute perfection of the One, immutable and finite, in contrast with the imperfection of the Multiple, the infinite and developing.[240] Yet nothing was further removed from Leonardo's concepts and one might think that to him, these drawings were the result of a *disegno* ("drawing") created, according to

the words used by his pupil Carlo Urbino, as "a concert of lines conceived by the spirit, associated with the ability to represent them in action."

After devoting himself to this brilliant *ludus mathematicus* for Luca Pacioli, Leonardo returns to the Platonic solids and works on them in pursuit of his own pleasure in transforming forms. In Florence between 1500 and 1506, he carefully read Pacioli's *Summa de arithmetica, geometria, proportione et proportionalita* ("Summary of arithmetic, geometry, symmetry, and proportion") in order to master the arithmetical concepts of continuous and discontinuous proportions, of multiples and fractions, and so on. At the same time he is again making drawings for Luca Pacioli (who is with him in Florence) of models of regular solids commissioned by the rulers of Florence. He becomes personally involved in the study of "transformations" and in 1505 he believes he is ready to start writing his own treatise on the subject. Entitled *De straformazione*, his first book would have dealt with the transformation (not very Platonic in spirit) of the four other cube-shaped regular solids.[241] Other drawings from a later date (fig. 74) show that he was designing marquetry in which the Platonic cube becomes an instrument of optical illusion—based on the ancient technique, which he developed in a particularly brilliant complex manner, of representing the cube as transparent.

The six engraved interlaced motifs based on drawings by Leonardo, produced between 1495 and 1500, have long perplexed interpreters and fired their imagination (fig. 75, 76). Thought to be emblems (today they would be called "logos") for an academy Leonardo is said to have founded (or dreamed of founding) in Milan, they used to be considered very personal works, full of complex, symbolic values. The discovery of the historical and social context of their production has removed the mystery surrounding these engravings, and it has also made possible the discovery of their truly Leonardo-esque dimension.

Leonardo does not invent this type of interlaced motif; he is following a fashion that has developed in the courts of Northern Italy in the third quarter of the fifteenth century. These decorative motifs become so popular that they are used for all kind of embellishment: wall decorations, floor tiles, bookbindings and ornaments for clothes.[242] In 1492, the humanist Niccolo da Correggio is said to have devised for Isabella d'Este an interlaced motif, called *fantasia dei vinci*, and this type of ornamentation is found in a number of contemporary portraits—among others, that of Cecilia Gallerani by Leonardo (fig. 269). Following a long decorative tradition, at the end of the fifteenth

century these interlaced motifs are thought of as a "science," as truly theoretical objects. By designing such motifs Leonardo not only meets the demands of contemporary Milanese fashion but also reveals himself an exceptional master of this genre, in which he produces a vast quantity of studies (fig. 77). That is how they came to be engraved and how inscriptions were inserted suggesting the existence of a Leonardo "academy." Such an academy never existed, and these inscriptions were probably the work of the engraver, refer-

Fig. 74. *Study of marquetry*, c. 1515, pen and brown ink on charcoal, 4¾ x 5¾ in. (12 x 14.7 cm.) Oxford, Christ Church.

ring to the "lesson" Leonardo gave on the subject.[243] A close examination indeed shows that they are probably models that had to be practiced manually in order to understand their composition. Contrary to what Vasari thought he had seen, the line is not continuous and it cannot be followed "from end to end." The overall design is based on a periodic system and, as Gerhart Egger has pointed out, the system of the knots cannot be understood simply by visual observation—it demands that it be carried out manually.[244]

This is a long way from being a mysterious "cryptographic signature" of Leonardo, or "some kind of admission card or reward for scientific sessions, the term *accademia* also having the meaning of a scientific or poetic 'tournament.'"[245] Indeed it would be a mistake to trivialize Leonardo's interlaced motifs. Their extreme complexity is still quite exceptional. Dürer copied them, Vasari saw them only as a waste of time,[246] but above all they reflect an old interest of Leonardo.

This interest reflected a fashionable trend among the Milanese, and Bramante

was one of those who shared the passion with which Leonardo "wasted his time" on this kind of geometric game. But Leonardo did not wait to go to Milan before designing interlaced motifs. On the back of the first surviving work in Leonardo's hand (the drawing of the Val d'Arno from 1473), Carlo Pedretti has identified the trace, almost rubbed out, of a study of an interlaced motif and mentions others on pages of the *Codex Atlanticus* dating from 1480–82.[247] Leonardo would probably have come across this type of motif

Fig. 75 and 76. *Motifs for the Accademia Vinciana*. Milan, Biblioteca Ambrosiana.

when he was working in the studio of Verrocchio, who had already used it in 1472 on the Medici tomb in San Lorenzo. But Leonardo's personal interest in the graphic representation of interlaced motifs goes back even further: in fact, it dates back to the days when he was learning to write *alla mercantesca* and studying calligraphy.[248] In commenting on the fine page devoted to the "controlled fantasy" of writing that appears on the sheet in the Uffizi dating from November or December 1478 (fig. 78), David Rosand shows how from the beginning, the pleasure of calligraphy evident in the notarial flourishes that Leonardo inherited from his father leads to "graphic independence": "The flourish detaches itself from the initiating letter from which it comes, [...] repeating as an independent graphic exercise the flourish leaves the word behind and, in so doing, discovers and explores its new potential as grapheme [...]. A small initial curve continues on its elegant course, defining the surface over which it runs. Then it turns back upon itself, a movement natural to the alphabetic course of writing. But [...] as soon the line has crossed itself forming a loop, it

participates in what to might be called the "spatialization" of linear movement
[...], an epitome of the act of drawing."[249] An undeniable continuity links these
loops generated by the free yet controlled movement of the hand on the 1478 sheet
and, some twenty years later, the dazzling application of the "science" of inter-
laced motifs. From one to the other, the practice is systematically and thor-
oughly studied, and Leonardo uses the medium to translate his feeling of the Being
of the world into a geometric figure, a "concept of the infinite (and of organic
generation) founded on an infinite variation of interlaced motifs, succeeding
each other inside a circle."[250] It is significant that the technique he uses to arrive
at the bilateral symmetry of the motif (folding the paper and transferring the
drawing through pricking and pouncing) is the same as he will use in 1508–10
on the large Windsor page with its almost mythical representation of *The organs
of a woman* (fig.198).[251] The organic geometry of life is one of the "wonders"
of Nature which Leonardo most admires, and while uncovering its secret laws
he seeks graphically to bring out its form, refined by the art of *disegno*.

Fig. 77.
Studies of knots,
Codex Atlanticus,
fol. 261r-a. Milan,
Biblioteca Ambrosiana.

Connections have been made between the interlaced motifs of the "Academy"
and the monumental decor of the Sala delle Asse in the Castello Sforzesco,
which is completed in 1498. In this, eighteen trees have their roots in a rocky
subsoil and cover the vault with their foliage, intertwining their branches to
follow the architectural structure of the room while concealing it; a golden

Fig. 78. *Studies of heads and machines.*
Florence, Uffizi, inv. 446 E.
Whole leaf and detail.

rope runs across the surface, tying together some of the branches (fig. 79). This decorative "invention" is absolutely original and, while meeting a particular demand most brilliantly, Leonardo also exploits and develops all the virtual symbolic values of tracery by combining the "natural" web of the branches and the "artificial" geometry of the *fantasia dei vinci*.

Situated on the ground floor, on the northeast corner of the Castello Sforzesco, the room was, like other rooms on which Bramante was then working, conceived as a resting place, a *locus amœnus* ("pleasant place") a kind of monumental *camerino* ("little room") providing a pleasing coolness in summer. The foliage-covered vault would provide the metaphorical equivalent in town of the "paradise" which was the country residence of Ludovico the Moor and Beatrice d'Este at Vigevano.[252]

But it goes without saying that for this kind of decor, the program also includes the political and social glorification of the Prince. (This aspect is very much expected in Milan since the designation or connotation of the place of government as a "paradise," unexpected today, is an established concept in the second half of the fifteenth century. It is founded on a long tradition, especially in Milan, which is widely echoed by Filarete).[253] The inscriptions on the four blazons containing the joint coats of arms of Beatrice and Ludovico, placed at the center of the vault, praise the Prince's politics by describing in detail the recent success of Milan's political and matrimonial alliance with the emperor Maximilian.[254] This glorification is also expressed symbolically in the motif of the trees. The tree with its leaves and roots is an emblem of the Prince (also found in Vigevano), and in addition the trees depicted by Leonardo, mulberries, are a direct allusion to Ludovico the Moor, the Italian word for mulberry being *moro* or *gelsomoro*. This symbolic connection makes the painted ceiling a threefold exaltation of Ludovico.

The mulberry with its protective shade is also, through the architectural significance given to its trunk, an image of the column that supports the State.[255] Moreover, ever since Pliny the Elder the mulberry had been considered the wisest and most cautious of trees because it flowers slowly and ripens fast; thus it can represent the art of governing.[256] Finally, the mulberry also refers to Ludovico's economic policies, since he had strongly encouraged the development of silk which already existed in Milan by planting a "countless number" of mulberries in the gardens of the villa Sforzesca in Vigevano.[257] The interlaced motif of the golden rope completes this ducal exaltation: while evoking the prestige of the court of Milan as far as elegance is concerned (the

Fig. 79. *Vegetal decoration*,
tempera on wall surface.
Milan, Castello Sforzesco,
Sala delle Asse. Detail.

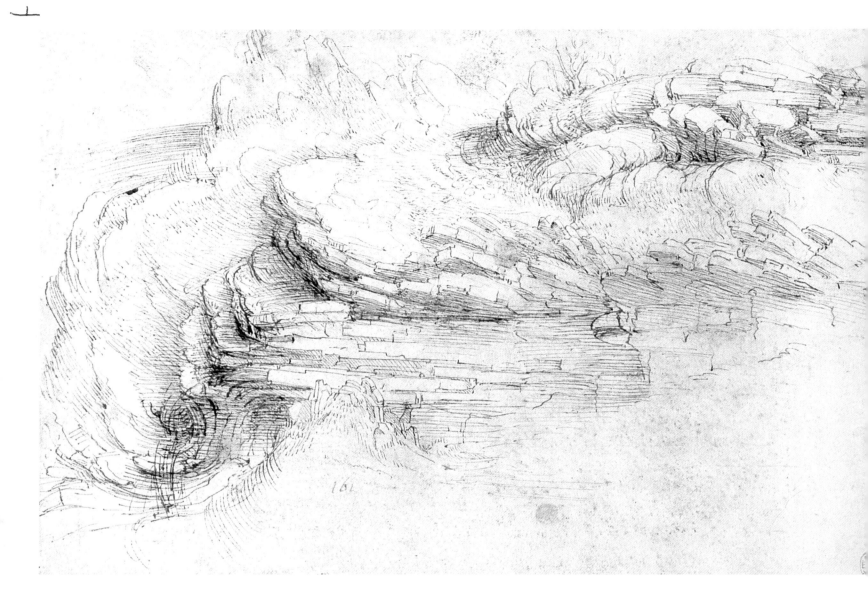

Above: Fig. 80. *Study of rock formations*, c. 1510–13,
pen and ink over black chalk, 7¼ x 10½ in. (18.5 x 26.8 cm.)
Windsor Castle, Royal Library, RL 12394.

Opposite: Fig. 81. *Study of rock formations*, c. 1494,
pen and ink on pink paper, 8¾ x 6¼ in. (22 x 15.8 cm.)
Windsor Castle, Royal Library, RL 12395.

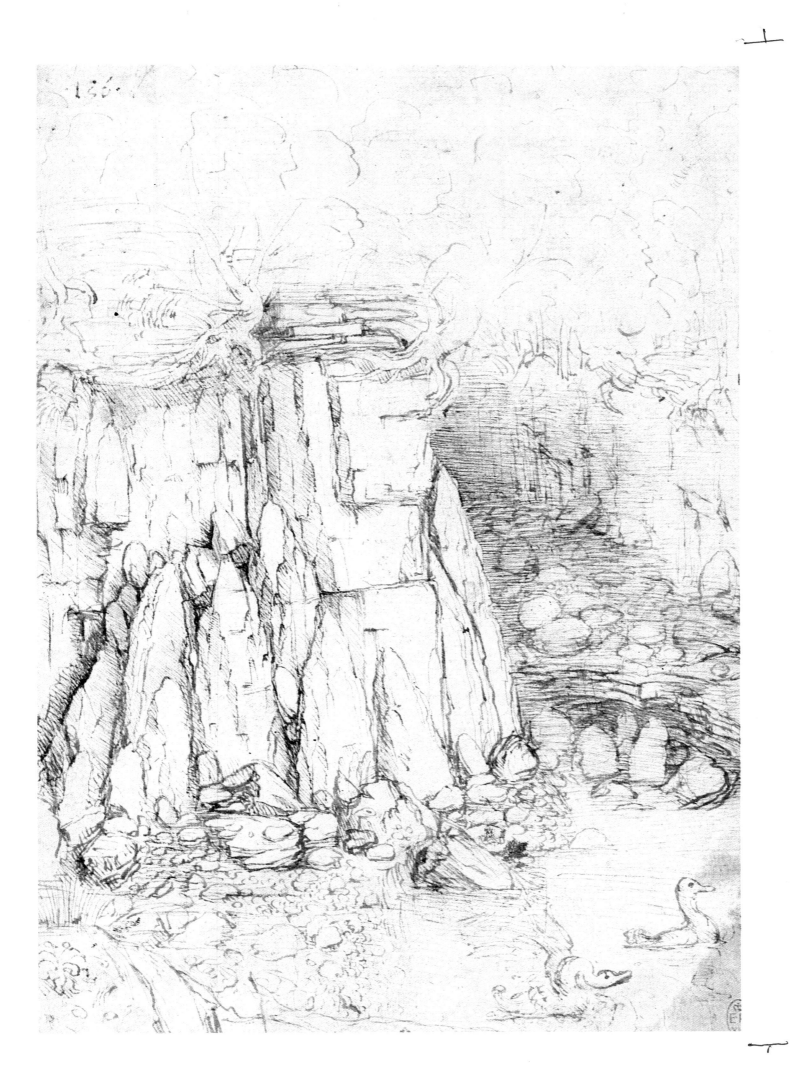

manufacture of gold thread and silk were a specialty of Milan), this golden rope can also, as suggested in a poem by the court poet Bellincioni, refer to Ariadne's thread and therefore also to Ludovico, the modern Theseus who overcomes all difficulties, and to the plant labyrinth of the Castello Sforzesco and even more, that of Vigevano.[258]

It is important to emphasize the complexity of this program in order to appreciate the ease with which Leonardo succeeded in bringing all these con-

Fig. 82. *Decorative screen, Codex Atlanticus,* fol. 988b. Milan, Biblioteca Ambrosiana. Detail.

cepts together. But the execution of this iconographic program also brings out Leonardo's most important personal interests, and it is these interests that give this decor its originality and its lively coherence.

The monochrome base of the decoration, the rocks from which the roots of the trees burst forth, is such an original invention that in 1893–94 it was thought that they were a later addition dating from the Spanish rule over the city.[259] Because of its monochrome tint this decoration also acts as a border round the room,[260] and the rocks also reflect Leonardo's geological interests expressed in various drawings (fig. 80, 81). Growing through the cracks in the rocks (the "bones of the earth"), each tree then freely develops the "immaterial movement" of its plant life, and the natural geometry of its ramifications (comparable to that of human blood vessels) invites the eye to become involved in an infinite movement which follows over and over again the paths slowly drawn by the continuous progress of the living power of the sap.[261]

In every aspect of this architecture of greenery, Leonardo has also glorified the alliance of nature and man, "the first instrument of nature." Far from being mere anecdotal details or research into the "effect of reality," the scars

of the branches cut off the vertical trunks are (apart from being a possible reference to one of Ludovico the Moor's emblems, the trunk with severed branches) a painted reference to the architectural motif of the column *a tron-choni*—and thus to the very origins of the architecture of Vitruvius, which is taken up again by Alberti, Filarete and Francesco di Giorgio.[262] Indeed it may have been Leonardo who introduced this motif in Milan. It appears in some of his drawings, particularly on folio 357v-a of the *Codex Atlanticus* in which it is used as an angle motif for a decorative screen, and, significantly, combined with spiral columns, and motifs and studies of *intreccio* (interlacing) and knots (fig. 82).

The alliance between man and nature takes place at its highest level in the interlaced motif of the knotted rope. This seems to hold together the entire construction of the plant's bending, intertwined branches, and its presence reflects the alliance of the wonders of nature and human industry. Before being spun and woven with gold, the silk thread (to which this silken rope, intertwined with the mulberry tree, is a definite reference) is "miraculously" manufactured (until it is one and a half kilometers long) by the figure-eight (and thus knot-like) movement of the head of a silkworm making its cocoon.[263] But, to become a textile, this "marvelous invention" has to go through the double processes of sericulture and silk manufacturing. By imitating nature, man continues its work and, as Edgar Wind pointed out (referring to Leonardo in this connection), it is remarkable that Pico della Mirandola, in his defense of natural magic, likens the art of the magician who "marries heaven and earth" to that of the Virgilian farmer who "marries elms to the vine": "The sympathetic skill of 'applying to each single object the suitable and peculiar inducements' achieves its 'maturest' triumph in the art of planting and husbandry."[264]

With its many layers of meanings, the decoration of the Sala delle Asse summarises and articulates some of Leonardo's deepest convictions regarding the life of nature and the part humans may play in it. Not the least of his courtly elegances is to have placed this evocation of the alliance of the creations of nature and of human art under the patronage of Ludovico Sforza and Beatrice d'Este with their joint coats of arms.

The Courtly Arts

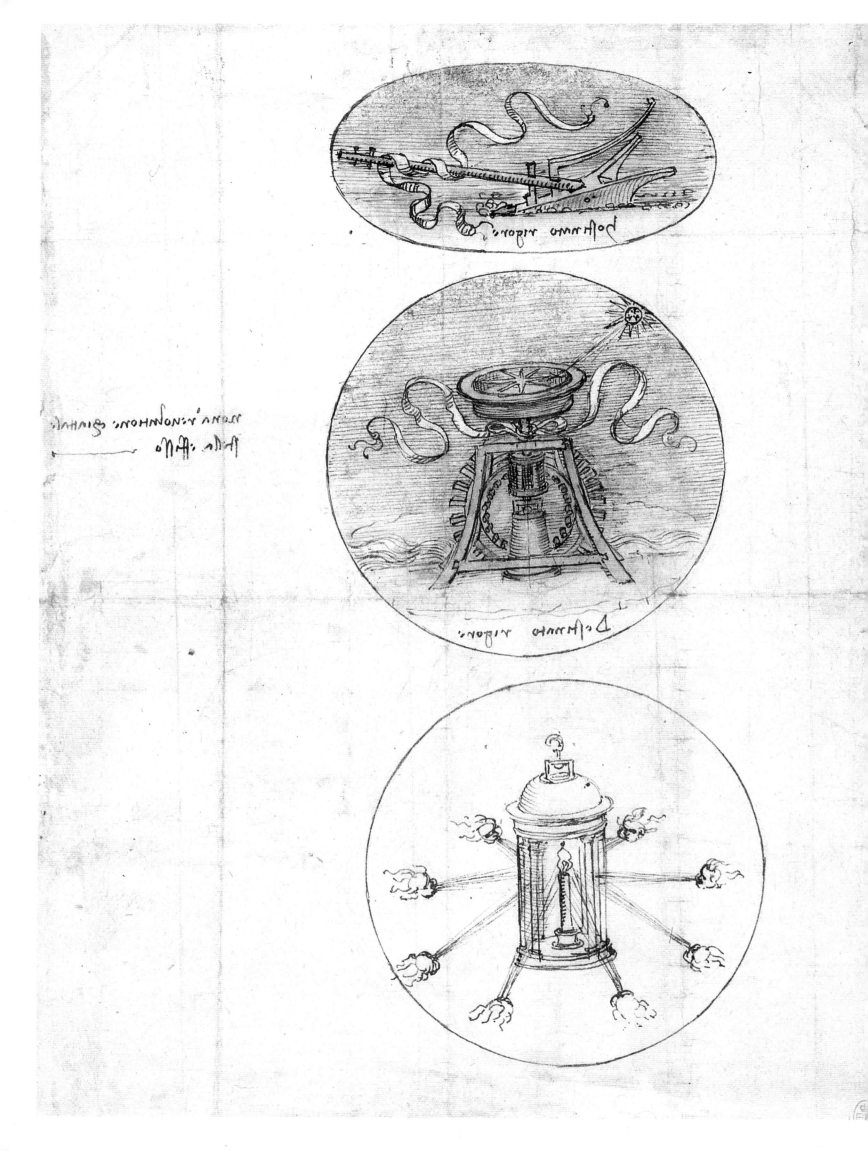

"Maestro Leonardo Fiorentino, in Milano"

Courtly Arts

Leonardo is profoundly Florentine. In spite of everything that distinguishes him from Alberti, Botticelli or Filippino Lippi, his artistic training and his intellectual approach to art make him, in the words of Martin Kemp, a "son of Florence." The short history of painting that he sketches out in about 1490 clearly shows this. To demonstrate that, after the long decline that followed Roman painting, it is necessary above all to imitate nature, "the mistress of the masters," he reduces this history to the two modern names of "Giotto Fiorentino" and "Tommaso Fiorentino, cognominato ('known as') Masaccio" (*Codex Atlanticus*, 141r-b). At roughly the same time, experimenting with a new pen, he writes his name as "Maestro Leonardo Fiorentino."[265] So, Leonardo was from Florence? But this proud statement is completed by the addition of "in Milano," which is worth examining more closely.

Leonardo arrives in Florence a little before 1470. He registers at the Guild of St Luke at the age of twenty and leaves the city when he is thirty. He only spends at most a total of twenty of the sixty-seven years of his life in Florence. It is the starting point of Leonardo's artistic career, but it is never a finishing point nor even an anchorage, as in the case of Michelangelo. He returns to Florence in 1500 (traveling first through Venice and Mantua), but that is because the French have expelled his princely protector from Milan. From then on, the rhythm of his life is determined by the search for a prince whose court might offer him a secure position. At the end of the summer of 1502, he goes to the Romagna with Cesare Borgia, son of Pope Alexander VI, who is expected to found a dynasty and a territory. The death of the pope puts an end to these expectations. Returning to the banks of the Arno in 1503, Leonardo leaves again in May 1506 to go and work in Milan for the French. Until July 1508 he goes back and forth between the two cities, finally settling down in Milan for a period of five years, working first for Charles d'Amboise, then Louis XII. In 1513, the French are permanently expelled from the Lombard capital. Leonardo goes back to Florence from October to December 1513, but he is actually on his way to the pontifical court in Rome where he finds a Medici pope and protector. But in 1516, after the Battle of Marignano, he accepts the invitation of the King of France (said possibly to be the future emperor) and hardly stops in Florence on his way to Amboise.

Page 146: Fig. 83. *Designs for plough, compass and lamp*, *c.* 1508–09, pen and ink, bister wash, and blue crayon, 10½ x 7¾ in. (26.9 x 19,5 cm.) Windsor Castle, Royal Library, RL 12701.

These moves between 1500 and 1516 in no way reflect psychological instability or dissatisfaction. From Vinci, Leonardo could only go to Florence. But after ten years in Florence, he had excellent professional reasons to leave the town of the Medicis for the court of the Duke of Milan. Surrounded by hills, Florence's horizon was much more restricted than what Europe's third city (after London and Paris) could offer him; and, most importantly, Milan was the seat of a prestigious court. The famous letter in which Leonardo proposes his services to Ludovico the Moor was particularly to the point because the Sforzas, in spite of their wealth, were not surrounded by an artistic milieu worthy of their political ambitions, and because Florentine artists had since the middle of the century played a decisive role in introducing the modern style of the Renaissance to Milan.[266] Nonetheless, by proposing his services to Ludovico in writing, without imposing any particular conditions, Leonardo is behaving in an unusual, almost humiliating, manner, since it was customary for the courts to invite artists or for them to be recommended by the prince in whose service they were.[267] According to Vasari, Leonardo was sent to the court in Milan by Lorenzo the Magnificent as an excellent musician, and overcoming all his rivals, he convinced the duke to keep him near him.[268] The reality was undoubtedly very different; when Leonardo arrived in Milan he started working with Ambrogio de Predis who had just been appointed court painter—while Bramante had been made court architect.[269] Leonardo's letter to Ludovico shows how much he wanted to leave Florence to go to Milan. Indeed, he had everything to gain.

First, he would have greater freedom. Florence had officially remained a republic; in general the work of artists was still subjected to the traditional rules of specific payment for each job, in several stages up to delivery of the finished work. By separating the various crafts, the authority of the guilds restricted the practice of "universal" talents. At court, on the other hand, a regular salary and the absence of guilds enabled artists to have very varied responsibilities while still having time for research and personal projects. Courts also had the reputation of being artistically more open-minded than the "bourgeois" cities: they encouraged innovation, originality, and "modernity" whose brilliance would be reflected on the prince, while the Florentine patrons (who had to avoid displays of excessive luxury) were more concerned with conformity between the appearance and the "content" of the work. Finally, at court the artist would be part of the entourage that was responsible for the glamour and embellishment of the prince's life: men of arms, hunting masters, writers,

musicians, singers, dance masters, jesters, dwarves, and so on. Accordingly the artists' prestige was greater at court than in the cities. The sovereignty of the artist and the elevation of painting and sculpture to the rank of a "liberal art," as well as the placing of painting and poetry on a same level, were themes that had been developed in the courts long before they entered the Neo-platonist milieu of the Accademia di Carreggi in Florence. While in 1442 the court humanist Lorenzo Valla believed that painting, architecture and sculpture were part of the liberal arts, Politian continued to see them as "mechanical arts." From this point of view, Florence and the Medicis (who officially could not have a court) were backward; when Lorenzo the Magnificent appointed Bartoldo di Giovanni his *familiaris* in 1480, he was following a practice which had been used in the courts in the fourteenth century—and it should not forgotten either that only the prince could ennoble his artists.[270]

The *Trattato di architettura* ("Treatise on architecture") written by Filarete between 1460 and 1464 reflects this awareness of the power and prestige enjoyed by the artist at court, which allows him to conceive grandiose urban projects like the ideal town of Sforzinda. It is even possible that Filarete has partly written his treatise to inform his compatriots of the status of the artist at court.[271] At all events, Leonardo at the court in Milan reacts in the same way as Filarete had before him. The device of the compass with its needle pointing at a sun with three fleurs de lys, and the motto "Who points to this star does not rotate" (fig 83) is conceived as the emblem of a court artist. It is drawn in about 1508–09, when Leonardo, now aged fifty-seven or fifty-eight, has settled in Milan again and is working for the French. This emblem undoubtedly expresses his satisfaction at having found, after nine years of uncertainty and travel, a royal court (Charles of Amboise rules in Milan in the name of Louis XII) that seems to guarantee the artist's employment for as long as it exists itself. Whatever its precise meaning (and even if the general motif has been specified by the patron), the allegory of the wolf and eagle (which again includes a compass) (fig. 84) has a similar context. The rays that emanate from the eagle (wearing the French crown and not the imperial one) guide the uncertain navigation of the wolf: in other words, only a strong power can guarantee safe arrival at port.[272]

When he returned to Florence in 1500, the city no longer had even a "disguised" prince, and, in addition, Leonardo was receiving very few commissions there. In 1502, he probably thought he had found his prince in the person of Cesare Borgia. In his contract appointing Leonardo as architect

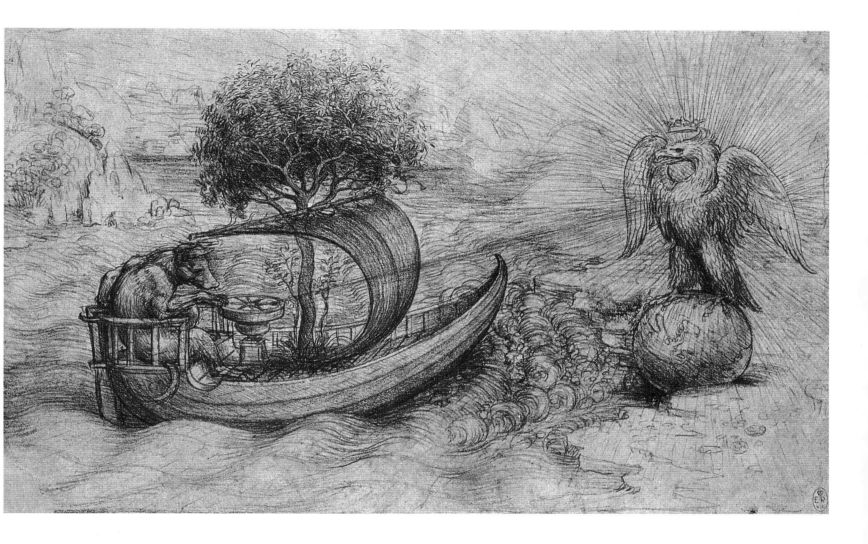

Fig. 84. *Allegory of the <u>wolf and the eagle</u>*,
c. 1510 (?), red chalk on gray-brown paper, 6¾ x 11 in. (17 x 28 cm.)
Windsor Castle, Royal Library, RL 12496.

and military engineer, Cesare Borgia calls him "prestantissimo et dilectissimo familiare" ("Most handsome and beloved friend"). But in 1503, Cesare Borgia's projects come to an abrupt end, and Leonardo only recovers his privileged status of court artist when he goes to work for the King of France. In 1507, Louis XII calls him "nostre chier et bien aimé Léonard da Vincy, nostre paintre et ingenieur ordinaire" ("our dear and good friend Leonardo da Vinci, our painter and engineer in ordinary"), guaranteeing him an annual salary, calculated to run from July to July. In 1519, the official document registering his funeral calls him "Lionard de Vincy, noble millanois, premier peinctre et ingenieur et architecte du Roy, meschanicien d'Estat, et anchien directeur de peincture du Duc de Milan"[273] ("Leonardo da Vinci, Milanese noble, first painter and engineer and architect to the King, mechanic of the State, and former director of painting for the Duke of Milan").

One can better understand some characteristic or "enigmatic" aspects of Leonardo's work, its universality and in particular its incompletion, by seeing them as the mark of a "courtly" practice of the arts. The letter he writes to Ludovico the Moor in 1482 is a perfect example: of the ten points he stresses, nine concern his skills as military engineer-architect, on land and on sea, for mortars and other machines, mobile bridges or the excavation of galleries in case of siege. The last point deals with "peacetime activities": in it Leonardo proclaims his abilities as architect, engineer (for canals and water-supply) and as the artist capable of glorifying the Prince through sculpture and painting.[274] Praised by Luca Pacioli as the "indefatigable inventor of new things," Leonardo owes much of his fame to his unrivaled talents as artist of the ephemeral, festivities and the theater, capable of designing costumes, scenery, and building machines. One of his inventions that was most famous in the sixteenth century was the mechanical lion that he created to honor both the king of France and the political alliance of the Medicis and France. Used for the royal entrances into Lyon and Florence in 1515, and again in Argenton in 1517, this lion (the *marzocco* symbol of Florence), "fabriqué avec admirable artifice" ("manufactured with admirable skill"), advanced in the direction of the king and, after a few steps, tore open its chest "pleine de lys et de diverses fleurs" ("full of lilies and all kinds of other flowers"). Now vanished, this automaton is mentioned by Vasari and Lomazzo, and in 1666 Félibien still speaks of it with great enthusiasm.[275]

Leonardo is a typical figure of the Renaissance courts, but his relationship with the court must not be trivialized. In fact, he exploits the freedom his status

gives him to develop his various fields of interest systematically. He even takes advantage of his position—so much so that Ludovico the Moor wants to replace him with someone else to complete the equestrian monument of Francesco Sforza. Even Baldassare Castiglione, a master *par excellence* of courtly good manners, regrets that he "should despise the art in which he is unique," namely painting, and that "he should have taken up philosophy in which he developed such strange concepts and curious fantasies that he could never depict them even with all his painting skills."[276] But this "philosophical" attitude is at the heart of his prestige, and Leonardo's various treatises (the first of which only date from 1485–90), in particular that on painting, owe their existence to it. Carlo Dionisotti has convincingly suggested that Leonardo's decision in 1490 to write his treatise on painting might have been connected with the traditional rivalry existing between writers and painters concerning their ability to praise the Prince in a lasting way.[277] This rivalry was further fanned by Ludovico the Moor who was disappointed and worried by Leonardo's inability to complete the equestrian monument of Francesco Sforza—a project that had been Leonardo's most powerful argument in persuading Ludovico to appoint him: "Furthermore, I shall undertake the production of the bronze horse that will be an immortal glory, an eternal homage to the blessed memory of the Lord your father and the illustrious house of the Sforza."

173

ARCHITECTURES

In his work on the history of architecture in the Renaissance, Leonardo Benevolo underlines the paradox that very quickly characterized the figure of Leonardo as architect: "Luca Pacioli, Antonio Billis and Vasari praise Leonardo as an 'excellent architect', but they make no reference to any work of the master, and the documents known until now indicate only three occasions where Leonardo was actually involved as architect: the model provided between 1487 and 1490 for the *tiburio* (lantern) of Milan cathedral, the notice given in 1490 about the construction of the cathedral of Pavia, and the works (unknown) carried out in 1506 for the French governor of Milan."[278] A reputation for excellence that is not supported by any concrete work: this paradox partly explains the hesitations of modern historians in determining Leonardo's place as an architect. According to Richard Schofield, Leonardo's sporadic interest in architecture would not have gone past the stage of general ideas, and he cannot really be accepted as an architect since, unlike his contemporaries Bramante, Giuliano da Sangallo or Amadeo among others, his name is never mentioned in the smallest contract connected with the construction of a building. Ludwig Heydenreich's opinion, on the other hand, is that Leonardo was interested in architecture throughout his life and, although he never built anything, his great experience and the vast knowledge that he had of the subject would have earned his deserved reputation. As for Carlo Pedretti, he devotes a large volume to *Leonardo architetto*. In his view, Leonardo was interested in architecture throughout his career and was actually involved in several rebuildings; his interest in architecture also revealed itself in his painting, his ornamental inventions and even in the drawings of allegories and emblems.[279]

The same uncertainty is found as to the position his drawings (and his texts) give Leonardo in the history of architecture. For some, the later years would mark a withdrawal by Leonardo from architectural matters and a decline in his inventiveness; others, Pedretti in particular, do not hesitate to speak of a grand finale. In any case, though all the specialists are in agreement in asserting Leonardo's enduring attachment to Tuscan forms—first and foremost the dome of Brunelleschi—some of his drawings show him in certain aspects as a forerunner of the Mannerist style of Giulio Romano in Mantua. But one might also feel that, far from being a master of the new architectural style which was

coming into existence in about 1500, Leonardo was on the margin of contemporary developments and that his style lacked homogeneity.[280]

The detailed study of external documents and of the notes and drawings contained in the manuscripts shows that, from the beginning of his career until his death, architecture regularly occupies Leonardo's mind. Suppose that for the moment one ignores his temporary architectural creations, such as the "pavilion of the duchess" at Vigevano, his designs for princely tents, his decorations for festivals, as well as his activities as a military engineer for Venice, Florence, Cesare Borgia and at Piombino. Even putting all these aside, the list of his own proposals and those actually planned at the request of a patron, consists of no fewer than fifteen entries, from the proposal of about 1480 for raising the Baptistery at Florence, to the designs for laying out the new city of Romorantin, on which he works until the eve of his death.[281] So it can no longer be said that he never had the responsibility for any building, or that he has showed only a sporadic interest in architecture.

In any case, it is by no means certain that none of his works has survived. It is possible that he had responsibility for buildings that still exist, where his involvement was more important than is usually thought.[282] Furthermore, recent restorations have thrown light on the role that he actually played in 1502 in the internal arrangement of the Rocca d'Imola (at the request of Cesare Borgia) and in the construction of the Medici stables in Florence in 1515–16.[283] In fact, Leonardo is consistently active in the field of architecture for the various princes who employed him: first, Ludovico the Moor from 1487 to 1489, Cesare Borgia from 1502 to 1503, Charles d'Amboise, governor of Milan, then Louis XII from 1506 to 1512, Lorenzo di Medici in Florence from 1515 to 1516, and finally François I from 1517 to 1519.

Even so the balance sheet remains thin. But one should also point out that, although the majority of his projects were neither completed nor even begun, this situation is not due to Leonardo's fickleness or the "utopian" character of his proposals. It arises sometimes from the inconsistency of his patrons: Manfredo Tafuri mentions "the incoherence of the cultural politics" of Ludovico Sforza.[284] Sometimes it is caused by the reversal of their political fortunes: the fall of Milan at the hands of the French interrupts the construction of the "Casa Guiscardi," which had been started some months earlier.[285] On yet other occasions it is simply the result of unforeseen events of history: the death of Lorenzo de Medici puts an end to the town planning and architectural project for the new Medici palace in Florence, and an epidemic of plague terminates François I's

projects for Romorantin and leads him instead to plan the construction of Chambord. Put another way, when his patron has the opportunity (and the time) to see a project through, Leonardo realizes it without delay (at Rocca d'Imola, for example, or the Medici stables in Florence). Also, when external circumstances bring about the cancellation of a project, the idea remains, ready to be reactivated when the moment comes.

It is nonetheless true that Leonardo is not an "architect" in the professional sense of the term. Unlike his colleagues Bramante and Giuliano da Sangallo, he does not specialize in this activity and, more than with Francesco di Giorgio or Michelangelo, architecture is only one of the activities which his "universality" leads him to engage in. Also his architectural drawings did not correspond to what one would expect from a professional architect. Even for the constructions where Leonardo is effectively involved, his drawings do not show architectural details (or they are mentioned separately elsewhere), and the projects are never presented as precise proposals on which the patron could give his advice, suggest changes or grant his final agreement. Folio 158r-a v-a of the *Codex Atlanticus* (fig. 88, 89) is an example of this point of view. The patron having used the top of the page to indicate what he wanted (number of rooms with their position and, sometimes, their dimensions), Leonardo develops the project on the same page. But these drawings do not go beyond the stage of sketches, and the notes (written from right to left and therefore intended for himself) tend towards becoming a short "theoretical treatise regarding domestic architecture."[286] It is revealing to compare these drawings, or those of folios 56r and 56v of *Manuscript I*, which date from the same period and which perhaps relate to the same commission, with for example Giuliano da Sangallo's project of 1513 for the Medici palace in the Piazza Navona in Rome (fig. 86), or the proposals of Antonio da Sangallo for the windows of the first floor of the Farnese Palace in Rome (fig. 87, about 1540–46). The very improvised character of Leonardo's architectural drawing is immediately noticeable, even if it concerns a project that is to be constructed by his patron.

Leonardo's approach to architecture is neither utopian nor idealistic. Even the idea of raising the Baptistery of Florence by placing it on steps and thus bringing it up to the same level as the entrance of the cathedral is no impractical fantasy: in 1455 the Bolognese architect Aristotile Fioravanti had moved the bell tower of the church of Santa Maria del Tempio in Bologna a distance of fifty feet (fifteen meters), and in 1458 Cosimo de Medici had asked him (in vain) that a bell tower in Florence be moved.[287] Fioravanti's technical feats

Opposite, top:
Fig. 86 and 87.
Giuliano da Sangallo,
*Plan for the Medici
palace, Piazza Navona.*
Florence, Uffizi, drawing
collection, A 7949 GFF.
Antonio da Sangallo,
*Design for the ground-
floor windows of the
Farnese palace in Rome.*
Florence, Uffizi, drawing
collection, A 1007r GFF.

Opposite, bottom:
Fig. 88 and 89.
Leonardo da Vinci, *Plans
for the Casa Guiscardi,
Codex Atlanticus,*
fol. 58r-a v-a. Milan,
Biblioteca Ambrosiana,

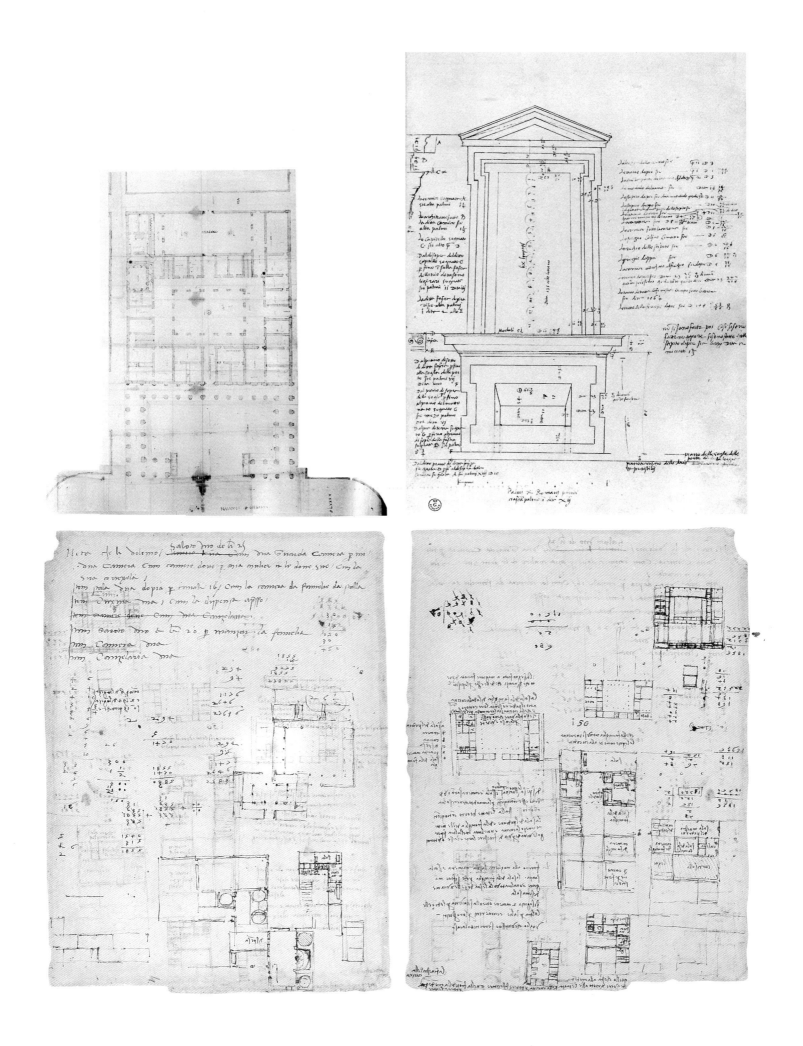

made him famous, and Leonardo's proposal in about 1480 may have seemed less unreasonable then than it seems to Vasari in the middle of the following century. Similarly, Leonardo's proposal to Sultan Bajazet II in 1503 to build a bridge across the Golden Horn consisting of a single arch with a span of nearly 800 feet (240 meters) was probably inspired by the bridge of Castel del Rio built by Andrea Furriera da Imola in 1499, which consisted of only one arch with a span of over 260 feet (80 meters).[288]

Fig. 90 and 91.
Plans for the development of Milan,
Codex Atlanticus,
fol. 73v-a and 73r-a.
Milan, Biblioteca Ambrosiana.

Leonardo's town planning projects are also very revealing. Unlike the ideal city of Sforzinda which Filarete pictured on the banks of the Indus, and unlike the projects for ideal cities conceived in the fifteenth and sixteenth centuries,[289] the thinking of Leonardo rests on a very functional concept of the urban organism, and it is assumed that his projects may possibly be carried out. The urban redevelopment, which was intended to accompany the building of the new Medici palace in Florence, is indeed more restrained than Cardinal Alessandro Farnese's project of the same period for linking his future palace in Rome to the Campo dei Fiori and, beyond that, to the Piazza Navona.[290] The project for urban expansion that Leonardo proposesd to Ludovico Sforza in about 1493 could not have been further from utopian. Following the urban policies that Ludovico wants to develop in Milan, it is what

today is called a regulatory plan, responding to practical considerations and based on a study of the pre-existing urban fabric, as is shown by the preliminary drawings and the summaries of which traces remain on some sheets of his notebooks (fig. 90). For an experimental sector of the area under consideration (between the Porta Tosa and the Porta Romana) (fig. 92), Leonardo plans a regular arrangement of buildings, streets and canals round a large square with a portico, intended for pedestrians. This sketch of a "pilot plan" is

Far left: Fig. 92.
Pilot project for the expansion of Milan,
Codex Atlanticus,
fol. 65v-b. Milan,
Biblioteca Ambrosiana.

Left: Fig. 93.
Development plan for a city with canals,
Ms. B, fol. 38r. Paris,
Institut de France.

accompanied by a long commentary legitimizing the plan with politico-economic reasons that Machiavelli would have agreed with: "All people obey their superiors and are ruled by them; and the great make an alliance with their rulers at the hands of whom they suffer two kinds of domination: through blood ties (*per sanguinita*) or through property (*per roba sanguinata*). That of blood is when their sons, like hostages, become a caution and a guarantee of their loyalty; the ties of property are when you build one or two houses for each person from which he can draw an income [...] The beauty of the city will enhance its reputation and there will be a good return for you both through revenues and from the eternal fame of its expansion [...] It will often happen that to have a more imposing residence, the outsider, owner of a dwelling in Milan, will go to live in his own house; to be in a position to

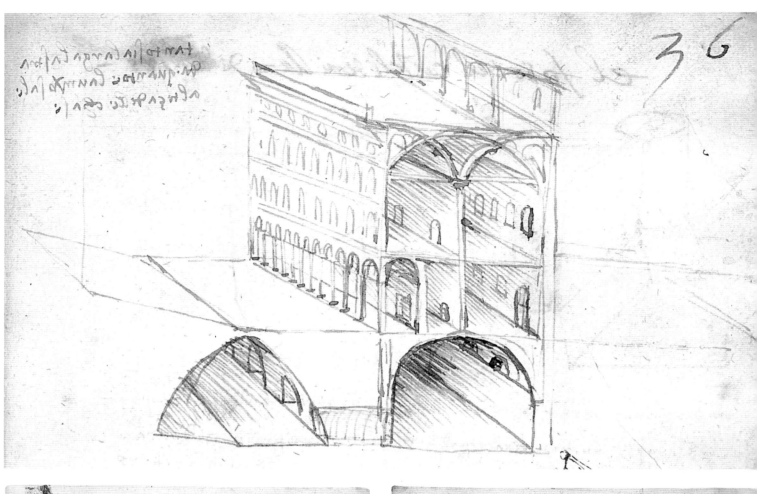

37

build, one must have a reserve of wealth, so that these inhabitants will find themselves separated from the poor [...] And even if he does not want to live in Milan, he will nonetheless remain loyal, so as not to lose the profits of his house with his capital" (*Codex Atlanticus*, 65v-b).[291]

It is towards 1487, following the plague that had struck down one-third of the population in 1484–85, that Leonardo designs his famous city on two levels. This may sometimes seem one of the least realistic urban fantasies (fig. 94, 95, 96). But for Leonardo this "new city" represents a radical reply to epidemics, which become catastrophes because of "such a considerable agglomeration of people, packed in like a herd of goats, on each other's backs, who fill every corner with their stench and sow pestilence and death" (*Codex Atlanticus*, 65 v-b). Thirty years later, Leonardo again takes up the idea of the canal sketches of 1487–89 (fig. 93) for the new (royal) city of Romorantin, and he insists once more on the circulation of the waters, which he arranges to control with sluices and to keep clean, so as to ensure the health of the city. This strictly functional logic does not prevent him from glorifying the monarchical order and "the setting of royal power."[292]

So, far from being utopian, Leonardo's urban projects are, in the same way as many of the military architectural drawings, "potential projects," or "experimental proposals."[293] They are "ideas for projects" and, since their actual realization depends on the constancy of the possible patron, each provides the opportunity for a precise theoretical reflection about architecture and urbanism. This "method" is quite similar to the one that animates Leonardo's "mental experiments" in the scientific field, and it enables us therefore to understand what his concept of architecture might have been, even though few actual traces of his activity as an architect survive.

Since the early 1480s, the completion of Milan cathedral had been hindered by a delicate problem. How could a *tiburio* (lantern) consisting of an octagonal cupola, enclosed in a tower of the same plan and surmounted by a central spire, be erected on the crossing of the transept, over 160 feet (50 metres) from the ground, given that the pointed arches joining the four pillars of the base were not solid enough? After the death of the architect who had conceived the project, those responsible for the Fabbrica (the "building committee") asked for opinions from many people, including Francesco di Giorgio, Bramante and Leonardo. The twenty sketches and the two large cross sections drawn by Leonardo develop, as Jean Guillaume put it, "all kinds of ideas, each one more extraordinary than the last" (fig. 85, 97, 98), but it remains impossible

Opposite page, top:
Fig. 94. *City on two levels*, Ms. B, fol. 36r. Paris, Institut de France.

Below left: Fig. 95. *City on two levels*, Ms. B, fol. 3r. Paris, Institut de France.

Below right: Fig. 96. *City on two levels*, Ms. B, fol. 3v. Paris, Institut de France.

to "identify a 'final design'." In fact, without attempting to reply to the real concerns of the Fabbrica, Leonardo embarked on a "twin research into 'weights' and 'forces' […] and the structure of domes." None of this was used and the joint scheme of Amadeo, Dolcebono and Francesco di Giorgio was adopted; this was carried out between 1490 and 1500.[294]

By chance, folio 270r-c of the *Codex Atlanticus* contains a draft of the letter that Leonardo writes to the Fabbrica between 1487 and 1490. This is the first surviving trace of Leonardo's architectural thinking. In typical style, having openly declared that the problem of the *tiburio* demands a preliminary methodical, scientific study, he embarks on a discussion, which, carried to its conclusion, would have become an actual treatise on the principles of construction.[295] Starting from the comparison (current at the time) between architect and doctor, he takes up again the ancient idea of analogy between the proportions of the human body and those of buildings (founded on the general analogy of macrocosm and microcosm). But he changes the field of application of this analogy: if the architectural edifice and the human body are analogous, this applies only to the functional organisms whose "health" depends on a good

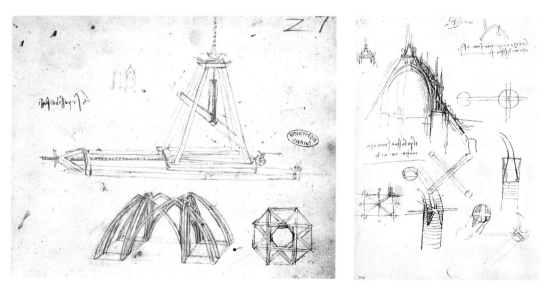

Right: Fig. 97.
Design for the lantern,
Ms. B, fol. 27r. Paris,
Institut de France.

Far right: Fig. 98.
Design for the lantern,
Codex Trivulzianus,
fol. 22v. Milan, Biblioteca
del Castello Sforzesco.

balance between their components. Leonardo then very logically puts the emphasis on the mechanical science needed for understanding the laws that rules the healthy operation of the two.[296]

This approach is present in all his architectural and urban thought. His "potential projects" concerning urbanism are examples. In Leonardo's city, the

analogy between microcosm and macrocosm leads to a new (and modern) concept of the city where the infrastructure had to guarantee "ideal" circulation and health within the urban organism.[297] The fundamental importance of circulation in his architectural thought begins at the level of the isolated building, with the particular attention he brings to the theme of the staircase. "A *dynamic* factor of western architecture insofar as it must control the movement between the floors," the staircase encourages one "to consider the architectural organism as a block of space punctuated by passages and provided with connections."[298] Leonardo supports his theme with remarkable invention and originality. The many drawings devoted to this "organ" of the building (fig. 99, 100) show his concern to provide separate means of circulation, for security reasons in the case of military architecture. A sheet from Windsor (fig. 101) that presents several sketches of staircases next to a diagram of the circulation of the blood in the human body explicitly illustrates the functional approach of Leonardo's analogy of architecture and the human body.[299]

But beyond this, Leonardo is most of all interested, as he is in the scientific field, in the analogy of the laws that rule nature and architecture. Respecting and exploiting "Necessity" (that is to say, the laws of the four "powers" of nature: weight, movement, force and percussion), architecture operates like a "machine": it is a game of forces in balance. The solidity of the building, its "health," stems from the capacity of its members to resist forces and transmit them, so that the whole ensemble becomes a game of thrust and counter-thrust. In this way Leonardo comes to imagine forms that are destined to have a good future, albeit much later, such as the inverted arch whose principle he sketches (fig. 102). He believes that it "would be better for support than the usual one because the inverted arch has beneath it the wall that supports its weakness, and the ordinary arch only has the air under its weakest part." This idea of the building as a balance of forces expresses itself with particular clarity in the way Leonardo defines the arch. Alberti saw it as a "folded girder," "a curved line of which we will only say that it is part of a circle." But for Leonardo it is "nothing other than a force caused by two weaknesses, because the arch […] is composed of two quarters of a circle, which, each being very weak in itself, want to fall down and, in each preventing the collapse of the other, these two weaknesses are converted into a single force."[300]

This context explains Leonardo's "potential projects" for military architecture. Unlike Francesco di Giorgio, apparently he hardly ever had the opportunity of turning his proposals into actuality,[301] but he made good use of his

Page 166: Fig. 99.
Drawings of staircases,
Ms. B, fol. 47r. Paris,
Institut de France.

Page 167: Fig. 100.
Drawings of staircases,
Ms. B, fol. 69r.
Paris, Institut de France.

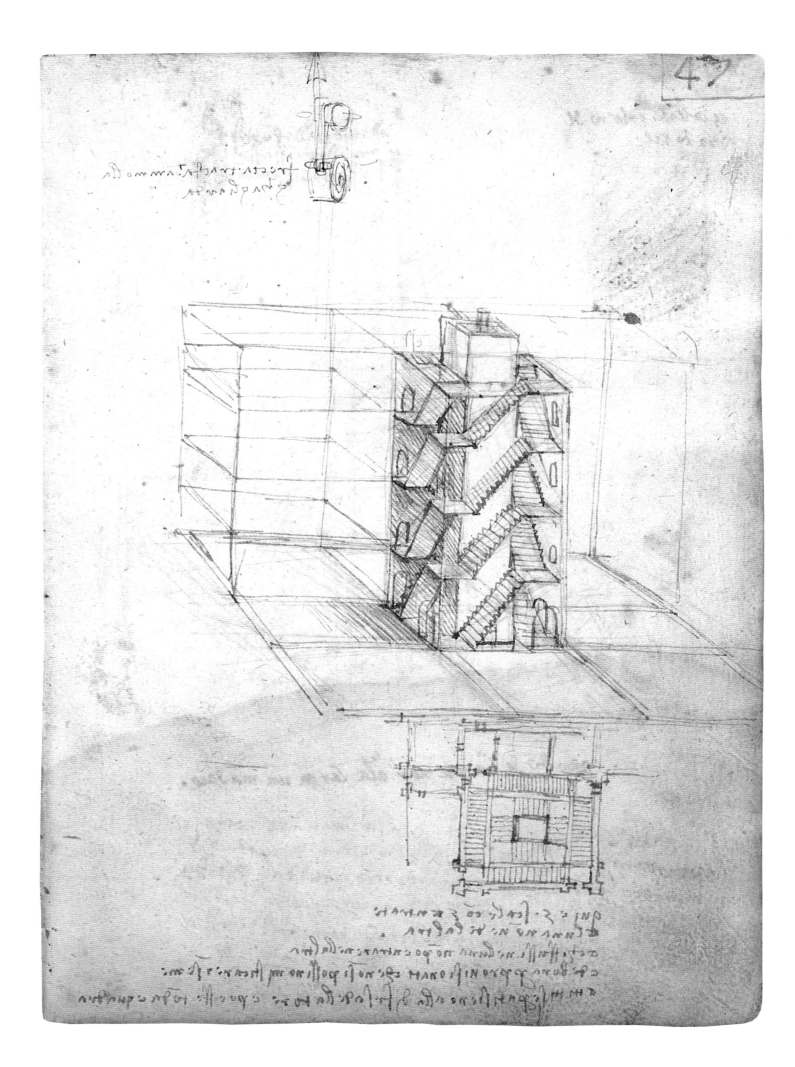

47

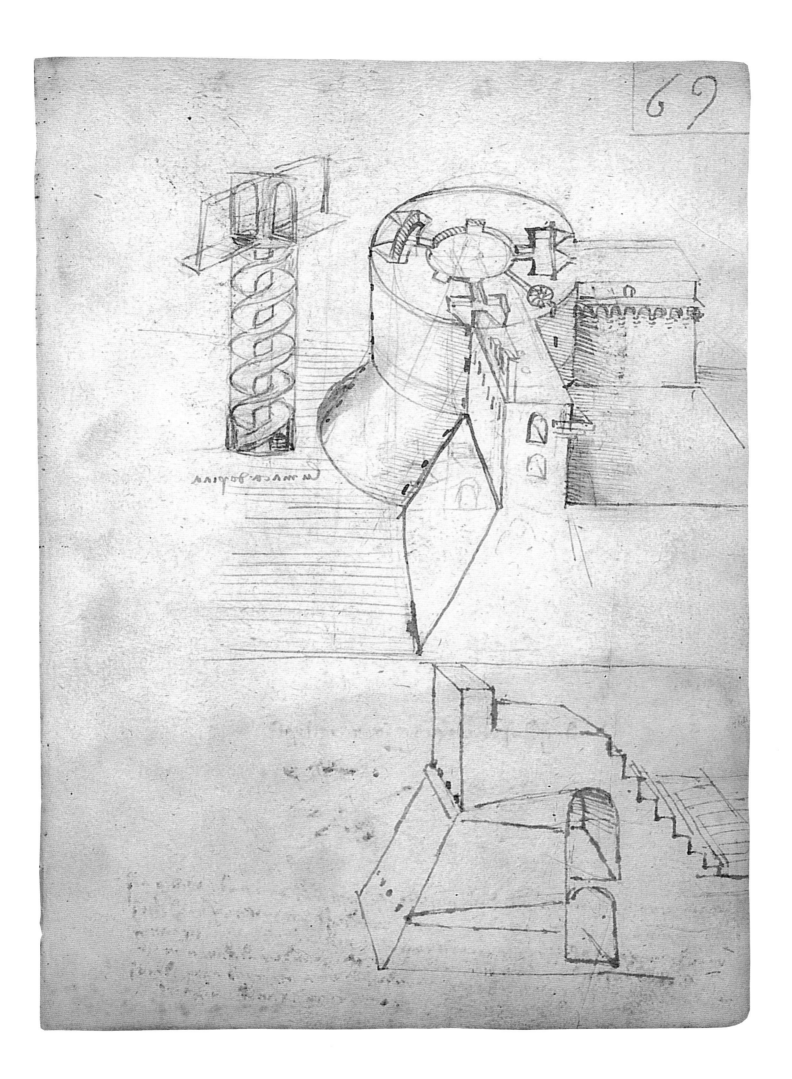

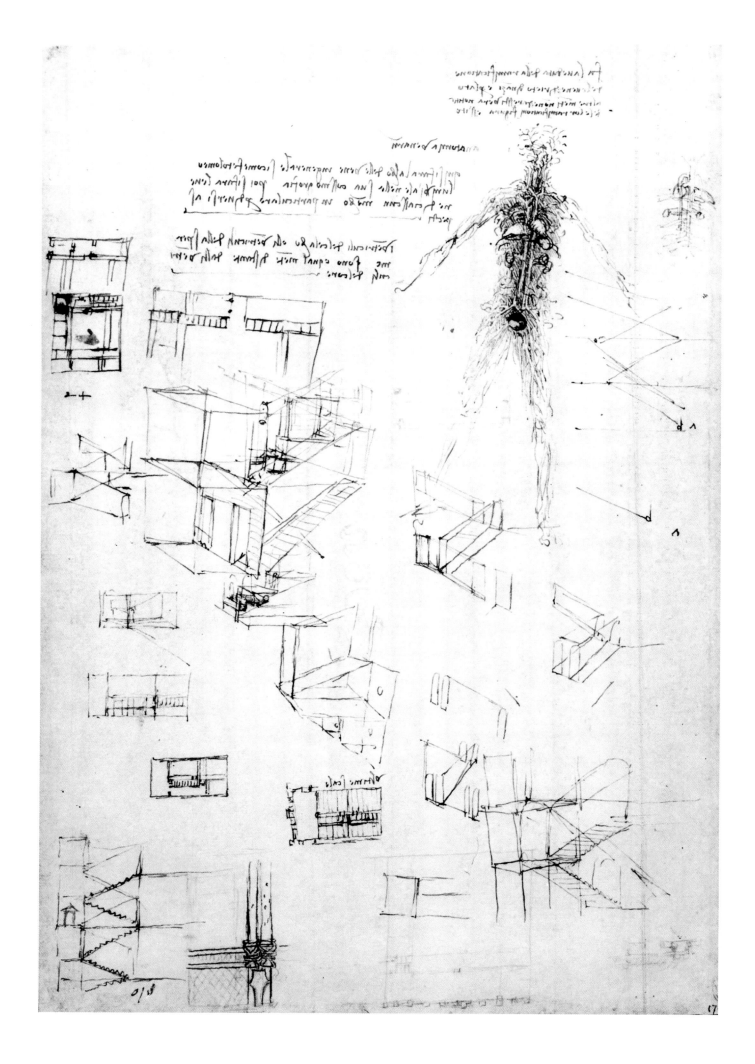

employment as a military engineer (in Venice and Florence, and by Cesare Borgia in the Romagna and Jacopo IV Appiani at Piombino) to develop his own thoughts on military architecture. With the development of the power of artillery, a decisive change occurs that will transform the fortified town from an exclusively defensive (and vertical) system into a "defensive-offensive"

Fig. 102. Inverted arch, *Codex Trivulzianus*, fol. 8r. Milan, Biblioteca del Castello Sforzesco.

arrangement that is predominantly horizontal.[302] Leonardo is evidently no stranger to this transformation: from 1485 to 1518, almost six hundred studies and sketches as well as numerous notes confirms his continuing interest in the problems of fortifications, which he studies while using his knowledge of statics, optics, ballistics and percussion. Folio 767r of the *Codex Atlanticus* (fig. 103) shows, for example, a rather implausible rectilinear defensive curtain; but it also demonstrates the defensive-offensive efficiency of a system using multi-directional loopholes and cannons set deeply within the wall. The drawing creates a dynamic visual effect that is reminiscent of the drawings of optics and is no doubt inspired by them.

Two studies created in about 1502–03 particularly deserve attention. The first is very well-known; it shows a circular fortress with concentric perimeters (fig. 104, 105). This has been seen by some as a radical innovation, truly a work of genius and the ancestor of the modern blockhouse. The detail of the "dolphin's back" roofing drawn in the center of the page actually seems to imply the use of a material similar to reinforced concrete. But Leonardo's idea

Opposite page: Fig. 101. *Staircase drawings and network of veins*, n.d., pen and ink with touches of sepia and red chalk, 11½ x 7¾ in. (29.2 x 19.7 cm.) Windsor Castle, Royal Library, RL 12592r.

169

is not so revolutionary as it appears. Not only is it not true that such a structure could not have built at that time,[303] but the circular form, adapted to passive defense, had a long tradition. The originality of this drawing actually depends on the radical fact that Leonardo adopts here the horizontal approach, the single central tower being enough to monitor the whole building. In this he follows all the logical conclusions of his ballistic studies on the rebounding of projectiles, by rounding his structures vertically as well as horizontally. He

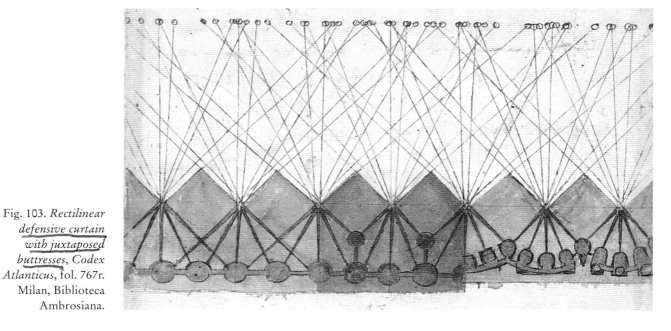

Fig. 103. *Rectilinear defensive curtain with juxtaposed buttresses*, Codex Atlanticus, fol. 767r. Milan, Biblioteca Ambrosiana.

thus arrives at a building whose actual strategic use is uncertain but which forms the most effective reply to the new power of the artillery and to the reciprocal interplay or balance of forces that this implies.

Folios 134r and 135r of the *Codex Atlanticus* (fig. 106) are on their face less striking, but they had more to offer at the time. By reducing the number of buttresses, by blunting the angles where they join and by resorting to the system of multi-directional loopholes, Leonardo achieves perfection in active defense, far beyond that which is proposed at the same time by Giuliano da Sangallo.[304] While the form of the building is entirely adapted to its function, it is also, poetically, that of a "'machine' of war," a veritable "nucleus of energy" inserting itself "into the surrounding space like a generating force, propagator of 'rays' infused with a 'spiritual virtue' and movement."[305]

This concept of a building as a balance of actions and reactions leads to an

Fig. 104 and 105. *Circular fortress, Codex Atlanticus,* fol. 133r (top) and 132r (bottom). Milan, Biblioteca Ambrosiana.

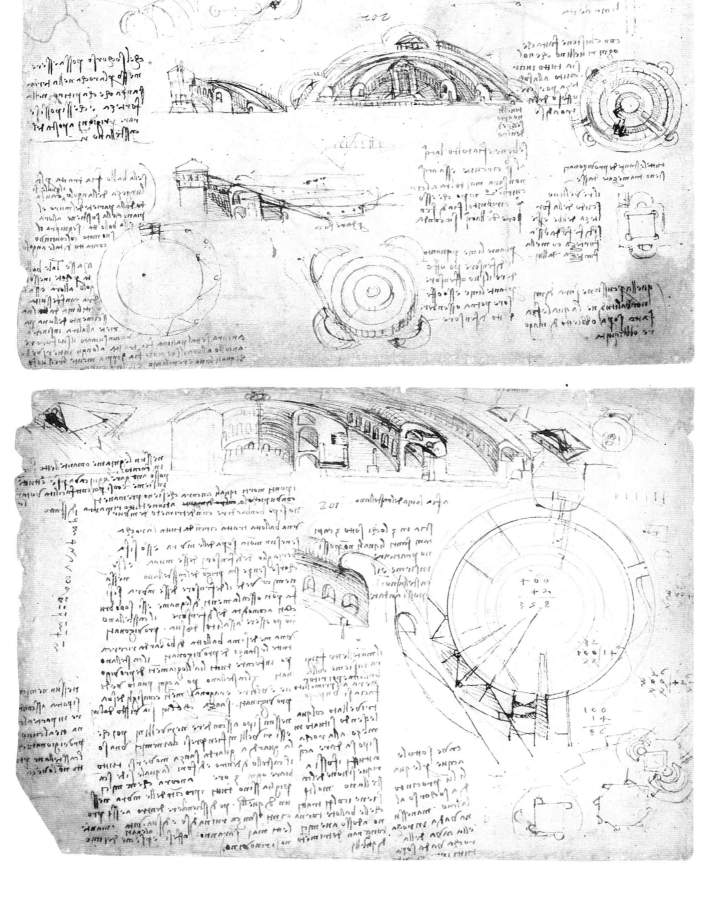

original approach to the question of architectural forms and their articulation. For someone concerned with the functionality of buildings as Leonardo was, the formal debate on contemporary architectural culture could only be arbitrary and abstract. Leonardo engaged in "architectonic thinking" about architecture;[306] in fact he aimed at (and developed in detail) "a kind of 'philosophy' of monumental art" in which he would work to "define *a priori* all possible types of architecture and [to] deduce the properties of each."[307] He therefore

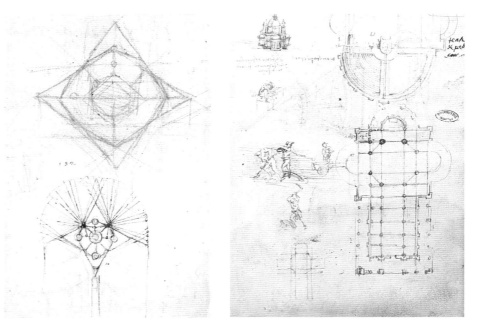

Right: Fig. 106. *Studies for a fortress*, Codex Atlanticus, fol. 135r. Milan, Biblioteca Ambrosiana

Far right: Fig. 107. *Theater for preaching or hearing the Mass*, Ms. B, fol. 52r. Paris, Institut de France.

rejects every preconceived idea, whether geometrical, intellectual or cultural, and, in the field of religious architecture, all transcendent feelings. The "theaters" that Leonardo designs "for preaching" or "for hearing the Mass" (fig. 107) were never built at the time. By turning the faithful into an actual "audience" accommodated on circular tiers surrounding the pulpit or the altar, Leonardo undoubtedly ensures perfect visibility, but at the same time he removes from the preacher or the officiator any possibility of surrounding himself with mystery—or of enjoying the prestige of a privileged, hierarchical position.[308] The churches with a central plan of which Leonardo creates many variations are hardly at all concerned with liturgical needs (fig. 109, 110, 111). Such a conflict between the form and function of the building is somewhat surprising in Leonardo. But it is also the case that, from Brunelleschi through Alberti, Michelozzo and Filarete to Giuliano da Sangallo, the church with a central

plan is at the heart of the architectural thought of the humanist Renaissance: while allowing a unitary organization of space, it provides a symbolic image of divine perfection.[309]

It is not however in this spirit that Leonardo approaches the question: this contemporary theme allows him to develop systematically his thinking on the formal articulation of the circle, the square and the octagon. It is significant that apart from a belated near-exception (fig. 113), he did not concern himself with the facades of his churches: even when they have a nave, he draws from the direction of the polygonal apse. By their very diversity, the alternative arrangements that he proposes for these churches[310] show that it is above all the principle of combination that inspires the drawings of Leonardo.

This same architectonic approach explains the almost complete absence of any studies of the details of architectural vocabulary (columns, capitals, frames, cornices, moldings, and so on). It is the syntax, the logical linking and the reciprocal organization of the parts of the building, that interest Leonardo—as the late sketch of folio 310v-a of *Codex Atlanticus* (fig. 108) brilliantly shows, where he fits together the volumes of the cube, the cross and the cupola. This indifference to what was to become the "system of orders" (Doric, Ionic, Corinthian, Composite, Colossal/minor) is remarkable for the time, and it might even be thought that he did not understand the internal logic.[311] But the fact is that he approaches this question without "cultural" prejudice. For example, against all the rules of classicism, he does not hesitate to interrupt an entablature with an arch (*Codex Atlanticus*, 136v-b); and, towards 1515–16, in one of his most detailed drawings (fig. 114), he conceives the motif of pediments fitted within one another, which is destined to be very successful in Mannerist and Baroque architecture in the future. In a general manner, the detailed use of the "vocabulary" is determined by the global unity of the architectural organism, conceived as "a spatial hierarchical system and in continuous 'expansion' where very different parts fit in a unitary ensemble."[312] The model made from the sketches of folio 5v of *Ms. Ashburnham* 2037 (fig. 110, 111) shows, for example, that the (circular) exterior of the building rested on an alternation of niches and apses, itself given rhythm by engaged columns. Inside, the reconstruction of the building has further revealed that Leonardo used the motif of pairs of opposed columns supporting an arch to connect the peripheral spaces and the main space, plastically and visually.[313]

Thus one touches on a characteristic trait of the architecture drawn by

Page 174: Fig. 108. *Studies of ancient arenas and volumetric scheme for a church with central plan, Codex Atlanticus,* fol. 310v-a. Milan, Biblioteca Ambrosiana.

Page 175: Fig. 109. *Studies of churches with central plan, Ms. B,* fol. 17v. Paris, Institut de France.

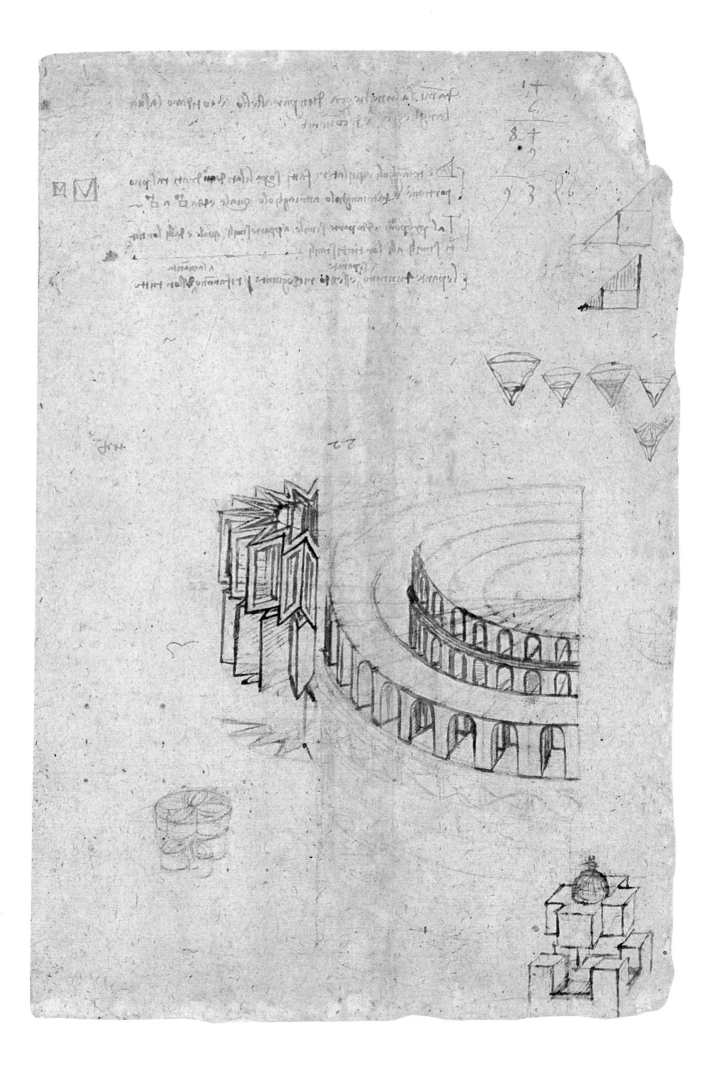

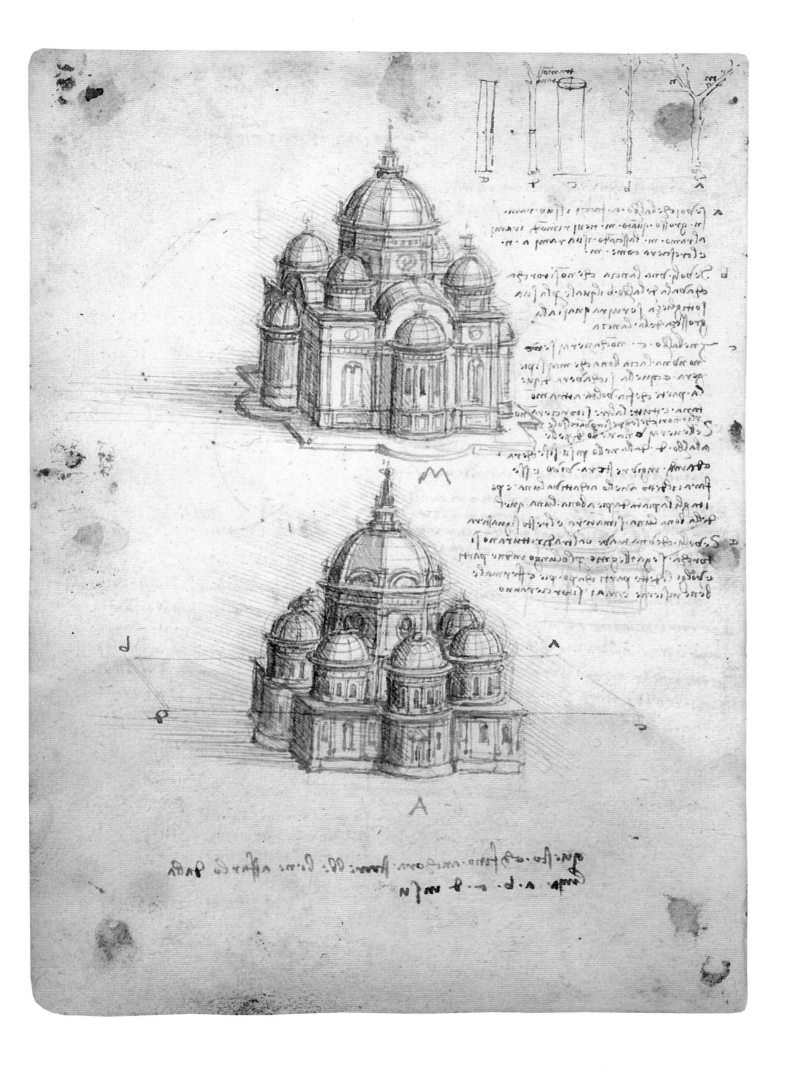

Leonardo (in which the architectural expression of his metamorphic rhythmical vision of the world is easily recognized): the dynamic co-penetration of forms. This is apparent in the drawing of the door with pediments set inside each other, it is visually suggested by the use of the inverted arch (fig. 102), and it exists rhetorically in the windows of the Medici palace planned in Florence in about 1515, where the columns *a tronchoni* (trunk-like) give birth to new branches and serve as a framework while symbolizing the revival of

Right: Fig. 110.
*View and plan of a
central plan church with
eight radiating chapels,*
Ms. Ashburnham, fol. 5v.
Florence, Biblioteca
Medicea Laurenziana.

Far right: Fig. 111.
*Cruciform churches, and
two with radiating plan,*
Ms. Ashburnam, fol. 3v.
Florence, Biblioteca
Medicea Laurenziana.

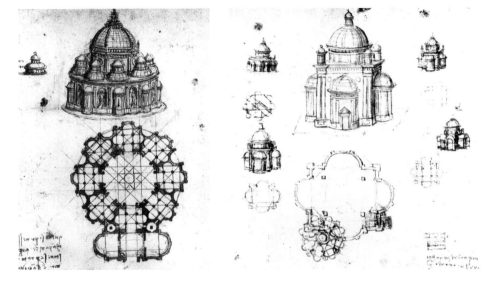

the Medicis.[314] It appears again in the drawing in which Leonardo is inspired by Bramante's Palazzo Caprini in Rome. On different parts of a projecting balcony, he arranges columns backed onto a wall that is sharply set back from the balcony itself (fig. 112); by doing this he accentuates the plasticity and relief of the facade and reduces the sharpness of the corner, ensuring a more continuous transition, formed of light and shade, to the surrounding space and atmosphere.[315] This research into the co-penetration of forms also explains Leonardo's predilection for the octagon, his "favored figure" for the composition of buildings.[316] Intermediate between the square and the circle, it makes possible the transition from one to the other; it is thus well adapted to serve, for example, as the support for a dome and for the arrangement of side chapels. The octagon can be repeated and give rise to multiple variations. As a "symbolic form" combining "two mother-figures of the natural order, the circle and the square, or equally well, by development, the sphere and the cube," the octagon also constitutes an "epistemological model" whose resources

Fig. 112. *Variations on the
Palazzo Caprini, facade of the palace-villa,*
cover of the *Codex On the flight of birds.*
Turin, Biblioteca Reale.

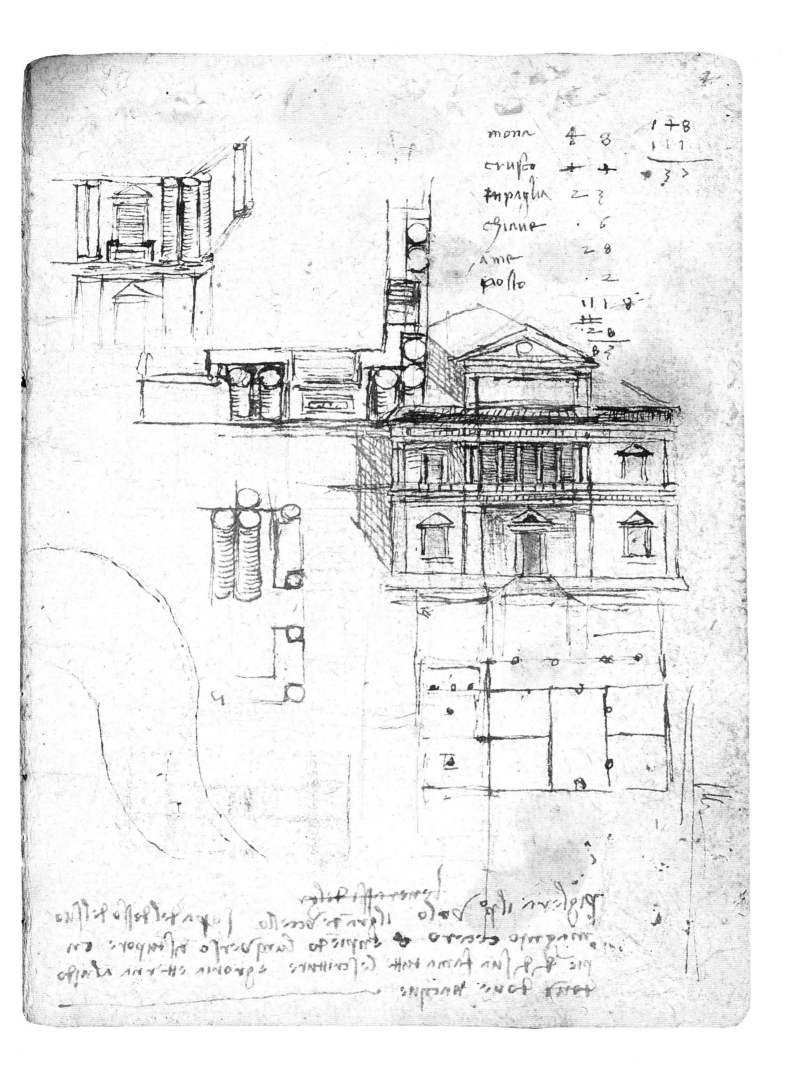

Leonardo experiments through drawing. These drawings may be architectural or mechanical, thus confirming his concept of architecture as a "machine."

So altogether, the art of building, *edificare*, is indeed for Leonardo a *cosa mentale* or mental thing.[317] But he does not conceive this activity of the spirit as a theoretical reflection on ideal, abstract buildings, in which the fixed order and immutable proportions of the cosmos would be reflected. In the image of nature, the building is an organism infused with forces created by "Necessity,"

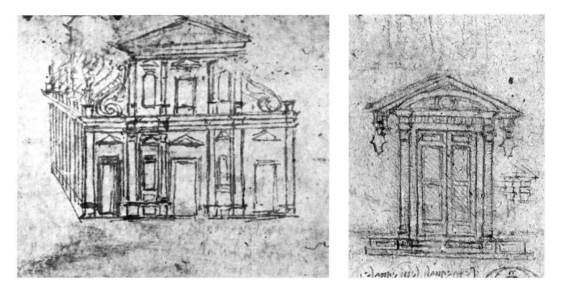

Right: Fig. 113. *Facade of church with nave*, pen and ink, 8½ x 6 in. (21.3 x 15.2 cm.) Venice, Galleria dell'Accademia, inv. 238v.

Far right: Fig. 114. *Door with pediments fitted within one another*, Codex Atlanticus, fol. 279v-a. Milan, Biblioteca Ambrosiana.

and it has to offer its users a rhythmical space, to move through and live in. From there came this idea of the city, the church and the palace "inserting themselves into the rhythm of nature, while following and experimenting with its laws."[318] From there too comes this concept of "open" architecture, where the wall must be more than a mere encloser of spaces, and this is achieved by doorways and loggias. From the villa (which Leonardo plans mentally for Charles d'Amboise and Francesco Melzi), this thinking leads to the French royal châteaux—and this appears to be the only trace of "influence" that Leonardo had on French architects.[319]

All this leads to Chambord and its staircase (fig. 115). For obvious chronological reasons, its construction cannot have been due to Leonardo, but all the same it is undoubtedly inspired by the ideas of the Master. In the center of a building whose plan had not previously been known in France, Leonardo thinks of drawing a monumental spiral staircase; its double revolution (derived from the staircases of dungeons, which he had thought about some years

earlier) takes the form of a vertically intertwined double spiral whose circle would be inscribed within the ideal octagon of the pillars. The staircase at Chambord gives posthumous architectural form to a dynamic configuration, which, as has been seen, had great significance in Leonardo's eyes.

But Chambord remains a unique chateau—just as the "potential projects" of Leonardo will remain on the margin of the architectural history of his time. Even in Italy, his researches are alien to the concerns of the Roman "grand

Fig. 115. Staircase of the Château de Chambord.

manner," of which Bramante was the main exponent. In France local traditions will be more receptive but, in the studies that he makes for the château of Romorantin (fig. 116), he attempts a synthesis between the Italianized châteaux of France and the palaces of Italy, and his proposals are less original than some contemporary French creations, Chenonceaux or Bury for example.[320] No doubt his sudden death and the conditions under which he has been employed by the King served to limit the impact of his presence in the limited sphere of royal architects (who maintained the idea of loggias on the exterior). But, more profoundly than these circumstances, the marginality of Leonardo as architect stems from the very originality of his approach to architecture: an architect engineer, marked throughout his life by the mechanical prowess and the organic image of Brunelleschi's dome, he does not share the cultural interests that inspire the "humanist" architects. Compared with Bramante, he is a theoretician of architecture, but the solutions which he imagines are inevitably (brilliantly) unconventional—that is to say, they are not

"classical," being simultaneously Gothic in some respects and already Mannerist in others.

This very singular position is confirmed by his almost complete lack of response to the Roman architecture of antiquity. His numerous drawings contain nothing related to Roman monuments and show no interest in aspects that are a major source of inspiration for his contemporaries: bosses, vast pillars and gigantic vaults. On the other hand, when he learns on a journey to

Fig. 116. *Idealized view of the Château de Romorantin*, 1508–09 or 1517–19, black chalk, 9¾ x 7 in. (24.5 x 18 cm.) Windsor Castle, Royal Library, RL 12292v.

Florence in 1507 that an Etruscan mausoleum has been discovered near Castellina in Chianti, he goes there and, having no doubt made a plan of this archeological discovery, he "restores" the vanished mausoleum, on a sheet as detailed as it is imaginative (fig. 117). The poetry attached to the original civilization, which had disappeared, evidently attracts him more than the grammar and syntax of the revered architecture of official antiquity.

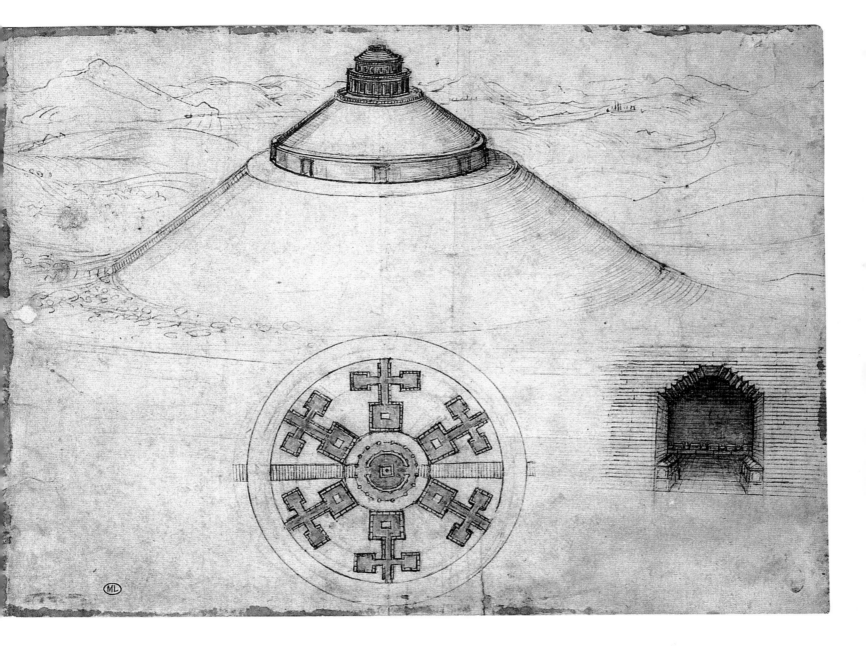

Fig. 117. *Etruscan mausoleum*,
pen and brown ink, brown wash and black chalk, 7¾ x 10½ in. (19.5 x 26.8 cm.)
Musée du Louvre, department of graphic arts, inv. 2386.

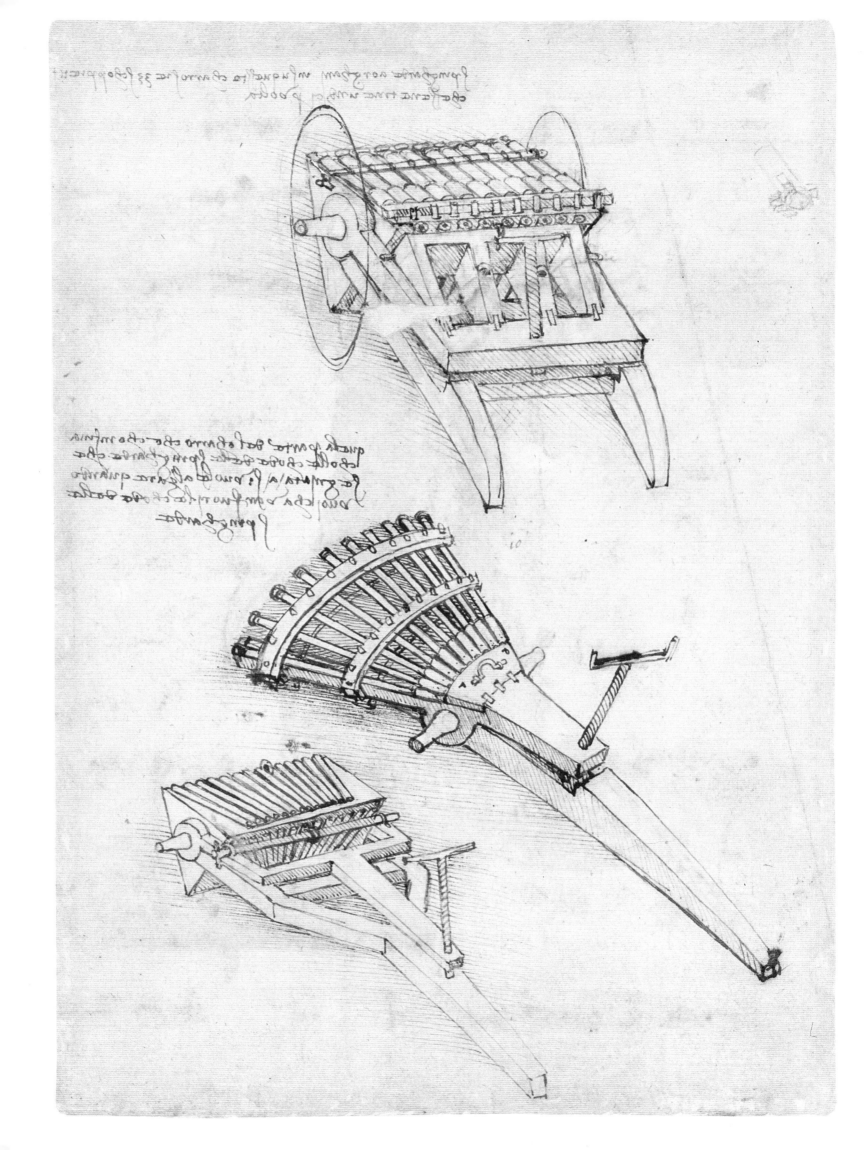

THE ART OF MACHINES

Today Leonardo's fame owes much to his activity as an engineer and to his famous machines. According to Bern Dibner, who does not hesitate to make him a "prophet" in the matter, the universality of his genius is marked in this field in an even more decisive way than elsewhere: not only do several of his inventions hold a place as important in the history of technology as the *Mona Lisa* enjoys in the history of painting, but he deserves the title of "the greatest engineer of all time" because, in several fields, his notebooks announce technological advances that will only be realized in the following centuries. This inventiveness is even more extraordinary because contemporary technical means are relatively rudimentary: the only available sources of energy, apart from water and wind (and to a small extent, heat) are muscular (human or animal), while the instruments known for the transmission of movement are limited to the winch, the wheel, the pulley, the cam, the ratchet, the screw, the crank and the connecting rod. Leonardo also reveals himself as a true visionary capable of imagining the ancestor of the airplane and the submarine, as well as the mortar (fig. 121), shells with fins (fig. 120) and the steam cannon (fig. 119).[321]

This is an impressive picture, and the models made today from his drawings seem to confirm it. But a closer study of the documents and the historical and social context of the engineering profession shows that it should be slightly moderated.

Reflections on engineering and the making of machines retain Leonardo's attention continually, and technology has a just claim to being one of his major interests. For example, more than three-quarters of the Madrid manuscripts are devoted to what would later be called arts and technology. Compared to what has been gathered from the architectural drawings, the pages that Leonardo devotes to technical researches contain, as well as rough sketches, completed projects, made from very sophisticated finished drawings, often accompanied by descriptive texts and detailed commentaries. In itself, this practice is exceptional at the time both in its continuity and for the fact that Leonardo studies an extremely large number of problems and different mechanisms. The mass of six thousand sheets of technical drawings (one-third of the documents bequeathed to Francesco Melzi in 1519) thus makes up the most enormous documentation, the most detailed and the most revealing archive on the tech-

Page 182: Fig. 118. *Machine gun, Codex Atlanticus,* fol. 56v. Milan, Biblioteca Ambrosiana.

nology of the Renaissance.[322] This abundance and diversity are reflected in the traditional classification of the technical fields in which Leonardo is interested. Without taking into consideration cartography at this point (although this was directly connected to his activities as a civil and military engineer), one can in general identify four very unequal areas of importance: weapons and machines of war, hydraulic machines, flying machinery, and general mechanics. But one can also group together a certain number of machines and mechanisms in the

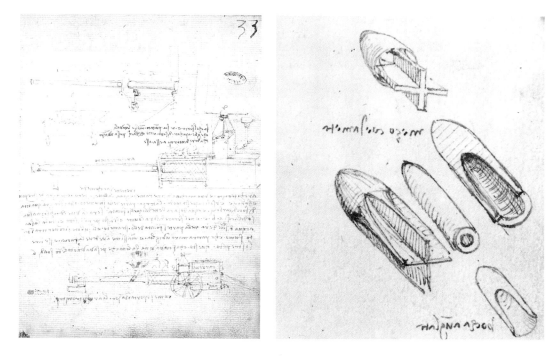

Far left: Fig. 119.
Steam cannon, Ms B,
fol. 33r. Paris, Institut
de France.

Left: Fig. 120.
Shells with fins,
Codex Arundel, fol. 54r.
London, The British
Library.

category "machines for entertainment and spectacles." As well as the automated lion already described, there is the moving scenery for Politian's *Favola d'Orfeo* (1490, *Codex Arundel*, 224r and 231v), the automobile (fig. 122), a certain number of musical instruments, and so on. In fact the variety of Leonardo's technical inventions escapes the boundaries of any rigid nomenclature. The systematic subject index of his mechanisms and machines amounts to no fewer than 138 entries, the majority of which consists of multiple references; and one of them, with thirty-two references, carries a title which shows how perplexed the specialists are: "Mechanisms of undefined function."[323]

Undoubtedly, technical inventiveness is one of the strongest, most creative aspects of Leonardo's "genius." In terms of the period, it fully embodies the prestigious image of the engineer-magician: as magician, the "engineer" bends

Pages 186–87: Fig. 121.
Mortar with explosive cannonballs, *Codex Atlanticus*, fol. 9v-a.
Milan, Biblioteca
Ambrosiana.

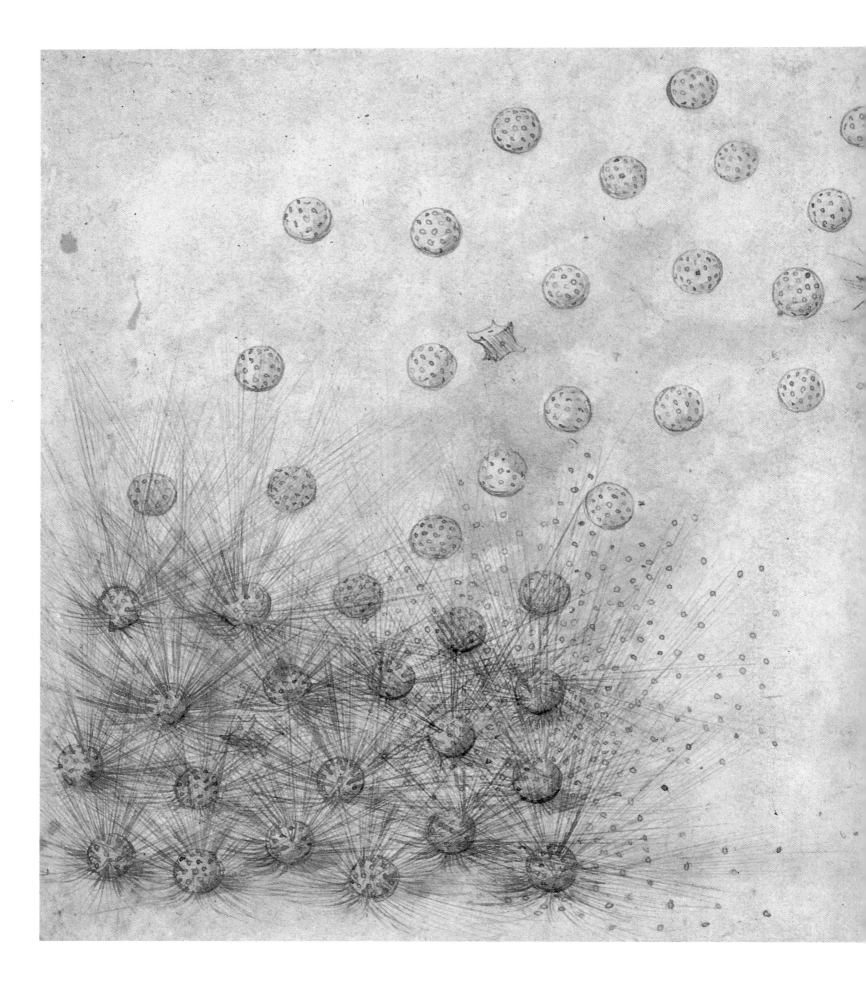

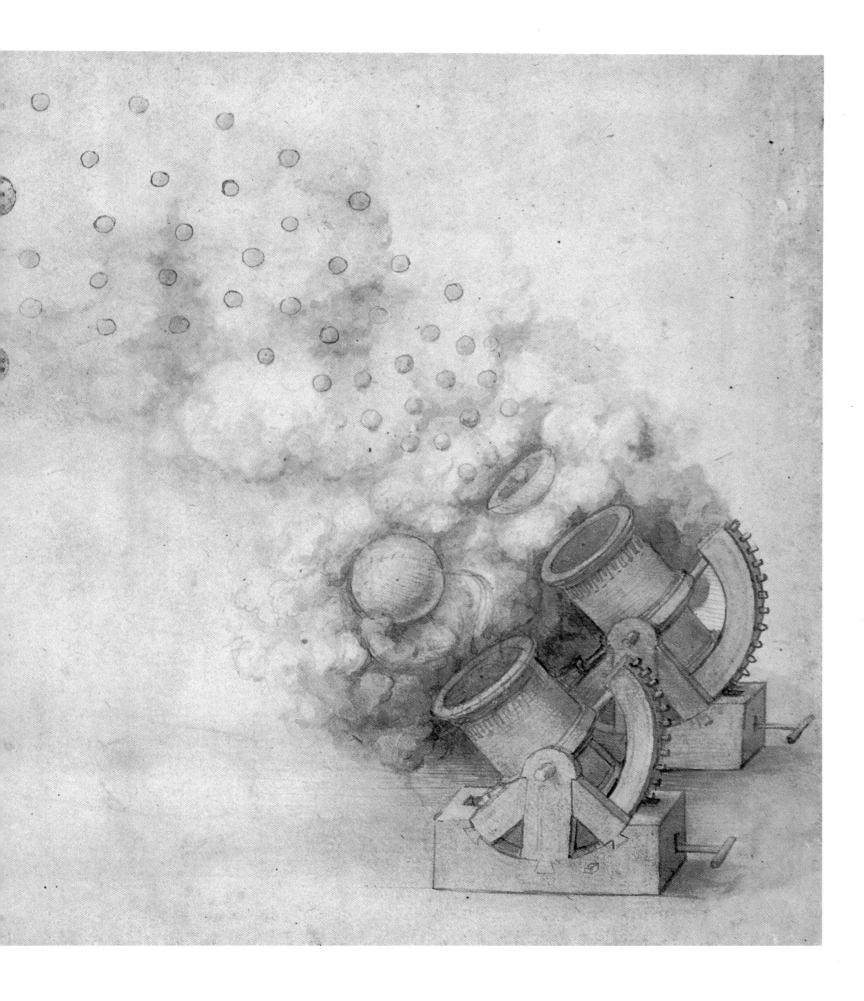

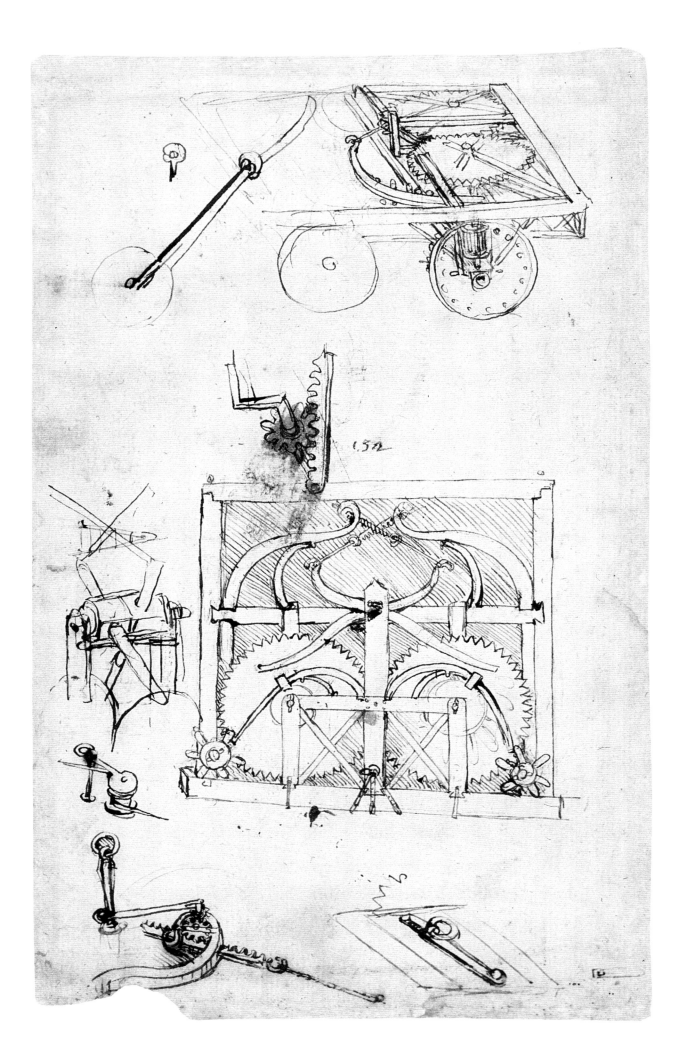

nature to the will and desires of man.[324] In his inexhaustible creativity, Leonardo nearly carries out point by point the program that Roger Bacon dreamed of in the middle of the thirteenth century: "One could construct means of sailing without oarsmen […]. One could also construct tanks which move without horsemen, through the effect of an admirable force. And I believe that the tanks fitted with scythes with which the Ancients fought were of this kind. One could also construct machines for flying, made in such a way that man, sitting at the center of the machine, could maneuver it by means of an instrument which would enable skillfully constructed wings to beat the air as birds do when they fly. And one could also construct a small winch capable of raising and lowering almost infinite weights […]. One could also construct instruments for walking on the sea and rivers, and for touching the very bottom without running the least risk […]. And it is certain that these instruments have already been constructed in antiquity and that one could make them today as well, apart from the flying machine, which to my knowledge no one has ever seen. […] We can construct an almost infinite quantity of instruments of this kind, as for example bridges that can be thrown over rivers without needing any kind of supporting pillars, and machines and inventions still unknown."[325]

But this text of Bacon, celebrated for its almost messianic optimism, shows precisely that the most futuristic dimensions of Leonardo's technical invention are not due to his personality alone. They are written in a tradition where fantasy and sometimes the fantastic are not absent. It has since been established for instance that the "inventions" as sensational as the diving suit, the parachute, the assault tank, multiple-barreled mortars, and the automobile all have antecedents.[326] So it is a question of locating what distinguishes Leonardo's exceptional ability, to determine how his engineering genius sets him apart from his colleagues. Because, once again, his practice, however remarkable it is, is not at all isolated.

Primus inter pares ("first among equals"), Leonardo is an exemplary figure, the most creative of the "engineers of the Renaissance,"[327] who threw away the assumptions of the past to pave the way for a technological revolution. In the fifteenth century these engineers of the Renaissance form a professional milieu with which Leonardo is connected in all its aspects. Brunelleschi obviously occupies first place: the feat of building the dome of Florence cathedral is still enthralling people at the end of the century. In 1472, Verrocchio's studio receives the commission to erect the copper sphere at the top of the lantern

Fig. 122. *Automobile*,
Codex Atlanticus, fol. 296v-a.
Milan, Biblioteca Ambrosiana.

on the cathedral, and the machines that Brunelleschi had used earlier enjoy a considerable prestige, in particular a three-speed reversible winch (fitted with an endless screw) and his counter-weighted crane. Several drawings of these by Leonardo have been found (fig. 124). But it must be said that he is not the only one to make such drawings: the Sienese Mariano di Iacopo, known as Taccola (fig. 123), Francesco di Giorgio Martini, Bonaccorso Ghiberti and Giuliano da Sangallo do so as well.[328]

The documentation left by Leonardo is undoubtedly extremely important, but it is also far from being alone. Brunelleschi himself left nothing apart from his works: he wrote nothing and the rough drawings ("*disegni brievi*"), which his biographer Manetti describes, cannot have been any more than sketches. However, as the century progressed, the social prestige that engineers enjoyed increased as they moved from one court to another, responding to the demands of princes. To confirm their cultural position and their dignity in the field of the humanities, they write treatises on this or that subject of their "art." This type of text already exists: in the fourteenth century, Guido da Vigevano and Conrad

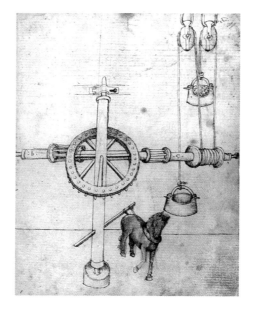

Fig. 123. Taccola, *Reversible winch inspired by Brunelleschi*, 1432–33, pen and ink, 11¾ x 8¾ in. (29.7 x 22.2 cm.) *Ms. Palatino* 766, fol. 10r, Florence, Biblioteca Nazionale Centrale.

Kyeser had written treatises (in good Latin), which, while mainly concerned with war machines, also proposed various instruments for use in time of peace. In the second quarter of the fifteenth century, the *Bellicorum Instrumentorum Liber* ("Book of equipment of war") by Giovanni Fontana contributes much, through the classical culture that the many references implies, towards publicizing the

Fig.124. *Brunelleschi's great crane, Codex Atlanticus*, fol. 965r. Milan, Biblioteca Ambrosiana.

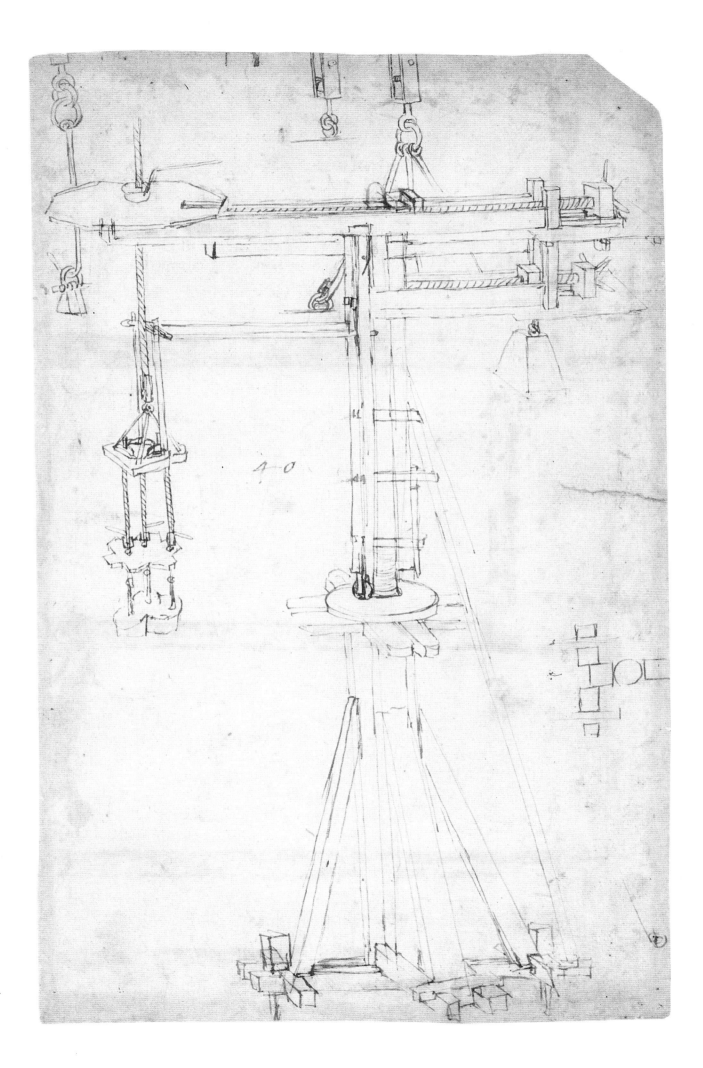

cultural dignity of this new literary "genre": the illustrated technical treatise. But there is a significant difference that separates these works from later treatises: professionally, Kyeser, Guido da Vigevano and Fontana were all three doctors. More than proposing machines designed for the world of work and efficient production, they, as sophisticated intellectuals, glorify the technical knowledge of the ancients to enhance the prestige of the mechanical arts.[329] This approach is also found to some extent in *De Ingeneis Libris* by Taccola who, significantly, proclaims himself "the Sienese Archimedes." For the whole of one part, his treatise aims to show machines described in the texts of antiquity that were not always easy to understand—as Taccola's drawings often confirm. But its importance is otherwise. With Taccola and, still more, Francesco di Giorgio, it is henceforth the engineers themselves who write and illustrate their own treatises: in becoming "authors," they aim to build on the foundations of humanism, the prestige of a new social figure, that of the artist-engineer-author.[330]

Leonardo is linked to this tradition. Moreover he annotates the treatise of Francesco di Giorgio that is in his possession and, though his training is similar to that of his colleagues, the diversity of his inventions corresponds, in theory at least,[331] to the diversity of the tasks that are the duty of the engineer at court. It is only at the end of the 1480s that a change takes place in his way of conceiving the profession of engineer, and he then dissociates himself, little by little but radically, from his colleagues in the field. Not surprisingly, one of the characteristic tendencies of this change is due to the fact that he no longer treats machines "case-by-case" (according to the habitual practice of the studio culture). His studies about locks, water mills and other hydraulic devices (which was a strong tradition in the Milan region) leads him to think that the improvement of existing machines must be based on knowledge of the energy used and the force that it brings into play. Also, perhaps even more than in other fields, a clear contrast is noticeable between his declarations of intent and his programs on the one hand, and his actual studies on the other: these remain fragmentary and, this time in striking contrast to some of his colleagues, Leonardo here as elsewhere fails to complete a single treatise.

Besides, the exceptional inventiveness that his multiple drawings seem to demonstrate must be qualified, because these drawings themselves do not all have the same stature. Putting aside those that, in the absence of any explanation, have not been successfully interpreted by the most informed modern specialists, one can divide them into four categories.[332] The first reproduce machines

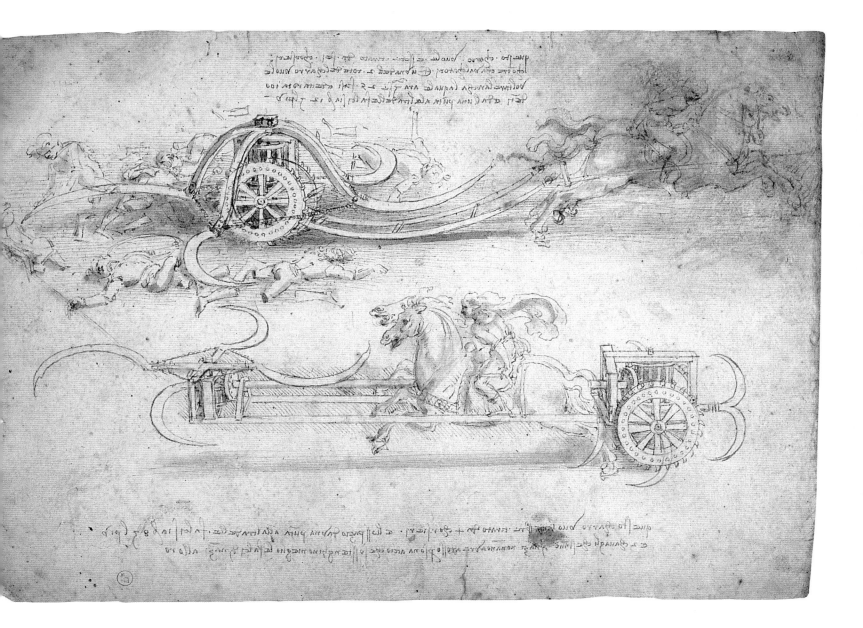

Fig. 125. *Tank fitted with scythes*. Turin, Biblioteca Reale .

constructed or described by others, repaired and sometimes improved by Leonardo: this includes machines originating from sources from antiquity (such as the splendid tanks armed with scythes, fig. 125), or modern ones (in particular, those of Francisco di Giorgio). But the category can also include machines that are actually in use in the fifteenth century, such as Brunelleschi's crane, or the clock movement (fig. 126), which seems to reproduce a well-known French mechanism of the fourteenth century, and also, perhaps, some

Right: Fig. 126. *Clock mechanism*, *Codex Atlanticus*, fol. 348v-a. Milan, Biblioteca Ambrosiana.

Far right: Fig. 127. *Hydraulic pump*, *Codex Atlanticus*, fol. 49r-b. Milan, Biblioteca Ambrosiana. Detail.

spinning machines or water mills, which, being particularly numerous in the Milanais, could not have failed to hold his attention. Other drawings are made in response to orders from the court; these concern above all military and hydraulic machines, such as one for bringing hot water to the "bath" of the duchess Isabelle d'Aragon;[333] and machines intended for court spectacles (theaters, parades, tournaments and the like), such as, for example, the "file" concerning the casting of the equestrian monument to Francesco Sforza. In this kind of drawing, the case-by-case approach remains the most common: it reflects the occasional demands from this or that patron, and Leonardo is not looking to relate the technical solution to the general principle. Other drawings on the other hand correspond to Leonardo's own researches. From the 1490s and independently of any commission, he seeks to make the world of machines a "paradise of mathematics," an application and an exploitation of the laws of universal mechanics. It is in this field that Leonardo differs most radically from his colleagues: in carrying out systematic studies about the fundamental

"elements" of applied mechanics, he rises above the status of "technician" to become the first "technologist" in European history.[334] A fourth type of drawing, frequently the most fascinating, corresponds to what Paolo Galluzzi called "a kind of 'dream' technology": with the same precision as Leonardo uses for existing machines, these illustrate fictitious mechanical devices—fictitious either because the materials needed for their construction did not yet exist,[335] or because their construction was technically impossible.

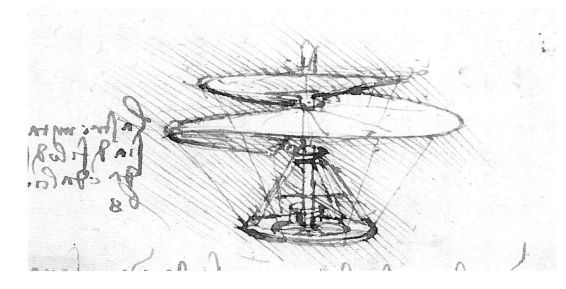

Fig. 128. *Flying screw*, *Ms B*, fol. 83v. Paris, Institut de France.

This is the case with the most celebrated of Leonardo's researches, which undoubtedly occupies him longest: the ornithopter or flying machine. Again, Leonardo is not the first Renaissance engineer, after Roger Bacon, to dream of such a machine: the drawings of a Sienese engineer, the "Anonymous Sienese," showing a man flying and a man hanging from a parachute are well-known, and Leonardo's idea of the famous helicopter or "flying screw" (fig. 128) had already been pictured by Taccola in a drawing in his *De Ingeneis* (folio 74v).[336] But Leonardo tackles the question in a systematic way that is foreign to his predecessors. He thinks about it since Florence, and, over the years, he develops the idea of a machine that, imitating nature (meaning the flight of birds), could be moved by the muscular power of its user: by beating his arms and pedaling with his feet, he would set the wings in motion either by means of mechanisms directly attached to his limbs, or by the transmission of their movement through a system of cranks, pulleys, wheelwork and so on. He studies different types of jointed wings (fig. 129, 131) and draws machines with two

or four wings, and with the body in a horizontal or vertical position (fig. 132, 133). He even designs a crossbow system (fig. 130) to solve what seems to him a major difficulty: the inadequacy of human muscular strength in relation to the weight and size of the machine. In the years 1503–06 he abandons this first hypothesis, and the detailed study of the gliding flight of birds encourages him to design a machine where the wings do not beat but are hinged in such a way as to present a larger or smaller surface to the currents and resistance of the air. Working together with the movements of the body, this would make soaring flight possible.[337]

The enthusiasm that he feels about this new idea is expressed in the famous prophecy: "The great bird will make its first flight on the back of the great Swan [Mount Cecero, near Florence], to the amazement of the earth, and it will fill all the annals with its great fame: and it will confer eternal glory on the bed where it was born" (*Codex On the flight of birds*, cover, 2r). However one of the most significant aspects of this research is not its unreality or the poetic character that it takes on in our eyes; on the contrary, it derives from the precision with which Leonardo develops his hypotheses technically—and to the fact that his work on ornithopters gives rise to consequences which not only concern the perfecting of hinged devices and the improvement in the transmission of movement, but also the concept of instruments enabling the speed of the wind and the humidity of the air to be measured. The flying machine could never have flown; it was indeed a dream, but this was a "technological dream": compared with the elementary drawings of the Anonymous Sienese, Leonardo's drawings show the conviction that it is only by mastering the whole range of physical data involved in the planned experiment and by producing the appropriate technical solution that the engineer will have any chance of surpassing nature by exploiting its laws.

That Leonardo's flying machine is still fascinating even today is precisely because of the exceptional technical and aesthetic quality of the drawings that sanction it. This is with good reason, because, as must be stressed, their "expressive" effectiveness makes up one of Leonardo's major contributions to the history of technology: the invention of modern technical drawing. Although it is difficult to place his contribution in the history of effectively implemented technology, these drawings of machines and mechanisms are radically innovative and rich in future potential. It is true that Leonardo does not invent this kind of drawing. Although, as has been seen, Brunelleschi had been content as a pioneer to replace the wooden model by sketches that were verbally

Page 196, top left: Fig. 129. *Study of removable wing*, *Codex Atlanticus*, fol. 341r. Milan, Biblioteca Ambrosiana.

Top right: Fig. 130. *Crossbow-powered flying machine*, *Codex Atlanticus*, fol. 314r-b. Milan, Biblioteca Ambrosiana.

Bottom left: Fig. 131. *Study of wing*, *Codex Atlanticus*, 308r-a. Milan, Biblioteca Ambrosiana.

Bottom right: Fig. 132. *Flying machine in extended position with four wings*, *Ms. B*, fol. 79r. Paris, Institut de France.

Page 197: Fig. 133. *Vertical flying machine*, *Ms. B*, fol. 80r. Paris, Institut de France.

explained to the workers called upon to realize them,[338] after him a tradition of engineering drawing began to form in the Quattrocento. With Taccola as with Francesco di Giorgio, one already finds drawings of machines in cutaway or exploded views making it easy to understand how they work (fig. 134). But, in their concern to become established unequivocally as "authors," Taccola and Francesco di Giorgio limited the primacy of drawing, each in practically the same terms. For the first, the *ingenium* ("genius") resided more

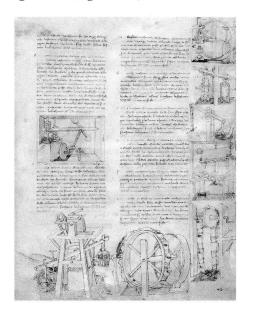

Fig. 134. Francesco di Giorgio, *Pumps*, *Ms. Ashburnham 361*, fol. 43r. Florence, Biblioteca Medicea Laurenziana.

"in the spirit and intellect of the architect than in the drawing and the writing"; for the second, the majority of things contained in his manuscript, *Opusculum de architectura* ("Little work on architecture") "exist more in the spirit and the *ingenium* of the architect than painting and drawings can show."[339]

These reservations are inspired by a "humanist" approach to the technical arts. With Leonardo such reservations disappear. His approach to technical illustration is identical to his approach to anatomy: not only does he draw his machines in exploded form but, unlike Francesco di Giorgio, he comes to represent them from many points of view, and above all, to present the details of these mechanisms in exploded, "anatomical" form (fig. 135). Folio 82r of *Ms. Madrid I* clearly shows the knowledge of the "expressive" virtues of drawing thus conceived: "These instruments are shown without their framework or anything else that would be an obstacle between the eye and what it is studying; later on these structures will be explained with lines."[340]

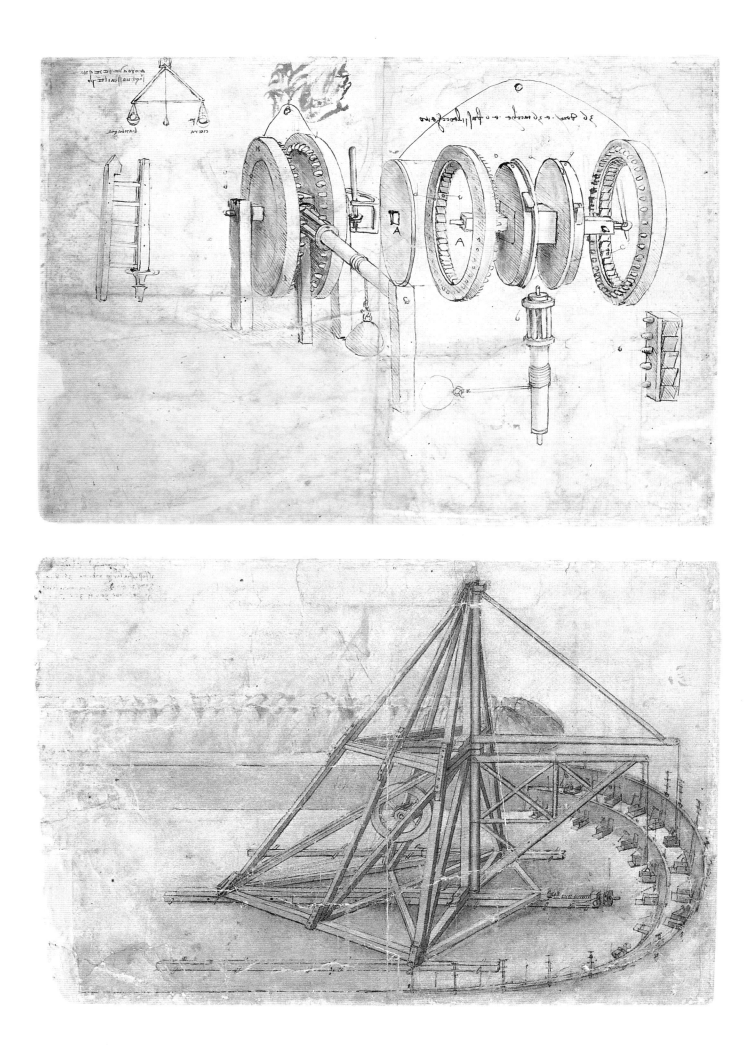

This "anatomical" approach is not done for the sake of surprise. It corresponds to an exact intellectual research: abandoning the habit of case-by-case in his theoretical practice, Leonardo aims to analyze and rearrange the "elements," meaning the mechanisms, on which the operation of various machines depend. He tries to reduce these machines to a limited number of "organs" and one of the characteristics of the spirit in which he tackles his activity as engineer arises from the fact that he brings as much attention to the detail of each element of

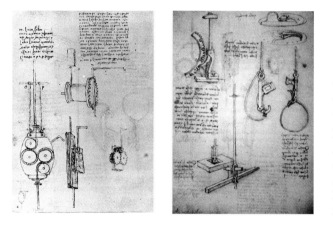

Left: Fig. 137. *Crank elevator*, *Ms. Madrid I*, fol. 9r. Madrid, Biblioteca nacional.

Right: Fig. 138. *Hooks with automatic release*, *Ms. Madrid I*, fol. 9v. Madrid, Biblioteca nacional.

the machine as to the whole. Some pages present complicated machines that are impressive and even grandiose—such as the giant mobile excavator designed for digging the canal of the Arno (fig. 136). Other drawings put forward proposals for machines of more modest size whose concept brilliantly foresees actual mechanisms (fig. 137, 138). Yet others—and these are the most significant from the point of view that interests us—meticulously present this or that element that could be used in the fabrication of machines. The spring for example is an important source of energy (particularly in clocks), so Leonardo draws up as complete a selection as possible and designs a machine for making them (*Madrid I*, 85r and 14v). Similarly, he draws two types of hinges with great accuracy (*Madrid* I, 172r) and accumulates so many different kinds of gearing that he devotes several pages specially to them (for example, *Madrid I*, 13r).

But there is still more. His technical drawings differ so much from those of his contemporaries because they are *working drawings*—the first, according to Alexandre Koyré, to have been conceived and drawn as such, to the extent that they can represent "the imagination of the theoretician and not the experience of the practical man."[341] This is a decisive point because it places us at the heart of Leonardo's inventive technique. Such an innovation in the technique of

Opposite page, top: Fig. 135. *Mechanism for converting alternating movement into continuous movement*, *Codex Atlanticus*, fol. 8v-b. Milan, Biblioteca Ambrosiana.

Bottom: Fig. 136. *Giant excavator*, *Codex Atlanticus*, fol. 1v-b. Milan, Biblioteca Ambrosiana.

201

industrial drawing is made possible by the Leonardo's exceptional mastery in placing these virtual objects in perspective and of rendering light and shade. In spite of their novelty, and in spite of the fact that they also sometimes go beyond the case-by-case so as to present themselves as "device types" from which variations can be devised, the drawings of Francesco di Giorgio reveal a certain gaucheness by comparison. No doubt they are sufficient for understanding the operation of such and such a machine and, subsequently, its construction; but they do not seek to prove the effectiveness of the mechanism implemented. Even the more controlled drawings of Bonnacorso Ghiberti or Giuliano da Sangallo remain entirely explanatory. Leonardo's are *convincing*. His working drawings not only possess a rare elegance; they are visually put in context, and they have the concrete appearance of objects which exist: the angle or angles of view, the subtlety of the shadows and the treatment of the background itself on which they are drawn gives them an extraordinarily persuasive, really rhetorical, effectiveness. As Paolo Galluzzi rightly points out, the clarity and dynamism of the drawing give "the impression that these improbable mechanisms will certainly work."[342] One could even think that this effectiveness convinced Leonardo himself that he would succeed in making the flying machine work. His technical drawings are inseparable from his artistic vision and practice, as is shown in the rare pages where the machine is shown in action, operated by human figures. Examples are the vibrant, noisy *Cannon foundry* (fig. 139) and, perhaps even more, the drawing in which Leonardo represents (was it ever carried out?) the experiment for checking the carrying force of his mechanical wing (fig. 140).

In this context it is evidently a delicate matter to work out the contribution that Leonardo made to the history of technology. It is possible that none of these machines has ever been constructed, and, in spite of the exceptionally finished quality of the many drawings, in this field as in others, he never published a treatise on machines and their "elements." Accordingly he had less influence on his contemporaries because his most innovative projects would have depended on a state of advanced technology that did not yet exist, and perhaps most of all because these projects did not answer any of contemporary society's needs. In his imagination Leonardo was undeniably a precursor: the drawing of the bicycle (fig. 27), clumsy because it is the work of an assistant, is enough to establish that. But it is also true that at the time this means of transport would have been of no interest or potential use, whether economic, social or military. One can see no reason why its construction should have

Fig. 139. *Cannon foundry*, c. 1503–04,
pen and brown wash, 13 x 19 in. (32.9 x 48 cm.)
Windsor Castle, Royal Library, RL 12275.

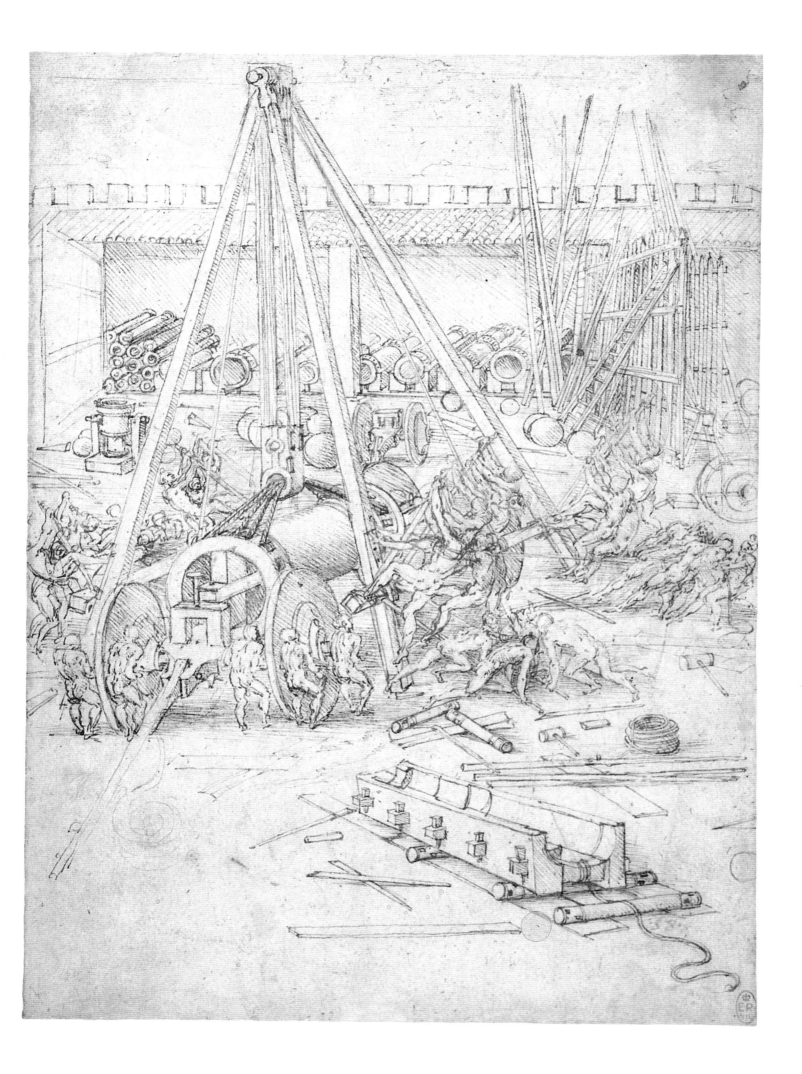

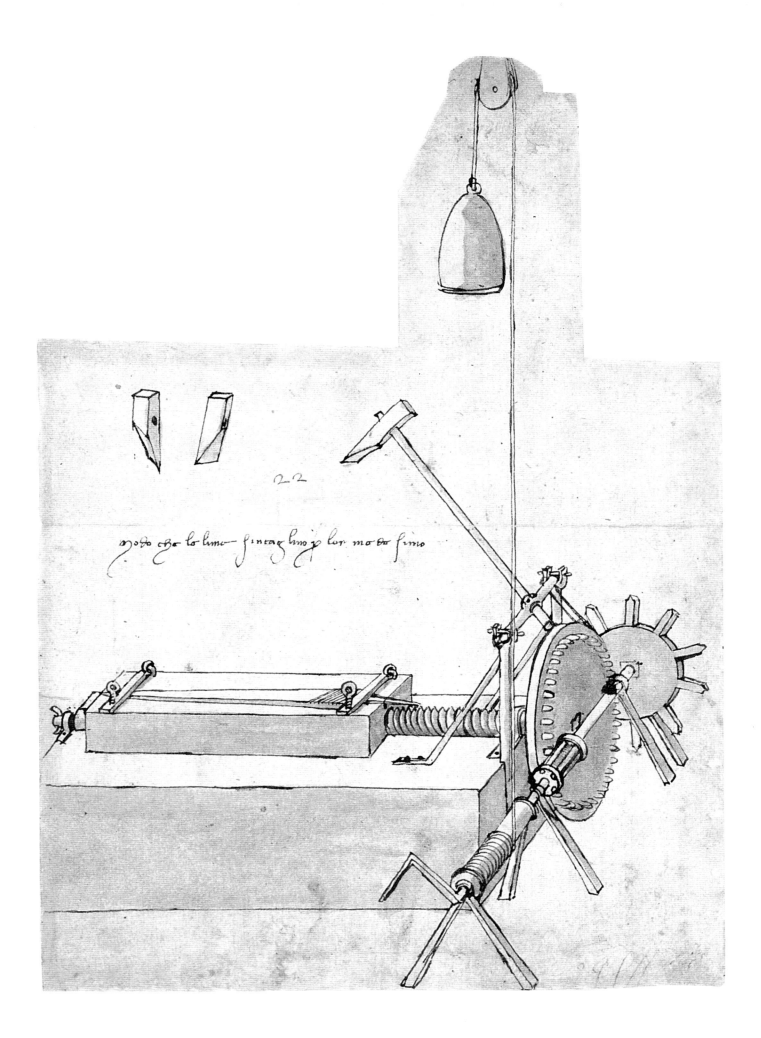

modo che lo lima f... gintaglino p lor modo fimo

been undertaken, and it was undoubtedly a marginal idea, derived perhaps from research on the flying wing which was partly operated by the movement of the limbs. It could even have come from the idea that seems to inspire some of his most advanced researches: making work economically profitable through the automation of the mechanical operations of production. One of his oldest technical drawings, the machine for making files (fig. 143), relates to this interest. It is found too at the end of the 1490s in the design of a machine

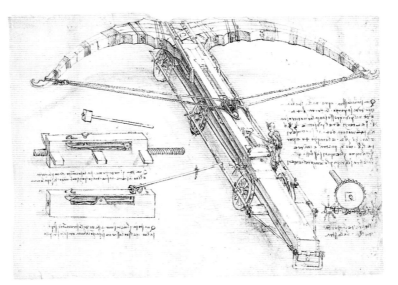

Fig. 144. *Giant crossbow*, *Codex Atlanticus*, fol. 53v a-b. Milan, Biblioteca Ambrosiana.

for automatically shearing woolen fabrics (fig. 142).[343] Commenting elsewhere on a project for automatically making pins, he notes: "A hundred times an hour times four hundred pins makes forty thousand an hour, that is, in twelve hours, four hundred and eighty thousand. But let us say four hundred thousand; at five cents a thousand, this makes twenty thousand cents, that is, a thousand lira a day from the work of a single man; and if he works twenty days a month, this makes twenty thousand lire a month, which is sixty thousand ducats a year."[344] In the same spirit, being interested (whatever may have been said) in the great invention of the century, printing, he devises a system that automatically returns the press to the working position after printing a page (*Codex Atlanticus*, 358r-b). One could multiply the examples—such as an automatic roasting spit with variable speed set in motion by the warmth of the air produced by the fire and using the propeller for the first time (fig. 141). As Bern Dibner has noted, a number of drawings are based on a combination of gears intended for use in automatic mechanisms where, following the

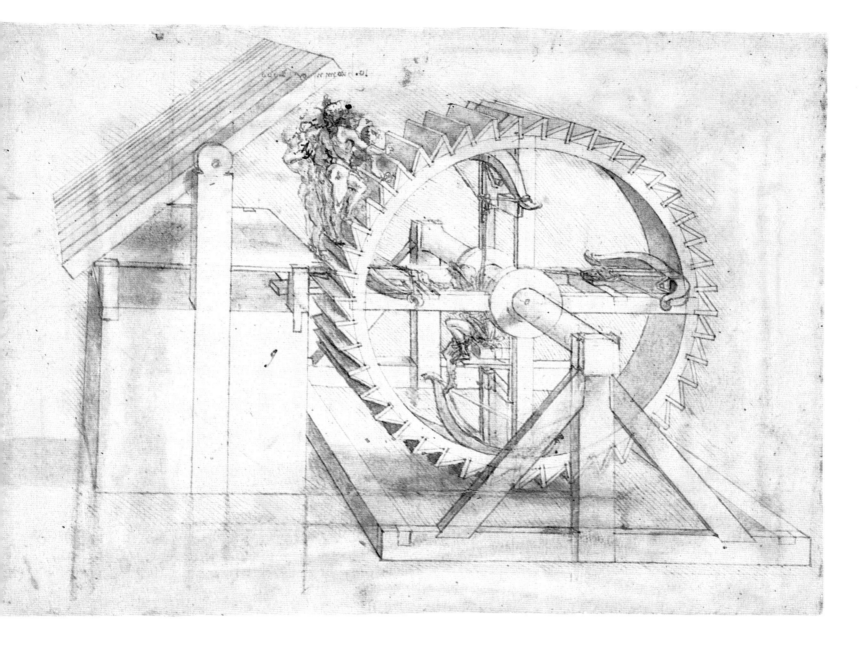

Fig. 145. *Rapid-firing crossbow, Codex Atlanticus*, fol. 387r.
Milan, Biblioteca Ambrosiana

principle of feedback, the machine corrects its lapses in operation by a device controlled by these same lapses.[345] This type of research is undoubtedly a technological advance; depending on the exploitation of the internal logic of the concept itself of the machine and mechanism, it makes Leonardo, in Bern Dibner's phrase, a "prophet of automation." But, taking account of the contemporary social situation and working arrangements, they do not respond to any actual economic need. Therefore, to understand Leonardo's

Fig. 146.
Rapid-firing crossbow,
Codex Atlanticus,
fol. 387r-b.
Milan, Biblioteca
Ambrosiana.

reason for these researches, one must relate them not to the objective of efficient production, but to what it is convenient to call the "poetry of mechanism." In this way it is easier to understand why, besides the "futuristic visions," some of Leonardo's most celebrated drawings concern devices that are already archaic at the time he takes an interest in them. This is the case with the drawings of the giant or rapid-firing crossbows (fig. 144, 145, 146), which are obviously overtaken by the development of artillery—on which Leonardo reflected as well—giving this kind of instrument the charm of obsolescence. One can also better understand why the transmission of "intermittent movement," its gearing down and its transformation (from alternating to continuous motion and vice versa) become a central concern of his applied mechanics, leading to his research on gear assemblies and the reduction of friction at essential points.

Is it a coincidence that the drawing illustrating a defensive system with a

perimeter fortified by vertical mortars (fig. 147) evokes the elegant lightness of decorative waterworks—which, it is known, Leonardo was interested in for their use in stately gardens? Almost entirely expressed through drawings, Leonardo's technological approach is inseparable from the rest of his thinking and activities. The relationship between his technical drawings and his anatomical ones has already been described. It is more than a simple comparison. The microcosm of the human body itself is, in the picture of the macrocosm, conceived as an

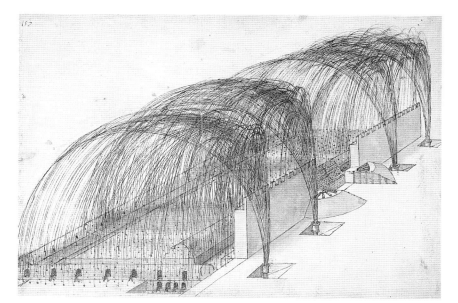

Fig. 147. *Vertical mortars*, *c.* 1503–04, pen and brown wash, 13 x 19 in. (32.9 x 48 cm.) Windsor Castle, Royal Library, RL 12275.

"organic machine"—and Leonardo, as we shall see, explains this concept in several of his anatomical "demonstrations." At the same time, regarding the flying machine, it is significant that before Newton he intuitively formulates the principle of aerodynamic reciprocity in terms echoing those by which he defines the strength of the arch: "The pressure that an object exerts against the air is the same as the pressure of the air against the object" (*Codex Atlanticus*, 381v-a). The world of Leonardo involves the universal play of forces giving rise to appearances. In working to rationalize the operation of existing machines or in imagining "improbable mechanisms" unlikely to be effectively constructed by his contemporaries, Leonardo gives form to devices that will demonstrate to the world the knowledge that has been acquired by man and controlled by the laws of the world. By imitating these laws, in other words by self-regulating themselves without human intervention from the moment that they are set in motion, these machines, whether simple or complex, turn the engineer,

in the same way as it did the painter, into an "equal of God," the creator of the "Paradise of mathematics," whom Leonardo dreamed of emulating, beyond his real activities as courtier.

GEOGRAPHIC MAPS

The cartographic drawings of Leonardo are traditionally associated with his activities as an engineer. It is indeed in his capacity as a military or civil engineer that after 1500 Leonardo comes to make a number of remarkably interesting maps. It is while he is in the service of Cesare Borgia that he makes the plan of the city of Imola (fig. 152) in 1502–03, as well as the two maps of central Italy (fig. 148, 149). Then, in using maps to study the possibility of diverting the Arno (fig. 151), he made a map of western Tuscany (fig. 150) for the city of Florence, which was still at war with Pisa. Finally, in about 1515 he draws up a map of the Pontine marshes to the south of Rome for Giuliano de' Medici.[346]

Leonardo's contribution to the science of cartography and the surprising modernity of his concept of cartographic drawing is often noted. For instance, the plan of Imola breaks with contemporary custom by showing, in orthogonal projection, only the ground plan of the buildings of the city. According to Martin Clayton this plan would not only have been "the most accurate and the most beautiful map of its time" but, according to Martin Kemp, it would also have been "the most magnificent production which has come down to us from the revolution which the Renaissance brought in the techniques of cartography."[347] At the same time, in the general map of central Italy (fig. 148), Leonardo overturns the conventions for representing relief. He gives up the arbitrary sheep-like representation of papier mâché mountains seen in bird's eye views, replacing it with the idea (actually very modern in spirit) of using washes of different intensity to follow the contours of the mountain chains—an idea taken up in the map of the lower Arno in the *Madrid II* manuscript (52v-53r). Thus one may say that Leonardo is the "creator of modern cartography."[348] But it is necessary to clarify and qualify this enthusiasm.

In the first place, Leonardo does not necessarily create the maps he draws. For his apparently very modern-looking map of the whole of central Italy (fig. 148), he uses as model an equivalent map that he found in a manuscript

Opposite page: Fig. 148. *Map of Tuscany and Emilia Romagna*, 1502–03, pen and sepia, 12½ x 17¾ in. (31.7 x 44.9 cm.) Windsor Castle, Royal Library, RL 12277.

Fig. 149. *Map of the Chiana valley*, 1504, pen and ink with blue and green wash, 16½ x 9½ in. (42.2 x 24.2 cm.) Windsor Castle, Royal Library, RL 12278.

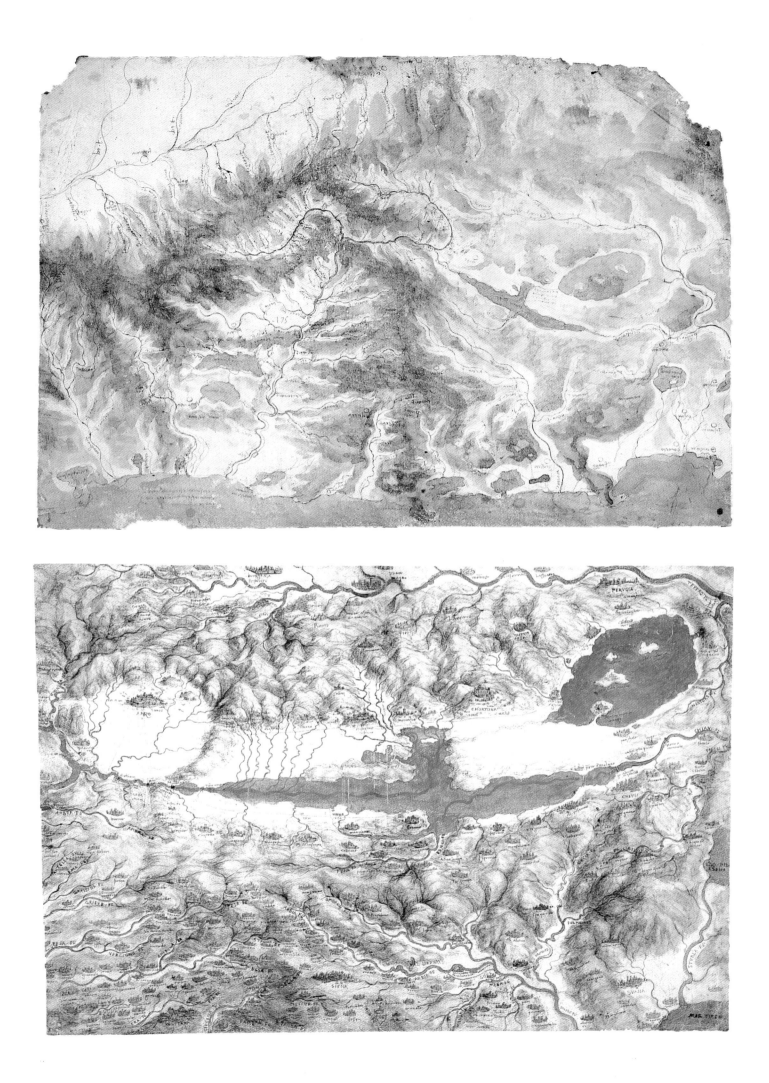

in the library at Urbino, where he spent the end of 1502 in the company of Cesare Borgia. The area covered, the distortions which can be seen and even the spelling of the names given come directly from this model.[349] In addition, Leonardo does not completely abandon the established conventions, and his drawing is very inconsistent in its accuracy. In spite of the beauty of the representation of the Pontine marshes, it is noticeable that the curve of the coasts is both exaggerated and simplified, while the transition between the mountains of the interior (drawn conventionally) and the plain descending towards the sea is much too abrupt. The map of the Val di Chiana (fig. 149) again uses the conventional birds-eye view relief, and, on top of that, the proportions of the land envisaged have been completely falsified so that the format can contain both the Tiber (whose meanders fit the upper edge of the sheet), the bend of the Arno on the left, Lake Bolsena on the right and even the sea in the bottom right-hand corner. This has resulted in a striking distortion that considerably enlarges the central part of the map, whose proportions are nonetheless correct in themselves. The reason is that Leonardo is not interested in the "true" measured representation of the territory but in the general system of the watercourses whose logic and apparently capricious density he is keen to visualize by fitting it within his format.

In fact, while the military or civil projects for which the maps are made vary according to the patron, they all have one point in common: they deal with hydrographic and hydrological problems. This explains the depth of Leonardo's interest in this kind of representation, which transforms the practice of cartography. The maps of central Italy make clear the river network of this vast region on both sides of the dividing line of the Apennines. The map of western Tuscany (fig. 150) has been made in response to a Florentine project, strongly encouraged by Machiavelli, for diverting the lower Arno so as to end the interminable siege of Pisa. Lastly, the map of the Pontine marshes has been drawn in connection with a drainage project in which Leonardo was only one of the participants and which, in 1521, would lead to a detailed proposal for the systematic drainage of the region. Leonardo also pays particular attention to the upper valley of the Arno and the twin lakes of the Val di Chiana, producing a highly detailed cartographic view of the area (albeit incorrect in its proportions). This is related to his own individual research concerning the building of a canal to bypass the Arno. To regulate its flow he had actually provided for the flooding of the Val di Chiana by means of an adjustable

Opposite page: Fig. 150. *Map of western Tuscany*, n.d., pen and ink on black chalk, 10¾ x 15¾ in. (27.5 x 40.1 cm.) Windsor Castle, Royal Library, RL 12683.

Fig. 151. *Map for the diversion of the Arno*, 1503–04, brown pen and ink on black chalk with wash, 13¾ x 19 in. (33.5 x 48,2 cm.) Windsor Castle, Royal Library, RL 12279.

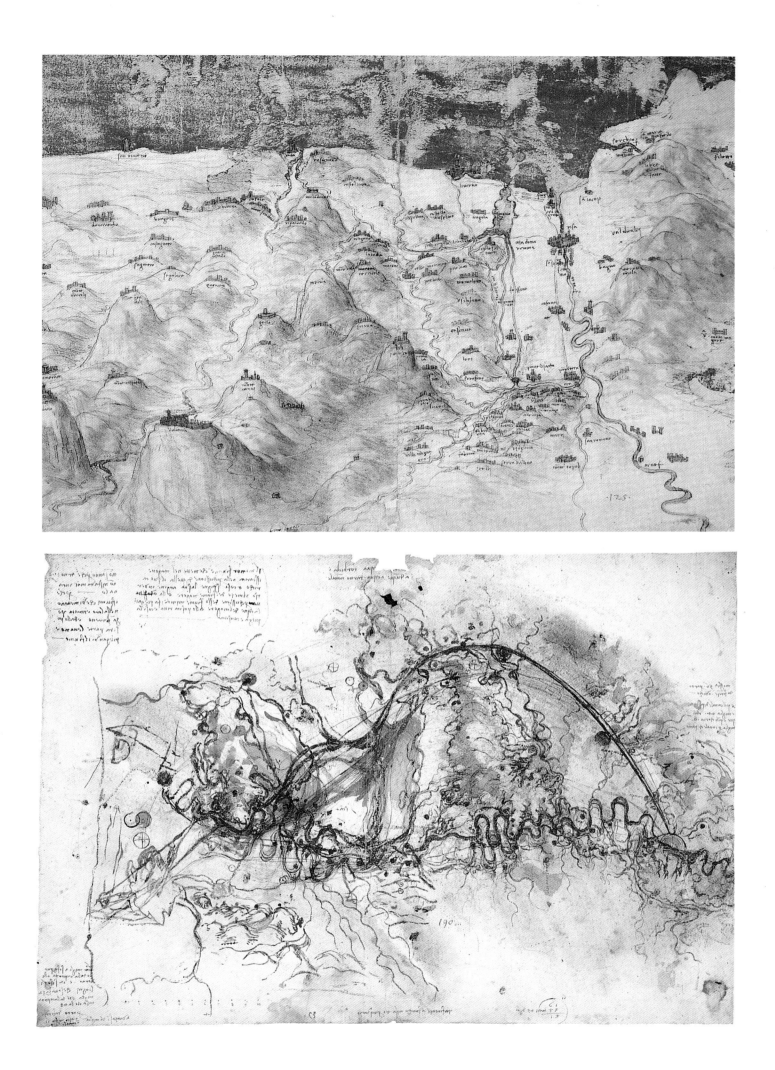

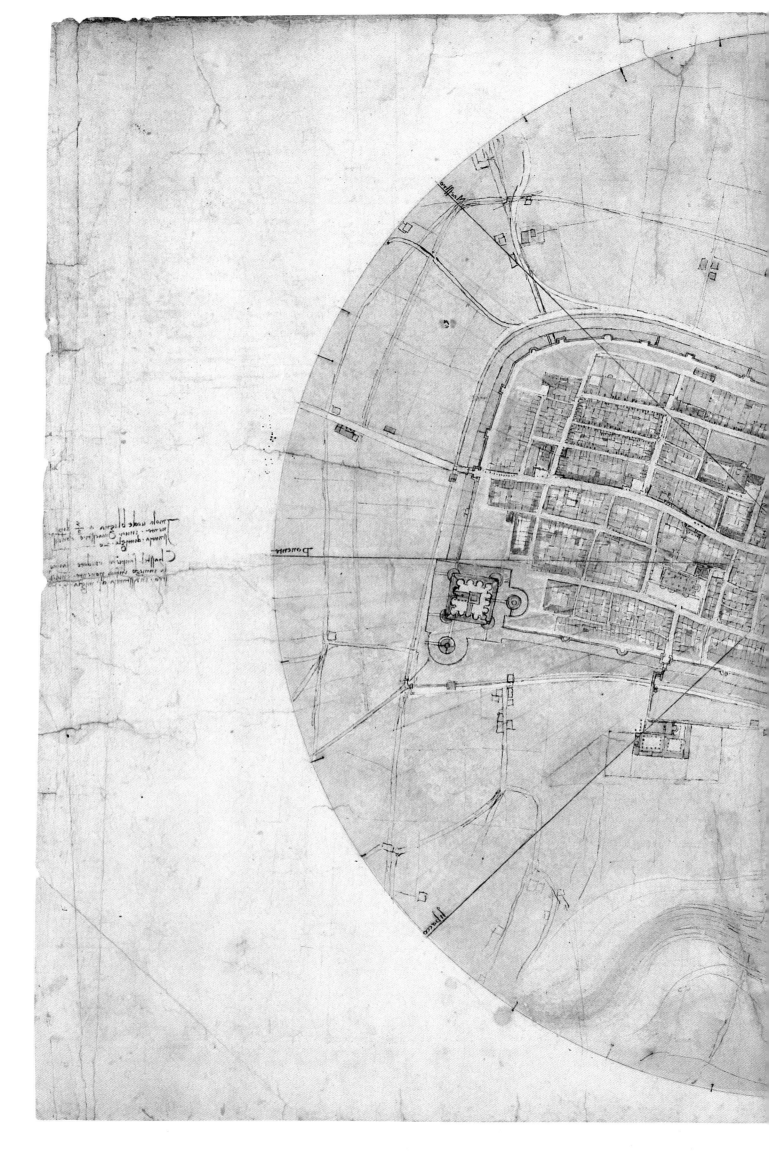

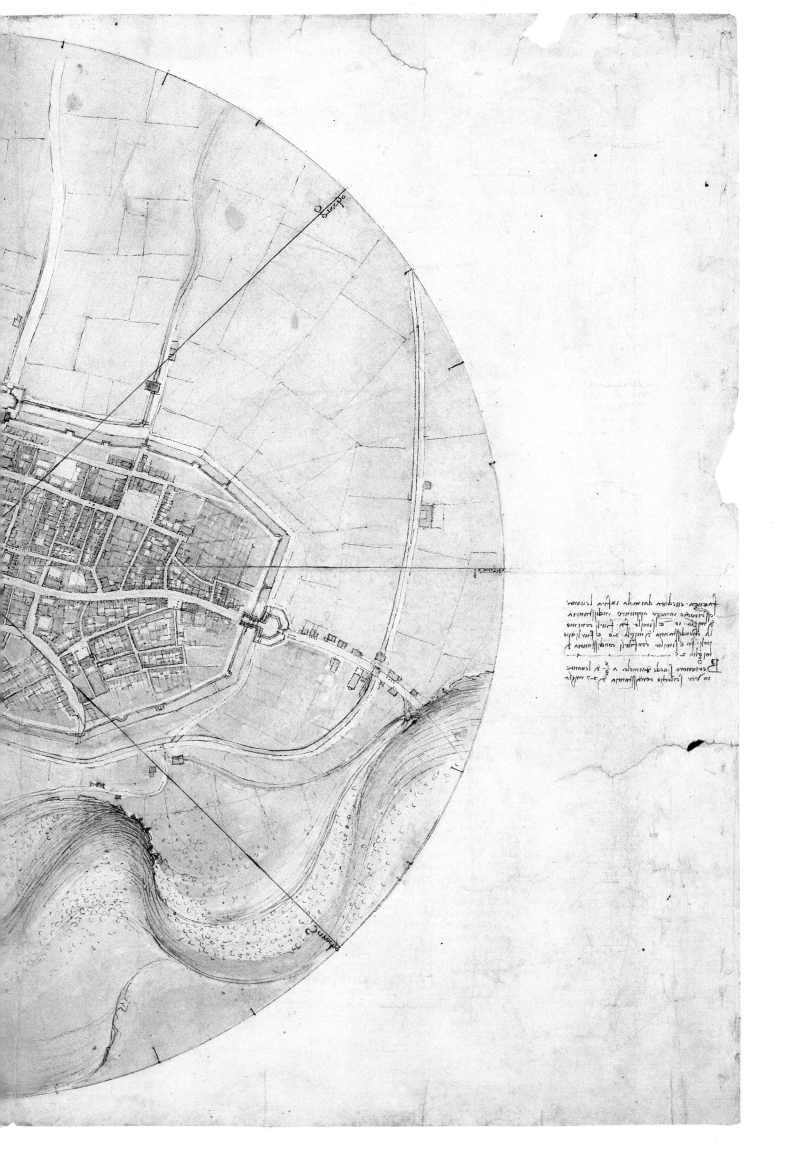

dam situated south-west of Arezzo. (This project was no doubt unrealizable, but it was the rationalization of an idea which had captivated the Florentines since the middle of the fourteenth century, and it is a pleasure to point out that the line adopted by Leonardo was the same as that followed by the modern express highway, as far as the Serravalle pass.)

This interest in water no doubt also indirectly explains the complexity of the questions the attentive reader might ask about the plan of Imola (fig. 152). Hailed with reason as the most successful, the most impressive, and the most beautiful of Leonardo's plans, the extraordinary modern feeling of this geometric "aerial" view of a fortified town in the Romagna actually leaves historians perplexed. It seems that here Leonardo has transcribed an urban reality that was thirty years old: apart from the Rocca (strengthened in 1499) and the Palazzo Riario (built in 1482, now called the Palazzo Sersanti), the buildings shown take practically no account of the changes made in the city after 1474 by Girolamo Riario, nephew of Pope Sixtus IV and husband of Caterina Sforza, daughter of Galezzo Maria, who brought him the city in her dowry.[350] It is hard to see what need Cesare Borgia would have had for the enclosed interior plan of a town when his main priority was to reinforce the fortifications. But the fact is that Leonardo used as model a map drawn in 1474 by the ducal engineer Danesio Maineri, introducing some modifications to it. The geometrical presentation of this map is also curious. Drawn as it is at the heart of a circle divided by four diameters into eight sectors of 45 degrees, each of them being in turn subdivided into four equal parts by thirty-two radii, this geometric plan suggests that it is the result of a systematic survey, bringing together measurements taken on the ground and angles measured from a fixed point (the tower of the town hall, at the crossing of the main streets). Far from being the fruit of a revolution by Leonardo in the technique of cartography, this method of presentation follows to the letter the method of surveying described by Alberti in his *Descriptio urbis Romae* ("Description of the city of Rome") written in the 1440s, and repeated in 1450 in *Ludi Matematici* ("On games of mathematics"), a copy of which Leonardo owned. Since Leonardo was actually redrawing a map of 1474, one might suppose that this method had already been used by Danesio Maineri, the author of the original plan—or even that, without further ado, Leonardo has superimposed this Albertian grid on the model that he was using.[351]

As Augusto Marinoni forcefully declared, the plan of Imola therefore poses

a question that remains unanswered: how is it that in 1502 Leonardo draws a plan corresponding to a reality that is thirty years old, with a technique and using instruments that he never uses or describes?[352]

The plan's style of presentation perhaps provides an element of an answer. The representation is most unusual: the cartographic circle extends well beyond the walls of the city to include the (faithful?) drawing of the fields, paths and roads, various dwellings and, finally, the meandering river near the town the Santerno. The movement of the water, its latent energy and the erosion of its banks are admirably and artistically "rendered": the living strength of the water brings its counterpoint to the perfect scientific geometry of the Albertian "horizon." This map, a real synthesis of science and art, reflects the feeling that Leonardo has for the natural world, and for the way, simultaneously glorious and fragile, human activity expresses its rationality in it. While the survey of the housing of Imola impresses by the elegance of its geometry, the striking curves made by the flow of the river Santerno reveal, like the vein-like tributaries of the rivers and streams of central Italy, the feeling for the "life of the earth," this organism, this living macrocosm.[353]

Overall, the plan of Imola reveals how the demonstrative efficiency of Leonardo's plans is as persuasive as it is scientific, and how it is as concerned with beauty of representation as it is with clear accuracy. If, as with anatomy, the cartographic representation is a "proven" knowledge of the world, this scientific knowledge expresses and affirms itself as an "effect of representation,"[354] that is to say, as a piece of rhetoric.

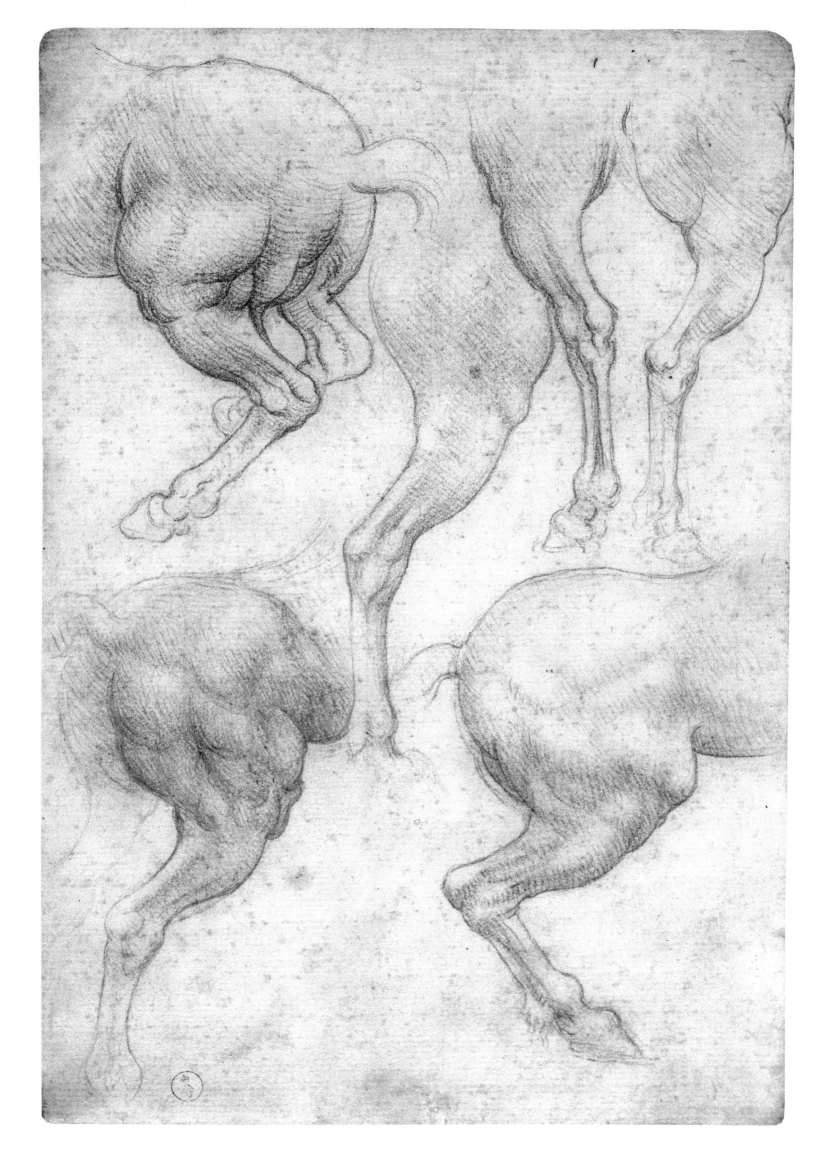

EPHEMERA AND CELEBRATION

According to his first biographer, the Anonymous Gaddiano, Leonardo was sent to Milan by Lorenzo the Magnificent to present a lyre to Ludovico the Moor. An excellent player of the lyre, Leonardo would have been accompanied by the young Atalante Migliorotti who had the reputation of being the greatest singer and interpreter of this instrument at the time, and Leonardo would have been his teacher. Over the years, this event became expanded to heroic proportions. According to Vasari, as already mentioned, Leonardo's musical talents surpassed that of all the other court musicians in Milan; and in 1590, Gian Paolo Lomazzo did not hesitate to describe him in his *Idea del tempio della pittura* ("Idea of the temple of painting") as "such an excellent lyre player that he was better than all the other musicians of his time." These exaggerations must not conceal the fact that the Anonymous Gaddiano's story contained an element of truth. Luca Pacioli, whose testimony there is no reason to doubt, refers to Leonardo's talents as a musician, and a few years later, Paolo Giovio confirms that Leonardo was an excellent singer as he accompanied himself on the lyre.[355]

There was nothing really remarkable about this. Leonardo was one of the very first "painter-musicians." Their number increased towards 1500 and their social success was due as much, if not more, to their music as to their painting. Giorgione was undoubtedly the most famous of them: "He loved playing the lute; he did it so well and sang so divinely that people in high places often called upon him to play at concerts and banquets."[356] Before him, Verrocchio too had been a good musician, as Sodoma, Sebastiano del Piombo, Rosso, and others would be later. This prestige of artist-musicians stemmed from the particular place of music in Italy in the Quattrocento. The refusal of humanism to accept anything that was or appeared to be "scholastic" led to a rejection of the masterly polyphony of the *ars nova*, that had made Italian music the most important in Europe in the fourteenth century. It was replaced by more spontaneous, "popular" fashions, the most important masters in the field of music now being Franco-Flemish, including among others Guillaume Dufay, Josquin des Prés, Heinrich Isaac and Jacob Obrecht. Humanism preferred the practical knowledge of the *cantor* ("singer") to the theoretical knowledge of the *musicus* ("musician"), and favored the simpler forms of polyphony known as the *frottola*, *strambotto* or *villotta*.[357]

Page 218: Fig. 153.
Studies of horses' hindquarters, c. 1508, Turin, Biblioteca Reale.

The letter sent in 1429 by the humanist Ambrogio Traversari to the Venetian Leonardo Giustiniani is significant from this point of view. A member of the Serenissima's Council of Ten and procurator of Saint Mark's, Leonardo Giustiniani (1388–1445) was also a humanist who translated Petrarch and wrote *Strambotti d'amore* ("Love songs"). Known as *giustiniane*, his love poems, written in highly stylized Venetian, had great popular success. Rather significantly, Traversari congratulated him for "having succeeded in things that, contrary to the customs of the ancients, are better known by the people than by scholars, such as the ability to sing very sweet musical tunes."[358] Similarly, it is significant that in 1508, in the translation of the second and third chapters of his *Theoricum Opus harmonicae disciplinae* ("Theoretical work on the disciplines of harmony"), Franchino Gaffurio, chapel master at the cathedral in Milan and probably also a friend of Leonardo's, emphasizes the fact that it is a time when "many illiterates (*illetterati*) are entering the music profession."[359] The prestige and popularity of unwritten music and its own tradition were bound to suit Leonardo, the *uomo sanza lettere*.[360]

Leonardo's musical talent also played an important part in his success in Milan. Traditionally, music had always been very important at the Sforza court, where singers and musicians enjoyed particular prestige. In 1471, Galeazzo Maria had founded a musical chapel to rival that of the cathedral and had appointed two masters, the abbé Antonio Guinati in charge of religious music and Gaspar van Werbecke for secular music. In 1474, the ducal chapel numbered no fewer than forty people, notably including Josquin des Prés. The most important musical figure of the time was undoubtedly Franchino Gaffurio (1451–1522). An exact contemporary of Leonardo, who may even have painted his portrait (fig. 191), he received his musical training at Lodi under Johannes Goodendag. But it was at the court in Mantua that he acquired the humanist cultural education that made him a theoretician of music whose non-academic approach also integrated popular polyphony. Chapel master at the cathedral in Milan from the mid-1480s until his death, he introduced an Italian repertory in contrast to the Northern tendency that prevailed at the ducal chapel. Appointed *musicae professor* ("professor of music") at the court of Ludovico the Moor in 1492, he published a treatise of musical practice, *Practica musicae*, twenty-five editions of which appeared between its first publication in 1496 and 1502. In the last twenty years of the century, the court of Ludovico the Moor was one of the most lively centers of music in Italy, where popular and scholarly traditions, and foreign and national tastes, met and mingled. As a result, apart

from the production of many works of sacred and secular music, Milan was also the place where the fashion developed for compositions inspired by the *frottola*, such as Italian *barzelette*, French "chansons" and Spanish *villancicos*.[361]

Not surprisingly, nothing remains of the pieces of music that Leonardo probably composed—even though eighteen of his one hundred and sixty rebuses were based on musical notes, thus indicating that he mastered musical notation (fig. 154). But there are two kinds of documents that throw some light on his activities in this field: his drawings of musical instruments and contemporary texts describing court events that he has helped to organize and in which music played an important part.

The vast number of musical instruments that he drew shows his lasting interest in the subject. On the whole, these drawings seem to have been inspired by the same enthusiasm as his engineering drawings. Leonardo works on improving existing instruments and, in particular, automating their operation. His objectives are to improve the speed of playing, to make keyboards easier to use, to achieve with a single instrument what would normally require several, and to make simple instruments capable of polyphony. Thus he designs a keyboard system for wind instruments enabling the finger holes to be closed by remotely-operated covers (fig. 30), using a system that will only be effectively applied in 1832. He is also very interested in drums and several of his drawings show that he is trying to extend the sound register, to vary the tone in the course of playing, and to automate the playing of complex rhythms by mechanical means (fig. 156 and *Codex Atlanticus*, 306v-a).[362] Other drawings suggest a type of more personal research. Reflecting his interest in the continuity of natural processes and phenomena and to remedy the discontinuous character of musical notes, Leonardo wants to replace the succession of separate notes by what might be called a *sfumato* (gradation) of sound . This research inspires his drawings of *glissando* flutes (like Swanee whistles) that, as explained in folio 397r-b of the *Codex Atlanticus*, "do not change the pitch of their tone in stages as do most wind instruments, but in the same way as the human voice." Above all, this research inspires the various drawings in which he tries to invent a *viola organista*, that is an instrument that could combine the tonality of the bow and the polyphony of the keyboard, a kind of organ with timbre similar to that of a string instrument (fig. 155). To a certain extent the *viola organista* is an improvement on the established method by which the hurdy-gurdy simultaneously produced one or more continuous sounds (the "drone")

Fig. 154. *Rebus,* Windsor Castle, Royal Library, RL 12192.

Fig. 155. *Organ violin*,
Codex Atlanticus, fol. 218r-c.
Milan, Biblioteca
Ambrosiana.

on which a melodic line is superimposed. To achieve this, Leonardo invents a device for moving the bow automatically, leaving the player free to use his two hands to play on a keyboard that brings the bow and the strings into contact with each other. In some drawings, the *viola organista* is shown using a bow while in others, the strings are sounded by means of a rotating wheel (in the same way as the hurdy-gurdy). But the more detailed and most interesting drawings are those that show a never-ending bow consisting of a mechani-

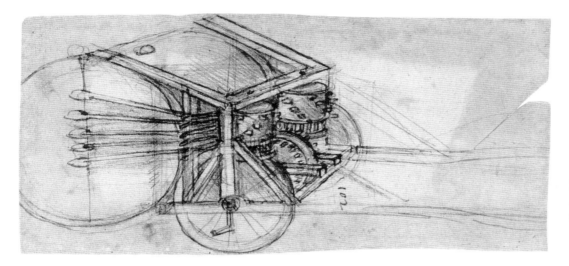

Fig. 156. *Wheel-driven drum, Codex Arundel*, fol. 218r-c and 306v-a. London, The British Library.

cally operated horsehair belt, guided by one or two pulleys, moving in a continuous or alternating movement.[363] The technical science of the engineer and Leonardo's observations on movement, its transmission and transformation, are used here in a most brilliant manner in the service of music, "the representation of things invisible." It is only at the beginning of the seventeenth century that a similar instrument will be built in Nuremberg by Hans Hayden, the celebrated *Nurnbergisch Geigenwerk* ("Nuremberg violin machine") described at length by Michael Praetorius in his *Syntagma Musicum* in 1618.

Other "musical" drawings by Leonardo are, on the other hand, directly linked to theatrical events, entertainments and court festivities in which music played an important part. For many of these, Leonardo held the important position of "apparatore," known in France as "arrangeur de festes" (impresario).[364] During the 1490s theatrical and court events were particularly sumptuous, partly inspired by the wish to emulate the Gonzaga court in Mantua or the Este court in Ferrara. In addition to the theatrical events organized at the court and in the palaces of his courtiers almost every year, Ludovico the Moor also used

the solemn celebration of important political or dynastic events to glorify his own princely magnificence. In 1490, the occasion is the wedding of Gian Galeazzo Sforza and Isabelle of Aragon; in 1491, the double wedding of Ludovico the Moor to Beatrice d'Este and that of Anna Sforza to Alfonso d'Este; in 1493, the wedding of Bianca Maria Sforza to the emperor Maximilian as well as the birth of Ludovico's first son; in 1495, it is the birth of his second son and his official investiture as legitimate duke of Milan. Ludovico also had a theater built in the Castello Sforzesco where events such as readings, music or dance could be organized, without the need to celebrate anything in particular. The theater was inaugurated in 1493 with *Mopsus and Daphne* by Niccolo da Correggio (who also presented his *Innamoramento di Orlando* there in 1495); and in 1496 a performance of *Timon* by court poet Bernardo Bellincioni was "staged" by Leonardo in honor of Isabelle d'Este.[365]

Leonardo's involvement in these events is documented on three occasions. In 1490, he designs the machinery and, probably the whole production of *Paradiso* by Bernardo Bellincioni, performed on the occasion of the wedding of Gian Galeazzo to Isabelle of Aragon; in 1491, he is asked to design the cortege and

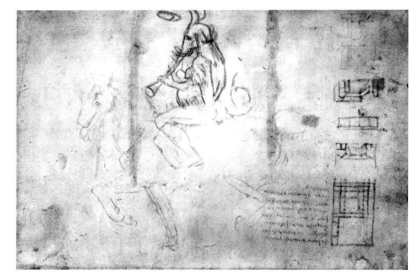

Fig. 157. *Musician costumed with an elephant's head*, *c.* 1507, black chalk, 7¾ x 11 in. (19.7 x 28 cm.) Windsor Castle, Royal Library, RL 12585.

parade for Galeazzo da Sanseverino, the general of Ludovico's militia and hero of the *Giostra* (tournament), organized during the three days of festivities celebrating the double wedding mentioned above; and finally, in 1496, he stages *Danaë*, written by Baldassare Taccone, at the palace of Count Gaiazzo. Music was an integral part of these events, and the musical originality displayed by

Leonardo on these occasions is confirmed by the description of the cortege of 1491: "The crowd of riders [...] waved gnarled sticks while ten high-pitched trumpets played an exotic little piece and musettes made from goatskins were played like bagpipes."[366] The famous musical monster on horseback (fig. 157) was probably part of Galeazzo da Sanseverino's parade of "wild men."

Naturally, music was only one of the aspects of the wide range of activities for which Leonardo was responsible as "apparatore" of festivities, and the theatrical and other events organized at the court were an ideal opportunity to make use of the "universality" of his talents. His inventions in the field of stage machinery are today the most studied part of his creations, but other aspects of these productions will be considered first. Far from being a waste of time or "futilities,"[367] they formed an essential dimension of the activities of the courtly artist, since he created for the court the image it wanted to have of itself, and the court itself took an active part in them. It is Isabelle of Aragon who personally opened the "festival and performance" of 1490 by performing two dances to the sound of tambourines, accompanied by two of her ladies-in-waiting and the ambassador of the King of Naples.[368] In 1496

Fig. 158. *Allegory of the State*, pen and brown ink, 8 x 11 in. (20.6 x 28.3 cm.) Oxford, Christ Church.

Leonardo himself makes a note of the names of the personalities who are to play the various parts in Taccone's *Danaë*.[369] Indeed, as Paolo Giovio wrote, at that time Leonardo's prestige is directly linked to his unrivaled talent in this field: "An admirable inventor and arbiter of elegance and the pleasures of the theater above all, singing skillfully as he accompanies himself on the

227

lyre, he was much appreciated and greatly loved by all the princes who knew him."[370] As in other fields, he studied all these subjects thoroughly while putting his own imprint on them.

His rebuses, allegories and other mottoes, fables, riddles in the shape of prophecies, witticisms, jokes and anecdotes—in other words Leonardo's "literary" works—are mostly inspired by these court practices. Ludovico the Moor was particularly fond of allegories and mottoes and, like Filarete, who created very complicated allegories for Francesco Sforza (sometimes in collaboration with him), Leonardo produces allegorical drawings intended to illustrate the merits of the Prince—probably for special occasions[371]—whether it be his Prudence as ruler or the Envy that his Virtues aroused (fig. 158).

Sometimes, however, the allegories seem to have a more personal dimension, that of Pleasure and Sorrow for instance, and if the drawing is not accompanied by a written explanation, the complexity and singularity of Leonardo's invention make its interpretation impossible today, as it probably was in the past.[372] Leonardo makes this genre his own, and he consciously cultivates its enigmatic character. Even though his rebuses (fig. 154) some-

Right: Fig. 159. *Prisoner*, after 1512, black chalk, 7¼ x 5 in. (18.4 x 12.7 cm.) Windsor Castle, Royal Library, RL 12573v.

Far right: Fig. 160. *Young man on a horse, c.* 1513, pen and ink on black chalk. Windsor Castle, Royal Library, RL 12574.

times cause disagreement among the experts,[373] they can often be explained and their relative simplicity, linked to the genre itself, arises from the fact that they were also parlor games—and therefore not too difficult to understand. Leonardo's approach to work is clearly reflected in the systematic accumulation of these word puzzles and in the fact that some of them seem

Fig. 161. *Young man with a lance*, after 1513, pen, ink and wash on black chalk. Windsor Castle, Royal Library, RL 12575.

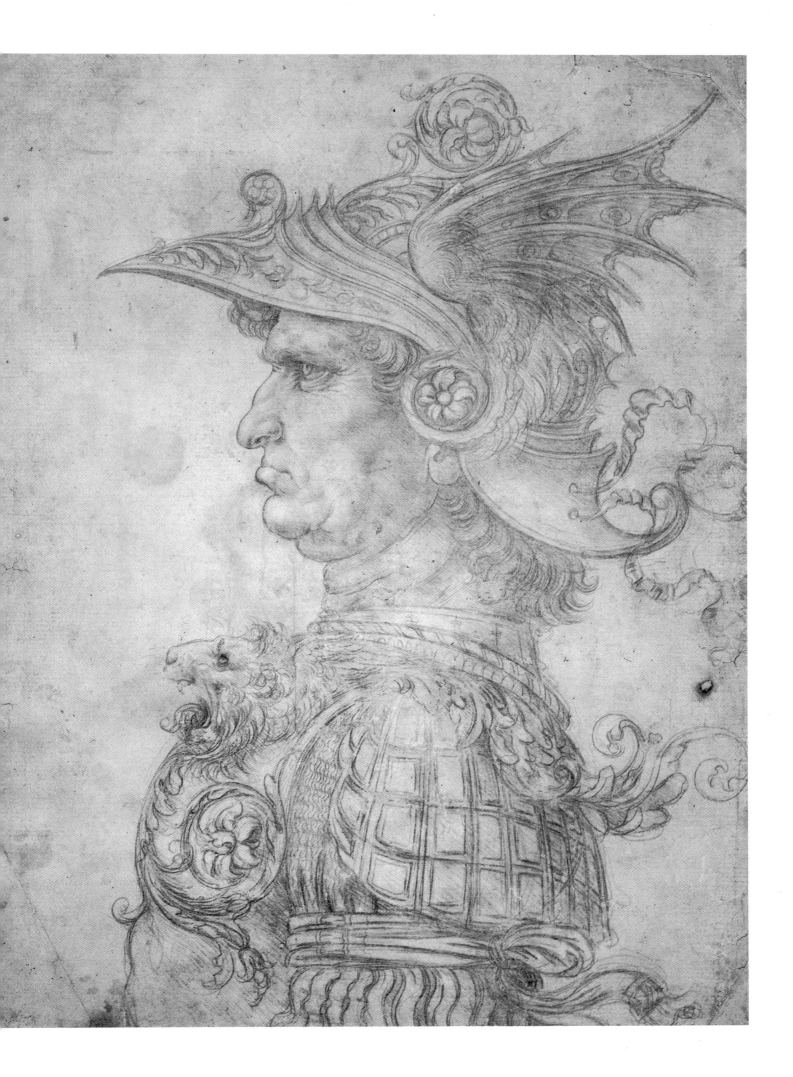

to have a personal dimension and were apparently not intended for use at court.[374]

It appears that word puzzles fell completely out of favour after 1490 and, between 1497 and 1499, Leonardo introduces the courtiers in Milan to a new kind of entertainment: the riddle, presented in the form of a terrifying prophecy, whose solution lies in the most ordinary aspects of daily life. Thus, the prophecy "the dead will come out of the earth and their proud movements will drive

Fig. 164. *Masks of monsters*, 1493–95, pen and ink on black chalk, 8½ x 4½ in. (21.5 x 11.2 cm.) Windsor Castle, Royal Library, RL 12367.

Page 230: Fig. 162. *Young man in theatrical costume*, c. 1513, black chalk, 5½ x 6¾ in. (14 x 17.3 cm.) Windsor Castle, Royal Library, RL 12576.

Page 231: Fig. 163. *Profile of a warrior as tournament captain*, c. 1480, silver-point on prepared ivory surface, 11¼ x 8¼ in. (28.5 x 20.8 cm.) London, The British Museum.

countless human creatures from this world" only means that " iron, dead, is extracted from the earth to make weapons that will kill many people." Another reads that "winged creatures will support people with their feathers"; this refers not to flying machines but to "the feathers used to stuff mattresses."[375] Written after the death of Beatrice d'Este in 1497, these recreational prophecies exploits and parodies the "prophetic awakening" that prevails in Italy at the end of the century. To some extent, Leonardo plays the part of a "street prophet" at court, momentarily terrifying his audience.[376] But these riddles also reveal certain collective anxieties and sometimes, as will be seen later, personal fantasies and pessimism. In fact, Leonardo takes these parodic prophecies seriously enough to think about—as was his wont—collecting and organizing them systematically in the form of a treatise.[377]

It was, however, as "apparatore" or "impresario" that Leonardo was best

able to express the universal extent of his inventiveness. Using today's terms for the various professional specialties, he was at the same time producer (and when required, choreographer), stage designer, wardrobe master and make-up artist, and, in his capacity of engineer-architect, inventor of stage machinery. Their late date prevents us from confidently associating several of his designs for theater costumes to particular plays documented elsewhere (fig. 159, 160, 161, 162). On the other hand, it is highly likely that the monstrous heads preserved on a sheet in the Royal Library, Windsor (fig. 164) were designed for Galeazzo da Sanseverino's cortege. On this occasion, as Leonardo himself writes on folio 15v of *Manuscript C*, he has imagined "costumes of wild men" whose description by a contemporary clearly expresses the "marvelous" nature of Leonardo's creations: "First there was a fantastic war horse, covered with scales of gold that the painter had embellished with peacock's eyes. Between the scales, where they opened up, wiry horsehair protruded, bristling like that of the most horrible wild beast. The head of the war horse was blond, as if made of gold but with a menacing look, and its long, curved horns sparkled. The decoration on the saddle, breast and arms of the rider [Galeazzo da Sanseverino] also consisted of gold scales embellished with peacock's eyes, and on his head was a winged serpent whose tail and legs were wrapped around his back. His shield was decorated with a resplendent bearded image in gold. Thus adorned, he led the cortege, followed by his attendants, men with long beards, on horses whose legs were decorated with balls of horsehair of various colors. As for the rest of their clothes, they much resembled wild barbarians, straight out of the forest, and they reminded us immediately of the Scythians and those generally known as Tartars."[378] Although not particularly innovative, the theme of the "wild men" being known already, Leonardo's interpretation of it shows an unparalleled creative imagination, all the more effective in that it reflects the amazing setting that he has planned for the homage paid by the cortege to Ludovico the Moor.[379]

Unrivaled for his costumes, Leonardo also designed hair styles, make-up and, complete designer that he was, even the weapons used on stage. His manuscripts contain several recipes for the dyeing of hair and, very interestingly, one of the drawings in the Royal Library at Windsor shows a study for the face of Leda (on which Leonardo was working in about 1504), that is also a model for a wig. This is irrefutably indicated by the accompanying inscription: "It can be taken off and put on without being damaged."[380] Similarly, the very beautiful sheet on which the hair style for Leda is shown from four different

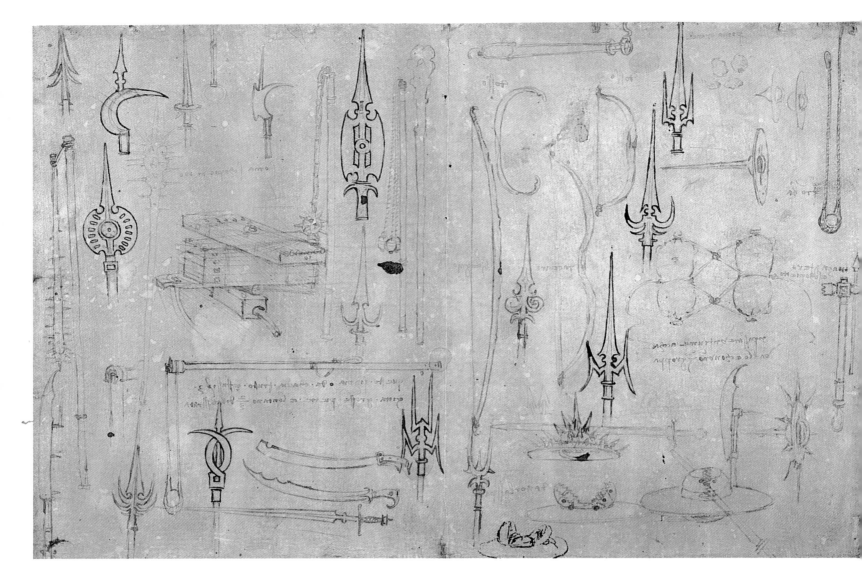

Fig. 165. *Studies of weapons*,
silver-point, pen and brown ink, 8¼ x 15¼ in. (21 x 39 cm.)
Paris, Musée du Louvre, inv. 2260.

angles may have been used as a study for a wig (fig. 166). It is also possible that the drawings of hand weapons that look as elegant as they are menacing were intended for the theater or court tournaments (fig. 165).

In Argentan from May 3 to May 6, 1518, on the occasion of the double celebration of the marriage of Madeleine de La Tour d'Auvergne to Lorenzo de' Medici and the baptism of the Dauphin of France, a day of *giostra* (tournament) was followed by two whole days of a lavish spectacle reenacting the

Fig. 166. *Studies for the head of Leda*, between 1504–10, pen and ink on black chalk, 8 x 6½ in. (20 x 16.2 cm.) Windsor Castle, Royal Library, RL 12516.

battle of Marignano around a papier-mâché castle. From its ramparts, cannons fired "with great noise, balls that bounced as they fell to the ground, to the great pleasure of all and without causing any damage, something new and arranged with great ingenuity," while other cannonballs made of paper exploded "noisily but without effect." After a long battle, the walls fell down to reveal a "strong bastion" that King François I took without difficulty.[381] Leonardo's name is not recorded on this occasion, but he probably took part in the conception of this imaginary battle, in which some of the war machines he had imagined and designed in Milan may have been used.

It was indeed in the world of the theater that the engineer came to construct his machines. From Bellincioni's *Paradiso* and Taccone's *Danaë* to Politian's *Orfeo*, the development of Leonardo's inventions can be followed, starting with the improvement of established techniques and going on to create

235

radical innovations, founded on the automated coordination of the mechanisms used.

In 1490, the ball for the marriage of Gian Galleazzo and Isabelle of Aragon, was opened by Isabelle, dressed "in the Spanish manner," dancing to the sound of tambourines. This was followed by a parade of masked dancers, dressed successively in the Spanish, Polish, Hungarian, Turkish, German and French style, who paid homage to the Duke in the name of the sovereigns of Europe, and then danced in honor of the Duchess.[382] After these choreographies, which were probably created by Leonardo, the actual "performance" began. Conceived as a ballet spectacle, it showed Jupiter accompanied by six planetary deities (Apollo, Mercury, the Moon, Venus, Mars and Saturn), paying homage to the beauty and virtues of the Duchess in a succession of speeches, songs and dancing. Set in the Duke's chapel, the room had been completely done up by Leonardo, and its vaulted ceiling was decorated with foliage that seemed to anticipate the Sala delle Asse. The "high point" of the spectacle was the "Paradise" from which the various planetary divinities descended after Jupiter's speech. Semi-oval in shape, its interior

Fig. 167. *Drawing for the scene of Danaë*, pen and bister, New York, The Metropolitan Museum of Art, Rogers Fund, inv. 17.142.2

was entirely painted in gold, embellished with numerous lights representing the stars, and its circumference was decorated with the twelve signs of the zodiac illuminated by lights placed in glass spheres. Here Paradise received the seven planets, rotating and dressed "as the poets described." Its "beauty and splendor" unveiled in two stages after three trumpet calls, caused utter

amazement among the spectators who "thought at first that they were looking at paradise itself."[383] In fact, Leonardo was only reviving an ancient piece of Florentine stage machinery. Developed by Brunelleschi in 1439 for the Ascension Day celebrations organized in the church of the Carmine on the occasion of the Council of Florence, the Paradise machine inspired a similar device created by Cecca in 1467, and used again in 1471, as it happened during Galeazzo Maria Sforza's visit to Florence.[384] But in Milan, the astonishingly sumptuous character of the setting further increased Leonardo's prestige and glory as "arranger" of spectacles.

Based on a similar principle, neither were the machines built in 1496 for the performance of Baldassare Taccone's *Danaë* in the palace of Gian Francesco Sanseverino, Count of Caiazzo, entirely radical or original. Leonardo, however, gave them a new use. Taccone's play involved several comings and goings between the palace of King Acrisius, the tower in which he had locked up his daughter, and the sky where Jupiter and the planets resided. In the second act, Mercury, comes down from the skies and goes up again, twice; in the third act, Jupiter turns into golden rain; in the fourth act, Danaë, who has turned into a star, ascends to the sky, and in the fifth act, Hebe descends from heaven, followed by Apollo. For this staging, Leonardo adapts the dramatic effects of the movements of descent and ascent—already common in the *sacre rappresentazioni* ("holy performances") of the Annunciation and Assumption—to a mythological play, using the so-called Florentine machines.

Directly connected with the performance of *Danaë*, a drawing in the Metropolitan Museum in New York (fig. 167) and several sketches on folio 358v-b of the *Codex Atlanticus* (fig. 170) clearly indicate the presence of a traditional mandorla. But it is possible that this was integrated into a more complex system that allowed part of the (apparent) ceiling of the theater to descend towards the stage.[385] Above all, Leonardo used these machines to achieve what would today be called "special effects" of a most impressive kind, in which stage music played an important part. As well as showing the golden rain falling on Danaë, the third act also had the amazingly realistic metamorphosis of Jupiter who "disappeared from sight" and turned into gold to the sound of "so many instruments that it was an incredible, enormous thing." Similarly, at the end of the fourth act, during Danaë's metamorphosis into a star, "the audience could see a star rising from the earth and rising up slowly towards heaven, with sounds so powerful that the palace felt as if it was going to fall down."[386] The association and simultaneousness of movement between earth and heaven,

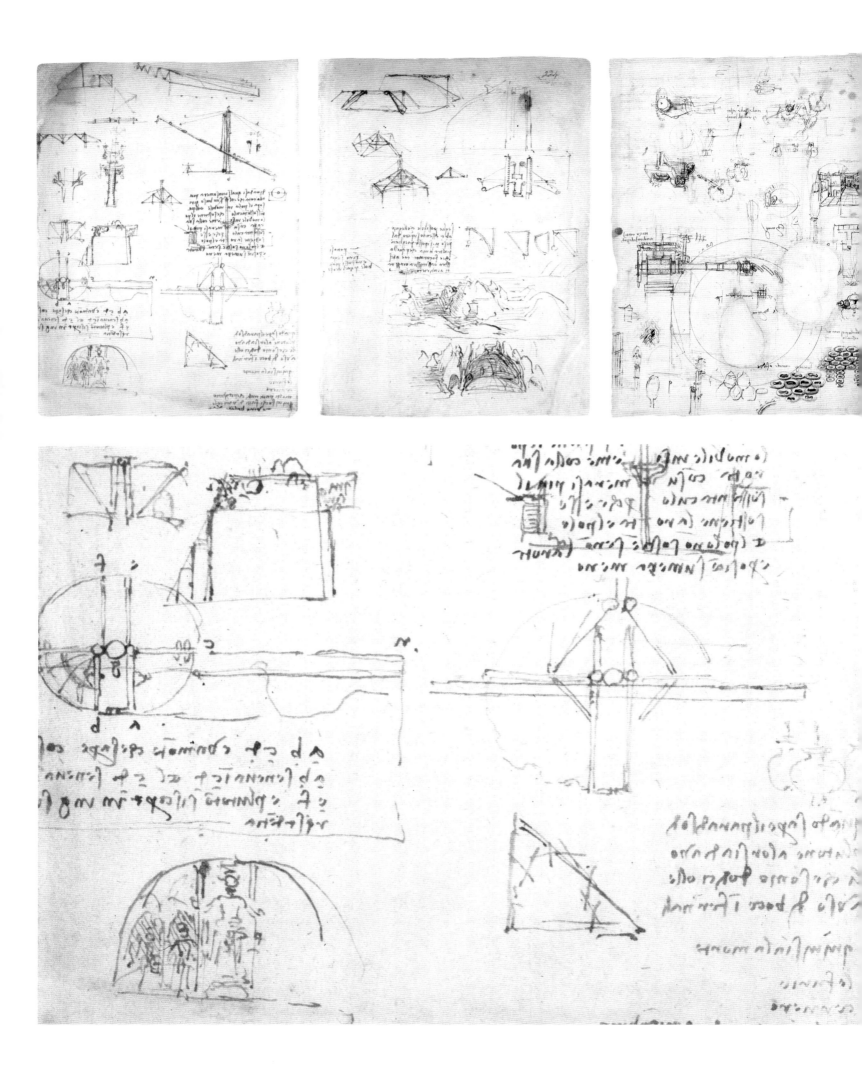

of metamorphoses and music of such cosmic violence were undeniably an extraordinary innovation.

Leonardo's participation in the staging of Politian's *Orfeo* raises more complicated questions. While the drawings of folios 231v and 224r of the *Codex Arundel* (fig. 168, 169) made possible Carlo Pedretti's brilliant reconstruction of the stage setting (fig. 171) (this time original) conceived by Leonardo, it is nevertheless impossible to know whether it was ever realized. (It is actually rather doubtful that it was, since Leonardo's machinery has never been described by an eye witness, it is never referred to, and it does not appear to have had any influence on the history of the theater before its reinvention in Florence in 1568.)[387] Nonetheless, Leonardo's idea was truly one of genius. For the descent of Orfeo to the Underworld, Leonardo conceived of a system of gearwheels, weights and counterweights, enabling the mountain—up until this point just scenery—to open up and reveal Pluto on his throne, rising from the depths of the Underworld. This was of course be accompanied, as Leonardo's handwritten notes indicate, by the terrifying singing of devils and the cries of children, the whole scene being illuminated by countless infernal lights.

Here Leonardo invents the first revolving stage in the history of the theater. Even more than the changing of scenery in full view, his idea means that the audience is brought visually inside the scenery itself. He sees it as a variation on Brunelleschi's machines, as is reflected in the fact that he himself calls this machinery "Pluto's Paradise," the term "paradise" referring not to the heavenly place but, technically, to the type of machine used to accomplish the appearance of gods in the theater. But the complexity of the effect so obtained and, most of all, the simultaneous timing of the mountain opening up and Pluto's throne rising from below the stage represents a great change and a considerable technical advance. These developments were made possible by Leonardo's engineering skills and his interest in the transmission and transformation of movement. At the same time, the idea of the mountain changing into an infernal cave is very reminiscent of the text mentioned earlier describing the "vast cavern" and the dual effect it had on him: "Fear and desire, fear of the dark, menacing grotto, and a desire to see if it did not enclose some extraordinary marvel." For Leonardo, the theater was also an art that enabled him to express his intuition of the world in a concrete manner.

Leonardo's conception of spectacular performances is inseparable from the rest of his activities. It is fascinating to see how his systematic and rational approach to stage setting leads him to develop proposals that will only see the

Opposite page, top left and bottom: Fig. 168. *Drawings for scenery for Orfeo, Codex Arundel,* fol. 231v. London, The British Library. Whole leaf and detail.

Top center: Fig. 169. *Machinery for Orfeo, Codex Arundel,* fol. 224r. London, The British Library.

Top right: Fig. 170. *Studies for the production of Danaë, Codex Atlanticus,* fol. 358v-b. Milan, Biblioteca Ambrosiana.

239

light of day much later. Apart from the automata (such as the lion, the automobile tank, and also the mechanical man seen on folio 216v-b of the *Codex Atlanticus*, which was certainly never built, fig. 173),[389] and the sets for *Orfeo*, his manuscripts show that he reflected on the best arrangement of the theater for the audience, and of the backstage area for the actors. They also show that he was the first to consider the idea of the curtain rising rather than falling, as had been traditional.[390] Finally, roughly sketched next to preparatory draw-

Fig. 171. Reconstruction by Carlo Pedretti of the stage machinery for *Orfeo*.

ings for the production of *Danaë*, and therefore datable to 1496–97, is the little drawing of a "humanist" stage on folio 358 v-b of the *Codex Atlanticus* (fig. 172). This preceded Baldassare Peruzzi's famous drawing of the "comic stage" by more than fifteen years; although, apart from experiments at Ferrara in 1508 and at Urbino in 1515, in the opinion of experts, Peruzzi's drawing would have been the first complete, "modern" expression of a stage in perspective, inspired by Vitruvius.[391]

It is therefore even more surprising that Leonardo was not called upon to take part in the organization of the great theatrical events taking place in Rome between 1513 and 1515, in which Girolamo Genga, Raphael and Peruzzi were involved, in spite of the fact that he was then living at the Belvedere. It is also striking that in spite of the prestige and fame of his actual achievements, they had no real impact on the history of the theater. This was probably because, in spite of the technical improvements made by Leonardo, his sets still reflected the Quattrocento spirit of the marvelous. While Roman humanist culture favored the ancient type of stage with its regular "size" and, above all, its static quality, Leonardo's dynamic conception aimed to achieve a complete spectacle, combining poetry, music, dance and machines, with moving structures

for the scenery. It is only in the second half of the sixteenth century that the court audience would put pressure, through "intermediaries," on theater designers and architects to complete the effect of theatrical illusion by using moving scenery and machines.[392] Leonardo's lack of influence on the history of the theater has not been caused by his capriciousness but by the political and social circumstances in which he was destined to exercise his universality.

Far left: Fig. 172.
Scenery from *Danae*.
Detail of Fig. 170.

Right: Fig. 173.
Studies for an automaton,
Codex Atlanticus,
fol. 216v-b.

EQUESTRIAN MONUMENTS

In the last paragraph of the letter he addressed to Ludovico the Moor offering him his services, Leonardo does not list his talents as man of the theater or even as a musician among his peacetime skills. This makes one think that this letter might have been written in Milan itself, after Leonardo, accompanied by Atalante Migliorotti, had presented his silver lyre to the Duke. On the other hand, Leonardo emphasizes his skills in civil engineering, and painting. But above all, he claims he is capable of building the equestrian monument that Ludovico the Moor wants to erect in memory of his father, Francesco Sforza.

The argument was well chosen. The project was an old one because it was Ludovico's brother, Galeazzo Maria Sforza, who had had the idea in 1473, seven years after succeeding his father as the head of the Duchy of Milan. It was not intended to be a funerary monument but a statue to glorify the dynastic legitimacy of the Sforzas. This was indicated by its chosen site outside the Castello Sforzesco, in the tradition of the Scaliger monuments in Verona and the descriptions of equestrian monuments that Filarete had pictured for the

ideal villa of Sforzinda. After the death of Galeazzo Maria—he was murdered in 1476—Ludovico gradually took power in place of the young Gian Galeazzo and, quite logically, at the beginning of the 1480s, he decided to take over his brother's project. That the large size of the monument (three times life-size) was itself part of a political program is supported by the *De Sculptura* by Pomponius Gauricus, which in 1504 stated that "very large" statues were those "that trebled one or more times the size of the human body," and that these were reserved for the gods, even though some Roman kings and barbarians were also so represented.[393] Leonardo's proposal was the more opportune because there was no other sculptor in Milan capable of undertaking such a task in bronze. Since the middle of the century it had become a Florentine specialty: Niccolo da Baroncelli and Antonio di Cristoforo made the statue of Nicolo III d'Este in Ferrara between 1444 and 1451 (destroyed in 1796); between 1445 and 1453, Donatello successfully completed Gattamelata's equestrian statue in Padua and, from 1479–80, Verrocchio worked on Bartolommeo

Fig. 174. Antonio del Pollaiuolo, *Drawing for the Francesco Sforza equestrian monument*, pen and brown ink, brown wash,11¼ x 9½ in. (28.5 x 24.4 cm.) New York, The Metropolitan Museum of Art, Lehmann Collection, inv. 1975.1.410.

Colleoni's statue, which was cast in bronze and installed in Venice after his death in 1488.[394]

At the time no other Florentine sculptor would have been capable of building such a monument, so Leonardo's offer was gladly accepted by Ludovico, who entrusted him with the task of completing the project. This occupied Leonardo

until 1494. In spite of his ultimate failure, the story of the successive stages and vicissitudes that accompanied the development of this monument is particularly interesting.

At first, until 1490 in fact, Leonardo works on the idea of a horse rearing over a vanquished enemy. Possibly inspired by some Imperial Roman coins but completely new for an equestrian monument, the idea probably originated with Ludovico himself, since it also occurs in a drawing by Antonio del Pollaiuolo, conceived for the Sforza monument (fig. 174). Such a request could not have failed to please Leonardo. The motif of the equestrian battle and rearing horse is also found in the *Adoration of the Magi*, a work he leaves unfinished in Florence because he is going to Milan. The motif is found again in *The Battle of Anghiari* dating from 1503–04, and also on the late page of studies of Saint George (fig. 175). Although only two drawings have survived that can be directly related to the actual study of this group (fig. 176, 179), during these same years Leonardo makes a systematic study of the proportions of the horse (fig. 177).

His aim is to combine the beauty of art with the science of nature and, following the advice of *De Statua* and Alberti's *De Pictura*, to make a choice from the scattered beauties of nature to achieve a more perfect but "true" beauty. This type of study was made both easier and more necessary by the prestige and popularity of horses in Milan. The stables of Ludovico and Galeazzo da Sanseverino competed with those of the Gonzaga in Mantua for the purity and variety of their breeds, and long before the famous Sala dei Cavalli ("Room of the horses") was painted by Giulio Romano at the Palazzo del Te in Mantua, the Sforza stables in Milan were embellished with such striking external decorations that they were mentioned in 1515: "Et hors icelles estables du coste dudit parc a grans cheuaulx en paincture de plusieurs coulers tous en differens arrestez." ("Outside these stables by the park are great horses painted in several colors all in different positions.")[395] It is quite possible that several of Leonardo's drawings were used as models for these paintings.

But in July 1489, Ludovico the Moor becomes discouraged by Leonardo's slowness and looks for another sculptor in Florence capable of completing the project.[396] On April 23, 1490, Leonardo writes on folio 15v of *Manuscript C*, that he is "starting work on the horse again." The momentary crisis is resolved by a radical change in the representation of the horse. Rejecting the motif of the rearing horse, Leonardo decides to adopt the more traditional image of the horse walking. This change in approach is not a return to the tradition of

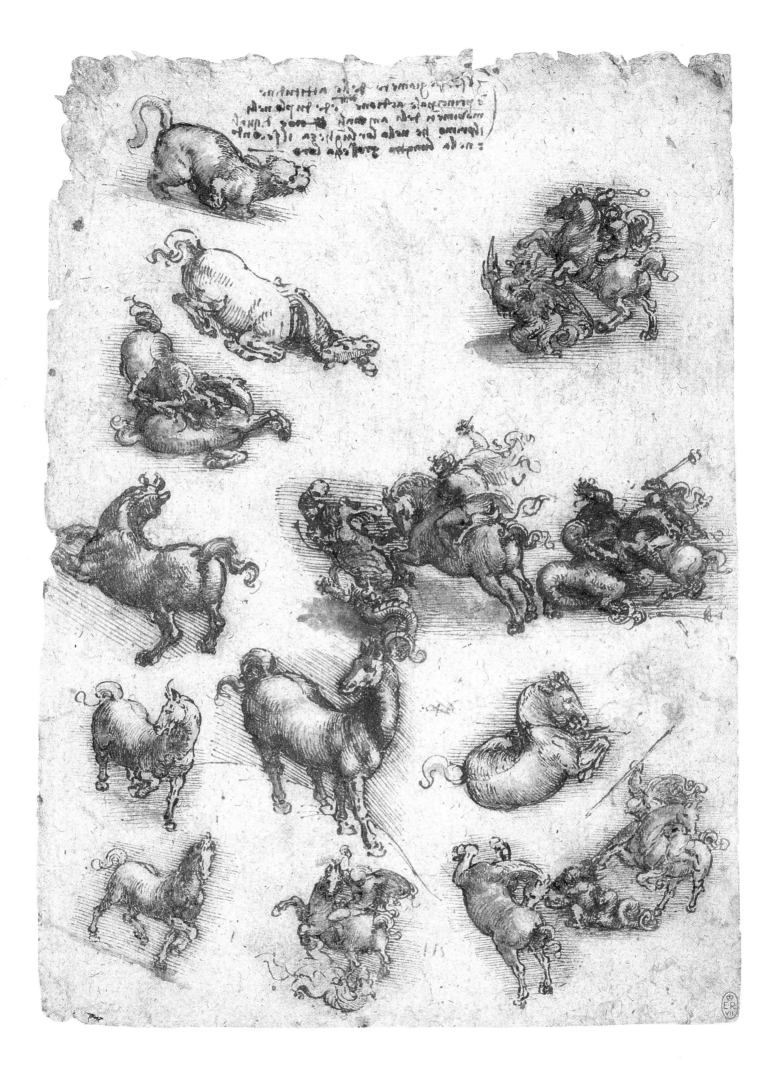

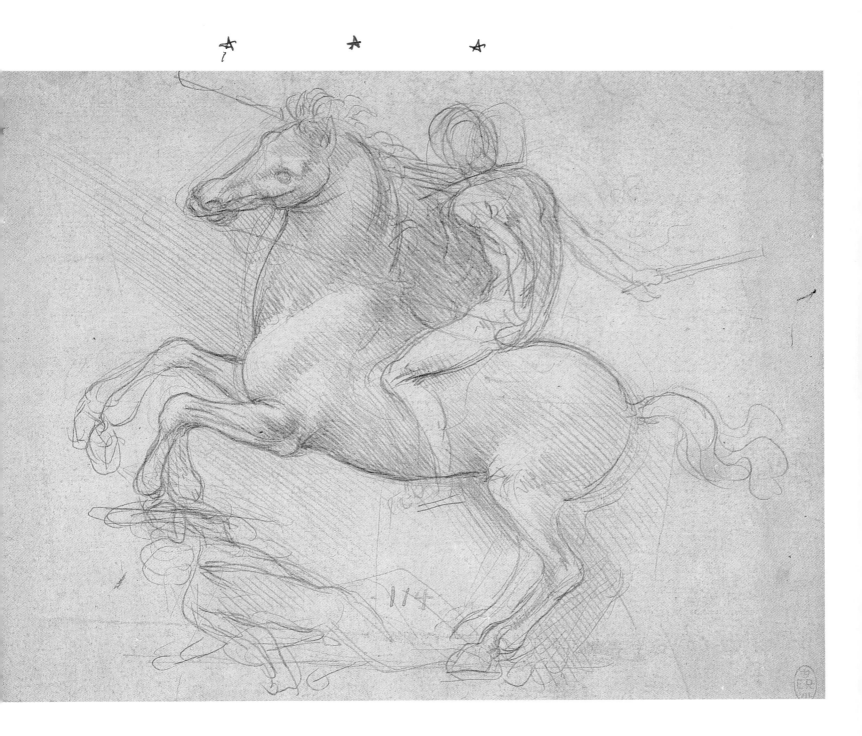

Above: Fig. 176. *Study of horseman* (first idea for the Sforza monument), 1485–90,
silver-point on blue prepared surface, 5¾ x 7¼ in. (14.8 x 18.5 cm.)
Windsor Castle, Royal Library, RL 12358 r.

Opposite: Fig. 175. *Studies of cats, horses and Saint George*, 1517–18,
pen and ink on light black chalk outlines, 11¾ x 8¼ in. (29.8 x 21.2 cm.)
Windsor Castle, Royal Library, RL 12331.

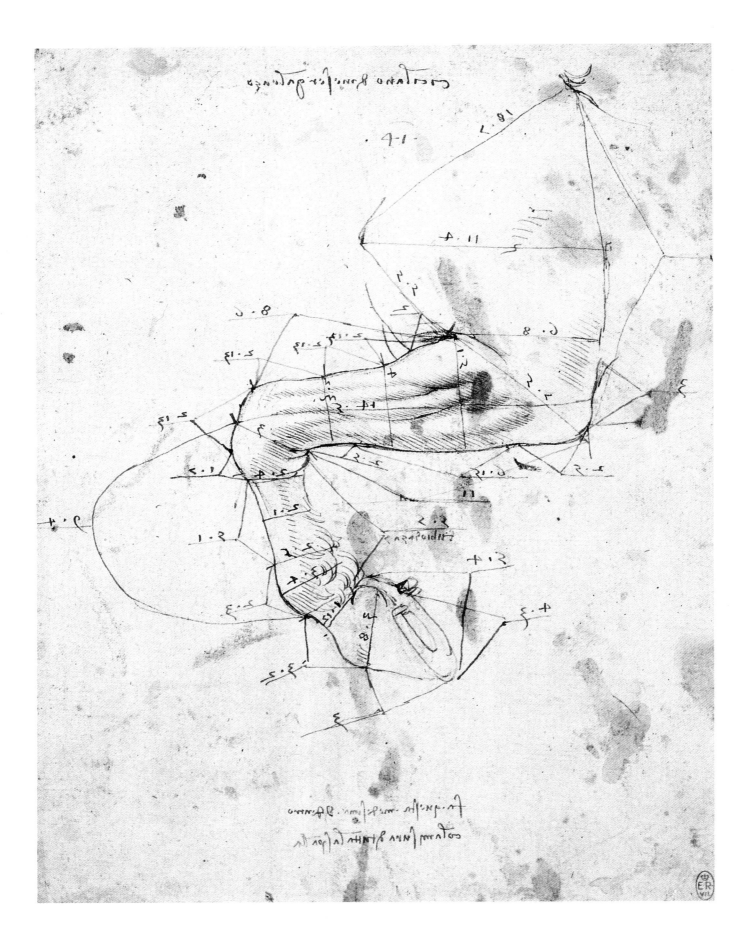

Fig. 177. *Proportions of horse's leg*,
c. 1491, pen, 9¾ x 7¼ in. (25 x 18.7 cm.)
Windsor Castle, Royal Library, RL 12294r.

Donatello or Verrocchio, but the result of a visit with Francesco di Giorgio to Pavia, where Leonardo sees the Roman equestrian statue in gilt bronze known as "Regisola." The minute drawing that he makes of it (fig. 178) is indeed accompanied by a rather revealing comment: "In that in Pavia, one praises the movement more than anything else. It is better to imitate ancient things than modern ones. Can beauty and usefulness not be associated, as one can see they are in fortifications and in mankind? Trotting is almost in the nature of

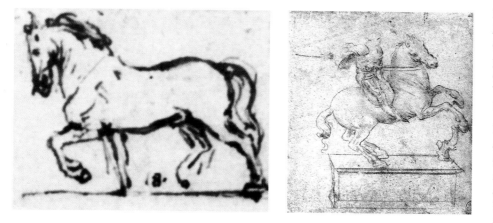

Far left: Fig. 178. *Horse walking* ("Regisola"), 1490, pen and ink, 1¼ x 1½ in. (2.9 x 3.6 cm.) Windsor Castle, Royal Library, RL 12345r.

Left: Fig. 179. *Study for equestrian monument* (first idea for the Sforza monument on a plinth), *c.* 1484, silver-point, blue prepared surface, 4½ x 4 in. (11.6 x 10.3 cm.) Windsor Castle, Royal Library, RL 12357r.

the free horse. There where the natural movement is absent, an artificial one must be created."[397] The controlled movement of the "Regisole" suggests to him a model of energetic configuration that, better than those of Donatello or Verrocchio, which were probably too static in Leonardo's eyes, leads to him adopt a pose for the horse that is also better suited for casting as a colossal statue and that would enable him to satisfy Ludovico's impatience.

Leonardo also undertakes new studies on proportions and, while accumulating a large amount of data unrelated to the project he is planning,[398] he completes a colossal model of the statue in clay. It is 23' 7" (7.20 m) high and towered over Donatello's Gattamelata (10' 6"/3.20 m) and Verrocchio's Bartolommeo Colleoni (13' 1"/4.00 m). Completed in 1493, it excites great admiration when it is shown on the occasion of the marriage of Bianca Maria Sforza and Emperor Maximilian. At the same time, in 1491 and again in 1493, Leonardo carries out research and thinks deeply about the work necessary for casting such a large mass in one piece. For reasons as obvious as they are unavoidable, Leonardo decides to abandon the ancient "lost wax" process that was still popular during the Renaissance.[399] He is therefore obliged to calculate the amount of metal needed and the ultimate thickness of the bronze

with the greatest accuracy. After repeated "mental experiments," he arrives at radically new technical solutions that will only be rediscovered (or applied) at the end of the seventeenth century with the casting in one piece of the colossal statue of Louis XIV by François Girardon.[400] Leonardo's drawings clearly reflect the intensity of his research (fig. 182, 183). As with some of his machines, in particular the ornithopter, these pages bring out his exceptional power of visualization and, instead of being drawings making possible the construction

Right: Fig. 182. *Diagram for casting the great horse, Ms. Madrid II*, fol. 149r. Madrid, Biblioteca nacional.

Far right: Fig. 183. *Framework for transporting the great horse, Codex Atlanticus*, fol. 216v-a. Milan, Biblioteca Ambrosiana.

of the machines they describe, they are impressive and convincing masterpieces in their own right (fig 180, 181).

The fact that this research did not produce any results was not Leonardo's responsibility but the consequence of the turbulent political circumstances in northern Italy at the time. On November 17, 1494, Ludovico the Moor gave all the bronze intended for the monument to Ercole d'Este for making cannons. Then in 1499, in the days following the capture of Milan by the troops of the French king, archers amused themselves by shooting arrows at the vast clay model. In so doing, they destroyed all traces of the project that had occupied Leonardo for over ten years. In 1510, Ercole d'Este asked the French who now ruled Milan for the return of the "molds" of the great horse; he would have liked to erect a monument to his own glory in Ferrara. But though politely received, his request was never granted.

Page 248: Fig. 180. *Armature of mold for the great horse, Ms. Madrid II*, fol. 156v. Madrid, Biblioteca nacional.

Fig. 181. *Mold for the great horse, Ms. Madrid II*, fol. 157r. Madrid, Biblioteca nacional.

Between 1508 and 1510, Leonardo again has the opportunity to design an equestrian monument. Still in Milan, he is asked to build the "Sepulcro" by

Giovanni Giacomo Trivulzio, Marshal of France, Marquis of Vigevano and Governor of Milan—a man who had played a fundamental part in the fall of Ludovico the Moor. Unlike the "great horse," this was not to be an outdoor monument. From what can be deduced from Leonardo's drawings and, in particular, from the only written document on the subject, an estimate written by Leonardo himself in 1507–08,[401] this was to have been a group surmounting a funerary monument to be erected in a chapel of the church of San Nazaro.

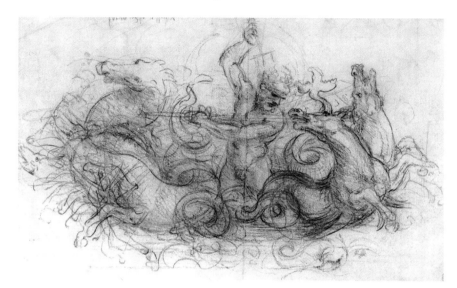

Fig. 184. *Study for a Neptune with sea horses*, 1503, black chalk, 10 x 15½ in. (25.1 x 39.2 cm.) Windsor Castle, Royal Library, RL 12570.

Giovanni Giacomo Trivulzio will not die until 1518, but his tomb was to show him lying on a sarcophagus, carried by six harpies, under a structure supported by four columns with bronze capitals, supporting a roof on which the equestrian group would stand; at each corner of the tomb two slaves were to stand, probably chained to the columns. The drawings show that Leonardo was uncertain about what form to give the surrounding structure, sometimes leaning towards Bramante's *Tempietto* in Rome, sometimes influenced by Michelangelo's first project for the tomb of Julius II, and sometimes considering an even more complex edifice such as a Triumphal Arch (fig. 185). Thus he sketches a sort of typology of the classic funerary monument. It is also significant that for the actual equestrian group, Leonardo returns to the idea of the rearing horse. The client commissioning the monument would probably have preferred a "Sforza" type of horse, that is, walking.[402] Yet among all the drawings relating to this project that have survived and ignoring a small sketch in the margin of sheet 12347 at Windsor, only one drawing shows the horse

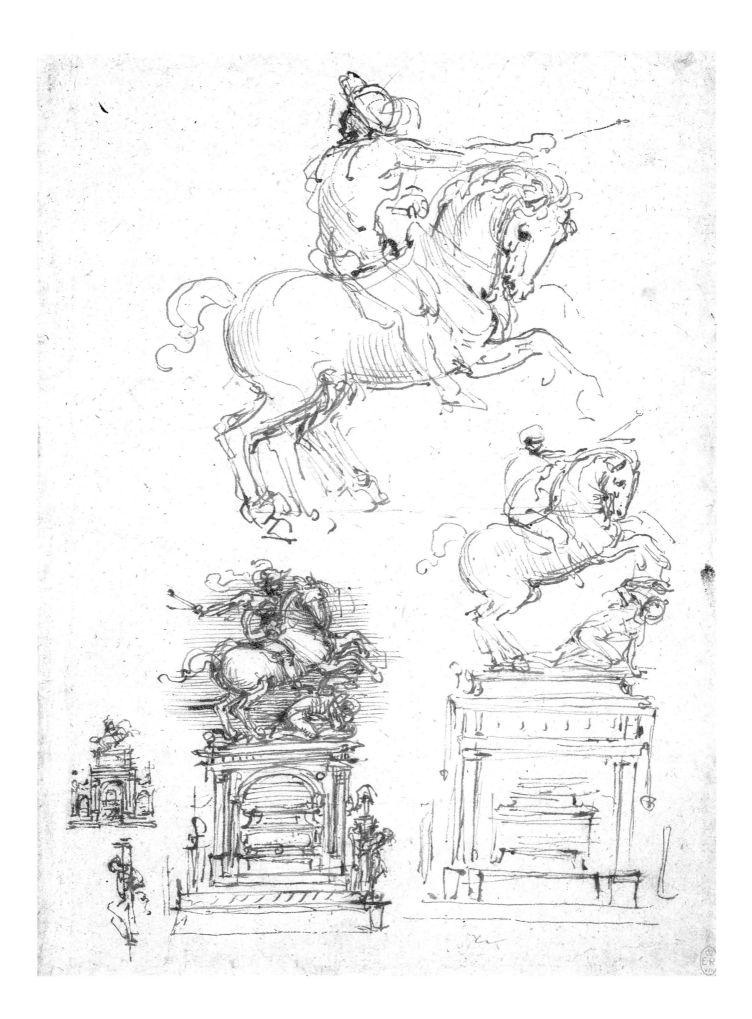

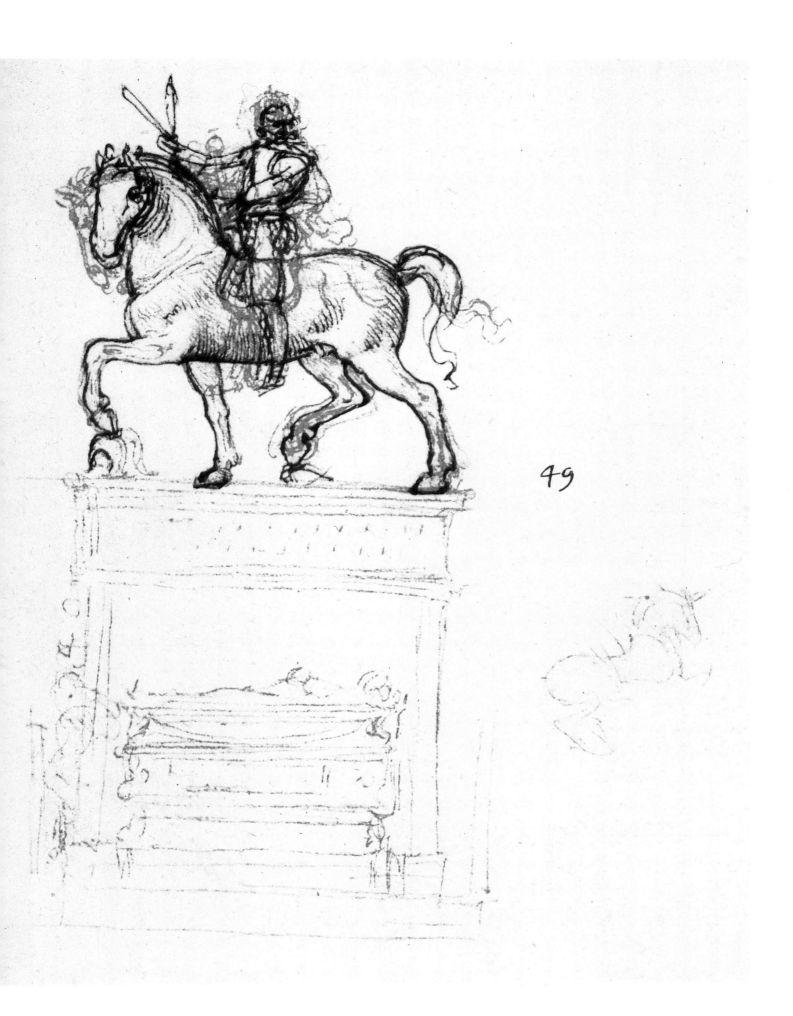

49

walking (fig. 186); the rearing horse appears regularly in compositions that are reminiscent both of the *Adoration of the Magi* and of the studies for *The Battle of Anghiari*. So far as the dynamic relation between the contrapposto of the rider and that of the horse is concerned, this is also reminiscent of the drawing of *Neptune*, made in 1504 for Antonio Segni; though lost, it is known through the sketch in the Royal Library at Windsor (fig. 184).

The French are definitively expelled from Milan in 1513, and so, like the

Right: Fig. 187. *Equestrian monument*, 1508–11, black lead point on white prepared surface, 8¾ x 6¼ in. (22.4 x 16 cm.) Windsor Castle, Royal Library, RL 12360r.

Far right: Fig. 188. *Horseman on a rearing horse*, bronze, 9½ x 10½ in. (24.3 x 26.5 cm.) Budapest, Szépmüvészeti Múzeum.

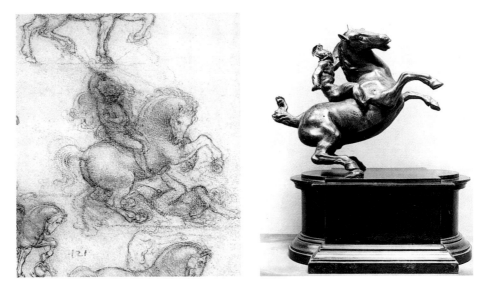

Page 252: Fig. 185. *Study for the Trivulzio equestrian monument*, 1508–11, pen and bister on gray paper, 11 x 7¾ in. (28 x 19.8 cm.) Windsor Castle, Royal Library, RL 12355r.

Page 253: Fig. 186. *Study for the Trivulzio equestrian monument*, 1508–11, black chalk and red chalk, 8½ x 6½ in. (21.7 x 16.9 cm.) Windsor Castle, Royal Library, RL 12356v.

Sforza "great horse," the Trivulzio monument will never be built. But Leonardo will have the opportunity once more to return to the theme of the equestrian monument. As has recently been convincingly demonstrated by Martin Clayton,[403] drawings that were earlier linked to the Trivulzio monument must now, for stylistic and technical reasons, be considered as late studies (1517–18) for an equestrian monument in honor of the King of France (fig. 187). While the horse walking (or even ambling) appears several times, the concept of the rearing horse is also included—and can be seen as what Kenneth Clark called "Leonardo's last word on a problem that had interested him all his life."[404] These late sheets suggest that, in spite or maybe because of the technical problems of such a project, Leonardo's private ambition was to do what none of his contemporaries had succeeded in doing: to create an equestrian monument in which "accidental" movement would express—as he successfully did in *The Battle of Anghiari*—the passion shared by man and animal.

However, as Carlo Pedretti pointed out,[405] it is hard to believe that Leonardo

should have seriously thought that drawings like the one in the center of sheet 12360r at Windsor (fig. 187) could have been used as models for a monumental sculpture; instead, they look more like wax models for small bronzes. This is significant in itself. Indeed, it is possible that there is a surviving trace of this research by Leonardo, apart from surviving sketches: the bronze statuette in the Budapest Museum, representing a rider without armor on a rearing horse (fig. 188). Even if its attribution remains debatable and although its anatomy is somewhat approximate compared with Leonardo's measurements and drawings, the idea of the group is undoubtedly his. The horse seems to have that three-dimensional characteristic of the rearing horses he draws between 1504 and 1507 and in about 1517–18 (fig 175). Without being able to state categorically that the statuette is the same as Leonardo's "sculpted horse" mentioned by Lomazzo in relation to a "horse of St. George" painted by Cesare da Sesto,[406] the complete absence of any iconographic definition of the group[407] invites the recognition of Leonardo's inspiration in it. An image of pure energy, outside all narrative context, this statuette with a height of nine and a half inches (twenty-four centimeters) condenses and refines the expression of this movement, both natural and passionate, that Leonardo always seeks to achieve in his compositions. Its small dimensions are themselves also quite significant. Because of the circumstances mentioned above, he was unable to satisfy his ambition of giving a monumental expression to the image he had of the rearing colossus; he therefore made it the size of an ornament. This was just like the tiny drawing of "Regisola," which was sufficient to enable him to conjure up in his mind the majestic grandeur of the ancient masterpiece, or like the lock of hair, seen close-up, that reflected the configurations of the cosmic whirlpools of turbulent water.

Pages 256: Fig. 189.
The Last Supper.
Milan, Santa Maria delle Grazie. Detail.

PART TWO

The Work of Painting

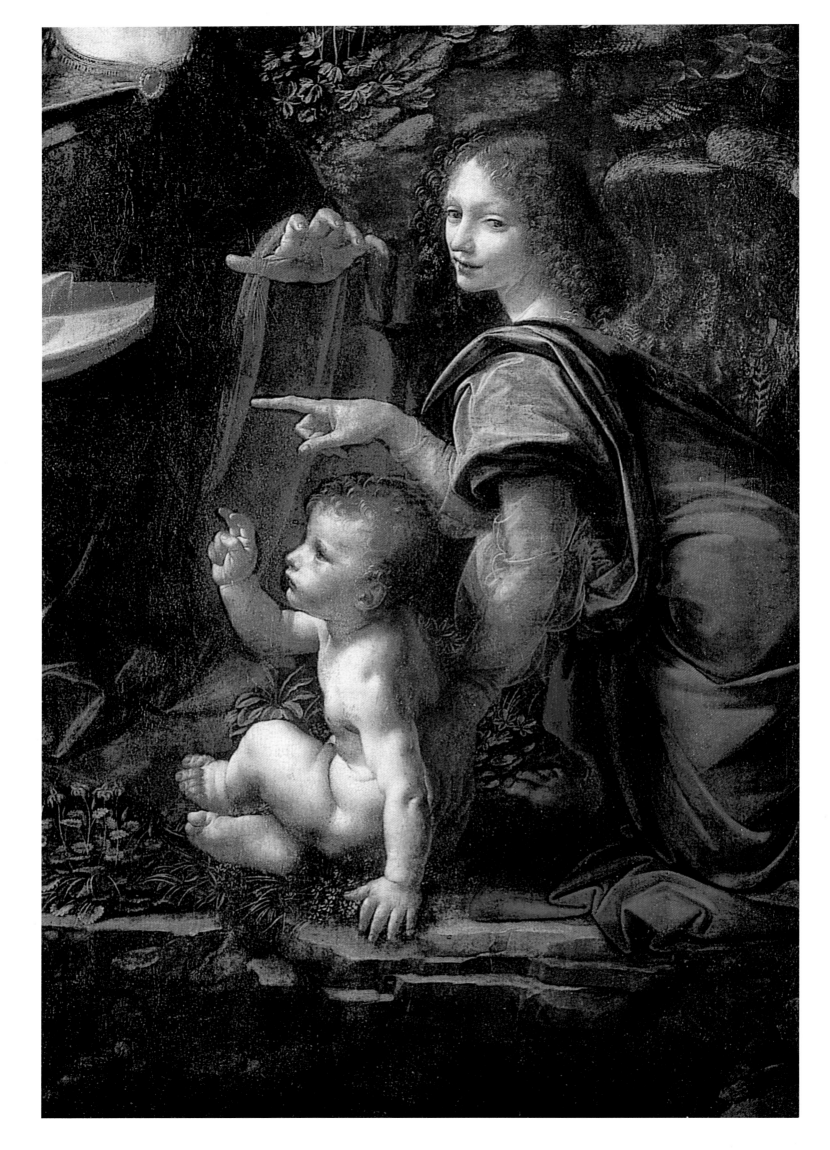

THE PAINTER'S DESIGN

PAINTING, "THE ABSOLUTE ART"

"The beauties brought together at the same time (through painting) give me so much pleasure by their divine proportion that I cannot think that there is another human work that could give me greater pleasure." (*Codex Urbinas*, 15r.) This could not be clearer: for Leonardo, who attributes these words to Matthias Corvinus, King of Hungary,[408] the pleasure he derives from painting is incomparably superior to that he could find in the other arts. This irresistible pleasure, "capable of robbing the spectator of his freedom," (*Codex Urbinas*, 18r) is certainly one of the reasons for the unique prestige of the art of painting in his eyes.

One should indeed say "in his eyes," because Leonardo's perception and approach to the world were determined above all by a visual sensitiveness. For him, sight is the first, "the best and most noble" of all senses: "Because to lose sight is to be deprived of the beauty of the universe, and to be like a man buried alive in a tomb, in which he could live and move." Even if there are still traces of the old "concepts," Leonardo's words in praise of the eye have an unrivaled enthusiasm and passion: "Don't you see that the eye embraces the beauty of the whole world? The eye is the master of astronomy, the author of cosmography, the adviser and corrector of all human arts; it transports men to the different parts of the world. The eye is also the prince of mathematics […] It has defined the altitudes and sizes of the stars, it has discovered the elements and their levels; it has made possible the forecasting of future events by following the course of the stars; it has created architecture, perspective, divine painting […] It is like a window of the human body through which the soul contemplates the beauty of the world and enjoys it, thus accepting the prison of the body, which, without this power, would only torment it. Human industry owes to it the discovery of fire, which gives back to the eye what darkness has taken from it. The eye has added the embellishment of pleasant gardens and agriculture to nature. But is it necessary to raise and extend my speech in this way? What has the eye not accomplished? The eye moves men from east to west, it invented navigation, and goes beyond nature. Nature's work is finite, but the work of human hands, ordered by the eye, is infinite, as shown by the painter who imaginatively represents an infinity of forms, animals, grasses, plants and places." (*Codex Urbinas*, 15r-v.)

Painting therefore comes before all the other arts. In the *Treatise on Painting*, the comparison between the arts, or *paragone*, is used as a platform for the

developments of the painter's art itself. It is true that this *Treatise on Painting* has been collected together and arranged by Francesco Melzi; but in doing so he probably followed Leonardo's words—and, in the new organization of the *Treatise* by André Chastel and Robert Klein, they have preserved and even strengthened this arrangement. It is also true that the motif of the *paragone* was not a new one at the end of the fifteenth century: Alberti had already stressed the preeminence of painting over sculpture in the *De Pictura* and even more so in its vernacular translation: "These arts are related, painting and sculpture being fueled by the same spirit. However, I shall always favor the spirit of the painter because he is involved in a much more arduous task."[409] Today this debate is completely obsolete, but it still deserves attention. Not only does its anachronism allow a better understanding of the historical specificity of Leonardo's thought (and painting), which has, in addition, also given it a new relief and very personal interpretation.

Although placing the painter and historian[410] on an equal footing, based on a variation of Horace's *Ut pictura poesis*, Alberti had restricted the debate on the comparison between arts to the comparison between painting and sculpture, thus initiating what was to become a classic "dispute" that developed during the sixteenth century to the point of becoming tedious. For his part, Leonardo deals with the motif of *paragone* in a more complex and unusual manner. Rather than concentrating only on the two arts of visual representation (painting, the art of the plane, and sculpture, the art of relief), he scrutinizes what he considers to be the four complementary arts of representation: painting and sculpture, naturally, but also music (representation of invisible things, sounds), and poetry, conceived of as the art of expressing human thoughts through language. The arguments Leonardo develops in praise of painting are even more original and personal in that no theoretical framework existed yet regarding the subject. The "modern" (or rather the "classical") theory of art only started being developed in the Quattrocento, and far from being an obstacle, the fact that Leonardo was at one and the same time, an artist, a systematic theoretician and a *uomo sanza lettere,* made particularly effective and productive "this frightening strength of reasoning supported by intelligence and memory" that had sufficiently impressed his contemporaries to be echoed by Vasari.[411] It is worth following his reasoning closely, since it provides insight into the painter's private ambitions.

Leonardo's first *paragone* deals with painting and poetry. It is decisive in that, while raising painting to the rank of a "liberal art," humanist culture

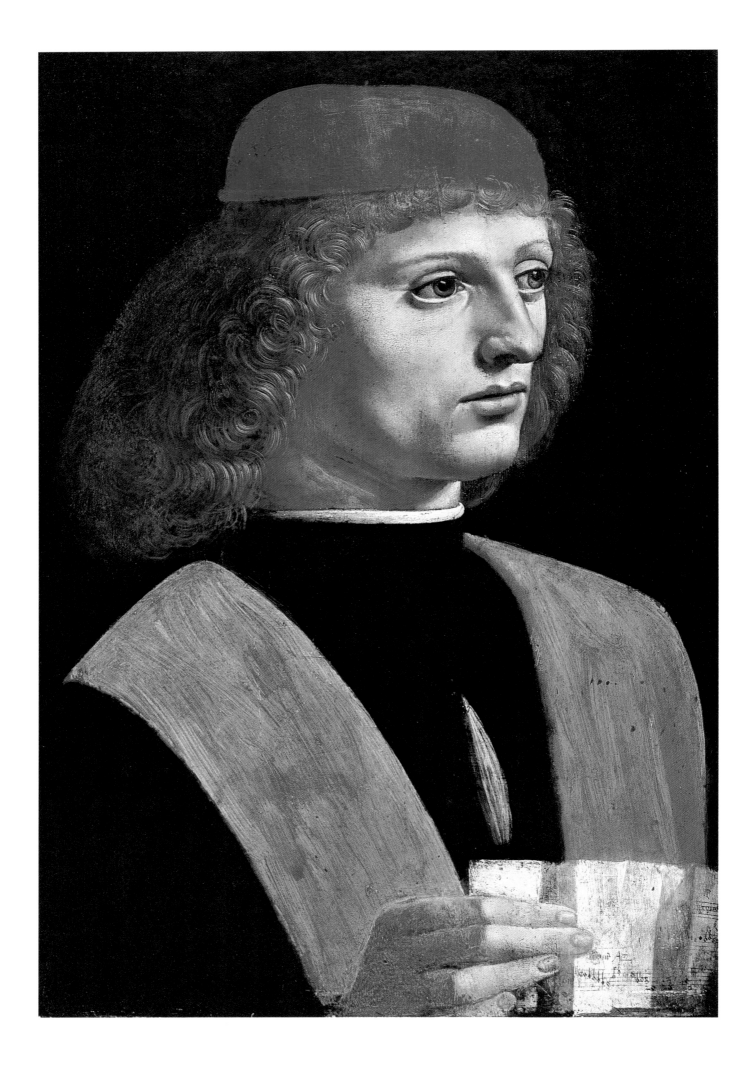

continued to favor the written or spoken word. According to Carlo Dionisotti, as already mentioned, it is even possible that Leonardo decided to write a treatise on painting in response to the condescension and criticisms directed at him in Milan by some humanists and court poets.[412] While in 1492 Marsilio Ficino included painting among the liberal arts, he did not mention a single contemporary artist in his entire work. In 1541, Mario Equicola, humanist at the court of Ferrara and then Mantua, will still write that "however praiseworthy Painting, Plastic Arts and Sculpture may be, they are still considered inferior to Poetry, both in authority and dignity. As far as Painting is concerned, it appeals more to the body than to the mind. One should therefore consider Poetry as more noble than painting, in the same way that the man who is able to make speeches is superior to the ordinary man."[413]

Leonardo develops two equally remarkable arguments against this predominant way of thinking. To some extent anticipating Lessing's *Laocoon*, the first argument opposes the linear successiveness of the poetic phrase to the harmonic and "concertante" simultaneousness of painting (and music): "The poet, who describes the beauty or ugliness of a body, represents it limb by limb, in a series of successive moments; the painter makes it visible all at once [...] The poet behaves in the same way as a musician who tries to sing on his own a song composed for four voices, singing in turn the soprano voice, then the tenor, contralto and finally the bass. This excludes the grace of the harmonic interaction that results from the harmonies" and that painting and music have in common.[414] Furthermore, addressing only the sense of hearing and depending on it, poetry, as one has seen, can only be inferior in dignity to painting. Leonardo here uses an argument whose content cannot fail to command attention because, in order to maintain the balance between the two arts, he upturns and consciously undermines the false equilibrium that supported humanist thinking, and that was to become canonical during the classic era. When he wrote that "painting is mute poetry and poetry blind painting," (*Ms. L*, 21) the observation would appear to be undeniable, based on the criteria of *paragone*; but it also quashes the proverbial authority and validity of the statement attributed to Simonides of Ceos, according to whom "painting is mute poetry and poetry a talking painting," whose apparent equilibrium aimed to confirm the supremacy of the word by not taking into account the specific contribution of the visual.[415] A close reading reveals that this statement clearly defines painting as an inferior (mute) kind of poetry, and poetry as a superior (speaking) kind of painting. As a *uomo sanza lettere*, Leonardo did not have any such

Fig. 191. *Portrait of a Musician*, c. 1485,
oil on wood, 17 x 12¼ in. (43 x 31 cm.)
Milan, Pinacoteca Ambrosiana.

prejudices and could, without shame, rethink acquired knowledge uninhibitedly. For him, humanist statements, whether quotations from Simonides of Ceos or Horace, had neither validity nor authority: painting *was not* like poetry, but, if a comparison had to be made, it was superior to it.

The second *paragone* deals with painting and music. The talent and reputation of Leonardo as a musician may have played a part in the development of this original parallel. But, as was suggested earlier on the subject of Leonardo's theory of music, it is above all the status of music as a liberal art founded on mathematics that makes it necessary to establish the relative superiority of painting on this point. Indeed, besides the fact that music addresses the sense of hearing, a sense that is inferior to that of sight, it has the ability to produce "harmonies through the combination of proportional elements produced together [...] These chords enclose the relationship between the elements from which harmony is created, that is not different from the line containing the elements of human beauty." But this harmony is ephemeral, and "painting triumphs over music and dominates it, because it does not disappear as soon as it is created, like the unfortunate art of music, that should therefore only be considered as painting's younger sister." (*Codex Urbinas*, 16r-v.)

The argument of duration is dealt with again in the third, more traditional, *paragone* of painting and sculpture because one of the arguments invoked by humanists in favor of sculpture (and later, in the sixteenth century, by the sculptors themselves) is the fact that sculptures are more resistant to time than painting—as was shown by the fate of works of art from antiquity. But Leonardo turns the argument upside down by stating that this "lasting quality does not give sculpture any nobility, because it stems from the material and size not from the artist." (*Codex Urbinas*, 21v.) The argument used is correct, but in the context of the *paragone* as Leonardo has formulated it, it is specious because it invokes in favor of painting its ability to create beauty more long-lasting than that of nature itself (*Codex Urbinas*, 16v). Leonardo's real answer is to be found elsewhere. It is contained in a central argument, developed as three proofs. Sculpture is inferior to painting because it is more manual, less "mental": "The sculptor works harder physically than the painter while the painter puts in greater intellectual efforts."[416] (*Codex Urbinas*, 20v.) This material aspect is immediately apparent from the physical effort that the sculptor must go through. The comparative portrait of the painter and the sculptor is well-known, but one should look at it again to perceive the courtly elegance that the painter has to aim for, according to Leonardo: "When producing his work,

the sculptor must make a manual effort, chiseling away to remove the superfluous marble or whatever kind of stone that surrounds the figure contained within it. This requires entirely mechanical movements, often accompanied by a lot of sweat that gets covered with dust, thus forming a crusty layer of mud; the sculptor's face is covered in marble dust and his white face looks like a baker's; he is covered in flakes and looks as if he has been standing in the snow; his house is dirty and full of shards and dust from the stone. With the painter, it is quite the opposite [...] because he is sitting comfortably in front of his work, well dressed, handling a light brush with pleasant colors; he wears the clothes of his choice, and his house is clean and full of nice paintings; he is often accompanied by music or readings from all kinds of beautiful works, which he listens to with great pleasure, without being bothered by the noise of hammers or other kinds of din." (*Codex Urbinas*, 20v.)

Furthermore, using and developing Alberti's argument, Leonardo considers that "sculpture is a simpler form of expression and requires less effort from the mind than painting" because "the painter must take ten points into consideration to ensure the success of his work, namely: light, darkness, color, volume, figure, positioning, distance, proximity, movement and rest. The sculptor only needs to consider volume, figure, place, movement and rest." (*Codex Urbinas*, 21v.) Finally, and most important of all, sculpture is less "universal" than painting. The latter is a "wonderful art, based on very subtle thinking, that sculpture is incapable of in its summary expression." Not only does the absence of color prevent the sculptor from "creating variety," but its "perspective views do not appear real at all" while "the space of the painter appears to extend for hundreds of miles beyond the work." Also, because of the absence of "aerial perspective," sculptors cannot represent transparent or luminous bodies, nor the reflection of rays and dazzling objects such as mirrors and other reflective objects, nor mists and gloomy weather and an infinity of things I shall not list so as not to be boring." (*Codex Urbinas*, 23r-v.)

This "infinity of things" that only painting, the "universal art" and *cosa mentale*, is capable of representing is the basis of its unrivaled prestige. It is not only in relation to other representative arts that painting is a "wonderful art," it is so in the absolute: "If the painter wants to create beauty capable of inspiring love, he has the ability to do so, and if he wants to create monstrous things that frighten or funny things to arouse laughter, or things capable of inspiring pity, he is their master and their god (*signore et creatore*); if he wants to create landscapes, deserts, shady and cool places for when it is hot, he depicts them;

and similarly, warm places for bad weather. If he wants valleys, if he wants to discover vast plains from mountain ridges, and if he wants to see the sea on the horizon, he has the power to create them (*egli n'è signore*). And if he wants to see high mountains from the bottom of valleys, or look down into deep valleys or see the coast from the top of high mountains—everything that exists in the universe in essence, presence or imagination (*per essenzia, presenzia o immaginazione*), exists first in the painter's mind, then in his hands; and these hands are so talented that they create at any particular moment a harmony of proportions embraced by the eye as if it were reality itself." (*Codex Urbinas*, 5r.) The enthusiasm expressed on this page should not diminish its importance in the history of the theory of artistic creation: Leonardo transfers the processes of divine creation to the field of human activity. Without being identical to God's creative power, the creative powers of man the painter "operate in their way at a different level of the microcosm."[417] The recto of folio 36 of the *Codex Urbinas* further developed this idea: "The divine character (*deità*) that characterizes the science of painting transforms the painter's spirit into the image (*similitudine*) of the spirit of God because he throws himself freely into the creation of all kinds of species ."[418]

Although these thoughts echo contemporary Florentine Neoplatonism, they are not vague for all that, and they are based on two original aspects of Leonardo's artistic thinking.

First, though he appears to be more interested in the scientific foundation and rational control of invention than in the origins and nature of the creative process itself, Leonardo describes this creation using terms that are significant. Before him, Francesco di Giorgio had praised the potential infinity of human inventions, comparing it with the repetitive, stereotyped character of animal constructions (such as the spider's web, the swallow's nest or bee's honeycomb), and he had declared that this power of invention was an innate gift of the *ingegno* of the artist. Similarly, Filarete saw *fantasia* and *fantasticare* as an imaginary dimension whose role was to complement the rational process of the architect's *pensare*. But Leonardo is the first artist who no longer separates the concepts of *fantasticare* and *pensare*, making *fantasia* itself a conceptual faculty; he is also the first to use terms with biological connotations to describe the process of artistic "invention."

Besides terms such as "to do" (*fare*), "to feign" (*fingere*) or "to figure" (*figurare*) that are found elsewhere at the time, Leonardo uses other words in new ways, such as "to create" (*creare*), "to give birth" (*partorire*), "to be born"

Fig. 192. *Madonna of the Rocks*. London, National Gallery. Detail

would say, is less interested in the "aspect" of things than in their "prospect":[422] "The painter who works by rote and guesswork, without trying to understand things, is like the mirror that captures everything in front of itself without examining it." The spirit of the painter is thus simultaneously the mirror and the interpreter of nature and the cosmos—and, "the universality of painting, which is an extension of the universality of conscience, requires an indefinite amount of work," which must be accepted "like a profane form of contemplative life."[423]

The "divine" power of painting does not arise from its almost magical ability to bring back those who have gone and revive those who are dead; it stems even less from the fact that it can turn famous painters such as Zeuxis into "celebrities," terrestrial stars who are too worldly. Neither does it stem from a mysterious inspiration, a Neoplatonist *furor* or this *idea*, this "interior drawing" that would later be recognized as the "divine spark" in man.[424] It is the result of the double transmutation, joint and inseparable, experienced by the spirit of the painter. Because, if it transforms itself into an "image" of the divine spirit, it must also "transform itself into the spirit of nature and become the interpreter between nature and art; he turns to the former to unravel the reasons of its developments, subjected to own laws." (*Codex Urbinas*, 24v.) In other words, the divine character of painting is inseparable from the fact that it is a "science" based on the knowledge of the internal laws of nature. But if geometry and arithmetic "only cover the knowledge of the continuous and discontinuous quantity," painting on the other hand takes into account "quality, that is, the beauty of the products of nature and the adornment of the world." (*Codex Urbinas*, 7v.) Painting is not satisfied with merely "reproducing" nature, based on the knowledge of its laws, it "completes" nature and the "picture is the only way to achieve complete harmony between the forms and thus reach the final accord."[425]

Painting "absorbs, links and completes all the activities of the spirit,"[426] thus giving the *paragone* as developed by Leonardo its full meaning and true recognition (integrated into what is almost a system of knowledge and what was not yet a "system of the arts"). This "scientific" character of painting also explains the extraordinary intellectual importance given to the painter's hand, which is probably where Leonardo's theory of art is at its most modern: "The science of painting resides in the spirit that conceives it; followed later by the execution, much more noble than the said theory or science." (*Codex Urbinas*, 19v.) Breaking entirely with the tradition that proclaimed the inferiority of the

"mechanical" arts and the superiority of the purely intellectual disciplines, he goes much further than raising painting to the status of a "liberal art." Leonardo condenses into a single phrase a "eulogy of the hand," inseparable from his enthusiastic and rhetorical eulogy of the eye. This "nobility" of manual craftsmanship clearly stems from the fact that it gives shape to the painter's thinking and "demonstrated" its existence by turning it into an object set in reality, an object belonging to reality.

It will later be seen how Leonardo progressively perfects this manual skill, and how he works to obliterate all traces of it in the finished work, the better to reveal the "mental" character of the painting. The "act of painting" certainly does not have the same value for him as it does today; neither does it have the value Titian was to give it in his bold physical handling of the pictorial material. The act of painting had a different, but just as noble, value for Leonardo. The simple, revolutionary phrase that proclaims the "nobility" of the work carried out by the painter's hand concludes a page in which Leonardo declares that there is no true science that does not rely on the exercise of the hand, and that "all the arts that need the hand of the scribe" can only be brought to a successful conclusion "by manual operations." "Writing is similar to drawing, which is part of painting. Astronomy and other disciplines also undergo manual operations, after mental ones." (*Codex Urbinas*, 19v.) Leonardo's eulogy of the hand might seem to anticipate today's attitudes, but its far-reaching effect will be better understood if it is related to Leonardo's "theory of knowledge" for which, as indicated earlier, the thinking of Nicholas of Cusa provided the intellectual framework—Nicholas of Cusa who saw painting as a model for the mind, and the "layman" making a wooden spoon with his own hands as a master for the philosopher and the orator.[427] It is as a painter that Leonardo defines knowledge. It is between the hand and the eye, from the eye to the hand and from the hand to the eye, that the divine character of painting is found and the painter's creation takes place, in the image of the divine Creation.

THE FUNCTIONS OF DRAWING

The divine character that distinguishes the "science of painting" is inconceivable without drawing. As Leonardo writes on the verso of folio 1 of the *Codex Urbinas*, the drawing is the "foundation" of painting and it is on the

basis of this premise that he considers that "painting" is the mistress of architecture, pottery, goldsmith's work, weaving and embroidery. Leonardo also believes that it has invented the characters of the various alphabets, "given figures to arithmeticians, taught the outlines of shapes to geometers, and educated opticians, astronomers, designers of machines and engineers." Some of Leonardo's activities will have been recognized here. Drawing is a vital stage in his research, whether scientific, technical or artistic, and it is at the center of the development of his thought. Not only does it enable him to clarify and know the visible, not only is it "the only satisfactory form of scientific investigation,"[428] but, more universally, it constructs the theoretical, conceptual model of the visible. As mentioned earlier, Leonardo's sensibility is that of a "visual" man, and his development is on the whole that of a "graphic thought": for him experience is "observation accompanied by a graphic report [...] The concept is the schema."[429] More than a drawing, one should speak of a "graphic act" to emphasize the active dimension, not only of recording, but of the performative and intellectually productive nature that distinguishes Leonardo's practice of drawing. As David Rosand put it: "Leonardo saw better when he had a pen or a black stone in his hand [...] The 'act of drawing' was the analysis" and, "through the controlled formal vocabulary he had developed in drawing, Leonardo imposed a graphic order on the apparently chaotic forces of nature."[430]

Together with this graphic, linear approach of a world that he perceives as consisting of an infinity of virtual, dynamic lines,[431] the great contribution of Leonardo's painting, considered as his distinctive feature and invented and discovered gradually, is *sfumato*, the shading or "blurring" that aims to remove the outlines of bodies. This apparent paradox and near-contradiction appears to be confirmed and justified in two passages where Leonardo evokes the outlines of bodies from the twin point of view of their "truth" and their "visibility." The "true" contour indicates the "exact" shape of the bodies, but it is not very visible in nature: "If the true outlines of opaque bodies are blurred close by, they will be even more blurred from afar; and since it is the outline that reveals the exact shape of opaque bodies, every time that distance prevents us from perceiving the whole, the perception of its parts and contours will even more lacking." (*Ms. E*, 80r.) This observation leads to practical advice that bases sfumato on the effective invisibility of outlines: "The lateral limits of these bodies are formed by the line of the surface, a line of invisible thickness. Therefore, painter, do not enclose your bodies in a line, especially

271

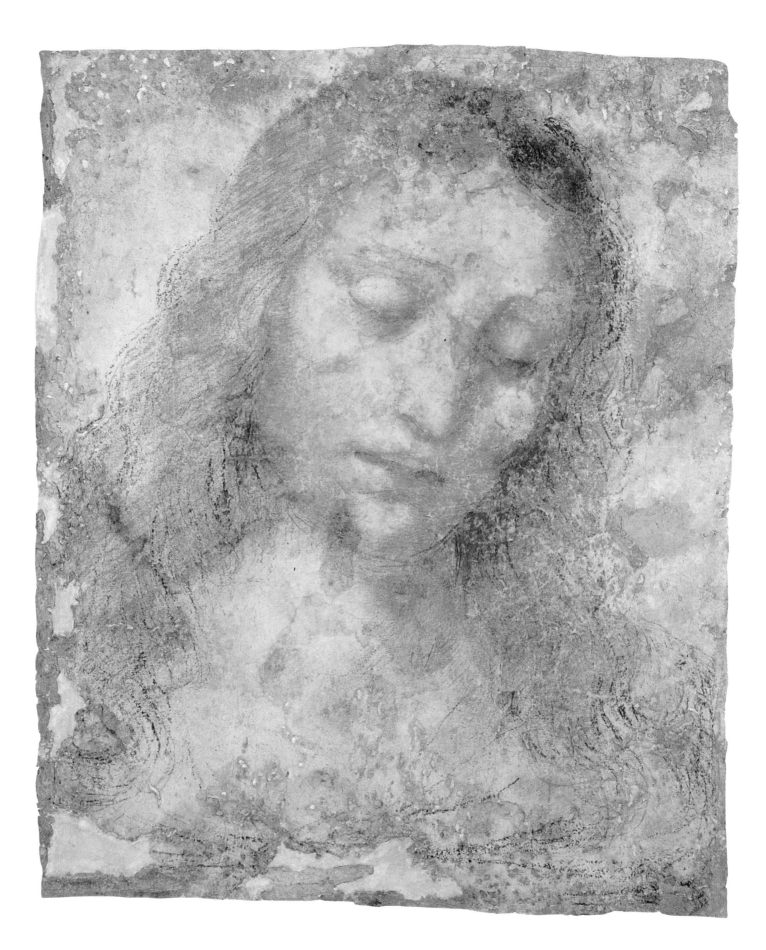

Fig. 193. *Study for the head of Christ for The Last Supper,*
pastel and charcoal, 15¾ x 12½ in. (40 x 32 cm.)
Milan, Pinacoteca di Brera.

the smallest things in nature, because not only can they not reveal their lateral outlines but, at a distance, even their parts are invisible." (*Ms. G*, 37r.)

These two texts raise the question of the "truth" of this outline that "reveals the exact shape of all opaque bodies:" what exactly is this invisible line's status of truth that is exalted in "scientific" drawing, whose aim it is to describe "the true outlines of opaque bodies?" Answering this question will bring us closer to understanding how the "science of painting" connects science and painting. What are the terms of this association? What are its implications? How does this provide a better understanding of Leonardo's conception of the "science of painting"? These questions also deserve to be asked because Leonardo introduces radical—and at first sight, contradictory—innovations into the practice of drawing for scientific illustration and drawing as a preparatory study for painting. It is true that the two kinds sometimes overlap. The drawings of plants and flowers for *Leda* could for instance be illustrations for a botanical work.[432] But these finished drawings are not in themselves innovative. On the contrary, Leonardo's most original preparatory drawings are those sketches in which he adopts a radically different approach from the one he uses in his scientific drawings. This fact is particularly interesting because in both cases Leonardo invents what would become the modern practice of drawing, whether dealing with scientific illustrations or artistic sketches. Yet again his universal genius seems to anticipate the specialized efforts of his successors. This is true, but one must go beyond this easy answer. Leonardo's graphic innovations are closely linked to contemporary scientific and artistic concepts and also to his own interests and private perception of the world of art. It is therefore worth examining these drawings more closely: it provides an opportunity to consider some of the links that exist, at the personal level of the graphic gesture, between the art of painting and the science of the world.

Although they had almost no impact, Leonardo's anatomical drawings were a radical innovation in the field of scientific illustration.[433] They visually "demonstrate" the knowledge acquired through experience, and it is significant that the accompanying texts become more scholarly as the drawings become more specific.[434] As Leonardo says when he introduces the treatise on human anatomy that he outlined in 1510–11, "this plan I have made of the human body, will be shown to you as if you had the actual man in front of you. […] You will learn about each part and each whole through a demonstration of each part […]. You will be shown three or four demonstrations of each part from different angles so that you have full and complete knowledge of everything you

want to know about the configuration of man." (Windsor, RL 19061r.) But it is also true that this educational aim was partly based on imagination, and this is a decisive point in relation to what follows. The scientific effectiveness of anatomical drawings arises from the fact that they show artificially what could not actually be seen from only one angle: "And you who say that it is better to look at a dissection than to look at these drawings would be right if it were possible to see in reality everything that these drawings show in a single figure. When dissecting, in spite of all your skill, you will only see or discover a few vessels and ducts, but, in order to acquire a true and complete knowledge, I have dissected more than ten human bodies [...]." (Windsor, RL 19070v.)

So, to draw is to know. Leonardo's anatomical drawings are so remarkably modern in approach that it has been said that "modern anatomical illustration was born" in the winter of 1510–11 in Milan.[435] Indeed, the modern scholar confirms in his specialist language the scientific perfection of such a page as the one where Leonardo has drawn the muscles of the arm and superficial blood vessels: "Among the veins one notices the lateral thoracic vein, a small mammary plexus, the thoracic-epigastric anastomosis of the perforating tributary branches of the internal thoracic veins, the inferior superficial epigastric vein, and possibly the superficial iliac circumflex. There is also a sketchy drawing recalling the ending of the internal saphena vein. It is probably the first correct dissection of this blood vessel."[436] Few texts show the layman the historical and scientific importance of Leonardo's graphic rigorousness so well as this passage.

The modern character of this page naturally comes largely from the artist's attention to "objective" exactitude. In spite of the portrait of the dissected dead man, there is no moralizing scene-setting on the theme of *Memento mori* ("Remember you have to die"), in contrast with Vesalius's practice in his work. On the contrary, the presentation of the illustration itself and its technique, show clearly only what is to be learned and understood. The two pages showing the muscles of the arms, shoulder and neck, represented in a revolving movement from eight successive points of view, have already been mentioned (fig. 70, 71). The drawing showing the deep structure of the shoulder (fig. 196, 1510–11) is perhaps even more remarkable. In it Leonardo juxtaposes three different techniques of representation, corresponding to three kinds of "scientific" approach. In the two drawings at the top, he shows the various parts separated from the whole in order to clarify the relationship between deep and superficial structures; the drawing at the bottom shows

only the deep structures, the muscles having been cut where they would have made the "demonstration" difficult to "read"; and the middle drawing on the right shows the muscles with string following the muscular lines of power, thus enabling the spatial structure of the whole to be seen. This concept of illustration and the scientific approach is undeniably a radical innovation, one that breaks with the contemporary practices found in text books on anatomy.[437] Antonio de' Beatis confirms this in his description of a visit to Leonardo in 1517 in the company of Cardinal Luis of Aragon: "This gentleman has written a treatise on anatomy, showing the limbs, muscles, nerves, veins, joints, intestines and everything that can be explained in the body of men and women, in a way that has never been done by anyone before. We have seen it all with our own eyes."[438]

But, in spite of the legitimate admiration aroused by these drawings, it is important to be aware of the "errors," sometimes considerable, that some of them reveal to an expert eye.

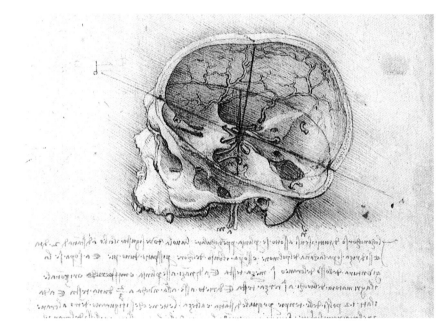

Fig. 194. *Internal view of skull*, 1489, pen and ink on light charcoal outline, scraped, 7½ x 5¼ in. (19 x 13.3 cm.) Windsor Castle, Royal Library, RL 19058r.

Some of these are due to the educational concern that governed the concept of the drawing. For Leonardo, "to know, is to know how to see,"[439] so to make known, is to know how to make people see. So, far from being a faithful picture, the very beautiful, much celebrated internal view of the skull (fig. 194, 1489) is a "constructed image" in which the base of the skull is seen from a sharper

275

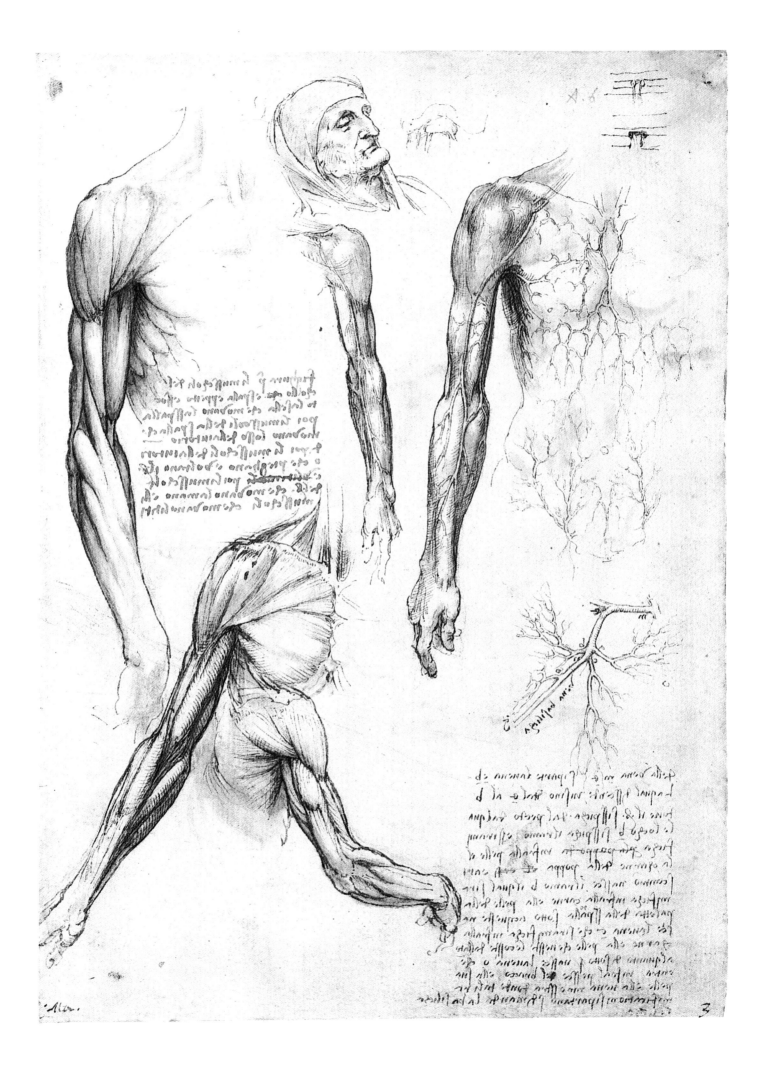

angle than the bone of the face. It strikes the art historian with "the unreality of its appearance." But the anatomist learns something from it: in his eyes, the image "has no equivalent as regards its relevance and its ideas" and he even wonders about the number of dissections that have been "synthesized" to achieve this drawing where the "description of the structures (morphology) is essentially correct."[440] This page is all the more significant because, as is revealed by the text that accompanies it, its "unreality" is caused by the scientific concept that it illustrates. As tradition had shown and as the linear axes superimposed on the drawing prove, Leonardo wants to "demonstrate" that the *sensus communis* (the place where all the senses meet) is situated in the geometric center of the head. Paradoxically, the demonstrative effectiveness of this drawing (that includes among other things "the first correct description of the meningeal arteries and their origin") cannot be separated from the scientific prejudice that organizes its presentation.

This kind of "unreality" disappears in the drawings that Leonardo makes in 1510–11, when he works beside Marcantonio della Torre, professor of anatomy at the university of Padua. Founded on the teleological concepts of Galen, according to which every organ and every part of the organ carries out the function that their form is suited for, the anatomical approach of Marcantonio della Torre demands meticulous observation, as Leonardo's drawings confirm. But, after the death of Marcantonio della Torre in 1511, some drawings show the impact of established concepts. Thus Leonardo "demonstrates" the existence of the pores that had been supposed to allow the blood to "sweat" from the right ventricle to the left ventricle (Windsor, RL 19074r, 1512–13). In general, Leonardo never gives up conceiving (and drawing) anatomy in relation to analogy, particularly when it allows him to "demonstrate" morphological or physiological facts that are impossible to see "in reality." The well-known drawing of the fetus and the internal wall of the uterus (fig. 144) is an example of this attitude. Belonging to a series of embryological studies that Leonardo makes after 1510, and undoubtedly carried out very slowly, (between 1511 and 1514, and perhaps even later), this page is justly celebrated for its main illustration. The drawing is very much in advance of the contemporary state of knowledge on this point. To convince oneself of this, it is only necessary to compare them with those added by an anonymous draftsman of the fifteenth century to the margins of a thirteenth-century manuscript.[441] Nevertheless, in spite of its beauty and apparent modernity, the drawing is incorrect and, according to the specialist, its errors are "serious."[442] It is of

Page 276: Fig. 195. *The muscles of the arms and surface vessels*, c. 1510–11, pen and ink with wash on charcoal outline and metal-point drawing, with small touches of red chalk, 11¼ x 7¾ in. (28.5 x 19.5 cm.) Windsor Castle, Royal Library, RL 19005r.

Page 277: Fig. 196. *Deep structure of the shoulder*, 1510–13, pen and ink with wash on charcoal outline and metal-point drawing, with small touches of red chalk. Windsor Castle, Royal Library, RL 19001r.

Fig. 197. *Uterus of a cow*, c. 1508, pen and ink, 7½ x 5¼ in. (19 x 13.3 cm.) Windsor Castle, Royal Library, RL 19055r.

course necessary to be a specialist to spot these mistakes, and to notice that they chiefly arise from the fact that, no doubt because he was unable to dissect a dead woman in childbirth, Leonardo had to rely on the principle of analogy: he drew a human fetus (probably dissected) inside a bovine kind of placenta ("cotyledonous" and not "discoid") that he had had the opportunity of studying in about 1508 (fig. 197). So in spite of its beauty and modern style, this drawing illustrates a genetic monster. But Leonardo could not resist the desire to represent "scientifically" a thing that he had never seen and that it would have been impossible for him to see "in reality."

He could extend this practice a long way. Thus the superb picture showing the woman's internal organs that he makes in about 1509 (fig. 198) is entirely imaginary, and the contrast between the art historian's comments and the specialist's is significant. To the first, "this powerful, highly worked drawing is the culmination of the studies of internal organs in *Anatomical Manuscript B*." It is remarkable for the various illustrative techniques that it uses: transparency, cross section, internal detail, and modeling with wash. The drawing has been pricked with holes for transferring it to another surface. No doubt it includes glaring errors, but these are related to Leonardo's desire to show the whole of the internal structure in a single drawing. He would soon give this up and, for the art historian, this drawing represents "in a kind of way the swan song of the medieval tradition." To the specialist in anatomy, overwhelmed by the serious mistakes that accumulated in the drawing, it has on the other hand "the effect of a quasi-mythical creature, and it shows the worst aspects of the beginnings of medical philosophy."[443]

So in about 1509, Leonardo is still creating scientific fictions in the same spirit as that which had led him, in 1492–93, to draw the famous illustration showing, in the words of its scholarly title, "the coupling of a male half-body and a female half-body" (fig. 330). We will return later to the fantastical implications of this drawing, to which Leonardo gave the main caption: "I reveal to men the first or perhaps second reason for their existence." Here one may just remark that, if the "errors" or anomalies that it includes reflect the scholarly concepts of the late fifteenth century, the evidently imaginary character of this "anatomy" makes it the equivalent of one of the "mental experiments" whose role in Leonardo's research has already been seen. Being confronted in his mind by an observation that is, strictly speaking, impossible, he invents a new image, physiologically "probable," because it is based on the state of contemporary knowledge. From this point of view, the drawing as "graphic

Fig. 198. *The organs of a woman*, c. 1509,
pen and ink on charcoal and red chalk outline
with bister wash, 18½ x 13 in. (46.7 x 33.2 cm.)
Windsor Castle, Royal Library, RL 12281r and v.

action" pushes its exploratory dimension to the limit—that is only one of imagination.

Here one is getting closer to what creates the intimate and dialectical unity in his "scientific fictions" and in the drawings through which the "science of painting" helps bring his figures to life.

Certainly, while scientific drawing depends on external observations that he summarizes, the preparatory drawing, as practiced by Leonardo, "generates" a figure that has its origin in the *fantasia* ("imagination") of the artist.[444] This is one of the privileges to which the science of painting owed its divine character: "If the painter wants to see beauties capable of inspiring love in him, he is master of creating them." (*Codex Urbinus*, 5r.) But the distinction between scientific drawing and the artistic approach is not a radical one on this account. Not only can scientific drawing make one see what cannot be seen "in reality"; not only can it imaginatively give an appearance to (mental) hypotheses about (invisible) configurations, but in some drawings of purely objective observation, such as those of plants or whirlpools of water for example, one can see the return of favored configurations, typical of Leonardo—the spiral shape in particular. Moreover, according to Ernst Gombrich, the drawing illustrating the percussion of "water falling upon water" (fig. 200) would have been conceived, by a process that was not radically different from that which gave birth to the "anatomy of coitus." "It is clear that it is not a snap-shot...but a very elaborate diagram of his ideas on the subject."[445] But this is to move forward too quickly and, above all, it simplifies the relationship between the eyes that see and the hand that draws. As David Rosand writes in this connection, "only by drawing did [Leonardo] truly come to understand, was his vision clarified. Whatever his theoretical propositions, they were formulated in and through graphic representation."[446]

One can attempt to clarify this relationship between the activity of looking, the graphic action and the revelation of forms that "in reality" are invisible, or barely visible. Structured by analogy, the dynamic configuration of the whirlpool or the spiral simultaneously organizes the perception of the eye that looks and the movement of the hand that draws; it structures the vision itself, whose graphic action creates the analysis and the synthesis at the same time. The drawing not only causes the reality being looked at to acquire intelligibility; it gives shape to the configuration that the eye arranges in the course of interrogating the latent rhythm of appearances. The line is the instrument of the "shaping" that the graphic action aims to achieve—and through which it is achieved.[447]

Fig. 199. *The fetus in the uterus,*
c. 1511–13, pen and ink, 12 x 83/4 in. (30.5 x 22 cm.)
Windsor Castle, Royal Library, RL, 19101.

283

At this level, the differences between scientific drawing and the preparatory drawing for a work of art become extremely blurred. As Leonardo actually practices them, the line has the purpose in either case of giving shape to a form, an outline, that is "in reality" invisible or barely visible, latent in the continuous flux of appearances. "Exact" or "true" in the scientific drawing, this line has to become harmonious and beautiful in the preparatory drawing—because, as mentioned earlier, unlike geometry and arithmetic, which are limited to "the

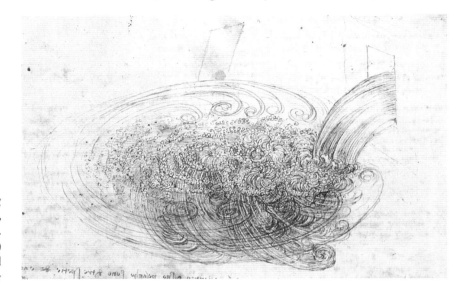

Fig. 200. *Water striking water*, 1507–09, pen and ink, 11½ x 8 in. (29 x 20.2 cm.) Windsor Castle, Royal Library, RL 12660v

knowledge of the continuous and discontinuous quantity," the science of painting deals with "the quality, that is, the beauty of the products of nature and the adornment of the world." It is this concept of the function of the line that underlies the revolution that Leonardo introduces into the practice of preparatory drawing. It is illustrated with particular effectiveness by one of the studies for the first version of the *Madonna and Child and Saint Anne* (fig. 201).[448] In going over the same places again and again, exploring the possibilities of his strokes to find the most rhythmic form, the hand of Leonardo ends up by producing an unreadable blur. Nothing can any longer be distinguished in this chaos, but his eye has perceived in the movement of his hand the hidden, buried, latent form, straining to become a figure. Leonardo marks this with a stylus and, turning the sheet over, makes it visible with a distinct line (fig. 202). As Ernst Gombrich has made clear, this procedure had no equivalent in tradition or in contemporary practice. This study for the *Madonna and Child and Saint Anne* remains an extreme case among all the preparatory drawings that have

survived. But it is not unique. Jotted on the recto and verso of the same sheet, the two sketches for the *Madonna and Child with a Cat* (fig. 203, 204) show for example that, from 1481–83, Leonardo could have been working in this way. In the lower part of what is today considered the verso of the sheet (fig. 203), Leonardo sketched many overlapping lines in his search for the right configuration. He then turned the drawing over to choose the outline that he preferred. The investigation then began again on the upper part, in particular

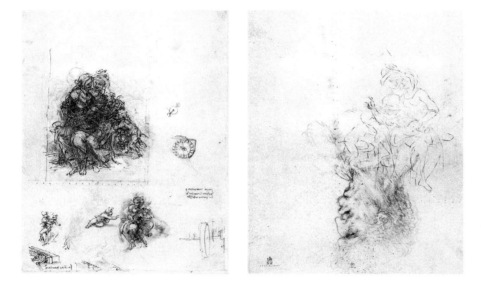

Far left: Fig. 201. *Study for the Madonna and Child and Saint Anne*, pen and brown ink, gray wash, 10½ x 8 in. (26.7 x 20.1 cm.) London, The British Museum, recto.

Left: Fig. 202. *Study for the Madonna and Child and Saint Anne*, black chalk, 10½ x 8 in. (26.7 x 20.1 cm.) London, The British Museum, verso.

concerning the head of the Madonna. Leonardo changed its position by drawing it in two directions, towards and away from Jesus and the cat. Finally, an ink wash clarified the relationships of the main volumes.[449]

In the *Treatise on Painting*, Leonardo gives the theoretical justification for this unprecedented practice, and it is not surprising to find here his fundamental concern with movement: "O you, painter of compositions (*istorie*), do not draw the elements (*membrifficationi*) of these compositions with defined outlines (*con terminati lineamenti*) because the same will happen as happens with many painters [...]: often the creature presented does not have movements adapted to the intention and, when the artist has brought a beautiful, pleasing arrangement of the elements (*membrifficationi*) to a conclusion, it will seem to him damaging to move that one higher or lower, or further back or further forward." (*Codex Urbinas*, 61v-62r.) A preparatory drawing like the one for *Neptune* (fig. 184) confirms that Leonardo did not have this complacency: above the group and no doubt to remind him of his decision when he will

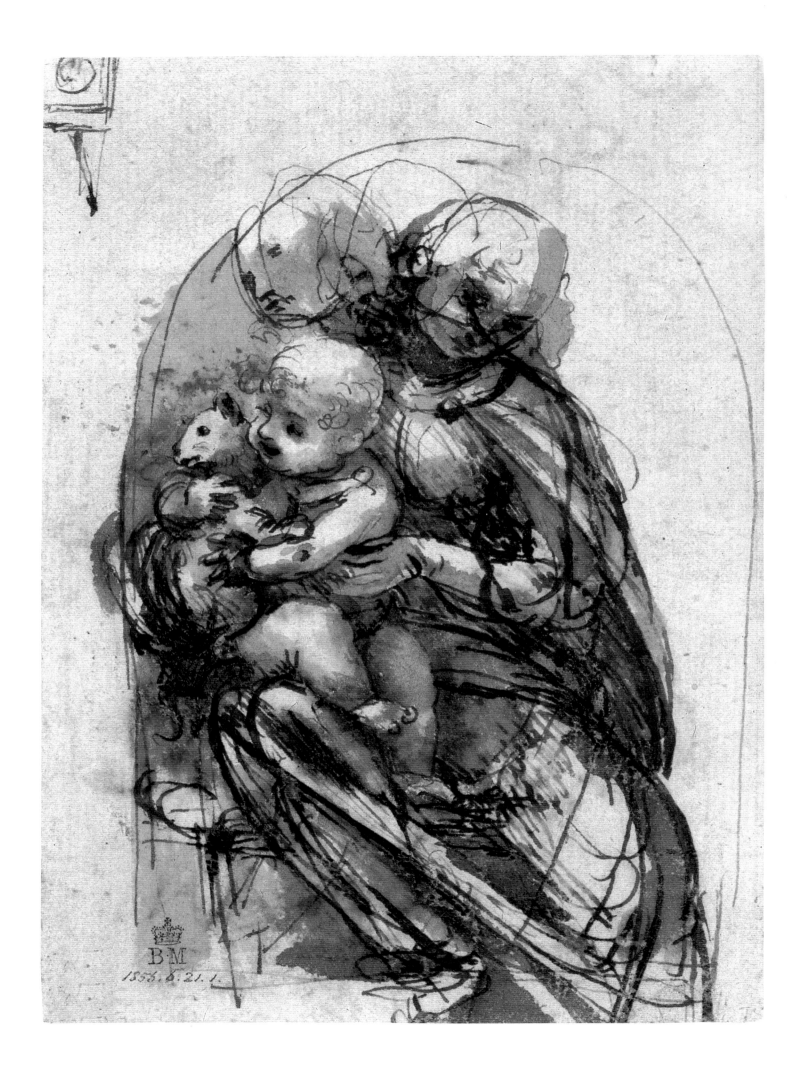

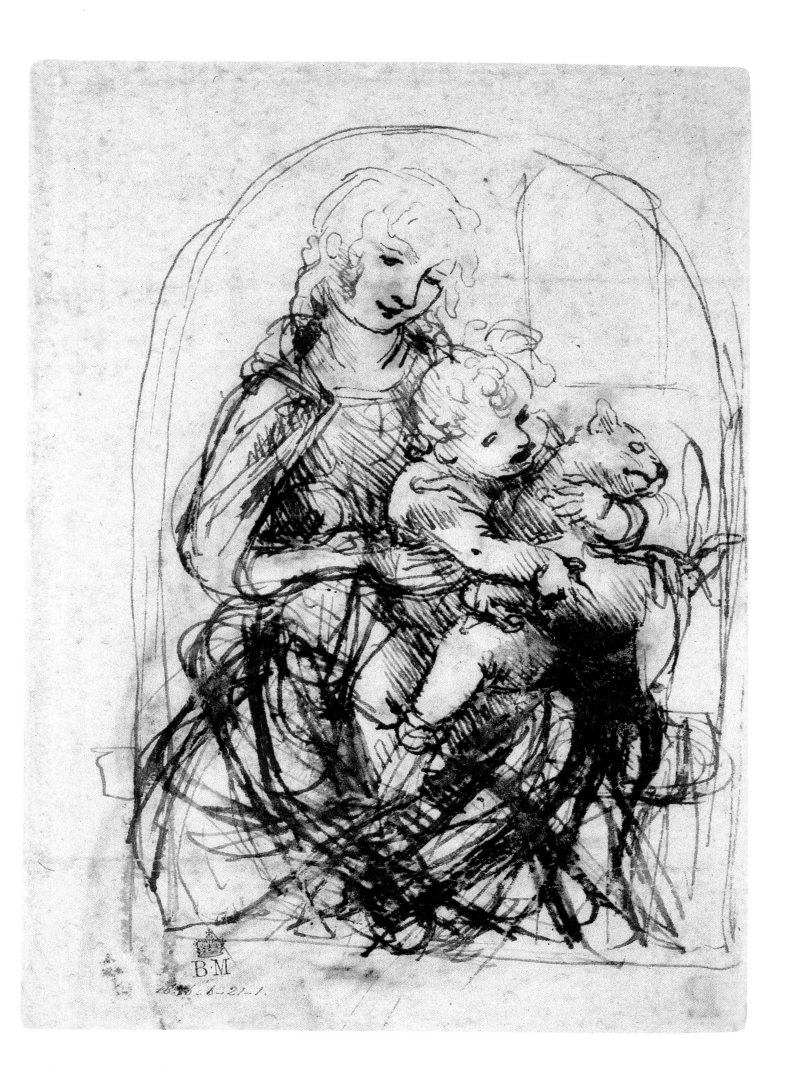

take up the drawing again, he writes: "*abasso i cavalli*" ("I lower the horses").

This advice is addressed particularly to the painter of compositions (*istorie*), and it concerns the arrangement of their elements (*membrifficationi*). There are good reasons for this. In his terminology, Leonardo fits in perfectly with the Florentine tradition, specifically that of Alberti. It was Alberti who made the *istoria* the masterpiece of the painter, defining it as a composition of bodies, limbs and surfaces (*corpora, membra, superficies*). It was Alberti too who thought that the circumscription, or "marking of the outlines" (*fimbriarium notatio*), must be carried out with "very thin lines that are almost invisible" or else "one would not see the edges of the surfaces in the painting but all kinds of cracks."[450] But Leonardo overturns Alberti's lesson. For Alberti, it was simply a question of concealing the outline, whose initial certainty remained the prime quality of the painter: before transferring his preparatory drawing of the surfaces, limbs and bodies to the work itself, he must establish "first of all their boundaries so as to trace [his] lines in their exact position."[451] It was only in the painting that the underlying circumscription should, as far as possible, become imperceptible. Also, as Michael Baxandall has shown, the very idea of composition based on surfaces, limbs and bodies found its theoretical model in the rhetorical definition from the oratorical period.[452] Very significantly (because it takes us back to the issues of *paragone* or comparison) Leonardo compares here the work of the painter to the writing of poetry: "Have you never looked at the poets who compose verses? They do not exhaust themselves by writing beautiful letters, and they do not hesitate to cross out some verses, so as write better ones. Therefore, painter, arrange the limbs of your figures roughly, and first see that the movements are appropriate to the state of the spirit of the animated beings occupying your composition, and only then consider the beauty and the quality of their limbs." (*Codex Urbinas*, 62r.) This unexpected association between poetry and painting (at the preparatory stage) indicates the extent to which Leonardo favors freedom in the search for the form and how, even in the exploratory gesture of the hand making overlapping strokes on the sheet, painting is a *cosa mentale* (a matter of the mind).

In this first stage in the gestation of the work, the graphic action therefore ends with the emergence of the "perfect" form from the chaos that the hand has generated. Invisible in nature because it is born of the spirit of the painter and his hand, this "poetic" form is more beautiful than nature. But, to release it, it is necessary that the active hand starts by creating this informal chaos,

Page 286: Fig. 203.
Study for the Madonna and Child with a Cat, pen and ink, 5¼ x 3¾ in. (13.2 x 9.6 cm.) London, The British Museum, verso.

Page 287: Fig. 204.
Study for the Madonna and Child with a Cat, pen and ink, 5¼ x 3¾ in. (13.2 x 9.6 cm.) London, The British Museum, recto.

288

forgetting its culture in order to give birth, in a first procreation, to the *componimento inculto* ("rough sketch") from which the harmonious world of the work will be freed and composed: "Because you must understand that, if this rough sketch ends up by agreeing with your idea, it will be even better that it should be further enhanced by the perfection present in all its parts." (*Codex Urbinas*, 62r.) In other words, and as the following part of the same text suggests, the active hand of the painter must, in this *componimento inculto*, generate a formal matrix equivalent to that which the marks in the clouds or on the walls form in his eyes. While being "absolutely devoid of perfection in each part," these marks can achieve perfection "in movements or other effects" and, a few lines earlier, Leonardo gives the painter this now well-known precept: "If you look at walls soiled by many marks or made of many-colored stones, with the idea of picturing some scene, you will discover analogies with landscapes, with scenery consisting of mountains, rivers, rocks, trees, plains, wide valleys and every kind of hill. You could also see there battles and figures with lively gestures and strange faces and clothes and an infinity of things, that you could bring together in a clear and complete form." (BN 2038, 22b.)

Unlike the marks on the wall, the *componimento inculto* is already inhabited and haunted by the mind of the painter and the form that he is looking for in it. In its movement, the hand seeks this form in the very flow of the reality that it is in the course of generating. Leonardo's painting expresses his morphological thinking about the world in the dynamic of its gestation: bringing together the chance results of the marks on the wall and the "exploratory gesture" of the creative hand, his approach is based on the conviction of a living analogy between the body of the painter and that of the world, between the microcosm and the macrocosm. Through the fluid rhythmical movement of his hand, the painter can create a fertile jumble of virtual figures from which, like God, he frees the form while fixing its movement.

With Leonardo, the scientific practice of drawing and that of *componimento inculto* are therefore less far apart than they might seem. In both cases the graphic action has the function of "inventing" (in the archeological sense of the term of "coming upon" and of bringing out) in the flow of the real the indissolubly true and beautiful form—and, in both cases, this invention is by means of the conventional tool of truth in the domain of figurative representation: the line, the character of the outline. This unexpected consistency is not surprising: if for Leonardo, painting is a science, then science is also an art.

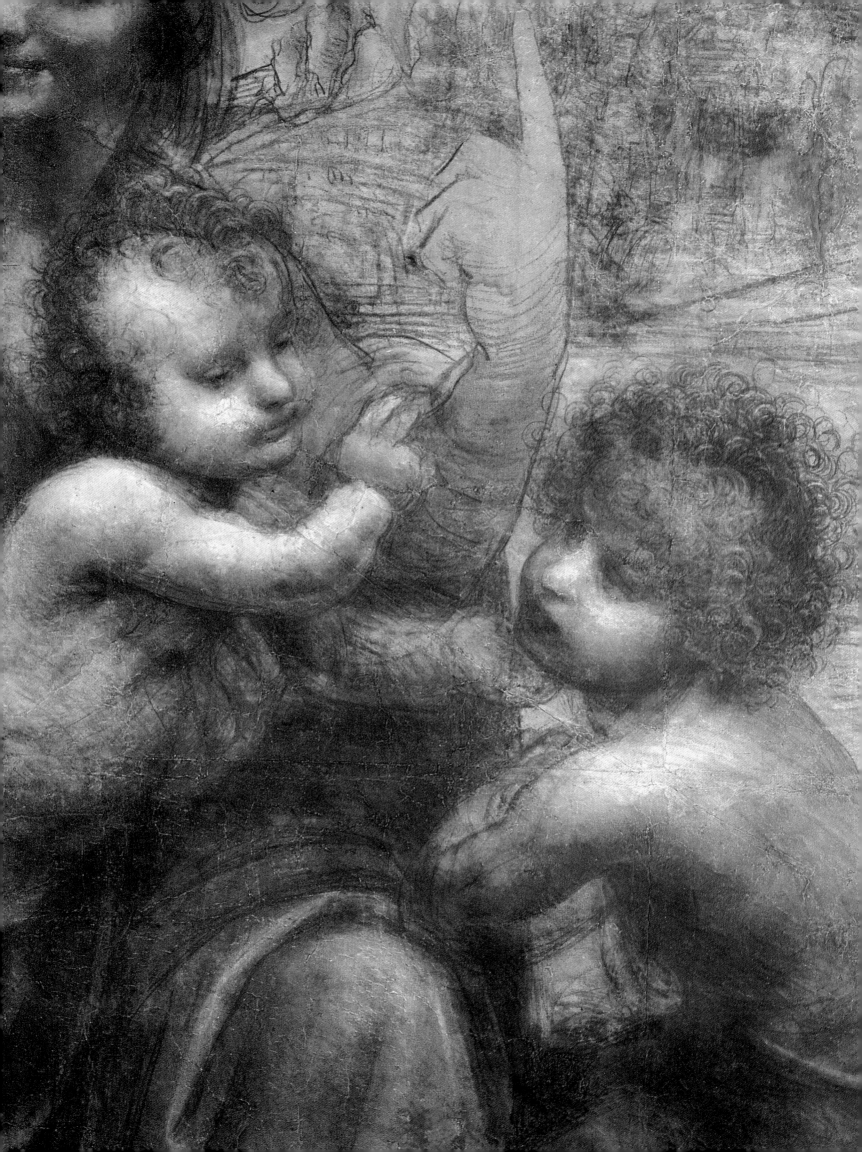

Still, the comparison raises difficulties. While scientific drawing culminates in the perfect precision of the line of outline, the perfection of painting consists rather in erasing it, and not, as Alberti would have it, in simply concealing it. This process is evident as the preparatory drawing changes as it gets nearer to the painted work. Having been "invented" within the chaotic flux of the rough sketch, the line of the outline, true and beautiful, is shaded off and erased (fig. 205). This final change of direction is decisive, engendering a "mental" coherence between these different approaches, creating a profound unity between pictorial sfumato and scientific linearity. Scientific drawing and observation select, isolate and surround; they reveal that which invisibly organizes appearances. On the other hand, painting (whose first stage of gestation is the preparatory drawing) deserves the name of science insofar as it imitates nature by its own processes, that is to say, nature as it is seen, without outlines. The line of outline is not false for all that: it is a convention, "imaginary" in relation to what is seen; it is a construction that "invents" the fixed objectivity of the object—and its demonstrative effectiveness arises precisely from the fact that it puts before our eyes that which is not visible "in reality."

From here, however, the truth of scientific drawing—and also, as has been seen, of technical drawing whose graphic principles are similar—takes on a rhetorical dimension. By making visible, by giving shape to that which in reality is not visible, the drawing achieves what images must do in the orator's discourse: "From images, the orator obtains *enargeia*, what Cicero called *illustratio* or *evidentia*, which seems to speak less than show, and which affects us as if we were at the heart of things."[453] One better understands how, through the perfection of their presentation, the technical or scientific drawings of Leonardo persuade the eye of the truth or, in the case of machines, of the constructional feasibility of their representations.[454] Through their difference, Leonardo's two practices of drawing use a single approach to art and reality: a truly rhetorical approach.

Leonardo's drawing has a rhetorical function first in that rhetoric is a technique, an art of persuasive efficiency. In scientific drawing and technique, the clarity and sharpness of the line have an effect of *evidentia* that can convince the viewer of the actual existence of what is hard or impossible to see in real life. Leonardo can therefore treat in a similar way the anatomical drawings that today we recognize as "true" and those that we recognize as "imaginary." In the preparatory drawings and painting on the other hand, the blurring of

Fig. 291. *Madonna and Child and Saint Anne*.
London, National Gallery. Detail.
(Whole picture p. 447)

the line enables the figure to emerge in such a way that it has a "living" air—which is the "truth" of the painting as well as its ultimate objective. In both cases, the truth and the life of the representation create an appearance, constructed in a persuasive manner. Perhaps even better, what the twin "evidence" of linear drawing and the blurred painting suggests is a "promise" of truth and life, in the sense in which Pliny the Elder understood it when he said that the line of the outline, which "promises what it does not show," formed the supreme "subtlety" of painting.[455]

In addition, Leonardo's drawing responds to a rhetorical approach where the rhetoric corresponded, in terms of language, to a theory of knowledge, expressed in particular by the Greek Sophists. According to Diogenes Laertius, the great Protagoras would also have been a grammarian; it was he who, among other things, distinguished the tenses and the four parts of speech for the first time; in other words, he logically structured the tenses and moods of verbs.[456] The thing could be true since, in Sophist thought, "it is names alone that give things their proper consistency in separating them in some way from the amorphous and indeterminate matter," and that "it is by his power to agree on the meaning of words and thus to distinguish the fixed within the moving that man is the instrument of the determination of the real."[457] Just as the Sophist appropriated blurred appearances by submitting them to the order of speech, similarly the graphic action of Leonardo appropriates the flux of appearances and organizes them with the order of the line. But, in the painted work, this line has to be erased because painting, like science and demonstrated knowledge, constructs a twin of Nature as it reveals itself—while the spirit of the painter transforms itself "into the image of the spirit of God."

"Useful convention, […] convenient graphic imagination,"[458] the clear, sharp line fixes the *schema* of things; the rough sketch and the science of painting make their *rhythm* emerge.

THE CONQUEST OF SHADOW

While Leonardo thinks of painting as a science, it is also because in his eyes it is a separate discipline, entailing specific demands and founding its practice like its theory on the scientific knowledge of natural phenomena and their processes. The idea that painting deals with representational "truth" is a characteristic theme of the Italian Renaissance in general, but with Leonardo it acquires a systematic character that ends up by making it exceptional. This idea only developed progressively, particularly through the critical relationship that Leonardo maintained with what was then the most advanced theory of scholarly painting: Alberti's *De pictura* ("On painting"). Dating from 1435, Alberti's book had suggested founding a "new art" of pictorial representation based on mathematics—even though painters (who wished "that things should be placed under their gaze") could in Alberti's opinion have recourse to "a fatter Minerva" than the mathematicians, who "making an abstraction of every material thing, assess forms and species of things by their intelligence alone."[459]

At the beginning of his career, Leonardo is to a great extent a follower of Alberti. Trained in Verrocchio's studio, he receives a solid grounding in linear perspective. His work of about 1473–75, the *Annunciation* (fig. 206) in the Ufizzi, corresponds to what a young artist was expected to know about the construction of pictorial space, the lines scored in the gesso preparation showing the care that Leonardo has given to this composition.[460] In many respects, Alberti "anticipated" what was to become Leonardo's science of painting. This not only concerns the fundamental nature of mathematics, it also deals with the fact that, in *historia*, the main aim of painting is to represent the "movements of the soul" through the movements of the body, while respecting this *convenientia* that requires that the bodies, by their size, their function, the consistency of their various parts and so on, be in harmony "with the action in which they are involved."[461] Alberti gave particular importance to the suggested movement of the figures, to their narrative effect and their grace, and some of Leonardo's reflections on this point seem directly inspired by Alberti. When for example he criticizes the disproportions between figures and the architectural setting, customary in the practice of Gothic painting but still present in some perspective works of the Quattrocento, he accurately recalls the short passage where Alberti blamed "strongly [...] these men who are painted in a house as if they were shut in a box where they could barely sit, rolled up in a ball."[462]

After "circumscription" and "composition," Alberti makes the "reception

Pages 294–95: Fig. 206. *Annunciation*, oil and tempera on wood, 38½ x 85½ in. (98 x 217 cm.) Florence, Uffizi.

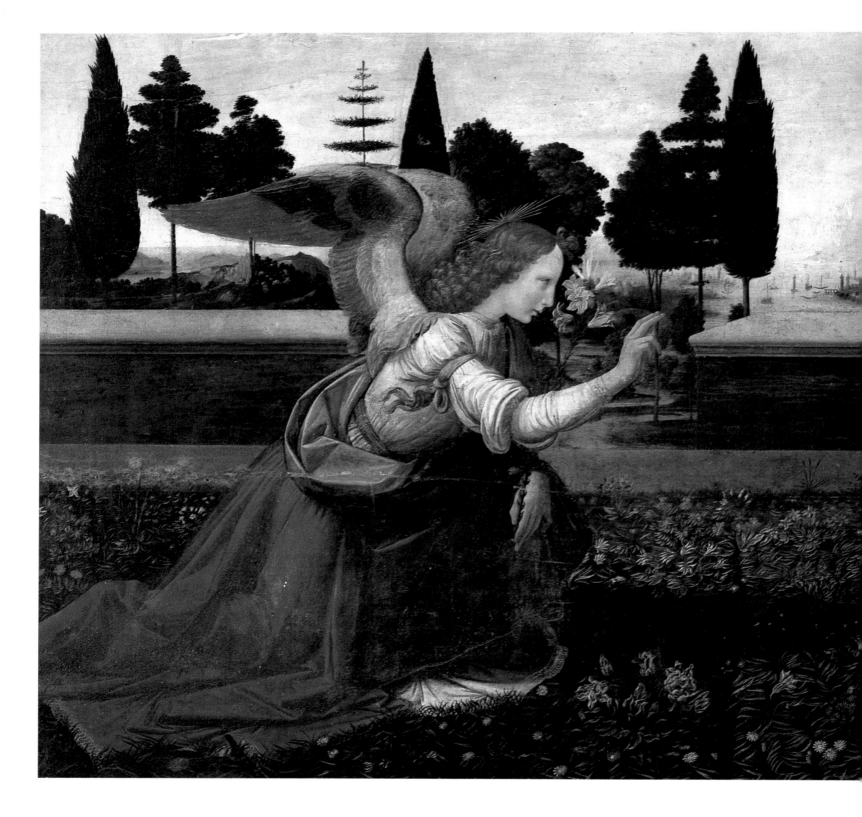

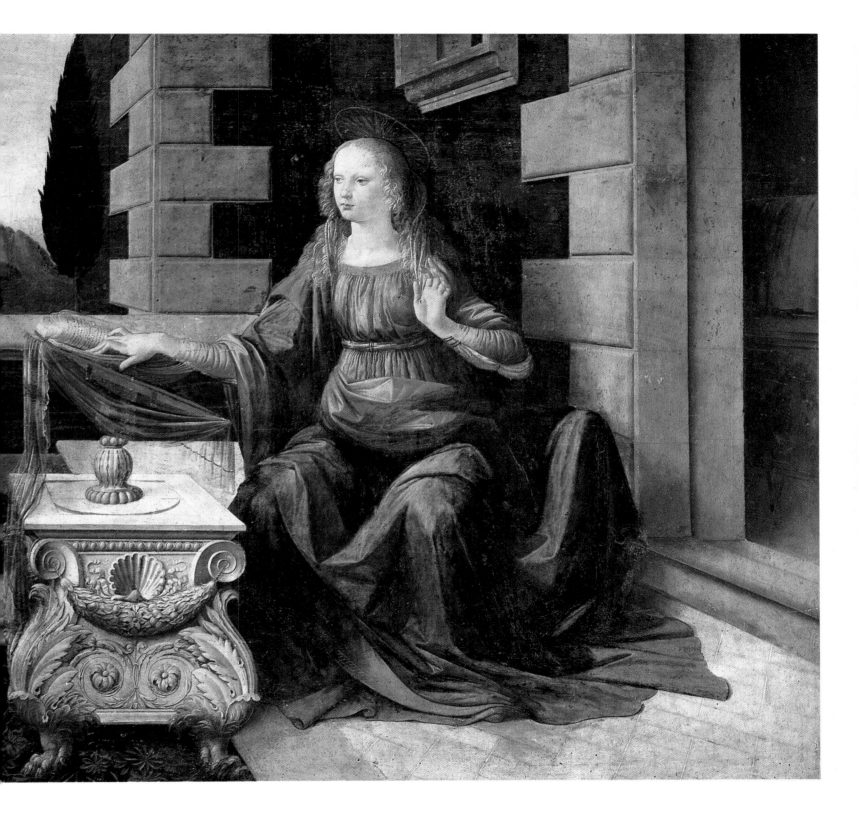

of light" the third part of painting. On this point he once again anticipates Leonardo, in the emphasis he places on shadows in the success and effect of the picture. The glory of Zeuxis arose among other things from the fact that he was "the first to have knowledge of light and shade" and Alberti considers "as a dull or mediocre painter anyone who did not perfectly understand what was the strength of every shadow and every piece of light on each surface." It is the shadows that give figures their "relief" ("what an artist should desire above all"), and Alberti describes with remarkable attention what the painter must do to master the gradations: "As with a very light dew, he will begin by modifying the black or white surface, as convenient, up to the line of separation. Next, he will add, if I may so put it, a sprinkling of black on this side of the line, a sprinkling of white on the other, and so on until he reaches a situation where the most lit place is entirely tinted with the more open color, and, above all, that this color, like smoke, dissolves into the adjacent parts."[463] The end of this passage might almost be by Leonardo. The very fact that Alberti relates the light and dark values to the addition of white or of black to the base color should not be ignored: in this he rejects the traditional practice, still advocated by Cennino Cennini, in which the relief was created either by saturation of the local color, or by changing the color of the shade (*cangiantismo*). In the Uffizi *Annunciation* Leonardo does exactly what Alberti advised in adding relief to the form independently of the color, by adding black or white: the blue does not become more blue, it becomes darker and, ultimately, each plane possesses "a uniformity of depth in the shadows" that creates the tonal unity of the whole.[464] If this practice is, according to John Shearman, "revolutionary," it is no less anticipated by Alberti's advice: "The richness and variety of the colors add much to the grace and the pleasure of a painting. But I would like educated painters to believe that one can use all one's skill and art to distribute only the white and black on the surface of the painting, and that it is necessary to apply all one's talent and all one's care to place these two colors properly."[465]

But the art of Leonardo has only just begun with the Uffizi *Annunciation*. His painting will develop its own science, that will no longer owe much to Alberti.

A careful study of the construction of the *Annunciation* reveals some distortions that indicate the freedom with which, from the start, Leonardo could play with the rules of geometrical perspective—in particular regarding the placing of the figures. Holding the pages of the book nearest to us, the right forearm of

the Virgin is not consistent with the position of the shoulder nor with that of the feet, to such an extent that the latter are spatially indicated by the perspective of the lectern: as Jacques Mesnil wrote in 1905, the angle that the forearm forms with the shoulder indicates "a completely broken elbow."[466] This could be a youthful "clumsiness," but it certainly suggests a relative indifference to geometric strictness.[467] In about 1481–82, the magnificent perspective study for the *Adoration of the Magi* (fig. 208) completely corrects the surprising spatial gaucherie of the drawing where Leonardo had jotted down his first idea for the picture (fig. 207); the sheet from the Uffizi also appears to be a demonstration of linear perspective as impeccable as it is brilliant. Nevertheless a close analysis (to which this kind of image is meant to be resistant) shows that the drawing of the lines to the vanishing point do not take account of the three levels shown in the foreground, that the horizontals of the geometric grid on the floor are irregularly arranged, and that, a more serious "error," the pillars supporting the terrace are not aligned and therefore form "an impossible building with interlaced arches."[468] Finally, and most probably, this perspective study was made independently of the main group that would occupy the foreground of the *Adoration*.

Fig. 207. *Sketch for the Adoration of the Magi*, black chalk, pen and brown ink, 11¼ x 8¼ in. (28.5 x 21.2 cm.) Paris, Musée du Louvre, department of graphic arts.

From the beginning of the 1490s, Leonardo seemed to conceive the construction of perspective and that of the figures separately—an attitude very unlike Alberti's, given that in *De pictura*, the perspective grid, itself developed from measurements of the human body, has as its purpose the positioning of figures in harmony with the architecture that defined the scope of the *historia*.[469]

over
G
leaf
insert

These "inconsistencies" in fact took on their full meaning, fifteen years later, with *The Last Supper* painted in the refectory of Santa Maria delle Grazie in Milan. The apparent simplicity of the perspective construction, its "evidence," hides an extremely complex work. By projecting the figures in front of their architectural surroundings, Leonardo concealed the contradictions and weaknesses inherent to the system of "regular" geometric perspective, while playing with them—and so he arrived at a construction that seems logical but resists any unequivocal reconstruction.[470] From Florence to Milan in fact, Leonardo's intellectual rigor (that Vasari called the *terribilità* of his concepts) and his desire to base the art of painting on scientific principles—and not just with the help of Alberti's "fatter Minerva"—led him to a radical reassessment of the very foundation of Alberti's theories: the assumed truth of geometrical perspective. He came progressively to replace it with a new consistency of image, founded on the unifying principle of shadow.

In the first place the criticism of Alberti's system was about its internal difficulties: that is to say, essentially about the contradictions encountered by the illusion of perspective in certain cases, which were connected with the very notion of the "viewpoint" from which the image had to be looked at to have the desired effect. Alberti had very logically advised placing the geometric horizon of the picture at the eye-level of the painted figures so as to create the impression of a continuity between the imaginary space and that of the spectators. But, given that the work was often fixed quite high up (as was the case with frescoes and even for altarpieces), this advice sometimes made it impossible to get to the ideal viewpoint from where the illusion would have worked. Moreover, the geometrical system assumed a fixed viewpoint, in front of what would later be called the "vanishing point"—which Alberti called the "central point" because it formed the projection onto the plane of the "central ray" of the eye that was looking at the picture.[471] Since the work implied a number of spectators positioned in various places, since it had a certain size and since its spectators would be bound to move backward and forward and parallel with it, the verisimilitude of the system and the illusion that it was trying to create would collapse. By moving, the viewpoint caused the reality of the surface forming the support of the image to reappear, and thus also obscuring the intended transparency of the "window" from which Alberti wanted the *historia* to be contemplated.[472] The ingeniousness of the system developed for *The Last Supper* meant that one single perspective image could respond to different viewpoints. Being founded not on perspective but on the

frontal view and (apparent) symmetry of the architecture and figures, the illusion of spatial continuity was preserved, apart from some slight differences, whatever the position of the spectators.[473] In other words, instead of the "point" to which Alberti reduced the body of the spectator, Leonardo took account of the actual physical conditions of visual perception. He did not reject the constructional efficiency of perspective, but he played with it to enhance the presence of the human figures.[474]

Apart from the almost invisible columns of the loggia where Mona Lisa is seated, the architecture of *The Last Supper* was the last that Leonardo painted. The remarkable absence of painted architecture in his works after 1500 is a very clear sign that he had moved a long way from Alberti's geometry. From the beginning of the 1490s, Leonardo's criticism of the limits of "regular" perspective increased to the extent that, following a wholly "scientific" approach, Leonardo took into account the physiological conditions of actual vision, as defined by contemporary science. On at least three points, the system of linear perspective denied or ignored them. First, far from being made up of a unique and unmoving eye, natural vision rests on the movements of the two eyes; secondly, as the hazy perception of outlines shows, the *virtus visiva* ("visual ability") did not, according to Leonardo, and as mentioned above, reside in a unique point; and thirdly, the atmospheric milieu in which objects are seen plays a sometimes fundamental part in the perception of distances (when the base of the objects is hidden from our view). In *Manuscript C* (1490–91) and *Manuscript A* (about 1492), Leonardo therefore tried to formulate principles of perspective that took account of these various factors. This thinking must be considered, albeit briefly: its unfinished character and the hesitations of some of its formulations show with what intensity he sought to found a "science of painting."

Beside "natural" perspective, which involved the processes of vision as such, "accidental" (or artificial) perspective included three different kinds of perspective that the painter had to master. The first was called *liniale* perspective; this was linear or geometrical perspective, within which Leonardo distinguished "simple" perspective (carried out "on a surface of which all parts are equally distant from the eye," that is to say, spherical) and "composite" perspective, drawn on a plane surface. Composite perspective itself included a sub-category, "accidental perspective combined with natural perspective" or, as it would later be called, anamorphosis.[475] The second perspective was called perspective *di colore*: its purpose was to determine the transformation of colors

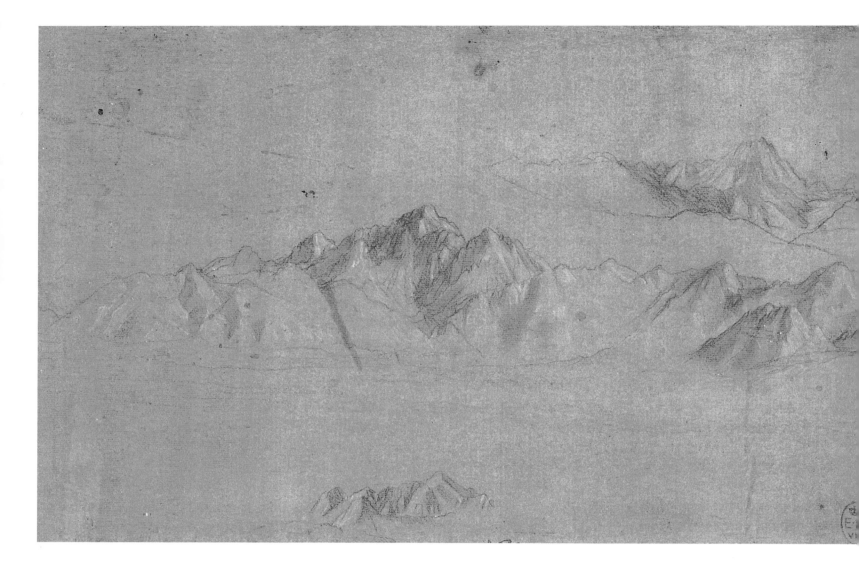

Fig. 209. <u>*Mountain range*</u>, n.d.,
red chalk heightened with white, on brick red prepared surface, 4¼ x 6¼ in. (10.5 x16 cm.)
Windsor Castle, Royal Library, RL 12410.

as a function of distance. The third was the perspective *di spedizione* (of visual sharpness) or *dei perdimenti* (deletions): he explained "how things must be less sharp in proportion to their distances." (*Manuscript A*, 98r.) To this system already complex in that the painter had to master the three elements simultaneously, Leonardo added a fourth perspective: aerial perspective or *aerea*, that dealt with the part played by the atmospheric milieu in the perception of distance through the transformation of colors created by the blue color of the air (*Manuscript A*, 105v).[476]

The atmospheric degradation of colors already existed in the studios of the Quattrocento, even in Florence. What distinguished Leonardo's approach was its systematic character and the fact that he wanted to found and control the practice "scientifically," trying for example to establish proportional rules for the degradation of colors on the model of the proportional reduction in size as a function of distance.[477] The sharpness of Leonardo's observation is undeniable, but his proposals also had their origin in medieval optics and Aristotle's *Meteorology*[478]—to the extent that the admirable views of mountains drawn in about 1511 (fig. 209) undoubtedly owe as much to memory, to reasoning and "mental experiment" carried out in the studio as to live observation.

One can, moreover, legitimately think that the shifts, sometimes decisive, after 1500, in his theory of the perspective of colors, are directly connected to the knowledge that he then had of *De coloribus* ("Of colors") attributed to Aristotle. Rejecting the idea that the air is naturally blue, he henceforth thought that this coloration was due to the mixture of the light of the sun and the darkness that surrounded the atmosphere. Similarly, while going more deeply into the description of the degradation of colors as a function of distance, he followed the pseudo-Aristotle when the latter says that colors owe their origin either to an optical mixture, or to superimposition, or to a mixture of black and white, the two extremes on the scale of possible colors. Above all, he adopted the idea according to which the "true" color of an object was an ideal impossible to perceive: all visible color actually depended simultaneously on the color of the object itself, the medium through which it was seen (that is to say, simultaneously on the luminosity of the medium and the distance at which the object in the medium was situated), and on the colored reflections of adjacent objects.[479]

The differences between the two versions of the *Madonna of the Rocks* showed how strongly Leonardo believed in the idea according to which atmospheric luminosity, lighting (that is to say also the shadows) and the reflections affected the appearance of colors. Commissioned from Leonardo in Milan in 1483, the

303

first version, the one in the Louvre, was probably painted between 1483 and 1486 (fig. 210). The date of the second version (fig. 211) is more problematic but the picture certainly could not have been started before the beginning of the 1490s, and it was probably carried out in two stages, starting between 1493 and 1499 and finished between 1506 and 1508.[480]

Whatever the situation and without considering here questions of iconography or the part of autography in each of the two works,[481] significant differences can be seen between them. In the second version, the area devoted to the sky is much reduced, and this decision allows the figures to be "logically" included in a more somber atmosphere. At the same time, the light is more clearly defined. In the 1483–86 version it is relatively uniform and does not establish a distinction between the luminosity of the background and the foreground, while the light in the London version clearly highlights the foreground by "falling" on the figures from above and from our left, almost in parallel with the plane of the representation. This luminous dramatization has the particular effect of accentuating the relief of the figures in relation to the background, while allowing a reduced treatment of the details in the shadows and in the outline of the figures. There is almost a paradox in the two paintings—but in this lies the science of painting that Leonardo tried hard to perfect. The more neutral light of the first version detaches the figures from the background without giving them the *rilievo* (relief) that is the perfection of painting.[482] The second picture on the other hand enables all the components of the image to be more united by enveloping them in a common shadow while at the same time bringing forward the group of figures towards the faithful.

The effectiveness of this new treatment of light is shown by the transformation of the angel. Even though the suppression of the gesture of the index finger may have been demanded by those who commissioned the painting because it drew too much attention to John the Baptist to the detriment of Jesus, it is a fact that Leonardo no longer needed this admonitory figure that was typical of Alberti's principles.[483] As a result of the light, the group already has sufficient presence that it does not need the angel's expression and pointing finger to invite the spectator to take part in the scene. The withdrawal of the angel's gaze into the plane of the picture is an indication of Leonardo's development in this respect (and of the awareness he had of it): his knowledge of light and shade enabled him to involve the spectator without needing to make an appeal to him. While closing in on themselves, the figures are co-present with the spectator, open to his emotional participation.

Fig. 210. *Madonna of the Rocks*, 1483–86, oil on wood, 78¼ x 48 in. (199 x 122 cm.) Paris, Musée du Louvre.

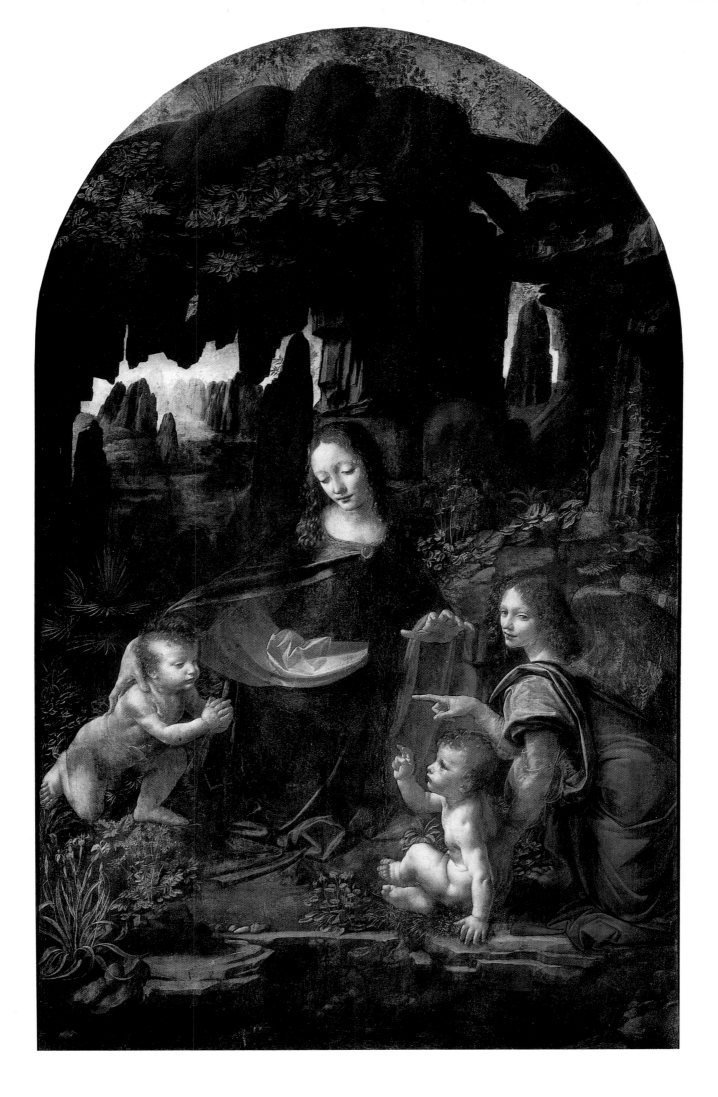

However, in reassessing the scientific and practical validity of regular perspective in the name of the realities of vision, Leonardo took on a considerable task. This was because, as Hubert Damisch has stressed, it was perspective that, while itself created by painting, turned it into a science.[484] Leonardo had therefore redefined painting as science once more, on different premises; a science that did not try to represent objects as they "are" but as they appear, in all the variations that are caused by incident light, the ambient medium and the multiple reflections that ran through it. He therefore became interested in phenomena that escaped the geometrical rationalization of vision or, to put it more accurately, in the determinations that linear perspective "excluded from its order."[485] It is significant that the two "parts" that make up the painting should according to him sometimes be the "figure," defined on the one hand as "the line that delimits the figure of the bodies and their details" and, on the other, as "the color contained within these limits," and at other times, more originally, as "the outline that envelops the forms" and the "shadow."[486] The two definitions are not in opposition since color depends on light and therefore on shade; but the second evidently had more weight in his eyes. Indeed when he returned to these two parts, it was to praise the superiority of "knowledge" and the "difficulty" that the mastery of shade demanded in relation to the outlines: "The outlines can be clarified by veils or flat panes of glass placed between the eye and the object to be drawn; but this procedure cannot be used for shadows, because of the imperceptible character of their limits."[487]

According to Leonardo, this importance of shade was a fundamental element in the science of painting, and it was quickly taken as a historic contribution on his part. For Lomazzo in 1590, it was through the art of shade that Leonardo had "achieved in the faces and bodies, that are really wonderful, everything that nature could present." For Vasari, Leonardo was the first who had "added a certain darkness to the practice of oil color that has enabled the painters of today to give strength and relief to their figures."[488] Leonardo's fondness for shade was not only a result of his sensitivity. In support of his new science of painting, he was backed by tradition, as expressed in Book XXXV of Pliny the Elder's *Natural History*. The importance of shadows for relief is mentioned repeatedly in his work. The mastery of shade had made Nicias of Athens famous and made the glory of Pausias of Sicyon. The latter, the first painter to become famous in the field of encaustic painting, had invented a procedure by which, "while all other painters represent a color by tending to white the parts that they want to make stand out, he [...] gave relief to shade through

Fig. 211. *Madonna of the Rocks*,
1503–06, oil on wood, 74½ x 47¼ in. (189.5 x 120 cm.)
London, National Gallery.

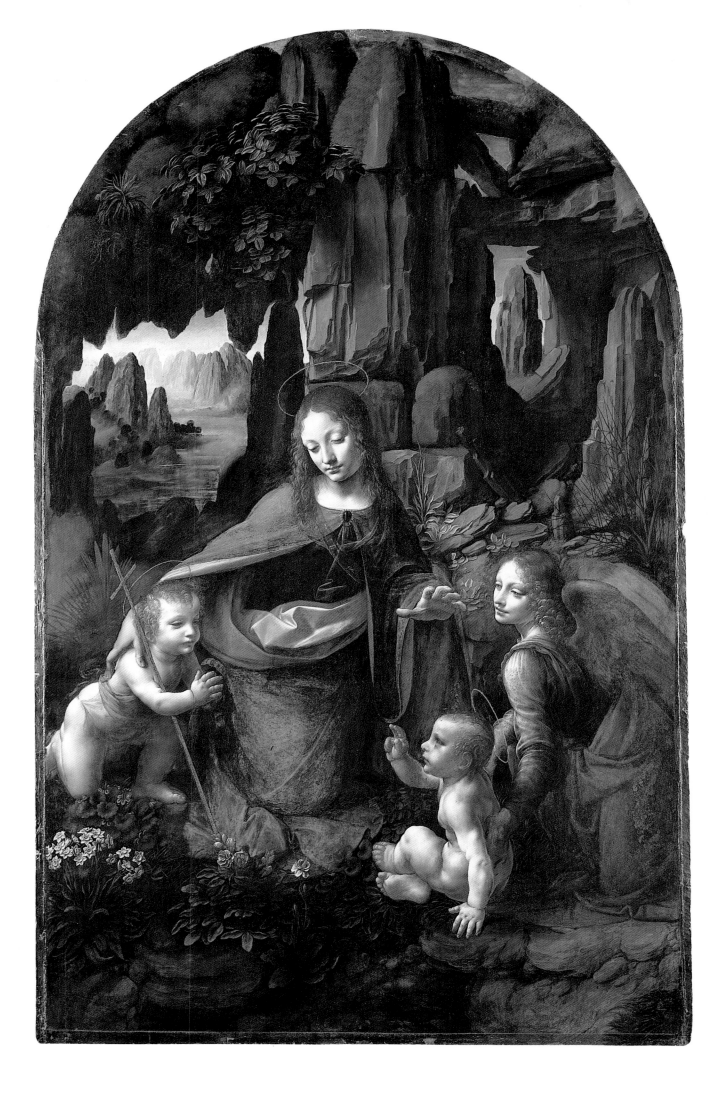

shade itself."[489] Pliny added above all that one of the inimitable inventions of the great Apelles, the undisputed master of "grace," lay in the veil of *atramentum* (or black) that he spread over a completed picture: by reducing the brilliance of the colors even up-close, from a distance this veil "gave, without it being noticed, a more somber tone to the brightest colors."[490] It is possible that the parallel between Leonardo and Apelles was more than a simple commonplace, and that Leonardo himself had conceived a "plan of action" consisting of trying to reinvent the ancient science of painting, by recreating its attitudes and techniques.[491]

To Leonardo, "shadows were indispensable for perspective because, without them, one does not understand solid bodies." (*Codex Atlanticus*, 250r.) "Shade reveals the form of the body" and these forms "could not show their details without shade." (BN 2038, 22a.) In this context it is significant that, in spite of the three books he was thinking about, in his *Treatise on Shadow*, devoted to "derived" (or cast) shadows, he did not manage to develop a method of constructing these cast shadows. This failure arose to some extent from the fact that the geometrical science of cast shadows, connected with optics and astronomy, implied that they would have a linearly-defined edge, while, according to his own observations, some shadows had "smoky edges" (*termini fumosi*), rather than distinct edges, How could shadows be treated geometrically if their borders were undefined? The question was still preoccupying him in 1513, but it would be Dürer who in 1525 would demonstrate how to construct cast shadows in painting in accordance with the laws of perspective.[492]

But the impasse that Leonardo had reached undoubtedly also had its origin in the fact that the shadows whose science he sought to possess were not so much those that suggest a clear articulation of the body in space but rather those that allow figures to emerge, in their volumes, from the shaded continuity of the painted surface, a microcosm of the image of the world. Although shadow does not belong to form since it changes according to the incidence of the light on the body, it is nevertheless shadow that makes one "understand" bodies and see their volumes. The shade that interested Leonardo was therefore that which showed the effect of the surrounding medium on the bodies that were visible in it—or, to be more precise, the shade that shows the interaction between the medium and the body. This was the meaning of his poetic formula in which he declared that "every opaque body is surrounded and clothed on its surface by shadows and light." (*Codex Atlanticus*, 250a.) What the shadows thus reveal when presenting figures surrounded by their medium,

is the luminous continuity of space that envelops and includes the "opaque bodies." Here again is the concept of "continuous quantity," infinitely divisible. But it is no longer a matter of the continuous quantity that geometry deals with: its coordinates are not linear, and they must be tonal because they are "scientifically" founded on the infinite continuity of light and shade. Leonardo therefore tried to define systems of proportional gradation for light and shadows. But there was still more: responding to the variations and movements of light, the continuity of shadows was also related to that of movement. In shaping for an instant the body that it clothed, shade demonstrated the movement of the world whose forms made the rhythm visible. The unity of the shade in the painting made heard "the continuous bass, below the *cantilena* ("sing-song") of particular colors."[493] This connection between shadow and movement was well understood by Vasari when he recalled the "terrible mobility" in paintings, achieved by "a certain darkness of well-understood shadows" (*terribil movenzia [...] per una verta oscurità di ombre ben intese*). It is true he was then talking about Giorgione, but it is also the case that, according to him, the latter had seen certain things from the hand of Leonardo, "very blurred and [...] terribly dark (*molto fumeggiate e cacciate [...] terribilmente di scuro*)."[494]

This virtual movement of shadow was the dramatic, aesthetic, and scientific impulse behind Leonardo's sfumato. Sfumato was based on the scientific approach of the physiology of vision but also followed the ancient tradition of grading tones to add relief in order to achieve it. In its most simple sense and according to the description that Galileo gave in his *Thoughts on Tasso*, sfumato consisted of a means of passing "without harshness from one color to another, as a result of which the painting comes to be sweet and round, possessing strength and relief."[495] But this technique developed effects whose consequences went further than simply achieving a convincing relief. Trying to make the surface and the "boundaries" of opaque bodies imperceptible through lack of definition, sfumato gave the painted representation a density without evident matter. Painting was no longer treated as a medium transparent to the external reality that it represented: it acquired an "internal depth"[496] within which, short of a true visibility, the spectator's gaze is invited to experience a specific visual presence—that is only declared elusive because it is difficult to express in words. This is how the Venetian Daniele Barbaro also perceived sfumato when, quoting in 1556 the famous eulogy on outlines by the ancient Greek painter Parrhasius, he declared that it was a "very sweet

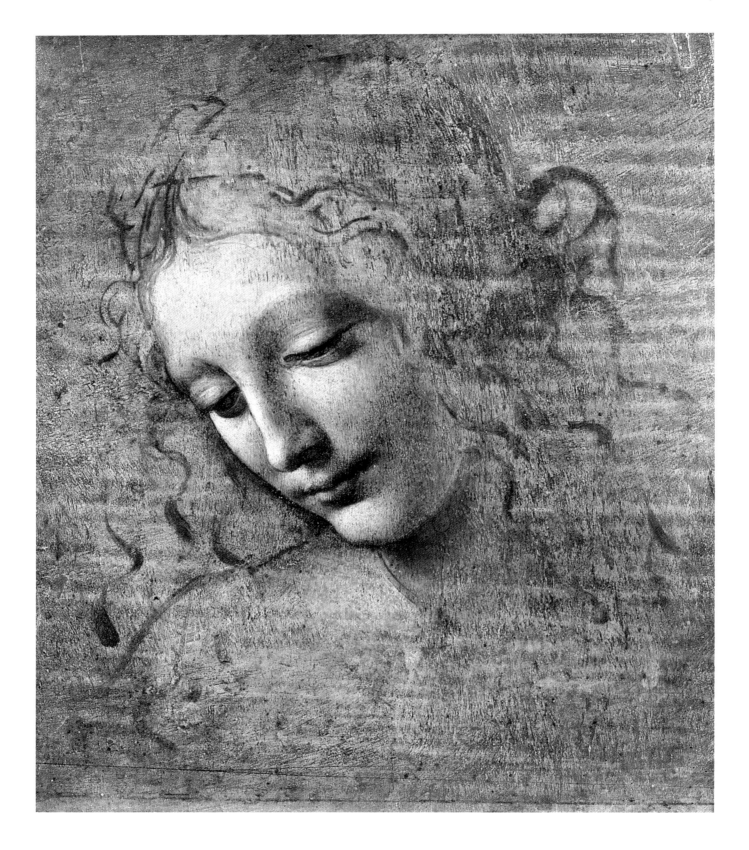

Fig. 212. *Head of a young girl with disheveled hair* or *La Scapiliata,*
umber and green umber heightened with white on wood, 9¾ x 8¼ in. (24.7 x 21 cm.)
Parma, Galleria nazionale

flight, a delicacy on the horizon of our visual perception, which is and which is not," that "makes us understand what we do not see" because "the eye thinks it sees what it does not see."[497] The visual evidence of sfumato "makes the painting a place where experience continually comes up against the limits of its knowledge;" it implies that the "fictions" of the painting are, like nature, full "of infinite reasons that are never in the experience."[498] The supreme expression of the science of painting and of its divine character, Leonardo's sfumato was also the power behind the poetry of his pictures and the mystery that seems to emanate from them.

The strange panel known by the name of *La Scapiliata* (fig. 212) encapsulates this poetry of mystery.[499] Though in places some lines suggest the form, the majority of the internal and external outlines are produced by the adjacent light or shade—and the infinite sweetness of the modeling is generated only by the veil of the shadows, covered by reflections, that clothe the face. Technically the work is a radical exception, corresponding to none of the contemporary practices of Leonardo. A monochrome painting using umber thickened with amber turning to green on a white lead ground, the panel is at the same time highly finished yet incomplete, as if suspended in a moment of equilibrium where the figure emerges, "living," and where any further work would freeze the potentiality inherent to indefiniteness. It is as if Leonardo was bringing together the genius of Parrhasius (the promise of outline) and the still greater quality of Apelles: knowing how to remove the hand from the picture in time.[500] It has sometimes been thought that this is a preparatory drawing. But no preparatory drawing painted on wood exists from the sixteenth century, and this face recalls as much that of Leda (fig. 283) as it does Saint Anne in the *Madonna and Child and Saint Anne*, or that of one of Leonardo's lost Madonnas. In fact, it is a typical Leonardo head, and it would be futile to try to link it to a precise subject: it is better to see it both as a mold and as a distillation of possible images. Entirely absorbed in herself, escaping from all iconographic definitition, she only possesses a single particular characteristic, the one that has given the picture its name: her hair that is sketched all loose, as far from the wig-like hair of Leda as it is from the tidy curls of Mary—and for that reason it is thought by some people not to be by Leonardo.

With its unusually mellow sfumato and mysterious purpose, *La Scapiliata* could be a work that Leonardo intended only for himself: more than a study, a kind of intimate "demonstration" of this divine science of painting that, let us not forget, made the painter "master of creating" the beauties capable of inspiring love.

Another reason for thinking that *La Scapiliata* might be a personal work, one in which Leonardo recreated for himself the unparalleled grandeur of antique painting, is its monochrome. Before recommending painters to use all their art to master the use of black and white, Alberti had with some reservation mentioned the choice of the ancient painters, Polygnotus and Timanthes, who only used four colors, and Aglaophon who was content with "a single simple color." Pliny had no such reservations since, according to him, "it is in using only the four colors that Apelles, Aëtion, Melanthus and Nicomachus, painters highly celebrated by all, have carried out the immortal masterpieces that one knows."[501] The color of *La Scapiliata* is not simple, but it is restricted and, above all, as Pliny's would have said, it is "austere." In general Pliny divided color into two kinds: the brilliant colors (*floridi*), " that the painter receives from his patron," and all the others, that were "austere" (*austeri*). Among these, some were natural and others manufactured—including white lead and burnt umber, without which, Pliny stressed, "one could not make shade."[502] Two of these "austere" colors used by the painters of antiquity appear in the "monochrome" of *La Scapiliata*—and the third, "amber," was no doubt made by Leonardo himself, just as Apelles made his white lead, using one of his own recipes, with a base of cypress or juniper sap.[503] This technical dimension might help to explain the meaning and purpose of *La Scapiliata* for Leonardo. Indeed Pliny had also indicated that some people preferred the painter Athenion, who was "more austere of color but more agreeable in this austerity, so that his science shone forth from his very painting," to Nicias, the meticulous master of light and shade,[504] Leonardo may have wanted to use the science of painting to become a "new Apelles," and in this case the austere sfumato of *La Scapiliata* might represent for him a personal "demonstration," a mental experience brought to a satisfactory conclusion, away from all the constraints of a commission.

One fact is certain: Leonardo progressed very gradually in his invention and mastery of the art of shade, sfumato, until, finally, it became the unifying principle of all his work. Starting with the *Portrait of Ginevra de' Benci*, the modeling of the face is very "soft," the shadows have no edges and according to John Walker, the modeling of the lips achieves a "delicacy" that Leonardo never surpassed again. Comparing this portrait with the variation produced by Lorenzo di Credi is enough to show the extent to which Leonardo already possessed an "internal" quality unparalleled in Florence at the end of the 1470s.[505] But the fusion between the figure and the surrounding atmosphere was still

Fig. 213. The *Annunciation*.
Florence, Uffizi. Detail.
(Whole picture pages 294–95)

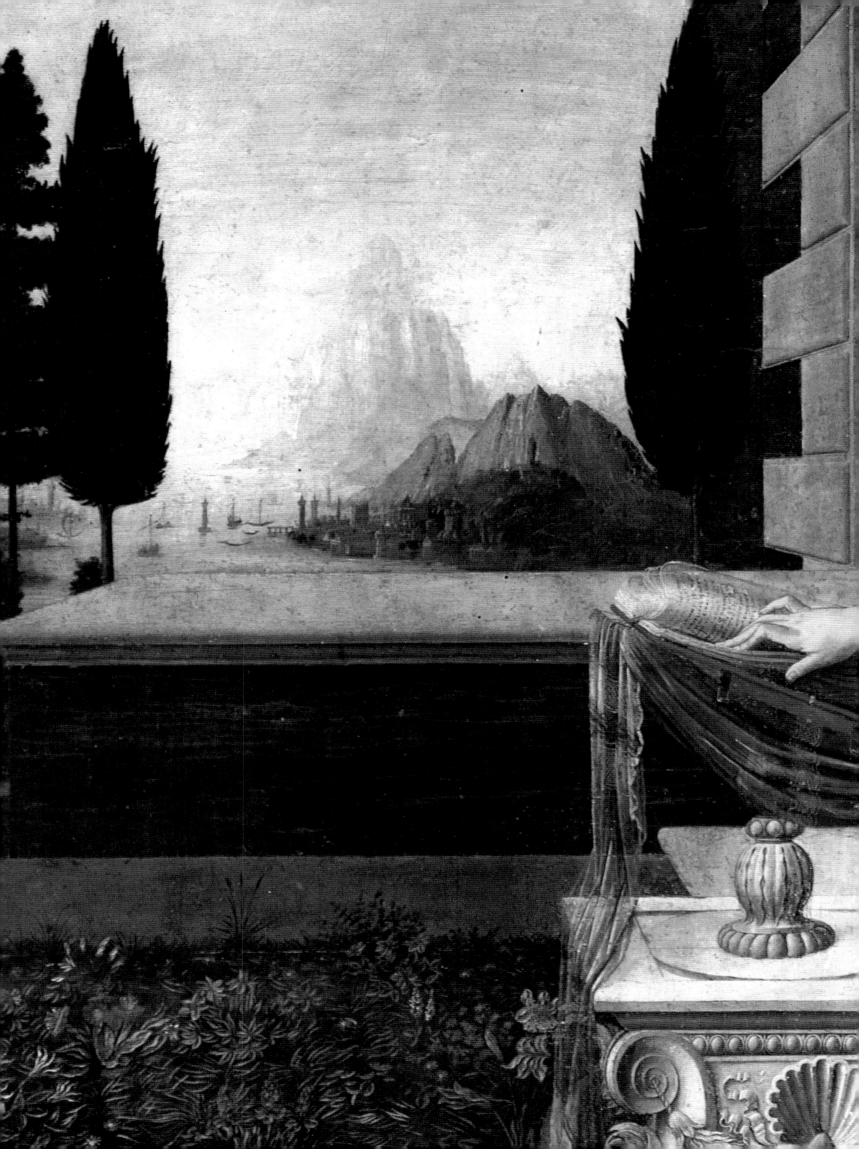

limited, in particular by the dark screen formed by the juniper tree. The limited character of the atmospheric unity of the work is even more obvious in the Uffizi *Annunciation*, where the outline of the figures shows hardly any sfumato, although it is already remarkably evident in the landscape of the background. In a way, Leonardo's aim was that the atmospheric fusion of the countryside should surround the figures in the foreground so as to "clothe them in shade." It has been seen how the two versions of the *Madonna of the Rocks* were perfect examples of this point of view, but the visual structure of *The Last Supper* shows even better the route that Leonardo was following. The geometric definition of the position of the figures in space is not clear— indeed, the figures are not situated in this space but in relation to it, and almost in a contradictory relationship with it. But these figures are quite clearly placed and integrated into the luminous atmosphere of the representation. Leonardo has conceived an arrangement that allowed him to place the head of Christ against a clear background, abolishing the architectural screens used in the earlier works, and also to have the light for the foreground come from the left—that is to say from the actual windows of the refectory. This created the luminous, dramatic unity of the whole, from the area of shadow on the left to the light that illuminates the last apostles on the right.

After *The Last Supper*, Leonardo gave up architectural settings and placed figures and nature in direct relation to each other. The relationship between the two can be spatially arbitrary, as it is for example in the two surviving versions of the *Madonna and Child and Saint Anne* and in the *Mona Lisa*. The figures and the background are articulated by the unity of tone and light in the composition. Sfumato then presides over the whole area. The relief and "the vague state of emergence" of the figures[506] do not necessarily depend on the darkness of the background: shade exists in a luminous atmosphere as well. But the effect of the painting is based on a limited, muted palette, on that "austerity" of colors whose praises Pliny sang.

This progressive conquest of the art of shadows was accompanied by two highly significant technical developments. The first affected Leonardo's general practice of drawing.[507] After 1490 Leonardo largely gave up using a metal point, silver or lead point, which he had very quickly mastered. From the very early 1480s, he had also mastered the effects of the pen in various studies for the *Adorations* (of the shepherds, and then the Magi). Then, from 1492–93, he began to use red chalk (sanguine) as well. In 1493–94, the relative awkwardness of its use in the study for a *Last Supper* (fig. 214) was partly caused by the

fact that this kind of drawing was unsuited to the medium of red chalk, which at that time Leonardo used like a pen. But far from giving it up, he progressively exploited the flexibility and luminous tactile values of the medium, as for example in the admirable *Copse of birches* of 1498–1500 (fig. 215), some of the studies for *The Battle of Anghiari*, and some grotesque heads drawn after 1495.

Fig. 214.
Study for a Last Supper, red chalk, 11 x 15¼ in. (26 x 39 cm.) Venice, Galleria dell' Accademia.

That this development should have been inspired by his research, profound as always, into luminous gradations is confirmed by the preparatory study of a bust of a woman for the *Madonna with the Spindles* (fig. 216). This drawing combines metal-point and red chalk in an unexpected way. As Martin Kemp has suggested, this brief return to the metal-point was no doubt in response to the need to capture with particular delicacy the slippery play of light and shade along the young woman's shoulders and bust. But the paper has also been given a preparation (necessary for metal-point) whose texture, different from that of earlier preparations, has given the line a quality that is "slightly rough."[508] As for the surprising use of red chalk on a background of almost the same color, a technique devised by Leonardo when he was preparing *The Last Supper* and taken up by his followers, this was evidently done to reinforce the unity between the figure and the background from which it emerged.

The second technical area in which Leonardo's technique changed significantly after 1500 also concerned the general question of luminous atmosphere, but it had a deeper meaning in that it dealt with Leonardo's personal and physical relationship with the work in progress. Recent technical studies have shown that before 1500, during what might almost, from this point of view,

be seen as a first stage in his artistic career, Leonardo did not hesitate to paint with his fingers—or, at least, to touch the still wet medium of the painting with his fingers to create the effects of shimmering luminosity by the light pressure of touch.[509] Noticed in the London version of the *Madonna of the Rocks* in the 1920s, this technique had actually been used since the end of the

Fig. 215. *Copse of birches*, *c.* 1508, red chalk, 7½ x 6 in. (19.1 x 15.3 cm.) Windsor Castle, Royal Library, RL12431r.

1470s, in the parts of the *Baptism of Christ* attributed to Leonardo. It is also found in the *Portrait of Ginevra de' Benci*, in *Saint Jerome* and in the *Adoration of the Magi*. In the London *Madonna of the Rocks* it is probable that the parts "touched" in this way are the oldest— and they would confirm that the picture was painted in two stages, begun a little before 1495 and completed between 1506–08. After 1500 on the other hand, at the same time as he almost gave up using metal-point, Leonardo seemed no longer to "touch" his pictures, and this technique was not used by his Milanese followers.

Though surprising at first glance, historians of painting technique are not particularly amazed by this revelation. This practice was not unusual at the end of the Quattrocento. Although he and Verrocchio were the only Tuscan painters to "touch" their works in this way, it was fairly common technique in Venice and the north of Italy. Giovanni Bellini had "touched" his pictures since the 1480s[510] and the practice spread so that after 1500 it was found in works by Cima da Conegliano, Marco Basaiti, Bartolomeo Montagna, Francesco Mazzola and Andrea Previtali. It disappeared after 1520. But this parallel is coincidental. The Venetians gave up the technique when they adopted relatively coarse canvases to practice *colorito alla veneziana* (Venetian

Fig. 216. *Study for the Madonna with the Spindles*, *c.* 1501, red chalk and silver-point on red paper, 8¾ x 6¼ in. (22.1 x 15.9 cm.) Windsor Castle, Royal Library, RL 12514.

coloring). These canvases were of cross or herringbone weave, prepared with a thick paste. This allowed them to fashion a textural surface that the figures shared, and at the same time seemed to emerge from.[511] This purely Venetian technique of coloring culminated in the "final manner" of Titian, and that suffices to indicate everything that sets it apart from Leonardo's technique of "touching."

In Verrocchio's studio, "touching" was associated with the recent introduction of the new medium of oil, whose attractive effects of transparency were not immediately mastered. Leonardo probably "invented" the technique in Florence in order to exploit the remarkable luminosity of oil as quickly as possible, but in the longer term it could only be a makeshift. As soon as he could "scientifically" achieve with his brush the luminous, shimmering effects for which he had needed to touch the wet painting with his fingers, Leonardo gave up for good what must in his eyes have been no more than a facile vulgarity.

Although Leonardo actually painted with his left hand, he "touched" his paintings with his right hand.[512] This observation of Leonardo's private working methods is of great interest. In contrast with the right hand and its physical role, the left hand was for him the one for drawing and writing—and one remembers how, in his comparative portrait of the painter and sculptor, he glorified spiritual lightness, in contrast with the physical effort and brutality to which the sculptor was inevitably subjected. In ceasing to touch his works with his right hand, Leonardo does not merely rub out, along with his imprints, the material traces of the work of the painter, the marks of concrete operations by which the work was made. His retreat from all physical contact with the picture no doubt had psychical overtones, as we shall see, but at this point, it showed above all to what an extent Leonardo embraced the idea of painting as a *cosa mentale* ("mental thing"). It did not mean that pictorial execution was, for him, inferior to the intellectual concept. On the contrary, it has been seen that execution was "more noble" than the concept. But it gained all its nobility from appearing not to have been created by the hand of man, to seem, like the miraculous images of Christ, *acheiropoietes*, purely "divine."[513] This would have been the personal objective of Leonardo's conquest of shade, to which he devoted the most personal part of his painting: to achieve, from the depths created by the dematerialized opacity of sfumato, the essence of mystery—mental in the case of the *Mona Lisa* and mystical for that of *Saint John the Baptist*.

THE PAINTER'S RHYTHMS

It was not simply by practicing the *componimento inculto* ("rough sketch") that Leonardo overturned the concept of preparatory drawing and therefore of formal invention. It was also by bringing about what Ernst Gombrich has called a "divorce between motif and meaning," to the extent that certain "images" would persist in his work and would receive different names according to the context in which they were used.[514] In fact, the process was more complicated because, more than just images, they were potential arrangements of images that changed and were never really identical. But Gombrich was right. Leonardo's extremely personal approach to creation led him to repeat certain motifs independently of the theme for which they were invented, and to go back to certain configurations to exploit their intrinsic power of expressive suggestion: the drawing became, itself, a source of inspiration. He often seemed to work on "motifs" for themselves, adapting them to specific projects that he was working on, rather than creating them in response to his projects. A good example of this procedure is the drawing of *Neptune* (fig. 184). According to Vasari, Leonardo created it in Florence for Antonio Segni, his "intimate friend," while he was working intensely on *The Battle of Anghiari* for the Palazzo Vecchio. This drawing is clearly a reworking of what had been the first idea for the central group of the fresco, preserved on a sheet in the Accademia in Venice (fig. 217). In the course of other studies it became progressively transformed (fig. 218), leading to the group of the "struggle for the standard," but, in more detailed form, it would at the same time give birth to the Neptune group. In a more general way, it has been noticed that a good proportion of the works drawn and painted by Leonardo in the years around 1480 form part of the same "genealogical tree" that originated in the development of the group of the Madonna adoring the Child. Apparently first created while preparing an *Adoration of the Shepherds*, this motif developed itself and diversified (fig. 219) to the point where it served as the common source for two works as different as *Saint Jerome* and the *Madonna of the Rocks*.[515]

Highly personal (even "solipsist" in the opinion of Ernst Gombrich), this practice resulted in the circulation of an abundance of complete or partial motifs of drawings within drawings and works within works, which gave the whole of Leonardo's production a coherence and a kind of "transverse unity" that is very remarkable. Without returning to the motif of the rearing horse, the extended hand of Mary traveled from the *Madonna of the Rocks* to the

Madonna with the Spindles. Even more striking, the right arm of Saint Peter in *The Last Supper*, studies for which are on a sheet preserved at Windsor (RL, 12546), reappeared a dozen years later as the left arm of Saint Anne in the *Madonna and Child and Saint Anne* in the Louvre—having, in the preparation of the first version this theme, served as the left arm of both Saint Anne and the Madonna, on the back of the British Museum sketch (on the front of which the right arm appears). The little Saint John the Baptist appearing in this sketch is descended in direct line from an earlier page of about 1478 (more than twenty years earlier). There Leonardo had introduced him after he had drawn the Madonna and Child, thus necessitating the reorientation of Mary's head towards him (Fig. 220).[516]

In other cases it is a precise configuration, which is used repeatedly, almost with the air of being an attribute of the person to whom it corresponds. This is the case with the patch of gilded fabric that decorates Mary's dress. In the Uffizi *Annunciation*, it is around her waist; some years late it is found, transformed and off-center, in the *Madonna with the Carnation* (fig. 229), then, yet again, in the two versions of the *Madonna of the Rocks*. It is tempting to look for a

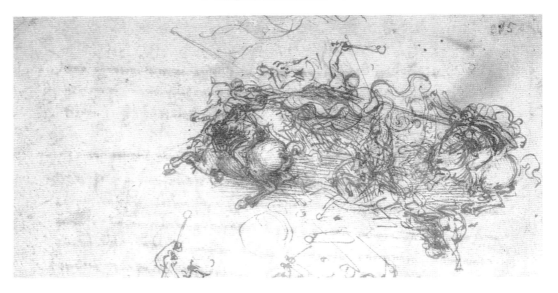

Fig. 217. *Study for The Battle of Anghiari*, detail, pen and ink, lead-point outline, 6¼ x 6 in. (16 x 15.2 cm.) Venice, Galleria dell' Accademia, inv. 215.

particular iconographic value in it, connected for example with the idea of the *Diva Matrix* ("Womb goddess").[517] But that would run the risk of being arbitrary because, if the folded material has a meaning, it must have been a very personal one known only to Leonardo himself. Equally, it would be wrong to look for a meaning in the arrangement of the folds of Mary's coat on her right

knee and hips. Appearing in about 1480 in the *Benois Madonna* (fig. 230), the fullness of the folds on the hip is again reminiscent of the "golden patch" that interested Leonardo at the time. The motif of folds then disappears and does not reappear until almost thirty years later, in the *Madonna and Child and Saint Anne* in the Louvre. Leonardo then redeveloped it very carefully, as the beautiful preparatory drawing in the Louvre (fig. 316) shows. It was changed again in the final work.

This tendency to carry out formal research independently of a given theme can be traced back to 1478 in the sheet containing many studies for the head and shoulders of a young woman (fig. 221). Probably started as preparatory research for a Madonna and Child, for which he soon found a solution (the most finished bust, situated near the top, in the center), Leonardo then multiplied the number of angles of view and poses, thus embarking on a series that was "potentially infinite."[518] The exercise of variation and combination was one of the essential components of Leonardo's research and his fertile inventiveness. Also, this approach undoubtedly helps to explain the unfinished state in which some projects and works were left: faced with the multiplicity

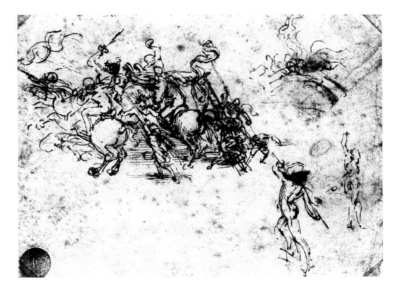

Fig. 218. Study for *The Battle of Anghiari*, pen and ink, 3½ x 6 in. (8.8 x 15.3 cm.) Venice, Galleria dell'Accademia, inv. 216.

of solutions and possible options, the very fact of choosing one rather than another created a boundary that restricted the flow of suggestions of possible images. This attitude also throws some light on a singular characteristic of Leonardo's creative process: when the opportunity arose, he worked on his projects in pairs. He sometimes simultaneously conceived and undertook

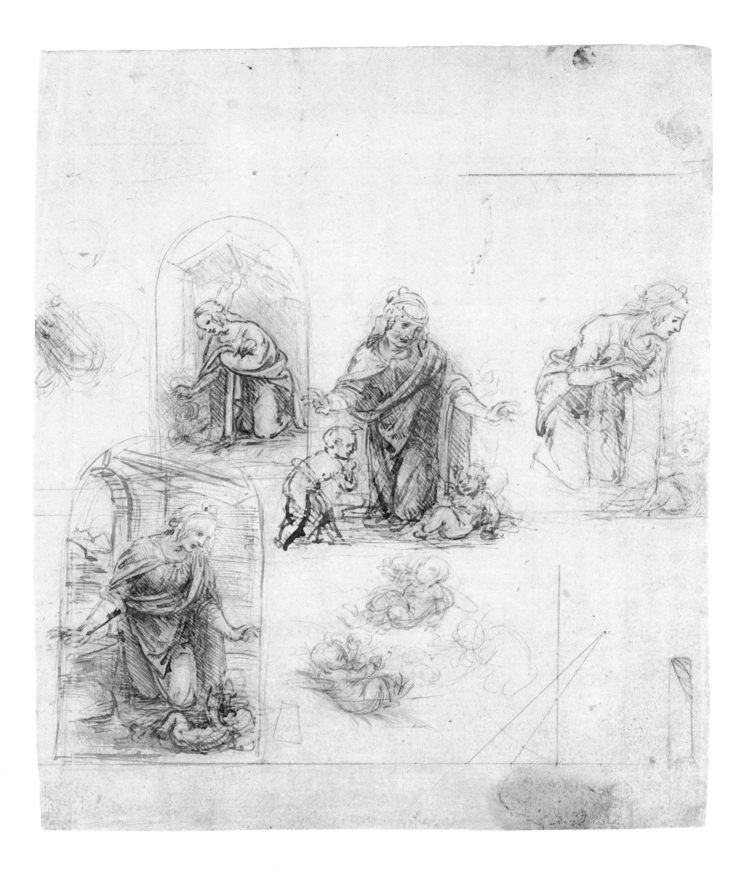

Above: Fig. 219. *Studies for a Nativity*,
pen and brown ink, 7½ x 6½ in. (19.3 x 16.2 cm.)
New York, Metropolitan Museum of Art, inv. 17-142-1.

Opposite: Fig. 220. *The Madonna and Child with Saint John the Baptist and other studies*,
pen and ink, 16 x 11½ in. (40.5 x 29 cm.)
Windsor Castle, Royal Library, RL 12276r.

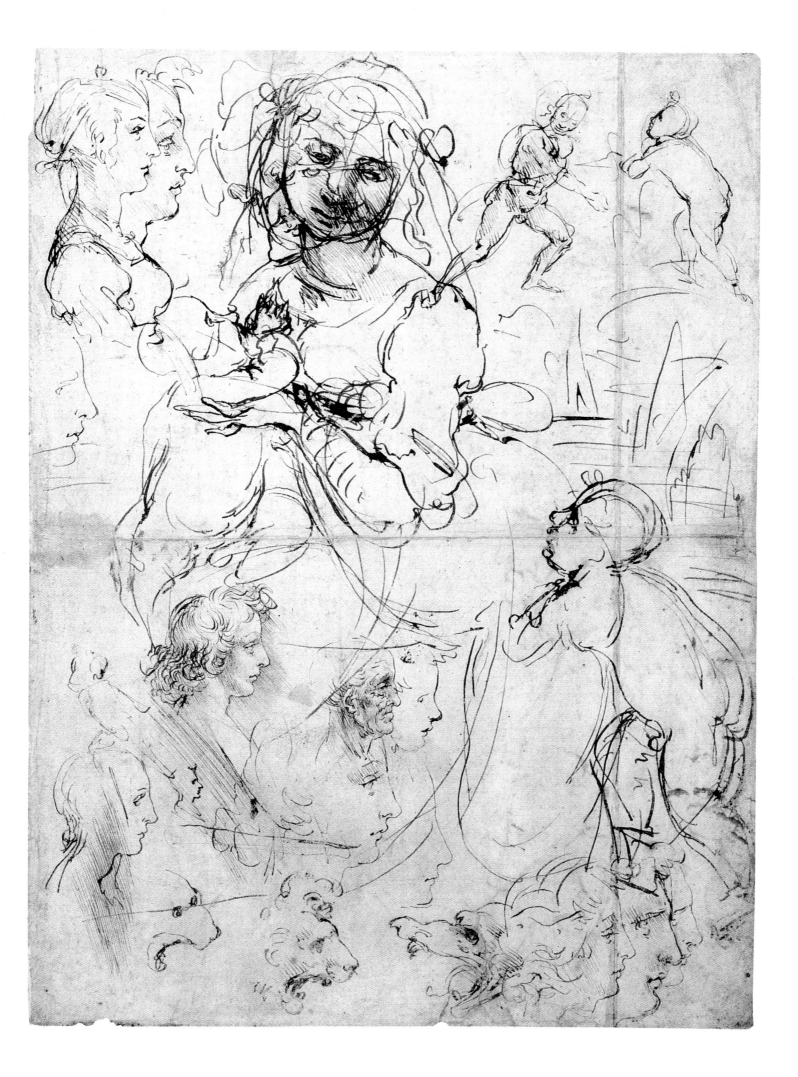

two solutions in response to the "artistic problem" raised by a commission or that he posed himself. Thus one of his first manuscript notes, in 1478, recorded that he "began the two Virgin Marys"; today these are unknown, but he was probably working on two versions of the same idea, perhaps the *Benois Madonna* and the *Madonna and Child with a Cat*. Thereafter, Leonardo regularly made two rival versions of the same project, whether simultaneously or one after the other. As well as the twin solutions represented by the

Fig. 221. *Study of the head and shoulders of a young woman*, 1478–80, silver-point on pink prepared surface, 9¼ x 7½ in. (23.2 x 19 cm.) Windsor Castle, Royal Library, RL 12513.

Mona? Lisa!

equestrian monument (rearing or not), it is known that there are two versions of the *Madonna of the Rocks*, two of *Leda and the Swan*, and three of the *Madonna and Child and Saint Anne*. Finally, the concept of the *Saint John the Baptist* in the Louvre is inseparable from that of the *Angel of the Annunciation* (lost, but known from a drawing and copies).

The case of the *Madonna with the Spindles* deserves particular consideration.[519] Today the work is known through various copies and variations, of which two appear to be particularly close to the original (fig. 222, 223). The original itself has disappeared; it was begun in about 1500–01 and was painted for Florimond Robertet, secretary to Louis XII, who in 1507 was to buy a bronze *David* by Michelangelo for his chateau at Bury. The painting was certainly delivered to its owner in about 1507. Leonardo was working on it in Florence in 1501, at the same time as he was working on a second cartoon (lost) of the

324

Madonna and Child and Saint Anne. This is mentioned in two letters written by the Carmelite Fra Pietro da Novellara to Isabella d'Este on April 3 and April 14, 1501, who was impatient to receive her portrait by the hand of the Master. According to Fra Pietro, Leonardo seemed to live "from day to day," and he could not bear to touch his paintbrushes (*"impatientissimo al pennello," "non puo patire el pennello"*) because geometry and his "mathematical experiments" had distracted him from painting. He was doing nothing apart

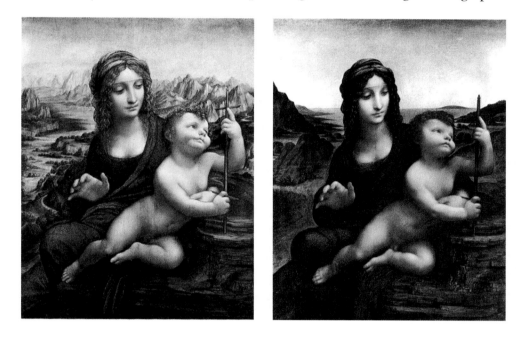

Far left: Fig. 222. Leonardo (and studio), the *Madonna with the Spindles,* oil on wood, 19¾ x 14¼ in. (50.2 x 36.4 cm.) New York, private collection.

Right: Fig. 223. Leonardo (and studio), the *Madonna with the Spindles,* oil on wood, 19 x 14½ in. (48.3 x 36.9 cm.) Drumlanrig Castle, collection of the Duke of Buccleuch.

from the cartoon of Saint Anne and the "little picture" for Robertet, of which the second letter gives an accurate description: it was a "seated Madonna (who seems) to want to unwind her spindles; the Child has one foot in the basket of spindles, he has taken the skein winder and he is looking attentively at its four arms in the shape of a cross and, as if he had a craving for this cross, he is laughing and holding it tightly, not wanting to give it to his Mother who seems to want to take it from him."

Fra Pietro had perfectly identified the important innovation that Leonardo introduced into the field of small devotional pictures with this Virgin and Child: the narrative power of a symbolic accessory.[520] The game of the Child with the skein winder leads to a contrasting animation within the group of figures: the representation seems to grasp the moment and suspend it, offering the devout gaze the possibility of sharing the characters' feelings, while

imagining the moments that preceded it and those that will follow. [521] This narrative setting explains the lively twisting movement of Mary's body and the peculiar position of her right hand, and the body of Jesus, as dynamic as it is complex. This creation of movement is inseparable from the transformation that Leonardo was introducing into the traditionally hieratic group of the Madonna, the Child, and Saint Anne, and it is this animation that would ensure the immediate success of the *Madonna with the Spindles.* From 1502, Michelangelo drew his inspiration from the pose of Jesus in the rather different context of the *Taddei Madonna* (fig. 224). As for Raphael, he returned to the arrangement on several occasions: in 1504–05, he gave a simplified version in the *Terranuova Madonna* (Berlin); in 1507, he used the pose of Jesus (out of its narrative context) in the *Bridgewater Madonna* (Edinburgh), and finally, in 1511, in the *Madonna of the Duke of Alba* (fig. 225) he gave his most finished interpretation of the Leonardo model of 1501.

In Fra Pietro da Novellara's description, there is one surprising detail: the basket of spindles that has given its name to the painting. In fact, it does not appear in any of the old copies of the work. The explanation is that Fra Pietro saw the picture while it was being painted (he described it as a "little painting that Leonardo was making"), and Leonardo no doubt abandoned the basket of spindles after his visit. But this information in itself demands attention: it shows that Leonardo could change his composition in the course of the work and, above all, it gives a lively interest to the two versions of the *Madonna with the Spindles* mentioned above (fig. 222, 223). A recent technical analysis has revealed a certain number of pentimenti (revised passages):[522] some involve the poses of the two figures, while others concern a perspective structure that, in a preliminary stage, existed on the left where the head of the Madonna came to lean, placing it spatially in relation to the distant landscape. The discovery of these pentimenti throws a new light on these panels. First of all it suggests that they were not copies: the genre of the copy hardly ever justifies pentimento—particularly when, as here, it has a bearing on a common element in the two works under consideration: the existence or otherwise of an architectural structure. The gestation of the two panels must be a result of the working arrangements in Leonardo's studio. In his letter of April 3, 1501, Pietro da Novellara recorded that Leonardo had hardly touched his brushes, "except that two of his assistants were making copies (*ritratti*) to which he put his hand from time to time." One might therefore suppose, with Martin Kemp, that from a drawing by Leonardo (that no doubt included the basket of spindles),

two versions had been "copied" simultaneously by Leonardo's *garzoni* ("lads"), and that Leonardo made a number of corrections in the course of the operation, that might or might not have been significant. (This would also explain in particular the relative weakness of the landscapes. The scenery in the New York version is typical of Leonardo, but the modeling of the mountains does not possess his rhythm and tonal subtlety. The seascape of the other version is more original and was no doubt conceived by Leonardo, but the weakness

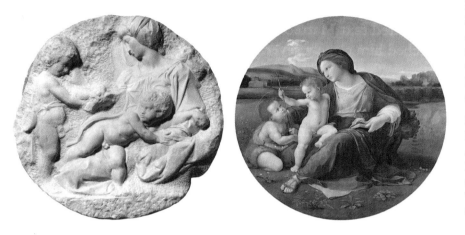

Far left: Fig. 224. Michelangelo, *Taddei Madonna*, c. 1502, marble tondo, diameter 43 in. (109 cm.) London, Royal Academy of Fine Arts.

Left: Fig. 225. Raphael, *Madonna of the Duke of Alba*, 1511, oil on canvas, diameter 38½ in. (98 cm.) Washington, National Gallery of Art.

of its execution means it must be attributed to an assistant.) Matured in the studio for the same length of time (for how many years?), the two works would have been like twin paintings; one of them had been intended for Florimond Robertet, while the other was conceived as the alternative version that Leonardo made whenever he had to make a choice. The "twin sisters" would have become progressively more different until they achieved their own maturity—but they would both have kept the mark of their common conception: the idea of the ensemble of the animated group, as well as the rejection of the painted architectural setting in the course of the work. It has been seen earlier that Leonardo gave up architectural settings in his painting after *The Last Supper* and this formed an important step in his artistic career. It is therefore not insignificant that this change took place during the gestation of a little picture for private devotion.[523]

Leonardo conceived the *Madonna with the Spindles* between 1500 and 1507, almost without touching it, and, even without dwelling on his other activities as engineer, anatomist and mathematician, he was also "working" on the *Madonna and Child and Saint Anne*, no doubt on the portrait of Isabella d'Este, and on the *Neptune* for Antonio Segni. He was about to start

327

on the portrait of Mona Lisa del Giocondo before undertaking the preparation for *The Battle of Anghiari*, and at the same time he was beginning to reflect on *Leda*, kneeling then standing. The importance is less in the quantity of these projects (although it challenges once again the notion of Leonardo's lack of productivity) than in their simultaneity. One has to imagine Leonardo thinking at the same time of all the compositions and forms that would give rise to works so far removed from each other in appearance. His life must have been like the description of him working on *The Last Supper* given in a celebrated text Matteo Bandello: "(Leonardo) often went, I have seen and watched him closely several times, early in the morning onto his scaffolding, because *The Last Supper* is so high up the wall; he was accustomed (I said) not to leave his paintbrush from sunrise until dusk and, forgetting to eat and drink, he painted without stopping. Then two, three or four days could pass without him touching it; other times, he would rest for one or two hours, thinking and meditating, he would consider his figures. I have also seen him (at whim or if an impromptu idea came to him) leave at midday, in full sun, from the Corte Vecchia where he was modeling this astonishing horse,[524] and go straight on to the Grazie: and, having climbed his scaffold, grab his brush and give one or two strokes to one of those figures and leave immediately to go elsewhere."[525]

This "method" of work explains why Leonardo could not paint in fresco, because the surface of the coating must be covered before it dries. The constraint of the *giornata* ("day's work") was a complete contradiction of Leonardo's meditative and simultaneous creative practice. Leonardo had somehow to invent a new technique of mural painting, and his failure does not mean that he did not try, on the model of the great technicians who had been the painters of antiquity. But what Bandello's text implies is more important: he helps us to understand the interaction of the various creations that were going on in Leonardo's mind. These involved not just the interactions that made his painting inseparable from his other "scientific" researches, but also his activities in the single field of painting where he was working simultaneously on various projects. His mind will have been occupied by the interaction of the various changing compositions, to which drawing (more rarely painting) gave form. It was in this uninterrupted flow, in this overlapping of "mental experiments," that the intimate, fundamental unity of his creations resided. These creations were the external manifestation, always subject to being redone or begun again, of an internal rhythm, that underlay and legitimized

his intuition of the rhythm of the world, and also formed the basis of his scientific approach to natural phenomena. So, for example, far from being a preparatory study for *Leda*, the almost scientific drawing of the Flower of Bethlehem (fig. 50) was most likely made after having been rapidly sketched at the bottom of a page preserved in Rotterdam.[526]

This rhythmic simultaneity and the reemergence of configurations, which the drawings in the notebooks made possible even after a number of years, were facilitated, and even perhaps encouraged, by the "disorder" and the "chaos" that reigned in the studio. The master (and the assistants) were able to modify pages[527] that had been used many years earlier in a completely different project. A single sheet preserved at the Accademia in Venice (fig. 226) contains a diagram of proportions drawn in pen in about 1490 and two studies of horsemen in red chalk connected with *The Battle of Anghiari*, dating therefore from 1503–04.[528] Is it surprising that the bald and expressionless profile of the horseman on the right looks like a younger brother of the one next to him, on whom the proportions of the face have been written? This connection reveals

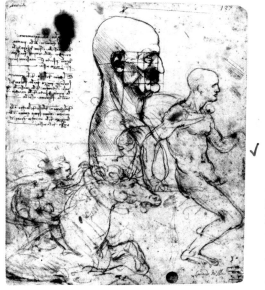

Fig. 226. *Bust of man in profile with studies of proportions and studies of horsemen*, pen and ink, lead-point and red chalk. Venice, Galleria dell' Accademia, inv. 236r.

an unexpected variation on the motif of the contrasted profiles, young and old, from which one can see how much Leonardo pursued it.

This internal rhythm of creation, and the need to follow it, was an essential element in Leonardo's oeuvre. It led to an extreme practice apparently without equivalent among his contemporaries: he took with him works whose

development seemed unsuccessful to him, instead of leaving them in place, unfinished, so that his patron could have them completed by someone else.[529] This happened first at the beginning of the 1480s with *Saint Jerome*, and this attitude, extremely "modern" in its concept of a relationship between the painting and its creator, resulted in the *Mona Lisa* and the *Madonna and Child and Saint Anne* going to France. No doubt the loss of the *Leda* on which Leonardo was working in Rome was also the result of this practice.

So it is clear that a linear chronological approach to Leonardo's oeuvre cannot be used in trying to understand the artistic development of his painting. If the spiral configuration is one of the figures by which Leonardo perceived and grasped the world, his own evolution of painting also follows a spiral progression. His returns were also advances, and the reemergence of a form was not a static event, as a quotation or a mechanical reuse, but it was enriched by what the movement itself had brought with it, after having buried the form and brought it out again. According to Kenneth Clarke, for example, the kneeling pose of *Leda* was inspired by the (rare) motif of a kneeling Anadyomene on a Roman sarcophagus—which, in passing, would imply or confirm the idea of a trip to Rome at the very beginning of the 1500s. The idea is attractive but, as David Rosand has remarked more recently, the pose of *Leda* is anticipated by that of the Virgin on the sheet from 1478 (fig. 220) where some promising motifs had been gathered very early on.[530] Purely formal in appearance, this connection is in fact very significant: if the association of Leda and Venus is legitimate and almost thematically to be expected, that of the Virgin and Leda is much less so. But the start of the 1500s was also a time when Leonardo poetically described the mythical island of Venus,[531] where the theme of fertility of nature relates the characters of *Leda* and *Mona Lisa* by way of contrast.[532] Leonardo's reflection on the legend of Leda was indissoluble (also by contrast) from his meditation on the warlike madness of *The Battle of Anghiari* (a page at Windsor has a sketch of Leda on her knee side by side with a rearing horse in the battle).[533] But one might also think that Leonardo had associated, in an imaginary way, his own *Fertilissima Trinitas* ("most fertile trinity") of Venus, Leda and Mary with the *Humanissima Trinitas* ("Most Human Trinity") that officially consisted of Saint Anne, the Madonna and Child.[534] Again, in the Rotterdam preparatory drawing for *Leda* (fig. 281), one of the new-born cygnets has the pose of Jesus in the *Madonna with the Spindles*, and the fact that one finds it again in some of the copies of the standing *Leda* painted by Leonardo

(fig. 283) makes one think that he must have kept this motif until the final version of his work.

This rhythm of creation and the labyrinth built around the motifs by the associations of ideas, of ideas and images, the condensations that were created only to disappear and resurface in a displaced form, all these prevent a linear approach to the development of Leonardo's painting. But chronology is also indispensable, if only to perceive precisely the phases where the simultaneity of the projects was decisive for the invention and those where, on the other hand, it was their sequence and their maturing that were decisive. We will therefore try to follow his painting through its dynamic, directly connected to the concrete and social conditions in which Leonardo could or could not work: first in situations of stability, in Florence and at the Milan court, then after 1500, during frequent trips that, however, hardly affected his "mental productivity" in the pictorial field. But the portraits are an exception. Throughout his career, from the end of the 1470s until the unknown date when he felt that the *Mona Lisa* was finished, Leonardo's portraits form a continuous series in which his reflection returned on itself and progressed independently of social demands.

Page332: Fig. 227.
Bust of an apostle, the right hand raised,
pen and metal-point on blue prepared surface,
5¾ x 4½ in.
(14.5 x 11.3 cm.)
Vienna, Albertina.

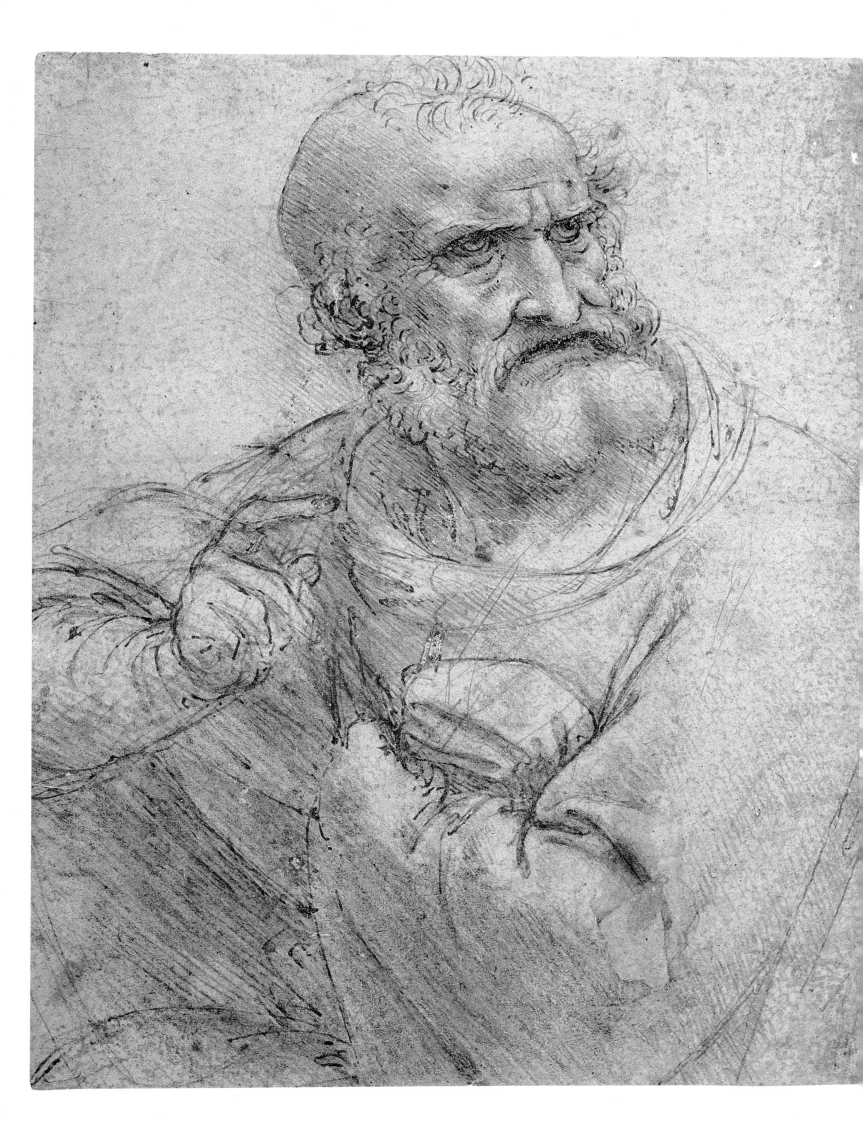

FROM THE *MAGI* TO *THE LAST SUPPER*

When he left Florence for Milan, Leonardo brought to an end a period of over ten years of work, during which he progressed from a young apprentice in Verrocchio's studio to one of the "masters" of the local school. Taking only his painting into account, these years were also in retrospect his most productive. Out of a total of thirty-eight documented works (preserved or lost) produced over a period of fifty years, fourteen date from the first Florentine period, 1470–81/82.[535] This period is the only one really deserving to be so named, his stays in Florence in the early 1500s being too often interrupted by various spells of traveling to be thought of as a "period." If his possible absence from Florence between 1476 and 1478[536] is taken into account, this abundance of paintings is quite remarkable and it enables the maturation of Leonardo's artistic personality to be followed. He was not precocious in his development—in 1482, he was thirty years old, the same age as Raphael when he painted the Stanza della Segnatura—but there is a great difference between Leonardo's first Florentine work, the *Dreyfus Madonna* (fig. 228) and his last, the *Adoration of the Magi*.

The power of the Vasari tradition is such that Leonardo's participation in the painting of the *Baptism of Christ* (fig. 19) is sometimes still considered his first pictorial work. It was said that Verrocchio began the work while the young Leonardo painted the angel furthest to the left, and that in view of the quality of Leonardo's painting, the master of studio, "humiliated to see that a child knew more than him," decided never "to touch a brush"[537] again. In fact, the angel fits in so harmoniously with the surrounding atmosphere that the *Annunciation* of the Uffizi and probably also the portrait of Ginevra de' Benci predate Leonardo's participation in the *Baptism*. Technical analysis of the painting has also established that three different artists worked on this panel, possibly including Botticelli, and it is also probable that the painting remained in Verrocchio's workshop for quite a long time, perhaps from the beginning of the 1470s until 1480. Leonardo had probably already left the workshop when he collaborated on this panel that was, to quote Pietro Marani's words, "one of the most interesting palimpsests of Florentine art at the end of the seventies of the Quattrocento."[538]

Verrocchio would have had no reason to give up his brushes after seeing

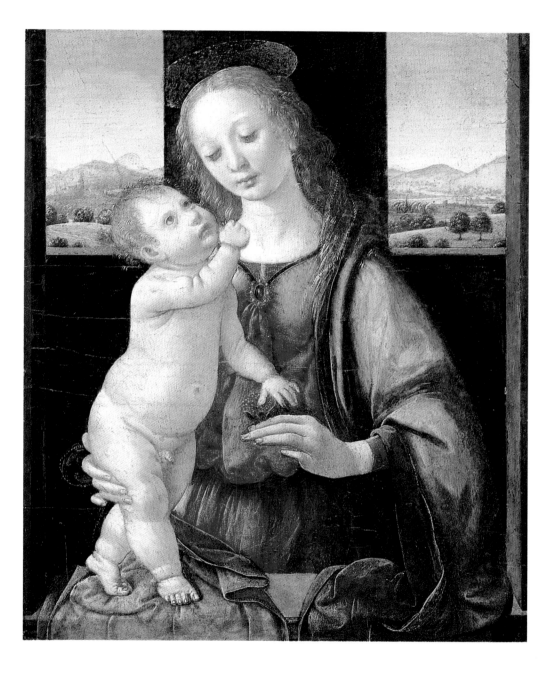

Fig. 228. *Madonna of the Pomegranate* or *Dreyfus Madonna*,
c. 1471, oil on wood, 6 x 5 in. (15.7 x 12.8 cm.), reproduced approximately actual size.
Washington, National Gallery of Art, Samuel H. Kress Collection.

Leonardo's first painting. Painted when he was not yet twenty, the tiny *Dreyfus Madonna* (6 x 5 in./15.7 x 12.8 cm) did not cause a stir in the history of painting—so much so that some experts even refuse to attribute it to Leonardo, wanting to see the mark of genius, characteristic of the established master, in every one of his paintings. The awkwardness of the badly proportioned body of Jesus and the landscape, more Flemish or Venetian, are indeed very different from what Leonardo was to produce just a few years later. This little oil painting on wood is in fact a Florentine variation of a devotional image perfected by Giovanni Bellini in Venice in the years 1450–60: the Virgin shown in front of a landscape holding onto the infant Jesus who is standing on a parapet. Verrocchio introduced the motif to Florence after a visit to Venice in 1469[539] and, by placing the Madonna directly in front of a sky and landscape, some versions produced by his studio (Metropolitan Museum, New York; Staatliche Museen, Berlin) may appear bolder than the *Dreyfus Madonna*. However, one only needs to compare Leonardo's panel with that in the Metropolitan Museum or, even better, with the painting rediscovered in 1968 in the Camaldolese monastery near Florence,[540] to realize how, in spite of the great similarity in the composition (particularly noticeable in Mary's right hand), Leonardo has intensified the relationship between the two figures, showing them in an intimate dialogue. He may have borrowed the idea of this emotional relationship from Filippo Lippi; it nevertheless remains a personal dimension of his style, as is confirmed in subsequent Madonnas in which this relationship is strengthened further while becoming more dramatic. Examples include the *Madonna with the Carnation* (about 1473) and the *Benois Madonna* (about 1478–80).

The general structure of the *Madonna with the Carnation* is very similar to that of the *Dreyfus Madonna:* the Virgin is holding the infant Jesus on a parapet, in the foreground of a room which looks out onto a distant landscape. But the painting is much more individual in its approach.[541] By sitting the child Jesus on the parapet, Leonardo is able to give the figure more movement (it involves the whole of his body, from the hands to the feet), and the strong physical presence of the figures is striking. Leonardo would return to the subject of the particular aspects of a baby's body and further perfect their expressiveness, but the Virgin in the *Madonna with the Carnation* is undoubtedly the most physical he had painted: the plump roundness of the face and neck is quite remarkable and suggests a lively, fertile fullness, enhanced by the light that caresses the flesh. Finally, there are two elements that carry

Fig. 229. *Madonna with the Carnation,* oil on wood, 24½ x 18¾ in. (62 x 47.5 cm.) Munich, Alte Pinakothek.

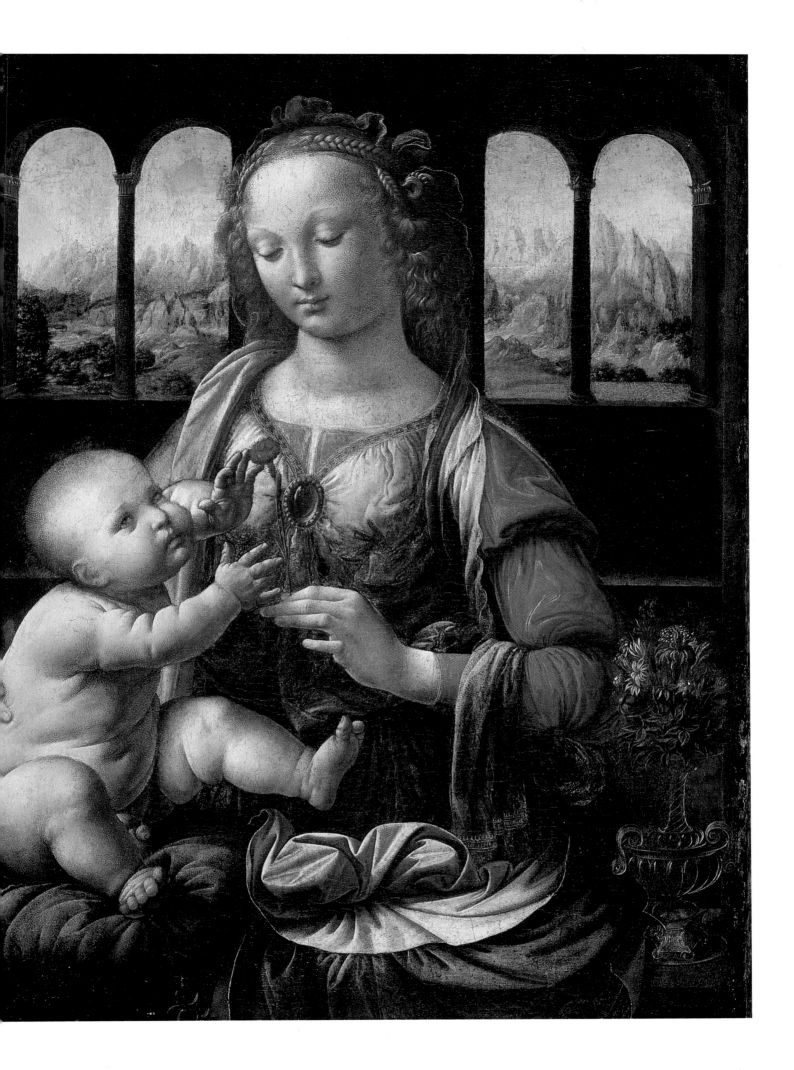

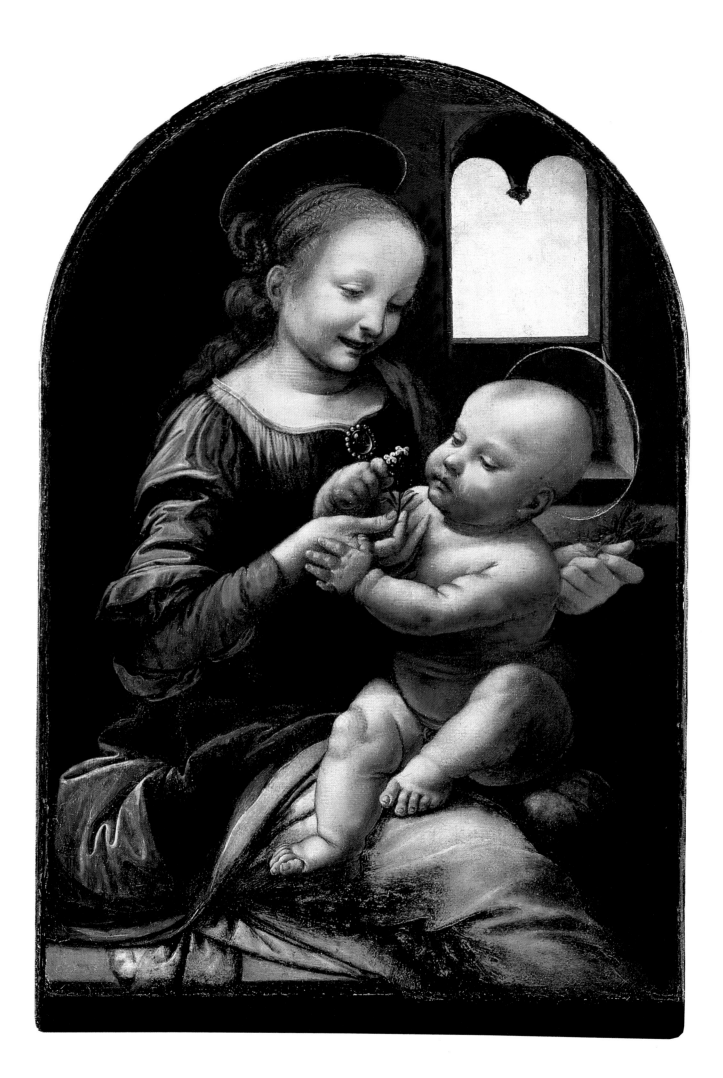

Leonardo's own stamp: the surprising piece of gold fabric placed arbitrarily on the parapet is the first variant of the gold fabric he had devised for the *Annunciation*, and through the window openings, the bluish mountains mark the reappearance, more clearly than in the *Annunciation*, of a motif that was to remain with Leonardo forever.

Although its material condition suffered greatly from its transfer onto canvas, the *Benois Madonna* (fig. 230) shows how much Leonardo had studied and perfected his approach, returning to the theme after a few years in which he had not painted very much. There is no longer anything conventional about the figure of the Virgin. The hair is drawn severely back from the forehead and its tresses and plaits, inspired by studies of hair carried out in Verrocchio's studio,[542] have an original look, as do the folds of the clothes on the hip and thigh—the first appearance of a configuration that would be used again in the final version of the *Madonna and Child and Saint Anne*. The results of Leonardo's research are particularly apparent in the animation of the figures. This no longer depends on the movement of Jesus alone: the two figures are actively involved by the intersection of their movements, forming a coherent group with its own internal dynamics. To achieve this, influenced again by Filippo Lippi, Leonardo has turned Mary in the direction of the background and, in an approach that heralds the *Madonna with the Spindles*, he has centered the action of the figures on the crucifer flower, obvious a symbolic accessory. Also, by contrasting the laughing face of the Virgin with the concentrated seriousness of Jesus, Leonardo has introduced an emotional tension remarkable for the time into the expression of the "movements of the soul" through the "movements of the body." While Mary is depicted as a cheerful, young mother, the expression on Jesus's face undeniably has an allusive meaning, but it is equally "natural", taken from life, as suggested by a drawing attributed, for want of better information, to the "circle of Verrocchio" (fig. 231).[543] It is indeed impossible to attribute the drawing with certainty to Leonardo or to identify it as a preparatory drawing for the *Benois Madonna*. It nevertheless confirms the growing impact of Leonardo on the "circle": it has been established that he contributed to a large extent to the definition of the "typology of the child" (where idealization was based on studies from life) that was beginning to develop in Verrocchio's studio at the end of the 1470s.[544]

The search for expressive dynamism in the poses of his figures led Leonardo to adopt a new approach to drawing in which he developed the composition

Fig. 230. *Madonna and Child* or *Benois Madonna*,
c. 1478–80, oil on wood transferred onto canvas,
19 x 12¼ in. (48 x 31 cm.)
St. Petersburg, The Hermitage.

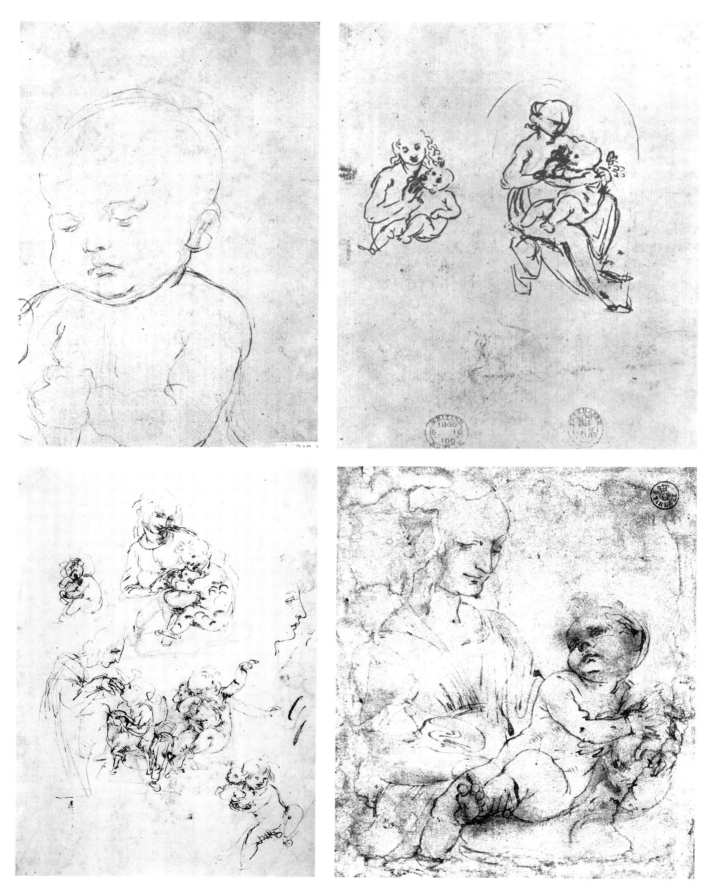

Top left: Fig. 231. Studio of Andrea del Verrocchio (Leonardo?),
Bust of an infant, silver-point and lead-point, 11¼ x 7¾ in. (28.3 x 20 cm.), Florence, Uffizi, inv. 212v.

Top right: Fig. 232. *Study for the Benois Madonna*, pen and lead-point, 7¾ x 6 in. (20 x 15.3 cm.), London, The British Museum.

Above left: Fig. 233. *Study for the Madonna and Child with a Cat*, pen and ink, 11 x 7¾ in. (28.1 x 19.9 cm.), London, The British Museum.

Above right: Fig. 234. *Study for the Madonna and Child with a Cat*, Florence, Uffizi, inv. 421 E.

of the group, a freer approach where form arises and then emerges from the artist's gestures. At the time of the *Benois Madonna* (fig. 232, in which the pose of the legs first appeared that was used again in the final version of the *Madonna and Child and Saint Anne*), this technique also appeared, still quite restrained, in the series of drawings for the *Madonna and Child with a Cat* (fig. 233, 234).The drawings are probably contemporary and the link between these two projects shows their complementarity in Leonardo's mind. In the *Madonna and Child with a Cat*, the child moves progressively away from his mother who holds him back; as a result, the movement becomes centrifugal, while in the *Benois Madonna* it becomes increasingly centripetal. This complementarity of Leonardo's research, simultaneous and contrasting at the same time, is the first appearance of the method of working "in pairs" that was typical of Leonardo's invention. It also prompted the establishment of a link between these drawings and the note in which Leonardo said, in 1478, that he had started the "two Madonnas," providing a date for the start of this work at the end of which only the *Benois Madonna* saw the light.

A common feature of the various Madonnas produced by Leonardo during this first phase is a background consisting of an interior looking out onto nature. But the fact that in the *Benois Madonna*, this window only looks out on a cloudless sky shows that for Leonardo the landscape was not the most important aspect of the theme.[545] By contrast, the landscape was a major innovation in the *Annunciation* of the Uffizi (fig. 206). Long the subject of many debates, the painting is certainly by Leonardo and was painted in the early years of his career, as indicated by the elements borrowed from the common stock of Verrocchio's studio. The most obvious is the base of the Virgin's lectern, a modified quotation from the sarcophagus of Giovanni and Piero de' Medici, commissioned from Verrocchio in 1469–70 and completed in 1472 (fig. 235). But the clumsiness in Mary's pose, mentioned earlier, is probably also partly due to the fact the figure has been given much the same pose as some of the *Virtues* who at the end of the 1460s and the beginning of the 1470s fascinated Florentine artists. Undeniably a product of the "circle of Verrochio," the Uffizi drawing of *Faith* (fig. 236) is very similar to Leonardo's version of it, including the rigidity of the right arm.[546] The style of the drapery is reminiscent of those studio exercises that Leonardo quickly mastered— and the delicate profile of the angel is reminiscent of Uccello, softened by Filippo Lippi. All these borrowed elements show that the work belongs to Leonardo's "formative phase." However, they should not detract from the

radical innovation of the overall arrangement of the *Annunciation* in the context of other Florentine paintings.

The exterior *Annunciation* was not an innovation in Florence, but it was usually depicted against an architectural background. Leonardo, on the other hand, makes full use of the width of the panel to give the landscape and diffuse atmosphere an importance unknown until then. In spite of its approximations, the linear perspective is very strong, emphasized by the motif of the

dressed stones decorating the corners of the wall. But although Leonardo placed the vanishing point at the center of the composition, he did not try to develop the effect of depth that an architectural perspective could have produced. On the contrary, very soon this perspective stops or, to be precise, it fades away: by making the last cypress and the corner of the wall coincide, Leonardo blurs the latter and creates an uninterrupted passage between the geometric site of the architecture associated with Mary and the hazy infinity of the landscape. The particular importance Leonardo attached to landscape is reflected in the fact that he was the first Florentine to introduce a harbor town into the landscape of an *Annunciation*; iconographically justified by the identification of Mary with the "port of salvation,"[547] the motif would often be used. But it is the misty atmosphere that gives the landscape its "Leonardoesque" quality, as well as the fact that it unfolds horizontally, spreading its luminosity across the entire surface of the panel: it is significant

that the low wall symbolizing the enclosure of Mary's *hortus conclusus* ("walled garden") and her virginal purity opens at the very place of the angel's gesture, and that this opening reveals a sinuous path (that Leonardo would use again in other works), that bends and curves to penetrate deep into the inhabited landscape.

It is therefore not surprising that a few years later, Leonardo's contribution to the *Baptism of Christ* should have been the landscape dominating the

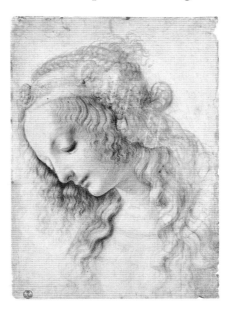

Fig. 237. *Female head*, Florence, Uffizi, inv. 428 E.

two angels, in which the poetic quality of distance, undeniable characteristic of Leonardo' style, is particularly palpable. However, even more than the landscape, it is the originality and especially the maturity of the angel painted by Leonardo that suggest a rather late date for his part in this work. Soon famous—so much so that in 1510 the painting, then at the convent of San Salvi, was referred to as "An Angel by Leonardo"—the angel, in his very immobility, shows a complex movement of torsion never before seen in Florence (even if the slightly rigid corners of the drapery conceal the suppleness of the contrapposto). By placing the angel with his back towards the viewer and by giving a pivoting role to the shoulder on whose vertical line the face is placed, dynamically turned towards the object of his gaze, Leonardo invented the position *di spalla* ("from the shoulder"), a pose full of future promise, particularly in the field of portraiture.[548] He used the pose again a few years later, with the head turned round by forty-five degrees, for the

angel in the *Madonna of the Rocks,* who this time is looking towards the spectator. It occurs again but from the front in the *Lady with an Ermine*, where it clearly reveals its function: to incorporate the figure dynamically in the space by a turning movement that projects the image of the body simultaneously in several directions. The face of the angel in the *Baptism* also displays a remarkable maturity, especially compared to his charming but prosaic neighbor. The luminous abundance of long, supple golden curls probably incorporated the "exercises on hair" carried out in the studio, of which Leonardo has left an example of exceptional quality (fig. 237).[549] The features of the face succeed in conveying the idea of a beauty that is ideal and personal at the same time, as if the ideal beauty of the angel has assumed the individual features of a portrait, this realistic effect being reinforced by the luminous quality of skin, delicately tinged with a rosy bloom.

In the *Baptism,* the body and face of Christ were also retouched in oil by Leonardo,[550] and it is not impossible that this intervention led him to attempt the masterpiece that *Saint Jerome* (fig. 238) would have become had it ever been completed. The tensions and uncertainties that are apparent in it are connected to the artistic problems that Leonardo's ambition had created, and lead one to believe that it was never finished because Leonardo was unable, in his own eyes, to find a satisfactory solution to these problems.

Together with the *Adoration of the Magi, The Last Supper* and the *Mona Lisa, Saint Jerome* is unanimously accepted as one of the four works that are known with certainty to be by Leonardo, but at the same time it is the work about which least is known. It is not mentioned in any contemporary document, except possibly in the long list of objects and studies drawn up by Leonardo in about 1482 that includes "some Saint Jeromes." It was first recorded in 1803, in the will made in Rome by the celebrated painter Angelica Kauffmann (1741–1807); it then appeared in the catalogue produced for the posthumous sale of the collection of Cardinal Joseph Fesch, Napoleon's uncle, who died in Rome in 1839. The sale took place in 1845, and between 1845 and 1857 the painting was bought by Pius IX for the Vatican picture gallery. The conditions in which Cardinal Fesch is said to have acquired the work are quite incredible. He discovered the picture, with the part corresponding to the head of the saint cut out, in an antique shop; later he found the missing piece—the head—in the possession of his cobbler who was using it as a stool. Apart from the miraculous luck of this two-stage discovery, one wonders how a work by Leonardo, from the collection of an artist as famous as Angelica Kauffmann, could have

Fig. 238. *Saint Jerome*, tempera and oil on wood, 40½ x 29½ in. (103 x 75 cm.) Rome, Pinacoteca Vaticana.

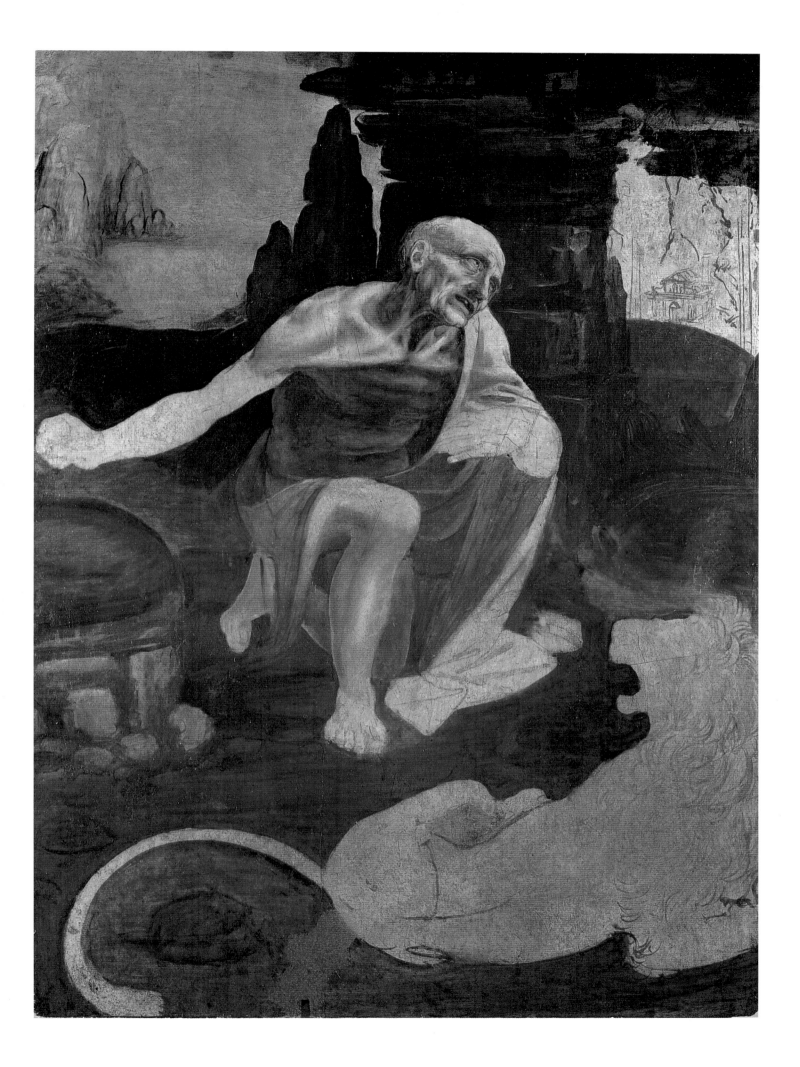

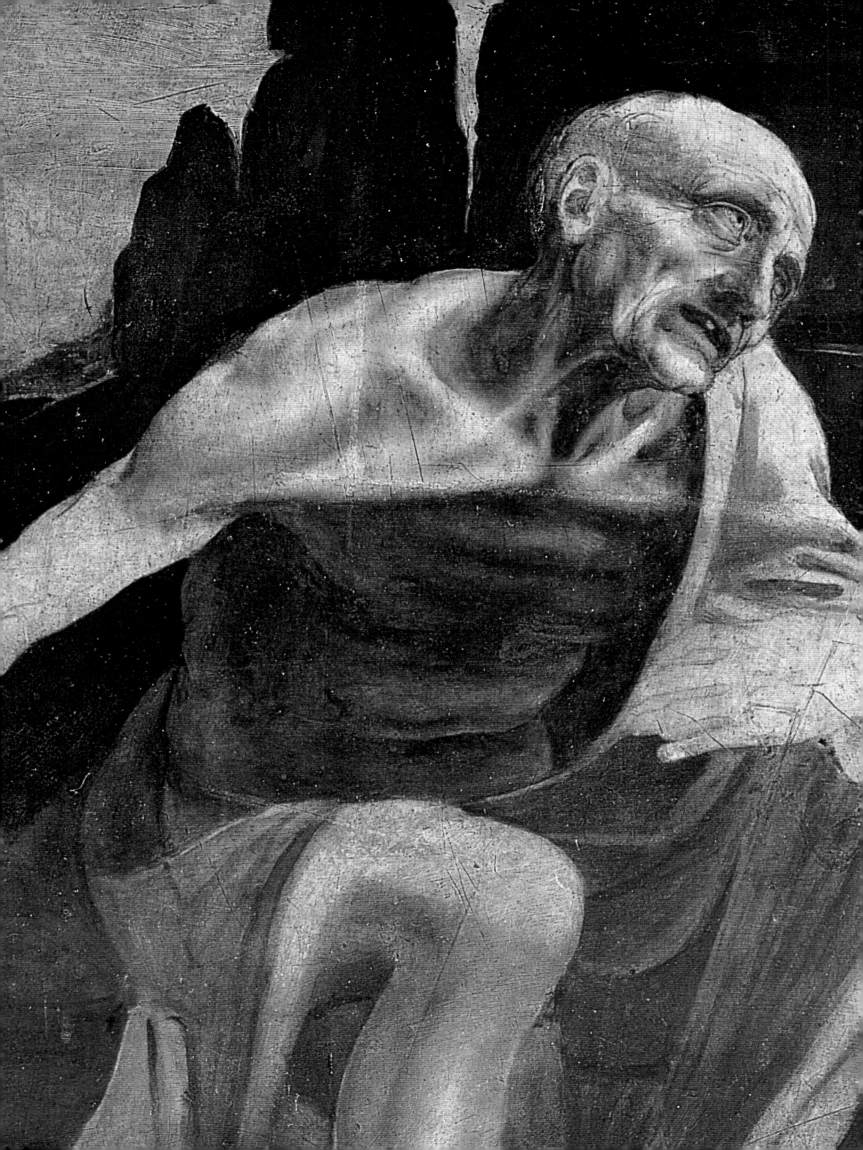

been lost and cut into two pieces. It is even more curious because the face, the part that was cut out so that it could more easily be put on the market, was precisely the part that was not for sale. But it would be rash to use this improbable story[552] as a reason for doubting the picture's authenticity. It is one of the pictures that Leonardo "touched" with his own hand (smearing the paint when it was still wet), and it is very unlikely that a forger, however brilliant, would have thought of doing this because it was not known until this century that Leonardo used this technique.

Nevertheless, the picture does contain anomalies and glaring inconsistencies. Round the figure, the composition groups three elements that are more juxtaposed than truly coordinated: the landscape in the background, the "rocky" window and its strange church, and the lion. Extraordinarily precise for the time,[553] the detail of the church is in a particularly incongruous position. The lion combines elegance and "natural ease" in a way that is absolutely unique for the years around 1480. The figure of Saint Jerome himself is strikingly reminiscent of Leonardo's anatomical studies—including some for *The Last Supper*, especially Judas. But Leonardo only started his anatomical studies in 1487; before this date, he will at best have done what Lorenzo Ghiberti had already recommended[554] and seen some studies by others, such as Antonio Pollaiuolo. Nevertheless, in this context, this observation gives a precise indication regarding Leonardo's ambitions at the time, which to a great extent explain these peculiarities.

The anatomical description of the body of Saint Jerome displays extraordinary virtuosity for the time. Far from being the first "demonstrative" anatomy in Florentine painting, it was inspired by those of Pollaiuolo or even, more directly, by those for *The Baptism of Christ*. But its expressive power was unparalleled in 1480: it is the violence in this expressive power that carries the spiritual message of the painting. When looking at the body, it is through anatomical errors, comparable in spirit to those of Pollaiuolo, that the spiritual message is delivered. In order to express the extreme effort and physical suffering in this old, emaciated body, Leonardo has drawn a network of moving tensions linking and intersecting the bones (the clavicle and the ribs), the tendons (those in the neck) and the great pectoral muscle. In his desire to increase the pathos of the figure, it might be said that he has gone too far, pushing the attachment of the great pectoral beyond the correct position and inventing a non-existent connection between the neck and this pectoral. But this anatomical license successfully heightens the effect of

Fig. 239. *Saint Jerome*.
Rome, Pinacoteca Vaticana. Detail.

the left clavicle, thus reinforcing the expressiveness and dynamism of the figure. Some thirty years later, an anatomical page would correct this anatomical error and show *a posteriori* how, in about 1480, Leonardo used anatomy as a means to a rhetorical end. Here, observation is only one aspect of the process: Leonardo did not hesitate to deform what he observed to make it pathetically more expressive, in order to translate the "movements of the soul" by those of the body.

The pictorial ambition of the painting is reflected in the extraordinary silhouette of the lion. It need only be compared with the lion Dürer painted in gouache in 1494 (Kunsthalle, Hamburg,) for it to be apparent that Leonardo was years ahead of him in his development as a painter: Dürer would only achieve a result of similar quality in 1521.[555] It is possible to retrace the path Leonardo followed in arriving at this silhouette. The dazzling profile of the lion reinterprets through painting, in other words two-dimensionally, the motif of the lion's mouth on the armorials, engraved and designed in Verrocchio's

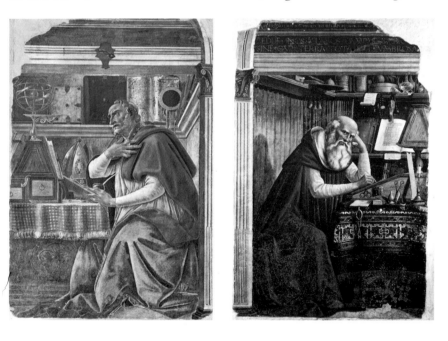

Right: Fig. 240. Sandro Botticelli, *Saint Augustine*, c. 1480, fresco, 60 x 44 in. (152 x 112 cm.) Florence, Ognissanti.

Far right: Fig. 241. Domenico Ghirlandaio, *Saint Jerome*, c. 1480, fresco, 72½ x 46¾ in. (184 x 119 cm.) Florence, Ognissanti.

studio—of which Leonardo gave his own version in about 1480 (fig. 163).[556] The power and elegance of the lion's silhouette arise from the fact that Leonardo has dealt with the head and tail of the lion in a heraldic manner, in the plan, while the relief of the body is created through the dynamic twisting of the spine. Produced at the same time as the studies for the *Madonna with the*

Cat—or slightly later—this silhouette highlights Leonardo's fascination with felines that eventually led to the famous page depicting the fight of Saint George.

Saint Jerome's face has been the object of the artist's ambitious elaboration. By brilliantly exploiting the superficial aspect of an emaciated face, Leonardo invented a type of face that could be described as that of a "mystical old man." He used this again, turned in the other direction, in the *Adoration of the Magi* where the head is found in the center of the group situated on the Virgin's left. If this invention is compared with what was taking place in Florentine painting in about 1480, one cannot fail to be reminded of the two faces of old men created at the same time by the other two leading members of "Verrocchio's circle": the *Saint Augustine* by Botticelli and the *Saint Jerome* by Ghirlandaio painted for the Vespucci family in the church of Ognissanti (fig. 240, 241). In Leonardo's mind, his *Saint Jerome* was perhaps a response, on several levels, to these two frescoes. Ghirlandaio's old man appears rather inert, while Botticelli's has a robustness and expressive vigor worthy of Andrea del Castagno. But, although individualized, his face remains "ideal" and, although his pose and expression evoke Leonardo's *Saint Jerome*, the very delineated conception of his hair and, above all, his beard gives him the rigidity of a statue—especially if his face is compared with the intense vibrancy of the face painted by Leonardo. By situating Saint Jerome in the desert and removing all his scholarly attributes, Leonardo chose a decidedly "non-humanist" version of the saint, in complete contrast to the inspiration of Ghirlandaio and Botticelli. Should one see in Leonardo's version the reaction of the *uomo sanza lettere* against the excessively cultivated and literary art of Florence at the time of the Medici?[557]

The painting is thus problematical in several respects—not as to its authenticity, about which there is no doubt, but because of the tensions that appear in it, the result of Leonardo's extreme ambition. The development and progress of his pictorial thinking in about 1480 was confronted by two major problems: although the silhouette of the lion and the body of Saint Jerome were "successful," how could the four elements of the painting (the landscape, the "window" looking out onto the church, the saint and the lion) be "brought together" harmoniously? And above all, how could he create a sense of unity between the figure of Saint Jerome and the rocky background against which it was depicted? A few years later, the *Madonna with the Rocks* would provide an answer to the second question—and it would lie in the representation of the hair and the drapery of Mary's clothes. It appears that in 1480 Leonardo

had not yet perfected that which would enable him to answer the question he was raising. It is therefore probable that he did not leave his painting in Florence but took it to Milan[558]: even in its preparatory stage, it was not good enough in his eyes to be left behind as a reminder of himself on the banks of the Arno.

On the other hand, he did leave the *Adoration of the Magi* (fig. 246) with his friend Giovanni Benci, the brother of Ginevra whose portrait he had just painted. This was because, although not finished, this large panel was successful enough to be seen, and it could even show how a new way of painting could develop in Florence. The questions left unanswered in *Saint Jerome* found their answers in this painting and, in a more general way Leonardo was now putting forward a concept of great narrative painting, the painting of *historia*, in which he went beyond Alberti's formulations, which were too simplistic in his eyes.

In March 1481, the monks of the Augustinian convent of San Donato in Scopeto (to which his father, Ser Piero da Vinci was attached) commissioned an *Adoration of the Magi* from Leonardo, giving him between twenty-four and thirty months in which to complete the work. As confirmed by a number of drawings dating from 1479–80, at that time Leonardo was preparing an *Adoration of the Shepherds* that had been commissioned by the Seigneury of Florence. He was never to paint it, but one of the poses he had conceived for the Virgin in the *Adoration of the Shepherds* was used in both the *Madonna of the Rocks*[559] and *Saint Jerome*, while the *Adoration of the Magi* used some of the poses designed for the shepherds of the Nativity. The relatively large number of preparatory drawings for the *Adoration of the Magi* shows the intensity and rapidity with which Leonardo developed this powerful theme, since it took him only one year to arrive at the already very advanced Uffizi panel. It nonetheless remained unfinished, although that was not necessarily Leonardo's fault.[560] After his departure for Milan, the order was passed on to Filippino Lippi who, while broadly inspired by Leonardo, standardized and clarified its iconography (fig. 245). The revolutionary character of Leonardo's painting did not arise only from the conditions of its commission or from the very personal character of its formal elaboration; in it Leonardo also took a definite position in what was the Florentine approach to the theme, as much from a pictorial as from a social and spiritual point of view. It was this ambition that gives the *Adoration of the Magi* the power of a masterpiece.

Indeed, Leonardo's composition is inconceivable without the work created by Botticelli between 1472 and 1475 for the chapel of Guasparre del Lama in

Opposite page, top: Fig. 242 and 243. Sandro Botticelli, *Adoration of the Magi*, c. 1475, tempera on wood, 43¾ x 52¾ in. (111 x 134 cm.) Florence, Uffizi. Whole picture and detail.

Bottom left: Fig. 244. *Study of figures for the Adoration of the Magi*, detail, pen and ink on metal-point outline, 11 x 8¼ in. (27.8 x 20.8 cm.) Paris, Musée du Louvre, department of graphic arts.

Bottom right: Fig. 245. Filippino Lippi, *Adoration of the Magi*, 1496, tempera on wood, 101½ x 56¼ in. (258 x 143 cm.) Florence, Uffizi.

Santa Maria Novella (fig. 242).[561] By omitting the cortege of the Magi, a theme current since the end of the fourteenth century, Botticelli was already approaching the subject in a manner that was new in Florence. This omission may have been connected with the fact that the Florentine procession of the Magi that progressed through the town on the feast of Epiphany had been canceled since 1470. This abolition was accompanied by a radical change in the formal presentation of the theme and in its spiritual interpretation. Botticelli rejected the lateral arrangement of figures that had permitted the development, parallel to the picture plane, of the arrival of the cortege in front of Mary and the Infant Jesus. Instead, he adopted a frontal arrangement, with the Holy Family at the center, and the Magi and their followers grouped on either side in a more or less symmetrical manner. He thus transformed what used to be a predominantly narrative scene into a ceremonial and liturgical representation: the Magi pay homage to the incarnated body of the Son, in the person of Jesus. A number of very controlled details highlight the liturgical importance of this commemoration of Epiphany, the kneeling pose of the three Magi, in particular, referring clearly to the pose that had become the rule for receiving the Host, the sacrament of the Eucharist.[562] As Rab Hartfield has shown, this change in the concept of the Adoration of the Magi was linked to the rapprochement that had progressively been made between the theme of Epiphany and that of the Eucharist. This was a legitimate association since they both referred to the manifestation of the divinity of the body of Christ, recognized by the Magi on the day of Epiphany and established as the foundation of the liturgy of the Mass during *The Last Supper*.

This liturgical dimension, which was fundamental to Botticelli's concept, was also adopted by Leonardo. Not only was it a "modern" pictorial interpretation of the theme, but it also gave the historical event its full meaning. The influence of Botticelli's painting on Leonardo's is undeniable: he followed the central arrangement of the composition, the kneeling pose of the three Magi, and the idea of the grandiose ancient ruins on the left, which, while symbolizing the downfall of pagan religion, were still rarely used when dealing with the theme of the Magi.[563] In the bottom right corner, he even used the figure of the young man whose expression beckons the viewer into the painting.

This common ground between the two artists also shows how Leonardo used Botticelli to differentiate himself radically from him. In Botticelli's painting, the figure looking towards the spectator is a self-portrait; in Leonardo's painting, it is not a self-portrait (contrary to what one might sometimes wish), and the

Fig. 246. *Adoration of the Magi*, 1481,
tempera, oil and lead white on wood, 95½ x 96½ in. (243 x 246 cm.)
Florence, Uffizi.

figure is not looking towards the spectator but outside the frame, suggesting an indefinite continuation of the crowd approaching Jesus and Mary. This looking away is an idea that was much thought about and perfected; it did not come to Leonardo immediately, as is shown by the preparatory drawing in which the same figure is looking at the spectator (fig. 244). In general, portraiture plays an important part in Botticelli's conception,[564] but no part at all in Leonardo's. Moreover, although influenced by Botticelli, Leonardo has transformed the whole concept of the representation (even liturgical) of the (historical) event of Epiphany. This is reflected in the different locations of the scene in the two paintings. With Botticelli, the place of the Epiphany is strongly structured by a twin, allusive architecture; in Leonardo's painting, the place is much less specific. With Botticelli, the rock formation that is used to present the Holy Family is clearly volumetrical and individual, while in Leonardo's picture it is undefined and, above all, it is not framed by any architecture. Leonardo has completely omitted Mary's "hut" and replaced it with two (symbolic) trees, expressing a vague idea of depth. As for the ruins in the background, these have become more important but their appearance is still undefined, and their structure can only be explained through their role in the composition of the painting.[565]

In fact, the only inspiration Leonardo drew from Botticelli was to rework his composition completely; his engagement with the work arose from his conception of the event of Epiphany itself—and thus also of the "history" painting that represented it. It is important to look at Leonardo's re-working in detail: it shows the seriousness with which he conceived the task of the painter and the importance of this *cosa mentale* that the act of painting was for him.

By placing the Virgin and Child Jesus in the top part of the painting, clearly above the vanishing point, Botticelli emphasized their importance as the object of worship: the angle of view in the painting corresponds, more or less, to that of the two kneeling Magi. At the same time, the background could not be developed any further except through marginal references. In contrast, Leonardo deliberately placed the Virgin in the lower part of the painting, while adopting the highest possible viewpoint. In this he followed an idea he had had from the start, as is shown by the first preparatory study for the overall composition (fig. 207). This choice enabled him to develop the background across the whole surface and opened up great possibilities for further enrichment and significant innovations.

Traditionally, developing the height of the background made it possible to

represent the route followed by the Magi, and this was how Filippino Lippi used it in his version of the theme. Leonardo reduced the Magi's cortege to a mere marginal reference: in the last stage of its procession, it turns its back on the agitation that is present in the rest of the background. The upper part of the painting is organized into two complementary areas. On the ruined building, whose type is difficult to identify, figures can be seen gesticulating and talking, sometimes vehemently, for incomprehensible reasons. On the right side of the picture, horsemen are fighting, heralding (as is often pointed out) the central motif of *The Battle of Anghiari*, painted twenty years later. But the reason for its presence in this painting is not clear for all that. It has been suggested that it was an adaptation of a fight with the dragon that Leonardo had planned for the *Adoration of the Shepherds* on which he was working in 1478–80.[566] It might also be seen as an enlargement and displacement of the traditional motif of the fight between the horses in the cortege, or even as a reference to the fight between the followers of the Magi and Herod's men, a theme taken from the Armenian apocryphal Gospel.[567] But within the composition of the painting this iconographical uncertainty is only secondary, because the group plays an obvious role in the scene: it expresses the violence of war and marks the first appearance of what would become a characteristic theme for Leonardo: the *bestialissima pazzia*, that most bestial madness, which, in combat, turns men into beasts. The composition displays a coherence between the background and foreground that goes beyond a narrative dimension. The background represents moral blindness as opposed to the Epiphany's glorious message of redemption, peace and love. Its action unfolds in parallel with the main plane of the painting (except for the strange riderless horse placed between the two trees—possibly a vestigial reference to the animals in the Nativity?), with the figures in the background tearing about in a story whose meaning is doubly obscure: past history, represented by the ruin that has become incomprehensible, and present history, blinded by warlike fury.

The treatment given to the area of Adoration is completely different; this contrast is further emphasized by the absence of a rational link with the background. This absence of a link became increasingly strong as Leonardo further developed his first idea for the painting. The two preparatory drawings for the overall composition used linear perspective to link the background to the foreground. But this link has disappeared in the final work and, when developing the area in which the Adoration takes place, he rejected any use of perspective, relying

Pages 356 and 357:
Fig. 247 and 248.
Adoration of the Magi.
Florence, Uffizi. Details.

355

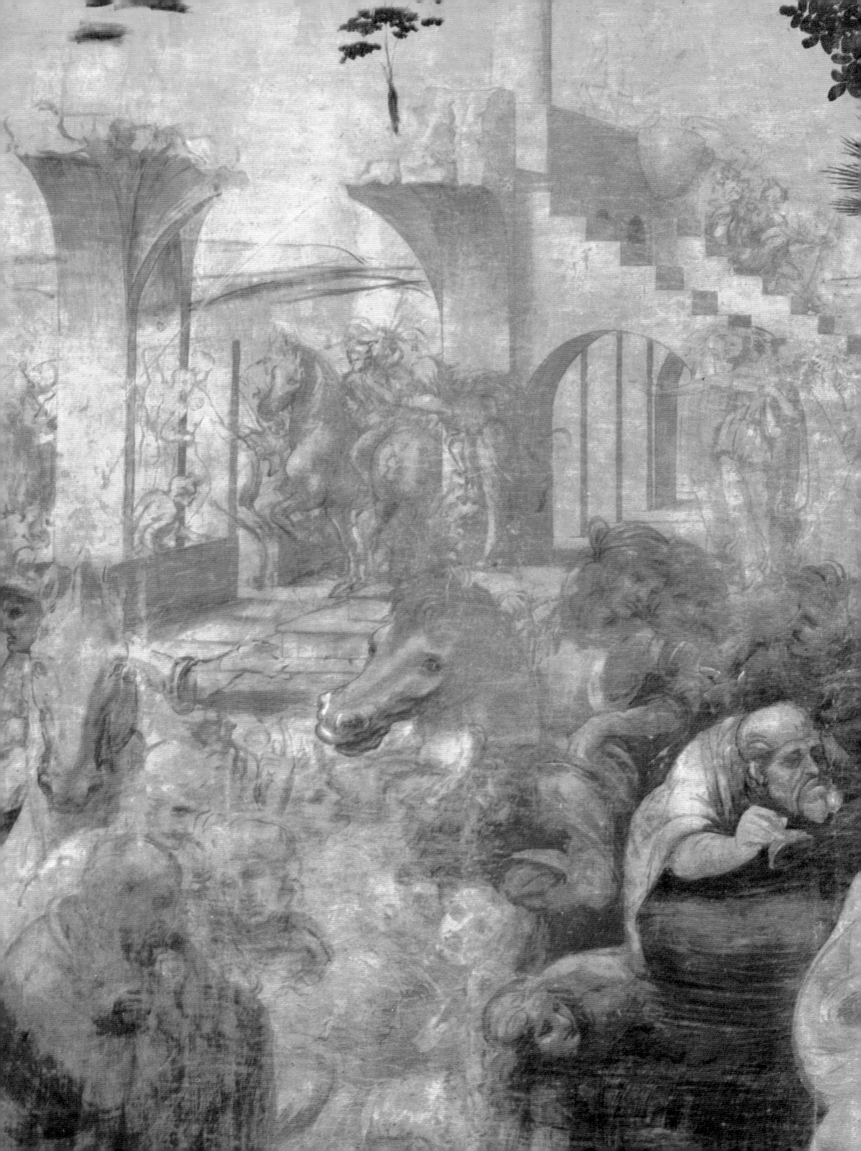

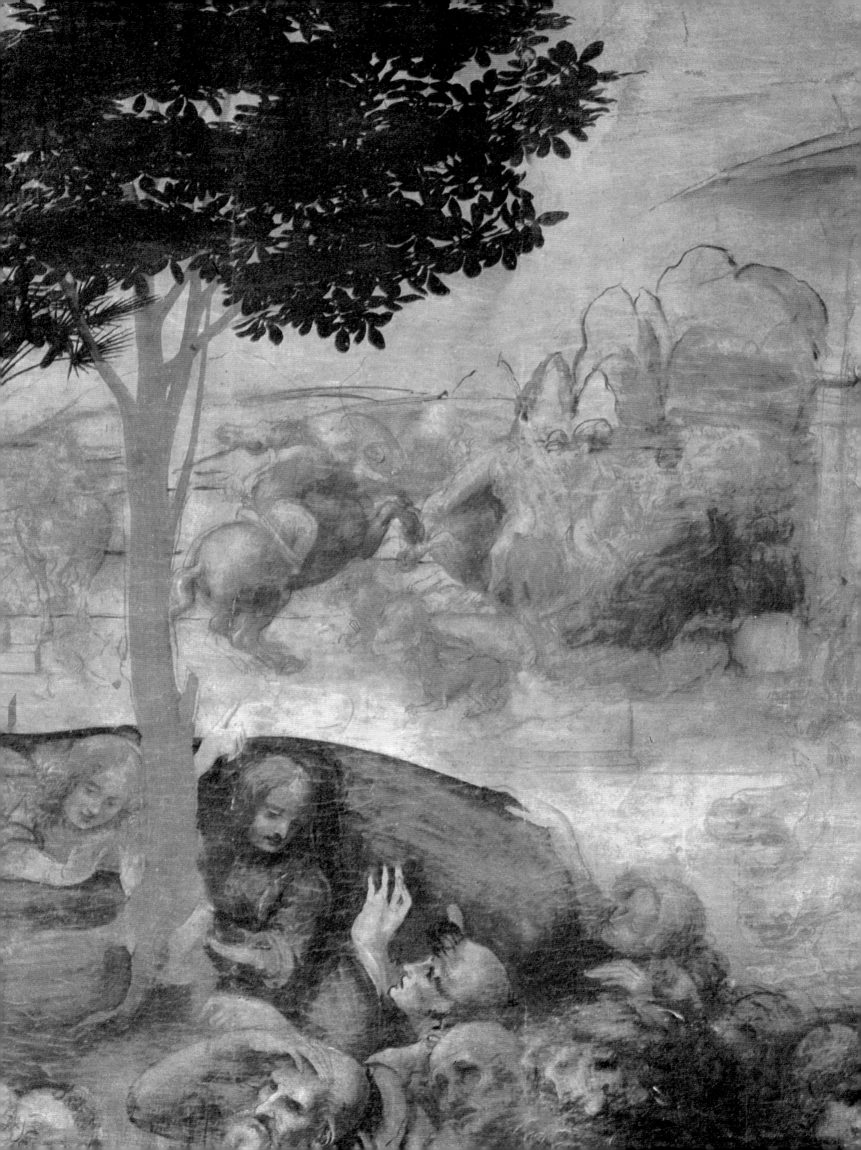

exclusively on the dynamic relations between the figures. It is true that on the surface these follow the geometric shape of a triangle (with the head of Mary as the summit) set within a semi-circle;[568] but more than a stable double geometric form, this arrangement produces a dynamic configuration, created by the gestures of the figures and to which they conform. Based on an idea already encountered with Leonardo, these figures generate an impression of dynamic space created by their own movements. The center of this field of force, the group of the Virgin and Child, has been placed slightly off-center in the composition, its geometric center being situated slightly to the left of the inclined head of Mary, and its medial vertical axis passing through her raised foot, rather than through the one which is resting firmly on the ground. There is no logically measurable gradation between the figures in the foreground and those standing behind the Virgin, and the differences in size seem quite arbitrary in places. The figures create their own lively, organic unity through their contrasting actions; the tempo increases from the edges to the center, from the periphery towards focal point that is both its source and goal. The diversity of these actions is a provisional synthesis of personal motifs and of new ideas, full of future promise. The pose of Jesus, for instance, and his relationship with Mary are developed from a study for the *Madonna and Child with a Cat*. Leonardo has opened up Jesus's gesture in an outward direction, receiving the offering while giving his blessing, at the same time maintaining the idea of Mary's hand holding onto the legs of the Infant Jesus, but placing it on top and not underneath. Among the new ideas, there are two instances of the index finger pointing to the sky. Here a reminder of the gesture with which one of the Magi pointed to the star, Leonardo was to develop this motif at great length over a long period with great success.

However, the relation between the two zones, that of blindness and that of revelation, does not rest exclusively on the principle of contrast. As its unfinished state shows, all areas of the panel were painted simultaneously. Leonardo did not start on one part and complete it before moving on to the next. In spite of the many preparatory drawings, he continued improvising as he painted, some figures still showing the trace of Leonardo's hesitation or change of mind. In fact, from the point of view of its overall composition, the painting follows the principle of contrast whose dialectical effectiveness Leonardo would formulate later: "Zones of character: the light figure on the dark background and the dark one on the light background. White with black, or black with white mutually reinforce each other. Contraries always

appear stronger in relation to each other." (*Codex Urbinas*, 75v.) Already very evident in its preparatory stage, the contrast between the top and the bottom of the painting suggests that, in its final state, the composition of the *Adoration of the Magi* would have been based on a dark foreground, punctuated by accents of lightness, thus giving relief to the figures, and a light background in which the figures would have appeared more distant because of a less strong relief. The luminous unity of the distant background (already used in *The Annunciation*) would have contributed to dematerializing them further. In this respect the *Adoration of the Magi* answers the questions that had been left unanswered in *Saint Jerome*.

Anachronistically, one might think of the solutions adopted in the following century by Tintoretto in Venice. But Leonardo's position was, historically and theoretically, very precise: it was against the background of the Florentine bas-relief, such as Ghiberti's *Gates of Paradise* or Donatello's *Saint George Killing the Dragon*, that Leonardo invented his style of painting.[569] As he was to state later in *Manuscript G* (folio 23b), "the background on which an object is painted is a most important thing in painting. [...] The aim of the painter is to make his figures stand out from this background." It was not, as one might add, to base his art on the supposed transparency of this background. It was through the knowledge of light and shade that the painter would be able to achieve an effect of relief in the background, not through linear perspective.

With his *Adoration of the Magi*, Leonardo displayed a new style of painting. In it, his brush followed the rhythm of his creative ideas, right up to the last moment. This approach is clearly reflected both in its separate parts and in the composition as a whole, the work only taking shape in its final conception on the surface on which it was painted. From the first general ideas to the particular details that emerged gradually, the artist's active memory had to preserve everything in its diversity, so that he could call upon everything that he had clarified in his own mind and which the surface to be painted was now challenging with its own, internal logic. This is the method Matteo Bandello was referring to when he described Leonardo's creation of *The Last Supper*. But this new style of painting also implied a "new art of painting:" through his immediate and explicit reference to Botticelli, Leonardo subverted the humanist concept of *historia* as it had been formulated in *De pictura* in 1435.

The *Adoration of the Magi* invalidated the concept of opposition between "tumult" and *historia* established by Alberti. Having made the construction

of linear perspective the basis of "composition," Alberti criticized painters who strive "to make the surface look full and not to leave empty spaces, do not follow any kind of composition but distribute objects at random and without any link so that their story does not reflect action but confused agitation" ("*non rem agere sed tumultuare historia videtur*"[570]). Yet here the opposite is here the case, because it is precisely in the "empty space" within the perspective construction where groups stand out clearly that, in the *Adoration of the Magi,* the narrative "moves in disarray." In the group depicted in the foreground where "emptiness" is only used to guide the eye towards the group of the Virgin and Child, it is tumult that triumphs—the opposite of the calm and hierarchic gathering depicted by Botticelli. But that is also where history "takes place," where it "acts," and its tumult is not "chaos." Leonardo does not pile up characters and gestures to convey chaotic abundance. All the agitation is caused by the same thing and leads to the same objective, the Virgin and Child. In its very "tumult," *historia* gives shape to the event it is supposed to represent: the spiritual and religious conflagration that the revelation of the truth of the Incarnation must have caused in history (for those who accepted it).

The dazzling light with which the Incarnation became part of history invests with meaning the gesture of the old man, who, above one of three Magi presenting his offering, holds his hand over his eyes to protect them against the brightness. This gesture traditionally refers to the blinding caused by the brilliance of the Star. But Leonardo has deliberately directed it towards the body of Jesus, while situating it straight above a hand whose index finger is pointing to the sky, another gesture traditionally used to indicate the Star. By bringing them closer together, Leonardo highlights the time spent waiting and the quest for the revelation. What this implies is more a spiritual conversion than the narrative of the Magi's journey to revelation. The pointed index finger is no longer used to point to the Star, since Jesus has already been found. It refers to the transcendent, invisible cause of history, beyond that of the story. Its indication is no longer narrative but metaphysical; this is the meaning it would have from now on in Leonardo's work.

Thus, unlike Botticelli, who gave a ceremonial version of the event, Leonardo decided to paint the very *historia* of the Epiphany, this bewildering event that completely changed the course of history for Christians. At the moment when the Magi recognize the divinity of the Infant Jesus, history finds its meaning in every sense of the term: its significance and its direction are now

Christian. In his description of the virginal intimacy of the birth, Leonardo had drawn Mary's bewilderment in the presence of the Son of God (fig. 219). (His use of one of the versions of this gesture in his *Saint Jerome* suggests an inversion: here this presence becomes absence.) But to paint the moment when the presence of the Son of God was publicly recognized as such, he depicted the tumult of a *universal* dazzlement—reflecting in this the meaning that Saint Augustine and the monks of his order who had commissioned the painting gave to the Epiphany.[571]

Leonardo's approach was therefore perfectly suited to the content of the theme it represented. But in 1480, it was also a response to Botticelli, and through him, to the "humanist" and Albertian concept of painted *historia*: Leonardo demonstrated that it was impossible to properly represent a historical event of this kind (i. e. the Epiphany) by relying on the clear intelligibility of the geometric structures of "regular" (linear) perspective. The criticism of Alberti is confirmed by the two figures who, on both sides of the picture, are a variation on Alberti's motif of the "admonishing"[572] character. While bearing the mark of duality and alternatives that are so typical of Leonardo, these two figures transform and subvert Alberti's simple idea that sought to open up the closed microcosm of the painted *historia* to the spectator.[573] On the left, the figure of the philosopher wearing a heavy robe reveals through his expression his incomprehension before this unexpected manifestation of the divine.[574] This was certainly not the feeling that ought to have been instilled in the faithful. On the right, the young man is the very embodiment of the "grace" that Incarnation offers—providing that it is accepted. As Alberti would have wished, he informs the spectator "of what is happening" in the painting and invites him to take part in the event. But at the same time, Leonardo did not want him to look in the direction of the spectator: by not introducing the mark of the spectator's presence into the painting, this "Albertian" figure takes on the role of opposition to Alberti, confirming at the same time the effective autonomy of the pictorial representation and its accessibility to the emotion of the spectator.

These choices by Leonardo regarding the painting of *historia* correspond to a profound change in the concept of history itself, by virtue of Alberti's postulate according to which the narration of history was always a "painting," regardless of whether its author was a painter or writer: "The latter paints with words, the former tells it with a brush."[575] With Alberti, the construction of the "stage" for the *historia* using perspective preceded the representation

of the figures who were then arranged clearly inside it. Leonardo's figures, on the other hand appropriate the space where the action takes place, defining the narrative scene of the place by their reciprocal movements. In doing this, Leonardo was taking part in the general evolution of historical representation that had begun in the last twenty-five years of the Quattrocento, and that also, for instance, led Florentine historiography to make human passions the driving force behind historical events.[576] But he formulated this concept with a rigor and coherence that made it a characteristic feature in his conception of history and his approach to *historia* painting: for him, an event was "painted" and "taught" through the contrasting and simultaneous reactions of the actor-spectators of the event. The *Treatise on painting* is very clear on this point: "Regarding the attention of those attending a remarkable event. All those attending some remarkable event take on various attitudes of surprise [...]; if the event is a religious one, spectators will turn towards it, with various gestures of devotion, such as during the presentation of the Host during Mass, etc."[577] (*Codex Urbinas*, 115v.) This text is very remarkable insofar as the "religious event" which Leonardo chooses as an example, the presentation of the Host, con-

Fig. 249.
Andrea del Castagno,
The Last Supper,
1445–50, fresco.
Florence, Santa
Apollonia.

denses the two religious "stories" he painted, the Epiphany and the Last Supper, in the symbolism of liturgical ritual. It is also striking to note that the painting of these religious events follows the same principles as that which inspired the representation of the wind: because the "movement in itself cannot be seen in the air," it was necessary to paint "what can be seen in the air," that

is the movement of "things swept away by it."[578] In both cases, whether dealing with the wind or the theme of Transcendence in History, representing what cannot be seen requires painting the visible results of the action of the invisible.

Some fifteen years after the *Adoration of the Magi, The Last Supper* (fig. 257) further confirmed Leonardo's conception of *historia* and considerably developed what he achieved at his departure from Florence.

The composition of *The Last Supper* completely overturned the traditional treatment of the theme, and its originality was such that the work, reproduced in engravings, quickly became famous in Italy and abroad.[579] One of the most obvious innovations was that Judas is seated among the apostles, instead of facing them, with his back towards the spectator (fig. 249). Rejecting Florentine examples, Leonardo probably found his inspiration in the Lombard tradition, which sometimes had Judas sitting with the apostles.[580] But most of all the innovation arose from the fact that, as in the *Adoration of the Magi*, Leonardo handled the theme of *The Last Supper* in a way that was both dramatic and liturgical at the same time, by referring to the important "events" that took place during the last meal Christ and his apostles shared: the warning of the

Fig. 250. Cosimo Roselli, *The Last Supper*, 1481–82, fresco. Vatican, Sistine Chapel.

betrayal by Judas and the institution of the Eucharist.[581] The traditional treatment of the subject already associated these two themes: for instance, in *The Last Supper* painted by Cosimo Rosselli in the Sistine Chapel (fig. 250), Judas, isolated, is clearly shown as the traitor by the devil sitting on his shoulder, and the only object on the table is a chalice, clearly indicating the theme of

the Eucharist. But this arrangement did not suit Leonardo's conception of *historia*. By clearly indicating that Judas was going to betray Jesus, Rosselli did not hide him in the *historia* as he was actually concealed in history, and this makes the story that the image is supposed to represent much less believable. Besides, Leonardo would obviously not be satisfied by the traditional liturgical approach based on the static juxtaposition of the figures.

As presented by Leonardo, *The Last Supper* succeeds in combining the

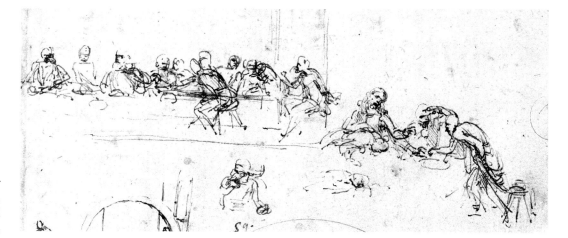

Fig. 251. *Study for The Last Supper*. Windsor Castle, Royal Library, RL 12542.

two versions of the gospel story in a "credible" manner. By placing Judas among the apostles, Leonardo "hides" him and thereby justifies the dramatic and contrasting reactions of the apostles to Christ's words warning them that one of them will betray him. Christ's gestures refer both to the institution of the Eucharist (his left hand offers the bread and the wine) and the announcement of the betrayal, since his right hand is stretched out towards a dish placed near Judas's hand. In the fresco, Leonardo rejected the motif of "Judas's communion" that he had originally considered, as is shown in the two preparatory drawings for the general composition (fig. 251); he abandoned John's version for that of Matthew or Mark.[582] However, moving away from the literal interpretation of the gospel story and from iconographical tradition, Leonardo handled the two events of the Last Supper at the same time. The uncertainty of the actual succession of events in the gospels permitted this, but the choice was also prompted by deeper reasons, which had a decisive impact on the content and appearance of the painting.

Far from being merely a brilliant solution to the problem of the dramatic *and* the ritual implications of the theme, the simultaneity chosen by Leonardo

Fig. 252. *The Last Supper*.
Milan, Santa Maria delle Grazie.
Detail from the left section, unrestored.

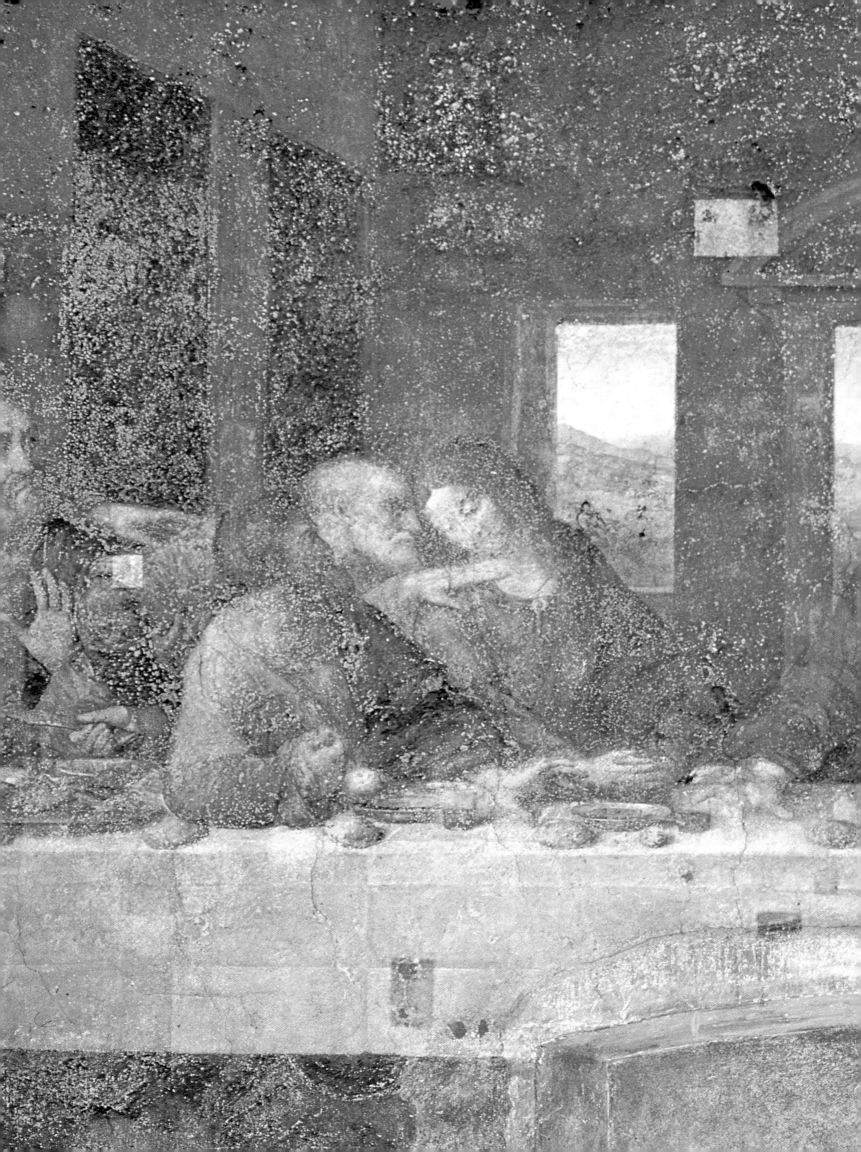

was a legitimate interpretation of the actual *religious* meaning of the Last Supper. As Saint Thomas Aquinas himself wrote, religion is not faith but "the attestation of faith through a number of external signs,"[584] and it is by defining these "external signs" that the Christian religion has progressively become identified as such. The first of these signs was none other than the Eucharist,

Fig. 253. Pieter Soutman (after Rubens), *The Last Supper*, engraving, 11½ x 39½ in. (28.9 x 100.5 cm.) Boston, Museum of Fine Arts.

established by Christ during the Last Supper and repeated regularly by the apostles "in memory of Him," and then in the celebration of Mass. This transformation of faith into religion practiced by the group (or community) of the faithful implies the consequent exclusion of those who do not share or recognize these rites. Judas's betrayal was part of the divine plan of Redemption, and Christ was not content with simply announcing the betrayal by one of the apostles; he was not content with establishing it in advance. He instigated it, or, in other words, his discourse "performed" this betrayal[585]—and at the same time he founded the group which, once the betrayal had taken place, would recognize itself in the communion of the eucharistic rite. The magnificent engraving (fig. 253) in which Pieter Soutman copied Leonardo's work (probably after a version by Rubens) interprets this explicitly: on the table, only the chalice and bread are left in front of Jesus and, in front of Judas, another piece of bread.[586] Saint John's gospel is probably the clearest on this point. Replying to the question of who will betray him Jesus said: "He it is to whom I shall give a sop, when I have dipped it. And when he had dipped the sop, he gave it to Judas Iscariot, the son of Simon. And after the sop Satan entered into him. Then said Jesus unto him, That thou doest, do quickly. [...] He then having received the sop went immediately out." (John 13:26–30). Therefore, although he rejected the dramatic episode as told in the gospel of

366

Saint John (which was the version he had first chosen), Leonardo retained and emphasized its religious message. In the final version, apparently closer to the gospels of Saint Mark and Saint Matthew, the group of apostles seated immediately on the right of Christ (John, Judas and Peter) clearly shows that this is the interpretation of the betrayal chosen by Leonardo (or his adviser,

Fig. 254 and 255. Details from *Study of figures for The Last Supper and a hygrometry project*, pen, silver-point and brown ink, 11 x 10½ in. (27.8 x 26.6 cm.) Paris, Musée du Louvre, department of graphic arts.

the Dominican theologian Vincenzo Bandello). The group thus depicted has brought together, in an unique manner, the three founding figures of the Christian religion in the strictest (and historical) sense of the word: Peter on whom the church would be built, Saint John the Evangelist, the favorite disciple, and Judas, whose exclusion led to the creation of the group.

It is therefore not sufficient to say that Leonardo brought these two moments closer together to blur the narrative sequence by inventing a kind of "sfumato" of time to represent the "living" dimension of the Last Supper.[587] As conceived by Leonardo, *The Last Supper* condenses the two acts of Christ that established the Christian religion into a single moment and a single event; it represents the founding of this religion, the inaugural moment that changed the course of history. It is therefore not surprising that the general principle of the composition is the same (but reinforced) as that of the *Adoration of the Magi*. It is also significant that in 1480, on the back of preparatory drawing for the *Adoration of the Magi*, Leonardo developed the motif of two figures in conversation that he turned into a group of characters seated at a table; he then added the figure of Christ, thus making this group seated at a table a prefiguration or first idea for *The Last Supper*, painted some fifteen years later. This drawing is another example of the continuity and unity of Leonardo's invention of form and the length of its gestation.[588]

367

In *The Last Supper* the figures appear to have been carefully arranged in linear perspective with the vanishing point in the figure of Christ, at the center of the picture. But because of the tight frame in which he has set the composition, Leonardo has made the figures "come forward" from the geometric background that consists of a coffered ceiling and tapestries hung on the walls.[589] The decision to "frame" *The Last Supper* in this way is fundamental: in doing so, Leonardo expressed the independence of his representation in relation to Giovanni Montorfano's *Crucifixion* placed opposite, and in relation to the architectural background in which his own fresco is placed. While Montorfano respected the shape of the lunettes, placing the three crosses in them, standing out against the color of the sky, Leonardo, on the other hand, used the three lunettes to reinforce the sophisticated dynastic setting and to strengthen the autonomy of his own representation. The figures themselves are too monumental to be able to occupy the space round a table of that size—and in addition Christ is larger than his companions. Leonardo takes great liberty with the linear perspective, and this is reflected in the fact that the supposedly identical width of the hangings increases with distance. Imperceptible to the naked eye, this irregularity helps to slow down the vanishing point of the perspective "visually," thus reducing the apparent depth of the room and making the figures in the foreground appear even more monumental.[590]

The autonomy of the figures in relation to the linear geometry of the composition is brilliantly, and surreptitiously, confirmed by their displacement within the vertical divisions of the surface produced by the three openings in the background, the corners at the back of the imaginary room, and the borders of the hangings.[591] The living symmetry of the apostles, gathered in four dramatic groups of three figures on either side of Christ, contrasts with the stable, geometric architectural environment. Looking more closely at Leonardo's work, the subtlety and rigor with which he has transformed the traditional arrangement of Last Supper is apparent. On the face of it, the heads of the apostles in the two end groups occupy approximately the same area of the first two hangings. However, they are distributed very differently in that space, and the stretched out arms on either side that create a link between these groups and the adjacents ones reach two different points in the overall geometry of the room: the corner of the room in the case of the group on the right, and the far edge of the third hanging in the case of the group on the left. The two central groups reveal a similar interaction between the geometric division of the surface and the distribution of the

Fig. 256. *The Last Supper*.
Milan, Santa Maria delle Grazie.
Detail from the right section, unrestored.

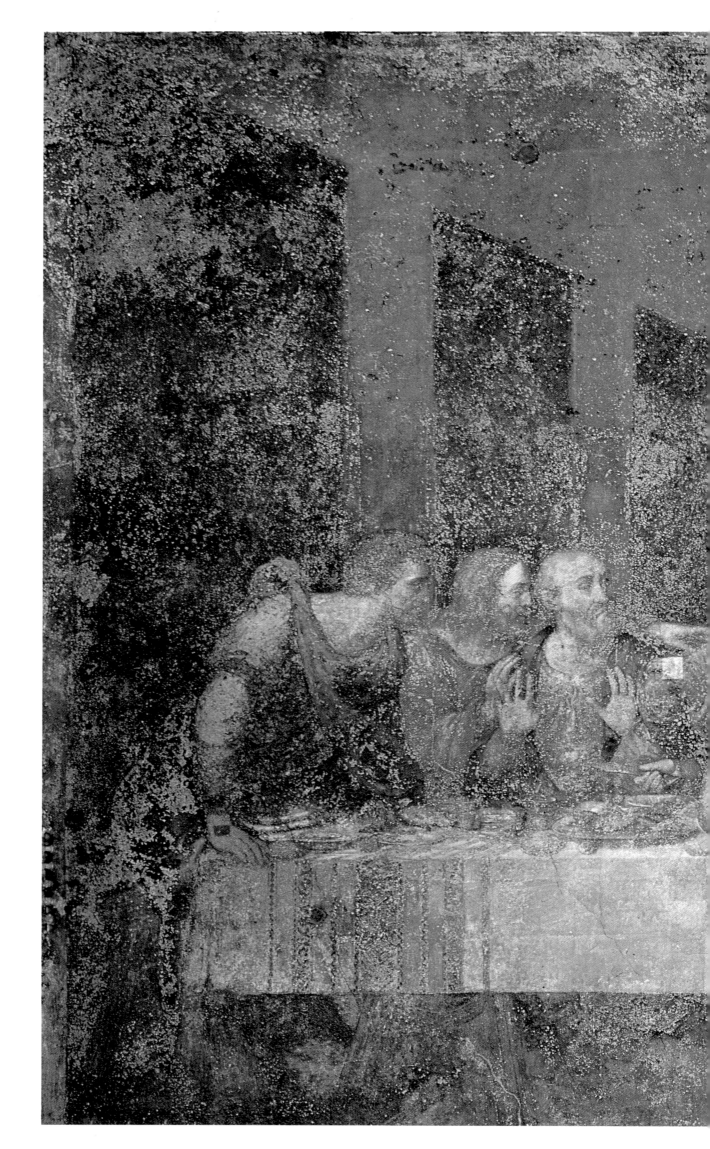

Fig. 257. *The Last Supper*, 1495–98,
tempera and oil on wall surface,
15 ft. 1 in. x 28 ft. 11 in. (460 x 880 cm.)
Milan, Santa Maria delle Grazie.
Condition before restoration.

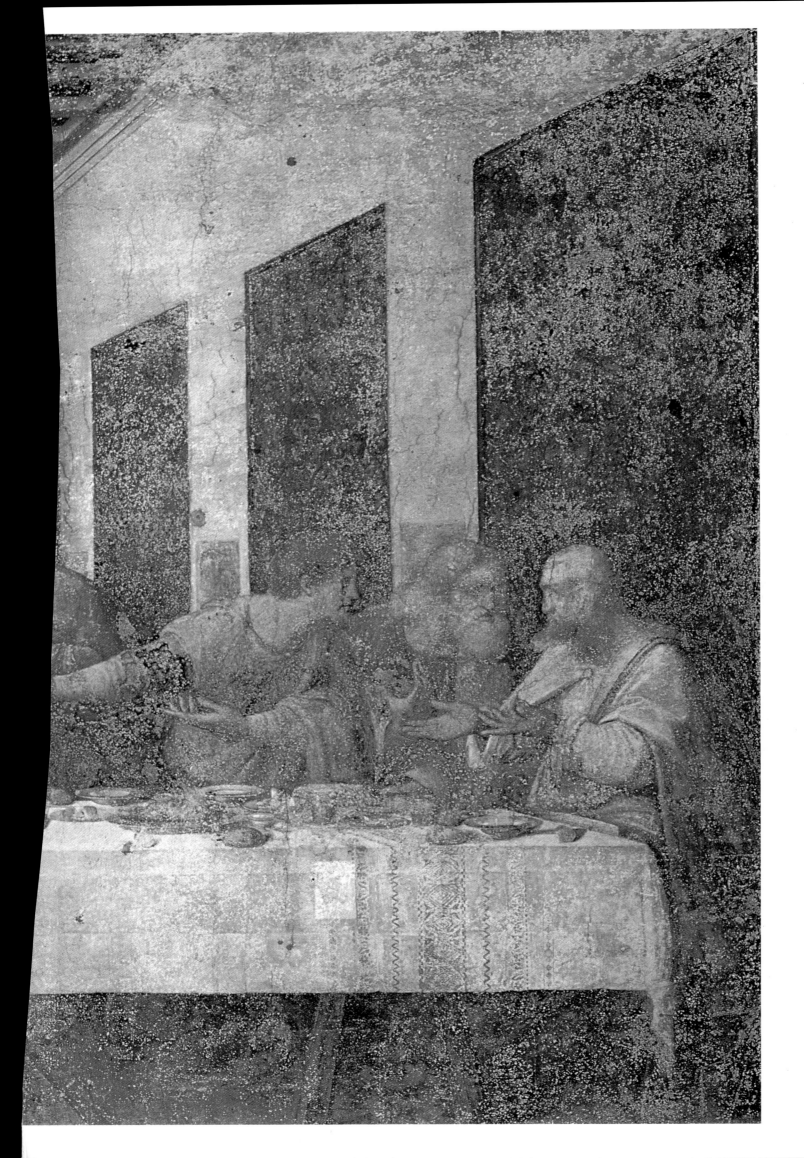

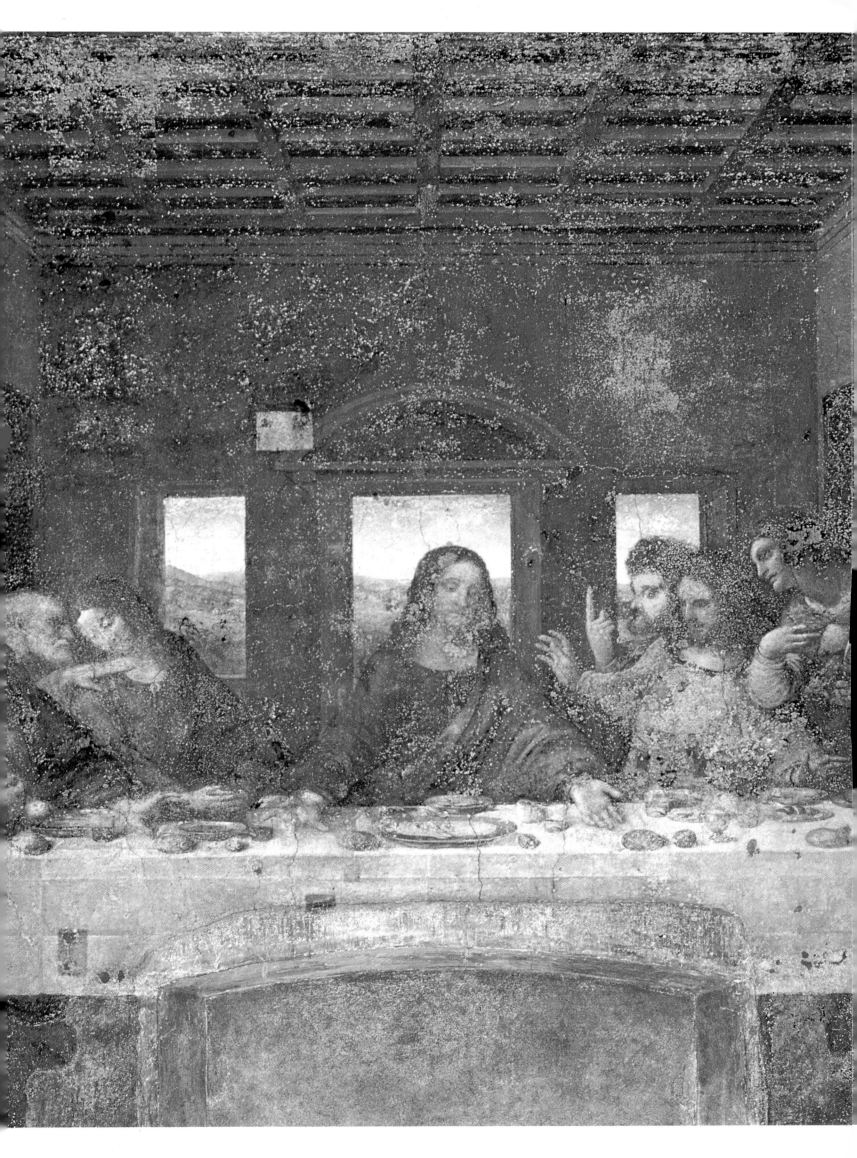

figures: while the heads in the group on the left are gathered between the edge of the third tapestry and the window-frame, those in the group on the right have been moved towards the center, nearer to Christ, and occupy the space between the corner of the room and the inside edge of the window. A number of echoes and "rhyming" expressions in the gestures of the figures add rhythm to these changes of position. Sometimes they create a dynamic effect of lateral movement: for example, the two stretched out hands to the right of Christ, and, on the left, the succession of open palms which quickly lead the eye from the end of the table to the center. At other times they create a contrary feeling of suspension and stasis in the movement, as shown by the palms of Saint Andrew on the right of Christ and the pointed index finger of Thomas on the left, and Judas's retreat with the parallel movement of James the Greater. The description of this animated disposition could be as interminable as an analysis of Leonardo's drawings of the movements of water.[592] Nonetheless, the principle that inspired it seems very clear: it is impossible to relate the disposition of the figures to the geometric grid of the surface. *The Last Supper* is not content with merely rejecting the traditional, juxtaposed, static composition. It emphasizes this rejection, and the interaction between the linear regularity of the perspective and the moving dynamic of the figures creates a feeling of *discordia concors* ("harmonious discord"); in musical terms, its unity would be based on the harmony of tone and the rhythmic arrangement in the development of a melodic line. In this way *The Last Supper* illustrates the triumph of painting and music over poetry, as Leonardo described it in the *paragone* (comparison) of the arts: "The poet cannot produce the harmony of music because he cannot say several things at the same time, as the harmonic proportion of painting is able to do. The latter composes the various elements at the same time and their delightful harmony is appreciated at the same time, as a whole and in detail; as a whole in relation to the meaning of the composition, and in detail in relation to the meaning of its components."[593]

Inside each of the groups, the different expressions of the figures has been carefully thought out by Leonardo. This is demonstrated by the preparatory drawings he produced for the figures—whether they were actually used in the painting or rejected (fig. 259, 260, 261, 262)—and in the famous description in which Leonardo, writing to clarify ideas out of which he would retain only a few elements, says: "One figure who is seen drinking has put down his glass and turned towards the figure who is speaking. Another, his fingers

Fig. 258. *The Last Supper*.
Milan, Santa Maria delle Grazie.
Detail of the central section, unrestored.

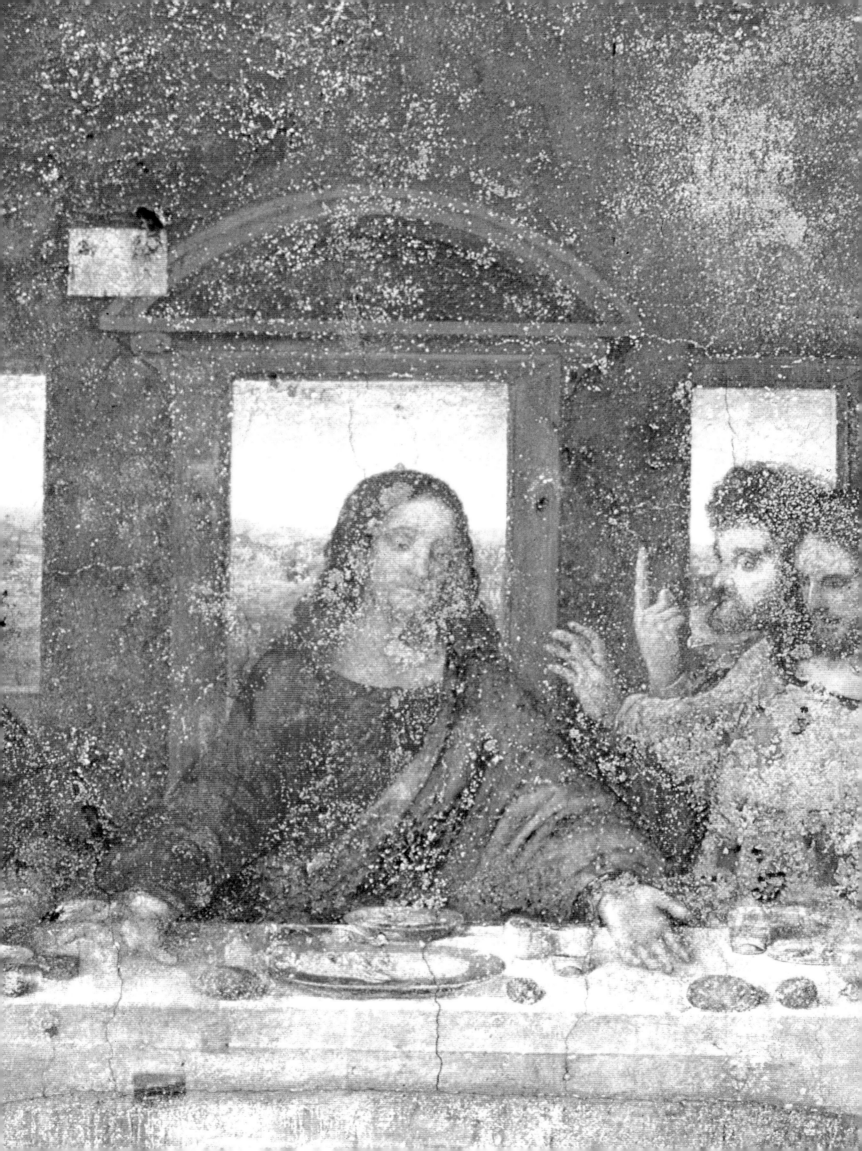

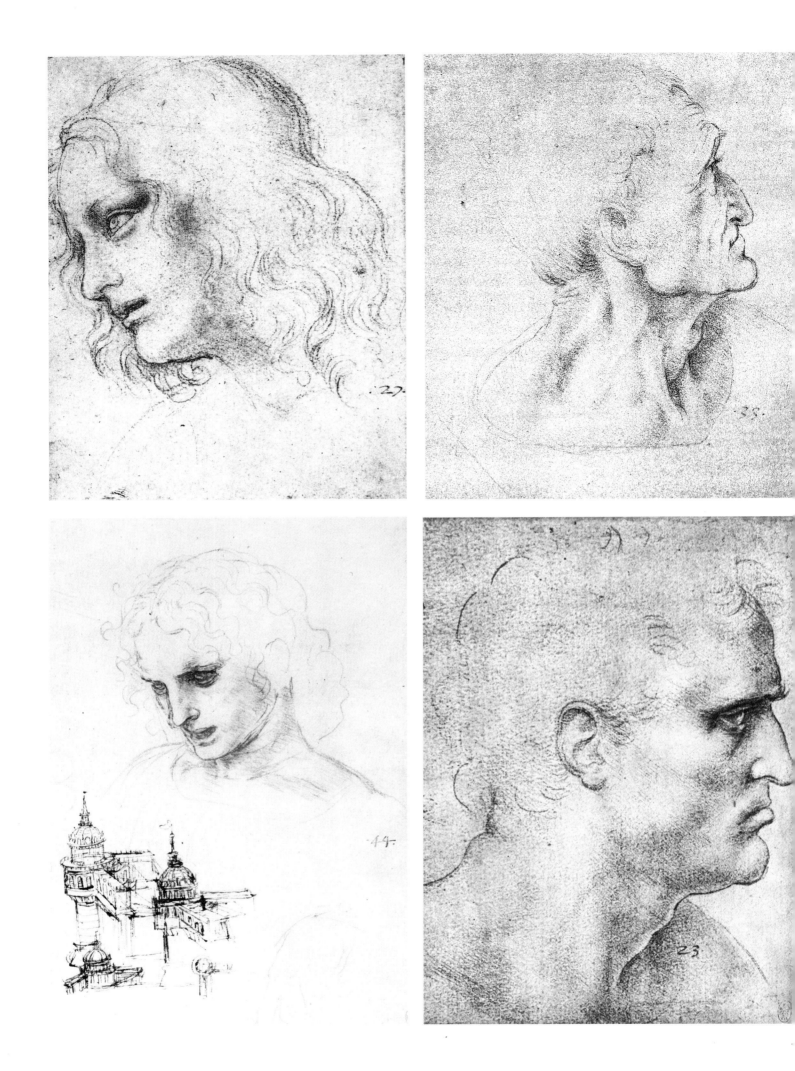

intertwined, turns towards his companion, scowling. Another one, showing the palms of his hands, raises his shoulders to his ears and his mouth expresses surprise. Yet another whispers in his neighbor's ear and the one who is spoken to turns towards him, listening, holding a knife in one hand and a half-cut roll in the other. Another is turning round holding a knife in his hand and upsetting a glass on the table. Another is looking on, his hand resting on the table. Another is blowing with a full mouth, another leans forward to see who is speaking, screening his eyes with his hand. Another draws back behind the one who is leaning forward and looks at the figure who is speaking, as he tries to see between the latter and the wall."[594] This description and the detailed studies of the expressive gestures justify the emotional deciphering of these "movements of the body," which Leonardo used to translate the "movements of the soul."[595] However, it should here be added that, in the transfer from the text to the picture, the anecdotal character has been reduced and the series of juxtaposed notations has become organically more unified, each figure with its own expression constituting a part of the whole and contributing to its continuity. What the painting here celebrates is the perturbing and yet unifying force of the words of Christ, reflected in the succession of reactions they arouse.

Far from being chaotic, the "tumult" is clearly organized in four groups of three figures. The idea of this arrangement, that only came slowly to Leonardo, as the preparatory drawings show, is undoubtedly the most important "formal" innovation of *The Last Supper*. Apart from the iconography, its innovation completely changed the very concept of representation. Artists like Rubens and Rembrandt turned to it as to the first "modern" image of the Last Supper,[596] because the distinct unity of each group is integrated dynamically into the composition as a whole through the double effect of the light and the movement that is present in the frieze of characters. Falling from the same angle as the natural light pouring through the windows of the refectory, the light in *The Last Supper* ranges from semi-darkness where Bartholomew is standing to the light shining brilliantly on Simon's bald head. According to Leo Steinberg, this distribution of the light further emphasizes the two meanings, narrative and liturgical, of the image. In the darkest part, the apostles' gestures foreshadow events that would take place for each apostle after the Crucifixion, while the gestures of the figures in the brightest part on the right reflect the liturgical tradition of the eucharistic rite.[597] Though very attractive as a whole, this interpretation is not completely satisfactory.

Opposite page, top left: Fig. 259. *Study for the head of Saint Philip*, *c.* 1495, black crayon, 7½ x 6 in. (19 x 15 cm.) Windsor Castle, Royal Library, RL 12551.

Top right: Fig. 260. *Study for the head of Judas*, *c.* 1495, red chalk on red prepared surface, 7 x 6 in. (18 x 15 cm.) Windsor Castle, Royal Library, RL 12547.

Below left: Fig. 261. *Head of apostle and architectural study*, red chalk and pen, 10 x 6¾ in. (25.2 x 17.2 cm.) Windsor Castle, Royal Library, RL 12552.

Below right: Fig. 262. *Head of a man in right profile,* red chalk on red prepared surface, 7½ x 5¾ in. (19.3 x 14.8 cm.) Windsor Castle, Royal Library.

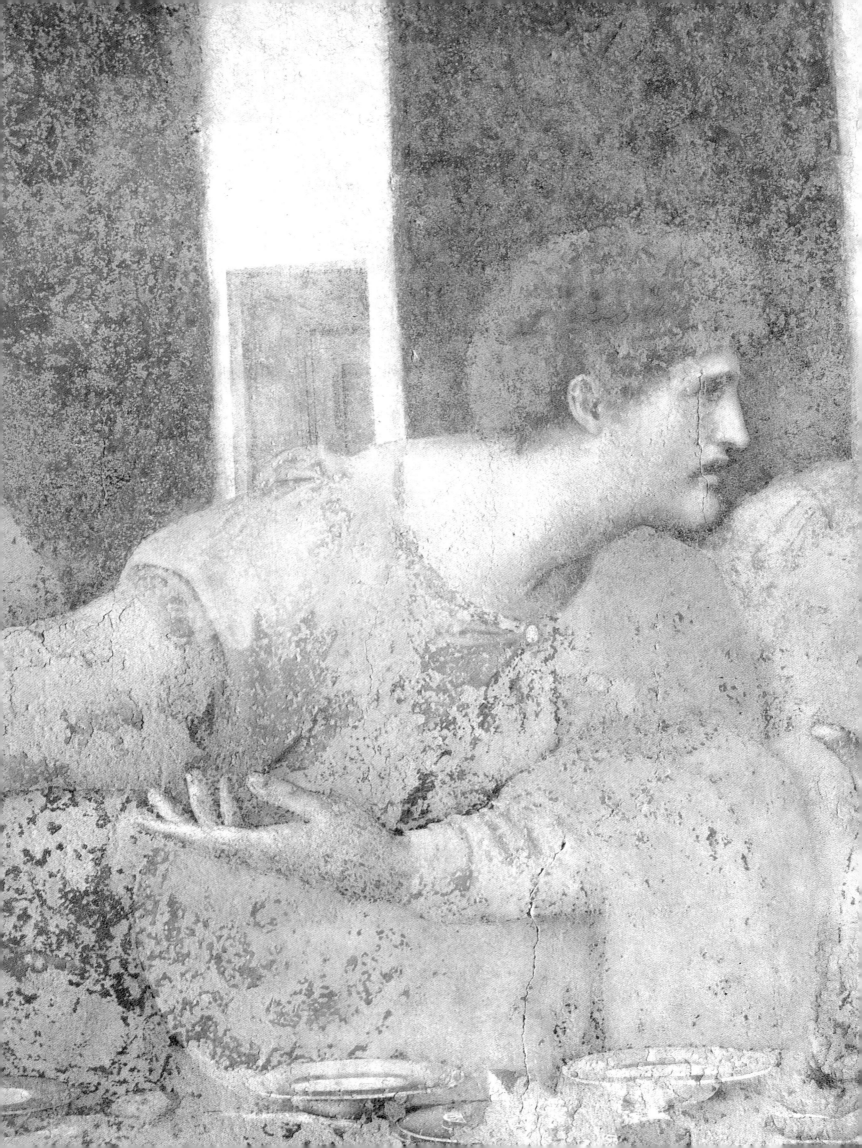

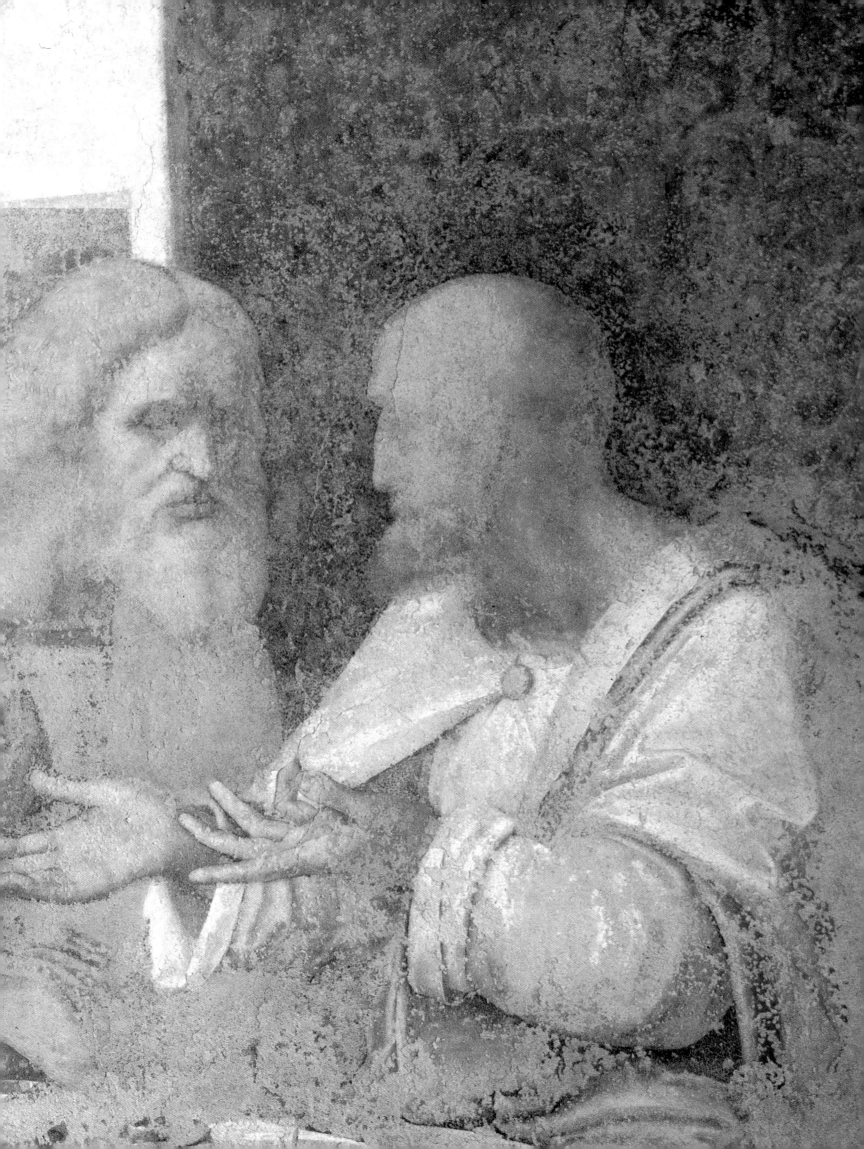

As has been seen, the group of Judas, Peter and John, for instance, has a dimension that reaches beyond narrative. Similarly, the outstretched palms of the apostle Thomas in the group on the far right have a clearly deictic function: he is pointing out Christ to Simon, whose gesture is one of interrogation, while between these two the hands of Thaddeus express a strong gesture of affirmation. But Leo Steinberg's interpretation is only incorrect in that it finds a single meaning in gestures that Leonardo meant to be allusions—with multiple meanings in that they must also be able to evoke the reaction of the apostles to both levels of Christ's discourse, summed up in the dual meaning of his gesture.

The association of light with gestures of a spiritual and liturgical kind seems indeed to describe the right side of the fresco very well, but it does not form a radical contrast with the left side, and more importantly, the movement of the figures is not, as Steinberg sees it, from left to right, from the shadows of history to the light of the revelation.[598] The movement originates in the center, emanating from the figure of Christ and spreading simultaneously in both directions; and, having reached the end of the table and the edge of the fresco, it returns towards the center, merging again through the figure of Christ. Ludwig Heydenreich noted the gradation in the intensity of the colors of the apostles' clothes, from the primary colors of Christ's garments to the tinted ones of the apostles' robes, increasingly flecked with light and shade as they are further from the center towards the left and right.[599] But it was Ernst Gombrich who was the first to recognize what actually structured the internal dynamics of *The Last Supper*. Starting from the unity of Leonardo's thought, he suggested that the arrangement of the figures in *The Last Supper* could be "a study of the impact a word is seen to make on a group recoiling and returning" in the same way as the impulse and surging which determines "the various forms assumed by moving water." To support his interpretation, he cites the quotation on the last page of the *Codex Leicester* in which Dante compares the dialogue between Saint Thomas and Beatrice to a double movement of the water, when it is struck in circular vase: "It is from the center to the outer circle, and from the outer circle to the center that water moves, depending on whether it is struck from inside or outside."[600] This very convincing comparison enables us to see in each group of apostles the configuration of a wave or surf in which two movements, one centrifugal and the other centripetal intersect and propagate simultaneously and indefinitely through all the figures in the composition. Christ's gesture alone would

Pages 378–79: Fig. 263.
The Last Supper.
Milan, Santa Maria delle
Grazie. Detail from the
right section, restored.

have been enough to indicate the source of this movement, but Leonardo further emphasized the strength of the impact (in the literal sense) of his words by the double movement of retreat by the apostles seated immediately next to him, James the Greater on his left and John on his right—a movement of retreat immediately counteracted by the forward movement of Matthew and Peter.

The carefully considered nature of this arrangement is further confirmed by another spectacular innovation: the marked distance, the only one clearly depicted as such, which separates Christ and Saint John, emphasized by the similarity in the colors of their clothes (although inverted) and the vertical mass of the pillar, at the back, that separates the door and the window. This position is a clear break with tradition, which usually had John resting against Christ's chest—and which Leonardo had retained at first. By thus rejecting the convention, Leonardo removed an element that was not only improbable but even unworthy of the celebration of the event: as the motif developed, it had made John look fast asleep during a sacramental ritual of the greatest importance. This distance between John and Christ could be explained by the gesture of Saint Peter, who, with his hand on John's shoulder, appears to be asking him what Christ has just said, as the gospel of Saint John tells it (13:24).[601] But this interpretation diminishes Leonardo's innovation. The distance resulting from Saint John's movement has no narrative value; far from being that interval recommended by Alberti to guarantee the intelligibility of the *historia*, it is a metaphysical interval reflecting the incommensurable distance between the twin nature of Christ, who is both human and divine, and that of his favorite disciple, who is only human. Here Leonardo is closest to Saint John's gospel (13:31–33): hardly has Judas left before Jesus says: "Now is the Son of man glorified, and God is glorified in him. [...] Little children, yet a little while I am with you. [...] Whither I go ye cannot come." The distance between John and Christ is closely connected with the eucharistic context of *The Last Supper*. As at the Epiphany, when the divine nature of Jesus's human body was universally revealed, so in *The Last Supper*, the miracle of transubstantiation, "performed" by the words, "This is my body, this is my blood," confirm this double nature, religiously repeated in the ritual of the eucharist. The importance of this movement is reflected in the equivalent contrasting gesture of the apostle James the Greater, on the left of Christ: stepping back with open arms, he looks amazed and dazzled by the sudden revelation of the miracle just performed—while Saint Thomas's pointed index

finger, in accordance with the traditional image of this apostle, confirms the supernatural dimension of the event.

This touches on a vital aspect of Leonardo's invention in *The Last Supper*. There is indeed a fundamental difference between the function of intelligibility of the Albertian narrative interval and the metaphysical dimension introduced in the tumult of the Last Supper by Leonardo's distance: what this concerns is the very concept of history and its representation.

The Albertian interval has an "after the event" character; it is a differentiation, a division introduced by the historian (painter or writer) into what happened in the flow, in the uninterrupted continuity of time. This separation creates the grid of what is, for Alberti's humanism, the historical intelligibility of events.[602] The Albertian concept of the "historical interval" is fully consistent with the Aristotelian concept of time in which the present is defined as *apostasis tou nûn*, the "isolation of the moment," the boundary between the past and the future—and it is not without interest that in Greek rhetoric the same word *apostasis* designates the construction of a sentence or a period in separate or distinct parts.[603] It is in and through this "boundary of the present" that the change takes place that creates "history." In the Albertian concept of *historia*, the temporal extent of the historical present is represented by the interval between the figures in the story that translates the temporal into spatial terms.[604] As has been shown, Leonardo's concept of time was not at all Aristotelian. If the instant of the present is an indivisible point, it is so in the manner of the points that make up the geometric line, in a continuous and indivisible movement: "The instant is in time, and it is indivisible. The instant has no time; time is created in the movement of the instant, and the instants are the terms of time."[605] It has also been shown that Leonardo's way of thinking led him to see bodies as being produced, at the end of a continuous process, by the "movement of the point." In this morphological way of thinking, the intelligibility created by the Albertian interval can only be arbitrary, removed from the continuous processes of "becoming." At the same time, to represent history at the moment it is taking place, when its course is changing, in such events as the Epiphany or the Eucharist, is to make visible the invisible "movement of the moment," that is, to paint the visible propagation of a "remarkable event" in history among the actors-spectators. This is what gives the "tumult" in the *Adoration of the Magi* and *The Last Supper* its full meaning: by painting the moment in which transcendence manifests itself and intervenes in the course of history, Leonardo has painted the invisible occurring

in the visible and "makes present" in his painting ("re-presents") the upheaval this occurrence causes.

As Ernst Gombrich suggested, the unity in Leonardo's artistic, philosophical and scientific concepts is genuinely remarkable. Through the parallel between the rhythm of the forms assumed by moving water and that of the arrangement of the apostles in *The Last Supper*, what underlies the composition of *The Last Supper* is a concept of Time in which, if the present instant is making history, it is because it is dynamically charged. More clearly than in the *Adoration of the Magi*, *The Last Supper* paints an instant that has been-historic because it was invested with this "Force" that Leonardo defined, let us not forget, as a "spiritual power," whose action imprints itself on the visible by affecting what it encounters and crosses in its movement.[606] In the *Adoration of the Magi* and *The Last Supper*, the driving power in the tumult of history lies in the revelation of the mystery of the Incarnation; or, to use the words of the French Franciscan preacher Saint Bernardino of Siena (a volume of whose work Leonardo had in his library), of the coming of "Eternity in time, immensity in measurement, the Creator in the creature […], the infigurable in the figure, the ineffable in the word, the uncircumscribable in the place, the invisible in the vision […]." Leonardo felt he had to present the coming of the Incarnation at the bewildering instant of its revelation, and its consecration.

We will see how, in the exclusively human *historia* of *The Battle of Anghiari*, this concept of the instant of history would logically take the form of a blind, confused mêlée in which only the "very bestial madness" of the human animal is evident.

PORTRAITS

The *Mona Lisa* (fig. 265) is more than Leonardo's best known portrait: it is the most famous painting in the world.

Ever since it was painted, the *Mona Lisa*'s fame has been tinged with ambiguity. In the middle of the sixteenth century, Vasari described the painting without ever having seen it; he claimed that it was unfinished and his text, an enthusiastic *ekphrasis* ("exposition") of the ideal portrait, may have been based on a copy he could have seen or perhaps even on a description by someone else—and, certainly, on what was supposed to be a beautiful portrait. From the start, the *Mona Lisa* was the example of a perfection that would make artists "tremble with fear": "Looking at this face, anyone who wanted to know how far nature can be imitated by art would understand immediately; even the smallest details were represented, made possible by the subtlety of painting. Her limpid eyes sparkled with life; highlighted by reddish, leaden hues, they were fringed with lashes, delicately depicted with the greatest care. The eyebrows, thicker in some places and thinner in others depending on the arrangement of the pores could not have looked more real. The nose with the ravishing, delicate pink nostrils was absolutely life-like. The curve of the mouth with the soft red lips set in the rosy hues of the face was not made from paint but from flesh itself. The attentive spectator would even notice the beating of the veins in the hollow part of the throat. It will be recognized that the execution of this painting is enough to make the strongest artist tremble with fear, whoever he may be. [...] The smile in her face was so attractive that it gave the spectator the feeling of facing something divine rather than human, it was something wonderful because it was life itself."[608] For Vasari, this life inherent to the portrait was at most commonplace, a *topos*, almost inevitable. However, three centuries later, she would terrify the French critics: Théophile Gautier saw in the *Mona Lisa* "the Isis of a cryptic religion who, believing herself alone, opens the folds of her veil, that the foolhardy who had surprised her would become mad and die." In 1869, Walter Pater gave a description of the *Mona Lisa* which was to mark several generations: the *Mona Lisa* "is expressive of what in the ways of a thousand years men had come to desire;" in her beauty, "into which the soul with all its maladies has passed [...] She is older than the rocks among which she sits; like the vampire she has been dead many times and learned the secrets of the grave."[690]

Page 384: Fig. 264. *Mona Lisa*. Paris, Musée du Louvre. Detail.

Fig. 265. *Mona Lisa*, also known as *La Gioconda*, 1503–05, oil on wood, 30¼ x 20¾ in. (77 x 53 cm.) Paris, Musée du Louvre.

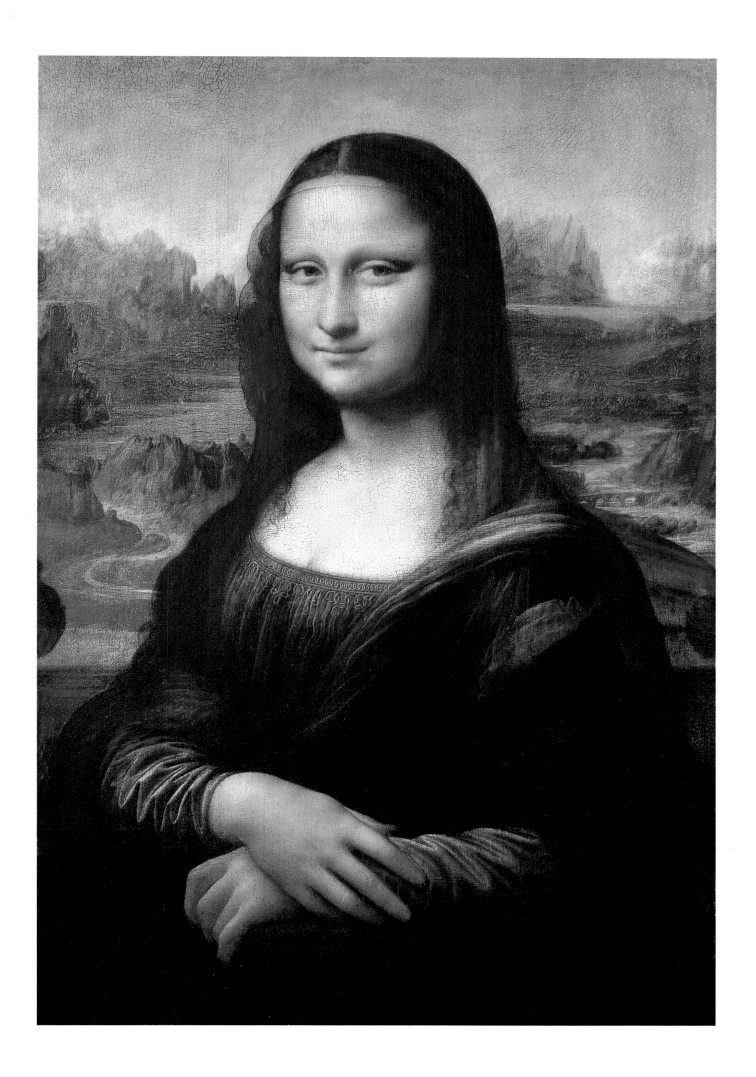

These often splendid texts still influence the way people look at the painting. In spite of the caricatures and its overexposure, the *Mona Lisa* still enjoys an almost religious prestige. But of course this has nothing to do with the importance of the picture in the history of portrait painting in the Renaissance (there is no mystery in Vasari's *Mona Lisa*), or in the development of Leonardo's painting. The *Mona Lisa* must nevertheless be put at the heart of Leonardo's portraits, because it occupies an exceptional place among them. Started in about 1503 and executed over a period of ten years, it is both the culmination of an idea that began before 1480 with *Ginevra de' Benci* (fig. 276), and a much re-worked return to this starting point. Of the six portraits by Leonardo to have survived, only the *Mona Lisa* and *Ginevra de' Benci*, the Florentines, are depicted with a background of nature; and only they look straight at the spectator, the object of their gaze.[610] With the *Mona Lisa*, Leonardo slowly but radically developed the very idea of the portrait until it became the depository of all his thoughts, expectations and ambitions as a painter. Trying to understand Leonardo as a painter is to try and comprehend how the genesis of the *Mona Lisa* became an experience to which previous portraits and the multiple facets of the "universal" artist contributed at various levels. But studying the *Mona Lisa* is also to try and see how this same painting was able, after the event, to fulfill unforeseeable expectations, how it was able to have *effects* which, though unknown at the time, were nevertheless potentially part of its structure.

But first the painting's historical background should be clarified: who the person represented in the painting is and the conditions of the commission. Putting an end once and for all, one hopes, to the myths surrounding the identity of the model, a careful study of the archives has enabled some light to be shed on the social conditions in which this portrait came to be painted.[611] Born in 1479, Lisa di Noldo Gherardini married Francesco del Giocondo in 1495. He was nineteen years her elder and had already been married twice: in 1491 to Camilla Rucellai (who died in the same year, having given birth to a son Bartolomeo) and, in 1493, to Tommasa Villani who died (in childbirth?) the following year. Lisa (now del Giocondo) gave her husband three children: Piero Francesco, born on May 23, 1496, a daughter (about whom it is only know that she died on June 6, 1499), and a second son, Andrea, who was born on December 1, 1502. Lisa di Noldo Gherardini was of fairly humble origins, since her dowry was only 170 florins (that of Maddalena Strozzi-Doni, whose portrait Raphael painted, was 1400 florins in 1506). Francesco

del Giocondo was, on the other hand, a well-to-do merchant who held public office in 1499, 1512 and 1524; he had dealings with important families, the Strozzi and the Doni, and a family chapel in the prestigious church of the Santissima Annunziata—in the care of those same Servants of Saint Mary (Servites) whose guest Leonardo was when he arrived from Milan, and whose notary was Leonardo's father.

The painting was commissioned in the spring of 1503. As a withdrawal of money by Leonardo in March suggests, he was relatively free at the time: after leaving Cesare Borgia's service, he did not receive his first important order until October 1503; this was *The Battle of Anghiari,* which would occupy him until 1506. For his part, Francesco del Giocondo had excellent reasons for ordering a portrait of his wife from a famous painter who was for the moment unoccupied. In April 1503, a few months after the birth of his second son, he installed his family in a new, larger house and, as was the custom at the time, the portrait of the wife who had given him two male heirs would have been part of the furnishings destined for the new house.[612] The social context of this commission removes the mystery of one of the elements of the painting that has always fired the imagination of its interpreters: the black veil covering Mona Lisa's hair. Far from exclusively signifying mourning, the black veil also indicated the status of wife. A manual for young girls written in Venice in 1461, the *Decor Puellarum,* recommended it as the "first nuptial garment" and, in daily life, the black veil covering the hair was customary for married women, indicating their virtues of chastity, devotion and obedience to God. Its presence in this type of portrait remains exceptional, but it can be explained by the popularity of black or dark clothes at the beginning of the sixteenth century. Spanish in origin, this fashion received the aristocratic seal of approval at the marriage of Lucrezia Borgia and Alfonso d'Este in 1502— and it is conceivable that Leonardo might have recommended the wearing of such an accessory as perfectly befitting the wife of Francesco del Giocondo.

This historical and social information can prevent mistakes in the interpretation of the portrait.[613] However, if the interpretation is not developed any further, these facts might somehow make the portrait appear commonplace and ordinary—in other words, make the *Mona Lisa* no different from the drawing in which Raphael clearly copied Leonardo's project at the stage it was in about 1504 (fig. 266). Nonetheless, Raphael's drawing is an exceptional document precisely because it shows how the finished painting differed from its preparatory stage. In 1504, Leonardo had not yet conceived

his "landscape." Nor had the foreground of the painting been planned: Raphael sketched a traditional parapet on which the left elbow is resting but not clearly, nor has the position of the left hand been clearly defined. Raphael would solve the problem in his own way in the *Lady with a Unicorn* (fig. 275), in which the lady holds the symbolic animal in her arms. But this solution could not satisfy Leonardo, since had already used it, ten years earlier, in the very different context of the *Lady with an Ermine* (fig. 269). Raphael's

Fig. 266. Raphael, *Young woman on a loggia*, pen and brown ink, 8¾ x 6¼ in. (22.2 x 15.8 cm.) Paris, Musée du Louvre, department of graphic arts.

drawing also shows that Leonardo had not yet completed his work of "idealization" on the face of the *Mona Lisa*: Lisa di Noldo Gherardini probably "looked" much more like the woman depicted by Raphael than the one painted by Leonardo. Nevertheless, Raphael's drawing does indicate the idea that, from the very beginning, had inspired the *Mona Lisa*'s construction: the loggia which places the figure in close contact with the spectator while still conveying the feeling of distant views. But this was not the painting that Leonardo had in mind and, in fact, Francesco del Giocondo was never to see the *Mona Lisa*.

Busy with *The Battle of Anghiari*, the *Madonna and Child and Saint Anne*, and in the planning stages of *Leda*, Leonardo soon recovered his rhythm—and he persevered with the portrait. Its gestation lasted about ten years and

the finished painting still showed traces of the social conditions in which it was conceived, although it could no longer be reduced to those conditions alone. Naturally, the enduring glory of the *Mona Lisa* and its effect on the world do not stem from its social definition. They arise from its artistic qualities, Leonardo's slowly maturing work of placing his figure, that is to say, in both giving her a pose and in positioning her on the canvas where she would take shape. A closer look is necessary to try to see how the *Mona Lisa* was made.

The loggia where she is sitting plays a fundamental role in the advance of the figure towards the spectator.[614] With its little wall and two columns, barely visible at the sides of the picture,[615] the loggia discreetly takes on two functions as a frame: for the figure in relation to the space outside the painting, and for the landscape within the painting. This duality plays an important part in the effect of the painting. Framing the figure, the columns serve to push the figure further forward than the picture plane they define, and indeed Mona Lisa has crossed the little wall that traditionally separates the figure from the spectator. But, framing the landscape, the columns turn it into a picture within the painting[616]—and, by establishing a place from where this landscape can be seen, they make it recede into the distance, all the more so because no transition is visible between this point of view and what it is looking at. By simultaneously framing the landscape and the upper part of the figure, the columns create on their own a very effective impression of oscillation, of back and forth motion: the landscape stretches out far behind them, while the figure stands out in front of them. Immediately but surreptitiously, this framing effect creates an atmosphere of uncertainty.

The landscape itself was for Leonardo an innovation in portrait painting: this was the first time that he placed the model directly in front of a view of nature. Apart from *Ginevra de' Benci*, in which the juniper tree played the part of a separating screen, all his other portraits were placed in front of a neutral background.[617] So here too, Leonardo drew inferences from his rejection of the use of architecture in the *Madonna with the Spindles*. In a way that is typical of Leonardo, exploiting the idea of the "suggested" landscape painted in about 1480 in the *Baptism of Christ*, and very close in spirit to the *Madonna and Child and Saint Anne*, which he was now working on, the landscape does not represent a particular place: it is first and foremost an anchor for the figure and, as such, it perfectly defined the "field" of the painting Leonardo considered very important because it gave relief to the figure. But, contemporaneous with the geological and hydrological studies of the

Codex Leicester, the landscape of the *Mona Lisa* also expressed Leonardo's fundamental intuition: the analogy between nature and human beings, between macrocosm and microcosm.[618] The portrait epitomizes the visible presence of nature through water, the blood of the earth, and mountainous rocks, which are its bones. The presence of the water is indicated by the bridge that defines the valley on the right (which will be returned to later, because its presence in this landscape where it is the only sign of human activity is so strange); and by the mountain lake, above the bridge, and on the left, the second lake, situated in the plain, bordered by a winding shore.

These two lakes are particularly revealing regarding the spirit in which Leonardo "invented" the *Mona Lisa*. They evoke two scientific questions that were fascinating Leonardo at the time. The first refers to the presence of water at the top of mountains; the second refers to the two lakes that, according to Leonardo, originally punctuated the course of the Arno until erosion removed the natural barriers that held them back. The first of these lakes occupied the plain that stretches from Florence to Pistoia and the second, upstream, the Val di Chiana, below Arezzo.[619] Yet, even more than that particular geographic area, the landscape in the *Mona Lisa* is reminiscent of the map on which, in about 1502, Leonardo had linked Lake Trasimene (top right) and the marshes of the Val di Chiana (fig. 149). On it he had drawn, but not colored, a river linking the two lakes, and the *Codex Leicester* explains that the Val di Chiana was originally linked to the "lake of Perugia." Transposing the cartographic view vertically, Leonardo has placed the Mona Lisa in front of an imaginary view of Lake Trasimene and the Val di Chiana as they existed before the life of the earth separated them. He thus gave his scientific vision of the world an entirely poetic interpretation. Because, following this (very personal) reference to the topography of the Arno as it might have been at the dawn of time, this primordial landscape represents the macrocosmic life of the earth and defines the imaginary background of the portrait: the happy and fertile Lisa del Giocondo, whose double and youthful maternity had fulfilled the expectations of the person who had commissioned the painting, becomes the incarnation of the vital power of the earth. This poetic analogy between Mona Lisa and the landscape is suggested by a series of interwoven "formal" echoes and continuities, from the rolling hills on the right, which appear like a continuation of the folds of the fabric on the left shoulder of the figure, to the winding course of the river (or road?) on the left, which reflects in the landscape the curly locks of the model.

Fig. 267. *Portrait de Ginevra de' Benci*.
Washington, National Gallery of Art. Detail.
(Whole picture p. 410)

And yet, the figure and the landscape appear quite different. There is a strong contrast between the mellowness of the figure and the wild austerity of the archaic landscape that is its background.[620] If Lisa del Giocondo embodies the vital force of nature, she also reflects the gracefulness characteristic of civilized human beings—as if, emerging from the *componimento inculto* that characterizes the primordial life of the earth, the figure has also taken up its harmony and given it the beauty of a form momentarily assumed by the universal movement of the world. The relation between the figure and the landscape is at the same time one of continuity and differentiation (the loggia defines this relationship), in other words a relationship of transformation or metamorphosis.

In spite of all its natural simplicity, the figure has been the object of a complex development. Without over-emphasising the innovation of representing Mona Lisa sitting in an armchair, it provided Leonardo with a remarkable solution to the question of how to deal with the lower edge of the picture other than by the traditional means of the parapet. The pose of the figure itself has been very carefully studied. Resting on the arm of the chair parallel to the picture plane, the left arm indicates that the entire lower part of the body is also parallel to this plane; the bust and head, shown almost full-face, have been turned towards the spectator, and the direction of the eyes ends this movement of rotation by finally placing the spectator in Mona Lisa's sight, perpendicular to the plane of the painting. Extremely supple and almost surreptitious, this internal rotation of the figure on itself was the result of some thirty years of reflection: while echoing the pose of *Gineyra de' Benci*, *Mona Lisa* also drew on the experience Leonardo acquired with the *Lady with an Ermine*, *La belle Ferronnière* and even *Isabella d'Este*. Apart from the *Portrait of a Musician* (and the blurred profiles of the Duke and Duchess of Milan introduced into the *Crucifixion* in the refectory of Santa Maria delle Grazie),[621] the portraits painted by Leonardo after 1480 all share this same rotating movement. The triple drawing in red chalk probably representing Cesare Borgia (fig. 268) was the result of similar research, although the lively mobility of the model has been achieved this time by moving the observer, based on an idea that is reminiscent of certain anatomical "demonstrations" mentioned earlier and was to have a limited but distinguished future.[622]

This systematic search for movement in portrait painting reflected what Leonardo considered the greatest (theoretical and practical) difficulty in the

genre. If the painter's aim was to represent his figures in relief against the background before which they stood in order to express the "movements of their soul" through those of the body, if that was one of the things that gave painting its "philosophical" dignity, how could this be achieved in portrait painting, which, according to the conventions of the time, had no narrative? How could one express the "temperament" of a model in a portrait, that is the stable equilibrium of the "humors" defining his or her "being," and not

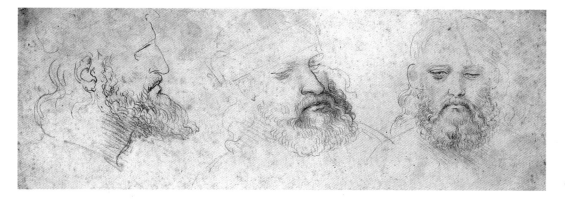

Fig. 268. *Triple portrait (Cesare Borgia ?)*. Turin, Biblioteca Reale.

merely a passion, which was temporary? How could one represent an "immobile movement" which reflected the internal, psychological life of the model while at the same ensuring that it was addressed to the person who had commissioned the painting? The question was crucial since, according to Leonardo (after Alberti), it was through his ability to represent the features of the beloved in a portrait that the painter was superior to the poet and superior in the eyes of the Prince who, like Matthias Corvinus, King of Hungary, preferred the portrait of his mistress to the poem written in her honor.[623]

In order to overcome this difficulty, the painter could "idealize" the figure, that is, transform the individual features into a "type" which would reflect a temperament physiognomically.[624] Leonardo was acquainted with this principle and a number of his drawings, in the tradition of Verrocchio, developed various versions of the "leonine" warrior. Nevertheless, even if the concept of the "idealized" portrait was at the heart of the Milanese portraits painted by Leonardo,[625] it was more in his drawings than in his painted portraits that he practiced this "physiognomical typology." Because his Milanese portraits were not exactly "heroic" portraits, idealization of the model was obtained in other ways. In the *Lady with an Ermine* (fig 269) and *La belle Ferronnière* (fig. 272), Leonardo refined the particular features of his models rather than

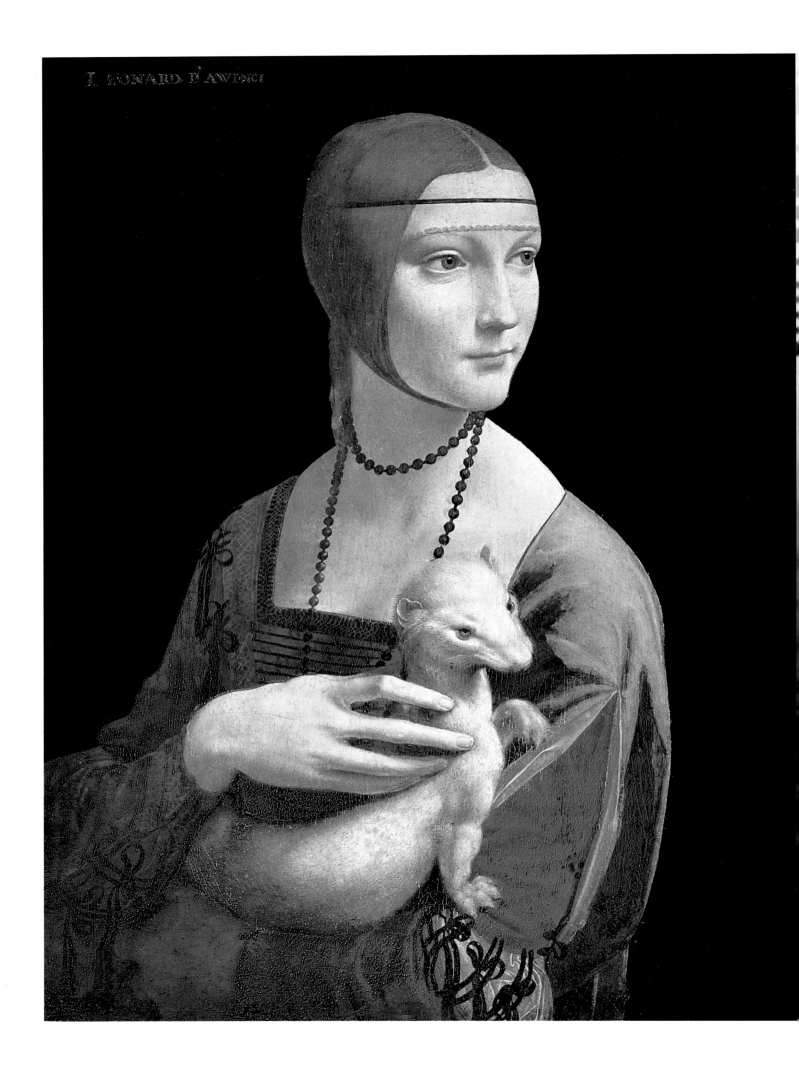

transforming them into a typical configuration—which would have made their interpretation easy but generic. The Mona Lisa's features appear to have been refined in a similar way. Another way of expressing the temperament of the model was by giving him or her a specific attribute that would be easy to "read." This is what Leonardo did in about 1488–90 in the *Lady with an Ermine*, where both the choice and representation of the attribute had been carefully thought out: symbolizing a purity that prefers to die rather than be sullied, the ermine is here attributed to Cecilia Gallerani, the mistress of Ludovico the Moor. This choice is explained iconographically by the fact that, as well as being one of Ludovico's emblems, the ermine (in Greek *galè*) was "appropriate" for Cecilia Gallerani. The idea was probably suggested to Leonardo by an adviser, perhaps the model or the Duke himself. But the presentation of the animal could only have been created by Leonardo. The ermine, by its twisting movement towards the spectator (from whom it protects its mistress), causes the model to hold it back with her right hand, but this gesture is made to look like a caress in which we may read Cecilia Gallerani's feelings for Ludovico the Moor, since the ermine was also the attribute of the Prince.[626]

It was not, however, this courtly use of the attribute that made the portrait *Cecilia Gallerani* so famous—Bellincioni, the court poet, wrote a poem about it, and in 1498 Isabella d'Este asked its owner to let her see it in order to compare the relative merits of Leonardo and Giovanni Bellini as portrait painters. It was the pose of the model who, with a completely unprecedented movement of the head, turns her face by ninety degrees to look over her shoulder in the direction of the light that is illuminating her. The pose is particularly ingenious in that, in spite of being twisted, the figure remains supple; this impression of suppleness is further emphasized by the curving movement of the necklace and most of all, by the movement of the animal. As arranged by Leonardo, the two figures participate in the same spiraling curve that is finally divided by the direction of their gazes. Leonardo has here invented an "art of the natural" that heralded what Baldassare Castiglione saw as the very source of gracefulness and the most important quality of the courtier: *sprezzatura*, this studied nonchalance in which "art hides art."[627] With the pose he gave his double model (the lady and the ermine), Leonardo here accomplished what Ghirlandaio recognized but could not attain in his portrait of Giovanna Tornabuoni: the perfection of the genre consisted of "being able to paint the soul and morals."[628]

Various precedents may have helped Leonardo achieve this: Flemish portraits

Fig. 269. *Lady with an Ermine*
(Portrait de Cecilia Gallerani),
1488–90, oil on wood, 21½ x 15¾ in. (54.8 x 40.3 cm.)
Krakow, Czartoryski Museum.

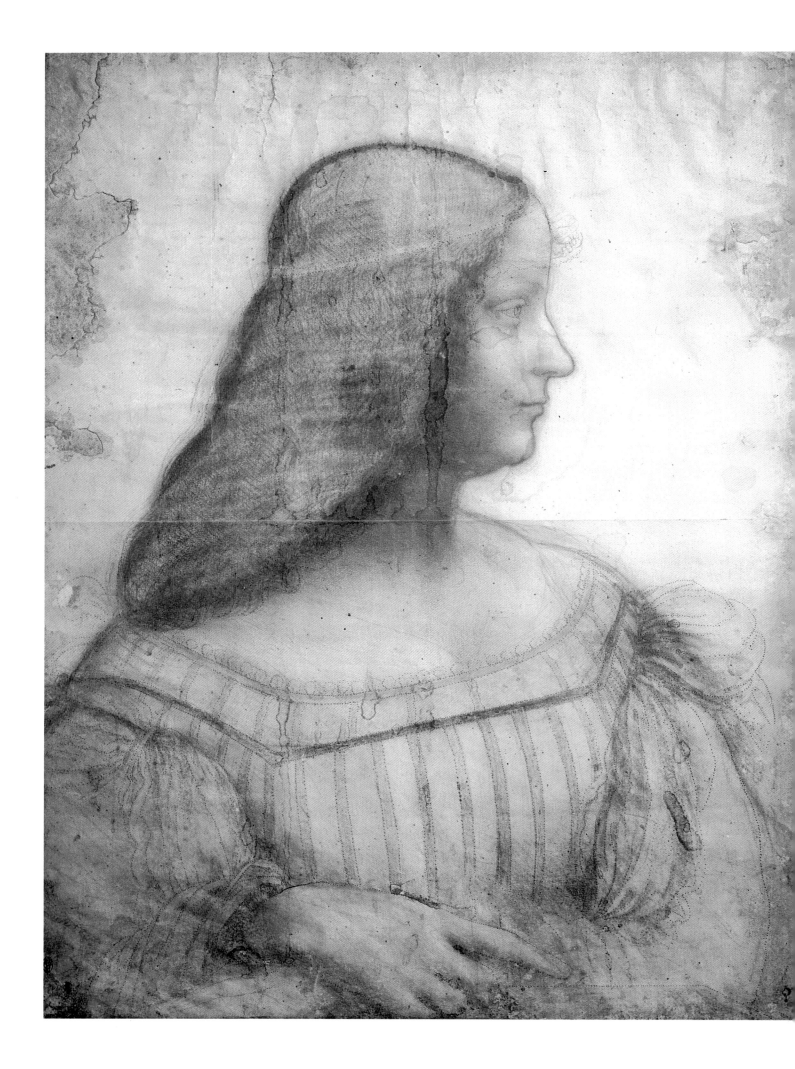

first of all, in which three-quarter-view poses had long been common, and above all, in Milan itself, the example of Antonello de Messina. The undisputed master of what might be called the "Italianized Flemish portrait," he had been summoned to Milan in 1475–76 by Galeazzo Maria Sforza, who was thinking of making him his court painter. Before Leonardo's arrival, his three-quarter-view busts represented the "most advanced taste in Milan,"[629] and *Portrait of a Musician* (fig. 191), the most "Antonellian" of Leonardo's portraits, might have been a kind of preliminary reaction to Antonello.[630] However, two points distinguish Leonardo and Antonello as portrait painters. First, *Portrait of a Musician* does not look at the spectator, nor do any of Leonardo's other portraits painted in Milan, while the direct look was one of Antonello's strengths. Insofar as Leonardo's two "Florentine" portraits (*Ginevra de' Benci* and *Mona Lisa*) look towards the spectator, the obliquity of the "Milanese" look probably reflected court etiquette or taste; but as will be seen, Leonardo exploited this "obliqueness" to develop the internal dynamic of the figure. Furthermore, apart from the double profile in the refectory of Santa Maria delle Grazie, Leonardo never became the Prince's portrait painter. It is surprising at first sight that Ludovico the Moor never felt tempted to make use of Leonardo's talent and prestige for his own portraits. This probably stemmed from the fact that the role of the princely portrait was always political, and that his taste was therefore guided by these political requirements.[631] Ludovico was not interested in Leonardo's brilliant innovations for his portraits and those of the Duchess, preferring to preserve the traditional, fixed pose in profile; this was because the princely portrait must not represent "the soul and morals" of the model. The profile, which can only be expressive of physiognomy, enjoyed all the prestige of traditional state portraits, inspired by ancient and modern coins. It confirmed the rank of the model, as it were, and this was extremely important to Ludovico the Moor, as his ducal legitimacy was quite fragile even after his official recognition by the Emperor. It would have been irresponsible on his part to allow himself to be represented in a private situation. Leonardo only produced two profile portraits, both drawings: one of an unknown young woman on a sheet at Windsor (fig. 271), and the other of *Isabella d'Este* (fig. 270), Duchess of Mantua, for which it may be assumed that Leonardo adopted this pose at her request—although he varied it by presenting the bust in three-quarter-view.

Except for *Isabella d'Este* and *Portrait of a Musician* (which also suggests that it was his first Milanese portrait), all portraits by Leonardo have their face (if

Fig. 270. *Portrait of Isabella d'Este*, 1500,
black chalk, red chalk and yellow pastel
on paper, 25¾ x 18 in. (63 x 46 cm.)
Paris, Musée du Louvre, department of graphic arts.

not their eyes) turned towards the spectator—who in the end would also be the owner of the portrait. This particular pose was made possible by the fact that the models in Milan were not leading characters politically: their relatively minor position in the political hierarchy enabled the conditions of the representation to be more flexible and opened up new possibilities of communication with the recipient. The arrangement in the *Cecilia Gallerani* portrait is particularly suggestive from this point of view. By representing her

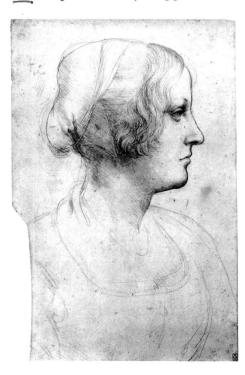

Fig. 271.
Profile of a young woman, after 1482, silver-point on pink paper, 12½ x 7¾ in. (32 x 20 cm.) Windsor Castle, Royal Library, RL 12505.

full-face, Leonardo succeeded in inventing what would become the pose of the portrait *di spalla*,[633] whose physical movement aimed to convey the impression, with *sprezzatura* (easy nonchalance), that the model was surprised by the unexpected arrival of the spectator—while covering her chest, that is, her intimate feelings. By representing the model full-face, Leonardo has carefully placed the ermine on Cecilia Gallerani's heart—concealing and revealing at the same time her feelings for the Prince. As for the turning movement, which expresses the surprise of the model with liveliness full of *sprezzatura*, it is probably addressed to the symbolic recipient of the portrait, the Duke himself, Ludovico the Moor, the shining light of his mistress, to whom she already responds with the suspicion of a smile.

Fig. 272. *Portrait of a Lady* or *La belle Ferronnière*, oil on wood, 24¾ x 17¾ in. (63 x 45 cm.) Paris, Musée du Louvre.

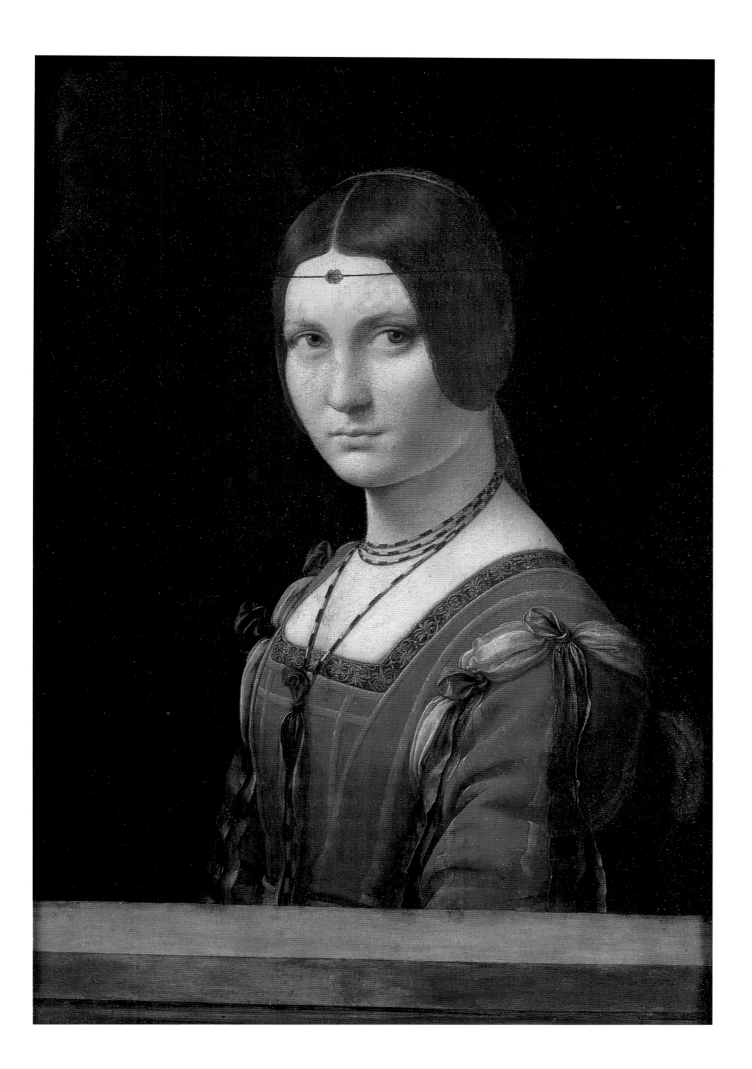

About a dozen years later, in 1495–99, the movement in *La belle Ferronnière* is less lively, and in any case the uncertainty regarding the model would make any particular interpretation of her pose arbitrary.[634] Nevertheless, one detail in the pose is clear: the model's gaze is not looking directly at us, and even by moving it is impossible to engage her eye. The angle her gaze forms with the picture plane seems to make her eyes move at the same time as the indiscreet spectator who might try to surprise her. With this simple "side glance," Leonardo continued into space the internal movement that discreetly enlivens the figure from bust to face. Unlike *Ginevra de' Benci*, whose gaze has fixed the body movement in a frontal pose, the eyes of *La belle Ferronnière* have already passed and blurred this boundary; combined with a minute inclination of the head, raising the gaze slightly, this distance in relation to the spectator's gaze has generated a movement in the spectator's relationship with the image, the more effective in that it has been achieved with fewer means.

Mona Lisa is the synthesis of these researches. Her gaze continues the movement into the picture space of the figure pivoting on itself, but in this case, while the movement becomes almost surreptitious, the gaze of this "Florentine" portrait catches and fixes the spectator: wherever the viewer is, looking from whatever position, she is looking at him. This effect was already present in *Ginevra de' Benci* but it has been made much stronger by the internal movement of the figure, which only stops with this gentle full-face gaze. One cannot therefore fail to associate the *Mona Lisa*'s gaze, Leonardo's theory of invisible "spiritual movements," and the wonderful power of the eye, capable of grasping the entire "field of the visible" from afar. It is true that in the end Leonardo rejected the optical theory of the "emission" of visual rays in favor of that of the "intromission" of *species*, but here the painted gaze is indeed "emitted" from and by the painting; thus it places the spectator in its power. From this interchange of looks between the figure and its recipient (the commissioner of the painting, the painter), the stake may indeed have been this *innamoramento* ("falling in love") whose unexpectedness may have its source in the beloved's gaze while the latter still keeps her reserve.[635] By the movement of her gaze, which continues that of her body, projecting its own "spiritual movement" out of the picture into the space from which she is looked at, *Mona Lisa* "goes out" to her recipient; but by its full-face all-seeing character, her gaze maintains an infinite distance.

The arrangement of the hands is inseparable from this effect. It took Leonardo over twenty-five years to perfect this pose, which on the surface is

Fig. 273. *Studies of hands*, before 1490, silver-point heightened with white on pink prepared surface, 8½ x 6 in. (21.5 x 15 cm.) Windsor Castle, Royal Library, RL 12558.

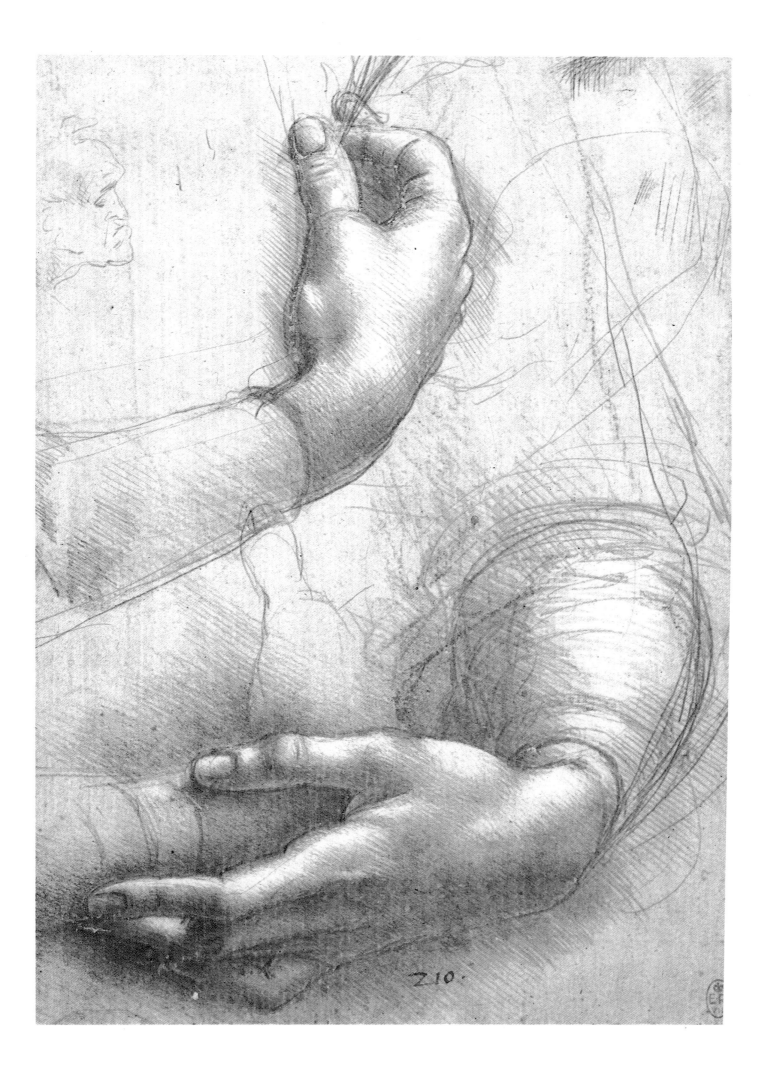

210.

simple and full of elegant nonchalance (*sprezzatura*). Looking at the position of the hands in all Leonardo's portraits, from *Ginevra de' Benci* to *Mona Lisa,* the difficulties he encountered with this detail are apparent.[636]

Because the lower part of the painting has been cut off (probably because of damage caused by damp),[637] it is difficult to imagine what the position of the hands in *Ginevra de' Benci* would have been. Traditionally, the study of hands at Windsor Royal Library (fig. 273) is associated with this picture. While clearly showing the impact of Verrocchio's models, Lorenzo di Credi's version of Leonardo's portrait supports this hypothesis,[638] but the stiffness of the drawing was, even at that time, too far from Leonardo's style to have accurately reproduced the position of the hands in his painting. The assumed original dimensions of the portrait of Ginevra de' Benci do not leave enough space for the left hand, raised, as represented by Lorenzo de Credi. It is therefore more likely that Leonardo placed the hands of the portrait as they are in the lower part of the Windsor drawing, with the right hand drawn in the upper part of the page showing the position of the fingers holding the symbolic accessory. In this case, Leonardo succeeded in softening Verrocchio's model by placing one hand on the wrist of the other, and in closing the figure on itself, by making her hands which are turned down in front of her body into a visual barrier, reflecting the moral theme of the portrait.

After this first success, the series of Milanese portraits appears to display much greater uncertainty and more hesitation.[639] In spite of the natural, dynamic expressiveness of the gesture, made possible by the presence of the ermine, the right hand in *Cecilia Gallerani* is clearly too large and brings to the painting the exaggerated style of the anatomical studies that Leonardo began in 1487; meanwhile, the left hand, in the shadow, remains unfinished. *La belle Ferronnière* avoids the presence of hands by resorting to the traditional parapet of northern origin; such a backward step suggests that Leonardo had not found a satisfactory solution, in his own eyes, for the position of the hands when the bust was almost in profile. The cartoon for *Isabella d'Este* confirms these problems. In spite of the rather damaged condition of the lower part of the drawing, the copies of the work reveal that the figure was shown behind a parapet, with the index finger of the right hand pointing at a book placed upon it. Simple, effective, and relatively traditional, this arrangement clearly indicated the "woman of letters" that Isabella d'Este was (and wanted to be seen as). It is even possible that she herself suggested the accessory of the book, thus inviting Leonardo to "stage" the parapet.

But the position of the hands remains uncertain: they are very high in relation to the bust, clearly higher than those of the *Mona Lisa,* which repeats the idea of the crossed hands. In a mediocre painting in the Ashmolean Museum in Oxford, copied from the drawing, this pose has been softened to make it more natural by lowering the height of the parapet.[640] As shown in the Louvre cartoon, Isabella d'Este's pose indicates an unhappy tension between the nonchalant suppleness of the crossed hands and the rigidity

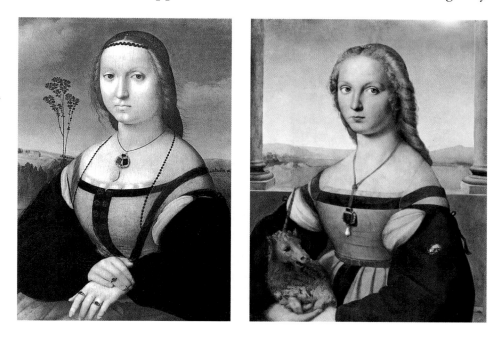

Far left: Fig. 274. Raphael, *Portrait of Maddalena Doni,* 1506, oil sur wood, 25 x 17¾ in. (63 x 45 cm.) Florence, Palazzo Pitti.

Left: Fig. 275. Raphael, *Lady with a Unicorn,* 1505–06, oil on wood, 25½ x 20 in. (65 x 51 cm.) Rome, Galleria Borghese.

resulting from their high position. It is hard to believe that Leonardo could have been satisfied with them in a finished portrait—unless he intended using this strange "movement of the body" to express the internal tensions present in the model.

In the *Mona Lisa* all these tensions have been resolved. Placed lower down, on the arm of the chair, the crossed hands are elegant, nonchalant and natural at the same time. This pose would often be copied by other artists, notably by Raphael who used it in his portrait of *Maddalena Doni* (fig 274) and later in *La Muta.* This success may have resulted from the fact that Leonardo was showing the hands, in painting, in the same position as young women in contemporary society were supposed to hold them. *Decor Puellarum,* the handbook of polite behavior written in Venice in 1461, stated that the "best position for the hands is one where they do not touch oneself,

each other, or any part of the body, except in the case of extreme necessity and with the greatest possible honesty; one must always hold oneself with the right hand placed on the left, in the middle of the body and in front [...]."[641] It was not common in contemporary Florentine portraits to show the hands just as they were, that is without holding an accessory with a particular meaning. Yet this is just what Leonardo has done: by excluding the presence of any symbolic attribute, he has, in an entirely original way, turned the hands into the moral attribute of the figure.[642] But this moral value no longer needs to be expressed anecdotally: it is expressed in Lisa del Giocondo's pose, whose attitude is a harmonious combination of morality and a "natural" bearing of the body.

This coded pose had an undeniable "civilized"[643] value, and it provided a solution to the "formal" problem of the hands, but Leonardo perhaps used it, perhaps, more because it contributed to the general effect of the portrait. The position of the hands in the *Mona Lisa* represents an important stage between the expression of the figure and its relation to the spectator. When the hands appear in the foreground of a portrait, their function is usually to emphasize this foreground, either by crossing it or by defining its boundary— often, by doing both at the same time. A well-known technique in Flemish portraits since Van Eyck, this approach became known in Italy at the end of the fifteenth century. Leonardo, however, used it in a different way, since he removed the traditional presence of this foreground. The emphasis on the hands therefore suggests a much greater closeness between the figure and the spectator, with the right hand projecting slightly beyond the plane of the arm of the chair, while their pose, resting on the arm of the chair, hints at a discreet barrier. Here the ancient gesture depicted in *Ginevra de' Benci* and *Isabella d'Este* expresses on its own, without an attribute or parapet, the boundary imposed on physical closeness by polite conventions. While encouraging a relationship with the spectator, Mona Lisa's relaxed hands also keep him discreetly at a distance. They condense in a single gesture the source of the uneasiness and ambivalence caused by the *Mona Lisa*, because at first glance she no longer seems likely to recognize "immediately" the social implications of a coded system of gestures.

Indeed, the entire painting is based on the dichotomy of moving closer and further apart, of attraction and backing away. It has already been pointed out how the inner frame of the loggia brings the figure forward, while drawing attention to the far distant landscape in the background. But there is more.

Although the figure stands out in relief against this background, the figure itself remains closely, laterally, anchored to it. Far from making the figure stand out against the background, the echoes and continuities between the figure and the landscape mentioned above, and the luminous unity of the painting as a whole, draw them closer together in the same misty atmosphere. This effect is emphasized by the height of the horizon—which Pater remarked on when he saw Mona Lisa as seated "among" the rocks. Unlike Raphael, who placed the (relatively regular) horizon considerably lower than the face in *The Lady with a Unicorn* (fig. 275), Leonardo raised this (very irregular and jagged) horizon to the level of the eyes of the figure. This raised horizon position is common in Leonardo's work, from the *Madonna with the Carnation* to the last version of the *Madonna and Child and Saint Anne,* and the *Adoration of the Magi*. But the effect of the figure as part of its natural environment is further emphasized here by the relation that Leonardo has created between the internal structure of the landscape and that of the face. It has often been pointed out that the apparent horizon of this landscape (not based on perspective) is higher on the right than on the left. Indeed, while the winding and curving in the lower part of the landscape echo the curly locks of the hair and the folds in the clothes of the figure, the smile slightly lifts from the mouth towards the eyes the part of the face that corresponds to the highest part of the horizon. As a result of this very slight, almost subliminal indication, the smile of the *Mona Lisa* also helps to conceal the difference of level of the background by somehow blurring it. Although standing out from the pictorial "field," Mona Lisa herself is at the same time structurally linked to it, within what should be called the "organism" of the picture—so much so that, as a variation on Walter Pater's metaphors, Kenneth Clark saw an "underwater goddess" in what is in fact the portrait of a lady sitting in a loggia overlooking a landscape.[644]

The reduction of distances in the upper part—creating in photographic terms the effect of a "telephoto lens"—gives rise to a dialectic of advance and retreat by the figure, which is confirmed in the lower part. Mona Lisa, as has been seen, advances well beyond the parapet of the loggia, beyond what the inner frame of the columns suggests as being the plane of the composition; but the arm of the chair (reinforced by the left arm of the model) restores the imaginary boundary that traditionally distinguishes the fictional depth of the painting and the actual space where the spectator stands. This impression has been achieved in a most effective manner. In contrast to Raphael's *Lady*

with a Unicorn, Leonardo has been careful not to define visually the spatial structure of the place where Mona Lisa is sitting. The distance separating the model and the wall of the parapet of the loggia is clearly visible in Raphael's portrait, but in Leonardo's this distance cannot be perceived because of the shady darkness of the area and the tight frame round the figure. As a result, Mona Lisa is both close and inaccessible; she is placed half-way, on the boundary defining and separating the spatial plane of the composition and the deeper space of the spectator—or, to use Leonardo's words, she gives form to the "being of nothing," the *essere del nulla* that is the surface of every opaque body and, even more so, that of a painted picture.[645]

This effect of a presence that is simultaneously close and distant, clear and uncertain, is completed by the famous "smile of the *Mona Lisa*." This was not an original Leonardo invention either. The smiling face was one of the specialties of Verrocchio's studio but, as Heinrich Wölfflin observed,[646] Leonardo toned down the open smile he had learned to depict in Verrocchio's workshop. By making it barely noticeable, he may have been following the same principle of elegant, polite restraint that inspired the position of the hands. This is how the handbook of good behavior, *Delle perfetta bellezza d'una donna*, written by Angelo Firenzuola in 1541, describes how a woman should smile: "Now and again close the right corner of the mouth, in a suave but lively movement, and open the left corner as if in a secret smile."[647] This description sounds surprisingly like the smile illuminating Mona Lisa's face, although it does not seem to recognize the difficulty of "performing" this simultaneous movement of the corners of the mouth in real life with gracefulness and *sprezzatura*. Firenzuola's handbook was published some time after the completion of the painting, and it is very possible that he might have been inspired by Leonardo's portrait in his description of the perfect smile, even without having seen the *Mona Lisa*; like Vasari, he could have known about it by reputation, or from seeing copies. After all, paintings too were supposed to provide courtiers with role models of behavior and elegance[648].

From Leonardo's point of view, this smile had a much deeper meaning. First, it had to express the model's temperament by its "immobile movement." In this respect, the *Mona Lisa* is very similar to *Cecilia Gallerani*, and above all, *Ginevra de' Benci* (fig 276). Indeed, Leonardo has painted three different temperaments in these portraits, but the difference was based less on the actual temperament of the model as Leonardo might have perceived it than on the request made by the person who had commissioned the painting—

whether it be the model herself, her lover or her husband. It is only by looking at these three portraits in this particular context that it is possible to interpret their expressions in a way that is not arbitrary. The liveliness of *Cecilia Gallerani* is that of the young mistress of the Prince of Milan, as she waits for her lover or is surprised by his arrival.[649] On the other hand, the portrait of *Ginevra de' Benci*'s is of a "sad" kind. This sadness is an important aspect of its originality because the "sad portrait" is undeniably rare. The idea of such a picture is unlikely to have been Leonardo's alone. The sadness of *Ginevra de' Benci* was probably part of the "program" of the painting, requested by the man who had commissioned it, Bernardo Bembo, the Venetian ambassador to Florence, and Ginevra's platonic lover. After Bembo's return to Venice, Ginevra de' Benci, one of the most prominent young women in Florence's sophisticated high society, left the city to live in the countryside in pious solitude.[650] But although her health was delicate and her pious nature a reality, her sadness in the painting was addressed to the man who had ordered the painting, Bernardo Bembo. The *Mona Lisa*'s smile, on the other hand, was the smile of a fulfilled mother, addressed to her husband; and furthermore, his name, del Giocondo, was reminiscent of *jucunditas*, jollity and pleasantness.[651] Some twenty-five years after having painted a "sad" portrait, Leonardo was probably more than happy to take up the offer of painting a portrait of the other kind, *jucundus* rather than *tristis*.[652] All three subjects are inviting the respective men who commissioned the portraits to share the feelings these ladies have towards them, which they are expressing before them.

These are the contextual, social and artistic facts behind the smile of the *Mona Lisa*. But although in 1478–80 Leonardo had responded brilliantly to Bernardo Bembo's request, he would never deliver the *Mona Lisa*. He took the portrait with him, unfinished, while his meditations slowly matured. When finished, the smile was still "suave and lively," to use Firenzuola's words, but Leonardo had also enriched its "secret"; it had acquired another meaning, less social, now intimately linked to the painter's most personal interests.

At the center of this interest, and as Firenzuola knew in recommending this kind of smile only "now and again," is the fact that any natural smile is transitory. By toning down the smile he had learnt to depict long ago in Verrocchio's studio, by making its movement less obvious, Leonardo reinforced its fleeting character. At the instant of transition between seriousness and laughing, the smile was, in Leonardo's terms, an image of the "movement of

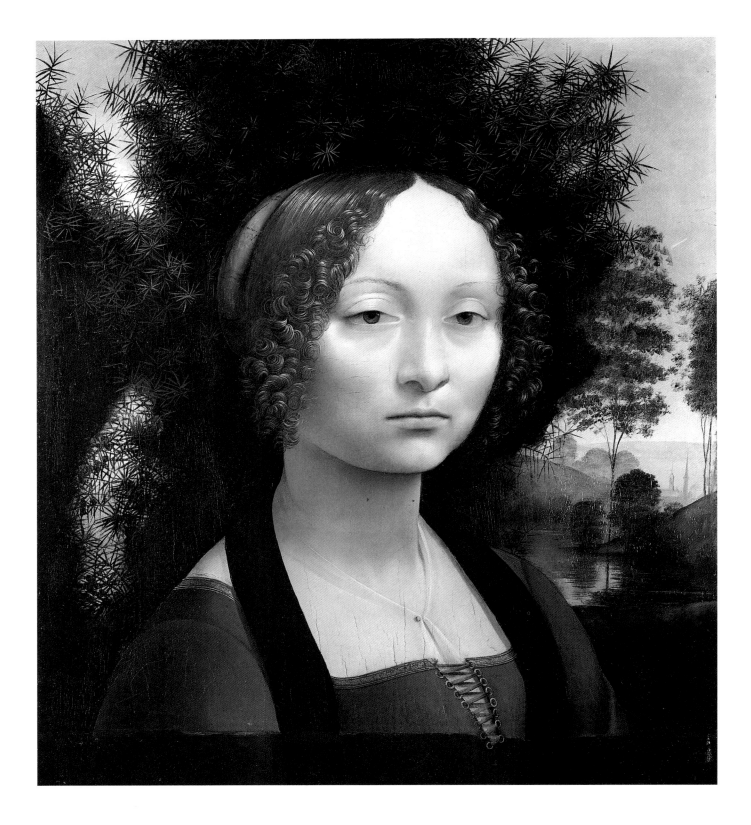

Fig. 276. *Portrait of Ginevra de' Benci*
c. 1474, oil on wood, 151/4 x 14½ in. (38.8 x 36.7 cm.)
Washington, National Gallery of Art, Ailsa Mellon Bruce Fund.

the instant" of time when, subtly and briefly, it gracefully metamorphoses the whole face—and not just the corners of the mouth as Angelo Firenzuola wrongly asserted. The *Mona Lisa*'s smile does more than establish a plastic link between the figure and the landscape that is its background; it expresses the metamorphosis of this immobile figure in time, the metamorphosis whose macrocosmic mode is represented in action by the landscape, in the action of that Time whose immemorial duration transforms every aspect of nature. From one to the other, from the landscape to the figure, another transition and another analogy is created: in the same way that the smile depicts the fleetingness of time on the face, similarly, what can be seen beyond the loggia, against which Mona Lisa stands out in relief, is infinite Time painted in the life of the earth.[653] From one to the other, from the landscape to the figure, there is a tension between the pleasing grace of the human body and the jagged rocks of the earth's body[654]—as if the landscape were a terrible yet fascinating macrocosmic anatomy of Mona Lisa's body. But also, in the transition from one to the other, the continuity of *chiaroscuro* and *sfumato* expresses in the "terrible movement" of their shadows, the fact that creatures and nature are both subject to the reign of Time: always moving, the shadow that "does not belong to things" is what reveals things.

In her portrait, Mona Lisa, the happy wife of Francesco del Giocondo, has progressively been metamorphosed into a female figure of beauty synthesizing Leonardo's deepest and most lasting interests. Distinguished by a feeling of continuous development, the *Mona Lisa* is inseparable from the Ovidian concept Leonardo had of Time, the destroyer of all things: like that of Helen, Mona Lisa's beauty is ephemeral and, following the concept discussed in the *paragone*, only the power of painting can give it a lasting quality superior to that granted by nature. The complexity of what is involved in this portrait makes its analysis literally endless, always leading the interpreter on towards other Leonardo-like associations of themes, researches and images. Based on the double movement of openness and reserve, coming forward and withdrawing, the impact of the painting both in the past and now stems fundamentally from the uncertain position in which it puts the spectator, this uncertainty making it irresistibly open to the projection of the spectator's own feelings.

The structure of the painting and the density of the associations of ideas that have gradually become established have made it a melting-pot for the many, often contradictory, expectations that the image endlessly fulfills. It

is probably no coincidence that, of all Leonardo's paintings, this is the one with the greatest intensity. Away from all iconography, away from the stress of commissions and programs, Leonardo has clearly "over-defined" the *Mona Lisa*, to satisfy himself and himself alone. The image bears the mark of the social conditions in which it was produced, but it also carries within it all its creator's past meditations, while also benefiting from Leonardo's work on the other two projects he was concentrating on during the "gestation" of the portrait: *Leda*, and the final version of the *Madonna and Child and Saint Anne*. Leda, Mary and Lisa, these three figures share a common quality: the capacity of a woman to bear children. But between the two mythical figures, Mona Lisa was the real wife of Francesco del Giocondo. Kenneth Clark was probably right when he thought that she had become the symbolic recipient of the fascination and revulsion Leonardo felt towards the process of procreation.[655]

In front of the panel on which *Mona Lisa* was gradually taking shape, Leonardo must have sometimes felt that he was in front of the "great cavern", "struck with amazement, in the presence of something unknown"—animated by this double feeling whose mark the portrait would bear forever and to which the prestige of the *Mona Lisa* would unwillingly bear witness: "fear and desire, fear of the dark, menacing grotto, and a desire to see if it did not enclose some extraordinary marvel."

Fig. 277. *Mona Lisa*.
Paris, Musée du Louvre. Detail.
(Whole picture p. 387)

THE EXPLODED COURT

I n spite of the many journeys following his departure from Milan in 1499, in the first fifteen years of the sixteenth century Leonardo experienced a period of great artistic production. Only seven works have survived: two in the form of preparatory "cartoons" (*Isabella d'Este*, and the London *Madonna and Child and Saint Anne* in London), two finished works from his own hand (*Mona Lisa* and *Saint John the Baptist*), two works produced in collaboration (the London *Madonna of the Rocks* and *Bacchus*), and one unfinished work from his own hand (the Louvre *Madonna and Child and Saint Anne*). But to this small number must be added the other works undertaken and sometimes completed by Leonardo, that are lost but known through a number of copies: the second "cartoon" for the *Madonna and Child and Saint Anne*, shown in Florence in 1501, the vast painting of *The Battle of Anghiari* for the Palazzo Vecchio in Florence that occupied him from the end of 1503 until 1508, the projects for *Leda* that led, in the same years, to the painted version, the portrait of *Monna Vanna* (or the "Naked Gioconda"), the *Head of Saint John the Baptist*, the *Angel of the Annunciation*, and the *Blessing of the Savior*.[656] Extending this list to include the two versions of the *Madonna with the Spindles*, the *Neptune* known in the form of a sketch but which perhaps reached the stage of "cartoon," as well the *Bacchus* owned by Anton Maria Pallavicino and the *Seduction of Proserpina* mentioned in the royal collections at Fontainebleau in 1642, a reassessment of Leonardo's activity is necessary. Far from losing interest in art in favor of science, Leonardo probably experienced his most fertile period after the age of fifty. During this time his work was also extremely varied in genre: as well as a large historical painting (*The Battle of Anghiari*), there were portraits (*Isabella d'Este, Mona Lisa, Monna Vanna*), mythological paintings (*Leda, Neptune, Bacchus*, the *Rape of Proserpine*), religious works of considerable size (the *Madonna of the Rocks, Madonna and Child and Saint Anne*), and smaller devotional panels (the *Madonna with the Spindles, Saint John the Baptist*, the *Angel of the Annunciation* and the *Blessing of the Savior*).[656]

The importance of Leonardo's work during this period is also reflected in the impact it had in Florence in the early years of the sixteenth century. Michelangelo responded immediately to the radically new composition of

Page 414: Fig. 278.
Study for The Battle of Anghiari, 1503–04, red chalk, 11 x 7¼ in. (27.7 x 18.6 cm.) Budapest, Szémüvészeti Muzeum.

416

the *Madonna and Child and Saint Anne*, painted in 1501, but he was also influenced by *Leda*, less obviously perhaps but with a longer lasting effect. Piero di Cosimo, Fra Bartolommeo and Andrea del Sarto were others who reacted to Leonardo's inventions, but it was in Raphael's work that Leonardo's influence was most obvious. The impact of the *Mona Lisa* on Raphael's Florentine portraits has already been mentioned, but it was the work produced or undertaken by Leonardo during this later period that played the most decisive part in Raphael's training; as Vasari observed, he studied Leonardo almost systematically between the ages of twenty and twenty-five in order to progress beyond the teaching he had had from Perugino.[657] For instance, having copied *Leda* as a drawing (fig. 286), he used and adapted the principle in *Original Sin* in the Stanza della Segnatura in 1508, and then, brilliantly, in the *Triumph of Galatea* in the Villa Farnesina in 1511. Similarly, he used the versions of the *Madonna and Child and Saint Anne* developed by Leonardo in Florence for his *Madonna of the Belvedere* (1506)—the Madonna's right leg is almost a quotation from the Virgin in the Louvre painting—while for the small *Madonna with the Lamb* (1507) he adapted the second project of the *Madonna and Child and Saint Anne*. In his series of Virgins with Jesus and Saint John the Baptist, concluding in 1511 with the Duke of Alba's *Madonna*, Raphael experimented with several variations on the kind of grouping whose invention has to be credited to Leonardo. As for *The Battle of Anghiari*, Raphael drew its central group in order to understand and clarify its structure more easily, and he also directly used a figure in the *Judgment of Solomon* in the Stanza della Segnatura that is known today from one of Leonardo's preparatory drawings for *The Battle*.

The great influence Leonardo had on Florentine artists in the early years of the sixteenth century can partly be explained by the fact that there were relatively few important painters in the city at the time. Of the masters of the last quarter of the fifteenth century, only Filippino Lippi and Sandro Botticelli were still active; however, the former died in 1504, and Botticelli, although he did not die until 1510, apparently did not paint much more after being accused on November 11, 1502 of sodomy with one of his assistants.[658] But the success of Leonardo's art was based on more important reasons: as Vasari rightly observed, Leonardo had completely changed the concepts and practice of Florentine painting. To the brilliant and paradoxical refinements of fifteenth century painting, he added the irresistible evidence of what Vasarian history would call the "*bella maniera*," that is, the style of the Renaissance at the peak of its

417

glory that suddenly made the elegance and even the subtleties of his predecessors and contemporaries obsolete and antiquated. This *bella maniera*, heralded in the 1480s with the *Adoration of the Magi* and progressively developed and perfected in Milan, was based on a new concept of unity in painting. No longer based on the sum of the parts that made up the painting, this unity was created by the movement running through the whole picture, thus creating a dynamic totality: the balance in the composition rested on the interaction of the figures, the contrast between the gestures expressing the organic cohesion of the groupings. As Meyer Schapiro said, "it was Leonardo who first developed the exemplary forms of such dynamically balanced compositions," the term "composition" here indicating "something imaginative and ideal, one of those fundamental structures or modes of grouping that characterize an era and become canonical, like an architectural order or a poetic form."[659]

The strength and coherence of Leonardo's invention, in other words his fully developed maturity, were evident in the effectiveness with which his personal research led to a wide range of solutions, which he worked out for each project in progress. The project of the *Madonna with the Spindles* inspired two very similar paintings, and the *Madonna and Child and Saint Anne* led to three different compositions; the studies for *Leda* resulted in two radically different solutions (with the figure kneeling or standing), the first of which had two alternatives; the general composition of *The Battle of Anghiari* allowed the distribution of a number of variations on the theme of a group of horsemen in battle; the *Saint John the Baptist* of the Louvre and the *Angel of the Annunciation* suggested two variations on the dynamic motif of the half-length figure of which the *Blessing of the Savior* is the iconographical pendent. At the center of this diversity and these many variations, there were typical configurations that were used more often than others—whether it was the structure of masses (the drawing of *Neptune* reworked and concentrated an idea that had been developed during the preparation for *The Battle of Anghiari*), or a particular pose: the child, lying down and pivoting on himself was the object of continuous research and, while returning to old ideas (the *Madonna and Child with a Cat*), Leonardo developed a variety of solutions, ranging from the first cartoon of *Madonna and Child and Saint Anne* to the *Madonna with the Spindles* and *Leda*.

What Leonardo offered Florence in the early years of the sixteenth century was a fullness of a style. Individually developed, and the fruit and expression of his most personal research, this style revealed the private unity of his

theoretical thought and his sentient intuition of the world. The spiral shape, whose importance has been seen in his morphological studies, determined the configuration of the body of Leda. Thus, well before Michelangelo, Leonardo invented what was to become one of the fundamental forms of classic elegance and "gracefulness" (before being transformed into "mannerist" paradoxes): the serpentine figure. Later in the sixteenth century, Gian Paolo Lomazzo believed that this contained "the very secret of painting" because it gave the figure "gracefulness" by allowing it to "show that it is capable of movement": since, according to Aristotle, fire was "the most active element of all and the shape of its flame the most capable of movement," the artist who wished to bring life into his figures and make them graceful must use the serpentine form that embodied the "living tortuosity of a moving serpent that is exactly the shape of the flame undulating," and the serpentine shape should not only be present in the figure as a whole but also "in each of its parts."[660] Lomazzo was here referring particularly to the sculptures in which Michelangelo developed the expressive possibilities of the internal torsions that were the result of the serpentine configuration. But Leonardo had already studied and exalted this "living tortuosity of a moving serpent," inseparable in his mind from the feeling of universal dynamism present in nature and his fascination with the spiral form; a true code of nature, inherent in all forms of life, found in water, and in the plant and animal realms. Mannerism would make the serpentine configuration one of the basic forms in its ornamental concept of beauty; but unlike the Mannerists, Leonardo used the serpentine form to bring life and movement to his figures, thus inventing the classic "gracefulness" of representation.

If Leonardo's style became a model for an entire generation of artists, it was because he was also a product of his own time and strongly affected by a fundamental subject of research that was a characteristic of the Renaissance as a whole: the expression and manifestation of movement. In 1567, in his *Primo libro del Trattato delle perfette proporzioni* ("First book of the Treatise on perfect proportions"), Vincenzo Danti stated that the body was, "from its origin to its end, mobile"[661]—and it has been seen how the *Codex Huygens* revealed what would have been Leonardo's Treatise on the *moto actionale*. But from 1435 onwards, Alberti's *De pictura* had linked the emotions that a painting could arouse directly to the representation of movement : the movements of the body must be "very well known by the painter" because it is "very difficult to make [them] vary [...] in accordance with the movements of

419

the soul, which are almost infinite"; similarly, like "the movements of the hair and of manes, branches, leaves and clothes," the seven directions in which a body could move had to be consciously observed and related to the age and the condition of the figures.[662] Broadly speaking, it would be correct to say that in his most personal research Leonardo achieved the classical perfection of the Albertian ideal of the moving figure—and his participation in this tradition field contributed to his overpowering prestige.

LEDA, 1504–08

The gestation of the *Leda* painting is a perfect example from this point of view. Leonardo worked on it from 1504 to 1508 (and possibly longer),[663] without having received any commission for it. It is therefore most likely that he was guided by personal reasons in his choice of a "mythological" subject: the love of Zeus, metamorphosed into a swan, for the daughter of the king of

Fig. 279 and 280. *Sketches for Leda*, details, *c.* 1504, pen and ink on black chalk, the whole 11¼ x 16 in. (28.7 x 40.5 cm.) Windsor Castle, Royal Library, RL 12337r.

Etolia (who bore two pairs of twins, each from a single egg: Pollux and Helen, and Castor and Clytemnestra). The theme of Leda was part of the "diffuse" artistic life of the late Quattrocento—so much so that the name of Leda had come to mean a woman of rare beauty.[664] Yet, apart from Filarete's relief on the bronze door of Saint Peter's in Rome, Leonardo was the first to make

Leda and the swan the central figures of an important composition. His interest in the theme clearly exceeded isolated or superficial curiosity.

The conditions in which the figure made its appearance in his work are also significant. The first sketches date from the same period as the studies for *The Battle of Anghiari*, a theme in striking contrast with that of Leda—although it will be remembered that Helen was the ultimate cause of the Trojan War, that Clytemnestra murdered Agamemnon, and that the Dioscuri, Castor and Pollux, were the heroes of many warlike exploits.[665] All the early sketches are themselves inseparable from the theme of the Virgin with the Child, in particular that of the *Madonna and Child and Saint Anne* on which Leonardo was still working. As Ann Allison observed, the motif of Leda in the sheet at Windsor (fig. 279) appears to have been superimposed on a larger drawing representing Mary and Jesus; alternatively, according to a more recent deciphering of this *componimento inculto*, Leonardo gradually transformed a kneeling Leda into a Virgin with the Child before adding Saint Anne, a little Saint John the Baptist and/or a lamb.[666] The results of this kind of deciphering are never absolutely certain, but this very first sketch indicates that at one time or another and in one way or another, while Leonardo was trying to find the right form through the rhythm of his own hand, he began to see a link between Leda and Mary, between the pagan love of Zeus for a mortal woman and the Christian Incarnation.

The first artist of the Renaissance to develop the theme of Leda in a serious manner, Leonardo treated it so originally that it was not used by artists other than his more or less direct imitators. Instead of describing the embrace of the swan and the woman (as Filarete had done and Michelangelo was to do), he represented the birth of the fruits of that embrace, without illustrating a particular moment in the love of Zeus and Leda. To Leonardo, Leda was never a narrative legend. On the contrary, the final version, of Leda standing (fig. 283), is, in the full sense of the word, an allegory whose meaning has been developed in a very personal way. It places Leda at the "crossroads" between the sexual attraction of physical love, and instinct, or maternal love.[667] Unlike Botticelli and his "modest Venus"—that he evokes selectively, however— Leonardo has completely bared the body of the woman, revealing it in all its beauty and power of carnal seduction. This physical context is confirmed by the flowers (supposedly aphrodisiac) that Leda is holding in her left hand and the movement of her arms, which hold and embrace the sinuous and unnaturally enlarged neck of the swan. This is not just a discreet reference to the

Fig. 281. _Leda and the Swan_, pen and ink on black chalk, 5 x 4¼ in. (12.5 x 11 cm.) Rotterdam, Museum Boymans-van Beuningen.

Fig. 282. _Leda and the Swan_, wash, pen and ink on black chalk, 6¼ x 5½ in. (16 x 13.9 cm.) Chatsworth, Devonshire Collection.

Page opposite: Fig. 283. _Leda and the Swan_ known as the _Spiridon Leda_, c. 1505, oil on wood, 52 x 30¾ in. (132 x 78 cm.) Florence, Uffizi.

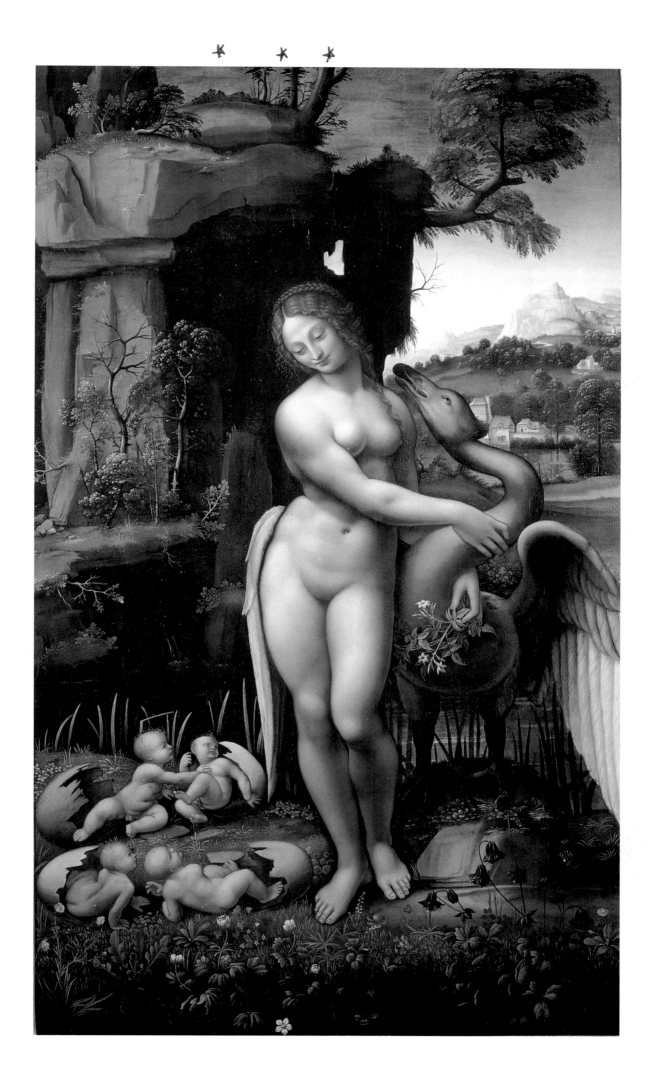

more intimate embrace of the lovers; Leonardo was here recalling the popular belief according to which swans copulated by intertwining their necks, completing the allusion by covering Leda's right hip and thigh with the wing of Zeus, majestic and soft. And yet, though her body is turned towards the swan, her eyes are looking at her new-born children who seem to represent the other choice that is now facing her. Maternal love, which drives her to feed and bring up her offspring, is a major component in the general equilibrium of the painting and its "message". The introduction of children is indeed an original iconographical invention by Leonardo within the Leda theme, an invention that inspired his very first composition of a Leda. At the center of the painting, Leda's supple serpentine pose reveals the "movement" of her "soul." But in doing so Leonardo was not trying to moralize the myth. Far from the Neoplatonist concepts of love that he had echoed in the 1490s, he associated the theme of "lust, the cause of the generation of life" to that of the mysterious fertility of the woman, her procreative power and her role in the endless continuation of life.[668] In a way, a little like the dialectical relationship that exists between Mona Lisa and the primordial landscape in which she is represented, Leonardo reveals in Leda a fascination similar to that which he was to express in 1509 in the "mythical" anatomical plate of the female internal organs (fig. 198).[669]

It is very significant that this theoretical elaboration of the mythological theme should develop progressively, at the same time as the complex, irresistible "formal" gestation of the motif. The starting point is to be found in the two "informal sketches" drawn in ink that show Leda half-kneeling, still closely linked to the theme of the Virgin (fig. 279 and 280). Some points deserve notice here. The swan is absent, and between the first and second sketch (from left to right), the position of Leda's hesitant head has turned away from what it was looking at on the ground on the left (possibly a child, part of the composition with Saint Anne, on which the drawing of Leda had been superimposed?), in order to look directly at the spectator. Also, to the right of these two framed sketches Leonardo has roughly drawn the outline of a silhouette for Leda that is much more erect. So, at the same time that the first idea began to slowly develop from the "underlying" arrangement of the Madonna and Child, or the Madonna, the Child and Saint Anne, the figure of the woman is becoming more upright while preserving the initial gesture of the right arm placed in front of the body. The idea of the kneeling figure led, probably in 1505, to two very beautiful, highly finished drawings, in which the swan and aquatic plants make their appearance. The differences

between the two drawings seem to indicate that the Rotterdam drawing (fig. 281) is earlier than the Chatsworth one (fig. 282). In the Rotterdam drawing, Leda is bending her head amorously towards that of her lover and, on the ground, an egg appears to have hatched; while in the Chatsworth drawing Leda is looking in the direction of the spectator—unless it is towards the two eggs hatched on the ground (the direction of the eyes is no longer readable) to which her right hand is pointing; the head of the swan is pointed towards

Fig. 284 and 285. *Leda standing*, Codex *Atlanticus*, fol. 156 rb. Milan, Biblioteca Ambrosiana.

Leda's head and she already has her left arm round his neck, while the right wing of the divine bird has begun to envelop the woman's right shoulder. Finally, confirming the unity of this general transformation, Leda's left leg shows that she is drawing herself up slightly as her head turns the other way.

However, between 1505 and 1507, Leonardo was still developing the motif of Leda standing. Three quick sketches exist, concentrating only on the pose of the woman (fig. 284 and 285), while folio D of *Manuscript B* in the Institut de France includes (below a drawing of imaginary weapons probably dating from 1487–90) the outline of the body, from the waist down to the feet, and an indication of the wing of Zeus wrapping itself round Leda's right hip. Together with studies of hair, these sketches are the only preparatory studies that have survived for the painting of *Leda* standing, known from the studio version in the former Spiridon collection. The other copy, in the Galleria Borghese in Rome, is also significant because of the difference in the position of the wing (often

425

repeated in copies) and for the pentimenti in the pose of the offspring revealed by X-ray photography.[671] This Roman version of the Leonardo *Leda* could be a contemporary of the Spiridon version: its main group was faithfully captured in a very beautiful drawing by a pupil (fig. 287) and it is this version that Raphael freely copied in about 1506 (fig. 286). While preserving one of the earlier *putto* poses revealed in the X-ray, he has made the neck of the swan "normal" and has drawn Leda looking towards the spectator, thus

Right: Fig. 286. Raphael after Leonardo, *Leda and the Swan*, pen and ink on metal-point sketch, 12¼ x 7½ in. (30.8 x 19.2 cm.) Windsor Castle, Royal Library, RL 12759.

Far right: Fig. 287. After Leonardo, *Leda standing*, 11 x 7 in. (28 x 17.5 cm.) Paris, Musée du Louvre, department of graphic arts.

adding a very Raphaelesque clarity to the subtle complexity of Leonardo's concept.

In the end Leonardo changed his original idea. Naturally, sources have been sought to explain such an important "formal" invention, and of course some have been found. So, the kneeling position might have been inspired by an "Anadyomene Venus" decorating a Roman sarcophagus that he may have seen on a hypothetical journey to Rome just after 1500; it is also reminiscent of a "Venus kneeling on a tortoise," now at the Prado and known at the beginning of the sixteenth century, as a number of drawings made during that period show. The pose of Leda standing is reminiscent of that of a Greek Ganymede, now in the Museo Nazionale in Naples, as well as being very similar to a Leda from antiquity, now in the museum of Cyrene. It has even been thought that the *putti* were inspired by the *putti* accompanying the statues of the river gods

of the Belvedere, discovered shortly before Leonardo's arrival in Rome in 1513 and in the restoration of which he could have participated.[672] However, apart from the difficult problems of chronology raised by this particular source, it is also rather unconvincing. The motif of the child stretched and twisting on himself had been present everywhere in Leonardo's art since the *Madonna and Child with a Cat,* and from 1500 onward, the various versions of *Madonna and Child and Saint Anne* brought the motif up-to-date, as shown in the so-called

Fig. 288.
Filippino Lippi, *Allegory of music* or *Erato*, 1503, tempera on wood, 24 x 20 in. (61 x 51 cm.) Berlin Dahlem, Gemäldegalerie.

"Weimar" page of sketches among others. Similarly, Leonardo did not need the inspiration of the "Anadyomene Venus" from antiquity for the pose of the half-kneeling Leda. As Gigetta Dalli Regoli remarked,[673] *Saint Jerome* in the Vatican had the same pose, and it was also anticipated in the kneeling of the Virgin (with the bare legs) mentioned above—which in addition included, from the end of the 1470s, the introduction of a Saint John the Baptist who would return again in the first idea for *Madonna and Child and Saint Anne.*

The relationship of the standing Leda and the *Allegory of music* or *Erato* (fig. 288) painted by Filippino Lippi in 1503 is more convincing.[674] But as has been shown, Leonardo's first "rough sketches" already included the idea of raising the kneeling figure and, above all, if he had been inspired by Filippino's muse, he considerably altered the composition by changing the position of the head. In Filippino's painting, the figure is animated by contrapposto as is Leonardo's,

but it is placed on the whole within the arc of a circle; with Leonardo the tilting of the head enriches the "formal" definition and replaces the simple two-part contrapposto with a three-part rhythm.[675] Leonardo has here invented the serpentine figure, whose gracefulness Raphael simplified—or just made "very graceful," to use Vasari's expression. Michelangelo on the other hand turned it in the direction of spiritual tension, as was shown in 1504 on the back of a preparatory drawing for *The Battle of Cascina*, where Michelangelo

Fig. 289. Michelangelo, *Sketch for a Leda*, c. 1504, lead-point and silver-point, 9½ x 8¼ in. (24.2 x 21.1 cm.) Florence, Uffizi, inv. 18737 F. Detail.

drew a Leda (fig. 289) who seems to have been abducted by the swan, prefiguring the violent rape of Ganymede. The perfection of a classical *bella maniera* in Leonardo's painting consisted in using the serpentine form to translate Leda's gentle hesitation, caught between two appeals and two amorous desires, both complementary and contradictory.

THE BATTLE OF ANGHIARI, 1503–06

While *Leda* represented the slow, gradual maturation of a personal work, *The Battle of Anghiari* was the brilliant response to the most important public commission that Leonardo had ever received. The political and artistic aspects at stake in this Florentine project were considerable: at the end of a year,

Leonardo found himself competing with the young Michelangelo in the most important room of the *Palazzo communale* (town hall). After a century, the authorities had resumed the policy of artistic competition that in 1401 had seen Brunelleschi and Ghiberti, among others, compete for the new doors of the Baptistery; a policy that made all Florentines both the judges and the spectators of the respective skills of their artists.

Commissioned in the autumn of 1503 and confirmed by a contract on May 4, 1504, the order for the painting placed with Leonardo occurred at a decisive moment in Florentine history. The city had succeeded in making peace with Cesare Borgia by being helpful to him, not least by granting him in 1502 the services of Leonardo in his capacity of military engineer; nevertheless Cesare's territorial ambitions were still a potential threat.[676] But in August 1503, the death of his father, Pope Alexander VI, shook the very foundation of his power. This led to a period during which the Florentine Republic appears to have enjoyed stability and prosperity under the leadership of Pier Soderni, a period that was to last some ten years. Soderni decided to complete the Republic's Sala del Gran Consiglio (built between 1495 and 1498) by commissioning a pictorial decoration which, like the Sala del Maggior Consiglio in the Ducal Palace in Venice, would celebrate the military glory of the city.[677] Clearly thought out, the political content of the decorative program was probably conceived by Soderini himself, advised by Machiavelli or more probably his first chancellor Marcello Virgilio di Adriani. The west wall, with four windows, was to have an altar in the middle, decorated with a painting representing Saint Anne, the Virgin and Child surrounded by the main patron saints of the city and others, harder to identify, "whose feasts," according to Vasari, "fell on the days of victories won by the city."[678] (Saint Anne was chosen because she was considered a particular protector of the city, the tyrant Gautier de Brienne having been expelled on her feast day in 1343.) Facing the altar, the gonfalonier was to be seated under a dais, carrying the statue of Christ the Redeemer (commissioned from Andrea Sansovino in 1502, but never made), whose feast, November 9, corresponded to the day when Piero de' Medici was expelled from Florence in 1494. On each side of the dais the walls were to be decorated with two large frescoes depicting the victories won by the Florentines against the Milanese at Anghiari in 1440 and against the Pisans at Cascina in 1364. There were two reasons these battles were chosen. The two victories had been won in territories that Florence had recently lost and regained again (Anghiari), or that she was about to reconquer (Cascina lay in the territory belonging to

Pisa that the Florentines had been trying to recover since 1494); and the battles took place on the banks of the two rivers, the Arno and the Tiber, on which the economic prosperity and political security of the Republic depended.

When in May 1504 the Seigneury officially confirmed their decision to commission *The Battle of Anghiari* from Leonardo and awarded him a monthly salary, he had already started working on the "cartoon" for which he had received an advance of twenty-five florins. He installed himself in the Sala del Papa in Santa Maria Novella to prepare this large cartoon, which he had to complete within one year. Although he could start painting before that date, he also had to produce a smaller panel on which to experiment with the technique he thought of using for the mural painting. According to several documents, Leonardo must have started painting in August or September 1504, and he worked regularly on the project until May 1506, the date on which he was authorized to spend some time at the court of Charles d'Amboise in Milan, having "made a small beginning on the large project he had been entrusted with," according to Pier Soderini in October 1506. Like *The Battle of Cascina, The Battle of Anghiari* was never completed. But unlike Michelangelo, who left Florence for Rome in 1505 without having done anything in the Sala del Gran Consiglio, Leonardo had at least started painting. Apart from the fact that he would never live in Florence for any length of time again, he decided not to complete the painting because of technical problems whose causes are unclear but which had led to a rapid deterioration of part of the painting that he had already done.[679] But between 1506 and 1563 (the date when Vasari began to work in the Sala del Gran Consiglio, making radical changes and covering the remains of Leonardo's painting) it had been possible to see "a group of horses and men (a part of the battle by Leonardo)" that was "something quite miraculous."[680]

The project was enormous since the surface to be covered was about fifty-six feet (seventeen meters) long and twenty-three feet (seven meters) high. In comparison, *The Last Supper* was "only" one-third of the size, measuring twenty-nine feet by fourteen and one-half feet (eight meters eighty centimeters by four meters forty). By 1506, Leonardo had painted the central group (known today from early copies) entitled *The Struggle for the Standard* (fig. 290, 291, 292), and probably a number of peripheral figures nearby, especially on the right. From the many preparatory drawings that have survived it has been possible to reconstruct with a reasonable degree of certainty the general composition of the battle as Leonardo had imagined it (fig. 296).[681]

The Struggle for the Standard occupied the central part of the composition.

Opposite page, top: Fig. 290. Laurentio Zacchia, *The Struggle for the Standard*, 1558, engraving, 14¾ x 18½ in. (37.4 x 47 cm.) Vienna, Albertina.

Bottom: Fig. 291. Peter-Paul Rubens after Leonardo, *The Struggle for the Standard*, c. 1600–08, black chalk, pen and ink, brown wash heightened with white and gray, 17¾ in. x 25 in. (45.2 x 63.7 cm.) Paris, Musée du Louvre, department of graphic arts.

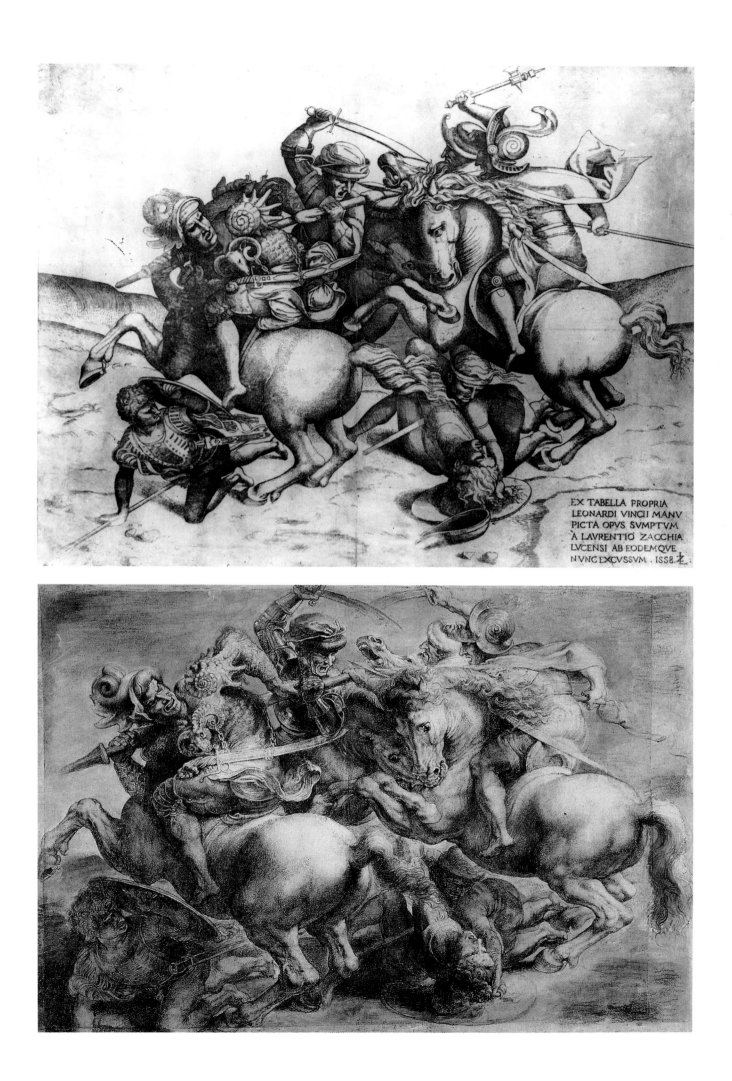

EX TABELLA PROPRIA
LEONARDI VINCII MANV
PICTA OPVS SVMPTVM
A LAVRENTIO ZACCHIA
LVCENSI AB EODEMQVE
NVNC EXCVSSVM . 1558 .

This choice is interesting, because the episode is not included in the story of the battle transcribed in the *Codex Atlanticus,* which gives a central role to the bridge over the Tiber, repeatedly taken and retaken by the soldiers. But this text, an Italian summary of the *Tropaeum Anglaricum,* a Latin poem written by the humanist Leonardo Dati in 1443, was not the only documentary source Leonardo had at his disposal. The story of the capture of two Milanese standards by Florentine horsemen can be found in the *Commentari,* written in the

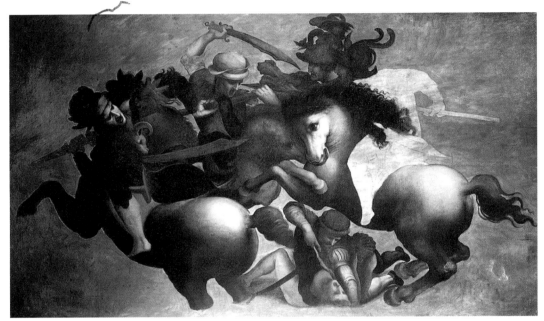

Fig. 292. After Leonardo, *The Struggle for the Standard,* also known as the *Tavola Doria,* copy or preparatory study on wood of the central episode of *The Battle of Anghiari,* 33¾ x 45¼ in. (86 x 115 cm.) Florence, Palazzo Vecchio.

vernacular by Neri di Gino Capponi, and since 1442 these standards had been kept at the Palazzo of the Priors in Florence in the *camera* of the Gonfalonier of Justice.[682] Leonardo had probably not been the only one involved in the choice of the subject. In a program of such political importance, it is likely that the authorities would have "indicated" the message that paintings were to convey. This hypothesis is even more likely in that, after the model of the Doge of Venice, Pier Soderini had been appointed "Gonfalonier for life" on November 1, 1502, the name of this ancient republican public office (meaning "standard-bearer") indicating the great symbolic value of civic imagery in Florence.[683] This political determination also explained the unusual choice of the central episode in the fresco planned by Michelangelo (fig. 293): this shows how, surprised by the enemy, the Florentine soldiers come out of the river where they were bathing to prepare for the battle to come. This episode enabled Michelangelo to glorify the

naked body in action, although this unexpected choice was no doubt made on Machiavelli's advice: it corresponded to his political message and to the creation, on his insistence, of a civic militia that could be rapidly mobilized.[684]

In spite of this overloaded political message, Leonardo's exceptional inventiveness and freedom led him to change the very concept of the battle painting—and to develop a type of composition which, from Giulio Romano to Rubens and beyond, would become the model for the modern battle painting.

Fig. 293. Aristotile da Sangallo (after Michelangelo), *The Battle de Cascina*, grisaille, 31 x 50¾ in. (78.7 x 129 cm.) Norfolk, Viscount Coke and the Trustees of the Holkham House.

As in *The Last Supper*, Leonardo turned his back on the current central Italian tradition. From Paolo Uccello (fig. 294) through Piero della Francesca (fig. 295) to the panels of *cassoni*, this tradition had conceived the representation of a battle in the form of a frieze composition depicting the two sides opposed to each other. Leonardo gave the imaginary depth of the battlefield a dramatic function: that is where he placed the bridge that was the center point of the battle. Though he turned the battle itself, in the foreground of the composition, into a furious and uncertain mêlée, he represented the story of the event with great clarity. His painted representation was therefore very different in spirit from the long text describing "the manner of depicting a battle," which juxtaposed isolated incidents, thus conveying the idea of mêlée as vast as it was incomprehensible.[685] Leonardo appears to have used only two elements from the text in his representation: the group of the two foot soldiers

433

beneath the horsemen in *The Struggle for the Standard* for which a preparatory drawing exists (fig. 299), and on the right, the standing figure with his back turned to the left who appears to be the "captain" calling the troops for assistance, described in the text and for which one of the Windsor drawings was probably a preparatory sketch.[686] This clarification of the text through the painting and the choice of elements to be represented were certainly made at the request of the patron, Pier Soderini, who would have insisted on narrative clarity in the decoration of a room of such political importance. But the principle itself of the painted *historia* and the constraints imposed by the dimensions of the pictorial field also involved the "composition" of what the text might have represented as the sum of a juxtaposed elements. The general composition of *The Battle of Anghiari* is in the Alberti tradition, in which the painter's first task was the create a "quadrilateral" "from which one could contemplate *historia*," the latter demanding a clear arrangement of its parts (or "composition") in order to appear to be "performing an action" and not to look "agitated and in disarray."[687] Yet—and this is where his intellectual strength showed itself—although the pictorial field had to be arranged clearly, Leonardo also wanted to express the confusion and uncertainty that are typical of fighting as it develops on the field of battle. This double apprehension places *The Battle of Anghiari* in the pictorial tradition of Paolo Uccello and Piero della Francesca and then carries it a step further.

In the three episodes of *The Battle of San Romano,* Uccello had proposed a clearly intelligible representation of the sequence of events. The first panel (fig. 294) depicts the beginning of the battle with, from left to right, the Florentine spears, Niccolò da Tolentino's gesture of command in the center and on the right the first clashes. The second panel shows the arrival of reinforcements with their commander Michele da Cotignola in the center, and on the left the famous "chronophotographic" figure, decomposing the movement of the horseman lowering his spear. The third panel, itself the center of the whole arrangement, represents the event which was to decide the victory: the fall of the captain of the Sienese troops, Bernardino della Ciarda, thrown from his horse by a spear—the latter changing color conclusively at the instant of the impact which had made history.[688]

In contrast to this concept of *historia* in which the painting must depict history in a clear and intelligible way, the two battles painted by Piero della Francesca in the church of San Francesco in Arezzo show how history only has an immediately understood meaning if Providence intervenes in the shape

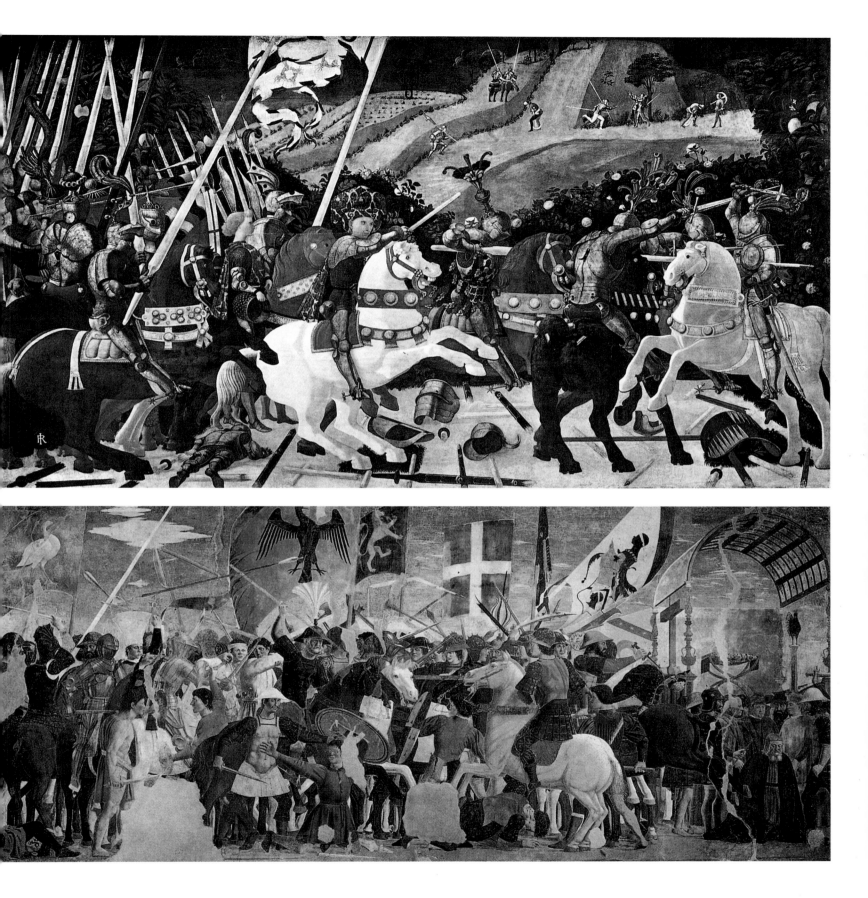

Top: Fig. 294. Paolo Uccello, *The Battle of San Romano*,
c. 1435–36, tempera on wood, 6 ft. x 10 ft. 6 in. (181 x 320 cm.), London, National Gallery.

Above: Fig. 295. Piero della Francesca, *The Battle of Heraclius against Chosroès*,
fresco, 11 ft. 9½ in. x 24 ft 6 in. (329 x 747 cm.), Arezzo, San Francesco.

of a miracle. In *The Victory of Constantine over Maxentius*, the outcome of the encounter is left in no doubt, the central space showing perfectly clearly that *historia* is "performing an action" here; and yet, the fresco does not depict a real battle, the gesture of the "sign of the cross" being "miraculously" sufficient to make the troops of Maxentius flee in terror. In contrast, in *The Battle of Heraclius against Chosroès* (fig. 295), Providence does not make an appearance and the mêlée remains confused, unintelligible, full of sound and fury; here *historia* depicts the tumultuous blindness that characterizes human history when God does not intervene.[689]

Putting aside the contrast between the historical and providential intelligibility of history, in *The Battle of Anghiari* Leonardo succeeded in presenting simultaneously the unfolding of the battle as a whole and the unintelligibility of individual actions. The whole battlefield is clearly organized in three groups: the call for Florentine reinforcements on the right, the retreat of the Milanese wounded on the left and, in the center, the symbolic episode of the battle for the standard. But, although he continued to place the crucial, history-making in the center, Leonardo makes the interpretation of the *historia* hard to understand. Far from being based on the clear confrontation of four figures—according to the traditional arrangement used in the background in the *Adoration of the Magi* and in the first sketches for *The Battle of Anghiari*—the group depicts the flight of a standard-bearer pursued by two enemies,

Fig. 296. Carlo Pedretti, overall diagram of *The Battle of Anghiari*.

while a fourth rider comes to his aid from the opposite direction, his sword raised to make the pursuers give up. The face-to-face confrontation of the clearly opposed enemies is now replaced by a violent lateral movement that moves the figures from right to left.[690] The general direction of the battle, from right to left, also suggests that the pursuers are Florentines, and the

standard-bearer and his ally Milanese. But Leonardo took care not to indicate this too clearly: the standard is not visible and, while the ram's head on the chest of the standard-bearer might be reference to the arms of the Milanese captain, Niccolò Piccinino, the clue is vague enough for the experts to disagree, even today.[691]

Freed from any particular episode, the central group of *The Battle of Anghiari* expresses and sums up what might be called a symbolic representation of the battle. In doing so it will certainly have pleased the Gonfalonier of the Republic, Pier Soderini. But it does more than that. By dressing the soldiers in unrealistic outfits (which are more reminiscent of theatrical costumes or the parade uniforms in which he was a great expert than battlefield armor), Leonardo "presents his representation" as such—thus giving it a universal dimension. The expressions of the soldiers were carefully studied, as the Budapest drawings show (fig. 278 and 297), and they reflect this universal quality. Although their faces are very individual and could have been inspired by real models, they do not look like portraits (even imaginary ones) of the historic protagonists of the battle: for example, Niccolò Piccinino or Guido da Faenza for the Milanese, and Niccolò di Pisa or Napoleone Orsini for the Florentines. Nonetheless, they are of very different types. This rather than the action itself, which is too confused, helps the two camps facing each other on the battlefield to be identified: the Florentines on the right and the Milanese on the left.[692] Leonardo's anatomical knowledge also enabled him to draw their expressions with rare precision and convincing persuasiveness; by fully exploiting the image's capacity for *illustratio* and its *enargeia*,[693] he has revealed the fury of war, expressed in the movement of the battle and shared by both man and animal (in accordance with the principle of analogy that is at the heart of his intuition and his scientific conception of the world).

This joint search for condensation and universalization is reflected in the series of preparatory studies that still survive.[694] Insofar as the incomplete documentation available allows, we believe that sheet 215A in the Venice Accademia was one of the first ideas for the composition (fig. 298). At the top, Leonardo has again used the image of the two horsemen about to finish off a third who has fallen to the ground that appears on an earlier sheet now at the British Museum (fig. 301), while making it more complex. In the bottom part he has used the same arrangement but added to it, creating two distinct groups in which horsemen and foot soldiers mingle in the mêlée. A few quick lines depict the arrows, the smoke and the dust described at length in the text

on how to represent a battle. A subsequent stage was jotted down on the recto of the Accademia sheet 215 where Leonardo made separate studies of foot soldiers and horsemen fighting. It is hard to know where the foot soldiers would have been positioned—the idea was abandoned somewhere along the way, or replaced by the soldiers crossing the river on foot. In contrast, the group of horsemen shows that Leonardo was trying to get away from the traditional confrontation typical of images of equestrian combat: the group of figures is directed to the left while the motif of the two foot soldiers struggling on the ground appears at the right. In a way that perfectly illustrates the Leonardo "method," this sketch was used again and further developed, finally becoming the group of Neptune (fig. 184).

Sheet 216 from the Accademia (fig. 218) is an important step forward in the overall representation of the composition. It includes the group of horsemen, which Leonardo has made more compact; he is getting closer and closer to the definitive solution. On the right, the bridge and the silhouette of the "captain" calling for reinforcements indicate that the group of horsemen will be in the center of the composition. In its final development, which has been lost, the composition became even tighter. Leonardo dispensed with the standing foot soldiers and replaced them with their fight on the ground—itself reworked separately (fig. 299)—thus emphasizing the unitary and organic cohesion, by making it more compact and dynamic. Finally, Leonardo simplified what he had made complex and, using the example of the continuous development of his own drawing as a source of inspiration and as a "formal" matrix, he succeeded in creating a configuration that contained all his intermediate versions, matured and active in the final work. The studies of details reveal very precisely the expressive potential perceived first in its mass and created within the global rhythm of the form.

Relatively few studies of the side groups of *The Battle of Anghiari* have been preserved. For the right, there are the Windsor "cavalcade" (fig. 300) and the profile of the "captain" with the bridge (fig. 218); for the left, the soldier seen from behind protecting the retreat of the wounded and, probably, the horse galloping from left to right, drawn in ink on the British Museum sheet (fig. 301) and redone in red chalk on a Windsor drawing (fig 302). Nothing indicates that Leonardo worked less on these parts, but it is a fact that when he left Florence for Milan, he had only painted the central group with probably a few of the figures on the right—and it was this group which until the 1560s would continue to "amaze" spectators already accustomed to

Page 440–41, Fig. 298. *Study for The Battle of Anghiari*, 1503–04. Venice, Galleria dell' Accademia, inv. 215 A.

Page 441, top: Fig. 299. *Study for The Battle of Anghiari: Soldiers fighting on the ground*, 1503–04, pen and ink, 3½ x 6 in. (8.7 x 15.2 cm.) Venice, Galleria dell'Accademia, inv. 214.

Center: Fig. 300. *Study for The Battle of Anghiari*, 1503–04, black chalk, lightly spotted with black, 6¼ x 7¾ in. (16 x 19.7 cm.) Windsor Castle, Royal Library, RL 12339.

Bottom: Fig. 301. *Study for The Battle of Anghiari*, 1503–04, pen and brown ink, 3¼ x 4¾ in. (8.3 x 12 cm.) London, The British Museum, inv. 1854-5-13-17.

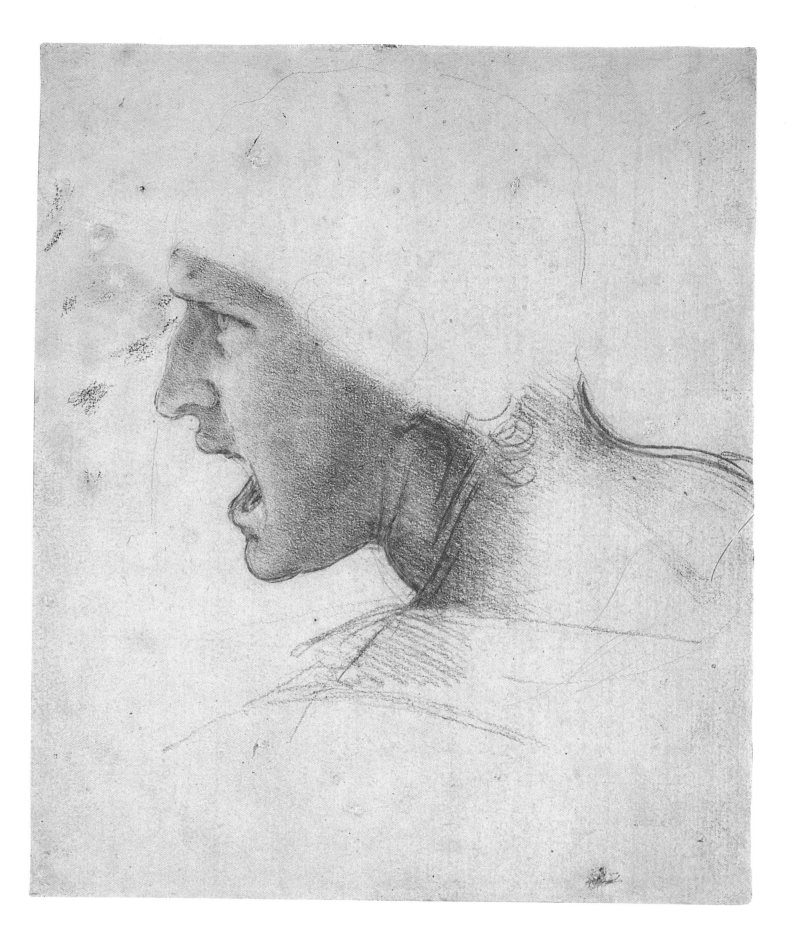

Fig. 297. *Study for The Battle of Anghiari*, 1503–04,
red chalk, 9 x 7¼ in. (22.7 x 18.6 cm.)
Budapest, Szépmüvèszeti Muzeum.

439

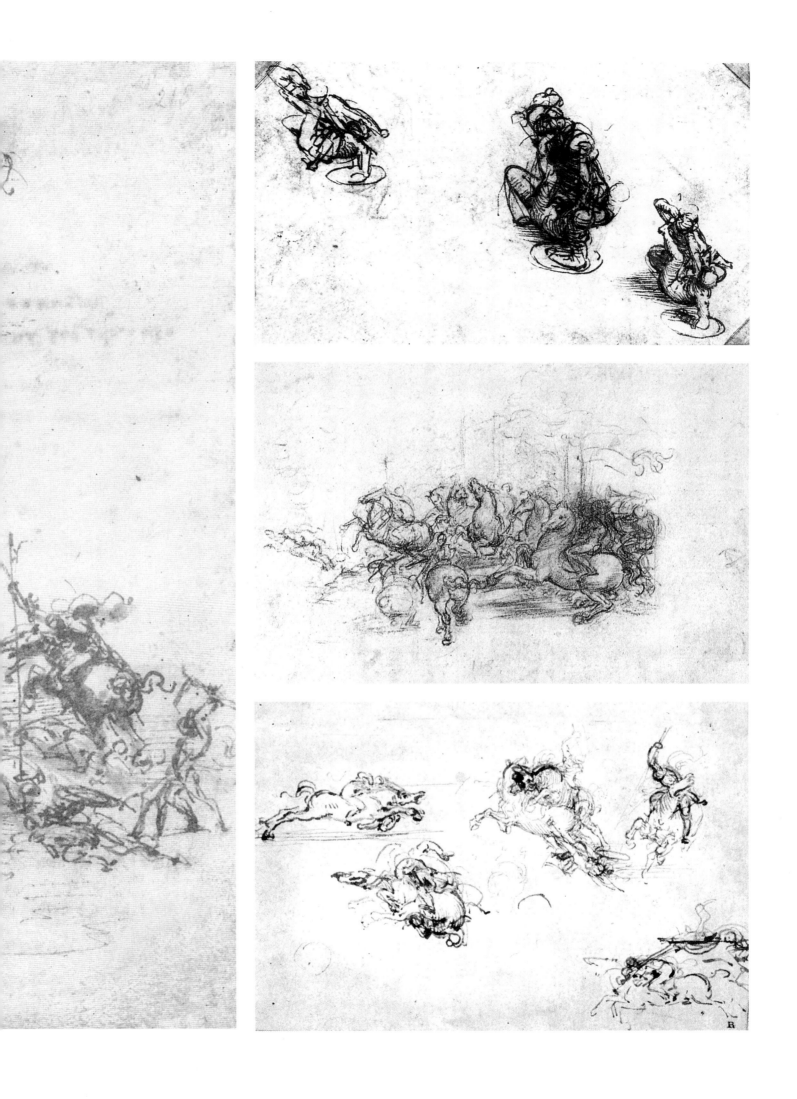

the magnificence of battle paintings. For Leonardo too, *The Struggle for the Standard* summed up, in the center of the painting, the image of the fury of war as he imagined it: a confusion of men and horses rushing through the pictorial space, themselves being traversed by a force whose greatness exceeded their own strength.[695] This group expressed in a "monumental" but still intelligible way the sensation of this force that, before taking on the cosmic shape of the Deluges, would lead in about 1511 to the enigmatic drawing of a

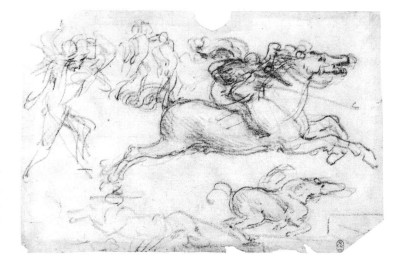

Fig. 302. *Study for The Battle of Anghiari,* 1503–04, red chalk, 6½ x 9½ in. (16.8 x 24 cm.) Windsor Castle, Royal Library, RL 12340.

Lilliputian human mêlée (fig. 303). Full of reminiscences of the unfinished work in Florence, crushed beneath a "celestial" battle of comparatively gigantic scale, this may have been inspired by an ancient sarcophagus representing the fall of Phaethon.[696] Soon after, Leonardo drew a hurricane carrying away men, women and horses in a terrible confusion under an enormous storm cloud inhabited by the god of the wind (fig. 304). The commissioning of the political painting of *The Battle of Anghiari* for the Sala del Maggiore Consiglio in Florence gave Leonardo the opportunity to express the role of this inhuman force in the history of men. This was concentrated in *The Struggle for the Standard*, of which the Doria version is probably the closest to the original that was painted over by Vasari.[697] Rubens understood this: in the copy he made from an engraving of the vanished painting (fig. 291), he added a sword, which was enough to transform into fleeting harmony the instant in which the irresistible impulse of the world in chaos had, for Leonardo, assumed the rhythm of a form in motion.

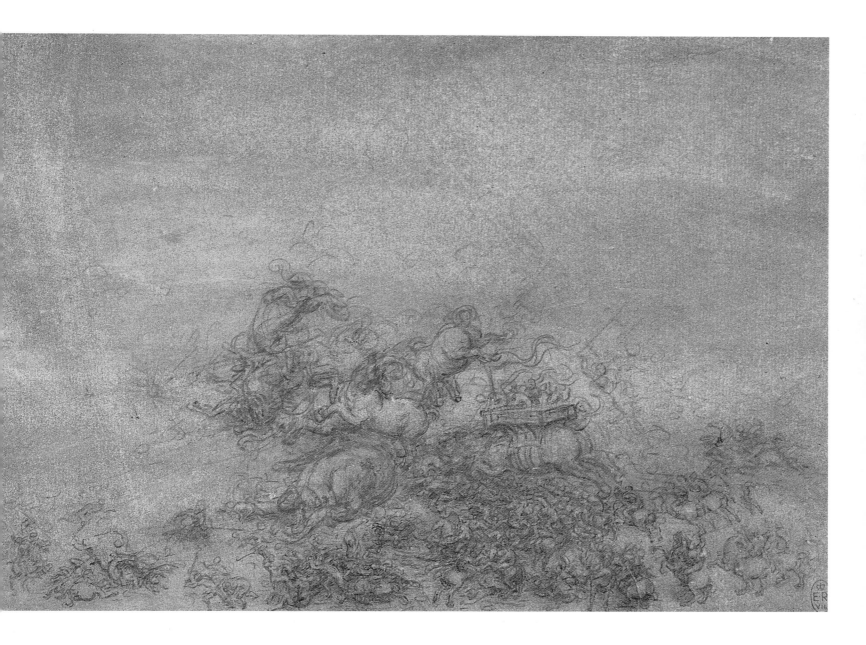

Fig. 303. *Battle, c.* 1511,
red chalk and black chalk on red prepared surface, 5¾ x 8¼ in. (14.8 x 20.7 cm.)
Windsor Castle, Royal Library, RL 12332

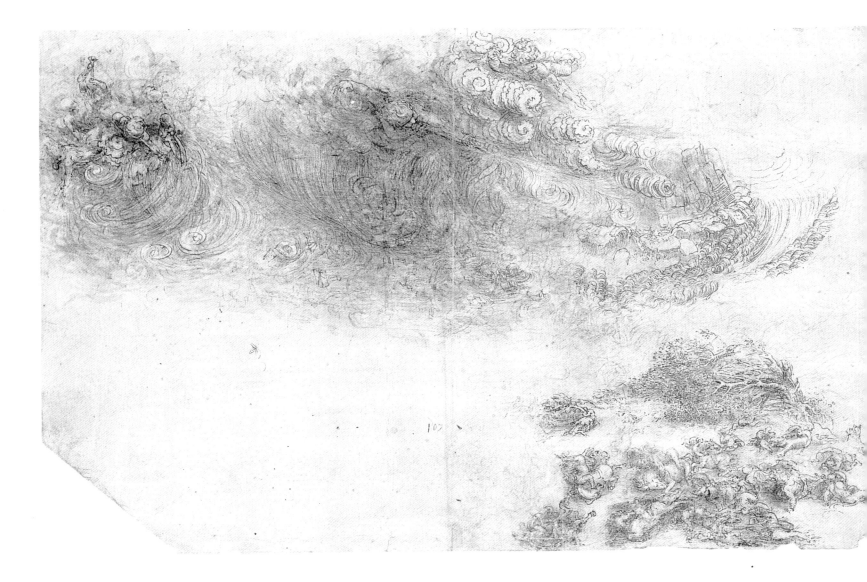

Fig. 304. *Storm*, black and white chalk heightened with ink,
on gray prepared surface, 10½ x 16 in. (27 x 40.8 cm.)
Windsor Castle, Royal Library, RL 12376.

MADONNA AND CHILD AND SAINT ANNE, 1499–1513

This same research into "form in motion" underlies Leonardo's work on the group of the *Madonna and Child and Saint Anne*, at least between 1499 and 1510. The "dossier" on this project is probably the most complex of all of those that survive. As well as several preparatory drawing, quite difficult to interpret, there are three different versions of the group known whose chronology is uncertain—and Vasari described a fourth one, which has been lost. However, the situation requires clarification because, between 1499 and 1510, Leonardo invented and changed configurations straight on the sheet. The result of this long period of gestation, the Louvre painting, is incomprehensible, unless one recalls the various hypotheses Leonardo had imagined during the preparatory stages.

It has sometimes been thought that the first project of this painting was made for the Servites of the Santissima Annunziata shortly after Leonardo's return to Florence. According to Vasari, at his own request Leonardo took over from Filippino Lippi the task of creating a painting to decorate the main altar. It was for this reason that Leonardo stayed as a guest with them. After holding them "in suspense without starting anything for a very long time," he "finally" produced a cartoon with the Virgin, Saint Anne and Christ. Exhibited for two days, it is said to have aroused the admiration of all, not only of artists but of "men and women, young and old" who "went there as they would on important feast days, to admire the wonders of Leonardo's work, the object of popular veneration."[698] Although Vasari's description of the cartoon does not correspond to any of Leonardo's known projects, in that it mentions a "little Saint John who is playing with a lamb," his story is not completely implausible.[699] But even so it would not mean that this version was necessarily the first of the series, because it was a Deposition that the Servites had commissioned from Filippino Lippi, and it was a Deposition that was finally painted by Perugino to decorate their main altar. It is hard to imagine that the Servites would have accepted such a radical change of subject without saying anything. It is now thought that the work was commissioned from Leonardo by the King of France Louis XII, in Milan itself, between October 5 and November 7, 1499. The cult of Saint Anne had grown very widespread in Europe, and Louis XII had an excellent personal reason for commissioning a painting representing Saint Anne. Having divorced Louis XI's daughter because of her infertility, he had married Anne de Bretagne (Anne of Brittany) in January

1499, and she gave birth to a daughter, Claude, on October 15, 1499. Not only was Saint Anne traditionally the patron saint of young married women, as well as infertile and pregnant women, but her cult and that of Saint John the Baptist had become widely established in Brittany.[700]

In his letter of April 14, 1501 to Isabella d'Este, Fra Pietro de Novellara mentioned that Leonardo had to finish something for the King of France before being able to work for Isabella.[701] If, as Vasari said, Leonardo "finally" produced a cartoon of the *Madonna and Child and Saint Anne* when he was with the Servites, it may not necessarily have been connected with the main altar of the Santissima Annunziata. In addition, it is possible that the people who for two days filed past the work that had not yet been painted may have done so for other reasons than purely artistic ones. After all, Saint Anne was also a special patron saint of Florence, protecting the city against her enemies and, before the inglorious bargaining of May 1501, the city was being seriously threatened by Cesare Borgia. If the Florentines came in droves to pay homage to Leonardo's work, it was probably more to ask their protector's intercession than to admire the artist's *bella maniera*.[702] Originally conceived as an ex-voto to thank Saint Anne for the royal birth, Leonardo's cartoon acquired a completely different meaning in the political and military context of the Florentine republic.

In attempting to follow and reconstruct the development of Leonardo's invention, these details are far from unimportant, because they reveal what probably happened in the seventeen months that elapsed between the time when Louis XII commissioned the work from Leonardo and the exhibition of the cartoon in Florence in 1501. As Fra Pietro da Novellara mentions, this cartoon included a lamb with which Jesus was playing, but it was not necessarily Leonardo's first project in response to Louis XII's request. This point is significant. Although there is no doubt that the Louvre painting (fig. 315) of the years 1510–13 was the culmination of a long process of transformation , there is no such certainty regarding the date of the London cartoon (fig. 305). Long thought to date from 1499–1500 (for no other reasons than stylistic ones), it has also been suggested that it was produced in about 1508–10 (this new date also being based on stylistic reasons). If Leonardo's reflection on the theme had started in Florence, it would no doubt have been assumed that the cartoon described by Fra Pietro Novellara was the first version, that Leonardo later changed it dramatically by replacing the lamb with Saint John the Baptist, and that finally he went back to his original idea. But on the other hand, since

Fig. 305. *Madonna and Child and Saint Anne with John the Baptist*, charcoal, touches of white on paper, 55¾ x 41¼ in. (141.5 x 104.6 cm.) London, National Gallery.

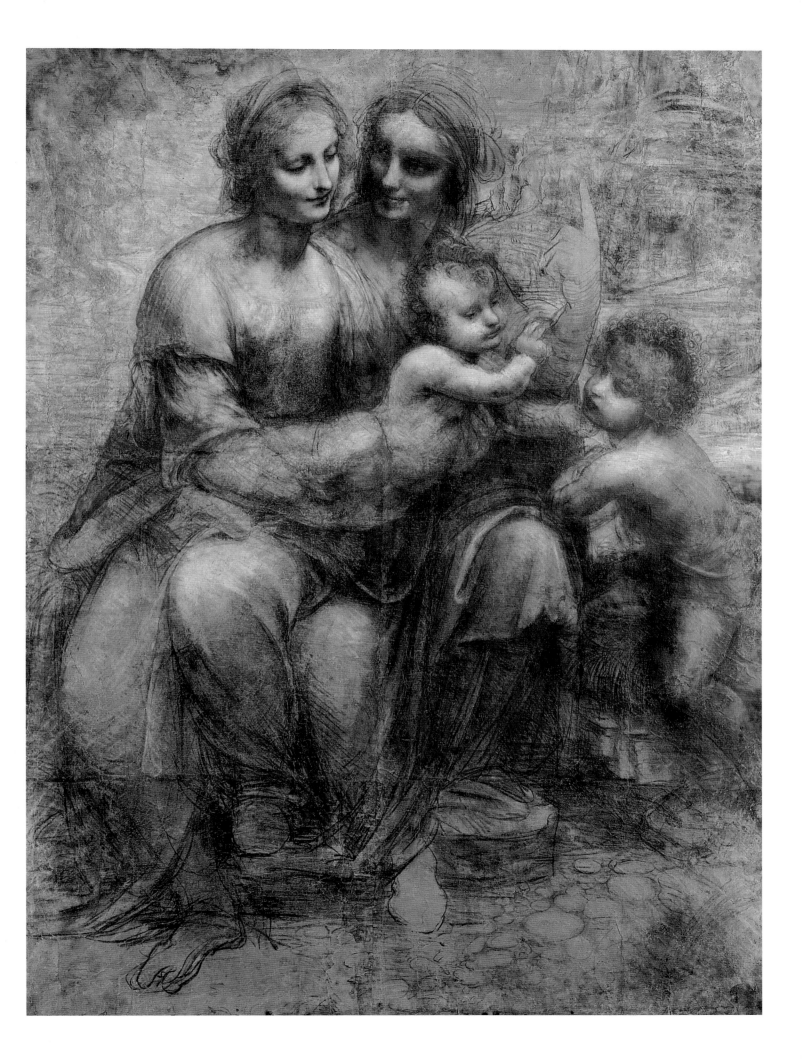

the work was commissioned in Milan, it is possible to suppose that the London cartoon was Leonardo's first idea, started in 1500, that in 1501 he replaced Saint John the Baptist with the lamb, and that finally he thoroughly reworked this second version in the Louvre painting[703].

A certain number of facts seem to support this hypothesis. Without insisting that the London cartoon aroused echoes in the Florence of 1501–02,[704] the internal, morphological logic of the process of "formal" invention seems more

Fig. 306. Brescianino, *Madonna and Child and Saint Anne,* (copy after the Leonardo cartoon, 1501). Formerly in Berlin, destroyed during the war.

coherent if the London cartoon is the starting point. Indeed, from 1499–1500 to 1510–13, as a result of the particular changes introduced by Leonardo, the same dynamic element expresses his power of organization more and more clearly: this is Jesus's movement and the complex, intertwined reactions this movement causes in the two other figures. While he did not invent the grouping of Saint Anne with the Virgin and Child, Leonardo upset tradition by adding a fourth figure whose presence leads to Jesus's action, which in turn influences the composition of the group as a whole.

In the Quattrocento there were two different ways in which the three figures were arranged. In the first and older configuration, the Virgin is seated on the knees of Saint Anne; their heads are next to each other (Saint Anne's

being slightly higher), and Jesus is either between the two women, or at Mary's side in her arms. Among those who adopted this arrangement were the Sienese Luca di Tommé in 1367 and Benozzo Gozzoli in 1470 for the panel in the Pisa museum (fig. 307). The second type is said to have been invented in Florence by Masolino and Masaccio in about 1425 (fig. 308); it "normalizes" the image slightly by having the Virgin seated lower than Saint Anne. The two figures can therefore be the same size, creating a majestic, hieratic verticality which

Far left: Fig. 307. Benozzo Gozzoli, *Tabernacle with Saint Anne, the Virgin and Child and three donors at their feet*, oil on wood, 56¼ x 35½ in. (143 x 90 cm.) Pisa, Museo Nazionale e Civico di San Matteo.

Left: Fig. 308. Masolino and Masaccio, *Saint Anne, the Virgin and Child*, c. 1447, tempera on wood, 69 x 40½ in. (175 x 103 cm.) Florence, Uffizi.

reflects the aspect of worship of the picture. This was the type adopted by Perugino in about 1500–02; Fra Bartolommeo also chose it for the altar picture of the Sala del Gran Consiglio of the *palazzo communale* in Florence.

The London cartoon (fig. 305) unquestionably belongs to the first type: Mary is sitting on the right thigh of Saint Anne and their heads are close together on the same level. while the Child is "between" the two. But as shown in the British Museum drawing (fig. 201), Leonardo has reworked the first type to such a degree that it is no longer recognizable. By introducing the figure of Saint John the Baptist (perhaps at the request of Louis XII), Leonardo was again using a motif and pose which he had developed in about 1478 on the Windsor sheet mentioned earlier (fig. 220). This time, however, the introduction of the figure has

led to a transverse turning movement in the figure of Jesus—which in turn uses a pose developed in the preparatory studies for the *Madonna with a Cat*, one which was used again in the *Adoration of the Magi* and the *Madonna with the Spindles*, with slight variations relating to the element to which Jesus is reacting. What characterizes the process of development illustrated on the British Museum sheet is the progressive amplification of the movement of the Child, his greater closeness to Saint John the Baptist, and the fact that, in the final stage of the invention (the cartoon), the left hand and pointing index finger of Saint Anne maintain a distance, creating a barrier or moment of suspense in the movement of the two children towards each other.[705] Throughout the series of drawings culminating in the "finished" work, the configuration changed at every stage, and it was this constant reworking that finally created the spiritual and theological "content" of the work. Irrevocably associated with her gaze towards Mary, Saint Anne's gesture pointing towards the sky is sufficient to indicate the special meaning in the children's play—although Mary is only giving it the loving attention of a happy mother. What is being played out between these two children is nothing less than the divinity of the Messiah Incarnate, known to Saint John, the last of the prophets.

With the introduction of Saint John the Baptist and the reactions this brings about, Leonardo has radically re-arranged and expanded the theme of the *Humanissima Trinitas* formed by the three figures of Saint Anne, Mary and Jesus.[706] However, if he completely reworked this version in about 1501, it was because it was not wholly successful in at least two respects. The two female figures are not clearly arranged—how does the Virgin rest on Saint Anne's right leg, and how are they distinguished from each other in depth? Secondly, in spite of her role in the symbolic dimension of the image, Saint Anne occupies a very secondary position, plastically speaking. The 1501 cartoon produced in Florence (fig. 306) corrects these mistakes in the arrangement and, while, replacing Saint John the Baptist with the lamb, Leonardo has emphasized the figure of Saint Anne by resorting to a vertical arrangement, inspired by the second type of configuration for the group.

This transformation did not take place all at once. The preparatory drawings that have survived (fig. 309, 310, 311) suggest that Leonardo started by correcting the Virgin's pose which was uncertain or unstable: she now sits transversely on her mother's lap instead of perching on her mother's right thigh. By doing this Leonardo achieved a more complex intertwining of the figures: previously the two bodies were simply juxtaposed, but now Mary's

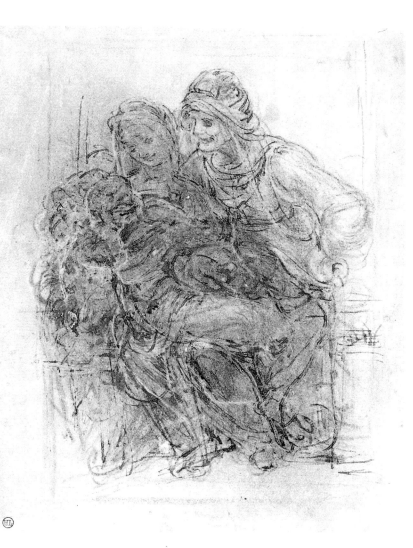

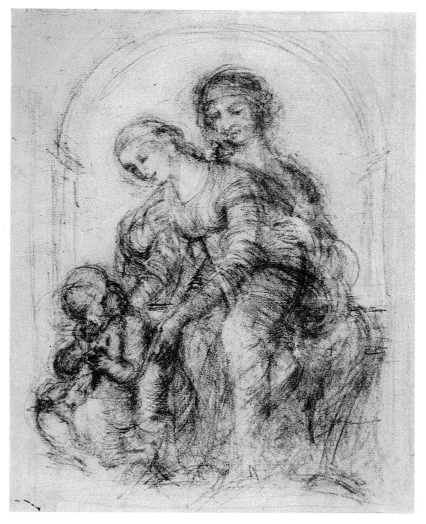

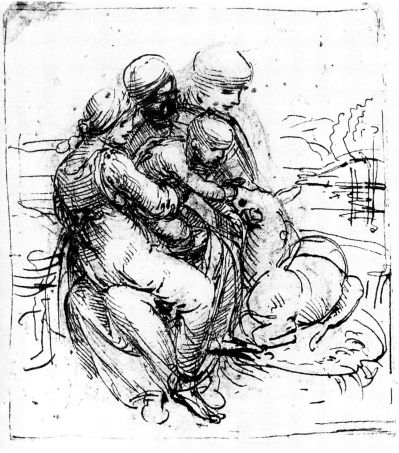

Above left: Fig. 309.
Study for the Madonna and Child and Saint Anne, pen and brown ink, 6½ x 4¾ in. (16.5 x 12 cm.) Paris, Musée du Louvre, department of graphic arts, RF 460.

Above right: Fig. 310.
Study for the Madonna and Child and Saint Anne, lead-point, 8½ x 6½ in. (21.8 x 16.4 cm.) Geneva, private collection.

Left: Fig. 311.
Study for the Madonna and Child and Saint Anne, pen and ink, 3½ x 6 in. (8.7 x 15.2 cm.) Venice, Galleria dell'Accademia, inv. 230.

451

head is on Saint Anne's right and her feet are on her left; the final arrangement of the group would use this interlocking of the two mother-figures, in a different and more complex form. But the two drawings—it is neither possible nor helpful to try and clarify the order in which they were produced—show a moment of hesitation, which was later overcome in the cartoon of 1501. Placing the group in front of what looks like a niche, the Louvre drawing (fig. 309) uses what had been Mary's left arm on the reverse of the British Museum drawing, and turns it into the left arm of Saint Anne (while he had abandoned this idea in the London cartoon). At the same time, however, he dropped the figure of Saint John the Baptist and retouched the pose of Jesus to such a degree that his action is practically indecipherable. The group as a whole forms a very strong unit, tighter and interlocked, while at the same time clearly pointed in the same direction (from right to left); this would be preserved in the 1501 cartoon. Reinforcing the human plausibility of the three generations, the aging of Saint Anne serves to humanize the appearance of the group, thus in a way reducing its theological impact.

The Venice drawing (fig. 311) also interlocks the two mother figures and maintains the idea of a group placed out of doors. While hesitating over the pose of Saint Anne, Leonardo has strengthened the theological meaning of the group by replacing Saint John the Baptist with a lamb. Perhaps inspired by the theme of Saint John the Baptist of which the lamb is a traditional attribute, it has now becomes a double of Jesus himself, the mystic lamb.[707] This is a particularly brilliant invention that Leonardo would never give up. As it is represented here, the lamb is craning its neck abnormally, in order to be blessed by Jesus. It was probably this disproportion that led Leonardo to introduce the second radical innovation in the treatment of the theme: the lowering of Jesus to the level of the ground. The idea is present in the Geneva drawing (fig. 310), the direct source of the 1501 cartoon. The architectural niche and the direction of the group as a whole (from right to left and from top to bottom) confirm the relationship between this composition and the Louvre drawing (fig. 309), but this time Leonardo has not interlocked the figures and has chosen the vertical configuration, favored by Masolino and Masaccio. He has made this more lively by adding a lateral movement: the Virgin sitting between the legs of Saint Anne's is getting up to restrain Jesus who turns towards her, while Saint Anne holds her back. The image corresponds exactly with Fra Pietro di Novellara's description of the 1501 cartoon—and it conveys the same theological image: "Leonardo represents a child Christ aged about one year

452

and a half who is escaping from his mother's arms, grasping a lamb and appearing to hold it tight. The mother raises herself as if she is getting off Saint Anne's lap, and she reaches for the child to try and take away from him the little lamb (sacrificial animal which represents the Passion). Saint Anne lifts herself slightly from her seat and seems to want to stop her daughter from taking the lamb away from the child. This could perhaps represent the Church not wanting the Passion of Christ to be prevented."[708]

Far left: Fig. 312.
Two infants embracing.
Windsor Castle, Royal
Library, RL 12564.

Left: Fig. 313. *Study for
the Madonna and Child
and Saint Anne*, red
chalk, 11¼ x 7¾ in.
(28.5 x 19.8 cm.)
Venice, Galleria dell'
Accademia, inv. 257.

As Fra Pietro da Novellara shows, this version conveys a complex spiritual and theological message in a manner that is undeniably more effective and satisfactory than the previous ones: not only has Leonardo established a clear visual continuity between the three figures, but the reference to the Passion and the Church is a more coherent and valuable addition than that of Saint John the Baptist; his presence introduced an element that is not really part of the theme of the *Humanissima Trinitas*, as Saint Anne's pointing index finger in the London cartoon shows. Yet, though Leonardo improved the composition from a thematic point of view, and though the figures are spatially more clearly related to each other, he has also lost something from a strictly "formal" point of view. The interlocking of the figures has disappeared and his choice of the "vertical type" has forced him to abandon the dynamic complexity created by the pose of Mary sitting on Saint Anne's lap, concentrated in the arrangement of the legs, which had been the constant object of his research since the British Museum drawing.

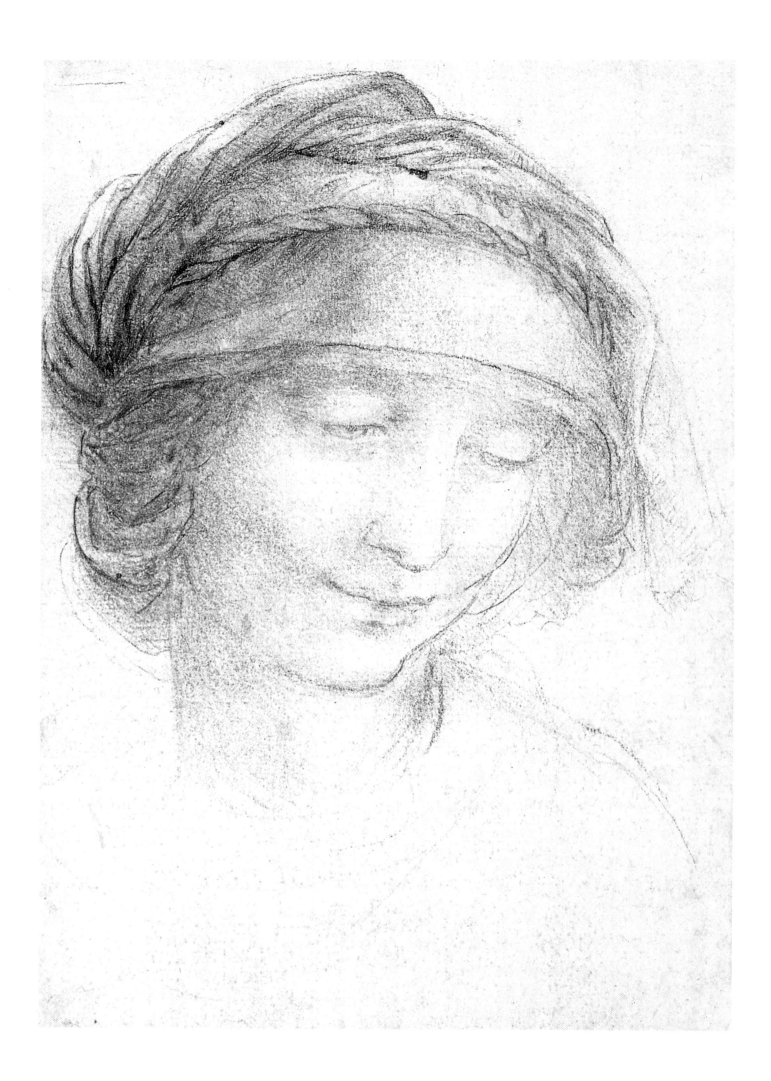

From 1506 onwards, he returned to the project. No sketch of the composition of the group has come down to us, and we only have studies for the female faces (fig. 314), the pose of the Infant Jesus (fig. 313) and the configuration of the clothes (fig. 316). But the Louvre painting (fig. 315) shows how Leonardo brilliantly succeeded in producing a synthesis of all his research without giving up the different ideas that he had had along the way. Extremely complex, the final composition of the group of figures succeeds in combining the vertical and lateral characteristics that define the two established "types," and in incorporating a dynamic dimension to the structure by adding a movement apparently as natural as it is manifestly artificial.

Reorientating the group to the right (as it was in the first idea and the Venice drawing) and with Jesus now on the ground, Leonardo has now made the Virgin lean over towards the Child. This final transformation draws from the Geneva sketch rather than the Venice one, and it has enabled Leonardo to emphasize the figure of Saint Anne: from her left foot to her face, slightly turned to the right, her figure confirms the verticality of the group and her head is clearly the summit of an (apparently) pyramidal composition. At the same time, Leonardo has emphasized the downward sideways movement that Jesus's action has created by arranging the three faces and the head of the lamb along the same oblique line. The faces of Jesus and his mother looking at each other is completed by the convergence of the gaze of Saint Anne and the lamb. The flowing unity of this arrangement is punctuated by the left elbow and forearm of Saint Anne, taken from the Louvre drawing; these intervene between Jesus and his mother more subtly and "naturally" than the pointing index finger of the London drawing. The internal dynamics of the arrangement are also emphasized by the gesture of Mary's arms, echoed by those of Jesus. But one of the most brilliant features of the Leonardo "invention" is the fact that, while being clearly articulated and dynamically distinctive, the figures tend to fuse into each other; the group now forms a living organic whole in a state of restrained separation, captured at the instant of its transformation. In order to achieve this effect, Leonardo has arranged his figures so that Mary's head covers Saint Anne's left shoulder, and more importantly, that the two right shoulders coincide exactly: thus Mary's right arm could visually also become that of Saint Anne. Without being immediately obvious, this invention ensures the strong cohesion of the group as a whole—thus brilliantly highlighting the Anne-Mary-Jesus relationship (the theme of this image) with the hand that completes this movement vanishing into the shadow of Jesus's stomach.

Fig. 314. *Study for the head of Saint Anne*,
1510–11, black chalk, 7½ x 5 in. (18.8 x 13 cm.)
Windsor Castle, Royal Library, RL 12533.

The verticality conveyed by the figure of Saint Anne is swept in a lateral movement by the convergence of dynamic indications drawing the figures to the right. Remarkably, all the expressive elements (faces and gestures) are concentrated on the right, thereby tending to reinforce the unbalancing effect of Jesus's movement. (The movement of Mary is one of the important transformations introduced into the arrangement pictured in the Venice drawing.) Leonardo's triumph consisted in correcting the imbalance he had introduced by the extraordinary configuration he gave to the folds of Mary's dress on her hip at the left of the group. The attention he paid to this arrangement is reflected in the preparatory drawing he devoted to it (fig. 316), but the latter should not hide the fact that he was using an idea that had already been present in the *Benois Madonna* (fig. 230), or the fact that the folds became increasingly "swollen," between the *Benois Madonna* and the preparatory drawing, and between the drawing and the finished painting. Devoid of any semblance of reality, they are there only as a device: they act as a visual counterweight, on the surface balancing the movement with which Jesus draws the group to the right.

The group does not as a whole reflect the pyramidal form, which is often—and far too easily—associated with the dynamic balance typical of Leonardo's work. Although the fundamental "tripod" could suggest the presence of a medial line, it is broken by the luminous projection of Mary's knee; situated near the vertical axis of the group, this relief is enough to change the stable, regular shape of the pyramid into a prismatic volume resting on its point, or as Luca di Pacioli would say in his *De Divina Proportione*, an irregular semi-octahedron, pivoted slightly to the right. But, having just described the geometric arrangement of the composition, it immediately becomes obvious that it is not quite right: the extremities of the figures are not contained within the geometric form and there are no straight lines or rectilinear configuration in the group. Far from being defined by straight lines, its moving balance rests on the interaction of rhythmic curves that cross each other and intertwine indefinitely. It is certainly no coincidence that the position of Saint Anne's legs is now similar to that of Mary's legs in the London cartoon—so much so that, apart from the introduction of Mary's blue mantle, one could attach these legs to the bust of the Virgin and see how Mary's continuous movement has developed from the London cartoon to the work in the Louvre. The movement with which she presented Jesus to Saint John the Baptist in the London cartoon, has now in the Louvre painting become one of restraining the same Jesus who has slipped to the ground and is stepping over the lamb to twist its neck.

Fig. 315. *Madonna and Child and Saint Anne,*
oil on wood, 66¼ x 51¼ in. (168 x 130 cm.)
Paris, Musée du Louvre.

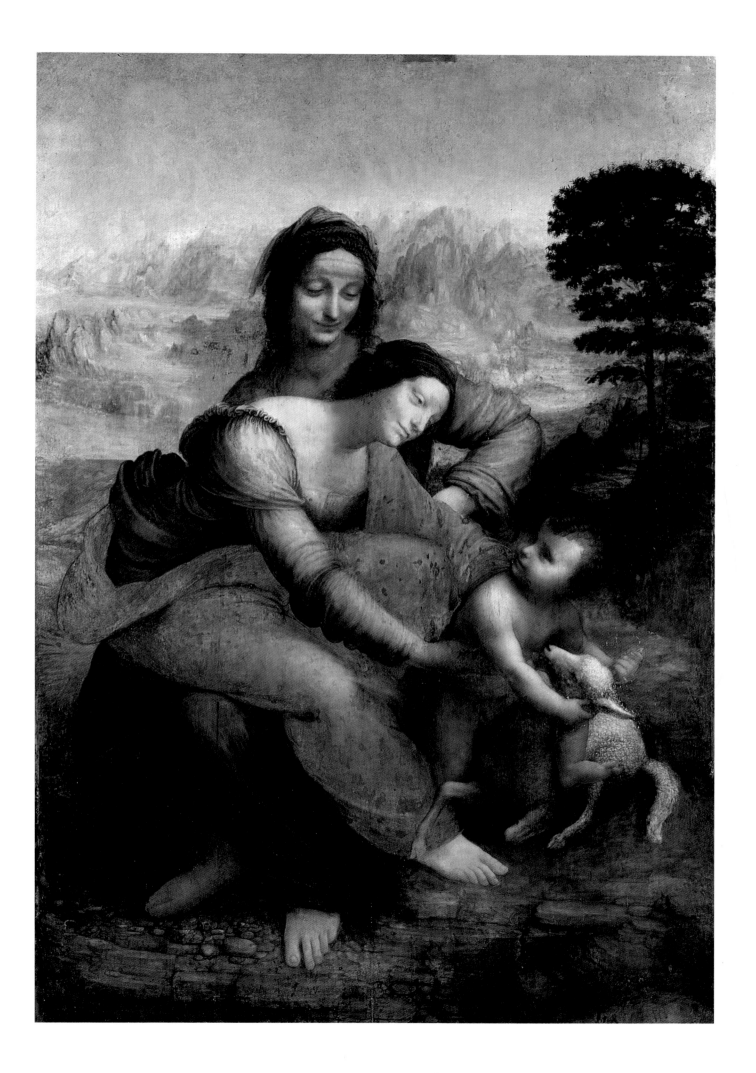

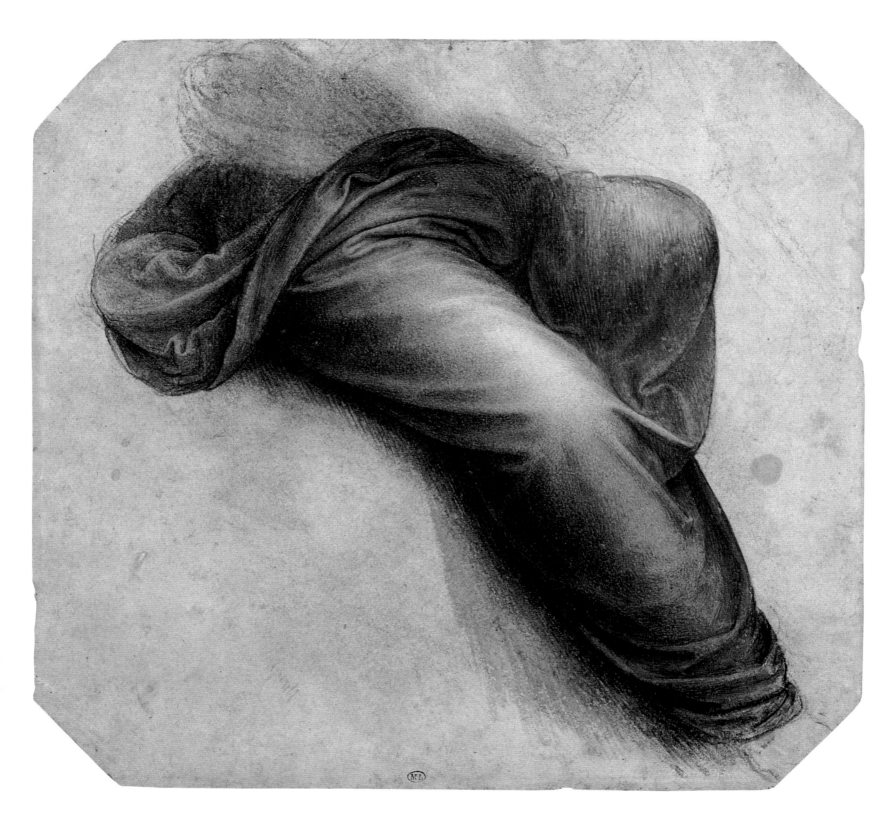

Fig. 316. *Study for Madonna and Child and Saint Anne*,
black chalk, Chinese ink wash, heightened with white, 9 x 9¾ in. (23.1 x 24.6 cm.)
Paris, Musée du Louvre, department of graphic arts.

Any attempt to carry out a geometric analysis of the intertwining and super-imposition of the configurations that animate and hold this group together would be both time consuming and useless. In its final version, the *Madonna and Child and Saint Anne* not only used and re-arranged various previous solutions; its form has been determined by the whole process of its development, the painting inviting the spectator to become aware of the living morphology of this "development beneath the form." To quote Paul Klee's words on the subject, the configuration of the *Madonna and Child and Saint Anne* was born "from movement, it is itself a fixed movement, and it is perceived in movement."[709] But in order to understand the meaning this work had in Leonardo's eyes, it is important to emphasize that the origin of the dynamization of the traditional hieratic image of the *Humanissima Trinitas*, the "prime mover" which gave the group its impulse and caused the figures to react, was none other than the movement of Jesus. It was this movement, once Saint John the Baptist had been replaced by the lamb, that led to the second important innovation in the theme: the lowering of Jesus to the ground.

Because it has no actual iconographic significance, this lowering of Jesus to the ground has hardly been commented on; yet this innovation was absolutely remarkable and concerns the content that Leonardo finally gave to the theme: a content that was developed between the Venice drawing and the Geneva one and that found its full expression in the Louvre painting. Perhaps inspired by the movement that Michelangelo gave Christ in the *Madonna of Bruges* in 1501—unless his work actually echoes Leonardo's cartoon in that respect—Leonardo depicted Jesus as emerging from between his mother's legs, representing him as "coming into the world." This metaphorical representation of birth is the clearest expression of the relationship between the figures, symbolized by the superimposition of Mary and Saint Anne and summed up in the right arm which, starting from Saint Anne's shoulder, belonging to Mary and finally merging with Jesus's stomach, unites the three figures in an organic manner. Is it pure coincidence that in 1527–28, the Venetian Lorenzo Lotto used the pose of the arms and left knee of the Leonardo Virgin in his own *Nativity* (fig. 317)? Perhaps not, since he paints Jesus's umbilical cord tied on his navel in a most remarkable manner.[710] Everything is represented as if, in this pose and detail, Lotto was explaining and unraveling in narrative the latent meaning he had recognized in Mary's gesture, whose right arm follows Jesus's movement while holding him back. But the "birth" Leonardo is referring to is not that of Bethlehem. The lowering of Jesus to the ground

represents, in a beautifully condensed manner, the descent of God Incarnate to earth, to die there. It also represents the descent of the Grace that redeems and saves mankind—and this context gives meaning to the rocky landscape of the background. Similar and probably contemporary with that of the *Mona Lisa*, this landscape no longer refers only to the mysterious fertility of woman; it also evokes the image of a land which has not yet been regenerated by Christ's sacrifice and the metaphor of the Virgin as a mountain from which Christ is born, "stone uncut by the hand of man." With this landscape, Leonardo links the *Humanissima Trinitas* to what is its theological background: the Immaculate Conception of Mary through Saint Anne, the necessary and mysterious condition of Jesus's Incarnation in Mary[711].

But this descent of Grace also refers to the regenerative power of Christ's death on the cross. Fra Pietro di Novellara was not mistaken, and simply by comparing the way Jesus is playing with the lamb in Leonardo's painting and in Raphael's one can see how much Raphael has softened and mellowed his model; Jesus is just climbing on the lamb to ride him, but in Leonardo's painting

Fig. 317. Lorenzo Lotto, *Nativity*, oil on wood, 21¾ x 18 in. (55.5 x 45.7 cm.) Siena, Pinacoteca Nazionale.

Jesus is not merely straddling the lamb, he is wringing its neck and, like a young Hercules, is about to break it against his left leg. Thus, the extraordinary preparatory work carried out by Leonardo since 1499 did not just concentrate on the "formal" aspects: in the use and progressive gestation of the matrix of the British Museum drawing, it was the conception and content of

the theme that were defined and determined by the work of the hand. Leonardo has transformed the hieratic configuration of a concept into an image in which this same concept developed its implications through the representation of a drama, less anecdotal and narrative than theological.

The genesis of *Madonna and Child and Saint Anne* confirms the *terribilità* of Leonardo's intellectual rigor, and it also shows how, if "the science of painting exists in the mind that conceives it," the "execution" could be for him "more noble than the said theory or science." It is in the execution that the idea arrives at the visible form, thus transforming the spirit of the painter into an image of the spirit of God.

SAINT JOHN-BACCHUS

As well as the three projects of *Leda, The Battle of Anghiari* and the *Madonna and Child and Saint Anne*, Leonardo also produced a number of panels for private individuals between 1500 and 1519. Only two of them have survived: a *Saint John the Baptist*, completely from his hand (fig. 318), and a *Bacchus*, probably produced as a collaboration (fig. 324). The preparatory drawings and, above all, contemporary copies of the lost originals give a fairly clear idea of what the rest of this production was like: besides the *Madonna with the Spindles*, described above, there was a *Head of Saint John the Baptist* (known through the Lombard versions and others), an *Angel of the Annunciation* (known through several copies, the best of which is in the Kunstmuseum in Basel (fig. 321) and a *Blessing of the Savior* (of which fourteen copies and variants have been listed). To these may be added the motif of Jesus and Saint John the Baptist embracing (fig. 312), the *Portrait of Monna Vanna* (fig. 322), the *Bacchus* (owned by Anton Maria Pallavicino and which the Duke of Ferrara wanted to buy in 1505) and the *Rape of Proserpine* (mentioned in the Fontainebleau collections in 1642). So it is clear that the losses have been considerable.[712] These losses are all the more to be regretted because, as the many copies and variations show, Leonardo's pictorial maturity had reached its peak and, in these paintings and drawings for private individuals, his personal treatment of the theme succeeded in revealing the intimate dimension of his creation. Today it is only possible to try and reconstruct this lost production from the clues provided by such traces and vestiges as survive.

The *Saint John the Baptist* from the Louvre, long thought to have been

461

Leonardo's last work but now believed to date from about 1509,[713] is a perfect example of the complexities of the implications that are typical of these private works. The panel is the culmination and synthesis of his pictorial research. Stripped of any narrative context, the gesture of the right hand with the pointing index finger gives—while condensing them—a universal dimension to the messages, quite similar and yet different, expressed in the *Adoration of the Magi*, *The Last Supper* and *Madonna and Child and Saint Anne*. By placing the right arm parallel to the picture plane, according to a formula that would be used by the Tuscan Mannerists in particular, Leonardo has given the figure a subtle internal spiral movement, all the more effective in that it seems to be directed towards the spectator. Finally, by placing the figure half-length against a strikingly dark background, Leonardo has made full use of the ability of sfumato to make the figure stand out against the background. The *Saint John the Baptist* is a perfect illustration of Vasari's comment on the *Angel of the Annunciation*, now lost: "[…] this genius, in his desire to increase the relief in his paintings, wanting to create the darkest backgrounds with his shadows, was looking for blacks that were darker than other blacks in order to make the light colors even more luminous. But this darkening of the colors resulted in making everything dark, looking more like the darkness of night than the delicate light of the day. His aim was to bring as much relief as possible into his paintings, in order to achieve finality and the perfection of art."[714] One may, in fact, agree with Carlo Pedretti that *Saint John the Baptist* illustrates an artistic theory, that this is an exemplary or a "paradigmatic" work,[715] or what today would be called Leonardo's manifesto on the art of painting.

This art implies a fundamental ambiguity in the definition of the "theme" of the figure. This *Saint John the Baptist* deviates radically from the established iconography regarding the physical type of the Precursor. He is neither the child nor the ascetic of the desert, but an adolescent or a young man; his beauty "combines the sensual gracefulness of a woman's body [...] and masculine gracefulness," and the ambiguous charm of his gaze. Associated with an iconographically exceptional smile that is even incongruous in the tradition of the theme, these aspects make him a figure of Christian love very close to the pagan Eros—so much so that some saw in him "a kind of angel of evil."[716]

This *Saint John the Baptist* is indissociable from the lost painting of the *Angel of the Annunciation* (fig. 321), a project that dates from 1503–04, as is shown by a pupil's sketch drawn on a sheet of drawings for *The Battle of Anghiari*

Fig. 318. *Saint John the Baptist*, c. 1508–13, oil on wood, 27¼ x 22½ in. (69 x 57 cm.) Paris, Musée du Louvre.

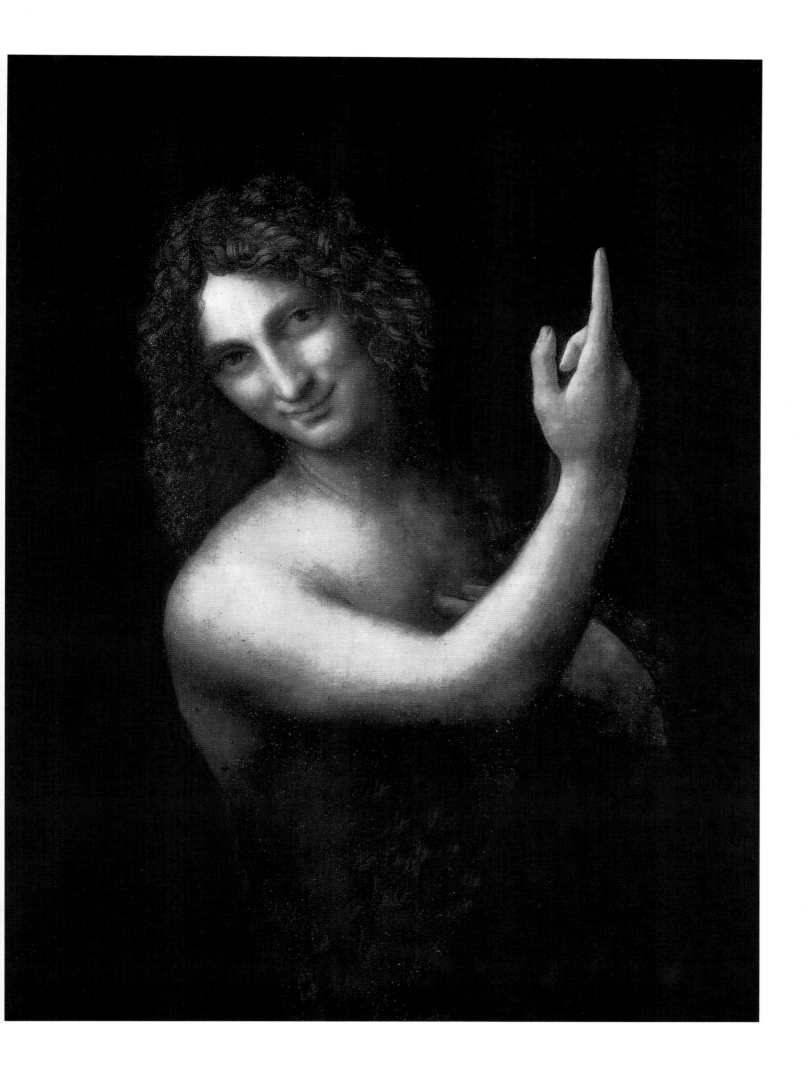

Fig. 319.
Angel in the Flesh,
c. 1513–14. Germany,
private collection.

Fig. 320. Leonardo and
disciples, *Sheet of studies
with the Angel of the
Annunciation*, *c.* 1505,
pen and sepia on gray
paper, 8¼ x 11¼ in.
(21 x 28.3 cm.)
Windsor Castle, Royal
Library, RL 12328r.

(fig. 320) and corrected by Leonardo. Leonardo's idea was simple and effective: by turning the angel Gabriel towards us, he puts us in the position of Mary who is being asked to "open herself" to the love of God to save humanity.[717] This arrangement has been seen as reminiscent of Antonello da Messina's Virgin of the Annunciation, represented twice by him, in about 1473–75, alone, under the angel's gaze. Leonardo may have known the second Virgin of the Annunciation by Antonello, directly or through a copy; her hand recalls Mary's in the *Madonna of the Rocks*.[718] But in that case his response would have been beyond the precise theme of the Annunciation. It was to Antonello's conception of painting that Leonardo responded by paying him homage, the conception of a painter as "son of Venus" whose pictorial strategy already aimed to place the spectator under the charm, or even better the seduction, of the painted work.[719] The disturbing effectiveness of the *Angel of the Annunciation* and *Saint John the Baptist* arises from the fact that Leonardo presented them removed from the narrative context that would explain iconographically (and thus justify) the "amorous" appeal. Thus he aroused in the spectator "an effect of affect" that was more attributable to the power of painting itself than to the devotional atmosphere, through which these representations were supposed to arouse the specific emotion of *affectum devotionis*.[720] The *Angel of the Annunciation* and *Saint John the Baptist* not only illustrate an artistic theory and a pictorial "manifesto"; they also reveal that "power" which the painter has (more than the poet) to "inflame man to love," and which is exalted by Leonardo in a famous page in the *Treatise on Painting*, written in about 1500–05: "[…] the painter forces the spirit of men to fall in love with and to love a painting that does not represent a living woman. It has happened that I have painted a picture with a religious theme, bought by a lover who wanted to remove the attributes of divinity from it so that he could kiss it without guilt; but in the end, respect overcame his sighing and desire, and he had to remove the picture from his house."[721] This anecdote is perhaps only a transposition of the passion inspired by the Aphrodite of Cnidus mentioned by Pliny the Elder;[722] it is no less an illustration of Leonardo's painterly ambition, to paint pictures with the power of making men and women who look at them fall in love with them.

The *Monna Vanna*, also known as the *Naked Gioconda*, was painted with this ambition in mind. She seems to have been a mistress of Giuliano de' Medici for whom Leonardo conceived the painting in Rome between 1513 and 1515. Probably left unfinished for reasons unconnected with Leonardo and taken

to France, the portrait was seen in Cloux by Antonio de Beatis in 1516. The painting has been lost, but its general disposition is known through a number of copies and variations on it (fig. 322).[723] These reveal the success of the new formula created by Leonardo, which was a source of inspiration for Raphael's *La Fornarina* and the naked female busts that abounded in Northern Europe in the sixteenth century, particularly among painters of the Fontainebleau school. Without any direct precedent, Leonardo's simple but radical invention consisted in representing the female figure completely naked. In condensing the nudity of Leda and the pose of Mona Lisa, Leonardo glorified physical beauty and sensual love. While no doubt wanting to revive a genre of painting that had made Apelles famous, he created the first modern erotic painting. Its invention reflected the hedonism of the Roman court, of which Raphael's frescoes at the Villa Farnesina are another beautiful example. In particular, it reflected the taste of his patron Giuliano de' Medici whom David Allan Brown called an "amateur libertine," and whom Baldassare Castiglione (who wrote *The*

Fig. 321. After Leonardo, *Angel of the Annunciation*, *c.* 1505–07, tempera on wood, 28 x 20½ in. (71 x 52 cm.) Basel, Kunstmuseum.

Courtier at that time) made the champion and harbinger of sensual love, contrasting him with Pietro Bembo's spiritual and Neoplatonist conceptions.[724]

The *Angel of the Annunciation* and *Saint John the Baptist*, on the other hand, have been subjected to a Neoplatonist interpretation. For Carlo Pedretti, their sensual presence is reminiscent of the "pagan symbol of Love addressing

mortals in the language of the Neoplatonists,"[725] personifying this Love, which Bembo exalts so lyrically at the end of *The Courtier*: "You, the sweet link with the world, the link between things celestial and things terrestrial, by a benevolent compromise you incline the higher powers to the government of the lower powers, and, bringing back the spirits of men to their principle, you unite them with it. You unite through the concord of elements, you push nature to produce, and you drive what is born to perpetuate life. [...] You are the father of true pleasures, of grace, peace, goodness and benevolence, enemy of ribald savagery and laziness, in a word the beginning and the end of everything good. And [...] you enjoy inhabiting the bloom of beautiful bodies and beautiful souls, and thereby sometimes reveal yourself a little to the eyes and understanding of those who are worthy of seeing you [...]."[726] But this comparison brings a problem with it. Although these words indeed recall many passages in which Leonardo exalted, the life of the macrocosm, this Neoplatonist interpretation of nature is not his: at no time do his writings ever evoke the

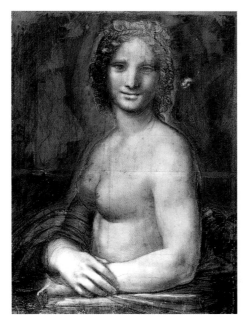

Fig. 322. After Leonardo, *Monna Vanna* or the *Naked Gioconda*, heightened gouache and black chalk on card, 28¼ x 21¼ in. (72 x 54 cm.) Chantilly, Musée Condé.

Platonist Eros to explain the life of things. He observed and described phenomena without looking for a higher cause. The Neoplatonist interpretation therefore cannot account for the intimate, personal meaning contained in these panels. At most, they are a socialized, cultured legitimization of it. The strength and emotional impact of *Saint John the Baptist*, probably also present in the

Angel of the Annunciation, are rooted in the deepest layers of Leonardo's psyche.

To understand more about this, a drawing rediscovered only a few years ago in a private collection must be considered. It forms the third stage of a process of transformation begun with the *Angel of the Annunciation* and *Saint John the Baptist*. Produced in about 1513–14 and wittily entitled the *Angel in the Flesh* by Carlo Pedretti (fig. 319), this drawing was obviously not intended to become a public work in the shape of a painting—and at the same time it explains the intimate motive behind the series which it completes. In it Leonardo used exactly the same pose he had imagined ten years earlier for the *Angel of the Annunciation*.[728] But the figure no longer has wings; the veil held in the left hand is transparent; the configuration of the right breast is clearly female, and the lower part of the body shows a powerfully erect male sexual organ.[729]

In a recent publication, this unusual picture was entitled *Study for a Bacchus*.[730] Such a contextualization is justified from a strictly iconographic point of view. The ithyphallic sexual organ and androgeny were indeed recognized characteristics of the figure of Bacchus, and Leonardo's "invention" is reminiscent of the humorous text, in which he glorified the male organ to the point of saying that man "is wrong to be ashamed of naming or showing it, constantly trying to cover and hide that which he should embellish and display with pomp, like an officiant."[731] But in the series of religious images with which it is clearly associated by its composition, this drawing is blasphemous. In extending the figure of the archangel Gabriel to include the upper part of the thighs so as to show an erection, Leonardo went very much against one of the principles of half-length religious representation. In his *Rationale divinorum officiorum* (written at the end of the thirteenth century, but forty-four editions of which were printed between 1459 and 1500), Cardinal Durandus explained that the Greek icons only represented figures to just above the navel and not lower in order to "avoid any bad thought."[732]

Moreover, by using the pose of the *Angel of the Annunciation* and not that of *Saint John the Baptist*, Leonardo made a choice that allows the importance this invention had for him to be defined. In humanist art and philosophy and its tendency towards pagan-Christian syncretism, Bacchus could easily be considered a mythological precursor of Christ, on the basis of the common theme of the vine and sacred intoxication. (At the end of the Quattrocento, the Bacchus-Christ connection appeared to be so common that in the letter he wrote to Savonarola in 1490 in defense of true Christian poetry, Ugolino Verino denounced the assimilation of the Bacchic thyrsus and the Christian cross

as one of those "impudences" to be fought against).[733] Less common, the association of Saint John the Baptist and Bacchus was permissible because of their common function as "precursors". By giving a crown made of vine leaves to a *Saint John the Baptist* that was directly inspired by Leonardo's, Andrea del Sarto clearly gave him an explicitly Bacchic dimension.[734] But by adding the Bacchic erection to what was for him an angel's figure, Leonardo stepped beyond the "authorised" boundary of contemporary syncretism: the condensation in Leonardo's approach was therefore probably different, more personal.

One might think that by transforming the figure of his angel into a bisexual being, Leonardo represented the original androgynous being that Plato, in the *Symposium*, sees as the basis of his philosophy of love, and Platonists of the Renaissance recognize in the commentaries of Philo and Origen on Genesis 1:27, in which it is written: "So God created man in his own image, in the image of God created he him; male and female created he them." "Plato's androgynous being" was a popular theme during the Renaissance, and it was probably not just a coincidence that Baldassare Castiglione in *The Courtier* entrusted Giuliano de' Medici (Leonardo's patron in Rome who commissioned the *Monna Vanna* from him) with the task of praising the primitive androgyny of the divine creature: " […] The male and female are by nature always together, and one cannot exist without the other; so, he who has no female must not be called male, according to the definition of the one and the other, nor female she who has no male. And since one sex alone reveals an imperfection, the ancients attributed both the one and the other to God; that is why Orpheus said that Jupiter was male and female, and why one reads in the Holy Scripture that God made men male and female in his own image, and why poets often confuse genders when they speak of the gods."[735] Nonetheless, while the theme of the androgynous being may have inspired Leonardo, the erection of the *Angel in the Flesh* remains a remarkable anomaly, which the obscenity of studio humour found in other drawings is not sufficient to explain. The drawing expresses an intimate aspect of Leonardo's thought that cannot be explained solely by the cultural and social context of his practice of painting.

This intimate aspect is probably not completely unconnected with what Lomazzo says in his *Libro dei Sogni* ("Book of dreams") on the subject of Leonardo's sexuality. In his first *Ragionamento*, ("Dissertation") Lomazzo invented a strange tale in which Leonardo tells how, lost in a mysterious forest of the Orient after leaving Milan because of his rejection by a certain Drusilla, he changed sex several times by eating the fruits of the trees in this forest—

and how he wished, in his female state, that Drusilla were present so that she could have intercourse with him, herself having been transformed into a man. The fifth *Ragionamento* of the *Libro dei Sogni* contains a dialogue between Phidias and Leonardo in which the latter eulogizes male homosexuality: unlike heterosexual love, useful only to perpetuate the species, male love was the characteristic of "philosophical mind"; it had developed after the initial bestial phase of human history, "at the same time as divine philosophy," because while heterosexuality was a "necessity of nature," the invention of the love of "boys" by man was a "rare and divine thing."[736]

It is impossible to say that Lomazzo was a reliable interpreter of Leonardo's behavior. But he was certainly well informed of Leonardo's reputation for this kind of behavior. While the fifth *Ragionamento* shows that Leonardo was well known for his homosexuality and that he could also have been an eloquent champion of the cause, the first *Ragionamento* seems to suggest the (unsatisfied) desire of an (androgynous) bisexuality. This suggestion in itself would be unimportant if it did not throw light on Leonardo's ability to express the (heterosexual) erotic nature of the female body in his painting, unlike Michelangelo, another great artist of the Renaissance who was homosexual. From *Leda* to the *Monna Vanna*, this dimension of his art was one of his greatest contributions to the history of painting during the Renaissance.[737] The *Angel in the Flesh* shows to what extent this ability was itself a conscious choice and perhaps, in the end, an intentional sublimation of his sexual drives. In spite of its seductive character, the drawing of the *Angel in the Flesh* is indeed not pleasant, as if censorship had prevailed by preventing the presentation of beauty at the very instant that the artist was expressing his most intimate and secret desire: to be at the same time man and woman, and to have at the same time an erect male organ and a full breast with an erect nipple, while inviting onlookers to enjoy this original ambivalence in its greater truth and richness.

The story of *Bacchus* (fig. 324), apparently Leonardo's last painting, together with the portrait of the *Monna Vanna*, on which he worked in Rome between 1513 and 1515,[738] confirm the coherence and power of this inspiration. The painting was conceived and executed like a Saint John the Baptist in the desert, and the preparatory study in red chalk, preserved at the Sacro Monte museum in Varese before it was stolen in 1974, clearly indicated the very innovative character of Leonardo's invention. Very unusually, the figure of the saint is completely nude, and it corresponds neither to the type of Saint John the

Baptist as a child nor to that as the emaciated, ascetic adult. Leonardo has turned him into a youth with a beauty worthy of classical art, which could be seen as a response to the *Ignudi* painted by Michelangelo on the vaulted ceiling of the Sistine Chapel.[739] The pose of this *Saint John the Baptist* actually combines two ancient models: the well-known sculpture of the *Young Man Removing Thorns* (fig. 323) and, slightly transformed and rotated 90 degrees, the pose of *Diomedes*, one of the most famous stones from antiquity in the

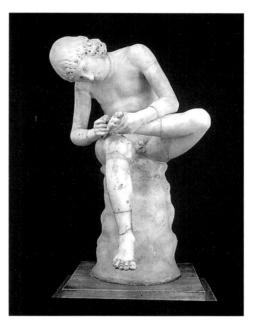

Fig. 323.
Hellenistic sculpture,
*Young Man
Removing Thorns*.
Florence, Uffizi,
inv. 1914 n. 177.

collections of Lorenzo the Magnificent, which Leonardo had sketched (fig. 32) in about 1503, changing the pose of the left arm so that its index finger pointed towards the sky.[740] This "antique" paganization of the desert saint reflected the atmosphere and taste prevailing in Rome under Pope Leo X, Giovanni de' Medici: in giving a Dionysian aspect to the last of the Christian prophets, Leonardo was only answering the expectations of a court milieu of which he probably hoped to become a part—in the same way that the *Mona Lisa* became *Monna Vanna*, the nude portrait of the mistress of a prince.[741]

But as the *Angel in the Flesh* suggests, everything was not so clear from Leonardo's point of view. Unfinished in Rome, the painting was probably among those he took to France, where in 1517 Antonio de Beatis mentioned a *Saint John the Baptist* among the various paintings in Leonardo's studio.[742] It became part of the royal collections during the seventeenth century. But it was no

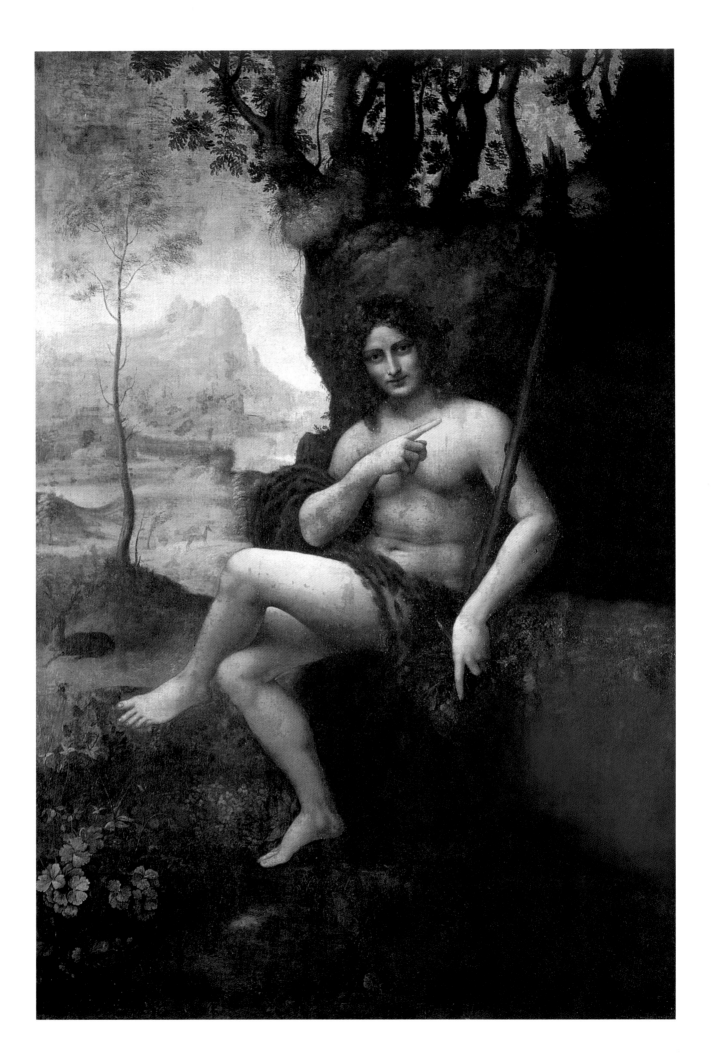

longer appreciated. In about 1625, Cassiano del Pozzo was quite explicit on the subject: "[…] Saint John in the desert, smaller than one-third life size. It is a very delicate painting but it is not much appreciated because it does not inspire devotion, and it lacks dignity and credibility.[743] "Between 1683 and 1695, several elements were added to the painting including a panther skin and a crown of vine leaves, and the cross was turned into a thyrsus: in the catalogue, "Saint John in the desert" became "Bacchus in a landscape."

On reflection, these devout people displayed an unusual clairvoyance. By turning Saint John the Baptist into Bacchus, they revealed the figure of the ancient god whose hidden presence adversely affected the image of the Christian saint and made its perception difficult. As Cassiano del Pozzo wanted, they made the image more credible and therefore, as they said at the time, more "worthy" or "decent." By giving this too-attractive hermit the attributes of an ancient god (thus doing the opposite of the "lover" who had asked Leonardo to remove the religious attributes of a religious figure so that he could kiss her without feeling guilty), they removed what was troubling them. Paradoxically, the retouched painting appears more "religious" than the original Varese drawing.[744] But this paradox is not actual, because the religion of this "Bacchus" was neither the Christian religion nor the pagan one, but the distant cult of a "nature" filtered by civilization. The credibility achieved by this devout censorship was obtained at the expense of the formidable yet seductive ambiguity which Leonardo was seeking to create: "a mystique whose secret we dare not penetrate, […] beautiful ephebes [who] do not lower their eyes but whose gaze is mysterious and triumphant since they know the secret of accomplishing a great happiness that must not be spoken about, […] this blessed reunion of the masculine and feminine."[745] With these ambiguous works, the last he was to paint, in which the love of invisible, spiritual beauty is expressed in the form of perturbing androgynous beauties, Leonardo was probably revealing an intimate desire, while glorifying the erotic power of art and the power of painting to "inflame with love" those whom it addresses.

Fig. 324. *Bacchus*, 1513–15,
tempera and oil on wood transferred
onto canvas, 69¾ x 45¼ in. (177 x 115 cm.)
Paris, Musée du Louvre.

474

LEONARDO AS A PERSON

Even in his lifetime, Leonardo's bizarre strangeness played an important part in his image and reputation as artist. To his contemporaries, one of his most remarkable qualities was his talent always to be able to invent *una cosa bizarra* ("a curious thing").[746] This was probably one of the requirements of the court artist and, as has been seen, the glory of the engineer was traditionally associated with that of the magician. From his "wild men" through his automata to his dragons (fig. 325), Leonardo's creativity, as the organizer of festivities and masquerades and in his role of master of ceremonies, was in a way a professional specialty. However, while the exercise of this profession of artist engineer explains many of his inventions that today are seen as the expression of an individual taste and attitude, Leonardo went further than his colleagues and above all, he dealt with these activities in a spirit that was at the same time more systematic and more personal. When, for example, he worked on the development of a life size mechanical man, a kind of robot whose wheelwork could carry out the most complex movements (fig. 173), the arrangement of the wheels followed and deconstructed the shape of a looped device on the same sheet, in which the elegance of notarial calligraphy is clearly seen—as if the mechanical wheelwork should imitate the dynamic structure which gives rhythm to the natural movement of the hand writing on paper.

For Ernst Gombrich, Leonardo's interest in automata and machines with surprising effects had to be seen in the context of his virulent condemnation of false magicians, astrologers and necromancers. By this polemic, Leonardo was exalting real "magic" through which the engineer and painter created "works" which had the same effect on spectators as natural objects.[747] The idea is attractive and even convincing, but the orientation of Leonardo's researches in this field, simultaneously systematic and individual, suggests that they went beyond simple professional rivalry and related to what could have been the intimate dynamic unity of his artistic practices and his social behavior.

Vasari's text throws some light on this delicate point. While giving Leonardo a strategic position in the "development" of the history of art as he saw it, he had some first hand accounts of contemporaries that enabled him to draw a mental portrait which, albeit imaginary, is nonetheless very informative. In

Fig. 325. *Dragon*, after 1513, black chalk,
pen and ink, 7½ x 10¾ in. (18.8 x 27 cm.)
Windsor Castle, Royal Library, RL 12369.

Vasari's eyes, it was Leonardo who inaugurated the "third manner," distinguished in particular by that "freedom which, without being restricted by the rule, must not transgress it," by that "grace," the "ultimate finality of the drawing," and by "this facility made of grace and delicacy, which appears between the seen and unseen."[748] These phrases perfectly describe Leonardo's art, in particular "the serpentine figure" and sfumato. However, though "grace," together with beauty and *virtù*, was one of the three gifts from heaven that Leonardo had been given, and though the concept of grace occurs several times in the *Life* of Leonardo, it is much less present than in the *Life* of the *graziosissimo* Raphael. This relatively sparing use of the term was probably not involuntary, since it was accompanied by repeated emphasis of Leonardo's strangeness and his eccentric behavior.

Two anecdotes reported by Vasari are particularly interesting: they imply that, from the beginning to the end of his artistic career, Leonardo was fascinated by terrifying, monstrous creations. In the first anecdote, Leonardo was still a young Florentine artist. He has been asked by his father to paint a buckler (*rotella*) for a farmer whom ser Piero found "very useful" because of his skill at "catching birds and fish." Instead of designing just any motif, Leonardo wondered "what he could paint on it to frighten the enemy, which would have the same effect as the Medusa's head in the past (*rappresentando le effetto stesso che la testa già di Medusa*)." "To this end, [he] gathered, in a room that only he used, large and small lizards, crickets, snakes, butterflies, grasshoppers, bats and other strange animals of this kind; [...] he created from them a little monster, very horrible and terrifying, whose poisonous breath set the air around it alight. He depicted it emerging from a dark crevice in the rock, spitting venom from its open mouth, fire from its eyes, fumes from its nostrils, looking so strange that it really had the appearance of a monstrous, horrible creature. He took so much trouble over this that the stench from all the dead animals in the room became unbearable; but Leonardo, so much in love with his art, was unaware of it." The result was such a success that Piero da Vinci, a shrewd notary, "without saying anything" obtained an ordinary buckler "decorated with a heart pierced with an arrow" that he gave the farmer, selling "his son's buckler secretly for one hundred ducats to merchants in Florence who soon after sold it to the Duke of Milan for three hundred ducats."[749] The second story takes place in Rome where Leonardo went "with Duke Giuliano de' Medici after the election of Pope Leo." He was by then a famous artist, and yet he remained involved "in all kinds of mad things." For instance, "on

the back of a very strange (*bizzarrissimo*) large lizard found by the wine-grower of the Belvedere, he fixed wings made of scales removed from other lizards that, with the help of mercury, vibrated with the movements of the animal; he added eyes, horns, and a beard, and then tamed it. He kept it in a box and terrified all the friends to whom he showed it."[750]

Too good to be true, these fictional accounts played a tactical role in Leonardo's biography. The first anticipated Leonardo's career in Milan while he was still in Florence, and the second explained why the great artist, involved in all that "madness," did not have the success he might have expected at the (Medici) court in Rome. But following the tradition of the *exemplum*, they also enabled Vasari to highlight what was in his eyes an original dimension of Leonardo's artistic inspiration. From ser Piero's farmer friend to the Belvedere winegrower, the two stories recall Leonardo's childhood in the countryside, and the tale thus highlights what distinguished Leonardo personally from a court artist (as it was conceived by the founder of the Accademia del Disegno in the absolutist Florence of Cosimo I de' Medici). The private dimension of this "monstrous" inspiration is also reflected in the fact that Leonardo was responding to a request from his father, and that the purpose of the miniature dragon was to "terrify all the friends to whom he would show it." By "framing" Leonardo's biography in this way, Vasari suggested that "divine grace" (which defined the fundamental contribution of the artist to the history of the *bella maniera*) was inseparable from a personal taste for the monstrous, that this grace stood out against a background of violence and chaos.

In this, Vasari showed himself a remarkably perceptive critic because Leonardo's work and thought were indeed inhabited, even haunted, by the monstrous—and Leonardo's interest in the monstrous went beyond the occasional pleasantries and festive events. As already described above, the "grotesque heads" were developed as a kind of treatise on "ideal ugliness," the deformed reverse side of beauty and the natural fate of all physical grace. In part, these drawings represented a synthesis of things he had observed, according to a practice which Vasari recalled: "He so loved to see bizarre physiognomies, with beards and hair like savages, that he would follow someone who had caught his attention for a whole day. He would memorize his appearance so well that on his return home he would be able to draw him as if he had him before his very eyes."[751] Predecessors of what would become caricature, these drawings often convey an impression of "comic *terribilità*."

They also highlight human absurdity, such as the bust of a woman made famous by the picture made of it by Quentin Massys (fig. 326). But other figures had other purposes. The "Monster from Dante" known through a copy made by Francesco Melzi (fig. 327), is more a physiognomic "essay," the allegorical portrait of the inner bestiality of humanity in general. With its goiter in the shape of testicles and its eyebrows shaped like horns, taking on the typical aspect of a devil's or satyr's sexual organ, this drawing is a variation on the two phallic heads by Leonardo, which Lomazzo had seen in Milan: in the manner of Arcimboldo's more ambitious compositions, these had an obvious allegorical dimension and were a moral portrait of the sexual animality that is hidden behind the most "gracious" beauty. It was clearly no coincidence that Leonardo gave his favorite assistant Gian Giacomo Caprotti, who had the beauty of an angel, the nickname of Salai, which is the name of one of the demons in Pulci's *Morgante Maggiore*.[752]

In his writings, Leonardo went from the simple joke to philosophical pessimism. "At first sight the black face is horrible and terrifying to look at, especially the eyes full of blood, below the frightening, dark eyebrows, enough to darken the sky and make the earth quake. [...] No one would be too proud to develop wings in order to escape from this flamboyant gaze: Lucifer has a face like an angel in comparison. Upturned nose, flared nostrils from which large hairs protrude and, below, the mouth with thick lips and yellow teeth and cat's hair at the extremities [...]" This famous description of the "giant of Libya" addressed to Benedetto Dei, a convincing virtual *ekphrasis* of a drawing of a monster, was probably only a "joke."[753] But there are many other texts that clearly imply that in the eyes of Leonardo, the beast, always ready to reveal itself, was also present in "normal" humanity. Certain "prophecies" were particularly impressive. This kind of literary game also involved the use of visions of horror; but sometimes Leonardo also added a more personal note, as, for instance, in the long "prophecy" describing the "Cruelty of man": "We shall see animals on the surface of the earth always fighting against each other to cause the greatest damage and often the death of both sides. Their malignity will know no boundaries; their proud members will cut down large numbers of trees in the vast forests throughout the universe; having fed, they will satisfy their desires by spreading death, suffering, pain, fear and persecution to all living things. Because of their pride, they will want to ascend into the sky but the weight of their limbs will keep them on the ground. There will be nothing left on earth, under the earth or in the waters that has not been persecuted,

hounded or sullied; the inhabitants of one country will be driven out of their own country into another. And their bodies will become the tomb and the transit of all the living bodies they have killed. Oh world, why do you not open up? Why do you not swallow them all in the depths of your vast caves and chasms so as not to show heaven such a cruel, pitiless monster?"[754]

The personal dimension reflected in this page is confirmed by the fact that Leonardo returned to this theme in other contexts, unrelated to the playful field of "prophecy." So, in a note addressed to man in general Leonardo called

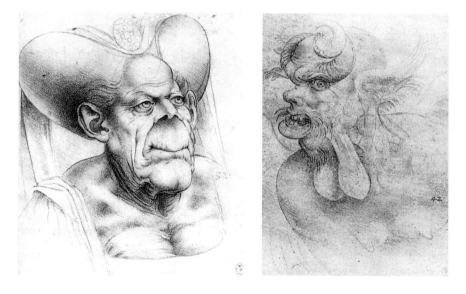

Far left: Fig. 326. After Leonardo, *Bust of grotesque woman*, *c.* 1490–91, red chalk, 6¾ x 5¾ in. (17.2 x 14.3 cm.) Windsor Castle, Royal Library, RL 12492.

Left: Fig. 327. After Leonardo, *"Dantesque monster,"* *c.* 1508, red chalk with touches of black and white, on red paper, 8½ x 6 in. (21.8 x 15 cm.) Windsor Castle, Royal Library, RL 12371.

him the "King of the wild beasts," and having used the metaphor of the gullet, the "tomb of all the animals," he even referred to primitive forms of cannibalism: "[...] Regarding mankind, it is impossible not to mention a supreme iniquity that does not exist among the animals on earth, since none of them eat their own kind, except in madness [...]; but you, as well as your children, you devour father, mother, brothers and friends; and you are still not satisfied and you go and hunt on the territories of others, capturing other men, cutting off their sexual organ and testicles, you fatten them up and push them down your own throat [...]."[755] Leonardo was vegetarian, like Pythagoras in Ovid's *Metamorphoses*, and this explains the violence of his condemnation of mankind's abominations caused by the ancestral carnivorous nature of man. But the mention of cannibalism is nonetheless surprising in the context of the social realities of his time. In fact, a similar archaic violence sometimes appeared to be the inspiration of his own imagination and, returning to the

"prophecies," to find expression under the guise of a literary game. "A large part of the male species will be prevented from procreating by having their testicles torn off," "The little children will deprived of milk," "A large number of women will have their breasts torn off and removed at the same time as their life is taken away."[756] As Leonardo explained, these three prophecies only referred to "the animals which are castrated," "the animals used for making cheese," and "the dishes prepared from sows." But until the puzzle was solved, it remained a vision of a rare violence that this game forced on the players. Sometimes it was sufficient for Leonardo not to explain a prophecy for the tension concealed within it to be felt. Thus the last sheet of the manuscript of *Madrid I* contains an isolated prophecy whose particularly enigmatic character could not conceal—and may even emphasize—its deeply personal dimension: in the form of a tercet consisting of rhyming hendecasyllables, it says: "I am he who was born before the father; I killed a third of the men; then I returned inside my mother's belly" ("*I'son colui che nacqui innanzi al padre; la terza parte delli omini uccisi; po'tornai nel ventre alla mia madre*").[757]

Thus, in the course of a text, the gentle Leonardo, said to buy caged birds in the market in order to set them free, conjured up strange and terrible images. His consciousness of these obscure, violent pulses and their close link with the artist's creative imagination help explain Leonardo's position regarding the expression of the self in a work of art.

"Every painter paints himself" ("*Ogni dipintore dipinge se*"); the expression was becoming commonplace, almost a proverb, towards the end of the Quattrocento.[758] It has a double meaning and can be taken in two different ways. It seems first to have appeared at the beginning of the century in a sonnet by Brunelleschi about a bad painter who painted figures as mad as himself, so the image had a negative connotation among artists. However, the idea was seen as positive aspect in art by Marsilio Ficino and the Florentine Neoplatonists for whom, far from being merely a mechanical production, a work of art reflected a state of mind, the soul of the artist, revealing like a mirror "the image of his state of mind." Between the early 1490s and 1510, Leonardo returned no less than seven times to this theme, developing it in a most original way. Seeing in this unconscious self-portrait of the artist against the background of his work the greatest danger and the greatest "vice" to which the "divine science" of painting might be exposed, he examined the processes of artistic creation in a new light. For him, the self-portrait, or as Martin

Kemp put it, the involuntary *automimesis*, of the artist was a preconscious oper-
ation, in a way instinctive, a "consequence of the intimate mechanisms of the
soul, this power which determines our judgment before it has become our
judgment (*"il nostro giuditio inanti sia il proprio giuditio nostro"*)."[759] But
while Marsilio Ficino believed that the soul of the artist acted in unison with
the "universal soul" of the world, to Leonardo the innate qualities of the soul
were as varied as the individuals, and the faculty of artistic invention was
inseparable from the qualities and faults of each artist. The innovativeness
(and great modernity) of Leonardo's approach lies in the fact that he shifted
the artist's reflection from the level of a metaphysical consciousness of art to
that of the psychic mechanisms of artistic activity—as a result seeing the soul
of the "artist" as a "spiritual force," an energy close to what would in modern
terms be called the subconscious.[760]

However, rather significantly, Leonardo developed an ambivalent attitude
towards this subconscious motor of creation. On one hand, he listened to its
suggestions, paying attention, for instance, to the configurations he saw in stains
and blemishes on a wall or in the magma formed by the semi-controlled
tracery of the "informal sketch" on a sheet and its *componimento inculto*.
On the other hand, he took great care in controlling its expression in order
to prevent any manifestation of involuntary *automimesis*. Resisting the temp-
tation of the soul to favor images that resembled it, the painter had first of all
to try to identify with the beings he depicted—because "no painter can paint
a figure if he cannot be it" (*"chi pinge figura, e se non po esser lei, non la po
porre"*)[761]— and if he discovered a fault in his work, he must take great care
to correct it properly so that, when the work became public, he did not pub-
lish anything that came only from his own resources or, to use Leonardo's
words, his own material.[762] Thus Leonardo developed a moral code, a profes-
sional ethic whose principles were much more demanding than those pro-
posed by Cennino Cennini (who insisted above all that the artist should lead
a morally and religiously well-ordered life), or Alberti, who was mainly con-
cerned with general education and social respectability.[763] For Leonardo, artistic
activity could not be brought to a successful conclusion without "a profane form
of contemplative life."[764] If it is better to draw in company so as to benefit
from the advantages of competition, Leonardo also mentioned repeatedly
the need to be alone to meditate on one's art: "The painter must be solitary some-
times, to reflect on what he sees, to talk to himself"; "So that the health of
the body does not harm that of the mind, the painter or drawer must remain

481

solitary, especially when he is inclined to speculations and considerations, which, continuously appearing in front of him, provide ample reserves for his memory. On your own, you will own yourself completely; with a companion you will only own half of you, and even less if he is indiscreet; with several, these inconveniences are multiplied."[765]

Still rare among artists, this need for meditative retreat must have been even more intriguing to Leonardo's contemporaries, because Leonardo was extremely sociable and sophisticated and was not averse to shine socially in company. Vasari's eulogy suggests that Leonardo himself greatly valued this social image: "[...] there was an infinite grace in even the smallest of his actions. [...] This spirit endowed by God with so much innate grace also had such a great power of reasoning supported by intelligence and memory, his hands so skilled at expressing his thoughts through drawing, that he dominated and confounded the greatest talents with his line of argument. [...] His conversation was so agreeable that he won the hearts of all. Although almost penniless, he always had servants, horses whom he loved very much and all sorts of animals, which he cared for with immense patience and care. [...] The splendor that shone through his wonderful features brought comfort to every sad soul; his discourse could bend the most obstinate wills one way or the other. [...] In his generosity, he welcomed and fed any friend, rich or poor, who had talent and merit. Each of his acts was the ornament and honor of the most humble and poor abode."[766] But in spite of this exquisite, polished courtesy, Leonardo remained fiercely independent to the point of seeming "to live day by day," as Pietro da Novellara reported, and to have politely resisted Isabella d'Este's insistent pressure. This double attitude—perfect sociability and ostentatious solitariness—was probably Leonardo's way of ensuring and expanding the "vital space" of the artist while developing "around the pictorial operation a range of peripheral activities of defense and exaltation."[767]

Leonardo's sociability was probably only a mask behind which he hid, to be out of reach and to preserve his interiority. An ideal motto for him would have been one inscribed on the cover of a portrait produced in Florence in about 1510 and accompanying a painted mask, surrounded by grotesques: "SUA CUIQUE PERSONA" ("To each his mask").[768] As is already known from the Turin self-portrait, what Leonardo revealed of himself was not his personality but his person, in the ancient and theatrical sense of the term.

To a certain extent, this attitude corresponded to the growing affirmation

of artistic individuality and personality prevalent in Florence at the beginning of the sixteenth century. The amazing indifference displayed by Leonardo in the face of his various setbacks was probably just a particular expression of the eccentricity that was beginning to mark the social personality of the artist.[769] But there was more to it than this. Indeed, it was not only through this deliberate defensive strategy against worldliness that Leonardo succeeded in protecting his inner self. As Margot and Rudolf Wittkower noted, in spite of the vast number of pages in his manuscripts—which in themselves are sufficient to reveal the extraordinary development of the personal dimension of his mental activity—his personality remains as "mysterious" for us as it was for his contemporaries; and Kenneth Clark wrote: "In all his writings—one of the most voluminous and complete records of a mind at work which has come down to us—there is hardly a trace of human emotion. We know nothing about his feelings, his tastes, his health, or his opinions on the events of his time."[770] Rare are the sentences or scraps of sentences that express a subjective feeling—such as the unfinished sentence written on a sheet used towards the end of 1478, "Fioravanti di Domenicho in Florence, my companion as beloved as my…" and whose lack of an ending may be the result of "emotion, or even anxiety (?) with which it was penned."[771] In this respect it is significant that the death of his father is only mentioned twice, very briefly and precisely, one mention having been even more "objectified" by being written (most unusually) from left to right—and Ludwig Heydenreich even believed that "his inner reserve, the impersonality of his nature, must have been so strong that they formed an insurmountable barrier between he and others—a barrier that neither he nor anyone else could cross."[772]

But is it really an "impersonality" that is being dealt with here? It might seem that Leonardo's intimate personality could be linked to this obstinate construction of a "person" conceived as a barrier, erected to keep at bay not the consciousness but the manifestations of an intimacy which, like the *componimento inculto*, was the still-undefined matter of the image of the self, shapeless, virtually chaotic, worrying and strange.

Once again it is Vasari who helps clarify Leonardo's attitude. At the very beginning of the third part of his *Lives*, Vasari draws the contrasting parallel between Leonardo and his Florentine contemporary, the eccentric Piero di Cosimo. The pleasures of conversation and the love of solitude, the affirmation of independence in the face of the patron's impatience, the talent for organizing festivities and masquerades, a taste for monsters, the satisfaction

experienced when encountering human or natural peculiarities, the *Life* of Piero di Cosimo perfectly echoes that of Leonardo, even in catastrophic events: while Leonardo died in the arms of François I, Piero di Cosimo, "one morning in 1521, was found dead at the bottom of some stairs"—and the stains on the walls that so inspired Leonardo became in Piero's eyes, "sputum of the sick," which he used to invent "the battles of horsemen, the most fantastic cities, the most incredibly vast countries." More generally, in the third part of the *Lives*, Piero di Cosimo's biography, by contrast, throws light on Leonardo's, since Vasari did not refrain from suggesting that the latter, "capricious and unstable," might almost be considered an eccentric. Piero di Cosimo, on the other hand, was a complete eccentric who lost his way in life because, according to Vasari, he had not "sufficiently controlled himself in life." Working "only for his pleasure and for the love of art," and as Vasari wrote in the 1550 version, forgetting to be "more sociable and more affectionate towards his friends," he led "the life of a savage," and "and he loved this detached life so much that any other would have felt like slavery compared to his own."[773] What Vasari's life of Piero di Cosimo surreptitiously reveals is the aspects that were concealed by the constraints of social graces: an archaic bestiality, an intimate savagery, the wild man—the ludicrous reverse of the court artist. This is in fact what Piero di Cosimo painted and what Vasari liked so much: primitive men, horrible monsters, "as beautiful as they are bizarre"—"whose deformity is so extraordinary, bizarre, fantastic that it seems impossible that nature could have created such strange malformations."[774] In fact, the motto "*ogni dipintore dipinge se*" would have applied perfectly to Piero di Cosimo.

The contrasting parallel developed by Vasari to compare Leonardo and Piero di Cosimo was not historically arbitrary. Piero took part with Leonardo in the commission entrusted with the task of deciding where to place Michelangelo's *David*, and his work also showed the impact Leonardo had on him. His *Battle of the Centaurs and the Lapiths* is presented like a mythological parody of the *Battle of Anghiari*, in particular the group on the left that looks like a twisted quotation of *The Struggle for the Standard*. If, in the general structure of his *Lives*, Vasari turned Piero di Cosimo into the buffoon and pathetic counterpoint of the princely artist embodied by Leonardo, the latter's impenetrability and his rejection of self-revelation also suggest that the grace of his art and his person, "this air of sweetness and gentleness that is so characteristic of him," to use Isabella d'Este's words, were only an

appearance, the socially visible form of a most blurred, uncertain intimacy.

The mystery surrounding Leonardo's personality, or to be more exact, the enigma it always was for his own contemporaries, could have arisen from the fact that this personality would have developed fully only in the construction of this person, this visible form of himself, simultaneously and inseparably projection and screen. Far from being only a response to a social context and a "peripheral activity of defense" developed around the pictorial activity, this construction would then have intimately linked to the consciousness he had of himself or, as Montaigne would say, of his "being."[775] It is possible that Leonardo observed his inner microcosm with the same "terrible rigor" as when he studied the macrocosm of the visible, and that for Leonardo the consciousness of the self was inseparable from the consciousness of the world. In the same way as the creatures of the world who are consumed with desire to return to a world of chaos, but also similar to the forms of art that the hand extracts from the "informal" sketch it has created, in Leonardo's own eyes his "me" could have been mainly a "rhythm," the form taken on by his infinite inner flux. The creator of himself as much as of his work, Leonardo would have constructed in this chaos, then extracted from it, his own form, that of a man who knew himself, intimately and ontologically, "without image"[776] other than "errant form"—since, as Ovid's Pythagoras said, "all image is an errant form" (*omnis vagans formatur imago*).

The drawing representing a young woman pointing with her left hand (fig. 328) takes on a special meaning in this context. Dating from the same period as the most finished dragon (fig. 325), it is one of the last drawings of Leonardo. It probably represents Matilda, the "lonely lady" who appears to Dante in Canto XXVIII of the *Purgatorio* as his final guide, along the Lethe, before his meeting with Beatrice and the journey to the celestial paradise. The pose and smile of the figure correspond quite closely to Dante's text, and the Botticelli-like character of the drapery is reminiscent of the latter's illustrations for *The Divine Comedy*.[777] There were very good reasons why he was attracted to this passage. Not only does Matilda start by explaining to Dante the movements of the air and water, and the origin of vegetation, but this "apparition of an extraordinary grace [...], undoubtedly represents, according to the interpreters, the earthly happiness [...] given to man in his state of innocence and more precisely in the garden of Eden."[778] One can imagine Leonardo following Dante towards this vision in which the grace of beauty is associated with the explanation of phenomena through their causes ("*per sua cagione*")

to dissipate the "mist surrounding intelligence." But he would not go further. Unlike the pointed index finger of Saint John the Baptist, Matilda's does not point towards heaven: it points to the world. Leonardo leaves it to the monks and friars to explain the invisible, because they "know all the mysteries through revelation."

("Sua cuique persona"): the person whom Leonardo has chosen as a screen for himself is that of the artist-philosopher, a lover of original beauty, creator of fictions, and curious investigator of all things, with the exception of God.

Fig. 328. *Young woman with pointing finger*,
after 1513, black chalk, 8¼ x 5¼ in. (21 x 13.5 cm.)
Windsor Castle, Royal Library, RL 12581.

TWO NOTES ON LEONARDO AND FREUD

A CHILDHOOD MEMORY
OR "THE MONKEY AND THE LITTLE KITE"[799]

Leonardo was the first artist of the Renaissance (and up until now the only one known) to have passed on an account of a "childhood memory," written in his own hand on folio 66v-b of the *Codex Atlanticus*. What this recollection describes is quite remarkable: "It appears that it is my destiny to write about the kite in particular because, in my first childhood memory, as I lay in my cradle, it seemed that a kite came to me and opened my mouth with its tail and struck me several times with its tail on the inside of my lips."[780] There is no doubt: Leonardo paid close attention to the psychic conditions of his intellectual and artistic activity.

This particular memory today plays an important part in the study of Leonardo's personality, and this is mainly because of what has been written on the subject since 1910 when Sigmund Freud wrote an essay about it, as brilliant as it was problematic: *A Childhood Memory of Leonardo da Vinci*. At the end of a long investigation, Freud succeeded in interpreting Leonardo's "memory" and translated it into "my mother pressed countless passionate kisses on my mouth."[781] In 1919, Freud still considered this text the "only beautiful thing" he had ever written.[782] However, in 1956, the art historian and theoretician Meyer Schapiro also wrote a long study of Leonardo's childhood memory and Freud's text, pointing out three types of error on which the Freudian interpretation of the "memory" was based:

– Freud read Leonardo's text in a bad German translation, which changed the kite into a vulture. This mistranslation considerably weakens the Freudian interpretation, because what mythology applied to the vulture (the hieroglyph for "mother" in Egypt, and the symbol of the Virgin for the Fathers of the Church) could not be applied to the kite. It would therefore be difficult to interpret Leonardo's fantasy as consisting of the "memory of having been suckled and kissed by his mother."

– Far from being exceptional, the central image in Leonardo's memory (the bird landing on the child's mouth) is the traditional image used in the most famous texts, from Antiquity to the *Golden Legend*, to announce the future of a hero based on an episode of his early childhood.

– Archive documents contradict the hypothesis that Leonardo was abandoned by his father during his early childhood and brought up by his mother Caterina on her own. As presented by Freud, Leonardo's childhood was an ill-founded reconstruction, based only on the mythical characteristics of a non-existent vulture that was unfortunately used to fill the gaps in existing documents.[783]

Furthermore, the study of the cult and representations of the *Madonna and Child and Saint Anne* in the fifteenth century rule out Freud's interpretation of the Louvre painting as an iconography invented by Leonardo to commemorate his "two mothers." In the end, Meyer Schapiro sees Freud's book as a "brilliant mind game" and states that there are "weaknesses which will be found in other works by psychoanalysis in the cultural fields: the habit of building explanations of complex phenomena on a single datum and the too little attention given to history and social conditions in dealing with individuals and even the origins of customs, beliefs and institutions."[784] So, while Freud's text has been strongly, and sometimes rigorously, defended by experts in the field of psychoanalysis,[785] art historians on the whole side with Meyer Schapiro in finding Freud's proposed interpretation "absurd."[786]

But it is necessary to review the material once again. The success of Meyer Schapiro's study has had the effect of making Leonardo's childhood memory "normal," almost banal. Yet its historical existence is in itself remarkable, and its content and context cannot be so easily diminished.

Freud's interpretation is undeniably based on mistakes and ignorance. But it is also true that there are two points in Leonardo's childhood memory that do not fit into the textual tradition mentioned by Meyer Schapiro: the detail of the tail in the mouth of an infant, and the fact that it belongs to a kite. Among the many winged animals to have landed on the mouth of a baby, according to tradition, include bees, a nightingale, a dove, an eagle—but never a kite. This bird has its own tradition, a whole series of specific connotations making it unlikely to be a bird of good omen. Its presence in Leonardo's memory therefore deserves more attention than art historians have given it. Freud asked "Where did this [kite] come from and how did it get there?"[787] and the question should also be asked in historical terms. It is not a question of looking for a "proof," for a contemporary text that would be identical to Leonardo's memory, or for a legend using the motif of the kite and the cradle. It is more a matter of reconstructing, even very partially, traces of current associations of ideas, of deciphering the "condensations" through which the kite might have acquired a latent meaning in about 1500,

reflecting the conscious meaning that Leonardo gave it when he turned it into the paradigm of the bird in flight. On the basis of suggestions, of resonances of words with words, of images with texts, it is possible to reconstruct a network of equivalents or analogies, a kind of dream-like, polymorphous bestiary, in the midst of which the kite of Leonardo's childhood memory may suddenly acquire its figurative power.[788]

The task is all the more justified in that Leonardo's "literary writings" contain a vast quantity of material drawn from scientific and folkloric tradition. Written down to satisfy his inexhaustible curiosity about behavior in life, these notes and disparate stories have been grouped by experts into broad categories, and they form the basis of Leonardo's bestiary, of his fables and his "prophecies." Although realizing the particular interest of the prophecies and attributing them to a childlike "playfulness" in Leonardo that would last throughout his life, Freud did not like to "see the master apply his energy on such futilites,"[789] so he failed to use this information in his interpretation of Leonardo's childhood memory. As a result, he missed vital information, all the more important in that it makes it possible to follow Leonardo's reworking of the texts from which he drew his inspiration. In one part of his writings, Leonardo reused and combined the traditional texts. If the kite only appeared as an "envious mother" in his bestiary, it was because he was happy to follow the negative tradition of the kite. Similarly, it would be wrong to attach too much importance to the fact that he twice mentioned the partridge's offspring as capable of finding its own real mother after its birth; Leonardo was after all, only quoting directly from the two different sources on which he based the whole of his bestiary.[790]

Leaving Leonardo's bestiary and prophecies,[791] it is worth concentrating on one particular fable: it provides the best explanation of this childhood memory and highlights the connections in the unconscious network linking the kite to the cradle, the *nibbio* to the *culla*.

"FABLE. A monkey, discovering a nest of young birds, approached the nest, full of joy. They were old enough to fly and the monkey could only catch the youngest one of them. Brimming over with happiness, the monkey took it back to its den; and looking at this little bird, she started to embrace it; and because of the passionate love she felt for it, she started to kiss it and turned and held it so tight that she finally took its life.

"This fable is for those who will suffer misfortune because they do not punish their children."[792]

This fable is found on folio 67r-a of the *Codex Atlanticus*, and the childhood memory itself is on folio 66v-b. This proximity may be a coincidence and, although Freud missed it because he deliberately ignored Leonardo's fables, it is curious that it did not attract the attention of one of the few art historians who have studied Leonardo's "dreams."[793] Yet, the fable of the monkey and the little bird seems to be remarkably similar to the "translation" Freud gave of Leonardo's childhood memory: "My mother pressed countless passionate kisses on my mouth."

The bird plays different parts in the fable and in the childhood memory: it is the baby who has become the little bird (and not the mother kite). The invention of this illegitimate offspring, suffocated with love, is all the more significant in that Leonardo uses here, again, a text by Pliny the Elder, and changes it by introducing his little bird: "Monkeys are extremely fond of their offspring. Tame monkeys who have given birth in our homes carry their young in their arms, show them to everyone, they are happy for us to stroke them, and they seem to understand the compliments we make them; as a result, they often kill them by holding them too tight."

This text is obviously the source that inspired Leonardo's fable of the monkey and the little bird. Leonardo has replaced the baby monkey in his mother's arms with a baby bird and, in giving the mammal an "illegitimate" offspring, he has also removed the detail of the "tame" monkey. This rearrangement by Leonardo creates a situation that is reminiscent of Leonardo's childhood. He was not abandoned by his father during his childhood but effectively taken in and adopted in a paternal house that was not his mother's "natural" house. One can picture his mother in the role of the "tame monkey," holding in her arms an offspring of a different species and suffocating it with over-possessive kisses.

The little bird of the fable therefore condenses a lot of material: it represents at the same time the kite at the cradle mentioned in the childhood memory, the illegitimacy of the offspring, and the censorship of an erotic fantasy (the kisses of the mother and the breast being sucked)—while at the same time the mother is endowed with a certain degree of threatening hostility, since she finally suffocates the baby bird. This element of menace also contributes to bringing out the similarity between the monkey of the fable and the kite of the childhood memory, since traditionally the kite presents a threat to is offspring.

Pliny's text starts with an equally suggestive remark about monkeys: "The animals closest to man identify each other by their tails." It was indeed the kite's

Fig. 329. Leonardo, *Study of coupling*, 1492–94,
pen and ink, 11¼ x 8 in. (28.4 x 20.2 cm.)
Windsor Castle, Royal Library, RL 19096.

tail that, in tradition as well as in the childhood memory, distinguished it among the birds of prey, and it is well known that the Italian word for bird (*uccello*) is the erotic term for a man's "tail," his sexual organ. From this point it would be possible to multiply the various associations of ideas *ad infinitum*, and the analysis of their interlockings would be endless. But this is not necessary, because it has already been shown that the childhood memory has its place in a more general network of associations of ideas, consisting of the anecdotes collected in the semi-scientific, semi-fabulous bestiary, in a tradition dating back to Pliny the Elder. The childhood memory was an expression and specific condensation of this, probably triggered by Leonardo's unconscious. Its expression came about through the secondary elaboration that consisted of his explanation that he was predestined to write about the flight of birds. The fable of the monkey and the little bird creates a mirror effect in relation to the childhood memory whereby monkeys and birds change roles, if not functions. In the childhood memory, the (excessively) affectionate mother is represented (disguised) as a kite, a jealous and repressive parent; in the fable, the mother is directly identifiable in this excessively loving monkey who ends up by suffocating her "bastard," this little bird that has every chance to be a little kite, a little *nibbio*, seized from its *culla*.

In spite of some factual errors, Freud's interpretation of Leonardo's childhood memory was probably not as incorrect as the partially historical study by Meyer Schapiro would suggest.

A "PRIMAL SCENE" BY LEONARDO

It was in about 1492–93 that Leonardo drew the sheet known as "coitus" (fig. 330), now in the Royal Library in Windsor, reference 19097v. Dating back to the period when Leonardo became seriously involved in dissection, the drawing "is one of the most incorrect by the artist from an anatomical point of view."[795] However, it was engraved at the end of eighteenth century and a lithograph of the engraving was included in the volume of *Original Designs of the Most Celebrated Masters in [...] His Majesty's Collection*, published by Chamberlaine in 1812. Thus this anatomical drawing by Leonardo was also one of the first to be reproduced and therefore became widely known. In 1917, Doctor Reitler commented on the anomalies, seeing in them the

expression of a "libidinous repression that almost led astray this great artist and researcher." In 1919, Freud quoted Reitler's text in the notes of the second edition of his own work *A Childhood Memory of Leonardo da Vinci*, and he thought Reitler's interpretation was quite close to his own "characterization" of Leonardo. But in 1923 Freud dissociated himself from Reitler's "exposition," observing that Reitler was drawing excessively "serious conclusions" from a "hasty drawing" of which "it is not even certain that all the parts [...] go together."[796]

By looking at the drawing in its historical context, it can be seen that, although the drawing is not as "hasty" as Freud thought it was (who admittedly had based his judgment on the lithography reproducing the engraving that in turn reproduced the original drawing), the anomalies noted by Reitler corresponded to the scholarly concepts prevalent at the end of the fifteenth century. It would therefore be difficult to draw any conclusions from it regarding Leonardo's psyche or sexuality. However, the clearly imaginative nature of this "anatomy" shows that it involved other considerations besides scientific ones. In order to try and define these considerations, the elements that actually belong to the artist must be extracted from the drawing by a kind of progressive approximation.

The sheet belongs to the first wave of anatomical drawings in which Leonardo still very much interpreted what he saw on the basis of what he knew. The double curvature of the male spinal column was a unique observation at the time, but the rest of the drawing abounds with errors and anomalies that are the result of his respect for tradition. Thus Reitler believed that by connecting the woman's breast directly to her sexual organs by the "galactophorous canal," Leonardo "tried to depict the coincidence in time of the beginning of lactation and the end of pregnancy, on the basis of sensible anatomical positioning."[797] Reitler was correct, and this unusual detail was still present in about 1509 in the drawing showing the woman's organs (fig. 198). The reason was that Leonardo was following the medieval tradition in which the mother's milk came from the menstrual blood that no longer flowed out her body during pregnancy; this blood nourished the child during pregnancy and continued to do so after it was born because, in the words of Isidore of Seville, what remained of it "flows through a natural passage to the breasts, and whitened by their virtue, this blood becomes milk."[798] In the same way, Leonardo was following Avicenna's theory in making a channel from the bone marrow that passed through the top part of the male sexual organ, and linking the testicles

Fig. 330. *The coupling of a male half-body and a female half-body.*
c. 1492–93, pen and ink, 10¾ x 8 in. (27.3 x 20.2 cm.)
Windsor Castle, Royal Library, RL 19097v.

to the heart by another channel: the first infused the "animal spirit" from the bone marrow, while the second linked the testicles, "sources of ardor," to the heart, seat of the emotions.[799]

Nothing very original up till now. But looking at the page as a whole, the texts and drawings mixed together reveal much more complex personal considerations.

Representing an anatomical section that defied representation, recording a scene that was actually impossible to observe, the drawing puts forward a (seemingly convincing) hypothesis on the process of procreation and replaces the impossibility of seeing with the evidence of the drawing. Leonardo proposed a theoretical fiction that would visually satisfy the insatiable curiosity of the researcher. Leonardo's attitude is quite significant here because this is not the only drawing of its kind. The Windsor sheet 19096 (fig. 329) has three sketches of coitus, one fairly advanced, and on the verso two more, very hasty. Drawing 19097v (fig. 330) is the most finished in this series: it reworks the previous drawings and extracts from them a clear picture of what they are trying to convey. Leonardo would not return to the subject; his interest in procreation and its processes having waned, he next turned to the "demonstration" of the embryo and its position in the uterus. It is no coincidence if one of these embryo drawings (RL, 19101r) is accompanied by a long text stating the descriptive superiority of painting over poetry. When the poet depicted with words what existed in nature, he "would be the equal of the painter if he could satisfy the eye with words as the painter does."[800] Drawing 19097v was therefore also supposed to "satisfy the eye." But what kind of satisfaction could this be? Leonardo had already expressed elsewhere his repugnance regarding the sexual act,[801] and it would be hard to reduce the significance of the drawing to the banality of the text placed near the mouth of the male figure: "With the help of these figures will be demonstrated/ the reason for many perils/ wounds and illnesses" ("*Per queste figure si dimostrera/ la cagione di molti pericoli/ di feriti e malattie*").

What kind of satisfaction would this give to Leonardo's eye? The drawing must be examined closely, because while it is the most finished in the series of the coitus drawings, the degree of finish of the figures is uneven, and this difference in finish provides certain clues regarding the Leonardo's interest in this type of representation.

Reitler had already noticed the difference in the treatment that distinguished the "demonstration" of the male and female genitals: the man's are depicted

"much more correctly" than the woman's, which are represented "with negligence."[802] But this difference was not in itself significant: it could be explained by the fact that Leonardo had problems mentally dissecting these organs. The difference in rendering between the two figures is, on the other hand, undeniably present in the overall representation of the two bodies. Although the feet are absent in both bodies, the representation of the male body is much more complete than that of the female body. The upper part of the woman's body has been left completely unfinished, and the internal organs have been reduced to the reproductive organs: it has no heart or digestive system, both of which are present in the male figure. But this was not negligence on Leonardo's part: presented in this manner, the body of the woman was only considered from the point of view of her reproductive function, and this function does not make a woman a "person" (the absence of a face is particularly striking). There is a text written above the woman's breast, as it were interrupting and replacing the upper part of the figure. It was the only text present on this part of the page until Leonardo introduced the pre-emptive observations legitimizing his drawing *a posteriori*. The content of this text is not uninteresting; situated at the level of the male heart and above the female breast, it says: "Division of the spiritual and material parts" ("*Divisione delli parti spi/rituali dalle materiali*"). Acting as an explanatory caption for this part of the drawing, and in the absence of a representation of the female head, it reinforces the idea that the woman is here only "material": she is only the physiological receptacle and the "spiritual" plays no part in her reproductive function, unlike in man in whom the same function is linked to the heart and the brain.

But in this Leonardo was only following the tradition that prevailed at the end of the Middle Ages. According to Aristotle, as interpreted by Albertus Magnus in particular, the blood with which the woman contributed to procreation was "an informal matter [...] while the sperm represents a purely masculine shape (*homunculus*) which, imposing itself on the menstrual matter in the act of conception, creates the fetus—formed in the image of man as man had been created in the image of God."[803] With the Christian myth, this inferiority of the reproductive woman became inseparable from the conditions of her own creation by God (from the rib of Adam), and the responsibility attributed to Eve for original sin. Medieval misogyny is well-known, but it may be useful—in relation to the panic, fear, and fascination inspired by the female sex—to evoke the image of woman drawn up by the German Dominicans, Heinrich Kramer and Jakobus Sprenger, in 1486 to explain that there were

497

more witches "among the weaker sex of women [...] than among men." Having recalled that "she is more carnal than man [... and that] there was a defect in the creation of the first woman," they do not hesitate to quote a twelfth century text without reservation: "This monster takes on a triple form: it adorns itself with the noble face of a lion, it sullies itself with the belly of a goat, it is armed with the venomous tail of a scorpion. This means: its appearance is beautiful, its contact fetid, its company fatal."[804]

This attitude was therefore not a characteristic unique to Leonardo, who, probably along with a number of his contemporaries, shared the misogynous view of women that the Renaissance would change (not completely but to a great extent), and which, because of his own interest in embryology, would also change for him.[805] The most personal part of the drawing of 1492–93, is not the anatomical fictions that are scientifically and ideologically traditional. The personal considerations of the drawing can be isolated by looking at the context of the page as a whole, against the background of the layout and in the development that this layout of the page reflects.

Approximately in the center of the page, a column of text provides a context for the drawing by linking it to a series of "precise" questions regarding human reproduction.[807] In this case, the writing scientifically legitimizes the drawing, a legitimization that Leonardo would emphasize further by the "pre-emptive" medical warning mentioned above.

At the top, there is another text, which would appear to be the title for the entire page because of its position, although it only mentions the double figure. The wording of the title is interesting in itself. After having written at a first stage: "I reveal to men the origin/of the second reason of their being," Leonardo added between the lines "the first or maybe the second." The whole text finally read: "I reveal to men the origin of the first or maybe the second reason of their being" ("*Jo schopro alli omini l'origine/prima or forse sechonda/della sechonda chagione di loro essere*"). This correction was not neutral: in the first formula, coitus was only the secondary cause of human existence, the first cause evidently was God, who created man in his image. On reflection, Leonardo then made sexual intercourse the first (or maybe the second) cause of human existence—and this reversal expressed in the shape of hesitation says much about his personal beliefs.[808]

Yet again the interest of this title (whose wording is very personal, arrogant rather than scientific) lies elsewhere at least as far as we are concerned. Because it was not only to other men that Leonardo revealed the origin of

their existence on earth, he also revealed the origin of his own existence to himself—and it is impossible not to mention here the "primal scene" of "The Wolf Man" as interpreted by Freud. With this carefully worked-out drawing, Leonardo only depicted the "image [...] of coitus performed in rather unusual circumstances and particularly favorable to observation."[809] It is even harder not to make a connection with the "primal scene" in that the drawing of coitus is not the only one on the page. Further down, below the column of scientific text, Leonardo has drawn two representations of the anatomy of an erect penis (another piece of imagination: how could one dissect an erect penis?). The first section is in profile, horizontal, showing the two internal channels of the organ; the second, in three-quarter view, shows the organ cut perpendicularly to its axis, its front part forming a 90-degree angle with the back part and the testicles. How can one fail to recognize here, under what the title of this page describes as "original coitus," an image of castration, the fear of which is reflected, according to Freud, in the scene (observed or imagined) of parental coitus, first (or perhaps the second) cause of life?

Eissler's blindness on this point is all the more surprising in that he reproduced the whole page and drew attention both to the approximate nature of the anatomy of the penis in Leonardo and to his "fear of castration."[810] But it is true that Eissler looked at the drawing out of context. Unlike the sketches that preceded it, Leonardo placed the scene of coitus in the middle of the page, with the texts and additional drawings providing a personal glossary to the main drawing.

In order to interpret this glossary, it is necessary to decipher this page in the order of the successive stages of its realization: from right to left and top to bottom, following Leonardo's left-handed custom. Having represented the original coitus, Leonardo depicted castration, but he did not stop there. Framed by the castrated organ, he then sketched a male torso, without face, head, arms, legs or sexual organs, on which he drew a grid from a system of proportion.[811] It is as if in the frontal presentation of this bust, which looks almost protected by the links of an ideal network, and in order to complete this journey back to the beginning, Leonardo has returned to the pure visibility of the "opaque body." It is as if painting, *cosa mentale*, the invention and the harmonious construction of a visible beauty, were for him the conclusion and the "screen response" (impersonal, universal and true) to the questions and anguish caused by the "origin of the first cause" of his own existence.

NOTES

1. C. Pedretti, "Eccetera: perché la minestra si fredda," *XV Lettura Vinciana*, Florence, 1975; M. Kemp, *Leonardo da Vinci. The Marvellous Works of Nature and Man*, London–Cambridge (Mass.), 1981 (edition consulted, Milan, 1982).
2. K. Clark, *Leonardo da Vinci*, intro. M. Kemp, New York, 1988 (edition consulted, *Léonard de Vinci*, Paris, 1967, p. 11).
3. A. M. Brizio, "Presentazione dei Codici di Madrid" *(Lettura Vinciana*, 30.9.1974), Florence, 1975.
4. See C. Pedretti, *Fragments at Windsor Castle from the Codex Atlanticus*, London, 1957, and K. Steinitz, "Le dessin de Léonard de Vinci pour la représentation de la *Danaé* de Baldassare Taccone," in *Le Lieu théâtral à la Renaissance* (ed. J. Jacquot), Paris, 1968, p. 39.
5. P. Duhem, *Études sur Léonard de Vinci. Ceux qu'il a lus et ceux qui l'ont lu*, Paris, 1906–13, 4 vol.
6. P. Galluzzi, "La Carrière d'un technologue," in *Léonard de Vinci, ingénieur et architecte*, Montreal, 1987, pp. 41–109, 317–19.
7. See A. Marinoni, "L'écrivain," in *Léonard de Vinci. L'humaniste, l'artiste, l'inventeur*, Paris, 1974, p. 302, n. 27.
8. See J.D. Passavant, *Raphaël d'Urbin et son père Giovanni Santi*, Paris, 1858–60, I, pp. 423–28. On the relationship between Raphael, Perugino and Leonardo, see D. A. Brown, "Raphael, Leonardo, and Perugino: Fame and Fortune in Florence," in *Leonardo, Michelangelo, and Raphael in Renaissance Florence from 1500 to 1508*, Washington, 1992, pp. 29–53.
9. M. Kemp, "Leonardo verso il 1500," in *Leonardo e Venezia*, Milan, 1992, p. 45.
10. On the successive "inventions," see R. Turner, *Inventing Leonardo*, New York, 1993.
11. R. Turner, "Words and pictures: the birth and death of Leonardo's *Medusa*," *Arte Lombarda*, 1983, 3, pp. 108ff.
12. G. Vasari, *Lives of the Artists*, tr. G. Bull, Harmondsworth, England, 1965 (edition consulted, *Les Vies des meilleurs peintres, architectes et sculpteurs*, Paris, 1983, 5, pp. 37–38).
13. Turner, *Inventing...*, op. cit., p. 117.
14. On Leonardo's fortunes at the end of the nineteenth century, see J.-P. Guillerm, *Tombeau de Léonard de Vinci. Le peintre et ses tableaux dans l'écriture symboliste et décadente*, Lille, 1981.
15. On Leonardo's reading, see G. de Santillana, "Léonard et ceux qu'il n'a pas lus," in *Léonard de Vinci et l'expérience scientifique au seizième siècle*, Paris, 1953, pp. 43–59; A. Marinoni, "I libri di Leonardo," in Leonardo da Vinci, *Scritti letterari*, Milan, 1974, pp. 239–257, and "La biblioteca di Leonardo," in *Raccolta Vinciana*, XXII, Milan, 1987, pp. 292–342.
16. See M. Warnke, *L'Artiste et la cour. Aux origines de l'art moderne*, Paris, 1985, p. 220.
17. E. Gombrich, "The Form of Movement in Water and Air" in *The Heritage of Apelles*, Ithaca, 1976 (edition consulted, "Les formes en mouvement de l'eau et de l'air dans les Carnets de Léonard de Vinci," in *L'Écologie des images*, Paris, 1983, pp. 209–210); Kemp, *Leonardo...*, op. cit., p. 318.
18. C. Dionisotti, "Leonardo, uomo di lettere," *Italia Mediœvale e Umanistica*, V, 1962, pp. 208–209 (who however exaggerated the range of this conflict slightly).
19. See among other texts of A. Koyré, *Du Monde clos à l'univers infini*, Paris, 1962 (1957), pp. 17–36.
20. G. Pico della Mirandola, *Oratio de Dignitate Hominis*, in *Œuvres philosophiques*, Paris, 1993, p. 7.
21. Ovid, *Metamorphoses* (edition consulted, *Métamorphoses*, Paris, 1988, XV, 178); A. Chastel, *Art et Humanisme à Florence au temps de Laurent le Magnifique*, Paris, 1959, pp. 414–16.
22. A. Marinoni, "L'Essere del nulla" (1960), in *Leonardo da Vinci letto e commentato*, Florence, 1974, p. 18.
23. See among others, J. Shearman, *Mannerism*, Harmondsworth, 1967.
24. D. Rosand, *The Meaning of the Mark: Leonardo and Titian*, The Spencer Museum of Art, University of Kansas, 1988 (edition consulted, *La Trace de l'artiste. Léonard et Titien*, Paris, 1993, p. 44).
25. Vasari, *Lives...*, op. cit., p. 19.
26. E. Benveniste, "La notion de 'rythme' dans son expression linguistique" (1951), in *Problèmes de linguistique générale*, I, Paris, 1966, p. 333.
27. In the sense that E. Panofsky gave it, after E. Cassirer, that is, a form as a result of which "un contenu signifiant d'ordre intelligible s'attache à un signe concret d'ordre sensible pour s'identifier profondément à lui," *La Perspective comme forme symbolique* (1925), Paris, 1975, p. 78.
28. Pedretti, "*Eccetera...*," op. cit., p. 31.
29. Vasari, *Lives...*, op. cit., pp. 31, 46; G. P. Lomazzo, *Idea del Tempio della pittura* (1590), ed. R. Klein, Florence, 1974, I, p. 148.
30. See Chastel, *Art et Humanisme...*, op. cit., pp. 501–02.
31. Phyllis Williams Lehmann and Karel Lehmann, *Samothracian Reflection. Aspects of the Revival of the Antique*, Princeton, 1973, pp. 15–47.
32. H. Ost, *Das Leonardo-Porträt in der Kgl. Bibliothek Turin und andere Fälschungen des Giuseppe Bossi*, Berlin, 1980.
33. B. Castiglione, *The Book of the Courtier* (*Le Livre du Courtisan*, Paris, 1987, ed. A. Pons, II, 39, p. 158).
34. K. Jaspers, *Lionardo als Philosoph*, Berne, 1953; Chastel,

"Léonard et la culture" (1952), in *Fables, Formes, Figures*, II, Paris, 1987, pp. 251–77.

35. Leonardo's expression directly recalls Marsilio Ficino who had defined beauty as "actus vivacitas et gratia quaedam in fluxu ipso refulgens." Further on the central significance of the idea of *impetus* in Leonardo's "natural philosophy" will be seen; see Marinoni, "L'écrivain," *op. cit.,* p. 80.

36. There is an echo here of the possible rivalries in the Milan court mentioned by Dionisotti, "Leonardo, uomo di lettere," *op. cit.*

37. On this division, see C. Maccagni, "Considerazioni preliminari alla lettura di Leonardo," in *Leonardo e l'età della ragione*, edited by E. Bellone and P. Rossi, Milan, 1982, pp. 53ff., and "Scienza e tecnica in Emilia e Romagna al tempo del Codice Hammer," in *Leonardo: il Codice Hammer e la Mappa di Imola presentati da Carlo Pedretti*, Florence, 1985, p. 176; A. Marinoni, "La biblioteca di Leonardo," *Raccolta Vinciana*, XXII, 1987, p. 297.

38. On the two hundred works read by Leonardo, see Maccagni, "Riconsiderando il problema delle fonti di Leonardo" (1970), in *Leonardo da Vinci letto e commentato*, Florence, 1974, p. 306.

39. These five books were Donato's Latin grammar, a *Lapidario*, Pliny, a book of *abaco*, and Morgante, see Marinoni, "La biblioteca...," *op. cit.,* p. 319. These are found in the other lists drawn up by Leonardo.

40. Quoted by Marinoni, "La biblioteca," *op. cit.,* pp. 316–17.

41. For a detailed analysis of the works in Leonardo's library, see Marinoni, "I libri di Leonardo," in Leonardo da Vinci, *Scritti letterari, op. cit.,* pp. 239–57.

42. From the few documents concerning his father and his family, one might suppose that Leonardo lived in Florence from 1465, the date of his father's second marriage. It was therefore probably in Florence that he followed the courses of the *abaco* before entering Verrocchio's studio at about fifteen years old.

43. On the *abaco* schools, see Maccagni, "Considerazioni...," *op. cit.,* pp. 57–60; P. F. Grendler, *Schooling in Renaissance Italy. Literacy and Learning, 1300–1600*, Baltimore–London, 1989, pp. 275ff.

44. See Grendler, *Schooling..., op. cit.,* p. 299.

45. Quoted by Grendler, *Schooling..., op. cit.,* p. 311.

46. See Maccagni, "Considerazioni...," *op. cit.,* p. 54.

47. On writing *alla mercantesca*, see Grendler, *Schooling..., op. cit.,* p. 325. On other left-handed people writing from right to left, see Maccagni, "Considerazioni...," *op. cit.,* p. 67, n. 50.

48. See Maccagni, "Riconsiderando...," in *Leonardo da Vinci letto..., op. cit.,* p. 298.

49. On Leonardo's attempts to learn Latin, see among others, Marinoni, "Saggio dagli appunti grammaticali e lessicali di Leonardo," in Leonardo da Vinci, *Scritti letterari, op. cit.,* pp. 227–31.

50. See E. Garin, "La città in Leonardo" (1971), in *Leonardo da Vinci letto..., op. cit.,* p. 317, n. 2. On Leonard's sources, see also Garin, "Il problema delle fonti del pensiero di Leonardo" (1953), in *La cultura filosofica del Rinascimento italiano*, Florence, 1961, pp. 388–401.

51. Kemp emphasizes the number of these scholarly books in Leonardo's library (*Leonardo da Vinci, op. cit.,* p. 293).

52. See Marinoni, "Leonardo e Euclide," in Leonardo da Vinci, *Scritti letterari, op. cit.,* pp. 258–267.

53. On his acquaintance with Pacioli, see also P. Galluzzi, "Leonardo, Pacioli e Savasorda," in *Leonardo dopo Milano. La Madonna dei fusi* (1501), Florence, 1982, pp. 87–91.

54. See *Codex Atlanticus* 225r-b: "Ricorda a Gioannino Bombardieri del modo come si murò la torre di Ferrara sanza buche. Dimanda maestro Antonio come si piantan bombarde e bastioni di dì o di notte. Domand'a Benedetto Portinari in che modo si corre per lo ghiaccio in Fiandra. Fatti mostrare al maestro d'abbaco riquadrare uno triangolo. Truova un maestro d'acqua, e fatti dire i ripari d'essa, e quello che costa un riparo, e una conca, e uno navilio, e uno mulino alla lombarda," quoted by Kemp, *Leonardo da Vinci..., op. cit.,* p. 90.

55. A. Koyré emphasized the importance of oral culture in Italy in the fifteenth century, "Léonard de Vinci 500 ans après" (1953), in *Études d'histoire de la pensée scientifique*, Paris, 1973 (1966), pp. 105–106.

56. See P. Sergescu, "Léonard de Vinci et les mathématiques," in *Léonard de Vinci et l'expérience scientifique au seizième siècle*, Paris, 1953, p. 76: "Toutes les diminutions de cylindres plus hautes que le cube conservent le nom de cylindre. Toutes les réductions de cylindres plus basses que le cube se nomment des planches." (*Forster*, I, 40).

57. See Koyré, "Léonard de Vinci 500 ans après," *op. cit.,* p. 113.

58. See J. Ackermann, "Leonardo's Eye," *Journal of the Warburg and Courtauld Institutes*, XLI, 1978, pp. 125–26. Chastel pointed out an equivalent practice to describe the problem posed in architecture by the curving of lintels, "Les problèmes de l'architecture de Léonard dans le cadre de ses théories scientifiques," in *Léonard de Vinci, ingénieur et architecte*, Montreal, 1987, p. 201.

59. See Marinoni, "Saggio dagli appunti...," *op. cit.,* pp. 232–36.

60. *Ibid.*, p. 238.

61. "Sommergere, s'intende le cose ch'entranno sotto l'acque. Intersegazione d'acque, fia quando l'un fiume sega l'altro. Risaltazione, circolazione, revoluzione, ravvoltamento, raggiramento, sommergimento, surgimento, declinazione, elevazione, cavamento, consumamento, percussione, ruinamento, discenso, impetuità, retrosi, urtamenti, confregazioni, ondazioni, rigamenti, bollimenti, ricascamenti, ritardamenti, scatorire, versare, arriver sciamenti, riattufamenti, serpeggianti, rigore, mormorii, strepidi, ringorare, ricalcitrare, frusso e refrusso, ruine, conquassamenti, balatri, spelonche delle ripe, revertigine, precipizii, reversciamenti, tomulto, confusioni, ruine tempestose, equazioni, egualità, arazione di pietre, urtamento, bollori, sommergimenti dell'onde superficiali, retardamenti, rompimenti, dividimenti, aprimenti, celerità, veemenzia, furiosità, impetuosità, concorso, declinazione,

commistamento, revoluzione, cascamento, sbalzamento, conrusione d'argine, confuscamenti," quoted by Gombrich, "Les formes en mouvement...," *op. cit.*, p. 213, n. 18.

62. C. Landino, "Prolusione petrarchesca" (1467), in *Scritti critici e teorici*, edited by R. Cardini, Rome, 1974, I. pp. 33–40, quoted by Marinoni, "Saggio...," *op. cit.*, pp. 231–32.

63. Giving these terms the meaning that Roland Barthes gave them in *Le Degré zéro de l'écriture* (1953): language is "like a Nature that passes wholly through the word of the writer"; style "is the product of a pressure, not of an intention, it is like a solitary, vertical dimension of thought"; writing is "the general choice of a tone, [...] Language and style are the objects; writing is a function: it is the relationship between creation and society" (in *Œuvres complètes*, Paris, 1993, I. pp. 145–47).

64. The expression is that of G. de Santillana, "Léonard de Vinci...," *op. cit.*, p. 45.

65. *Ibid.*, p. 45.

66. Marinoni, "Leonardo as a writer," in *Leonardo and His Legacy, An International Symposium*, ed. C.D. O'Malley, Berkeley–Los Angeles, 1969, p. 63.

67. See Marinoni, "La biblioteca...," *op. cit.*, pp. 303–04.

68. See Léonard de Vinci, *Scritti letterari*, *op. cit.*, pp. 190–93, 194–99. Chastel did not hesitate to include these two fictitious letters in his "edition" of the *Treatise on Painting*, *Traité de la peinture*, Paris, 1960, pp. 57-62. Indeed he saw in them "des descriptions de tableaux imaginaires, l'exploration de tableaux impossibles, dont les moyens provisoires—mais commodes—de la littérature soutiennent la complexité" (p. 57).

69. Marinoni, "Leonardo as a writer," *op. cit.*, p. 65.

70. For a recent viewpoint on the practices of Florentine studios, see *Maestri e botteghe. Pittura a Firenze alla fine del Quattrocento*, Florence, 1992, ed. M. Gregori, A. Paolucci, C. Acidini Luchinat.

71. According to A. Cecchi, "Percorso di Baccio d'Agnolo legnaiuolo ecc.," *Antichità viva*, 1, 1990, p. 42, n. 11, Florence had 54 *botteghe* for working marble, 40 goldsmiths, and 84 woodworking shops; see P. Adorno, *Il Verrocchio. Nuove proposte nella civiltà artistica del tempo di Lorenzo il Magnifico*, Florence, 1991, p. 31. In 1472, the city also had 270 workshops for wool, 83 for silk, and 70 butchers, see B. Kempers, *Painting, Power and Patronage. The Rise of the Professional Artist in Renaissance Italy* (1987), London, 1992, p. 348, n. 8. Pedretti (*Leonardo architetto*, Milan, 1981, p. 14) points out that the tradition of the machinery of Brunelleschi was conveyed to Leonardo through Verrocchio's studio, notably during the task of installing the gilded copper sphere on the top of the lantern of the cathedral, an operation on which Verrocchio was working from 1468 until May 27, 1471.

72. The expression is from P. Marani, who raised the question of the *Baptism of Christ* in *Léonard de Vinci. Catalogue complet* (1989), Paris, 1991, pp. 41-45; see also A. Bernacchioni, "Le botteghe di pittura: luoghi, strutture e attività" in *Maestri e botteghe...*, *op. cit.*, pp. 37–38.

On the collaboration between Leonardo and Lorenzo di Credi on the Louvre *Annunciation*, see J.-P. Cuzin, in *Léonard de Vinci. Draperies*, Paris, 1989, pp. 100–03.

73. On the studio's technique with draperies, see *Léonard de Vinci. Draperies*, *op. cit.*, especially pp. 38–39.

74. *Ibid.*, pp. 44–55.

75. See Pedretti, "Les " draperies " habitées," in *Léonard de Vinci. Draperies*, *op. cit.*, p. 18. In the same catalogue, see the excellent analysis by F. Viatte, "Corpo vestito d'ombre" (pp. 21–33), which draws out the technical, historical and theoretical implications of these exercises.

76. Vasari, *Lives...*, *op. cit.*, 5, p. 19. For Alberti on grace and movement, see L. Alberti, *On Painting and Sculpture*, tr. C. Grayson, London, 1972 (edition consulted, *De la peinture–De Pictura (1435)*, Paris, 1992, pp. 184–89 [II, 44–45]).

77. See J. Shearman, "Leonardo's Colour and Chiaroscuro," *Zeitschrift für Kunstgeschichte*, XXV, 1962, pp. 13–47. See Viatte, "Corpo vestito...," *op. cit.*, p. 27, bringing to mind the passage where Vasari recalls the "darkest depths" of Leonardo that have the effect "of not leaving any light areas and evoking night rather than the delicate light of day" (Vasari, *Lives...*, *op. cit.*, p. 38).

78. The connection was made by Chastel, "Léonard: pans et plis," in *Léonard de Vinci. Draperies*, *op. cit.*, p. 11.

79. See Chastel, *Léonard de Vinci par lui-même*, Paris, 1952, pp. 13–14.

80. See Kemp, *Leonardo da Vinci*, *op. cit.*, p. 293: "Libro primo dell'acque in sé; libro 2° del mare; libro 3° delle vene; libro 4° de'fiumi; libro 5° delle nature de'fondi; libro 6° delli obietti; libro 7° delle ghiaje; libro 8° della superfizie de l'acqua; libro 9° delle cose che in quella son mosse; libro 10° de'ripari de'fiumi; libro 11° delli condotti; libro 12° de'canali; libro 13° delli strumenti volti dall'acqua; libro 14° della fare monatre l'acque; libro 15° delle cose consumate dall'acque." The note on folio 35r of the *Codex Leicester* was pointed out by Pedretti, "Presentazione," in *Leonardo: Il Codice Hammer...*, *op. cit.*, p. 23.

81. Maccagni, "Riconsiderando...," *op. cit.*, p. 292.

82. See *Leonardo: Il Codice Hammer...*, *op. cit.*, p. 46.

83. See Maccagni, "Riconsiderando...," *op. cit.*, pp. 292–293.

84. *Ibid.*, p. 294.

85. See Clark–Pedretti, *Leonardo da Vinci. Drawings at Windsor Castle*, London, 1968, I. pp. 135–37.

86. See Marinoni, "Les machines impossibles de Léonard," in *Léonard de Vinci ingénieur et architecte*, *op. cit.*, pp. 127–29.

87. C. Pedretti, *Leonardo da Vinci. Studi di Natura dalla Biblioteca Reale nel Castello di Windsor*, Florence, 1982, pp. 35–36.

88. See Gombrich, "The Form of Movement...," *op. cit.*, p. 186.

89. See J. Ackermann, "Leonardo's Eye," *op. cit.*, p. 121.

90. *Ibid.*, p. 98. Ackermann points out (p. 134) that, towards 1490, Leonardo identified and understood the function of the pupil but he could not coordinate his observation with his own system of understanding. This kind of impasse also arises in relation to anatomy.

91. Chastel, "Introduction," in Leonardo da Vinci, *Traité de la peinture, op. cit.,* p. XV.

92. E. Winternitz, "Léonard et la musique," in *Léonard de Vinci. L'humaniste…, op. cit.,* pp. 121–25. The wind instrument with a complete keyboard, as invented in Munich in 1832; the *glissando* instrument had no successor apart from the "etherophone," an electronic instrument invented in 1924 by the Soviet engineer Léon Thérémin (Winternitz, p. 122).

93. For its reconstruction, see K. Steinitz, "Leonardo architetto teatrale e organizzatore di feste," in *Leonardo letto e commentato, op. cit.,* pp. 253, 268–69, 271–73.

94. See Clark, "Leonardo and the Antique," in *Leonardo's Legacy, op. cit.,* pp. 28–29.

95. On Francesco di Giorgio, see *Francesco di Giorgio e il Rinascimento a Siena, 1450-1500,* ed. L. Bellosi, Milan, 1993, 2 vol.

96. On this theme, after F. Saxl, "Science and Art in the Italian Renaissance" (1938), in *Lectures,* London, 1957, pp. 111–24, in particular pp. 118ff., see E. Panofsky, "Artist, scientist, genius: notes on the 'Renaissance Dämmerung'" in *The Renaissance: A Symposium,* New York, 1953 (edition consulted, *L'Œuvre d'art et ses significations. Essais sur les "arts visuels,"* Paris, 1969, pp. 101–34), and, among others, J. Ackerman, "The Involvement of Artists in Renaissance Science," in *Science and the Arts in the Renaissance,* ed. J.W. Shirley–F. D. Hoeniger, Washington–London–Toronto, 1985, pp. 94–129.

97. Vasari, *Lives…, op. cit.,* 5, p. 34.

98. According to Sergescu, "Léonard de Vinci et les mathématiques," *op. cit.,* these inventions amounted to about three hundred in all.

99. See Santillana, "Léonard et ceux qu'il n'a pas lus," *op. cit.,* p. 44. The connection between Leonardo and Daedalus was made by Santillana, *ibid.*

100. Koyré, "Léonard 500 ans après," *op. cit.,* p. 109.

101. See Sergescu, *op. cit.,* pp. 86–87.

102. See Sergescu, *op. cit.,* p. 80.

103. According to Ackermann, "Leonardo's Eye," *op. cit.,* p. 125, Leonardo's optical vocabulary shows a good knowledge of the basic scientific texts.

104. On this development, see Galluzzi, "La carrière…," *op. cit.,* pp. 73–76.

105. Koyré, "Léonard de Vinci…," *op. cit.,* p. 110.

106. See Ackermann, "Leonardo's eye," *op. cit.,* p. 128, n. 59, and Kemp, *Leonardo da Vinci, op. cit.,* pp. 308–10. This attitude is found in relation to anatomy in general, see later.

107. Kemp, *Leonardo da Vinci, op. cit.,* p. 92.

108. See P. Francastel, *Peinture et société* (1950), Paris, 1977, p. 115.

109. E. Cassirer, *Individuum und Kosmos in der Philosophie der Renaissance,* Leipzig–Berlin, 1927 (edition consulted, *Individu et cosmos dans la philosophie de la Renaissance,* 1927, Paris, 1983, p. 68).

110. See J. K. Gadol, *Leon Battista Alberti: Universal Man of the Early Renaissance,* Chicago, 1969 (edition consulted, *Leon Battista Alberti. Homme universel de la Renaissance,* Paris, 1995, p. 183, n. 68).

111. On the writing of Nicholas of Cusa, see A. Minazzoli, "Introduction" in *Nicolas de Cues, Le Tableau ou la vision de Dieu,* Paris, 1986, pp. 25–28.

112. E. Garin, "Il problema delle fonti…," *op. cit.,* p. 395.

113. On these phrases, see R. Klibansky, "Copernic et Nicolas de Cues," in *Léonard et la culture scientifique, op. cit.,* p. 229.

114. See Marinoni, "L'écrivain," *op. cit.,* pp. 73–74.

115. See R. Dugas, "Léonard de Vinci dans l'histoire de la mécanique," in *Léonard de Vinci et l'expérience scientifique…, op. cit.,* pp. 92–93.

116. *De transmutationibus geometricis* is dedicated to Paolo dal Pozzo Toscanelli. The latter, a famous doctor and master at the *abaco* school, friend and adviser of Brunelleschi, author of a little treatise on perspective in Italian, was probably known to Leonardo (see A. Parronchi, "Della Prospettiva di Paolo dal Pozzo Toscanelli," in *Studi sulla dolce prospettiva,* Milan, 1964, pp. 583ff., in particular pp. 588–93). Furthermore, Leonardo had written his name on a folio of the *Codex Atlanticus* (as someone to consult? See Richter, 1439). Also, the first Italian edition of the works of Nicholas of Cusa was made at Corte Maggiore, near Milan, in 1502—at the expense of the Marquis of Pallavicini with whose family Leonardo had been in contact— and it was dedicated to Georges d'Amboise, governor of Milan and Leonardo's patron. On these matters, see R. Klibansky, "Copernic et…," in *Léonard de Vinci et l'expérience scientifique…, op. cit.,* pp. 225–26.

117. Quoted by Cassirer, *Individuum…, op. cit.,* p. 67.

118. Nicholas of Cusa, *De idiota,* in Cassirer, *Individuum…, op. cit.,* pp. 292–93. On painting as a model of Nicholas of Cusa's thought, see A. Minazzoli, "Introduction" *op. cit.,* pp. 16–17. From a humanist point of view, the thinking of Nicholas of Cusa could almost pass for a philosophical variation on a theme inspired by Pliny the Elder, and set at the end of the Quattrocento: art "always begun and unfinished" (*inchoata semper arte et imperfecta*); see, in 1488, Politian's reflection in his *Liber Miscellaneorum* (1489), quoted by V. Juren, "Fecit Faciebat," *La Revue de l'Art,* 26, 1974, p. 29, n. 8.

119. On the thought of Nicholas of Cusa in general, see M. de Gandillac, *La Philosophie de Nicolas de Cues,* Paris, 1941.

120. RL, 19019r, quoted in Kemp, *Leonardo da Vinci…, op. cit.,* p. 112.

121. Michel Foucault, *Les Mots et les choses. Une archéologie des sciences humaines,* Paris, 1966, p. 32.

122. *Codex Leicester,* 34r-3B, tr. in *Carnets,* I, p. 91.

123. On this point, see in particular Kemp, "The Crisis of Received Wisdom in Leonardo's Last Thought," in *Leonardo e l'età della ragione,* ed. Enrico Bellone e Paolo Rossi, Milan, 1982, pp. 33–36. The study of these texts shows that Leonardo's sources were more medieval than classical.

124. Pedretti, *Leonardo da Vinci. Studi di natura dalla Biblioteca Reale nel Castello di Windsor*, *op. cit.*, p. 50.

125. See Kemp, "The Crisis...," *op. cit.*, p. 34 and "Analogy and Observation in the Codex Hammer," in *Studi Vinciani in memoria di Nando de Toni*, Brescia, 1986, p. 132.

126. See on this point the remarks of Enzo Macagno, "Analogies in Leonardo's Studies of Flow Phenomena," in *Studi Vinciani in memoria di Nando de Toni*, *op. cit.*, pp. 19–24, quoting the modern works of Grenet, Keynes and Polya on the heuristic function of the analogical method.

127. Quoted by M. Clayton in M. Clayton and R. Philo, *Leonardo da Vinci: The Anatomy of Man*, Houston–Boston, 1992 (edition consulted, *Léonard de Vinci. Anatomie de l'homme*, Paris, 1992, p. 50).

128. For the explanation of Leonardo's errors, see R. Philo, in *Leonardo da Vinci: The Anatomy of Man*, *op. cit.*, pp. 50–52. See also Leonardo da Vinci, *Les Carnets* [*The Notebooks*], Paris (1942), 1989, p. 125.

129. Kemp, "Analogy and Observation...," *op. cit.*, pp. 107–10.

130. See Kemp, "Leonardo da Vinci: motions of life in the lesser and greater worlds," in *Nine Lectures on Leonardo da Vinci*, London (University of London), n.d., p. 12; K. Keele, "Leonardo da Vinci's Science of Man," in *Leonardo's Legacy...*, *op. cit.*, pp. 38–39.

131. A. Marinoni, "L'Essere del nulla" (1960), in *Leonardo da Vinci letto e commentato da...*, *op. cit.*, p. 18.

132. Keele, "Leonardo's Science of Man," in *Leonardo da Vinci e l'età della ragione*, *op. cit.*, p. 430.

133. Keele, *ibid.*, pp. 427–28.

134. Kemp, "Analogy and Observation...," *op. cit.*, pp. 128–30.

135. On these points, see Kemp, "Analogy and Observation...," *op. cit.*, pp. 112–13, and Keele, "Leonardo's Physiology..." *op. cit.*, p. 42 and "Leonardo's Science of Man...," *op. cit.*, pp. 423–24.

136. Kemp, "Analogy and Observation...," *op. cit.*, pp. 130–32.

137. See also Kemp, *Leonardo da Vinci*, *op. cit.*, p. 129.

138. Keele, "Leonardo's Science of Man...," *op. cit.*, pp. 428–29.

139. The expression is from Paolo Galluzzi, "La carrière d'un technologue," in *Léonard de Vinci ingénieur et architecte*, Montreal, 1987, p. 94.

140. See E. Bellone, "L'infanzia della scienza," in *Leonardo da Vinci e l'età della ragione*, *op. cit.*, pp. 24–25.

141. *Ibid.*, p. 24.

142. See Kemp, "Analogy and Observation...," *op. cit.*, p. 132.

143. The expression is from G. Sarton, commented on and criticized by Panofsky, "Artist, scientist...," *op. cit.*, p. 106.

144. *Ibid.*, p. 106ff.

145. See C. Maccagni, "Scienza e Tecnica in Emilia e Romagna al tempo del Codice Hammer," in *Leonardo: il Codice Hammer e la Mappa di Imola*, Florence, 1985, p. 176.

146. See Panofsky, "Artist, scientist...," *op. cit.*, p. 119, who develops these points pp. 111ff. See also J. Ackerman, "The Involvement of Artists in Renaissance Science," *op. cit.*, pp. 94–129, and S. Edgerton Jr., "The Renaissance Development of the Scientific Illustration," *ibid.*, pp. 168–97.

147. Th. Kuhn, *The structure of Scientific Revolutions*, Chicago, 1970 (edition consulted, *La Structure des révolutions scientifiques*, Paris, 1983).

148. See M. Kemp, "Leonardo and the Visual Pyramid," *Journal of the Warburg and Courtauld Institutes*, XL, 1977, pp. 143–46, and J. Ackermann, "Leonardo's Eye," *op. cit.*, pp. 127ff. Another example of this uncertainty is the way in which, to explain the movement of a boat or a bird, Leonardo rejected the theory of "antiperistasis" that distinguished Aristotelian aerodynamics and hydrodynamics, while continuing to have the greatest interest in the flexibility of the ambient milieu for movement; on this point, see among others, E. Gombrich, "The Form of Movement..." *op. cit.*, p. 205.

149. See Kuhn, *The Structure...*, *op. cit.*, pp. 122–23. On Leonardo's discouragement, see Gombrich, "The Form of Movement...," *op. cit.*, p. 204.

150. See A. Koyré, "Galilée et la révolution scientifique du XVIIe siècle" (1955), and "Galilée et Platon" (1943), in *Études d'histoire de la pensée scientifique*, Paris, 1966, pp. 201 and 172ff. respectively.

151. See Gombrich, "The Form of Movement...," *op. cit.*, p. 202.

152. See Kuhn, *The Structure...*, *op. cit.*, pp. 46 and 147.

153. Kuhn, *ibid.*, p. 116 and, for a description of this "dislocated world," pp. 101–13.

154. Kuhn, *ibid.*, p. 127.

155. See Koyré, "Galilée et la révolution scientifique...," *op. cit.*, pp. 196 and 199.

156. See Koyré, "Galilée et Platon," *op. cit.*, p. 190.

157. See Koyré, *ibid.*, pp. 169 and 195.

158. On these markers, see Keele, "Leonardo da Vinci's Science of Man," *op. cit.*, pp. 425–26.

159. See Koyré, "L'apport scientifique de la Renaissance" (1949), in *Études d'histoire...*, *op. cit.*, p. 59.

160. On this point, see Kemp, "The Crisis...," *op. cit.*, pp. 29–31.

161. See Kemp, *Leonardo da Vinci...*, *op. cit.*, pp. 236–37, 280–82.

162. See Koyré, "L'apport scientifique...," *op. cit.*, p. 51.

163. See Bellone, "L'infanzia della scienza," *op. cit.*

164. See Lévi-Strauss, *La Pensée sauvage*, Paris, 1962, chap. 1.

165. See Koyré, "L'apport scientifique...," *op. cit.*, pp. 51–53. On Leonardo's hostility towards magic, in his famous text against necromancy, see *Scritti letterari*, ed. A. Marinoni, *op. cit.*, pp. 161ff. On his more complicated attitude to alchemy, see in particular C. Vasoli, "Note su Leonardo e l'alchimia," in *Leonardo e l'età...*, *op. cit.*, pp. 69–77.

166. On the "homemade" as a characteristic of wild thought and of a "first science," see Lévi-Strauss, *La Pensée sauvage*, *op. cit.*, pp. 30ff.

167. See Léonard de Vinci, *Les Carnets*, *op. cit.*, I, p. 287 and Keele, "Leonardo da Vinci's Physiology...," *op. cit.*, p. 40.

168. On the role of the "scientific community" in "normal" scientific thought, see Kuhn, *The Structure...*, *op. cit.*, pp. 21ff. and 40ff.

169. On this point, see among others Kemp, "The Crisis...," *op. cit.*, p. 28.

170. See Kemp, *Leonardo da Vinci...*, *op. cit.*, p. 285. Perhaps the most glaring example of confusion is provided by the way in which, without needing to do so, Leonardo used the (superseded) Aristotelian theory of "antiperistasis" to confirm that of *impetus*, which was precisely the opposite, and which he also supported. See Kemp, *Leonardo da Vinci, op. cit.*, pp. 123–25. On Leonardo and the notion of *impetus*, see later "The World of Leonardo," p. 106.

171. On this point, see in particular, Galluzzi, "La carrière d'un technologue," *op. cit.*, pp. 94ff.

172. See Leonardo da Vinci, *Scritti letterari, op. cit.*, pp. 184–85.

173. A. Koyré, "Remarques sur les paradoxes de Zénon" (1922), in *Études d'histoire de la pensée scientifique*, Paris, 1961, p. 31.

174. On these interactions, see C. Pedretti, *The Literary Works of Leonardo da Vinci. A Commentary to Jean-Paul Richter's Edition*, London, 1977, I, pp. 220–22.

175. See C. Pedretti, *The Literary Works...*, *op. cit.*, II, p. 313.

176. On these points, see among others, Pierre Sergescu, "Léonard de Vinci et les mathématiques," in *Léonard de Vinci et l'expérience scientifique..., op. cit.*, p. 81, and A. Marinoni, "L'Essere del nulla" (1960), in *Leonardo letto e commentato..., op. cit.*, pp. 18–19.

177. See E. Panofsky, *The Codex Huygens and Leonardo da Vinci's Art Theory*, London, 1940 (edition consulted, *Le Codex Huygens et la théorie de l'art de Léonard de Vinci*, Paris, 1996).

178. *Trattato della Pittura*, § 300 (edition consulted, Leonardo da Vinci, *Traité de la Peinture*, tr. Péladan, Paris, 1910, p. 162 [no. 462]).

179. F. Saxl, "Science and Art in the Italian Renaissance," in *Lectures, op. cit.*, p. 121.

180. On this point, see among others, E. Gombrich, "The Form of Movement...," *op. cit.*, pp. 200ff., M. Kemp, *Leonardo da Vinci, op. cit.*, pp. 124ff.

181. See Koyré, in *Léonard de Vinci et l'expérience scientifique du XVIᵉ siècle*, Paris, 1953, p. 243.

182. "I define force as spiritual power, immaterial and invisible, animated by a brief life that manifests itself in bodies that as a result of accidental violence are not in their natural inertia or state. I say spiritual, because an active, immaterial life resides in this force, and I call it invisible, because the body in which it manifests itself does not increase in weight or volume; and of short duration because it is constantly seeking to vanquish the cause that has created it, and when vanquished the latter dies" (*Ms. B*, 63r), *Carnets, op. cit.* I, p. 72.

183. *Ibid.*, p. 538. See also pp. 527–38.

184. See Kemp, "Analogy and Observation...," *op. cit.*, p. 110, and "Leonardo da Vinci: motions of life in the lesser and greater worlds," *op. cit.*, p. 18.

185. Gombrich, "The Form of Movement...," *op. cit.*, p. 206.

186. See also, *Carnets, op. cit.*, II, pp. 101–03.

187. Text given in *Carnets, op. cit.*, II, p. 129 (*Leicester*, 8r).

188. The complete text is given in *Carnets, op. cit.*, II, pp. 287–89 et 290–92.

189. Gombrich, "The Form of Movement..." *op. cit.*, pp. 208–10.

190. See J.-P. Richter, *The Literary Works of Leonardo da Vinci*, commented on by C. Pedretti, II, p. 209, § 1092.

191. After K. Clark, who put forward an order based on the fact that the theme would be treated in a more and more personal manner (*Leonardo da Vinci, op. cit.*, p. 319), C. Pedretti (*Studi di natura, op. cit.*, pp. 56–58), rearranged the sheets in the order 12378, 12384, 12386 and 12383 (where the storm ended by rejoining the sea); Martin Clayton (*Leonardo da Vinci. One Hundred Drawings from the Collection of Her Majesty the Queen*, London, 1996, pp. 160–163), made a series of four drawings from 12385, 12382, 12384, 12383.

192. Clark, *Leonardo da Vinci, op. cit.*, p. 323.

193. See Kemp, *Leonardo, op. cit.*, pp. 304ff. and "Analogy and Observation...," *op. cit.*, pp. 123–25.

194. This concept is explained in other sheets of *Ms. F*, for instance folio 56r ("Your whole discourse tends to conclude that the earth is a star almost identical to the moon, and in this way you will prove the nobility of our world...") and, especially, folio 41v: "How the earth is not at the center of the sun's orbit, any more than it is at the center of the universe, but at the center of its elements which accompany it and which are united by it. And if a person stood on the moon, the more it would be above us, like the sun, the more this earth, with the element of water, would seem below him, and this person would fulfill the role of the moon for us." This last page is particularly close to Nicholas of Cusa's notes on the subject. See *De la Docte Ignorance*, Paris, 1930 (edition consulted, 1979), II, 11–12, pp. 54ff.

195. C. Vasoli, "La Lalde del Sole di Leonardo" (1972), in *Leonardo letto..., op. cit.*, pp. 327–50, in particular 336–48.

196. Heliocentrism was not a new hypothesis at the time, and this notation could in addition echo a point of view that was not necessarily Leonardo's.

197. Vasoli, "La Lalde..." *op. cit.*, p. 341.

198. On this point, see in particular, Kemp, "Leonardo da Vinci: motions of file...," *op. cit., passim*.

199. This is the title of a fine piece by A. Marinoni, "L'Essere del nulla" (1960), in *Leonardo letto, op. cit.*, pp. 7–28.

200. See Marinoni, "L'Essere del nulla," *op. cit.*, p. 21.

201. *Ibid.* p. 24.

202. On these points, see Kemp, "Leonardo and the Visual Pyramid," *op. cit.*, et J. Ackermann, "Leonardo's Eye," *op. cit.*

203. See Kemp, "Leonardo and the Visual Pyramid," *op. cit.*, p. 142.

204. For a clear exposition of this question, see Leonardo da Vinci, *Le Traité de la Peinture*, ed. Chastel/Klein, Paris, 1960, pp. 99–101.

205. On Leonardo and anamorphosis, see C. Pedretti, "Un soggetto anamorfico," *Studi Vinciani*, Geneva, 1957, pp. 68ff. According to Lomazzo (after Melzi), the study of anamorphosis was not merely a private amusement, since Leonardo painted anamorphically "a dragon fighting

with a lion, a surprising thing to see, as well as horses intended for François de Valois, King of France."

206. See Gérard Wajeman, "L'Œil de Léonard de Vinci," *Quarto. Revue de l'École de la Cause freudienne en Belgique*, 53, winter 1993–94, pp. 21 and 23. Indeed, Alberti states explicitly that the physiological conditions of vision do not concern the painter: "It was no small matter in Antiquity to know whether the rays came from the surface or from the eye. This is a rather difficult question and we shall therefore leave it as being without any use." "There is no reason to discuss the opinion which places vision at the very junction of the interior nerve or that which says that images are imprinted on the surface of the eye like a moving mirror. Neither need we any longer mention all the functions which the eye fulfills in vision. All we need in these commentaries is to demonstrate briefly what is necessary for our subject" (L. B. Alberti, *De la Peinture. De Pictura* (1435), I, 5 and 6, Paris, 1992, pp. 81–83 and 85). Alberti's "humanist" approach is here clearly distinguished from Leonardo's radical, self-taught approach.

207. Quoted by Ackermann, "Leonardo's Eye," *op. cit.*, p. 130.

208. Koyré, "Remarques sur les paradoxes de Zénon," *op. cit.*, p. 29. The observations that follow were inspired by pp. 29–34 of this piece by Koyré.

209. Koyré, "Remarques sur…," *op. cit.*, p. 33.

210. Panofsky, *The Codex Huygens…*, *op. cit.*, p. 81.

211. Koyré, "Remarques sur…," *op. cit.*, pp. 33–34.

212. *Ibid.* pp. 33–34.

213. Vasari, *Lives…*, (1568), *op. cit.*, 5, pp. 19 and 60 (translation redone from the original text).

214. E. Benveniste, "La notion de 'rythme' dans son expression linguistique," *op. cit.*, p. 333.

215. P. Valéry, "Léonard et les philosophes" (1929), in *Introduction à la méthode…*, *op. cit.*, p. 130.

216. P. Valéry," Introduction à la méthode de Léonard de Vinci," in *Introduction à la méthode…*, *op. cit.*, p. 27.

217. P. Valéry, "Léonard et les philosophes," *op. cit.*, p. 130.

218. Ilya Prigogine and Isabelle Stengers, *La Nouvelle Alliance. Métamorphose de la science* (1979), Paris, 1986, p. 372. I warmly thank Jean Petitot for having drawn my attention to this singular and very recent *modernity* of Leonardo. The lines that follow owe much to our conversations on this subject.

219. Prigogine-Stengers, *La Nouvelle Alliance*, *op. cit.*, p. 390.

220. M. Serres, *La Naissance de la physique dans le texte de Lucrèce*, quoted by Prigogine-Stengers, *op. cit*, p. 379. On this tradition, its exclusion from the science of Galileo and Newton, and its revival at the hands of Diderot, among others, see Prigogine-Stengers, *op. cit.*, in particular "Les deux cultures," pp. 132–61.

221. See Kemp, *Leonardo da Vinci*, *op. cit.*, p. 135.

222. *Ibid.*, p. 276.

223. Valéry, "Introduction à la méthode…," *op. cit.*, p. 28.

224. This method is explicitly recommended by Leonardo: "So, thanks to my plan you will become acquainted with every part and every whole, by means of a demonstration of each, seen from three different points of view, […] as if you were holding the limb in your own hand and you were turning it in all directions until you had learnt everything you wanted to know," *Carnets*, *op. cit.*, I, p. 170. These three views become eight in the two folios mentioned here, the text and eight-pointed star drawn in the bottom right corner of RL, 19008v explaining the method of illustration used—and which changes midway. See M. Clayton, *Leonardo de Vinci: The Anatomy…*, *op. cit.*, p. 102.

225. *Convenientia* is a "resemblance linked to space in a 'near to near' way […] Those things are "convenient" whose edges touch, whose fringes mingle […] Through this, movement is communicated, as well as influences, passions and properties." *Aemulatio* acts "on the basis of a resemblance without contact. There is something in emulation which is like a reflection and a mirror […] Things can imitate each other from one end of the universe to the other without concatenation or proximity: through its reduplication by a mirror, the world abolishes the distance which is its own; it thereby triumphs over the place which is given to each thing," *Les Mots et les Choses*, *op. cit.*, pp. 33 and 34–35.

226. Panofsky, *The Codex Huygens*, *op. cit.*, p. 33.

227. *Ibid.*, p. 35.

228. *Ibid.*, pp. 76–77.

229. *Ibid.*, pp. 76 and 19.

230. *Ibid.*, p. 19.

231. For this term "fantastic imitation," see G. Comanini, *Il Figino*, in Paola Barocchi (ed.), *Trattati d'Arte del Cinquecento. Tra Manierismo e Controriforma*, III, Bari, 1962, p. 256.

232. Chastel, *Art et Humanisme…*, *op. cit.*, pp. 414–16.

233. See G. de Santillana, "Léonard et ceux qu'il n'a pas lus," in *Léonard et la pensée scientifique…*, *op. cit.*, pp. 50–54.

234. See C. Pedretti, *Leonardo architetto*, *op. cit.*, pp. 96–99.

235. See E. Garin, "Il problema delle fonti del pensiero di Leonardo," in *La Cultura filosofica del Rinascimento italiano*, Florence, 1961, p. 391.

236. Santillana, "Léonard et ceux…," *op. cit*, p. 54.

237. The term "biological" is borrowed from G. de Santillana, and "vitalist" from Prigogine–Stengers, who use it to characterise, through Diderot, "une des plus anciennes sources d'inspiration de la physique, le spectacle du développement progressif, de la différenciation et de l'organisation apparemment spontanée de l'embryon" (*op. cit.*, pp. 135–36).

238. See Kemp, *Leonardo da Vinci*, *op. cit.*, p. 134.

239. The correspondence between Cigoli and Galilée is given in "Macchie di sole e di pittura, carteggio di L. Cigoli–G. Galilei, 1609–13, a cura di A. Matteoli," *Bollettino della Accademia degli Euteleti della Città di San Miniato*, XXXII, 1959, p. 33.

240. E. Wind emphasized the difference between this purely Platonic and the (theological) one of Nicholas of Cusa or the (Neoplatonist) one of Marsilio Ficino, see "Ripeness is all," in *Pagan Mysteries in the Renaissance*, New Haven,

1958 (edition consulted, *Mystères païens de la Renaissance*, Paris, 1992, p. 120).

241. See Kemp, *Leonardo da Vinci, op. cit.*, pp. 230–34.

242. See Carmen Bambach Cappel, "Leonardo, Tagliente and Dürer: 'la scienza del far di gruppi,'" in *Achademia Leonardi Vinci,* IV, 1991, pp. 72ff.

243. Bambach Cappel, *op. cit.*, p. 88. The allusion was all the more effective in that Leonardo's name, "Vinci," could be interpreted as the plural of "vinco," meaning "osier," and thence "link," "strap."

244. See Bambach Cappel, *op. cit.*, p. 90.

245. Chastel, in Vasari, *Lives..., op. cit.*, p. 49.

246. On Dürer, see Vasari, *Lives..., op. cit.*, p. 34, who says of Leonardo: "He himself wasted his time by drawing the interlacing of ropes methodically set out so that they could be followed from one end to the other, until they filled a circle."

247. C. Pedretti, "A Proem to Sculpture," *Achademia Leonardi Vinci*, II, 1989, p. 34.

248. See above, p. 40. It is significant in this context that the Venetian Giovanni Antonio Tagliente, who defined interlacing as a *scienza*, had also been a master of calligraphy, see Bambach Cappel, "Leonardo, Tagliente...," *op. cit.*, p. 76.

249. D. Rosand, *The Meaning of the Mark..., op. cit.*, pp. 28–29. Rosand says that he borrowed the term "spatialization" from Valéry. Indeed, in the passage in which he starts by comparing what he calls the "*chronolization* of space" with the "spatialization of space," Valéry clarified, without realizing it, the intimate relationship which, in about 1495, linked the pattern of platonic bodies to that of tracery: "A stable form can be replaced by an appropriate speed in the periodical transfer of a well-chosen object (or element)" ("Introduction..." *op. cit.*, p. 27).

250. Pedretti, *Leonardo architetto*, Milan, 1983, p. 298. This organic procreation of forms one from another is very evident in the drawing in the *Codex Atlanticus* 281r-a, very similar to the sixth engraving of interlacing, where the framework of the drawing rests on a rhythmic succession of six- and twelve-pointed stars, which generate themselves reciprocally. See Bambach Cappel, "Leonardo, Tagliente...," *op. cit.*, p. 78.

251. See Bambach Cappel, "Leonardo, Tagliente...," *op. cit.*, pp. 79–80.

252. On the historical circumstances of the program and death of Béatrice d'Este in 1497, see Kemp, *Leonardo da Vinci, op. cit.*, pp. 166-67.

253. See Carroll W. Westfall, *In this Most Perfect Paradise*, 1974, Pennsylvania State University (edition consulted *L'Invenzione della città. La strategia urbana di Nicolo V° Alberti nella Roma del '400*, Rome, 1984, pp. 261ff.) who notes in particular that, since 1340, the *castello* of Azo Visconti had a number of rooms so named (p. 272).

254. See Kemp, *Leonardo da Vinci, op. cit.*, pp. 168–70.

255. P. Marani, "Leonardo e le colonne *ad tronchonos*: tracce di un programma iconologico per Lodovico il Moro," *Raccolta Vinciana*, XXI, 1982, pp. 118–19; Dawson Kiang, "Gasparo Visconti's *Pasitea* and the Sala delle Asse," *Achademia Leonardi Vinci*, II, 1989, p. 101, who quotes the metaphor of the protective shade of the *Moro*.

256. See E. Wind, "Pagan Mysteries...," *op. cit.*, p.126, who recalls Ludovico the Moor in this connection.

257. D. Kiang, "Gasparo Visconti's *Pasitea*...," *op. cit.*, pp. 107–08.

258. *Ibid.*, pp. 108–09.

259. On the conditions of the first restoration of the Sala delle Asse, see in particular M. Rosci, "La Sala delle Asse," in *Leonardo. La Pittura*, Florence, 1977, pp. 115ff.

260. On the role which the border plays in classical painting in the "autonomization" of the representation, see in particular L. Marin, "Les combles et les marges de la représentation," *Rivista di Estetica*, 17 (1984), pp. 11-33.

261. The roots in the rocks also recall the fable of the nut destroying the wall where a crow had let it fall, see Leonardo da Vinci, *Scritti letterari* (1952), ed. A. Marinoni, Milan, 1974, p. 82.

262. See Marani, "Leonardo e le colonne...," *op. cit.*, pp. 106ff. and John F. Moffitt, "Leonardo's 'Sala delle Asse' and the Primordial Origin of Architecture," *Arte Lombarda*, 92–93, 1990/1–2, pp. 76–90, in particular pp. 82ff.

263. See D. Kiang, "Gasparo Visconti's *Pasitea*...," *op. cit.*, p. 10, which mentions *Bombyx*, the didactic poem in two volumes written in 1512 by Marco Girolamo Vida from Cremona, who corresponded with Isabella d'Este on this subject in 1519.

264. E. Wind, "Pagan Mysteries...," *op. cit.*, pp. 125–26.

265. Quoted by Kemp, *Leonardo da Vinci, op. cit.*, pp. 13–14. See Richter-Pedretti, *The Literary Works..., op. cit.*, II, p. 313 (§ 1368).

266. See M. Warnke, *Höfkünstler: Zur Vorgeschichte des modernen Künstlers*, 1985 (edition consulted, *L'Artiste et la cour. Aux origines de l'artiste moderne*, 1985, Paris, 1989, p. 65). See also Kemp, *Leonardo da Vinci, op. cit.*, pp. 85–86.

267. See Warnke, *op. cit.*, pp. 116–17.

268. Vasari, *Lives..., op. cit.*, 5, p.38.

269. See Warnke, *op. cit.*, p. 68, n. 112.

270. On these points, see Warnke, *op. cit.*, pp. 71–73 and 77–78.

271. *Ibid.*, p. 70.

272. On these drawings, see L. Reti, "'Non si volta chi a stella è fisso.' Le "imprese" di Leonardo da Vinci," *Bibliothèque d'Humanisme et de Renaissance*, 1959, XXI, pp. 7-54, in particular pp. 13ff. and 46ff. See also Warnke, *op. cit.*, pp.69–70, and, for the drawings, K. Clark–C. Pedretti, *The Drawings of Leonardo da Vinci in the Collection of Her Majesty the Queen at Windsor Castle*, London, 1968, I, pp. 179 and 85–86.

273. See L. Beltrami, *Documenti e memorie riguardanti la Vita e le Opere di Leonardo da Vinci*, Milan, 1919, p. 156.

274. The complete text of the letter is given in Leonardo da Vinci, *Carnets, op. cit.*, II, pp. 534–35.

275. Félibien, *Entretiens sur les vies et les ouvrages des plus excellents peintres anciens et modernes* (1666), Geneva, 1972, I, p. 220. See also Kate T. Steinitz, "Leonardo, architetto

teatrale e organizzatore di feste" (1969), in *Leonardo letto...*, *op. cit.*, p. 266, and Pedretti, *Leonardo architetto*, *op. cit.*, pp. 209 and 322–23.

276. B. Castiglione, *The Book of the Courtier* (1528), (edition consulted, *Le Livre du Courtisan*, Paris, 1987, p. 158 [II, 39]).

277. C. Dionisotti, "Leonardo, uomo da lettere," *op. cit.*, pp. 207ff.

278. L. Benevolo, *Storia dell'architettura del Rinascimento*, Rome–Bari, 1977, p. 267.

279. R. Schofield, "Leonardo and architecture," in *Nine Lectures on Leonardo da Vinci*, London, n.d., pp. 88-95. L. Heydenreich, "Leonardo and Bramante: Genius in Architecture," in *Leonardo's Legacy...*, *op. cit.*, p. 140, and "Leonardo architetto," in *Leonardo letto...*, *op. cit.*, pp. 29–45; C. Pedretti, *Leonardo architetto*, Milan, 1978 (edition consulted 1981).

280. On his relationship with Mannerism, see Pedretti, *Leonardo architetto*, *op. cit.*, p. 173; on the absence of stylistic homogeneity and his marginal position in relation to contemporary architecture, see J. Guillaume, "Léonard et l'architecture," in *Léonard de Vinci, ingénieur et architecte*, Montreal, 1987, pp. 285 and 249ff.

281. According to Pedretti (*Leonardo architetto*, *passim*), the list of Leonardo's architectural proposals (or plans for proposals) were as follows: in Florence, raising of the Baptistery; in Lombardy, consultation on the *tiburio* (lantern) of the cathedral (1487–90, fig. 85, 97, 98), project for a city on two levels (about 1487, fig. 94, 95, 96), urban expansion of Milan (1493, fig. 92), proposals for Vigevano, noble palaces in Milan (Casa Guiscardi, about 1497–99, *C.A.* 158r-a, v-a, palace of Cecilia Gallerani, *RL* 12579v); in Florence (1500), advice for San Miniato et San Salvatore, commission for a copy of the Villa Tovaglia from Francesco Gonzaga; for Cesare Borgia (1502–03), map of Imola (fig. 152) and proposals for the Rocca d'Imola; in Florence, proposal for the Verrucca fortress (1503–05); for Jacopo IV Appiani, project for the redevelopment of the Rocca de Piombino; in Lombardy, Villa for Charles d'Amboise (1508), Villa Melzi at Vaprio d'Adda (1513); in Florence, Medici Palace (1515), Medici Stables (1515–16); in France, city of Romorantin (1517–18).

282. According to Pedretti, who is probably too optimistic, the arrangement adopted for the *tiburio* of Milan's cathedral might have closely followed the ideas of Leonardo, he having conveyed them to Francesco di Giorgio when he arrived in Milan (*Leonardo architetto*, *op. cit.*, pp. 36ff.). Similarly, the gallery built at the base of Brunelleschi's dome and left unfinished after Michelangelo's criticisms could also be attributed to him (*ibid.*, pp. 144–47).

283. On this point, see Elio Rodio, "Le stalle Medici di Leonardo," in C. Pedretti, *Leonardo architetto, op. cit.*, pp. 259–62.

284. M. Tafuri, *L'Architettura dell'Umanesimo* (1969), Bari, 1972, pp. 72–73.

285. Pedretti, *op. cit.*, pp. 72–77.

286. Pedretti, *op. cit.*, p. 73.

287. See C. Maccagni, "Scienza e tecnica in Emilia e Romagna al tempo del Codice Hammer," *op. cit.*, p. 177. On Aristotele Fioravanti, see *Aristotele Fioravanti a Mosca, 1475–1975, Arte Lombarda,* 44-45, 1976, in particular Sandra Tugnoli-Pattaro, "Le opere bolognesi d'Aristotele Fioravanti architetto e ingegnere del secolo quindicesimo," pp. 35-70, et Werner Oechslin, "La fama di Aristotele Fioravanti, ingegnere e architetto," pp. 102–20.

288. Pedretti, *op. cit.*, p. 170.

289. On the ideal cities of the Renaissance, see in particular P. Marconi, *La Città come forma simbolica. Studi sulla teoria dell'architettura nel Rinascimento*, Rome, 1973.

290. On the redevelopment of Rome, see Luigi Spezzaferro (in collaboration with Richard J. Tuttle), "Place Farnèse: urbanisme et politique," in *Le Palais Farnèse*, Rome, 1981, I, 1, pp. 96ff.

291. See Pedretti, *op. cit.*, pp. 57–63.

292. J. Guillaume, "Léonard et l'architecture," *op. cit.*, p. 261.

293. The expression "potential project" is from P. Marani, "Léonard, l'architecture de fortification et ses problèmes de structure," in *Léonard de Vinci, ingénieur et architecte, op. cit.*, p. 304, while "experimental proposal" is from M. Tafuri, *L'Architettura...*, *op. cit.*, p. 72.

294. For a clear exposition of this complicated question, see J. Guillaume, "Léonard et l'architecture," *op. cit.*, pp. 209–23. C. Pedretti on the other hand supposes that Francesco di Giorgio had an influence on Leonardo, see above, note 282.

295. The text is given in Leonardo da Vinci, *Carnets*, *op. cit.*, II, pp. 525–26.

296. See P. Galluzzi, "La Carrière d'un technologue," in *Léonard ingénieur et architecte, op. cit.*, pp. 101–02.

297. See E. Garin, "La città in Leonardo" (1971), in *Leonardo letto...*, *op. cit.*, pp. 321; Guillaume, "Léonard et l'architecture," *op. cit.*, pp. 257ff.; Luigi Firpo, "Léonard urbaniste," in *Léonard ingénieur et architecte, op. cit.*, pp. 287 and 299.

298. Chastel, "Palladio et l'escalier" (1960), in *Fables, formes, figures*, Paris, 1978, p. 473.

299. For a typology of Leonardo's staircases, see Guillaume, "Léonard et l'architecture," *op. cit.*, pp. 261–66.

300. See Corrado Maltese, "Il pensiero architettonico di Leonardo," in *Leonardo. Saggi e ricerche*, Rome, 1954, p. 343. According to C. Maltese, Leonardo's major architectural problem was "the rib multiplied in all directions of space" (*ibid.*).

301. Except perhaps for the Verrucca fortress, see Pedretti, *Leonardo architetto, op. cit.*, pp. 170ff.

302. See P. Marani, "Leonardo e l'architettura fortificata: connessioni e sviluppi," in *L'Età della ragione, op. cit.*, p. 120. The work of reference on this point is P. Marani's book, *L'architettura fortificata negli studi di Leonardo da Vinci*, Florence, 1984.

303. See P. Marani, "Léonard, l'architecture de fortification et ses problèmes de structure," in *Léonard, ingénieur et architecte, op. cit.*, p. 313.

304. P. Marani, *Disegni di fortificazioni da Leonardo a Michelangelo*, Florence, 1984, p. 23.

305. P. Marani, "Leonardo e l'architettura fortificata: connessioni e sviluppi," in *L'Età della Ragione…, op. cit.*, p. 124. See also A. Chastel, "Les problèmes de l'architecture," *op. cit.*, p. 202. In a less poetic but also "interactive" manner C. Pedretti feels (*Leonardo architetto, op. cit.*, p. 162) that Leonardo's military structures after 1500 seem to "be fashioned by the trajectories of the projectiles which interlace like the sightlines of the spectators."

306. In the lovely expression of C. Maltese, "Il pensiero architettonico…," *op. cit.*

307. A. Chastel, *Art et Humanisme à Florence…, op. cit.*, p. 428.

308. C. Maltese, "Il pensiero architettonico…," *op. cit.*, pp. 344–46.

309. See R. Wittkower, *Architectural Principles in the Age of Humanism*, London, 1949, pp. 1-28; Guillaume, "Léonard et l'architecture," *op. cit.*, p. 224.

310. On this typology, see L. Heydenreich, *Die Sakralbau-Studien Leonardo da Vinci's* (1929), Munich, 1977, and Guillaume, *op. cit.*, pp. 224–41.

311. Guillaume, *op. cit.*, p. 242.

312. *Ibid*, p. 245.

313. *Ibid*, p. 248.

314. See Pedretti, *Leonardo architetto, op. cit.*, p. 251.

315. See Guillaume, *op. cit.*, pp. 249–51.

316. On this point, see in particular Chastel, "Les problèmes de l'architecture…," *op. cit.*, pp. 203–06.

317. *Ibid*, p. 197.

318. E. Garin, "La città…," *op. cit.*, p. 317.

319. See Guillaume, *op. cit.*, p. 282.

320. On these questions, see Guillaume, *op. cit.*, p. 278ff.

321. See Bern Dibner, among others, in "Leonardo: Prophet of Automation," in L. Reti and B. Dibner, *Leonardo da Vinci Technologist*, Norwalk (Conn.), 1969, pp. 37–60.

322. See P. Galluzzi, "La Carrière d'un technologue," in *Léonard de Vinci ingénieur et architecte, op. cit.*, p. 43.

323. See Gustina Scaglia, "Une typologie des mécanismes et des machines de Léonard," in *Léonard de Vinci ingénieur et architecte, op. cit.*, pp. 145–61, in particular pp. 153–61.

324. See P. Galluzzi, "Le macchine senesi. Ricerca antiquaria, spirito di innovazione e cultura del territorio," in *Prima di Leonardo. Cultura delle macchine a Siena nel Rinascimento*, Milan, 1991, pp. 16–17.

325. R. Bacon, *De mirabili potestate artis et naturae* (1250), quoted by among others Angelo Cerizza and Carlo Alberto Segnini, "Il cammino della tecnologia," in *Laboratorio su Leonardo*, Milan, 1983, p. 43.

326. See P. Galluzzi, "La Carrière d'un technologue," *op. cit.*, p. 92, with the bibliography.

327. See Bertrand Gille's classic, *Les Ingénieurs de la Renaissance*, Paris, 1964.

328. On the drawings of Brunelleschi's machines, see P. Galluzzi, *Les Ingénieurs de la Renaissance de Brunelleschi à Léonard*, Florence–Paris, 1995, pp. 99–116.

329. On this point, see P. Galluzzi, "Le macchine senesi…" *op. cit.*, pp. 16–18.

330. See P. Galluzzi, *op. cit.*, pp. 36ff. and *Les Ingénieurs…, op. cit.*, p. 16.

331. See P. Galluzzi, "La Carrière d'un technologue," *op. cit.*, p. 42 which correctly underlines the overzealousness of B. Gille who, in his pioneering study (cited in note 327), excessively trivialized Leonardo's inventions in reaction against the tradition that tended to see him as a unique genius.

332. For this classification, see P. Galluzzi, *op. cit.*, pp. 44–46.

333. See Pedretti, *Leonardo architetto, op. cit.*, pp. 328–29.

334. A. Koyré, "Léonard 500 ans après," *op. cit.*, p. 112.

335. See Kemp, *Leonardo da Vinci, op. cit.*, p. 160 on the machine for shearing woolen cloth (*C.A.*, 397 r-a) (fig. 142).

336. See P. Galluzzi, "Leonardo e gli ingegneri senesi," in *Prima di Leonardo, op. cit.*, p. 213.

337. For a description of these mechanisms and their principles, see Marco Cianchi, *Le Macchine di Leonardo*, Florence, n.d., pp. 45–61.

338. See Scaglia, "Une typologie…," *op. cit.*, p. 145.

339. See P. Galluzzi, "Le macchine senesi…," *op. cit.*, pp. 19 and 36.

340. Quoted by Pedretti, "Il foglio di Weimar," in *Leonardo e il leonardismo a Napoli e a Roma*, Florence, 1983, p. 72.

341. A. Koyré, "Léonard de Vinci 500 ans après," *op. cit.*, pp. 111–12.

342. Galluzzi, "La Carrière d'un technologue," *op. cit.*, p. 68.

343. See Kemp, *Leonardo da Vinci, op. cit.*, p. 160.

344. Quoted by B. Dibner, "Leonard prophet of automation," *op. cit.*, p. 40. To support his ambitious scheme for diverting the Arno, Leonardo underlined its many economic advantages for the whole region, quoted by L. Reti, "Leonardo the technologist. The problem of the Prime Movers," in *Leonardo da Vinci the Technologist, op. cit.*, p. 90.

345. See Dibner, "Machines et engins de guerre," in *Léonard de Vinci. L'humaniste, l'artiste, l'inventeur*, Paris, 1974, p. 168.

346. On Leonardo's maps in general, see M. Kemp, "Leonardo's Maps and the "Body of the Earth"," *Bulletin of the Society of University Cartographers*, 17, 1984, pp. 9–19; Susan Kish, "Leonardo da Vinci: the Mapmaker," in *Imago et mensura mundi. Atti del IX Congresso internazionale di storia della cartografia*, Rome, 1985, pp. 89–98. See also Pietro C. Marani, "La Mappa di Imola di Leonardo," in *Leonardo: il Codice Hammer e la Mappa di Imola presentati da Carlo Pedretti*, Florence, 1985, pp. 140–41; Martin Clayton, *Leonardo da Vinci. One Hundred Drawings from the Collection of Her Majesty the Queen, op. cit.*, pp. 89–105 and 129–31.

347. See M. Clayton, *Leonardo da Vinci, op. cit.*, p. 94; M. Kemp, *Leonardo da Vinci, op. cit.*, p. 211.

348. H. Burns, *Raffaello architetto*, Milan, 1984, p. 421, quoted by P. Marani, "La Mappa di Imola…," *op. cit.*, p. 140.

349. S. Kish, *op. cit.*, pp. 94–97.

350. See Fausto Mancini, *Urbanistica rinascimentale a Imola da Girolamo Riario a Leonardo da Vinci*, Imola, 1979, quoted by among others Augusto Marinoni, "La pianta di Imola,"

in *Leonardo artista delle macchine e cartografo,* ed. Rosaria Campioni, Florence, 1994, pp. 77–81.

351. The Windsor sheet 1286 shows ground plans for the Imola housing project drawn by Leonardo. But we agree with Mancini and Marinoni that this was not necessarily the same kind of approach as for the town as a whole, see Marinoni, *op. cit.,* pp. 80–81.

352. *Ibid.,* p. 81.

353. Kemp stresses the "perceptible feeling of life" that enlivens Leonardo's maps, "Leonardo's Maps...," *op. cit.,* p. 12.

354. See Louis Marin, "Les voies de la carte," in *Cartes et figures de la terre,* Paris, 1980, p. 52.

355. On all these points, see in particular A. Marinoni, "Leonardo, la musica e lo spettacolo," in *Leonardo e gli spettacoli del suo tempo,* ed. Mariangela Mazzocchi Doglio, Gianpiero Tintori, Maurizio Padovan and Marco Tiella, Milan, 1982, pp. 13ff.

356. Vasari, *Lives...,* *op. cit.,* 5, p. 60.

357. See Nino Pirrotta, "Musiche intorno a Giorgione," in *Giorgione. Convegno Internazionale di Studi,* Castelfranco, 1979, pp. 41–45.

358. Quoted by Pirrotta, *op. cit.,* p. 42.

359. Quoted by Maria Luisa Angiolillo, *Leonardo, feste e teatri,* Naples, 1979, p. 93.

360. Regarding Leonardo's actual theory of music, as it appears particularly in the *paragone* with painting, see Marinoni, "Leonardo, la musica...," *op. cit,* p. 14–16, which emphasizes that, on the theoretical level, Leonardo continued to conceive of music as a theory of vertical proportions, that is, music as part of the *quadrivium* of the seven liberal arts. This attitude is all the more surprising in that he was a fine singer, and he also developed a theory that the surface is produced by the movement of the point. His attitude can probably be explained by the fact that he developed his theory of music in the context of the *paragone* and exaltation of painting. The superiority of painting over poetry stems from the fact that it rests, like music, on a "concert" of accords and harmonies; its superiority over music can be explained by the fact that it lasts while the accords produced by it "younger sister" are forced to "be born and die in the one and same accord."

361. On these points, see among others, Giampiero Tintori, "la musica al tempo di Leonardo," in *Leonardo e gli spettacoli...,* pp. 17–19, M. Mazzocchi Doglio, "Leonardo 'apparatore' di spettacolo a Milano per la corte degli Sforza," *ibid.,* pp. 41ff.

362. See E. Winternitz, *Leonardo as a Musician,* New York, 1982, and also, "Léonard et la musique," in *Léonard de Vinci. L'humaniste, l'artiste, l'inventeur,* Paris, 1974, pp. 118–19, with a detailed analysis of the different systems of drums pictured by Leonardo; see also Marco Tiella, "Gli strumenti musicali disegnati da Leonardo da Vinci," in *Leonardo, la musica...,* *op. cit.,* pp. 97–99.

363. See E. Winternitz, "Leonardo's invention of the viola organista," *Raccolta Vinciana,* XX, 1964, pp. 1–42; Tiella, "Gli strumenti...," *op. cit.,* pp. 91–96.

364. See Angiolillo, *Leonardo...,* *op. cit.,* pp. 3 and 80.

365. On the importance of the theatre in Milan, see F. Malaguzzi-Valeri, *La Corte di Ludovico il Moro,* Milan, 1913, I, pp. 534ff.

366. Tristano Calco, quoted by Mazzocchi Doglio, "Leonardo 'apparatore'...," *op. cit.,* p. 47.

367. According to Sigmund Freud's expression in *Eine Kindheitserrinerung des Leonardo da Vinci,* Vienna, 1910 (edition consulted, *Un Souvenir d'enfance de Léonard de Vinci,* Paris, 1987, p. 163).

368. See Mazzocchi Doglio, "Leonardo 'apparatore'...," *op. cit.,* p. 42.

369. *Ibid.,* pp. 51–53, and Kate T. Steinitz, "Le dessin de Léonard de Vinci pour la représentation de la *Danaé* de Baladassare Taccone," in *Le Lieu théâtral à la Renaissance,* Paris, 1968, p. 36.

370. Quoted by among others Angiolillo, *Leonardo...,* *op. cit.,* p. 94.

371. See Kemp, *Leonardo da Vinci...,* *op. cit.,* pp. 150–52.

372. For Leonardo's texts explaining these allegories, see A. E. Popham, *The Drawings of Leonardo da Vinci,* with an Introduction by Martin Kemp, London, 1994, nos. 107 and 108.

373. On Leonardo's rebuses, see A. Marinoni, *I rebus di Leonardo da Vinci raccolti e interpretati,* Florence, 1954. For a different interpretation of these rebuses, see for example, C. Pedretti, "Tomi," in *Passare il tempo. La letteratura del Gioco e dell'intrattenimento dal XII al XVI secolo (Atti del Convegno di Pienza, 10–14 sett. 1991),* Rome, 1993, pp. 313–16.

374. See Carlo Vecce, "Leonardo e il gioco," in *Passare il tempo...,* *op. cit.,* pp. 285–86.

375. The prophecies are given in Leonardo da Vinci, *Scritti letterari,* ed. A. Marinoni (1952), Milan, 1974, pp. 115–38.

376. See C. Vecce, *op. cit.,* pp. 287–302.

377. See Leonardo da Vinci, *Scritti letterari,* *op. cit.,* p. 120 (no. 46) and p. 132 (no. 134).

378. Tristano Calco, quoted by Mazzocchi Doglio, "Leonardo 'apparatore'...»," *op. cit.,* p. 47.

379. The description of this parade is given in Giuseppina Fumagalli, "Gli 'uomini selvatichi' di Leonardo," *Raccolta Vinciana,* XVIII, 1960, pp. 138ff.

380. See Angiolillo, *Leonardo...,* *op. cit.,* p. 92 (the drawing is numbered 12515).

381. The complete account is given in Angiolillo, *Leonardo...,* *op. cit.,* pp. 84–87.

382. For a description of these costumes, see Angiolillo, *op. cit.,* pp. 40–42.

383. For a detailed description, see Angiolillo, *op. cit.,* p. 43.

384. See Mazzocchi Doglio, "Leonardo 'apparatore'...," *op. cit.,* p. 46.

385. See Steinitz, "Le dessin de Léonard...," *op. cit.,* pp. 35–40.

386. The original text is given in Steinitz, *op. cit.,* pp. 37 and 38.

387. On the problem of this production of *Orfeo* by Politian staged by Leonardo, see Angiolillo, *op. cit.,* pp. 55–56 and 70–72, Mazzocchi Doglio, *op. cit.,* pp. 53–54.

388. See Giovanni Attolini, *Teatro e spettacolo nel Rinascimento,* Rome–Bari, 1988, p.109.

389. On the mechanical man, see C. Pedretti, *Leonardo architetto, op. cit.*, p. 323.

390. On these points, see Mazzocchi Doglio, "Leonardo 'apparatore'…," *op. cit.*, p. 60.

391. See among others Jean Jacquot, "Les types de lieu théâtral et leurs transformations de la fin du Moyen Âge au milieu du XVIIᵉ siècle," in *Le Lieu théâtral à la Renaissance*, Paris, 1968, p. 477; K. Steinitz, "Leonardo architetto teatrale e organizzatore di feste" (1969), in *Leonardo letto e commentato da…, op. cit.*, pp. 260–61.

392. On this particular point, see J. Jacquot, *op. cit.*, pp. 479ff.

393. On the political context of the Sforza monument , see Virginia L. Bush, "The Political Contexts of the Sforza Horse," in *Leonardo da Vinci's Sforza Monument: the Art and the Engineering*, ed. Diane Cole Hall, Bethlehem–London, 1995, pp. 79–81.

394. On equestrian monuments in Italy in the fifteenth century, see in particular Dario A. Covi, "The Italian Renaissance and the Equestrian Monument," in *Leonardo da Vinci's Monument…, op. cit.*, pp. 40–56.

395. Pasquier le Moine, quoted by Pedretti, *I cavalli di Leonardo. Studi sul cavallo e altri animali dalla Biblioteca Reale nel Castello di Windsor*, Florence, 1984, p. 45; see also Jane Roberts, "Introduzione," in *I cavalli…, op. cit.*, p. 16.

396. See Pedretti, *I cavalli…, op. cit.*, p. 47; Kemp, "Leonardo's Drawings for 'il Cavallo del Duca di bronzo': the Program of Research," in *Leonardo da Vinci's Sforza…, op. cit.*, pp. 67–68.

397. For a detailed analysis of this note, see Pietro Marani, *L'architettura fortificata negli studi di Leonardo da Vinci. Con il catalogo completo dei disegni*, Florence, 1984, p. 291, and C. Pedretti, "Leonardo architetto militare prima di Gradisca," in *L'architettura militare veneta del Cinquecento*, ed. Sergio Polano, Milan,1988, p. 81.

398. See Kemp, "Leonardo's Drawings…," *op. cit.*, p. 74. On the infinitesimal proportional quantities that Leonardo arrived at, see E. Panofsky, *The Codex Huygens, op. cit.*, pp. 38–39.

399. On the problems posed by this technique, see Pomponius Gauricus, *De Sculptura* (1504), ed. Robert Klein, Geneva-Paris, 1969, pp. 209ff.

400. For a description of the technical operations foreseen by Leonardo, see Maria Vittoria Brugnoli, "il Cavallo," in *Léonard de Vinci. L'humaniste…, op. cit.*, pp. 86–109, and, more recently, W. Chandler Kirwin and Peter G. Rush, "The Bubble Reputation: In the Cannon's and the Horse's Mouth (or the Tale of Three Horses)," in *Leonardo da Vinci's Sforza…, op. cit.*, pp. 87–110, which underlines the relationship between the technique adopted by Leonardo for the Sforza horse and that of casting cannons, and wonders about the actual possibility of making such a casting with the methods envisaged by Leonardo.

401. See Jean-Paul Richter, *The Literary Works of Leonardo da Vinci* (1883), London, 1970, II, pp. 9–11 (no. 725), commentary by Pedretti, II, pp. 15–17.

402. Pedretti, *ibid.*, p. 16.

403. M. Clayton, *Leonardo da Vinci…, op. cit.*, pp. 141ff.

404. Quoted by Clayton, *op. cit.*, p. 141.

405. C. Pedretti, *I cavalli…, op. cit.*, p. 75.

406. Gian Paolo Lomazzo, *Trattato dell'arte della pittura, scoltura et architettura* (1584), Florence, 1974, ed. Roberto P. Ciardi, p. 155.

407. In spite of the bold hypotheses of Maria Grazia Agghazi, who saw it as a portrait of King Francis I as King Arthur, and identified in it a model for an equestrian statue of the King, see *Leonardo's Equestrian Statuette*, Budapest, 1989, summarised in *Leonardo e Venezia*, Milan, 1992, pp. 281–82.

408. See Leonardo da Vinci, *Traité de la Peinture*, ed. André Chastel-Robert Klein, Paris, 1960, p. 210.

409. Alberti, *De Pictura* (1435), Paris, 1992, tr. Jean-Louis Schefer, pp. 139–41 (II, 27). On *paragone* in the fifteenth and sixteenth centuries, see Lauriane Fallay d'Este, *Le Paragone. Le parallèle des arts*, Paris, 1992.

410. L. B. Alberti, *De re aedificatoria*, VII, 10: "The contemplation of a beautiful painting […] gives me an exquisite pleasure of spirit as great as reading a wonderful history. The one and the other are paintings: the one paints a things with words, the other conveys it with the brush" (see *L'Architettura*, ed. Paolo Portoghesi–Giovanni Orlandi, Milan, 1966, II, p. 609).

411. Vasari, *Lives…, op. cit.*, 5, p. 34.

412. See above, p. 16 and note 18.

413. Quoted by L. Fallay d'Este, *Le Paragone…, op. cit.*, pp. 19, 88–89.

414. Leonardo da Vinci, *Traité de la Peinture, op. cit.*, p. 39. The final condemnation of the poet is so virulent that we can sense in Leonardo's words the bitterness he felt as a result of the prestige enjoyed by the poet *letterato* and the relative lack of it in the case of the painter *sanza lettere*: "Thus he remains very far behind the painter as far as the representation of corporeal things; and for the invisible things, he is behind the musician. But he uses other disciplines, he can go to fairs like a merchant selling goods invented by others. This is what he does when he borrows the science of others, for example, that of the orator, astronomer, cosmographer, etc., which are sciences totally distinct from poetry. He is thus like a broker who brings together several people to conclude a deal. If you wish to define the actual function of the poet, you will find that he is no more than a gatherer of goods stolen from other disciplines, from which he then produces a mendacious compound, or if you wish to be more civil, a fictional compound […]" (*Codex Urbinas*, 19r). We only need to compare this text with that in which Leonardo ironically presents his own activities to perceive the latent violence which could exist on a social level between court painters and poets: "I shall do like he who, out of poverty, arrives at the fair last and, not being able to buy as he likes, chooses all the things already seen and not accepted by others, but refused because of their low value. With this merchandise, scorned and refused by others—the reject of many buyers—I shall load myself, and go not

to the great cities but to the poor villages." (*Codex Atlanticus*, 119v-a). See above, p. 36.

415. See in particular, Rensselaeer W. Lee, *The Humanistic Theory of Painting*, New York, 1967 (edition consulted, *Ut Pictura poesis. Humanisme et théorie de la peinture, XVᵉ-XVIIIᵉ siècles*, Paris, 1991, pp. 7–10).

416. On the range and future of this idea of "intellectual effort," see Sergio Rossi, *Dalle botteghe alle accademie. Realtà sociale e teorie artistiche a Firenze dal XIV al XVI secolo*, Milan, 1980, pp. 84–85 and 116ff.

417. See M. Kemp, "From "Mimesis" to "Fantasia"; the Quattrocento Vocabulary of Creation and Genius in the Visual Arts," *Viator*, VIII, 1977, p. 383.

418. On all these points, see Kemp, "From 'Mimesis'...," *op. cit.*, pp. 353–54, 370–73, 379–81, 396.

419. Alberti, *De pictura..., op. cit.*, II, 25–26, pp. 131–33.

420. *Ibid.*, II, 26, p. 135.

421. The expression "conscious mirror" is taken up again by Chastel–Klein, in Leonardo da Vinci, *Traité de la Peinture, op. cit.*, p. 50.

422. "One should be aware that there are two ways of seeing objects, one of which consists in just seeing them, and the other in examining them closely. Just seeing is nothing else than naturally receiving in the eye the form and resemblance of the object that is being seen. But to see and examine an object means, besides the simple, natural perception of the form by the eye, trying to get to know this same object better by applying oneself particularly carefully: thus it could be said that the simple aspect is a natural operation and that what I call the *Prospect* is the work of reason." Quoted by André Félibien, *Entretiens sur les vies et les ouvrages des plus excellents peintres anciens et modernes* (1685–88), Geneva, 1972, pp. 282–83.

423. Chastel, *Art et Humanisme..., op. cit.*, p. 422.

424. See E. Panofsky, *"Idea:" Ein Beitrag zur Begriffsgeschichte der alteren Kunsttheorie*, Leipzig–Berlin, 1924 (edition consulted, *Idea. Contribution à l'histoire du concept de l'ancienne théorie de l'art*, Paris, 1983, p. 108).

425. Chastel, "Actualité de Vinci et des écrits léonardiens sur la peinture," in Leonardo da Vinci, *Traité de la Peinture, op. cit.*, p. XVIII.

426. Chastel–Klein, in Leonardo da Vinci, *Traité de la Peinture, op. cit.*, p. 35. For a schematic visualization of this system of knowledge and the connection that emerged between "sciences" and "arts," see *ibid.*, p. 34. On the birth of the "system of the arts," see Paul Oskar Kristeller, "The Modern System of the Arts" (1951-1952), in *Renaissance Thought*, II, New York, pp. 163–227.

427. See above, p. 69.

428. Chastel, *Art et Humanisme..., op. cit.*, p. 412.

429. Chastel, "Actualité de Vinci...," *op. cit.*, p. XX. The expression "graphic thought" is also from Chastel *(ibid)*, but see also David Rosand, *The Meaning of the Mark: Leonardo and Titian*, University of Kansas, 1988 (edition consulted, *La Trace de l'artiste*, Paris, 1993, p. 40).

430. Rosand, *The Meaning..., op. cit.*, pp. 49 et 53.

431. "The mass of air is full of an infinity of pyramids, made up of rectilinear rays, caused by the surfaces of opaque bodies which are found there; [...] and although their courses are full of intersections and crossings, nonetheless they do not become confused with each other [...]" (B.N. 2038, 6v).

432. See C. Pedretti, "La 'Leda di Vinci,'" in *Leonardo e il leonardismo a Napoli e a Roma*, Florence, 1983, p. 80, andt Gigetta dalli Regoli, "I fiori della Leda," in *ibid.*, pp. 92–93.

433. On the reasons for this absence of influence (actually limited to "artistic anatomy"), see Kenneth D. Keele, "Leonardo da Vinci's Influence on Renaissance Anatomy," *Medical History*, VIII, 4, October 1964, pp. 360–70. Anatomical drawings have been favored here over "scientific" drawings because they allow the relationship between drawing and painting to be more easily understood. Also they have been much studied and therefore allow a clear judgment to be made of their scientific correctness by modern standards.

434. See M. Kemp, *Leonardo da Vinci, op. cit.*, p. 274.

435. M. Clayton, in *Leonardo da Vinci, The Anatomy..., op. cit.*, p. 96. See Kemp, *Leonardo da Vinci, op. cit.*, p. 267.

436. R. Philo, in *Leonardo da Vinci, The Anatomy..., op. cit.* The comments that follow are directly inspired by the observations of M. Clayton and R. Philo in this work.

437. See E. Panofsky, "Artist, scientist...," *op. cit.*, pp. 115ff., and Clayton, *op. cit.*, pp. 11-13.

438. Quoted in M. Clayton and R. Philo, *Leonardo da Vinci, The Anatomy..., op. cit.*, p. 83.

439. E. Cassirer, *Individuum, op. cit.*, p. 201.

440. M. Clayton and R. Philo, *Leonardo da Vinci, The Anatomy..., op. cit.*, p. 36.

441. Paris, Bibliothèque Nationale de France, *Ms. lat.*, 7056, fol. 88. See E. Panofsky, "Artist, scientist...," *op. cit.*, p. 121.

442. See R. Philo, *op. cit.*, p. 127.

443. M. Clayton and R. Philo, *Leonardo da Vinci, The Anatomy..., op. cit.*, pp. 78–80.

444. If he invited the painter to make graphic notes of faces that he found striking, it was above all to train the memory: see among others, D. Rosand, *The Meaning..., op. cit.*, p. 37–38. In these preparatory drawings Leonardo never produced that synthesis of beauties that had made Zeuxis so famous through Pliny's anecdote of the young girls of Crotone. Pliny the Elder, *Historia Naturalis* (edition consulted, *Histoire naturelle*, XXXV, 64, Paris, 1985, tr. Jean-Michel Croisille, pp. 64–65).

445. E. Gombrich, "The Form of Movement...," *op. cit.*, p. 194.

446. D. Rosand, *The Meaning..., op. cit.*, p. 50.

447. On this idea of "figurability," see in particular Louis Marin, "Entre psychanalyse et histoire de l'art, la figurabilité," in *De la représentation*, Paris, 1995, pp. 62–70.

448. See E. Gombrich, "Leonardo's Method for Working out Compositions" (1952), in *Norm and Form. Studies in the Art of the Renaissance*, London, 1966, pp. 58–63.

449. For a detailed description of this process, see M. Kemp,

The Mystery of the Madonna of the Yarnwinder, Edinburgh, 1992, p. 53.

450. L. B. Alberti, *De Pictura, op. cit.,* p. 158 (II, 35) and p. 146 (II, 31).

451. *Ibid.,* p. 160. This importance of the exact line from the very start of the preparatory drawing is confirmed by the use of *velum* that allows each thing to be positioned in its "position," pp. 146–48.

452. See M. Baxandall, *Giotto and the Orators: Humanist Observers of Painting in Italy and the Discovery of Pictorial Composition, 1350–1450,* Oxford, 1971 (edition consulted, *Les Humanistes à la découverte de la composition en peinture,* Paris, 1989, pp. 160ff.).

453. Quintilian, *De l'institution oratoire,* VI, 2, Paris, 1831, III, p. 160.

454. This "educational" and convincing dimension of scientific illustration is in fact a general characteristic of the contribution of the Renaissance to the history of the sciences. See among others, James Ackerman, "The Involvement of Artists in Renaissance Science," *op. cit.,* pp. 94–129, in particular pp. 98 and 102ff.

455. Pliny the Elder, XXXV, 67–68, *op. cit.,* p. 66: "*Haec est picturae summa subtilitas.* […] *Ambire enim se ipsa debet extremitas et sic desinere, ut promittat alia post se ostendatque etiam quae occultat.*"

456. Diogenes Laertius, edition consulted, *Vies, doctrines et sentences des philosophes illustres,* Paris, 1965, II, pp. 185–87.

457. Eugène Dupréel, *Les Sophistes,* Neuchâtel, 1948, pp. 37 and 38. On the Sophists, see also Mario Untersteiner, *I Sofisti,* Milan, 1967.

458. D. Rosand, *The Meaning…, op. cit.,* p. 53.

459. See Alberti, *De pictura* (1435), *op. cit.,* p. 73 (I, 1).

460. See M. Kemp, *The Science of Art. Optical Themes in Western Art from Brunelleschi to Seurat* (1990), New Haven–London, 1992, p. 44.

461. Alberti, *op. cit.,* p. 169 (II, 39).

462. *Ibid.* See Leonardo da Vinci: "Many painters have the great fault of making the dwellings of people and other elements of the setting in such a way that the town gates do not reach the knees of the inhabitants, even if they are closer to the spectator then the man who is supposed to enter through them. We have seen porticoes carrying many people while the columns supporting them would have fitted in the palm of the hand of a man who was leaning on it like on a light stick. Such things must be avoided at all cost." (*Codex Urbinas,* 136r-v)

463. Alberti, *op. cit.,* p. 197 (II, 47).

464. See John Shearman, "Leonardo's Colour and Chiaroscuro," *op. cit.,* p. 17.

465. Alberti, *op. cit.,* p. 191 (II, 46).

466. J. Mesnil, "Botticelli, les Pollaiolo et Verrocchio," *Rivista d'Arte,* II-III, 1905, p. 37, quoted by C. Pedretti, *Leonardo architetto, op. cit.,* p. 278.

467. For the probable spatial incoherence of the corner of the wall, hidden by the Virgin but revealed by a precise geometrical reading, see Pedretti, *op. cit.*

468. See Pedretti, *op. cit.,* pp. 283–86.

469. See Alberti, *op. cit.,* pp. 115 (I, 19) et 153–56 (II, 33–34).

470. For divergent opinions on the perspective construction of *The Last Supper,* see Joseph Polzer, "The Perspective of Leonardo considered as a painter," in *La prospettiva rinascimentale. Codificazioni e trasgressioni,* Florence, 1980, pp. 233–47 ; Marichia Arese, Aldo Bonomi, Claudio Cavalieri et Claudio Fronza, "L'impostazione prospettica della 'Cena' di Leonardo da Vinci: un'ipotesi interpretativa," in *ibid.,* pp. 249–59; C. Pedretti, *Leonardo architetto, op. cit.,* pp. 276–78; M. Kemp, *The Science of Art…, op. cit.,* pp. 44-45; Francis M. Naumann, "The 'costruzione legittima' in the Reconstruction of Leonardo da Vinci's 'Last Supper'," *Arte Lombarda,* 52, 1979, pp. 65–89.

471. See Alberti, *op. cit.,* pp. 91 (I, 8), and 116–17 (I, 19).

472. See Alberti, *op. cit.,* p. 116. For Alberti, and this must be stressed, the "window" that he created in the wall did not open onto the world, contrary to what has often been said. It opens onto *historia.* His text is clear: "First I trace on the surface to be painted a square of the size I want, with right angles, and which for me is an open window through which we can contemplate history" ("Principio in superficie pingenda quam amplum libeat quadrangulum rectorum angulorum inscribo, quod quidem mihi pro aperta finestra est ex qua historia contueatur.")

473. See the brilliant, convincing demontration of M. Arese, A. Bonomi, C. Cavalieri and C. Fronza, "L'impostazione prospettica…," *op. cit.*

474. To a certain extent, this attitude in relation to the balanced statements of "humanist art" corresponds to the criticism that Bramante expressed during the same period regarding the universality of the architectural principles of humanism. See Arnaldo Bruschi, *Bramante architetto,* Bari, 1969. Leonardo belonged to the generation that, at the end of the Quattrocento, reflected and highlighted the crisis over the principles of humanism that would contribute to the definition of the "classical" Renaissance and of Mannerism. See the remarks on this point by J. Shearman, "Leonardo's Colour…," *op. cit.,* pp. 38–41.

475. The principles of anamorphosis consist in combining the foreshortening of the object on the picture plane and the foreshortening of the plane itself. See Kemp, *The Science of Art…, op. cit.,* p. 49–50. Away from the position assigned to the eye, away from the "viewpoint" and facing the picture plane directly, the shape that is represented on it is unidentifiable, unnamable and truly monstrous; it can only be "correctly" recomposed from the viewpoint, circumscribed by a "unique hole" through which one must look (*Ms A,* 38a). See *Traité de la Peinture,* ed. Chastel–Klein, p. 108. Thus Leonardo returned to the ocular device used by Brunelleschi, but he did so in order to propose a lateral view of the picture plane and thus subvert the very foundation of perspective geometry. On this point, see Hubert Damisch, *Théorie du "nuage." Pour une histoire de la peinture,* Paris, 1972, pp. 185–89.

476. Opposed to Aristotelian concepts, the idea that the air is blue in colour follows directly from the medieval optical

theory inspired by Alhazen. See Janis C. Bell, "Color Perspective, circa 1492," *Achademia Leonardi Vinci*, V, 1992, pp. 64–77, in particular pp. 70–73. Leonardo renounced it in 1500 by following *De coloribus* then attributed to Aristotle, see below.

477. See Janis C. Bell, "Color Perspective,…," *op. cit.*, p. 68.

478. J. Bell, *op. cit.*, pp. 65ff.

479. On these points, see J. Bell, "Aristotle as a Source for Leonardo's Theory of Colour Perspective after 1500," *Journal of the Warburg and Courtauld Institutes*, 56, 1993, pp. 100–18.

480. For a clear summary of the question, see Pietro C. Marani, *Léonard de Vinci. Catalogue complet des peintures* (1989), Paris, 1991, pp. 55–58 and 66–68.

481. The work was commissioned from Leonardo and the brothers Ambrogio and Evangelista de Predis in 1483 by the brotherhood of the Immaculate Conception for their chapel in the church of San Francesco Grande in Milan. For the iconography of the Immaculate Conception, see in particular Mirella Levi d'Ancona, *The Iconography of the Immaculate Conception in the Middle Ages and Early Renaissance, Monographs on Archaeology and Fine Arts Sponsored by the Archaeological Institute of America and the College Art Association of America*, VII, 1957. It recalls (pp. 73–75) that the commissioning of the work was directly connected to the debates on the Immaculate Conception that set Dominicans against Franciscans, and to the victory of the latter, sanctioned by two papal bulls in 1482 and 1483. The debate had been particularly heated in Milan where Vincenzo Bandello, Vicar of the Dominicans of Lombardy and future adviser to Leonardo for *The Last Supper*, had written a treatise opposing the Franciscan doctrine of the Immaculate Conception. Leonardo's iconographic choices remained original and the emphasis placed on the little Saint John the Baptist, presented as the last prophet of the Immaculate Conception, would be corrected in the second version, probably at the request of those who had commissioned the painting. Regarding the iconographic link between the rocks and the Immaculate Conception, see Joanna Snow Smith, "An Iconographic Interpretation of Leonardo da Vinci's *Virgin of the Rocks* (Louvre)," *Arte Lombarda*, 67, 1983–84, and "Leonardo's *Virgin of the Rocks* (Musée du Louvre). A Franciscan Interpretation," *Studies in Iconography*, XI, 1987, pp. 35–94. Regarding the autography of the two versions, the original contract suggests a collaboration of the de Predis brothers in the Louvre version which today experts tend to attribute to Leonardo alone; as far as the London version, is concerned, opinions vary, ranging from the idea that the work is by someone else completely to the opinion that tends to prevail today, that the painting is entirely autographic but unfinished. See P. Marani, *op. cit.*, p. 66.

482. On *rilievo* as the purpose of painting, see Leonardo da Vinci, *Traité de la Peinture, op. cit.*, p. 169: "[…] the painter's objective is to make the figures seem to stand out from the background."

483. On the "Albertian admonitory figure," see Alberti, *op. cit.*, p. 179 (II,42).

484. See H. Damisch, *Théorie du "nuage"…, op. cit.*, p. 218.

485. Regarding perspective as "structure of exclusion," see H. Damisch, *op. cit.*, pp. 170–71: if "in its normal, scientific, rational practice, perspective works like a technique of appropriation and rearranging the real," it is also true that perspective "only has to know the things that it can arrange in order;" in this way it becomes a "structure of exclusion whose coherence is based on a series of refusals, but which at the same time must make place for what it excludes from its order, such as for the background on which it is imprinted." It was on making this "background" visible that Leonardo concentrated.

486. Quoted by Shearman, "Leonardo's Colour…," *op. cit.*, p. 13. See Leonardo da Vinci, *Traité de la Peinture, op. cit.*, p. 79 (*Codex Urbinas*, 45v and 50r).

487. Leonardo da Vinci, *op. cit.* (*Codex Urbinas*, 133v).

488. Giovanni Paolo Lomazzo, *Idea del Tempio della Pittura* (1590), Florence, 1974, ed. Robert Klein, p. 130 (chap. XIV); Vasari, *Lives…, op. cit.*, 5, p. 46. See also Sabba de Castiglione who, in 1554, made Leonardo the "primo inventore delle figure grandi tolte dalle ombre delle lucerne," quoted by Shearman, "Leonardo's Colour…," *op. cit.*, p. 30.

489. Pliny the Elder, *Historia naturalis, op. cit.*, p. 89 (§ 127). On Nicias of Athens, see *ibid.*, p. 91 (§ 131).

490. *Ibid.*, p. 78 (§ 97). *Atramentum* is one of the "austere" colours whose origin and manufacture Pliny describes in § 30 and 41–42. On its meaning to Leonardo, see below.

491. See Weil–Garris Posner, "Raphael's *Transfiguration* and the Legacy of Leonardo," *Art Quarterly*, 1972, pp. 342–74, in particular p. 354. See also John F. Moffitt, "Leonardo's 'sfumato' and Apelle's 'atramentum'," *Paragone*, 1989, 40, no. 473, pp. 88–94, in which he points out that *atramentum* was a varnish invented by Apelles from burnt ivory and recalls Leonardo's recipes for *vernice d'ambra* that he used in his sfumato. For the significance of these connections in relation to *La Scapiliata*, see below.

492. T. Da Costa Kaufmann, "The Perspective of Shadows: The History of the Theory of Shadow Perspective," *Journal of the Warburg and Courtauld Institutes*, XXXVIII, 1975, pp. 258–87, in particular pp. 270–75.

493. J. Shearman, "Leonardo's Colour…," *op. cit.*, p. 32.

494. Vasari, *Lives…, op. cit.*, 5, p. 20 (changed in translation) and p. 60. On the relationship between Giorgione and Leonardo, see in particular Diecio Gioseffi, "Giorgione e la pittura tonale," in *Giorgione. Convegno Internazionale di Studi*, Castelfranco Veneto, 1979, pp. 91–98; David Rosand, "Giorgione e il concetto della creazione artistica," in *ibid.*, pp. 135–39; Giles Robertson, "Giorgione e Leonardo," in *idem*, pp. 195–99.

495. Galileo Galilei, *Considerazioni al Tasso* (song I, verse 1), quoted by Alexander Nagel, "Leonardo and *sfumato*," *Res. Anthropology and aesthetics*, 24, autumn 1993, p. 7.

496. The expression is A. Nagel's, *op. cit.*, p. 17.

497. Daniele Barbaro, *I Dieci libri dell'Architettura tradotti e*

commentati da Daniele Barbaro, VII, chap. 5, quoted by A. Nagel, *op. cit.*

498. See A. Nagel, *op. cit.*

499. The technical peculiarity of *La Scapiliata,* and the mystery of its initial function and destination resulted in the fact that it was often ignored by Leonardo experts who did not know where to place it in his work as a whole. C. Pedretti has explained that the work can be attributed to Leonardo in spite of the mystery surrounding its origins. See *Leonardo e il leonardismo a Napoli e a Roma, op. cit.,* pp. 115–16. See also Eugenio Riccomini, "Il Leonardo di Parma," in *Leonardo: il Codice Hammer…, op. cit.,* pp. 141–42.

500. On this quality of Apelles, see Pliny the Elder, *Historia naturalis, op. cit.,* p. 71 (§ 80).

501. See Alberti, *De Pictura, op. cit.,* p. 191 (II, 46); Pliny the Elder, *op. cit.,* pp. 58–59 (§ 50).

502. Pliny the Elder, *op. cit.,* p. 49 (§ 30) and 59 (§ 38).

503. On these recipes, see Leonardo da Vinci, *The Literary Works,* ed. Jean-Paul Richter (1883), Oxford, 1970, I, p. 364 (§ 635 and 636).

504. Pliny the Elder, *op. cit.,* p. 92 (§ 134): "[…] austerior colore et in austeritate iucundior, ut ipsa pictura eruditio eluceat."

505. J. Walker, "*Ginevra de' Benci* by Leonardo da Vinci," *Report and Studies in the History of Art,* National Gallery of Art, Washington, 1967, pp. 1-23, in particular pp. 11 and 18–19.

506. The expression is that of André Chastel, in Leonardo da Vinci, *Traité de la Peinture, op. cit.,* p. 76.

507. On what follows, see in particular, M. Clayton, "L'Ultima Cena," in *Leonardo e Venezia, op. cit.,* pp. 232–34; M. Kemp, *The Mystery of the* Madonna of the Yarnwinder, *op. cit.,* pp. 49 and 65.

508. M. Kemp, *op. cit.,* p. 49.

509. See T. Brachert, "A Distinctive in the Painting Technique of the Ginevra de' Benci and of Leonardo's other Early Works," *Report and Studies in the History of Art,* National Gallery of Art, Washington, 1969, pp. 85–104.

510. On this point, see also E. Battisti, "Ricostruendo la complessità" and G. Bertorello–G. Martellotti, "Per una lettura critica dei dati tecnici," in *La Pala ricostituita. L'Incoronazione della Vergine e la cimasa vaticana di Giovanni Bellini. Indagini e restauri,* Venice, 1988, pp. 11 and 92 respectively.

511. See D. Rosand, *Peindre à Venise. Titien, Véronèse, Tintoret* (1981), Paris, 1993, pp. 26–27.

512. Brachert, *op. cit.,* p. 103, note 18.

513. On these points, see the remarks of A. Nagel, "Leonardo and *sfumato," op. cit.,* pp. 17–19.

514. E. Gombrich, "Leonardo's Method…," *op. cit.,* p. 62.

515. See M. Clayton, "Studi per Adorazioni," in *Leonardo e Venezia, op. cit.,* pp. 188–205. The connection between the *Saint Jerome* and the study for an *Adoration* on sheet RL 12560 at Windsor is especially convincing.

516. For a detailed analysis of this page, see M. Kemp, *The Mystery…, op. cit.,* p. 50.

517. See A. Barb, "Diva Matrix," *Journal of the Warburg and Courtauld Institutes,* 1953, pp. 193ff.

518. Kemp, *The Mystery…, op. cit.,* p. 57.

519. On the *Madonna with the Spindles,* see *Leonardo dopo Milano. La Madonna dei fusi* (1501), ed. C. Vezzosi, Florence, 1982, and M. Kemp, *The Mystery…, op. cit.*

520. See Gigetta Dalli Regoli, "Leonardo intorno al 1501: il tema del gioco," in *Leonardo dopo Milano…, op. cit.,* pp. 25–31.

521. For a "cinematographic" reading with the effect of "play back," see C. Pedretti, "Introduzione," in *Leonardo dopo Milano…, op. cit.,* p. 21.

522. See Kemp, *The Mystery…, op. cit.,* pp. 16–18.

523. On the idea of "twin" works, see *ibid.,* p. 20—however, this does not mention the interesting fact of the rejection, somewhere along the way, of architecture as a link between figure and landscape. Also, according to Cecil Gould, the two works would have been produced simultaneously, one for Florimond Robertet and the other for Charles d'Amboise (see "Leonardo's *Madonna of the Yarnwinder.* Revelations of reflectogram photography," *Apollo,* 1992, 136, pp. 12–16).

524. A curious memory. Matteo Bandello indeed arrived in Milan in 1495, at the age of fifteen, and was entrusted to the care of his uncle, Prior of Santa Maria delle Grazie. As has been seen, the project of the "great horse" was abandoned in 1494. Possibly Leonardo continued to "work" on it mentally once the model was finished, thinking about it without touching it—and, who knows, perhaps a little rearing horse was born from these meditations?

525. M. Bandello, *Tutte le opere di Matteo Bandello,* ed. Francesco Flora (1934), 1952, Verona, I, p. 696 (new LVIII).

526. The drawing of *Leda* dates from 1503–04 and that of the Flower of Bethelehem from 1506–08. See C. Pedretti, in *Leonardo da Vinci. Studi di natura dalla Biblioteca Reale nel Castello di Windsor,* Florence, 1982, pp. 43–44.

527. Only some pages, because others, readied for publication, were certainly treated with more care.

528. See Giovanna Nepi Sciré, "Studi di proporzione," in *Leonardo e Venezia, op. cit.,* p. 224.

529. See G. Dalli Regoli, "Il problema dell'autografia nei dipinti di Leonardo," in *Leonardo e il leonardismo…, op. cit.,* p. 70.

530. See K. Clark, "Leonardo and the Antique," in *Leonardo's Legacy. An International Symposium,* ed. C.D. O'Malley, Berkeley–Los Angeles, 1969, pp. 18–20; D. Rosand, paper given to a seminar of the Centre d'histoire et théorie de l'art de l'EHESS, June 1994, to be published.

531. On the poetic writing of this description, see A. Marinoni, "Il Regno e il Sito di Venere," in *Poliziano e il suo tempo,* Florence, 1957, pp. 273–87.

532. See M. Kemp, *Leonardo da Vinci…, op. cit.,* pp. 258–59.

533. See K. Clark, "Leonardo and the Antique," *op. cit.,* pp. 19ff.

534. On the "*Humanissima Trinitas,*" see Meyer Schapiro, "Leonardo and Freud: an Art-Historical Study," 1956 (edition consulted "Léonard et Freud: une étude d'histoire

de l'art" in *Style, artiste et société,* Paris, 1982, pp. 93–138, in particular pp. 110–15).

535. Pietro C. Marani, *Léonard de Vinci. Catalogue complet* (1989), Paris, 1991, p. 18.

536. It is suggested by the chronology (assumed, it is true) that the documented works are between 1471 and 1481–82. The period 1471–76 included the *Dreyfus Madonna,* the *Annunciation,* the *Madonna with a Carnation,* the *Portrait of Ginevra de' Benci;* the *Benois Madonna,* Leonardo's work on the *Baptism of Christ* and the *Adoration of the Magi* can only be placed at the end of the 1470s (from 1478). The documented works therefore fall into two phases: 1471–76 and 1478–82.

537. Vasari, *Lives...,* op. cit., 5, p. 35.

538. For a view on this question, see P. Marani, *op. cit.,* pp. 41–42, and Nicoletta Pons, "Dipinti a più mani," in *Maestri e botteghe. Pitture a Firenze alla fine del Quattrocento,* Milan, 1992, pp. 37–39.

539. See Craig Hugh Smyth, "Venice and the Emergence of the High Renaissance in Florence: Observations and Questions," in *Florence and Venice. Comparisons and Relations,* Florence, 1979, ed. Sergio Bertelli, Nicolai Rubinstein, C. H. Smyth, I, pp. 209–49, in particular pp. 221ff. On Bellini's *Madonna and Child,* see Rona Goffen, *Giovanni Bellini,* New Haven–London, 1989, in particular pp. 23ff.

540. See C.H. Smyth, *op. cit.,* p. 225. This panel is a studio work painted in 1471 for the chapel of the noble Venetian Pietro Delfino, who was a cloistered monk. See also the note by Anna Paola Rizzo, in *Maestri e botteghe...,* op. cit., p. 71.

541. This probably refers to the *Madonna* described by Vasari, *Lives...,* op. cit., 5, p. 37: "Leonardo then painted a *Madonna,* a very beautiful painting, that was with Pope Clement VII; in it, he had depicted, among other things, a carafe full of water with flowers, of a marvelous truthfulness, with drops of water forming like dew on its surface so perfectly rendered that it looked more real than reality." It probably dates from 1473, rather than from 1478–80, because of its similarity with the structure of the *Dreyfus Madonna* (the gesture of whose right hand Leonardo used here), because of the introduction of the yellow piece of fabric that Leonardo had just invented for the *Annunciation,* and also because of the "internal logic," which dates the dramatic animation of the *Benois Madonna* and the studies for the *Madonna with the Cat* to the period of 1476–80.

542. See Caterina Canova, "Ritratti e teste ideali," in *Il disegno fiorentino del tempo di Lorenzo il Magnifico,* Milan, 1992, pp. 110–15.

543. On this drawing, *ibid.,* p. 98.

544. *Ibid.*

545. In the same way there are no birds or clouds in Leonardo's skies—although he observed and drew both very carefully. This absence is one of the reasons that, in my opinion, supports the attribution of the *Madonna Litta* (St. Petersburg, the Hermitage) to a disciple, after a drawing by Leonardo in the Louvre.

546. In 1469, the *Arte della Mercanzia* commissioned the series of *Virtues* from Piero del Pollaiuolo. But Verrocchio had taken part in the competition and, from 1464, he had been paid for a sketch of *Faith.* In 1470, Botticelli was allocated two *Virtues,* of which he only painted *Fortitude.* On the drawing in the Uffizi, see Gigetta Dalli Regoli, "Il disegno nella bottega," in *Maestri e botteghe..., op. cit.,* pp. 83–84.

547. On the identification of Mary as a "port," see Eugenio Battisti, "Le origini religiose del paesaggio veneto" (1980), dans *Venezia Cinquecento,* 2, 1991, pp. 9–26, in particular pp. 22–23 where Battisti emphasizes the presence of a port in the *Adoration of the Magi* painted by Ghirlandaio en 1486. Battisti also quotes from *Hymnes mariaux* whose text consists of a beautiful description of a lyricism appropriate for the landscapes of Leonardo: "*Cortina dei cieli, cielo senza nuvole, aria leggera, profumata, primavera./ Nuvola luminosa, splendida, chiarissima, candida, leggera, serena, pura, mattutina [...]/ Bruma, nebbia, nube della montagna della legge [...].*"

548. See C. Pedretti, "Ancora sul rapporto Giorgione–Leonardo e l'origine del ritratto di spalla," in *Giorgione. Convegno internazionale di studi,* Castelfranco Veneto, 1979, pp. 181–85, which strangely does not mention the Angel in the *Baptism* in this connection.

549. On this drawing, see in particular C. Canova, "Ritratti e teste ideali," *op. cit.,* pp. 114–15.

550. On the importance of Leonardo's interventions in the *Baptism,* see P. Marani, *Léonard de Vinci, op. cit.,* p. 42, and N. Pons, "Dipinti a più mani," *op. cit.,* p. 38.

551. On all these points, see Diodecio Redig de Campos, "San Gerolamo," in Leonardo, *Le Pitture,* Florence, 1977, pp. 65–68, and P. Marani, *op. cit.,* pp. 50–52. The list of 1482 is given in J. P. Richter, *The Literary Works, op. cit.,* § 680, I, p. 387. The presence in this list of "the head of a Duke" and "many drawings of groups" (that is, of knots) suggests that it was drawn up in Milan. But the plural "several Saint Jeromes" does not make it certain that it refers to the painting itself. Leonardo also included "una nostra donna finita" and "un altra quasi, ch'è in profilo"; would he be referring here to the two Virgins started in 1478?

552. But it true that the fragment that has been cut has traces of scissors on the reverse side.

553. Redig de Campos sees in it a reference to Alberti's facade of Santa Maria Novella, completed in 1470, *op. cit.,* p. 66.

554. See M. Clayton, in *Leonardo da Vinci, The Anatomy..., op. cit.,* p. 12.

555. See D. Arasse, *Le Détail. Pour une histoire rapprochée de la peinture,* Paris, 1992, pp. 86–87.

556. On this drawing, see in particular Antonio Natali, in *Il disegno fiorentino..., op. cit.,* pp. 246–47.

557. The originality of Leonardo's *Saint Jerome* is such, even within the typical iconography depicting him as a penitent in the desert, that Daniel Russo does not mention him in his book *Saint Jérôme en Italie. Étude d'iconographie et de spiritualité, XIII^e-XVI^e siècles,* Paris–Rome, 1987.

558. See P. Marani, *op. cit.*, which points out the echoes of *Saint Jerome* in Lombardy.

559. See M. Clayton, "Studi per Adorazioni," in *Leonardo e Venezia, op. cit.*, pp. 188–203.

560. See A. Natali, "Re, cavalieri e barbari; le 'Adorazioni dei Magi' di Leonardo e Filippino Lippi," in *Pittori della Brancacci agli Uffizi. Gli Uffizi, studi e ricerche*, 5, 1981, pp. 73–84, which mentions that the monks of San Donato at Scopeto were excommunicated in 1483—which shows their independent spirit—and suggests that the theologian who inspired Filippino Lippi's *Adoration of the Magi* was probably not the same as the one who had advised Leonard (p. 73).

561. On this *Adoration of the Magi*, see Rab Hartfield, *Botticelli's Uffizi "Adoration." A Study in Pictorial Content*, Princeton, 1976.

562. See R. Hartfield, *op. cit.*, p. 40. The frontal, centralized disposition had been foreshadowed by the London tondo in 1470. But the latter did not include the systematic kneeling of the Magi and the cortege (with trumpet blowers) was still there.

563. See R. Hartfield, *op. cit.*, pp. 58ff.

564. See R. Hartfield, *op. cit.*, pp. 68–100.

565. The two parallel stairs on either side of the three arcades could evoke the interior architecture of a church whose chancel would be raised above a crypt, as in San Miniato al Monte in Florence, or, even more interestingly, in the project for a facade conceived in 1463 by Alberti for the church of San Sebastiano in Mantua and inspired by the paleochristian funerary basilicas. The church was still unfinished when Alberti died in 1472 and construction was abandoned in the late 1470s; but the fame of the building was great enough that in August 1485, Lorenzo the Magnificent asked for the *modello* of the building, probably in relation to the project of Poggio a Caiano (see Arturo Calzona, "Il San Sebastiano di Leon Battista Alberti," in A. Calzona and Livio Volpi Ghirardini, Il *San Sebastiano di Leon Battista Alberti*, Florence, 1994, p. 85). The reconstruction of this project by R. E. Lamoureux (*Alberti's Church of San Sebastiano in Mantua*, New York–London, 1979), closely resembles the present state of the facade, is very similar to Leonardo's architectural drawing in the *Adoration of the Magi*. But it is possible that the two stairs planned by Alberti were arranged laterally and perpendicularly to the axis of this facade, see Arturo Calzona, *op. cit.*, p. 91. In any case, the comparison with the Albertian project is certainly worth looking at more closely because, although it may not have been directly inspired by Alberti, Leonardo's architectural invention reveals the same freedom in his relationship with antique art as Alberti's did—about which Cardinal Gonzaga observed in 1473 that the antique-type style of San Sebastiano had such a *viso fantastico* that it was difficult to know whether the building would have finally had the shape of a "church, mosque or synagogue" (quoted by A. Calzona, op., cit., p. 102 and 191). I warmly thank Mr. Pierre Bourlier for having drawn my attention to this question during a seminar at the Center d'histoire et théorie de l'art de l'E-HESS.

566. See K. Clark, "Leonardo's Adoration of the Sheperds and the Dragon Fight," *Burlington Magazine*, LXII, January, 1933, pp. 21–26; see C. Pedretti, *I cavalli di Leonardo, op. cit.*, pp. 38–39.

567. On the motif of the struggle between animals, after Charles Sterling, "Fighting Animals in the Adoration of the Magi," *The Bulletin of the Cleveland Museum of Art*, LXI, December 1974, pp. 350–59, see Maurice Brock, *Le Secret de la peinture, ou la postérité de Parrhasios: recherches sur l'art italien du Moyen Âge tardif et de la Renaissance*, Paris, 1996, Thèse d'État (École des Hautes Études en Sciences Sociales), II, pp. 155–67. On the reference to the apocryphal Armenian evangelist, see A. Natali, "Re, cavalieri e barbari...," *op. cit.*, p. 73.

568. This association of the semi-circle and the triangle was already found in Botticelli, but in a very different spirit. See Hartfield, *op. cit.*, pp. 109–10.

569. See Luisa Becherucci, in *Leonardo. La Pittura, op. cit.*, p. 76.

570. L. B. Alberti, *De Pictura..., op. cit.*, p. 171. See M. Brock, *Le Secret de la peinture..., op. cit.*, pp. 165–67.

571. For the universality of the Revelation through the Magi, see R. Hartfield, *op. cit.*, pp. 55–56. As the theme first originated with Saint Augustine, it is not surprising to find it in Leonardo's work since the painting was commissioned by the regular canons of Saint Augustine of the congregation of San Salvatore of Bologna for their convent of San Donato in Scopeto.

572. L. B. Alberti, *De Pictura..., op. cit.*, p. 179 (II, 42): "Furthermore, it is good that in a story there is someone who warns spectators of what is happening; that he invites them to look [...] or even that by his gestures he invites you to laugh or cry with the characters."

573. On the "closure" of the work, inherent in the Albertian system, see Hans Belting, *Das Bild und sein Publikum im Mittelalter: Form und Funktion früher Bildtaf. d. Passion*, Berlin, 1981 (edition consulted, *L'Arte e il suo pubblico. Funzione e forme delle antiche immagni della Passione*, Bologne, 1986, pp. 58–60).

574. Regarding the gesture of the hand holding the beard, expressing incomprehension in the face of an unexpected manifestation of the divine, see H. Janson, "The Right Arm of Michelangelo's Moses," in *Sixteen Studies*, New York, n.d., pp. 291–300. The identification of this character as Saint Joseph (among others by Natali, "Re, cavalieri, barabari...," *op. cit.*, p. 73) remains very uncertain. It would seem more likely to identify the latter (traditionally) in the figure who, behind the Virgin, holds a gift that had already been offered by the first of the Magi. These uncertainties are sufficient in themselves to indicate the originality of Leonardo's approach.

575. L. B. Alberti, *De Re Aedificatoria*, VII, 10: "Pictor uterque est: ille verbis pingit, hic penniculo docet rem," see note 386.

576. On this question, see in particular Donald J. Wilcox, *The*

Development of Florentine Humanist Historiography in the Fifteenth Century, Cambridge (Mass.), 1969, and Nancy S. Struever, *The Language of History in the Renaissance. Rhetoric and Historical Consciousness in Florentine Humanism,* Princeton, 1970.

577. Leonardo da Vinci, *Traité de la Peinture, op. cit.,* ed. Chastel–Klein, p. 141. Also see the text devoted to the attention of a crowd listening to a speech, pp. 143–44.

578. Ibid *op. cit.,* p. 68.

579. On this fame, see among others Clelia Alberici, *Leonardo e l'incisione,* Milan, 1984, pp. 59ff.; also see *Leonardo's Last Supper: Precedents and Reflections,* ed. David A. Brown, Washington, 1983.

580. On the Lombard tradition of placing all the apostles on the same side of the table, see Jack Wasserman, "Reflections on the *Last Supper* of Leonardo da Vinci," *Arte Lombarda,* 66, 1983, pp. 15–34, in particular pp. 33–34; Alessandro Rovetta, "La tradizione iconografica dell'Ultima Cena in Lombardia," in Marco Rossi et A. Rovetta, *il Cenacolo di Leonardo. Cultura domenicana, iconografia eucaristica e tradizione lombarda,* Milan, 1988, pp. 28ff.

581. On this association of the two themes, see Leo Steinberg, "Leonardo's *Last Supper,*" *The Art Quarterly,* winter 1973, pp. 297–390, which in particular takes up and deepens the interpretation put forward by Johann Boloz Antoniewicz in 1904 (see pp. 308ff.). See also the criticism of Steinberg by Creighton Gilbert, "Last Suppers and their refectories," in *The Pursuit of Holiness in Late Medieval and Renaissance Religion,* ed. Charles Trinkaus and Heiko A. Oberman, Leyden, 1974, pp. 371–407, in particular pp. 393ff., refuted by J. Wasserman, *op. cit.,* pp. 26–30. But P. Marani still sees nothing more in *The Last Supper* than a reference to the Eucharist, preferring to interpret it as an announcement of the coming betrayal. See *La Cena di Leonardo,* Milan, 1986, p. 17.

582. In Mark (14:20), the traitor is the one "that dippeth with me in the dish"; in Matthew (26:23), it is "he that dippeth his hand with me in the dish"; in Luke (22:21), it is he whose hand is "with me on the table"; and in John (13: 26), it is the one to whom Jesus gives the dipped sop of bread.

583. John says nothing about the institution of the Eucharist; in Matthew and Mark, the announcement of the betrayal precedes the institution of the Eucharist; in Luke, the announcement of the betrayal follows the institution of the Eucharist.

584. Saint Thomas Aquinas, *Summa Theologica,* IIa, IIae, 94, art. 1: "Religio non est fides, sed fidei protestatio per aliqua exteriora signa."

585. On the ideas of "establative" and "performative," see Émile Benveniste, "La philosophie analytique et le langage" (1963), in *Problèmes de linguistique générale,* Paris, 1976, I, pp. 267–76: "The performative statement [...] serves to carry out an action. To express such an statement, is to carry out the action [...] A performative statement that is not an action does not exist. It only has an

existence as an action of authority [...] There is no performative statement but that containing the mention of the act, viz. I order."

586. On this engraving, see "Leonardo's *Last Supper*"...*, op. cit.,* no. 3.

587. See L. Steinberg, "Leonardo's *Last Supper,*" *op. cit.,* pp. 302–03, which distinguishes the six successive moments of the narrative that would be present in the work.

588. On this drawing, see the brief observations of M. Kemp, "Introductory Essay," in A. E. Popham, *The Drawings of Leonardo da Vinci,* London, 1994, pp. 23–24.

589. If one drops a vertical perpendicular line from the visible area of the ceiling, one notices that the latter stops very clearly "behind" the figures in the foreground; the same is true of the tapestries: the one nearest to the foreground is placed behind the table where the apostles are sitting. Finally, the lateral framing, originally reinforced by a painted pilaster, conceals the fact that the imaginary room of *The Last Supper* is slightly larger than the actual refectory. On the principles that inspired this construction, see above, p. 300. The very detailed analysis by Francis M. Naumann ("The 'costruzione legittima'...," *op. cit.*) leads to the conclusion that the perspective diagram of *The Last Supper* itself "is open to simultaneous and compatible interpretations" (p. 86). M. Kemp is right in believing that the diversity of possible solutions for the perspective construction of *The Last Supper* shows that it would be useless to try and reconstruct "the" solution adopted by Leonardo: perspective is used here to create an "effect" in the composition, which itself is conceived as a totality. See *The Science of Art..., op. cit.,* p. 147–48. see also P. Marani ("Il Cenacolo...," *op. cit.,* p. 16) which goes so far as to consider the problem of the perspective construction as "marginal."

590. See F. M. Naumann, *op. cit.,* pp. 83–84.

591. The upper part of the preparatory drawing in Windsor (RL, 12542) shows regular blind arcades, strangely evocative of an archaic framing concept (see M. Clayton, "L'Ultima Cena," in *Leonardo e Venezia, op. cit.,* p. 230). This presence confirms the fact that, from the very beginning, Leonardo wished to create a regular scansion on the surface against which the interaction of the figures would be more obvious. In the final work, this effect is obtained by the internal scansions on the surface, the painted frame serving to emphasize the effect of projection of the figures.

592. For example, the group with Judas contains two backward movements (Judas and John) and one forward movement (Peter), while the symmetrical group with Thomas consists of two forward movements (Thomas and Philip) and one backward movement (James the Greater). With the side groups, the movement in the left one towards the center is "launched" from the edge by Bartholomew (and held back by the palms of Andrew's hands), while in the right group, it is Matthew's hands that create the sliding movement towards the center after the "halting" gesture of Thaddeus. See also the analysis by P. Marani on the vari-

ation in the positions of the heads of the apostles, "Il Cenacolo…," *op. cit.,* pp. 12–13.

593. Leonardo da Vinci, *Traité de la Peinture,* ed. Chastel–Klein, *op. cit.,* p. 39. See J. Wasserman, "Reflections…," *op. cit.,* pp. 30-31, which underlines the importance of this simultaneity in the ensemble of *The Last Supper,* but without mentioning its role from the point of view of the religious content of the work. For an analysis of musical proportion in the composition, see Thomas Brachert, "A Musical Canon of Proportion in Leonardo da Vinci's *Last Supper,*" *Art Bulletin,* LIII, 1971, pp. 461–66. L. Steinberg, *op. cit.,* p. 338, more simply describes a composition founded on the principle of "musical counterpoint."

594. Leonardo da Vinci, *Traité de la Peinture, op. cit.,* p. 68.

595. See for example Ludwig Heydenreich, *The Last Supper,* London 1974, pp. 47ff., for whom each apostle is identifiable not because of a particular attribute or written name, but because the gestures would correspond to the temperament ascribed to them in the Gospels. However, this way of identifying the apostles is still quite hazardous: Heydenreich identifies the apostles on the basis of the relation between their gestures and subsequent history—and he reaches parallels and regroupings that differ from those of another who followed the same method, L. Steinberg, *op. cit.,* pp. 331ff.

596. See "Leonardo's *Last Supper*: Precedents and Reflections," *op. cit.,* nos. 11, 12, 13, 14, 15, 17.

597. See L. Steinberg, "Leonardo's *Last Supper,*" *op. cit.,* pp. 331–35: the succeeding events would be readable in Peter, holding the knife he would use on the Mount of Olives, in John, whose hands have the same pose as they would at the foot of the cross, in Judas, whose tense neck evokes his hanging, in Andrew, whose hands anticipate his future crucifixion, in Bartholomew, with the knife of his martyrdom, and in James the Less, whose hand reaches behind Andrew to touch the shoulder of Peter, who was to become the first Bishop of Rome, while he would become the first Bishop of Jerusalem.

598. See L. Steinberg, *op. cit.,* p. 338, who also recalls that it is at the centre, in the figure of Christ, that the *"formative principle"* of the work has its origin, as much for its movement as for its colours (p. 340).

599. L. Heydenreich, *The Last Supper, op. cit.,* pp. 66–67.

600. E. Gombrich, "The Form of Movement…," *op. cit.,* pp. 206–07. Dante, *Il Paradiso,* XIV, 1-3. P. Marani rightly points out the fact that the development of *The Last Supper* is inseparable from Leonardo's many interests and researches during the 1490s, in which the study of movement played a central role. See "Il Cenacolo…," *op. cit.,* p. 9.

601. See for example J. Wasserman, "Reflections…," *op. cit.,* p. 33.

602. On this point and the meaning that "division" (or periodization) of historical narrative had in Florence in the Quattrocento and the move from the model of Livy to Sallust, see D. Wilcox, *The Development of Florentine Humanist Historiography…, op. cit.* On the importance of this division of the narrative in painting, see my remarks in "Piero della Francesca, peintre d'histoire?," in *Piero teorico dell'arte,* ed. Omar Calabrese, Rome, 1985, pp. 85–114.

603. On the "apostasis toû nûn," see Aristotle, *Physics* (edition consulted, *Physique,* IV, 13-14, Paris, 1926, p. 157, tr. H. Carteron).

604. On the spatialisation of historical time in history painting, see Louis Marin, *Détruire la peinture,* Paris, 1977, pp. 93–97.

605. See above, p. 104.

606. From this point of view, *The Last Supper* anticipates the theories of Leonardo on the *"Primo motore"* that, while remaining stationary, gives its movement to the universe. See above, p. 116 and P. Marani, "Il Cenacolo…," *op. cit.,* p. 14, which does not draw all the consequences from this observation.

607. Saint Bernardino of Siena, *De triplici Christi Nativitate,* in *Pagine scelte,* ed. Dionisio Pacetti, Milan, 1954, p. 54.

608. Vasari, *Lives…, op. cit.,* 5, pp. 43–44. The description of the eyebrows is particularly unexpected today. However, rapid conclusions that he could not be trusted as a reliable witness should be avoided. It is indeed possible that Leonardo had painted them like that and that they disappeared during an ancient restoration of the painting. (See K. Clark, "Mona Lisa," *Burlington Magazine,* March 1973, p. 147.) Moreover, it is equally possible that Vasari saw the portrait of Mona Lisa. In 1524 an inventory was made after the death of Salai, who had been Leonardo's favorite pupil and who had always been at his side in France; Leonardo had bequeathed to him a number of original paintings, including a *"Ledda,"* a *"quadro de Santa Anna,"* a painting *"dicto la Joconda"* (see Janice Shell and Grazioso Sironi, "Salai and Leonardo's Legacy," *Burlington Magazine,* CXXXIII, 1991, pp. 95–108). On Leonardo's death, Salai is thought to have brought these paintings back to Italy. However, the discovery of this inventory raises as many questions as it answers. Nothing provides certain confirmation that the paintings brought back from France were originals: their return to the collections of Francis I in France still cannot be explained; indeed, they might have been excellent copies by Salai himself—which does not help much in the present analysis. It is, on the other hand, very interesting to learn that in Leonardo's entourage, the painting was called *"La Joconda"*: this detail confirms the identity of the model and expresses the "pleasing" nature of the portrait. As far as the lashes and eyebrows of *La Joconda* are concerned, they must have been less visible than this "escutcheon of a beautiful face" imagined by Vasari would suggest. Eyebrows are usually not very obvious in the faces of Leonardo's female characters. In *The Courtier,* Baldassare Castiglione twice mentions, while deploring it, the fashion which drove women to pluck their eyebrows and the top of their forehead, see *Le Livre du Courtisan,* Paris, 1987, p. 46 (I, 19) and p. 78 (I, 40): "[…] They try to compensate through artifice the

various deficiencies of nature; [...] that is why they pluck the hairs of their eyebrows and their forehead [...]." Regarding the "commonplaces" of female beauty at the beginning of the 16th century, see Giovanni Pozzi, "Il ritratto della donna nella poesia d'inizio Cinquecento e la pittura di Giorgione," in *Giorgione e l'Umanesimo veneziano*, Florence, 1981, ed. Rodolfo Palluchini, pp. 309–41.

609. On these interpretations of the *Mona Lisa*, see Jean-Pierre Guillerm, *Tombeau de Léonard de Vinci. Le peintre et ses tableaux dans l'écriture symboliste et décadente*, Lille, 1981, which quotes Gautier p. 33, and Pater p. 199, n.11.

610. With *Monna Vanna* (or the "Naked Gioconda") probably conceived in Rome for Giovanni de' Medici, which will be considered in the last chapter of this book (fig. 322).

611. For all that follows, see Frank Zöllner, "Leonardo's Portrait of Mona Lisa del Giocondo," *Gazette des Beaux-Arts*, March 1993, pp. 115–38.

612. The relatively large size of the *Mona Lisa* supports this interpretation. Measuring 77 x 53 cm, it is the largest of Leonardo's portraits that have survived.

613. Like those who have made Mona Lisa a young widow (see K. Clark, "Mona Lisa," *op. cit.*, p. 147, and Donald S. Strong, "The Triumph of Mona Lisa," in *Leonardo e l'età della ragione, op. cit.*, pp. 255–70) or a pregnant woman (see Kenneth K. Keele, "The Genesis of Mona Lisa," *Journal of the History of Medicine and Allied Sciences*, 1959, XIV, 2, pp. 135–59).

614. The function of the loggia is more formal than iconographic, in spite of Donald S. Strong ("The Triumph of Mona Lisa," *op. cit.*) who interprets the *Mona Lisa* as personifying the Chastity of the young widow triumphing over Time, following the tradition placing Chastity in a high tower. No doubt Raphael took the idea of the loggia for *The Lady with the Unicorn*, in which the attribute confirms her virtue, but on the other hand Leonardo gives the *Mona Lisa* no attribute and the context of the two works is radically different.

615. As the painting reveals no traces of being cut at the sides, there is no reason to suppose that these columns were visible at the beginning. On the contrary, their thinness emphasizes their effect by diminishing their role of imaginary architecture in favor of a redoubling of the border (see following note). It is probable that this idea came to Leonardo while he was working on the painting and that the columns were more developed in the preparatory cartoon that inspired Raphael first in the drawing he made of it and subsequently in the *Lady with the Unicorn* (see fig. 266, 275). See Zöllner, "Leonardo's Portrait...," *op. cit.*, p. 120.

616. On the function of the Albertian frame, see Alfonso Procaccini, "Alberti and the 'Framing' of Perspective," *The Journal of Aesthetics and Art Criticism*, XL, 2, Fall 1981, pp. 29–39, in particular pp. 34–35. See also Louis Marin, "Le cadre de la représentation et quelques-unes de ses figures," *Cahiers du Musée National d'Art Moderne*, 24, summer 1988, p. 67, and "Les combles et les marges de la

représentation," *Rivista d'Estetica*, 17, 1984, p. 14. The importance of the role of the frame and border in the consciousness of artists at the beginning of the sixteenth century is clearly reflected in the anecdote about Fra Bartolommeo reported by Vasari: to avoid the encroaching of frames (made by carpenters) onto the painted surface, Fra Bartolommeo had invented the idea of painting, along the edges of his panels, a niche in perspective whose *cornici* formed an *ornamento* in their own right for the figures (see Vasari, *Lives..., op. cit.*, 5, p. 124) Regarding the importance which this "border" sometimes acquires in painting in the Italian Renaissance, see D. Arasse, "L'opération du bord. Observations sur trois peintures classiques," in *Cadres et marges, Actes du quatrième colloque du CICADA* (December 1993), ed. Bertrand Rougé, Pau, 1994, pp. 15–25.

617. It has sometimes been thought that a window was originally painted behind the left shoulder of the figure in *La Dame à l'hermine*, see David A. Brown, "Leonardo and the Idealized Portrait in Milan," *Arte Lombarda*, 1983, 67, p. 103. A recent technical analysis has shown that there was nothing there, see Maria Rzepinska, "The 'Lady with the Ermine' Revisited," *Achademia Leonardi Vinci*, VI, 1993, p. 191, which on the other hand confirms that the background has been darkened and that it was originally lighter, which would have softened the contrast of light.

618. See Webster Smith, "The Mona Lisa Landscape," *Art Bulletin*, June 1985, pp. 183–99, which exhaustively develops an idea put forward by M. Kemp, *Leonardo da Vinci..., op. cit.*, pp. 244–47.

619. On the first question, see above, p. 77; on the second, see M. Kemp, *op. cit.*, and Jane Roberts, "Catalogo del Codice Hammer," in *Leonardo: Il Codice Hammer e la Mappa di Imola*, Los Angeles–Florence, 1985, p. 53 (*Codex Hammer* 9A). The description of the two lakes appears after a long passage on the presence of fossils in places that are high up. Rejecting the explanation of the Flood, Leonardo related their presence to that of water, retained in the past by rocky barriers.

620. See the similar position of D. Rosand, "Alcuni pensieri sul ritratto e la morte," in *Giorgione e l'Umanesimo veneziano, op. cit.*, pp. 302–05, and "The Portrait, the Courtier and Death," in *Castiglione. The Ideal and the Real in Renaissance Culture*, New Haven–London, 1983, ed. Robert W. Hanning and David Rosand, pp. 107–15.

621. On the attribution of these portraits to Leonardo, see P. Marani, *Léonard de Vinci..., op. cit.*, p. 90.

622. On this possible triple portrait of Cesare Borgia and the reasons for doubting the model's identity, see C. Pedretti, *Disegni di Leonardo da Vinci e della sua scuola alla Biblioteca Reale di Torino*, Florence, 1975, pp. 10–11. P. Marani (*Leonardo e i Leonardeschi a Brera*, Florence, 1987, p. 43) was the first to indicate the relationship between this drawing and the triple portrait of a goldsmith painted by Lorenzo Lotto in about 1530–35 (Vienna, Kunsthistorisches Museum)—which suggests that Leonardo would have drawn this portrait in Milan and brought it with him

to Venice; Cesare Borgia was indeed in Milan in 1499. See P. Marani, "Leonardo a Venezia e nel Veneto: documenti e testimonianze," in *Leonardo e Venezia, op. cit.,* p. 34.

623. On this "fable" invented by Leonardo, see above, p. 260. On the question of "movements of the soul" in the portrait, see John Pope-Hennessy's authoritative study, *The Portrait in the Renaissance* (1979), Princeton, 1989, pp. 101ff.

624. See Peter Meller, "Physiognomical Theory in Renaissance Heroïc Portraits," in *The Renaissance and Mannerism. Studies in Western Art, Acts of the Twentieth International Congress on the History of Art,* Princeton, 1963, II, pp. 53-69.

625. See David A. Brown, "Leonardo and the Idealized Portrait…," *op. cit.*

626. See David A. Brown, "Ladies with the Ermine and the Book," *Artibus et Historiae,* 1990, p. 52. See also Thomas Martone, "Leonardo da Vinci's Reaction Portraits," *Rivista di Studi Italiani* (Université de Toronto), II, 2, 1984, pp. 27–72, who interprets the attribute and pose of the model as a function of her reputation as a poet. The idea is not incorrect but it should not be seen as the only key to the painting's interpretation: Thomas Martone is thus led to an artificial interpretation of Cecilia Gallerani's expression, "irritated" by (and reserved in front of) the sudden intervention of an undefined person.

627. On *sprezzatura,* see Alain Pons, "Présentation de Baldassare Castiglione" in B. Castiglione, *Le Livre du Courtisan* (1528), Paris, 1987, ed. Alain Pons, pp. XXff.

628. In this portrait painted in 1488, the cartouche painted behind model's neck reads: "Ars utinam mores/animumque effingere/posses pulchrior in ter/ris nulla tabella foret/MCCCCLXXXVIII." Thomas Martone (*op. cit.,* p. 42) points quite rightly that one of the most remarkable innovations in Leonardo's portraits was the fact they expressed the temperament (or personality) of the model by means of their facial expression rather than by the use of traditional symbolic accessories which accompanied the figure to help the spectator "read" it .

629. See D. A. Brown, "Leonardo and the Idealized Portrait…," *op. cit.,* p. 105.

630. On the problems raised by the autography of the picture, see P. Marani, *Léonard de Vinci…, op. cit.,* pp. 59–60. The date of the work is no doubt quite early, because, in spite of its qualities, the stiffness of the pose seems to put the portrait before *The Lady with the Ermine.*

631. See D. A. Brown, "Ladies with the Ermine…," *op. cit.,* pp. 47 and 60. On the general significance of these political and hierarchical influences on the formal arrangement of the statement of the portrait, see D. Arasse, "Les portraits de Jean Fouquet," in *Il Ritratto e la Memoria. Materiali 2,* Rome, 1993, ed. Augusto Gentili, Philippe Morel, Claudia Cieri-Via, pp. 61–75.

632. On this profile and the problems of date which it raises, see K. Clark and C. Pedretti in *The Drawings of Leonardo da Vinci in the Collection of Her Majesty the Queen at Windsor Castle,* London, 1968, I, p. 88. Based on the technique used, the drawing appears to date from 1486–88, thus

placing it in Leonardo's Milanese period; but the model's hairstyle is typically Florentine. These two observations undermine the hypothesis put forward by Herman T. Colenbrander who very temptingly, sees in it a first stage of Isabella d'Este's profile. "Hands in Leonardo Portraiture," *Acchademia Leonardi Vinci,* V, 1992, pp. 39–40.

633. See C. Pedretti, "Ancora sul rapporto Giorgione-Leonardo…" *op. cit.,* p. 182.

634. On *La Belle Ferronnière,* see P. Marani, *Léonard de Vinci, op. cit.,* p. 64. The expression of the face is even more difficult to assess in that the hair arrangement covering the left ear is a later repainting.

635. On this theory of *innamoramento* and its role in the creation of effects in paintings, see D. Arasse, "Le corps fictif de saint Sébastien et le coup d'œil d'Antonello," in *Le Corps et ses fictions,* Paris, 1983, ed. Claude Reichler, pp. 55–72.

636. On these hesitations, see H. T. Colenbrander, "Hands in Leonardo Portraiture," *op. cit.,* pp. 37–43, which looks at the question from a rather different point of view.

637. See John Walker, "Ginevra de' Benci by Leonardo da Vinci," *Report and Studies in the History of Art,* National Gallery of Art, Washington, 1967, p. 12.

638. According to J. Walker (*op. cit.,* pp. 14–16), it could be the same model, Lorenzo di Credi having produced a second version of the portrait after the commissioner of the portrait, Bernardo Bembo, Ginevra's platonic lover, had taken Leonardo's painting with him to Venice.

639. *The Musician* (whose hand could be a subsequent addition, possibly autograph) is excluded from this analysis because the question of the expressiveness of the hands is irrelevant here. However, it clearly shows the influence of Flemish painting through the intermediary of Antonello, and this observation also supports the idea that it is earlier than Cecilia Gallerani's portrait.

640. See H. T. Colenbrander, "Hands in Leonardo Portraiture," *op. cit.,* p. 41.

641. *Decor puellarum,* Venice, 1461, quoted by F. Zöllner, "Leonardo's Portrait…," *op. cit.,* p. 136, note 105. Much more effectively than the iconographic reference to the "Tower of Chastity," this pose of the hands was thus sufficient to suggest the virtue of Mona Lisa. This position had already been used with the hands of the woman in the *Double portrait* of Filippo Lippi (New York, Metropolitan Museum); and it was also used, with a slight variation, for the hands of Giovanna Tornabuoni by Ghirlandaio, both in the portrait in the Thyssen-Bornemisza collection (Madrid) and in the fresco in Santa Maria Novella, Florence.

642. See F. Zöllner, *op. cit.,* p.126. Thus the expression of the model's personality is not reduced to its single facial expression—as T. Martone tries to suggest in "Leonardo's Reaction Portraits," *op. cit.,* p. 42.

643. The term refers to the classic analyses of Norbert Elias, *La Civilisation des mœurs* (1939), Paris, 1973.

644. K. Clark, "Mona Lisa," *Burlington Magazine,* March 1973, p. 145.

645. On "essere del nulla," see above, p. 117. For a similar effect achieved by different means but which also involves an "internal plane" articulating the unlocatable "position" of the figure, the imaginary "space" of the background and the real one of the spectator, see my comments on the *Venus of Urbino* by Titian in "L'opération du bord...," *op. cit.,* pp. 20-22.

646. Heinrich Wölfflin, *Klassische Kunst* (1888), edition consulted *Classic Art,* London–New York, 1968, p. 29.

647. This connection had already been noticed by Robert de La Sizeranne, "Léonard de Vinci et l'esthétique du portrait," *Figaro Illustré,* February 1896, pp. 29–31.

648. On this point, see my remarks in *La Renaissance maniériste,* Paris, 1997.

649. J. Walker, "Ginevra de' Benci...," *op. cit.,* p. 18, stresses this "variation" in the expression of the three portraits, but curiously attributes the differences to sadness or melancholy, thus interpreting Cecilia Gallerani's expression as "appealing wistfulness."

650. On the renown of Ginevra de' Benci, a "beacon" of educated Florentine society, and on Bernardo Bembo, see J. Walker, *op. cit.,* pp. 2ff., and Jennifer Fletcher, "Bernardo Bembo and Leonardo's Portrait of Ginevra de' Benci," *Burlington Magazine,* CXXXI, 1041, December 1989, pp. 811–16.

651. This comparison is justified by the importance attributed to names in the sixteenth century (see for instance Vasari on the relation between the respective first names of Michelangelo and Raphael and their style, "terrible," like the archangel of Judgment Day, and "gentle," like the archangel who helped Tobias). Regarding the (supposed) genuine affection of Francesco del Giocondo for his third wife, see F. Zöllner, "Leonardo's Portrait...," *op. cit.,* p. 119. From this point of view it is also significant that the portrait should have been known as *"La Joconda"* in Leonardo's own entourage. see above, note 608.

652. On the classic example of Poussin's two self-portraits, painted according to a variation on the musical "mode" of each, see the fascinating analysis by Louis Marin, "Variation on an absent portrait: the self-portraits of Poussin" in *Sublime Poussin,* Paris, 1995, pp. 186–208.

653. See the remarks of D. Strong, "The Triumph of Mona Lisa," *op. cit.,* pp. 261ff., who, in order to describe this appearance of the landscape invents the expression of *timescape* to refer to this landscape. This symbolic investment of the landscape probably explains the presence of the bridge near the left shoulder of the figure: the only trace of human activity paradoxically visible in this "primitive" landscape. The bridge is an accessory commonly used, by Leonardo and his followers in particular, to indicate the passage of time. See C. Pedretti, "Leonardo in Sweden," *Acchademia Leonardi Vinci,* VI, 1993, p. 206. As it is represented, the bridge even gives the impression of being the last trace of an ancient human presence, in a moving awareness of macrocosmic time, the remnant of a primordial state of the earth and an earth from which man in his turn would have disappeared.

654. See D. Rosand, "Alcuni pensieri...," *op. cit.,* pp. 304–05.

655. K. Clark, "Mona Lisa," *op. cit.,* pp. 149–50.

656. For an opinion on these works, see P. Marani, Léonard de Vinci..., *op. cit.,* pp. 132–48.

657. On Leonardo's impact on Florence in the years 1500–07, see in particular P. Marani, "I dipinti di Leonardo, 1500-1507: Per una cronologia," in *Leonardo, Michelangelo and Raphaël in Renaissance Florence from 1500 to 1508,* Washington, 1992, ed. Serafina Hager, pp. 9–28, and David Alan Brown, "Raphaël, Leonardo and Perugino: Fame and Fortune in Florence," *ibid.,* pp. 29–53.

658. Frederick Hartt, "Leonardo and the Second Florentine Republic," *Journal of the Walters Art Gallery,* 44, 1986, p. 106. On the end of Botticelli's life, see Vasari, *Lives...,* op. cit., 4, pp. 261 and 262.

659. Meyer Schapiro, "Leonardo and Freud...," *op. cit.*

660. Gian Paolo Lomazzo, *Trattato dell'arte della pittura, scoltura e architettura* (1584), I, 1, in *Scritti sulle arti,* Florence, 1974, ed. Roberto Paolo Ciardi, II, p. 29.

661. Vincenzo Danti, *Il Primo Libro del Trattato delle perfette proporzioni di tutte le cose che imitare e ritrarre si possono con l'arte del disegno* (1567), chap. XI, in *Trattati d'arte del Cinquecento. Fra Manierismo e Controriforma,* Bari, 1960, ed. Paola Barocchi, I, p. 237.

662. Alberti, *De Pictura, op. cit.,* II, 41–45, pp. 174–88.

663. On the questions of chronology concerning the two versions, see P. Marani, *Léonard de Vinci, op. cit.,* pp. 142–45, and Martin Clayton, *Leonardo da Vinci. One Hundred Drawings from the Collection of Her Majesty the Queen,* London, 1996, pp. 76-77, which reports a final drawing relating to *Leda* in 1514–15.

664. See Gigetta Dalli Regoli, "Mito e Scienza nella "Leda" di Leonardo," XXX *Lettura Vinciana,* Florence, 1991, pp. 8-9. See also Carlo Pedretti, *Leonardo. A Study in Chronology and Style,* London, 1973, p. 97, which quotes a note in which Leonardo recalls in 1508 "the daughters of my lord Alfeo and Leda Fabbri," probably referring to the models for the female figures.

665. See Pierre Grimal, *Dictionnaire de la mythologie grecque et romaine,* Paris, 1951.

666. See Ann H. Allison, "Antique Sources of Leonardo's *Leda,*" *Art Bulletin,* LVI, 1974, 3, p. 380; Johannes Nathan, "Some Drawing Practices of Leonardo da Vinci: New Light on the *Saint Anne,*" *Mitteilungen des Kunsthistorischen Institutes in Florenz,* XXVI, 1992, pp. 85–101, in particular 85–89.

667. On what follows, see G. Dalli Regoli, "Mito e Scienza...," *op. cit.,* pp. 14–20.

668. On the Neoplatonist concept of the lover, see *Codex Trivulzio* 6a: "The lover is moved by the beloved object as sense is by the sensitive, and they unite and become one and the same thing. The work of art is the first thing to be born of this union; if the beloved object is vile, the lover becomes vile. When the object he is united with befits the one united, he derives delectation, pleasure and satisfaction from it" (see J.-P. Richter, *The Literary Works..., op. cit.,* II, p. 249, no. 1202). C. Pedretti (*The*

Literary Works of Leonardo da Vinci. A Commentary to Jean-Paul Richter's Edition, Oxford, 1977, II, pp. 248–49, and *Leonardo da Vinci, op. cit.,* p. 99) quotes a text of 1506–08 in which sexual attraction is described in a completely different spirit: "The man wishes to know if the woman will consent to the lust which he hopes for, and when he sees that is the case and that she desires the man, he asks her to participate and implements his desire. And he cannot know it without admitting to it and when he admits to it, he makes love (*fotte*)." Regarding the power of the role of the woman and the female womb in procreation, see Gigetta Dalli Regoli, *op. cit.,* p. 19, who quotes the passage in which Leonardo states that the "seed of the mother has the same power in the embryo as that of the father," which was an exceptional statement for the time.

669. On the "mythical" character of this plate, see above, p. 280.

670. Published and analyzed by C. Pedretti, "A Ghost Leda," *Raccolta Vinciana,* XX, 1964, pp. 379–83. The drawings of weapons date back to 1487–90, so the presence of Leda's silhouette would be the result of an accidental transfer from a drawing on another sheet. The drawing usefully indicates that as far as the position of the swan's wing is concerned, the Spiridon *Leda* is the closest to Leonardo's original idea, and it also corresponds to Leonardo's written observations on the shape of the wings of birds.

671. For very full documentation on *Leda,* see *Leonardo e il leonardismo a Napoli e a Roma, op. cit.,* pp. 79–116. The Spiridon *Leda* has recently been cautiously attributed to the Spanish painter Fernando Yanez de la Almandina, the "Ferrando Spagnolo" who worked with Leonardo on *The Battle of Anghiari.* See P. C. Marani, in *L'Officina della maniera. Varietà e fierezza nell'arte fiorentina del Cinquecento fra le due repubbliche, 1494–1530,* Florence, 1996, p. 128.

672. For these sources from antiquity, see K. Clark, "Leonardo and the Antique," in *Leonardo's Legacy..., op. cit.,* pp. 18ff.; Ann H. Allison, "Antique Sources of Leonardo's *Leda,*" *Art Bulletin,* LVI, 1974, 3, pp. 375ff.; M. Kemp and J. Smart, "Leonardo's *Leda* and the Belvedere River Gods," *Art History,* III, 2, 1980, p. 182–93; see also *Leonardo e il leonardismo..., op. cit.,* pp. 88–91.

673. G. Dalli Regoli, "Mito e Scienza...," *op. cit.,* p. 11.

674. See Kemp-Smart, "Leonardo's *Leda*...," *op. cit.,* p. 188.

675. *Ibid.,* p. 189.

676. In May 1501, only a humiliating agreement had succeeded in preventing the town from being captured and pillaged: the Seigneury had to pay a ransom of 36,000 florins to the Valentinois and hand over the mining town of Piombino. See Hartt, "Leonardo and the Second Florentine Republic," *op. cit.,* p. 100.

677. On what follows, see J. Wilde, "The Hall of the Great Council of Florence," *Journal of the Warburg and Courtauld Institutes,* 7, 1944, pp. 65ff.; C. Pedretti, "Nuovi documenti riguardanti la *Battaglia d'Anghiari,*" in *Leonardo inedito. Tre saggi,* Florence, 1968, pp. 53–78; F. Hartt, "Leonardo and..." *op. cit.,* pp. 97ff.; Nicolai Rubinstein, "Machiavelli and the mural decoration of the Hall of the Great Council of Florence," in *Musagetes. Festschrift für Wolfram Prinz,* Berlin, 1991, pp. 275–85; Alessandro Cecchi, Antonio Natali, Carlo Sisi, "L'Officina della maniera," in *L'Officina della maniera..., op. cit.,* in particular pp. 10ff.

678. Vasari, *Lives..., op. cit.,* 5, p. 126.

679. According to C. Pedretti ("Nuovi documenti...," *op. cit.,* pp. 69-70, which is founded on the *Libro* by Antonio Billi published in about 1518), the technical problem could have been due to the fact that Leonardo had been supplied with oil that had been tampered with. But it is also possible that the deterioration was due to the recipe invented by Leonardo himself, see A. Cecchi, in *L'Officina della maniera, op. cit.,* p. 104.

680. Letter from Agnolo Doni dated August 17, 1549, quoted by Pedretti, *op. cit.,* p. 71.

681. See Cecil Gould, "Leonardo's Great Battle Piece. A Conjectural Reconstruction," *Art Bulletin,* XXXVI, 1954, pp. 117–29, and C. Pedretti, "Nuovi documenti...," *op. cit.,* ill. 61 (which with some slight differences follows Gould's arrangement).

682. The summary of the battle used by Leonardo is given in his *Carnets, op. cit.,* II, pp. 385–86, and in *Traité de la Peinture,* ed. Chastel–Klein, *op. cit.,* p. 70. See also Machiavelli, *Istorie Fiorentine,* V, 33, who lays emphasis on the struggle for the control of the bridge and simply observes: "Flags and chariots were also taken" (in *Œuvres,* Paris, 1996, pp. 868–870). On Leonardo's precise sources, see A. Cecchi, in *L'Officina della maniera..., op. cit.,* p. 12.

683. See M. Kemp, *Leonardo da Vinci, op. cit.,* pp. 223–26; F. Hartt, "Leonardo and...," *op. cit.,* pp. 103–04 and 110. Kemp emphasizes (p. 226) that in taking power in 1342, Gautier de Brienne had had the Florentine standard destroyed, the better to mark the change of rule that had taken place.

684. According to M. Kemp (*op. cit.,* pp. 223–25), the episode might even represent a false alarm, provoked deliberately on the eve of the fight to show that soldiers should always be ready for battle. But Michelangelo had probably arranged the episodes of the battle around the central group and into the depth of the background. See A. Cecchi, in *L'Officina della maniera..., op. cit.,* p. 112.

685. This long text, superbly writeen, is given among others in the *Carnets, op. cit.,* II, pp. 267–69 and in *Traité de la Peinture,* ed. Chastel–Klein, *op. cit.,* pp. 63-65.

686. For the drawing of this "captain," see C. Gould, "Leonardo's Great Battle Piece...," *op. cit.,* p. 122. In the written description of the battle, these two incidents are conveyed in the following terms: "You will be able to see a wounded man falling to the ground and covering himself with his shield, and the enemy leaning over him, trying to kill him [...] You will see the reserve forces waiting full of hope and ready to act [...] as they wait for the captain's order; and similarly the captain, with his baton

raised, runs towards the reserve forces to show them where they are wanted."
687. See above, p. 301.
688. On the chronology of these three panels and the differences between the actual conditions of battle and its representation, see Franco and Stefano Borsi, *Paolo Uccello,* Paris, 1992, pp. 308ff.
689. On Piero della Francesca's two battle pieces and the "vision of history" that they imply, see my remarks in "Piero, peintre d'histoire ?" in *Piero teorico dell'arte,* Rome, 1985, *a cura di* Omar Calabrese, pp. 85–114, and "*Oltre le scienze dette di sopra:* Piero et la vision de l'histoire," in *Piero della Francesca and His Legacy, Studies in the History of Art,* 48, ed. Marilyn Aronberg Lavin, Washington, 1994, pp. 105–13.
690. C. Gould rightly stresses the originality of such a choice, in which Leonardo's taste for movement can be recognized.
691. The identification of the Florentines on the right and the Milanese on the left is almost unanimous, but Kemp has some good arguments for the opposite interpretation. See *Leonardo da Vinci, op. cit.,* p. 227.
692. On the identification of the two sides through their expression and physionomic types, see C. Gould, "Leonardo's Great Battle Piece…," *op. cit.,* 121.
693. According to Quintilian, *Institutio Oratoria,* VI, 2, *enargeia* is "that quality of the discourse that Cicero called illustration and evidence, that seems less to say things than to show them, and this affects us as if we were in the middle of these things" (Paris, 1831, III, p. 160). Leonardo's "illustrative" effectiveness is well confirmed by Vasari's description of this group: "Fury, hatred and rage are no less perceptible in the men than in the horses; two of these, their front legs interlocked, are fighting with their teeth in a combat as desperate as the horsemen in the struggle for the standard. A soldier who has grabbed it turns round suddenly while urging his horse to be off; he is hanging onto the pole as he tries to pull it from the hands of the soldiers surrounding him; two of the defenders are holding it with one hand and raising the other to try and cut the wood with their swords; an old soldier wearing a red beret is holding tightly to the pole with one hand while screaming and brandishing a saber with the other; he strikes a furious blow as he tries to cut the hands of the two soldiers who are fighting with all their might, gnashing their teeth, as they fiercely defend their flag. On the ground, between the legs of the horses, the foreshortened figures of two soldiers can be seen fighting; the one on the ground, is waving his legs and arms as he tries to escape death, that is, the other soldier above him, who is raising his arm as high as possible so as to sink the fatal dagger in his throat with all his strength"
694. On this sequence, see C. Gould, *op. cit.*; Giovanna Nepi-Sciré, "La Battaglia di Anghiari," in *Leonardo & Venezia, op. cit.,* pp. 256–79.
695. This fusion of man and animal perhaps also reflects the difference between these two records of the battle in the

"camera di Lorenzo" where Uccello's battle paintings were displayed, accompanied by the three panels representing the fights of lions and dragons, a hunting scene and a Judgment of Paris. See F. and S. Borsi, *Paolo Uccello, op. cit.,* p. 308.
696. On this drawing, see K. Clark–C. Pedretti, *Leonardo da Vinci. Drawings at Windsor Castle, op. cit.,* I, p. 30.
697. On the "tavola Doria," see C. Pedretti, "La 'Tavola Doria'," in *Leonardo inedito…, op. cit.,* pp. 79-86, and A. Cecchi, in *L'Officina della maniera…, op. cit.,* p. 104.
698. See Vasari, *Lives…, op. cit.,* 5, p. 43.
699. On the possible existence of this cartoon, see J. Wasserman, "A Rediscovered Cartoon by Leonardo da Vinci," *Burlington Magazine,* CXII, 1970, pp. 194–204, and Johannes Nathan, "Some Drawing Practices of Leonardo da Vinci: New Light on the *St. Anne,*" *Mitteilungen des Kunsthistorischen Institutes in Florenz,* XXVI, 1992, pp. 85–101. But it remains probable that Vasari here confused the London cartoon with that of 1501.
700. See J. Wasserman, "The Dating and Patronage of Leonardo's Burlington House Cartoon," *Art Bulletin,* Sept. 1971, LIII, 3, pp. 312–25, in particular pp. 324–25. On the development of the cult of Saint Anne at the end of the Quattrocento, see M. Schapiro, "Leonardo and Freud…," *op. cit.,* pp. 111ff.
701. The text of this letter is given, for example, in *Leonardo dopo Milano…, op. cit.,* doc. 44. On this letter in relation to the *Madonna of the Spindles,* see above, p. 325.
702. See F. Hartt, "Leonardo and the Second Florentine Republic," *op. cit.,* p. 100.
703. On these different proposals, see P. Marani, *Léonard de Vinci…, op. cit.,* pp. 103–04.
704. See P. Marani, "I dipinti di Leonardo, 1500-1507…," *op. cit.,* pp. 11ff.
705. See the very detailed analyses of Virginia Budny, "The Sequence of Leonardo's Sketches for the *Virgin and Child with Saint Anne and John the Baptist,*" *Art Bulletin,* LXV, 1, pp. 34–46.
706. On the term *Humanissima Trinitas,* see M. Schapiro, "Leonardo and Freud…," *op. cit.,* p. 115.
707. On this condensation, see in particular M. Schapiro, *op. cit.,* pp. 126–27.
708. For the complete text, see among others, *Leonardo dopo Milano…, op. cit.,* doc. 27 and 28.
709. On this phrase of Paul Klee, see *Théorie de l'art moderne,* Paris, 1977, p. 38.
710. On this *Nativity* by Lorenzo Lotto, see my remark in "Lorenzo Lotto dans ses bizarreries: le peintre et l'iconographie," in *Lorenzo Lotto. Atti del Convegno internazionale di studi per il V Centenario della nascita,* Treviso, 1981, pp. 367–70.
711. On the theme of the Virgin-mountain and Christ "*mons de monte sine manu hominis excisus*" or "*lapis sine manu caesus,*" see Eugenio Battisti, "Le origine religiose del paesaggio veneto" (1980), *Venezia Cinquecento,* 2, 1991, pp. 10–11 and 24.
712. On these various vanished pictures, see P. Marani, *Léonard*

de Vinci..., op. cit., pp. 140–41 and 145–48; *Leonardo e il leonardismo a Napoli e Roma, op. cit.,* pp. 146–50; for *The Rape of Proserpine,* see C. Pedretti, *Leonardo. A Study in Chronology and Style,* London, 1973, p. 174.

713. On this date, see C. Pedretti, *op. cit.,* pp. 166–67.
714. Vasari, *Lives..., op. cit.,* p. 38.
715. C. Pedretti, *Leonardo..., op. cit.,* p. 169.
716. P. Marani, *Léonard de Vinci..., op. cit.,* p. 118.
717. On the exchange of *caritas* between God and Mary, see Jacques de Voragine, *La Légende dorée,* Paris, 1967, I, pp. 250–51, who quotes Saint Bernard. The "Hail, full of grace" is explained by the fact that "the grace of divinity is in her breast, the grace of charity is in her heart [...]" and "it is by ineffable divine charity that the Word is made plain."
718. See in particular C. Pedretti, *Leonardo..., op. cit.,* p. 167.
719. On Antonello's "Venus" concept and practice of painting, see Maurice Brock, "Vasari et la triple séduction d'Antonello de Messine," in *Antonello da Messina. Atti del convegno di studi tenuto a Messina dal 29 novembre al 2 dicembre 1981,* Messina, 1988, pp. 537ff.; D. Arasse, "Le corps fictif de Sébastien et le coup d'œil d'Antonello," in *Le Corps et ses fictions,* Paris, 1983, ed. Claude Reichler, pp. 55–72.
720. On the *affectum devotionis,* see E. Panofsky, "Imago Pietatis....." (1927), in *Peinture et dévotion en Europe du Nord à la fin du Moyen Âge,* Paris, 1997, pp. 13–28; Sixten Ringbom, *Icon to Narrative. The Rise of the Dramatic Close-Up in Fifteenth-Century Devotional Painting* (1965), Doornspljsk, 1984.
721. Leonardo da Vinci, *Traité de la peinture,* ed. Chastel–Klein, *op. cit.,* p. 137 (*Codex Urbinas,* 13v).
722. This is the interpretation made by Chastel–Klein, *op. cit.,* p. 221.
723. On what follows, see in particular David A. Brown, in David A. Brown and Konrad Oberhuber, "Monna Vanna and Fornarina: Leonardo and Raphael in Rome," in *Essays Presented to Myron P. Gilmore,* Florence, 1978, ed. Sergio Bertelli and Gloria Ramakus, II, pp. 25–37.
724. See D.A. Brown, *op. cit.,* pp. 33–34.
725. C. Pedretti, *Leonardo..., op. cit.,* p. 167.
726. B. Castiglione, *The Book of the Courtier* (1528), (*Le Livre du Courtisan,* Paris, 1981, ed. Alain Pons, p. 403 [IV, 70]).
727. See C. Pedretti, "The Angel in the Flesh," *Achademia Leonardi Vinci,* IV, 1991, pp. 34–48.
728. The autograph character of the drawing was not in doubt when it was discovered recently. However, the right arm is as "badly" drawn as that of the angel on the sheet of 1503–04 (fig. 320) which experts believe to be the work of a pupil subsequently corrected by Leonardo's pen. But in any case, even though it might not be by Leonardo himself, this drawing is a perfect example of the work produced in his studio: the idea can only be his or come from his immediate entourage.
729. The sex is less visible than the rest of the figure because at an unknown time someone has tried to erase it. See C. Pedretti, "The Angel...," *op. cit.,* p. 39.

730. C. Pedretti, *Leonardo. Il disegno,* Florence, 1996, p. 33.
731. Leonardo da Vinci, *Carnets, op. cit.,* I, p. 128. The (rather humorous) text is worth quoting in full because it somewhat corrects the received idea regarding Leonardo's sexual "phobia"; it is heterosexual sex that he finds repugnant but male sex arouses completely different feelings in him: "Regarding the penis. The latter is linked to human intelligence and sometimes it has an intelligence of its own; in spite of the will which wishes to stimulate it, it is obstinate and does as it wishes, sometimes moving without the man's permission or even without him knowing; whether he is asleep or awake, it only follows its own impulse; often man is asleep and it is awake; and sometimes man is awake and it is asleep; very often man wants to use it but it refuses; very often it wants it and man forbids it. Thus it appears that this being has a life and intelligence very distinct from that of man and that the latter is wrong to be ashamed of naming it or displaying it, always trying to cover and conceal what he should decorate and display with pomp like an officiant."
732. Durandus, *Rationale divinorum officiorum,* I, iii, 2, "Graeci etiam utuntur imaginibus pingentes illas, ut dicitur, solum ab umbilico supra, et non inferius, ut omnis stultae cogitationis occasio tollatur [...]," quoted by S. Ringbom, *Icon to Narrative..., op. cit.,* p. 40.
733. The letter of Ugolino Vierino is quoted by S. Meltzoff, *Botticelli, Signorelli and Savonarola.* Theologia Poetica *and Painting from Boccaccio to Poliziano,* Florence, 1987, p. 41. On the Bacchus–Christ relationship through bacchic drunkenness, see in particular Edgar Wind, "Orpheus in Praise of Blind Love," in *Pagan Mysteries in the Renaissance* (1958), (edition consulted *Mystères païens de la Renaissance,* Paris, 1992, pp. 75–76 and 298).
734. See Sydney J. Freedberg, "A recovered work of Andrea del Sarto with some notes on a Leonardesque connection," *Burlington Magazine,* CXXIV, 1982, p. 287–88, which also recalls the *Ovid Moralisé* by a connection between Saint John the Baptist and Bacchus. On this theme, see in particular E. Wind, "Pan and Proteus," in *Pagan Mysteries..., op. cit.,* pp. 227ff.
735. B. Castiglione, *The Book of the Courtier* (*Le Livre du Courtisan, op. cit.,* p. 246 [III, 14]).
736. G. P. Lomazzo, *Il Libro dei Sogni,* in *Scritti sulle arti,* ed. Roberto Paolo Ciardi, Florence, 1973, I, pp. 19–22 and 104–06, and C. Pedretti, "The Angel...," *op. cit.,* p. 36.
737. See above regarding the European success of *Monna Vanna.* Like Carlo Amoretti (1804), D. A. Brown stresses that several of Leonardo's erotic mythological drawings were destroyed in the eighteenth century; it is likely that their preservation would have had an influence on Leonardo's image (see "Leonardo and Raphaël...," *op. cit.,* p. 64, n. 32).
738. On the part of autography in this picture, see P. Marani, *Léonard de Vinci, op. cit.,* p. 119.
739. S. J. Freedberg, "A recovered work...," *op. cit.,* p. 285, emphasises the importance of this innovation. C. Pedretti

connects his pose with the *Ignudi* in the Sistine Chapel in *Leonardo...*, *op. cit.*, pp. 164–65.

740. See K. Clark, "Leonardo and the Antique," in *Leonardo's Legacy...*, *op. cit.*, pp. 28-29; C. Pedretti, "La 'Leda di Vinci,'" in *Leonardo e il leonardismo...*, *op. cit.*, p. 79.

741. According to C. Pedretti (*Leonardo...*, *op. cit.*, p. 164), it might even be the painting that Leo X commissioned from Leonardo and on the subject of which, Leonardo having immediately set about distilling oils and grasses, the pope is said to have cried out: "Alas! Here is a work which will never be finished; he is already thinking of the end of the work before having even started it" (See Vasari, *Lives...*, *op. cit.*, 5, p. 46).

742. According to Pedretti, *op. cit.*, p. 166, there is no evidence that the *Saint John the Baptist* seen at Cloux is the half-length painting that is today in the Louvre.

743. Quoted by among others by Angela Ottino della Chiesa, in *Tout l'œuvre peint de Léonard de Vinci*, Paris, 1965, p. 109.

744. C. Pedretti, *Leonardo...*, *op. cit.*, p. 165.

745. R. Muther (*Geschichte der Malerei*, 1909), quoted by Sigmund Freud, *Eine Kindheits...*, *op. cit.*, p. 147.

746. E. Gombrich, "Leonardo and the Magicians: Polemics and Rivalry" (1983), in *New Light on Old Masters, Studies in the Art of Renaissance*, IV, London, 1986, p. 76.

747. *Ibid.*, pp. 72ff.

748. Vasari, *Lives...*, *op. cit.*, 5, p. 19.

749. Vasari, *Lives...*, *op. cit.*, 5, pp. 35–37 (translation adapted).

750. *Ibid.*, p. 45 (translation adapted).

751. *Ibid.*, p. 38 (translation adapted).

752. On Leonardo's phallic monsters, see G. P. Lomazzo, *Trattato dell'arte della pittura, scoltura et architettura* (VII, 16), in *Scritti sulle arti.*, *op. cit.*, II, p. 553: "One could mention and paint many other monsters, and among those produced by Leonardo da Vinci in Milan, the first one is a very beautiful young man, with his penis on his forehead, without a nose and with another face on the back of his head which had the male sexual organ below the chin with the ears attached to the testicles, these heads having ears like a faun; the other monster had the penis attached above the nose, the eyes on the sides of the nose and, otherwise, it too was a very beautiful young man [...]." See also C. Pedretti, *Leonardo...*, *op. cit.*, p. 144, and, for Salai's surname, "The Angel in the Flesh," *op. cit.*, p. 35.

753. The complete text (*Codex Atlanticus*, 96v-b) is given in *Leonardo da Vinci, Scritti letterari, op. cit.*, ed. A. Marinoni, pp. 191–92 and in *Traité de la peinture, op. cit.*, ed. Chastel–Klein, pp. 57–58.

754. *Codex Atlanticus*, 370v-a, in *Scritti letterari, op. cit.*, p. 129.

755. See J.-P. Richter, *The Literary Works of Leonardo da Vinci, op. cit.*, II, p. 104, no. 844. For a psychoanalytical interpretation of Leonardo's repeated references to cannibalism, see K. R. Eissler, *Leonardo da Vinci: Psychoanalytic Notes on the Enigma*, New York, 1961 (edition consulted, *Léonard de Vinci. Étude psychanalytique*, Paris, 1980, pp. 288–98).

756. *Codex Atlanticus*, 370r-a, in *Leonardo da Vinci, Scritti letterari, op. cit.*, p. 126.

757. *Ibid.*, p. 138 (*Ms. I*, 191v).

758. On what follows, see A. Chastel, *Art et Humanisme à Florence...*, *op. cit.*, pp. 102–04 and 423–25; R. Klein, "Giudizio et gusto dans la théorie de l'art au Cinquecento" (1961), in *La Forme et l'intelligible*, Paris, 1970, p. 341; Martin Kemp, "'Ogni dipintore dipinge se': a Neoplatonic Echo in Leonardo's Art Theory?" in *Cultural Aspects of the Italian Renaissance. Essays in Honor of Paul Oskar Kristeller*, New York, 1976, pp. 311–23; Frank Zöllner, "'Ogni Pittore Dipinge Sé,' Leonardo da Vinci and 'Automimesis,'" in *Der Künstler über sich in seinem werk. Internationales Symposium der Bibliotheca Hertziana*, Rome, 1989, coord. Matthias Winner, Weinheim, 1992, pp. 137–49; D. Arasse, *Le Sujet dans le tableau*, Paris, 1997, pp. 7–9.

759. See A. Chastel, *Art et Humanisme...*, *op. cit.*, p. 423 (and Leonardo da Vinci, *Traité de la Peinture, op. cit.*, p. 195). For a description of these "intimate mechanisms," see Kemp, " 'Ogni Dipintore...' ," *op. cit.*, p. 314–15: taking up various medieval interpretations of the Aristotelian theories, Leonardo believed that, because the soul formed the body and judgment, and judgment controlled invention, since judgment displayed individual variations (which corresponded to the forms of the body created by each individual soul), their inventions would inevitably "resemble" their masters in their external appearance: "[...] our judgment guides the hand in the creation of the contours of the figures until it is satisfied. Since judgment is a faculty of the soul with which it makes up the form of the body in which it resides, according to its will, when it has to remake a human body using the hand, it would willingly make again that which he discovered first. Thus it often falls in love with things that resemble it and return its love" (*Ms. A*, 15).

760. See A. Chastel, *op. cit.*, pp. 423–24.

761. Chastel, *op. cit.*, p. 104, whose translation explains while also limiting the meaning of the sentence: "No painter could produce a figure if he did not intentionally first identify with what it must be."

762. This last word ("*materia*" in the *Codex Urbinas*, 34r) is sometimes interpreted as a writing error for "*miseria*"; Leonardo would have been saying that one should not publish one's own deficiencies. But "*materia*" does appear to correspond more with Leonardo's thought and should therefore be favored.

763. For Cennino Cennini, see *Le Livre de l'art* (*Il Libro del arte*), Paris, 1991, ed. Colette Déroche, pp. 75–76 (I, 29); For Alberti, see *De Pictura...*, *op. cit.*, III, 52, p. 209-211: "[...] I wish that the painter, in order to achieve all this perfectly, should be above all, an upright man and that he should be educated in the liberal arts. [...] the artist himself must scrupulously conform to high principles; he should also have a humane nature and graciousness in order to acquire that favor that is a firm assurance against poverty, and money that will provide the best help to perfect his art."

764. See A. Chastel, *Art et Humanisme...*, *op. cit.*, p. 422 and Leonardo da Vinci, *Traité de la Peinture, op. cit.*, p. 200. This taste for solitude is also expressed in the "fable" of the stone that wanted to join its fellow creatures (in *Scritti letterari, op. cit.*, pp. 91–92), interestingly also used by Alberti, see Eugenio Garin, "La città in Leonardo" (1971), in *Leonardo letto e commentato..., op. cit.*, pp. 313–15.

765. See Leonardo da Vinci, *Traité de la Peinture, op. cit.*, ed. Chastel–Klein, p. 200. On the need to draw in company, see *ibid.*, p. 203.

766. G. Vasari, *Lives..., op. cit.*, 5, pp. 31, 34–35, 46.

767. A. Chastel, "Actualité de Vinci...," *op. cit.*, p. XII.

768. On the cover of the portrait, see A. Natali in *L'Officina della maniera..., op. cit.*, p. 134 (no. 31a).

769. See Margot and Rudolf Wittkower, *Born under Saturn*, New York, 1963, (edition consulted *Les Enfants de Saturne. Psychologie et comportement des artistes de l'Antiquité à la Révolution française*, Paris, 1991, pp. 89ff.).

770. K. Clark, *Leonardo da Vinci, op. cit.*, p. 337.

771. D. Rosand, *The Meaning..., op. cit.*, p. 26.

772. L. Heydenreich, *Leonardo da Vinci*, London, 1954, p. 20, quoted by M. and R. Wittkower, *Born under Saturn, op. cit.*, p. 98. On the two notes concerning the death his father, see M. Schapiro, "Deux méprises de Léonard de Vinci suivies d'une erreur de Freud" (1955–56), in *Style, artiste et société, op. cit.*, pp. 139–46.

773. See G. Vasari, *Lives..., op. cit.*, pp. 84–91. On the portrait by Piero di Cosimo and the issues it raises, see D. Arasse, "Piero di Cosimo, l'excentrique" (1991), in *Le Sujet dans le tableau, op. cit.*, pp. 41–57.

774. G. Vasari, *Lives..., op. cit.*, 5, p. 88.

775. See in particular *Essais*, III, 11, "Des boiteux": "je n'ai vu monstre et miracle au monde plus exprès que moi-même [...]. Plus je me hante et me connais, plus ma difformité m'étonne, moins je m'entends en moi" (edition consulted, Paris, 1962, p. 1114).

776. On the meaning of this expression here, see Agnès Minazzoli, *L'Homme sans image. Une anthropologie négative*, Paris, 1996, which enables Leonardo's morphological (and non-anthropocentric) thought to be placed in its philosophical tradition and Renaissance context.

777. On this identification, see K. Clark, *Leonardo da Vinci Drawings at Windsor Castle* (1935), London, 1968, p. 114, and C. Pedretti, *Leonardo..., op. cit.*, p. 23.

778. Jacqueline Risset, in *Dante, Le Purgatoire*, Paris, 1988, pp. 14 and 333.

779. Version brought up to date and abridged from the text "Léonard et la culla del nibbio: pour une approche historique du 'souvenir d'enfance,'" in *Symboles de la Renaissance*, II, Paris, 1982, pp. 59–69 and 226–29.

780. See Jean-Paul Richter, *The Literary works of Leonardo da Vinci* (1883), London, 1977, p. 342, no. 1363: "Questo scriversi distintamente del nibbio par che sia mio destino perchè nelle prima ricordatione della mia infantia e'mi parea che, essendo io in culla, che un nibbio venisse a me e mi aprisse la bocca colla sua coda, e molte volte mi percuotesse col tal coda dentro alle labra."

781. Sigmund Freud, *Eine Kindheits..., op. cit.*, p. 131.

782. Quoted by J.-B. Pontalis, in "L'attrait des oiseaux," in *S. Freud, Un souvenir..., op. cit.*, p. 9.

783. M. Schapiro, "Leonard and Freud...," *op. cit.*, pp. 93–138.

784. *Ibid.*, p. 137.

785. See in particular K. R. Eissler, *Leonardo da Vinci, op. cit.*, and, more recently, Jean-Pierre Maïdani Gérard, *Léonard de Vinci. Mythologie ou théologie?*, Paris, 1994.

786. See A. Chastel, "Léonard de Vinci: la réputation d'un peintre," in *Tout l'œuvre peint de Léonard de Vinci*, Paris, 1968, p. 8.

787. See S. Freud, *op. cit.*, p. 98.

788. The historical approach is particularly efficient for reconstructing the material used by what Freud calls the "figuration through symbols in dreams" when he points out that the symbolism used in the dream is also present "in all the unconscious imagery, in all the collective representations, including popular ones: in folklore, myths, legends, sayings, proverbs, common plays of words." (*L'Interprétation des rêves*, Paris, 1967, p. 301).

789. S. Freud, *Eine Kindheits..., op. cit.*, p. 163.

790. See E. Solmi, "Le Fonti dei manoscritti di Leonardo da Vinci," *Giornale storico della letteratura italiana*, 10–11, 1908, pp. 118 and 163.

791. For the networks of associations of ideas concerning the kite and those unconnected with Leonardo's texts, and for the analysis of an important change in the "bestiary," made by Leonardo to a passage in Pliny's text, see my study "Leonardo et la *culla del nibbio*: pour une approche historique du 'souvenir d'enfance'" in *Symboles de la Renaissance*, II, Paris, 1982, pp. 61–69, in particular pp. 63–66.

792. Leonardo da Vinci, *Scritti letterari*, Milan, 1974 (1952), ed. A. Marinoni, p. 83.

793. James Beck, "I sogni di Leonardo," XXXII *Lettura Vinciana*, Florence, 1993, who mentions the fable of the monkey and the little bird and highlights the connection with the theme of the kite (p. 17–18), but without drawing any conclusion regarding its connection with the childhood memory.

794. Version brought up to date and abridged from the text "Léonard de Vinci et l'origine du corps," in *À corps perdu, Revue d'esthétique*, 27/95, issue prepared by Murielle Gagnebin and Christian Gaillard, pp. 27–36.

795. R. Philo, in M. Clayton and R. Philo, *Leonardo da Vinci: The Anatomy, op. cit.*, p. 38, and see above, p. 280.

796. See S. Freud, *Eine Kindheits..., op. cit.*, pp. 68–71, and K. R. Eissler, *Leonardo da Vinci..., op. cit.*, pp. 220ff.

797. See Freud, *op. cit.*, p. 69.

798. Isidore of Seville, *Etymologiarum sive originum libri XX*, Oxford, 1911, II, 11, 1, 77: "Nam post partum si quid sanguinis nondum fuerit uteri nutrimentum consumptum naturali meatu fluit in mammos, et earum virtute albescens lactis accipit qualitatem," quoted by Charles T. Wood, "The Doctor's Dilemma: Sin, Salvation and the Menstrual Cycle in Medieval Thought," *Speculum*, LVI, 1981, p. 119.

799. See M. Clayton, *op. cit.*, p. 48. The testicles are described

as "sources of ardor" in the penultimate phrase of the central column of sheet RL, 19097v: "Come i coglioni sono/causa d'ardimento."

800. Leonardo da Vinci, *Carnets*, Paris, 1942, II, p. 230 (Richter, no. 681).
801. Leonardo da Vinci, *op. cit.*, I, p. 104:"The act of coitus and the organs involved are of such hideousness that, if it were not for the beauty of the faces and ornaments of the actors, and restraint, nature would lose human nature."
802. Quoted by S. Freud, *Eine Kindheits...*, op. cit., p. 69.
803. C. Wood, "The Doctor's Dilemma...," *op. cit.*, p. 115. This concept of procreation is very close to what is involved in Leonardo's approach to the preparatory drawing when the contour line finally gives a shape (extracted from it) to the magma of the "informal sketch" in which the hand follows the flux of its own gesture (see above, p. 284). This may be one of the personal reasons that inspired Leonardo's vocabulary when he described artistic creation (see above, pp. 266–68): in Leonardo's eyes the latter was very similar to the process of procreation as imagined by the scientists of the time.
804. Heinrich Kramer and Jacobus Sprenger, *Le Marteau des sorcières*, Paris, 1973, p. 207 (Question VI). Published in Strasbourg in 1486, the *Malleus Maleficarum* was the "authorized illustration" of Innocent VIII's papal bull *Summis desiderantes affectibus* (see *op. cit.*, p. 30), and the Dominican archbishop of Florence, Antoninus (who died in 1449) was "the most modern authority on whom the author of *Malleus* based his thinking" (*idem*, p. 22).
805. Leonardo's library included a edition of *Manganello*, whose author is unknown. The title is a nickname for the male sexual organ. It is a virulent (and traditional) pamphlet against women. On Leonardo's evolution concerning the role of women in procreation, see above, p. 424.
806. See A. Marinoni's observations on the aesthetic design of some pages of Leonardo's manuscripts, "Gli scritti di Leonardo," in *Leonardo scienzato*, Florence, 1981, p. 102.
807. The text is given in *Carnets, op. cit.*, I, p. 181. The translation omits two sentences regarding the testicles: the first in the column ("nota quello che affare i coglioni col

corso del spermo") and the penultimate ("Come i coglioni sono/causa d'ardimento").

808. For C. Pedretti, the first "cause" is the testicles, source of the sperm according to Galen, and the second the soul, infused into the body by the spinal cord, according to a theory developed by Avicenna, derived from Hippocrates (in C. Pedretti, *The Literary Works of Leonardo da Vinci. A Commentary to Jean-Paul Richter's Edition*, London, 1977, II, p. 109, n° 841). But in this case, one cannot see in what the alternative of "the first or perhaps the second cause" consists, Leonardo presenting both "causes" simultaneously in his drawing. It is more plausible to link the "first cause" to the creation of Adam by God, since in his first edition of the *Lives* in 1550, Vasari stated that Leonardo had developed "in his mind such a heretical doctrine that it was no longer based on any religion, as he placed scientific knowledge above Christian faith" (see *Lives...*, op. cit., 5, p. 47). In 1568, the suppression of this passage was one of the many corrections made by Vasari to adapt his text to the stricter religious atmosphere following the conclusion of the Council of Trent.
809. S. Freud, *Cinq psychanalyses*, Paris, 1967, p. 349. On the "unusual circumstances" of the coitus represented by Leonardo, see the (humorous) remarks of Reitler in *Freud, Ein Kindheits...*, op. cit., pp. 69–70.
810. See K. Eissler, *Leonardo da Vinci...*, op. cit., p. 224.
811. The male figure presented in profile on the extreme left of the page should be included in the analysis. Devoid of any sexual organ and displaying a digestive system as simplified as it is absurd, it has under the navel (linked to the stomach [?] and indicated by the word *bellico*) a curious excrescence, drawn afterwards, connected to the intestine and designated by the abbreviated inscription *matr~*. Extended horizontally, the anatomized penis seems to be pointing at this figure with a peculiar insistence. Should one see in this connection with the cut sexual organ the reflection of an anguish or culpability linked to homosexuality? For a psychoanalytical interpretation of this part of the sheet, see Cécile Meyssan, in *À corps perdu, Revue d'esthétique*, 27, 95, pp. 172–73.

BIBLIOGRAPHY

This bibliography only includes works and articles directly used in this book and quoted several times in the notes. References to titles quoted only once are given in the corresponding note.

ACKERMANN, J., "Leonardo's Eye," *Journal of the Warburg and Courtauld Institutes*, XLI, 1978. "The Involvement of Artists in Renaissance Science," in *Sciences and the Arts in The Renaissance*, ed. John W. Shirley and F. David Hoeniger, Washington–London–Toronto, 1985.

ALBERTI, L. B., *De Pictura* L. Alberti, *On Painting and Sculpture*, tr. C. Grayson, London, 1972 (edition consulted, *De la Peinture–De Pictura [1435]*, tr. Jean-Louis Schefer, Paris, 1992).

ALLISON, A. H., "Antique Sources of Leonardo's *Leda*," *Art Bulletin*, LVI, 1974.

ANGIOLILLO, M. L., *Leonardo, feste e teatri*, Naples, 1979.

ARASSE, D., "Le Corps fictif de Sébastien et le coup d'œil d'Antonello," in *Le Corps et ses fictions*, Paris, ed. Claude Reichler. 1983. "L'Opération du bord. Observations sur trois peintures classiques," in *Cadres et marges. Actes du IVᵉ colloque du CICADA*, ed. Bertrand Rougé, Pau, 1994. *Le Sujet dans le tableau*, Paris, 1997.

ARESE, M., BONOMI, A., CAVALIERI, C., FRONZA, C., "L'impostazione prospettica della 'Cena' di Leonardo da Vinci: un'ipotesi interpretativa," in *La prospettiva rinascimentale. Codificazioni e trasgressioni*, ed. M. Dalai-Emiliani, Florence, 1980.

BAMBACH CAPPEL, C., "Leonardo, Tagliente and Dürer: 'la scienza del far di gruppi,'" *Achademia Leonardi Vinci*, IV, 1991.

BAROCCHI, P., *Trattati d'arte del Cinquecento. Tra Manierismo e Controriforma*, ed. P. Barocchi, 3 vol., Bari, 1960.

BATTISTI, E., "Le origine religiose del paesaggio veneto," in *Esistenza, Mito, Ermeneutica. Scritti per Enrico Castelli* (edition consulted, *Venezia Cinquecento. Studi di storia dell'arte e della cultura*, 1991, I, 2), Padua, 1980.

BAXANDALL, M., *Giotto and the Orators. Humanist observers of painting in Italy and the discovery of pictorial composition, 1350–1450* (edition consulted, *Les Humanistes à la découverte de la composition en peinture, 1340–1450*, Paris, 1989, tr. Maurice Brock), Oxford, 1971.

BELL, Janis C., "Color Perspective, circa 1492," *Achademia Leonardi Vinci*, V, 1992.

BELLONE, E., "L'infanza della scienza," in *Leonardo da Vinci e l'età della ragione*, ed. Enrico Bellone and Paolo Rossi, Milan, 1982.

BENVENISTE, É., *Problèmes de linguistique générale*, 2 vol., Paris, 1966.

BORSI, F., BORSI, S., *Paolo Uccello*, tr. Adriano Gubellini and Michel Luxembourg, Paris, 1992.

BRACHERT, T., "A Distinctive in the Painting Technique of the Ginevra de' Benci and of Leonardo's other Early Works," *Report and Studies in the History of Arts*, National Gallery of Art, Washington, 1969.

BRIZIO, A. M., *Presentazione dei Codici di Madrid, XIV Lettura Vinciana*, Florence, 1975.

BROCK, M., *Le Secret de la peinture, ou la postérité de Parrhasios: recherches sur l'art italien du Moyen Âge tardif et de la Renaissance* (Thèse d'État, École des hautes études en sciences sociales), Paris, 1996.

BROWN, D. A., "Leonardo and the Idealized Portrait in Milan," *Arte Lombarda*, 67, 1983. "Ladies with the Ermine and the Book," *Artibus et Historiae*, 1990. "Raphael, Leonardo and Perugino: Fame and Fortune in Florence," in *Leonardo, Michelangelo and Raphael in Renaissance Florence from 1500 to 1508*, ed. Serafina Hager, Washington, 1992.

BROWN, D. A., OBERHUBER, K., "*Monna Vanna* and *Fornarina*: Leonardo and Raphael in Rome," in *Essays Presented to Myron Gilmore*, ed. Sergio Bertelli and Gloria Ramakus, Florence, 1978.

CANOVA, C., "Ritratti e teste ideali," in *Il Disegno fiorentino del tempo di Lorenzo il Magnifico*, Milan, 1992.

CASSIRER, E., *Individuum und Kosmos in der Philosophie der Renaissance*, Leipzig–Berlin, 1927, (edition consulted, *Individu et cosmos dans la philosophie de la Renaissance*, tr. Pierre Quillet, Paris, 1983).

CASTIGLIONE, B., *Il Libro del Cortegiano*, Venice, 1528, (edition consulted, *Le Livre du Courtisan*, Paris, 1987, translated and introduced by Alain Pons).

CECCHI, A. NATALI, A., SISI, C., "L'Officina della maniera," in *L'Officina della maniera. Varietà e fierezza nell'arte fiorentina del Cinquecento fra le due republiche, 1494–1530*, Florence, 1996.

CHASTEL, A., *Art et Humanisme à Florence au temps de Laurent le Magnifique*, Paris, 1959, (edition consulted, Paris, 1981). "Actualité des écrits léonardiens sur la peinture," in Léonard de Vinci, *Traité de la peinture*, ed. A. Chastel, R. Klein, Paris, 1960. *Fables, formes, figures*, 2 vol., Paris, 1978. "Les Problèmes de l'architecture de Léonard dans le cadre de ses théories scientifiques," in *Léonard de Vinci, ingénieur et architecte*, Montreal, 1987.

CLARK, K., *Leonardo da Vinci* London, 1935, (edition consulted, Paris, 1967, tr. Eleanor Levieux and Françoise-

Marie Rosset). "Leonardo and the Antique," in *Leonardo's Legacy. An International Symposium*, ed. C.D. O'Malley, Berkeley–Los Angeles, 1969. "Mona Lisa," *Burlington Magazine*, CXXV, March 1973.

CLARK, K., PEDRETTI, C., *Leonardo da Vinci. Drawings at Windsor Castle*, 3 vol., London, 1968.

CLAYTON, M., "Leonardo da Vinci anatomist," in *Leonardo da Vinci: Anatomy of Man: Drawings from the Collection of Her Majesty Queen Elizabeth II*, Houston–Boston, 1992 (edition consulted, *Léonard de Vinci. Anatomie de l'homme. Dessins de la collection de la reine Élisabeth II*, tr. Caroline Rivolier, Paris, 1992). "Studi per Adorazioni," in *Leonardo & Venezia*, Milan, 1992. *Leonardo da Vinci. One Hundred Drawings from the Collection of Her Majesty the Queen*, London, 1996.

COLENBRANDER, H. T., "Hands in Leonardo Portraiture," *Achademia Leonardi Vinci*, V, 1992.

DALLI REGOLI, G., "Mito e Scienza nella "Leda" di Leonardo," *Lettura Vinciana*, Florence, 1991.

DAMISCH, H., *Théorie du "nuage." Pour une histoire de la peinture*, Paris, 1972.

DIBNER, B., RETI, L., *Leonardo da Vinci Technologist*, Norwalk (Connecticut), 1969.

DIBNER, B., "Machines et engins de guerre," in *Léonard de Vinci. l'humaniste, l'artiste, l'inventeur*, Paris, 1974.

DIONISOTTI, C., "Leonardo, uomo di lettere," *Italia Medioevale e Umanistica*, V, 1962.

DUGAS, R., "Léonard de Vinci dans l'histoire de la mécanique," in *Léonard de Vinci et l'expérience scientifique au XVIᵉ siècle*, Paris, 1953.

DUHEM, P., *Études sur Léonard de Vinci. Ceux qu'il a lus et ceux qui l'ont lu*, 4 vol., Paris, 1906–13.

EDGERTON Jr, S., "The Renaissance Development of the Scientific Illustration," in *Science and the Arts in the Renaissance*, ed. John W. Shirley and F. David Hoeniger, Washington–London–Toronto, 1985.

EISSLER, K. R., *Leonardo da Vinci*, New York, 1961 (edition consulted, *Léonard de Vinci. Étude psychanalytique*, Paris, 1980, tr. Sophie Mellor-Picaut).

FALLAY D'ESTE, L., *Le Paragone. Le parallèle des arts*, Paris, 1992.

FOUCAULT, M., *Les Mots et les choses. Une archéologie des sciences humaines*, Paris, 1966.

FREEDBERG, S. J., "A recovered work of Andrea del Sarto with some notes on a leonardesque connection," *Burlington Magazine*, CXXIV, 1982.

FREUD, S., *Eine Kindheitserinnerung des Leonardo da Vinci*, 1910, (edition consulted, *Un souvenir d'enfance de Léonard de Vinci*, Paris, 1987, tr. Janine Altounian, André and Odile Bourguignon, Pierre Cotet and Alain Rauzy).

GADOL, J. K., *Leon Battista Alberti. Homme universel des débuts de la Renaissance*, Paris, 1995, tr. Jean-Pierre Ricard, Chicago, 1969.

GALLUZZI, P., "La Carrière d'un technologue," in *Léonard de Vinci, ingénieur et architecte*, Montreal, 1987. "Le macchine senesi. Ricerca antiquaria, spirito di innovazione e cultura del territorio," in *Prima di Leonardo. Cultura delle macchine a Siena nel Rinascimento*, Milan, 1991. *Les Ingénieurs de la Renaissance de Brunelleschi à Léonard*, Florence–Paris, 1995.

GARIN, E., "Il problema delle fonti del pensiero di Leonardo," 1953, in *La cultura filosofica del Rinascimento*, Florence, 1961. "La città in Leonardo," 1971, in *Leonardo letto e commentato*, Florence, 1974.

GOMBRICH, E., "Leonardo's method for Working out Compositions," 1952, in *Norm and Form. Studies in the Art of the Renaissance*, London, 1966. "The Form of Movement in Water and Air" in *The Heritage of Apelles*, Ithaca, 1976 (edition consulted, "Les formes en mouvement de l'eau et de l'air dans les Carnets de Léonard de Vinci," in *L'Écologie des images*, Paris, 1983, tr. Alain Lévêque). "Leonardo and the Magicians: Polemics and Rivalry," 1983, in *New Light on Old Masters. Studies in the Art of the Renaissance, IV*, London, 1986.

GOULD, C., "Leonardo's Great Battle Piece. A Conjectural Reconstruction," *Art Bulletin*, XXXVI, 1954.

GRENDLER, P. F., *Schooling in Renaissance Italy. Literacy and Learning, 1300–1600*, Baltimore–London, 1989.

GUILLAUME, J., "Léonard et l'architecture," in *Léonard ingénieur et architecte*, Montreal, 1987.

GUILLERM, J.-P., *Tombeau de Léonard de Vinci. Le peintre et ses tableaux dans l'écriture symboliste et décadente*, Lille, 1981.

HARTFIELD, R., *Botticelli's Uffizi "Adoration." A Study in Pictorial Content*, Princeton, 1976.

HARTT, F., "Leonardo and the Second Florentine Republic," *Journal of the Walters Art Gallery*, 44, 1986.

HEYDENREICH, L., *The Last Supper*, London, 1974.

JACQUOT, J., "Les types de lieu théâtral et leurs transformations de la fin du Moyen Âge au milieu du XVIIᵉ siècle," in *Le Lieu théâtral à la Renaissance*, Paris, 1968.

KEELE, K., "Leonardo da Vinci's Science of Man," in *Leonardo's Legacy. An International Symposium*, ed. C.D. O'Malley (reprinted in *Leonardo e l'età della ragione*, Milan, 1982, ed. Enrico Bellone and Paolo Rossi), Berkeley–Los Angeles, 1969.

KEMP, M., "Leonardo da Vinci: motions of life in the lesser and greater worlds," in *Nine Lectures on Leonardo da Vinci*, London (University of London), no date. "'Ogni dipintore dipinge se': a Neoplatonic Echo in Leonardo's Art Theory?," in *Cultural Aspects of the Italian Renaissance. Essays in Honour of Paul*

Oskar Kristeller, New York, 1976. "Leonardo and the Visual Pyramid," *Journal of the Warburg and Courtauld Institutes*, XL, 1977. "From "Mimesis" to "Fantasia": the Quattrocento Vocabulary of Creation and Genius in the Visual Arts," *Viator*, VIII, 1977. *Leonardo da Vinci. The Marvellous Works of Nature and Man*, London–Cambridge (Mass.), 1981, edition consulted, Milan, 1982. "The Crisis of Received Wisdom in Leonardo's Last Thought," in *Leonardo e l'età della ragione*, ed. Enrico Bellone and Paolo Rossi, Milan, 1982. "Leonardo's maps and the 'Body of the Earth,'" *Bulletin of the Society of University Cartographers*, 17, 1984. "Analogy and Observation in the Codex Hammer," in *Studi Vinciani in memoria di Nando de Toni*, Brescia, 1986. *The Science of Art. Optical themes in western art from Brunelleschi to Seurat*, New Haven–London, 1990. "Leonardo verso il 1500," in *Leonardo & Venezia*, Milan, 1992. *The Mystery of the Madonna of the Yarnwinder*, Edinburgh, 1992. "Leonardo's Drawings for 'il Cavallo del Duca di bronzo': the Program of Research," in *Leonardo da Vinci's Sforza Monument: the Art and the Engineering*, ed. Diane Cole Hall, Bethlehem–London, 1995.

KEMP, M., SMART, J., "Leonardo's *Leda* and the Belvedere *River Gods*," *Art History*, III, 2, 1980.

KIANG, D., "Gasparo Visconti's *Pasitea* and the Sala delle Asse," *Achademia Leonardi Vinci*, II, 1989.

KISH, S., "Leonardo da Vinci the Mapmaker," in *Imago et mensura mundi. Atti del IX Congresso internazionale di storia della cartografia*, Rome, 1985.

KLIBANSKY, R., "Copernic et Nicolas de Cues," in *Léonard de Vinci et l'expérience scientifique au XVIᵉ siècle*, Paris, 1953.

KOYRÉ, A., "Remarques sur les paradoxes de Zénon," 1922, in *Études d'histoire de la pensée philosophique*, Paris, 1961 (edition consulted, Paris 1971). "Galilée et Platon," 1943, in *Études d'histoire de la pensée scientifique*, Paris, 1966 (edition consulted, Paris, 1973). "L'apport scientifique de la Renaissance," 1949, in *Études d'histoire de la pensée scientifique*, Paris, 1966 (edition consulted, Paris, 1973). "Léonard de Vinci 500 ans après," 1953, in *Études d'histoire de la pensée scientifique*, Paris, 1966 (edition consulted, Paris, 1973). "Galilée et la révolution scientifique du XVIIᵉ siècle," 1955, in *Études d'histoire de la pensée scientifique*, Paris, 1966 (edition consulted, Paris, 1973). *Du monde clos à l'univers infini*, 1957, Paris, 1962.

KUHN, T., *The Structure of Scientific Revolutions*, Chicago, 1962 (edition consulted, Paris, 1983).

LÉONARD DE VINCI, *Les Carnets* (Arrangement and notes by Edward MacCurdy, tr. by Louise Servicen), Paris, 1942. *Scritti letterari*, ed. Augusto Marinoni (edition consulted, Milan, 1974), Milan, 1952. *Traité de la peinture*, ed. André Chastel and Robert Klein, Paris, 1960.

LÉVI-STRAUSS, C., *La Pensée sauvage*, Paris, 1962.

LOMAZZO, G. P., *Trattato dell'arte della Pittura, Scoltura et Architettura* (edition consulted, in *Scritti sulle arti*, Florence, 1973, ed. Roberto Paolo Ciardi), Milan, 1584. *Idea del Tempio della Pittura*, Milan, 1590, (edition consulted, Florence, 1974, tr. and commentary by Robert Klein).

MACAGNO, E., "Analogies in Leonardo's Studies of Flow Phenomena," in *Studi Vinciani in memoria di Nando de Toni*, Brescia, 1986.

MACCAGNI, C., "Riconsiderando il problema delle fonti di Leonardo," 1970, in *Leonardo letto e commentato*, Florence, 1974. "Considerazioni preliminari alla lettura di Leonardo," in *Leonardo e l'età della ragione*, ed. Enrico Bellone and Paolo Rossi, Milan, 1982. "Scienza e tecnica in Emilia e Romagna al tempo del Codice Hammer," in *Leonardo: il Codice Hammer e la mappa di Imola presentati da Carlo Pedretti*, Florence, 1985.

MALTESE, C., "Il pensiero architettonico di Leonardo," in *Leonardo. Saggi e ricerche*, Rome, 1954.

MARANI, P. C., "Leonardo e le colonne *ad tronchonos*: tracce di un programma iconologico per Lodovico il Moro," *Raccolta Vinciana*, XXI, 1982. "Leonardo e l'architettura fortificata: connessioni e sviluppi," in *L'età della ragione*, ed. Enrico Bellone and Paolo Rossi, Milan, 1982. "La Mappa di Imola di Leonardo," in *Leonardo: il Codice Hammer e la Mappa di Imola presentati da Carlo Pedretti*, Florence, 1985. *Il Cenacolo di Leonardo*, Milan, 1986. "Léonard, l'architecture de fortification et ses problèmes de structure," in *Léonard de Vinci, ingénieur et architecte*, Montreal, 1987. *Leonardo da Vinci. Catalogo completo delle pitture* (edition consulted, *Léonard de Vinci. Catalogue complet des peintures*, Paris, 1991, tr. Isabelle Rabourdin), Florence, 1989. "I dipinti di Leonardo, 1500–07: Per una cronologia," in *Leonardo, Michelangelo and Raphael in Renaissance Florence from 1500 to 1508*, ed. Serafina Hager, Washington, 1992.

MARIN, L., "Les combles et les marges de la représentation," *Rivista d'Estetica*, 17, 1984.

MARINONI, A., "L'Essere del nulla," 1960, in *Leonardo letto e commentato*, Florence, 1974. "Leonardo as a Writer," in *Leonardo and His Legacy, An International Symposium*, ed. C. D. O'Malley, Berkeley-Los Angeles, 1969. "L'Écrivain," in *Léonard de Vinci. L'humaniste, l'artiste, l'inventeur*, Paris, 1974. "I Libri di Leonardo," in *Léonard de Vinci, I Scritti letterari*, Milan, 1974. "Leonardo, la musica e lo spettacolo," in *Leonardo e gli spettacoli del suo tempo*, ed. Mariangela Mazzocchi Doglio, Gianpiero Tintori, Maurizio Padovan et Marco Tiella, Milan, 1982. "La biblioteca di Leonardo," *Raccolta Vinciana*, XXII, Milan, 1987. "Les machines impossibles de Léonard," in *Léonard de Vinci, ingénieur et architecte*, Montreal, 1987. "La pianta di Imola," in *Leonardo artista delle macchine e cartografo*, ed. Rosaria Campioni, Florence, 1994.

MARTONE, T., "Leonardo da Vinci's Reaction Portraits," *Rivista di Studi italiani* (Université de Toronto), II, 2, 1984.

MAZZOCCHI DOGLIO, M., "Leonardo 'apparatore' di spettacolo a Milano per la corte degli Sforza," in *Leonardo e gli spettacoli del suo tempo*, ed. Mariangela Mazzocchi Doglio, Gianpiero Tintori, Maurizio Padovan and Marco Tiella, Milan, 1982.

NAGEL, A., "Leonardo and *sfumato*," *Res. Anthropology and aesthetics*, 24, 1993.

NATALI, A., "Re, cavalieri e barbari: le 'Adorazioni dei Magi' di Leonardo e Filippino Lippi," in *Pittori della Brancacci agli Uffizi, Gli Uffizi. Studi e ricerche*, 5, 1981.

NATHAN, J., "Some Drawing Practices of Leonardo da Vinci: New Light on the *St. Anne*," *Mitteilungen des Kunsthistorischen Institutes in Florenz*, XXVI, 1992.

PANOFSKY, E., *The Codex Huygens and Leonardo's Art Theory*, Warburg Institute (edition consulted, *Le Codex Huygens et la théorie de l'art de Léonard de Vinci*, Paris, 1996, tr. Daniel Arasse), London, 1940. "Artist, Scientist, Genius: Notes on the 'Renaissance-Dämmerung,'" in *The Renaissance, Six Essays*, ed. W. Ferguson, New York, 1952. (edition consulted in *L'Œuvre d'art et ses significations. Essais sur les "arts visuels*,*"* Paris, 1969, tr. Marthe and Bernard Teyssèdre)

PEDRETTI, C., *Fragments at Windsor Castle from the Codex Atlanticus*, London, 1957. *Studi Vinciani*, Geneva, 1957, 2. *Leonardo inedito. Tre saggi*, Florence, 1968. *Leonardo. A Study in Chronology and Style*, London, 1973. "Eccetera: perchè la minestra si fredda," *XV Lettura Vinciana*, Florence, 1975. *The Literary Works of Leonardo da Vinci compiled and edited from the Original Manuscripts by Jean-Paul Richter. Commentary*, 2 vol., Oxford, 1977. *Leonardo architetto*, Milan, 1978 (edition consulted, Milan, 1981). "Ancora sul rapporto Giorgione-Leonardo e l'origine del ritratto di spalla," in *Giorgione. Convegno internazionale di studi*, Castelfranco Veneto, 1979. *Leonardo da Vinci. Studi di Natura dalla Biblioteca Reale nel Castello di Windsor*, Florence (n. 62), 1982. "La 'Leda' di Vinci," in *Leonardo e il leonardismo a Napoli e a Roma*, Florence, 1983. *I cavalli di Leonardo. Studi sul cavallo e altri animali dalla Biblioteca Reale nel Castello di Windsor*, Florence, 1984. "The Angel in the Flesh," *Achademia Leonardi Vinci*, IV, 1991.

PHILO, R., Commentary on the Plates in *Leonardo da Vinci: Anatomy of Man: Drawings from the Collection of Her Majesty Queen Elizabeth II*, Houston–Boston, 1992 (edition consulted, *Léonard de Vinci. Anatomie de l'homme. Dessins de la collection de la reine Élisabeth II*, tr. Caroline Rivolier, Paris, 1992).

PIRROTTA, N., "Musiche intorno a Giorgione," in *Giorgione. Convegno Internazionale di Studi*, Castelfranco, 1979.

PONS, N., "Dipinti à più mani," in *Maestri e botteghe. Pitture a Firenze alla fine del Quattrocento*, Milan, 1992.

PRIGOGINE, ILYA and STENGERS, I., *La Nouvelle Alliance. Métamorphose de la science* (edition consulted, Paris, 1986), Paris, 1979 .

RETI, L., see Dibner and Reti, 1969.

RICHTER, J.-P., *The Literary Works of Leonardo da Vinci compiled and edited from the Original Manuscripts*, 2 vol., London, 1883, (edition consulted, Oxford, 1970).

ROSAND, D., "Alcuni pensieri sul ritratto e la morte," in *Giorgione e l'Umanesimo veneziano*, ed. Rodolfo Palluchini, Florence, 1981. *The Meaning of the Mark: Leonardo and Titian*, The Spencer Museum of Art (edition consulted, *La Marque de l'artiste, Léonard et Titien*, Paris, 1993, tr. Jeanne Bouniort), University of Kansas, 1988.

SANTILLANA, G. De, "Léonard et ceux qu'il n'a pas lus," in *Léonard de Vinci et l'expérience scientifique au XVIᵉ siècle*, Paris, 1953.

SAXL, F., "Science and Art in the Italian Renaissance," 1938, in *Lectures*, 2 vol., London, 1957.

SCAGLIA, G., "Une typologie des mécanismes et des machines de Léonard," in *Léonard de Vinci, ingénieur et architecte*, Montreal, 1987.

SCHAPIRO, M., "Leonardo and Freud: an Art-Historical Study," 1956, *Journal of History of Ideas*, 17 (edition consulted, "Léonard et Freud: une étude d'histoire de l'art," in *Style, artiste et société*, Paris, 1982, tr. Jean-Claude Lebensztejn).

SERGESCU, P., "Léonard de Vinci et les mathématiques," in *Léonard de Vinci et l'expérience scientifique du XVIᵉ siècle*, Paris, 1953.

SHEARMAN, J., "Leonardo's Colour and Chiaroscuro," 1962, *Zeitschrift für Kunstgeschichte*, XXV, 1962, pp. 13–47.

SHELL, J. and SIRONI, G., "Salai and Leonardo's Legacy," *Burlington Magazine*, CXXXIII, 1991.

SMYTH, C. H., "Venice and the Emergence of the High Renaissance in Florence: Observations and Questions," in *Florence and Venice. Comparisons and Relations*, ed. Sergio Bertelli and Nicolai Rubinstein, Florence, 1979.

STEINBERG, L., "Leonardo's *Last Supper*," *The Art Quarterly*, winter 1973.

STEINITZ, K. T., "Le dessin de Léonard de Vinci pour la représentation de la *Danaé* de Baldassare Taccone," in *Le Lieu théâtral à la Renaissance*, ed. Jean Jacquot, Paris, 1968. "Leonardo architetto teatrale e organizzatore di feste," 1969, in *Leonardo letto e commentato*, Florence, 1974.

STRONG, D. S., "The Triumph of Mona Lisa," in *Leonardo e l'età della ragione*, ed. Enrico Bellone and Paolo Rossi, Milan, 1982.

TAFURI, M., *L'Architettura dell'Umanesimo*, Bari, 1969 (edition consulted, Bari, 1972).

TIELLA, M., "Gli strumenti musicali disegnati da Leonardo da Vinci," in *Leonardo e gli spettacoli del suo tempo*, ed. Mariangela Mazzocchi Doglio, Gianpiero Tintori, Maurizio Padovan and Marco Tiella, Milan, 1982.

TURNER, R., "Words and Pictures: the Birth and Death of Leonardo's *Medusa*," *Arte Lombarda*, 3, 1983. *Inventing Leonardo*, New York, 1993.

VALÉRY, P., *Introduction à la méthode de Léonard de Vinci*, 1919, Paris (1894) (edition consulted, Paris, 1957).

VASARI, G., *Le Vite de' più eccellenti pittori, scultori ed architettori*, Florence, 1550–68, (editions consulted, Florence, 1906; *Les Vies des meilleurs peintres, sculpteurs et architectes*, Paris, 1981–87, edited by André Chastel).

VASOLI, C., "La Lalde del Sole," 1972, in *Leonardo letto e commentato*, Florence, 1974. "Note su Leonardo e l'alchimia," in *Leonardo e l'età della ragione*, ed. Enrico Bellone et Paolo Rossi, Milan, 1982.

VECCE, C., "Leonardo e il gioco," in *Passare il tempo. La letteratura del Gioco e dell'intrattenimento dal XII al XVI secolo (Atti del Convegno di Pienza, 10–14 sett. 1991)*, Rome, 1993.

WALKER, J., "*Ginevra de' Benci* by Leonardo da Vinci," *Report and Studies in the History of Art*, National Gallery of Art, Washington, 1967.

WARNKE, M., *Hofkünstler. Zur Vorgeschichte des modernen Künstlers*, 1985, (edition consulted, *L'Artiste et la Cour. Aux origines de l'artiste moderne*, Paris, 1989, tr. Sabine Bollack).

WASSERMAN, J., "Reflections on *The Last Supper* of Leonardo da Vinci," *Arte Lombarda*, 66, 1983.

WILCOX, D. J., *The Development of Florentine Humanist Historiography in the Fifteenth Century*, Cambridge (Mass.), 1969.

WIND, E., *Pagan Mysteries in the Renaissance*, London, 1958, (edition consulted, Paris, 1992, tr. Pierre-Emmanuel Dauzat).

WINTERNITZ, E., "Léonard et la musique," in *Léonard de Vinci. L'humaniste, l'artiste, l'inventeur*, Paris, 1974. *Leonardo as a Musician*, New Haven, 1982.

WITTKOWER, M. and R., *Born under Saturn*, New York, 1963, (edition consulted, *Les Enfants de Saturne. Psychologie et comportement des artistes de l'Antiquité à la Révolution française*, Paris, 1991, tr. Daniel Arasse).

WOOD, C. T., "The Doctor's Dilemma: Sin, Salvation and the Menstrual Cycle in Medieval Thought," *Speculum*, LVI, 1981.

ZÖLLNER, F., "Leonardo's Portrait of Mona Lisa del Giocondo," *Gazette des Beaux-Arts*, March 1993.

INDEX OF PROPER NAMES

Thaddeus, Saint, 380
Thales, 129
Theseus, 142
Thomas, Saint, 366, 374, 380, 381
Timanthes, 312
Tintoretto (Jacopo Robusti, known as), 359
Titian (Tiziano Vecelli, known as), 270
Tolentino, Niccolo da, 434
Tommé, Luca di, 449
Tornabuoni, Giovanna, 397
Torre, Marcantonio della, 82, 95, 278
Traversari, Ambrogio, 221
Trivulzio, Giovanni Giacomo, 251, 254
Turner, Richard, 13

Uccello, Paolo, 341, 433, 434
Urbino, Carlo, 104, 105, 120, 129, 133

Valéry, Paul, 14
Valla, Lorenzo, 150
Valturius, 36, 41, 43
Van Eyck, Jan, 406
Vasari, Giorgio, 12, 13, 19, 28, 31, 52, 65, 120, 134, 149, 152, 156, 160, 220, 255, 261, 300, 309, 319, 334, 386, 388, 408, 417, 428, 429, 430, 442, 445, 446, 462, 474, 476, 477, 482, 484, 485
Vasoli, Cesare, 115
Venturi, Adolfo, 29
Venturi, Giovanni Battista, 31
Verino, Ugolino, 468
Verrocchio, Andrea del, 11, 39, 46, 47, 52, 53, 135, 189, 220, 242, 247, 293, 316, 334, 336, 339, 341, 348, 349, 395, 404, 408
Vesalius, Andreas, 88, 274
Vespucci, family, 349

Villani, Tommasa, 388
Vinci, Ser Piero da, Leonardo's father, 476, 477
Vinci, Caterina da, Leonardo's mother, 489
Vigevano, Guido da, 190, 192
Virgilio di Andriani, Marcello, 429
Vitellius, Aulus, 118
Vitruvius (Marcus Vitruvius Pollio), 95, 105, 120, 143, 240

Walker, John, 312
Werbecke, Gaspar van, 221
Wind, Edgar, 143
Winternitz, Emanuel, 62
Wittkower, Margot and Rudolf, 483
Wölfflin, Heinrich, 408

Zeuxis, 269, 296

INDEX OF WORKS

The works taken from the codexes and manuscripts are listed under the name of the volume to which they belong
(Codex Arundel, Atlanticus, Forster, Huygens, Leicester, Trivulziano, Urbinas,
Codex on the Flight of Birds, and the French, Madrid, and Windsor Manuscripts).
The numbers printed in bold refer to illustrations.

540

PHOTOGRAPHIC CREDITS